When Time Began to Rant and Rage

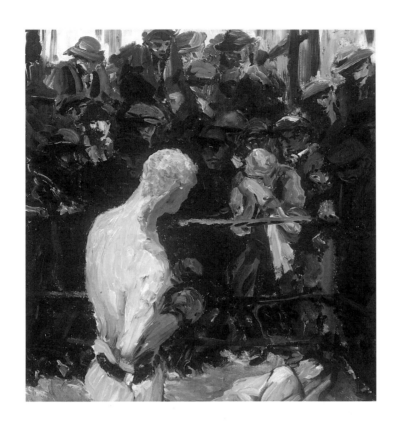

Know, that I would accounted be
True brother of a company
That sang, to sweeten Ireland's wrong,
Ballad and story, rann and song;
Nor be I any less of them,
Because the red-rose-bordered hem
Of her, whose history began
Before God made the angelic clan,
When Time began to rant and rage
The measure of her flying feet
Made Ireland's heart begin to beat;
And Time bade all his candles flare
To light a measure here and there;
And may the thoughts of Ireland brood
Upon a measured quietude.

First stanza from William Butler Yeats,
"To Ireland in the Coming Times" (1892)
from *The Rose*, 1893

When Time
Began to Rant and Rage

Figurative Painting

from Twentieth-Century Ireland

JAMES CHRISTEN STEWARD

Editor

With essays by

BRUCE ARNOLD

SIGHLE BHREATHNACH-LYNCH

AIDAN DUNNE

MARIANNE HARTIGAN

KENNETH MCCONKEY

CAOIMHÍN MAC GIOLLA LÉITH

PAULA MURPHY

PETER MURRAY

JAMES CHRISTEN STEWARD

COLM TOÍBÍN

MERRELL HOLBERTON
PUBLISHERS LONDON

Published on the occasion of the exhibition
When Time Began to Rant and Rage: Figurative Painting from Twentieth-Century Ireland
organized by the University of California, Berkeley Art Museum

Exhibition itinerary:

Walker Art Gallery, Liverpool

16 October 1998 – 10 January 1999

Berkeley Art Museum
10 February – 1 May 1999

Grey Art Gallery, New York University

grey art gallery

25 May – 24 July 1999

Barbican Art Gallery, London
September – December 1999

Published 1998 by Merrell Holberton Publishers Ltd.
© 1998 by The Regents of the University of California, Berkeley

The exhibition *When Time Began to Rant and Rage: Figurative Painting from Twentieth-Century Ireland* and accompanying programs have been made possible in part by a major grant from the National Endowment for the Humanities, dedicated to expanding American understanding of human experience and cultural heritage.

NATIONAL ENDOWMENT FOR THE
HUMANITIES

Additional funding for this exhibition was provided by the American Ireland Fund, the British Council in conjunction with the Department of Education for Northern Ireland, and the Department of Foreign Affairs, Dublin.

The British Council
in association with
The Department of
Education for
Northern Ireland

Produced by Merrell Holberton Publishers Ltd.,
Willcox House, 42 Southwark Street, London SE1 1UN

Designed by Roger Davies

Library of Congress Catalog Card Number: 98-87897

ISBN 1 85894 059 1 (hardcover)
ISBN 1 85894 074 5 (paper)

Printed in Italy

Jacket/cover: Dermot Seymour, *The Russians*
will Water their Horses on the Shores of Lough Neagh (Plate 62)

Contents

AIB Group The Arts Council/An Chomhairle Ealaíon

Armagh Museum, courtesy Ulster Museum Arts Council of Northern Ireland

Elizabeth Ballagh Crawford Municipal Art Gallery, Cork

Lady Davis-Goff Hallward Gallery, Dublin

Hirshhorn Museum and Sculpture Garden, Smithsonian Institution

Hugh Lane Municipal Gallery of Modern Art, Dublin Imperial War Museum, London

Irish Museum of Modern Art Eithne Jordan, courtesy Rubicon Gallery, Dublin

Michael Kane Sandra Leibbrand and Mícheál O Brolacháin Niall and Dorothea MacCarvill

Peter F.J. Macdonald Kate Middleton Joseph M. and JoAnn Murphy

National Gallery of Canada, Ottawa National Gallery of Ireland Dr. Patricia Noone

Blaise and Dolores O'Carroll Pyms Gallery, London

Sligo County Library Michael H. Traynor and Orlaith Traynor Ulster Museum

University of Ulster Walker Art Gallery, Liverpool

The Walters Art Gallery, Baltimore, Maryland Private collections

PHOTOCREDITS

Jack Rutberg Fine Arts, Los Angeles: Fig. 61

Photo RMN-Arnaudet: Fig. 83

Bryan F. Kiriadge: Plate 37

Photothèque des Musées de la Ville de Paris: Fig. 76

Foreword

It has become of late almost a commonplace among commentators on the Irish scene to observe that it is, at last, Ireland's moment in the sun. This observation is based first on the enormous successes of the Irish economy in recent times – including the fastest growing GNP among members of the European Union, giving birth to the term "the Celtic Tiger" – and second on a resurgent cultural arena – from the awarding of the Nobel Prize for Literature in 1995 to Seamus Heaney (whose presence will, parenthetically, grace the Berkeley campus during the Berkeley run of the present exhibition), to the enormous popular success of books such as Frank McCourt's *Angela's Ashes* or the quieter but no less substantial critical success of Seamus Deane's *Reading in the Dark*. A succession of young Irish playwrights, including Martin McDonagh – characterized by the *The New York Times* as "the latest sensation of Irish writing" – Conor McPherson, and Marina Carr, have stormed first London and more recently the New York stage. The Irish classics are revived and rediscovered: the past year has seen several projects on the life and writings of Oscar Wilde; San Francisco's American Conservatory Theater will present O'Casey's *Juno and the Paycock* in 1999 in celebration of the present exhibition. Rarely a week goes by that the *New York Times* "Arts & Ideas" pages do not engage with – and typically champion – the latest Irish play, novel, film, actor, or dance. When the *Times* published a piece in December 1997 entitled "The Arts Find Fertile Ground In a Flourishing Ireland" this only confirmed the point – even if the visual arts seemed still to be further to the background than the performing and literary arts.

This was not news, of course, to those of us who have been paying attention. Both of the leading international auction houses, Sotheby's and Christie's, have recently developed specialist sales of Irish art, for example. From the time of my own first visit to Belfast in 1993, under the auspices of the British Council and as a guest of the Ulster Museum, I have been intensely aware of the cultural energy pouring forth from both the Irish Republic and Northern Ireland. Indeed, the inspiration for this project came initially from

a series of studio visits I made while in Belfast – where I saw firsthand, amongst others, the extraordinary work of David Crone and Rita Duffy for the first time. Apart from a similarity of stylistic concerns shared by artists working in Expressionist veins, I was struck by the degree to which the painting coming out of Belfast expressed the kind of vitality that poured out of Berlin in the 1980s. Indeed it is tempting to draw parallels. To paint in Belfast in the early 1990s, where the art market has for the past generation often been negligible and opportunities for public display have been limited; to choose to stay in the face of these constraints, and in the face of repeated disappointments during the failed ceasefires of the 1990s: these were acts of commitment that created an intensity reminiscent of Berlin in the years before the Wall came down.

Certainly the situation in Belfast and throughout Ireland (which for simplicity I take here to refer to the geographic island; when distinctions are to be made, I shall refer to the North, the South, the Republic, etc.) has changed greatly in the past five years. Armed troops were omnipresent in Belfast in 1993; now, as I write, a peace treaty has been negotiated for the first time since 1973, and will be put to referenda in both the North and the South in May 1998. Prosperity has brought extraordinary opportunities as well as new challenges, challenges to maintain the physical beauty of the Georgian city of Dublin, to control growth in the Irish countryside, to absorb the reverse migration that Ireland is seeing for the first time in over a century, to sustain manageable growth as subsidies from the European Union are inevitably reduced or eliminated. The success of Irish cultural projects internationally challenges us to regard the full complexity of the Irish situation, rather than descending into safe stereotypes of a certain touristic simplicity that can be held at arm's length.

It seems fortuitous for our project, then, that the world's attention has recently turned to Ireland in new and often positive ways. Indeed I feel privileged to participate in Ireland's moment in the sun. My initial impulse was simple: to develop an exhibition of Irish painting that drew on the

energy I witnessed five years ago. My first thought was to focus on contemporary Irish painting with the express intention of bringing it to a public for whom this has been little known. Yet it quickly seemed that something more than a glance at contemporary painting was needed, a project that would provide a context for looking at the work being done today in Dublin, Belfast, and throughout the island. There have been not a few travelling exhibitions that focussed on individual Irish painters, or groups of contemporary painters, or specific collections, such as the distinguished collection of Brian Burns that has been shown in Boston, Dublin, and New Haven. And yet each of these in their own way has not had the sweep that, it seemed to me, would be important for encouraging an appreciation of the Irish visual arts outside of Ireland. This project, examining the intersection of Irish painting, culture, and politics in the twentieth century – that is to say roughly from the advent of a defined independence movement to the present – is thus the result.

With this decision to look at the crossroads of the visual, cultural, and political in place, other parameters had to be established. Clearly parameters were required – we are, after all, surveying 100 years of painting with only 75 examples and with serious space and budgetary constraints. The most important of these choices was to focus exclusively on painting, a decision largely made for practical reasons concerning the travel of sculpture and the light sensitivity of works on paper (although a companion exhibition of works on paper will be mounted both in Berkeley and New York). The second key choice was to focus exclusively on representational painting in which the figure is central, as this seemed the most compelling area in which cultural issues and subject matter could be explored. Yet we do not pretend that this selection represents the definitive exhibition of twentieth-century Irish art. Such a project would perforce need to include sculpture, installation, photography, and video, and even then such a project is destined to be incomplete: much of the most compelling art made in Ireland in recent years has been in the form of mural art on the walls of Belfast, which by their nature cannot travel. And this may account for a certain perceived bias in the contemporary selection here: to a very great extent much of the most powerful pro-Unionist, pro-Orange painting has taken the form of mural painting or public art, and cannot therefore be included here.

It bears saying, I think, that our goal has been the presentation of a balanced and unbiased selection of what we can consider to be the best Irish painting in the representational, figurative idiom. This involves, by its nature, subjective judgements. And while we have benefited from the advice and views not only of our international advisory committee but of numerous colleagues engaged in the world of Irish painting, in the end the selection, and the responsibility for its failings, is mine. And if *When Time Began to Rant and Rage* is by its nature incomplete, we present it as a provisional investigation that will, we hope, bring a new awareness of Irish painting to audiences in England and the United States, and will encourage useful discussion of an area of artistic achievement that has remained too little known beyond its own shores.

An exhibition of this complexity obviously does not happen without the involvement of a great number of organizations and individuals. I must first, therefore, offer my warm thanks to those lenders and collaborators who have offered their time and their precious loans. I therefore single out those lenders who have also opened their archives and offices to me in developing this project: Barbara Dawson, Director of the Hugh Lane Municipal Gallery of Modern Art in Dublin; Alan Hobart of Pyms Gallery in London, who has done so much to develop international awareness of Irish painting; Raymond Keaveney, Director of the National Gallery of Ireland, as well as his colleagues Adrian Le Harivel and Hilary Pyle; Brian Kennedy, Senior Keeper at the Ulster Museum in Belfast, and his colleagues Eileen Black and Anne Abernethy; and Declan McGonagle, Director of the Irish Museum of Modern Art in Dublin. Warmest thanks also to those artists who gave up precious time in their studios to help me learn about the riches of contemporary painting in Ireland, most notably David Crone, Rita Duffy, Patrick Graham, and John Kindness.

Equally important to the success of this undertaking have been the many donors who have helped to underwrite this project, most notably the National Endowment for the Humanities, the federal agency dedicated to expanding American understanding of human experience and cultural heritage. Their enthusiastic and generous support for this project reaffirms the importance and viability of multi-disciplinary humanities projects within the art museum context. Additional major support has been provided by the American Ireland Fund, whose San Francisco-based

supporters, including Brian Burns, Maryon Davies Lewis, William Roth, and William Vincent, have enthusiastically endorsed our efforts. I am also most grateful to the British Council in Belfast and its director there, Peter Lyner, for first introducing me to my subject through a series of travel grants, for providing multi-year support, and for being, along with Brian Ferran, Director of the Arts Council for Northern Ireland, warm hosts and allies in Belfast. Likewise, I thank the Cultural Affairs Division of the Department of Foreign Affairs in Dublin for their interest in promoting international awareness of Irish culture. Finally, warm thanks are due to the Trustees and International Fellows of the Berkeley Art Museum, most especially my supporters and friends John Bransten and Phoebe Cowles, for endorsing this project and many others.

This project has made at times extraordinary demands on the staff of the Berkeley Art Museum, who have been ideal colleagues and friends. I should like to thank first my assistant, Eve Vanderstoel, for her whole-hearted devotion to making this project – and so many others we have developed together at Berkeley – the best that it could be. Second I must thank John Losito, for eighteen months Research Assistant and now Assistant Curator on this project, for doing much of the needed information-gathering and writing, and for being a warm and generous addition to our team. Thanks go also to all my wonderful colleagues at this dynamic institution, including Jacquelynn Baas, Director, for giving me a free hand to develop a topic that no one, in 1993, knew they were interested in; Lisa Calden, Registrar, for coordinating the complex shipping and travel arrangements for this project; Tom di Maria, Assistant Director for External Relations, and Janine Sheldon, Development Director, for their long efforts both to secure needed financial support and to devise vital marketing strategies; Sherry Goodman, Curator for Education, for working with me to develop and implement the extraordinary education programs that have become the trademark of this museum; Edith Kramer, Curator of Film at the Pacific Film Archive, and Kathy Geritz, Associate Film Curator, for endorsing and then brilliantly executing the companion film programs; and Nina Zurier, for devising a sensitive gallery installation and for designing all the relating materials.

The exhibition tour has also been a vital component of this project, both for making it financially viable and for allowing us to share our work with audiences in three other important urban centers. At the Walker Art Gallery, Julian Treuherz, Keeper of Art Galleries, has been a great supporter of this project from its early days. Thanks are also due to Richard Foster, Director of the National Museums and Galleries on Merseyside; Edward Morris, Curator of Fine Art; Alex Kidson, Curator of British Art; and David McNeff, Gallery Registrar. At the Grey Art Gallery and Study Center, we thank Lynn Gumpert, Director; Frank Poueymirou, Deputy Director; Michelle Wong, Gallery Manager/ Registrar; and Lucy Oakley, Education and Program Coordinator; along with their colleagues at the Glucksman Ireland House at New York University, Patricia King, Director, and Eliza O'Grady, Assistant Director. Thanks are also due to Ann Philbin, Director of the Drawing Center in New York, for her enthusiasm in preparing a companion exhibition that looks at conceptual works on paper. With respect to our London venue, we thank Melvyn Barnes, Director of Libraries and Art Galleries for the Barbican Centre; John Hoole, Curator of the Barbican Art Gallery; and his colleagues Carol Brown and Ann Jones. Finally, also in London, I thank Hugh Merrell, Paul Holberton, and their team at Merrell Holberton Publishers Ltd for their enthusiasm, patience, and interest in the development of this catalogue, which I dedicate to Gerry Wiener, who has consistently been (with apologies to Yeats) a true brother of this company.

James Christen Steward
Chief Curator
BERKELEY ART MUSEUM
April 1998

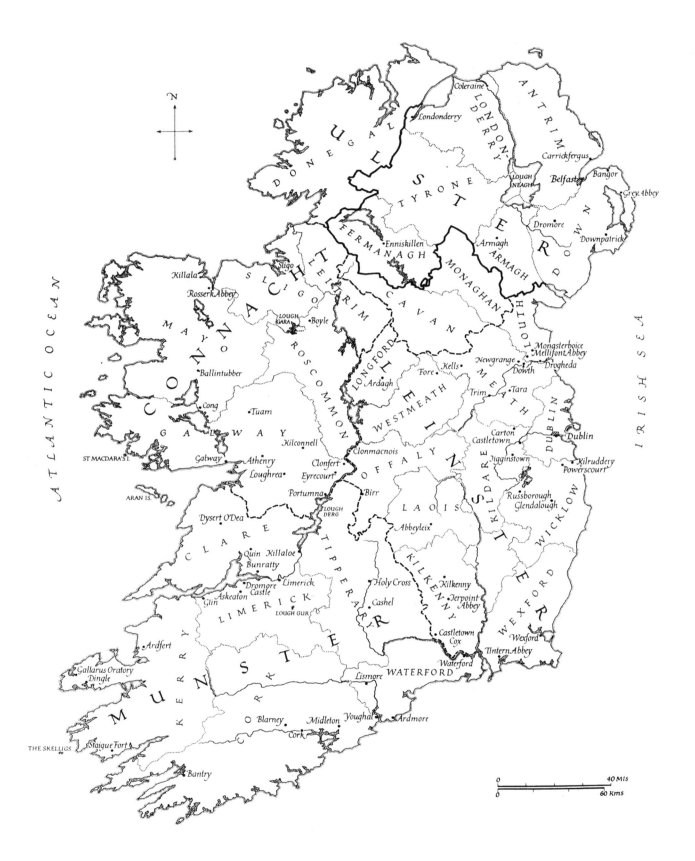

Map of Ireland

Chronology

1800

Act of Union passed incorporating Ireland into the United Kingdom

1870

Home Government Association (becoming the Home Rule League in 1873) founded by Isaac Butt

1877

Charles Parnell elected president of Home Rule Confederation of Great Britain

1879

Michael Davitt founds Irish National Land League in response to poor harvests

1886

Government of Ireland bill, introduced by British Prime Minister William Gladstone, defeated in House of Commons; its introduction raised fears of Catholic dominance in the North; "Orangeism" revived explosively

1889

Charles Parnell involved in divorce suit, leading to fall of Irish National Party and setting back the nationalist cause for ten years

1890s

Cultural nationalist movement develops, does much to revive interest in speaking and study of Irish

Belfast (population ca. 350,000) is Ireland's largest city

1893

Gladstone introduces another Home Rule bill (the second Government of Ireland bill), but is again defeated

Gaelic League founded by Douglas Hyde and Eoin MacNeill

1895

The Importance of Being Earnest, by Oscar Wilde, first performed

1902

Cathleen ni Houlihan, by W.B. Yeats (with Lady Gregory?), performed starring Maud Gonne

1903

Separatist journalist Arthur Griffith forms the National Council, a nucleus for Griffith's Sinn Féin

Independent Orange Order founded

Lady Gregory publishes *Poets and Dreamers*

J.M. Synge's *In the Shadow of the Glen* generates major controversy

1907

Dockers' strikes and riots in Belfast

J.M. Synge's *The Playboy of the Western World* opens, provoking riots

1908

Sinn Féin (literally "We Ourselves") is launched

1913

The unionist Ulster Volunteer Force (UVF) in the north, the Irish Citizens' Army, and the nationalist Irish (National) Volunteers in the south all formed

Massive strikes in Dublin, leading to starvation, riots, and death

1914

British House of Commons passes a Home Rule Bill (passed also by the House of Lords two years later) triggering urban unrest

1916

The Easter Rising, resulting in deaths of over 300 civilians, over 130 British soldiers, and 70 rebels, along with mass destruction in Dublin

24 April

Irish Republic proclaimed in Dublin, provoking martial law; 3,500 arrested

29 April

Rebels surrender

3 and 12 May

Fifteen rebel leaders, including Patrick Pearse, executed

1918–19

Nationalists gradually establish unofficial alternative government, including their own parliament (Dáil Éireann, the "Irish Assembly")

1919–21

War of independence fought by Irish Volunteers, renamed the Irish Republican Army (IRA), against Crown forces in Ireland, including Royal Irish Constabulary, police Auxiliaries and regular British Army soldiers

1920

Government of Ireland Act passed, creating Northern and Southern Ireland and affording limited self-government to each

Riots in Belfast and Derry; judicial process suspended

21 November

Ireland's first "Bloody Sunday". Fourteen killed when Michael Collins orchestrated the assassination of British military intelligence officers operating undercover in Dublin. In reprisal "Black and Tans" opened fire on spectators attending football match at Croke Park, killing twelve and injuring 70.

1921

Truce between Republicans and British Crown forces

6 December

Anglo-Irish Treaty signed, and later approved (January 1922), officially creating the 26 counties of the Irish Free State (six counties of Ulster remaining in British hands)

1922

January

Provisional government formed by Michael Collins

20 May

Michael Collins and Eamon de Valera (last surviving commander of the Rising) agree to "the Pact," making peace between the government of the Irish Free State and the Republicans

16 June

Bitter election fought on issue of the Anglo-Irish Treaty, returning a majority of Treatyites , leading to civil war of unparalleled bitterness between government and extreme Republicans

"Special Powers Act" passed in Northern Ireland, remaining on the statute-book for 50 years

12 August

Sinn Féin founder Arthur Griffith dies

22 August

Michael Collins ambushed and killed while making military inspections in Co. Cork

Publication of James Joyce's *Ulysses* in Paris

1923

In response to political assassinations, total of 77 anti-treaty Republicans executed by Free State Government between December 1922–May 1923

23 April

Liam Lynch, leading anti-treaty military commander, killed in action

24 May

Anti-treaty forces declare a ceasefire

22 June

Northern Ireland Education Act setting up non-denominational schools opposed by Presbyterians and boycotted by Catholics

10 September

Irish Free State enters League of Nations

Poet W.B. Yeats awarded the Nobel Prize for Literature

1925

11 February

Legislation passed effectively prohibiting divorce in the Irish Free State

Boundary Commission established and meets secretly, to resolve boundary between Irish Free State and Northern Ireland, made difficult by small nationalist majorities in some Northern Ireland counties

3 December

Agreement to maintain existing border, confirming partition

Film censor appointed

1926

16 May

Eamon de Valera leaves Sinn Féin, founds Fianna Fáil

Rioting at opening of Sean O'Casey's *The Plough and the Stars*

1927

10 July

Assassination of Kevin O'Higgins, vice president of Executive Council, former Minister for Justice

11 August

Electricity Supply Board established

1929

16 July

Censorship of Publications Act

Proportional representation abolished in Northern Ireland parliamentary elections

12 October

Shannon hydro-electric scheme commences operations

1930

Censorship Board established with wide-ranging powers to ban books and periodicals

1931

IRA banned in Irish Free State

11 December

Statute of Westminster, giving effective legislative autonomy to Irish Free State and other dominions of the British Commonwealth

1932

16 February

Fianna Fáil wins general election, only six years after the party's establishment

30 June

De Valera repudiates agreement on payment of land annuities to Britain. Annuities withheld, provoking retaliatory trade legislation and "tariff war"

1933

3 May

Act removing Oath of Loyalty to the British Crown from Irish constitution

22 August

Neo-fascist organization of "Blueshirts" (National Guard) founded (supposedly to protect Treatyites from Republican extremists) and outlawed

2 September

Cumann na nGaedheal, Centre Party and National Guard join to form Fine Gael

1935

28 February

Sale and import of contraceptives made illegal

1936
Senate of the Irish Free State abolished
18 June
IRA declared illegal by de Valera
11 December
Amending Act removes references to Crown
 from the Irish constitution, eliminates
 role of Governor-General, creating
 instead a directly elected Presidency

1937
14 June
De Valera's new constitution approved,
 after vetting by senior Catholic clergy,
 establishing the Irish Republic (Éire),
 asserting the unity of the island of
 Ireland but giving de facto recognition to
 partition and recognizing "special
 position" of the Catholic Church

1938
25 April
Anglo-Irish agreement on trade and
 finance, ending tariff dispute
25 June
Douglas Hyde, a Protestant, Celtic scholar,
 and co-founder of Gaelic League,
 becomes first President of Éire

1939
16 January
IRA begins bombing campaign in England
2 September
Éire announces intention to stay neutral in
 World War II (colloquially known in
 Ireland as the "Emergency")
Censorship rampant in art, literature, and
 music, opposed by many writers, notably
 Sean O'Faolain in The Bell
W.B. Yeats dies

1940
3 January
Emergency legislation against IRA
 introduced

1941
April–May
German air-raids on Belfast. Belfast heavily
 bombed; a few bombs fall on Dublin in
 error
James Joyce dies

1944
14 January
Irish Labour Party splits

1945
16 June
Seán T. O'Kelly elected President of the
 Irish Republic

1947
13 August
Health Act extends powers of country
 councils and provides maternity care
Universal secondary schooling enacted in
 Northern Ireland

1948
4 February
General election: Fianna Fáil (in power
 since 1932) loses overall majority;
 coalition government takes over under
 Fine Gael member J.A. Costello
Out of office, de Valera tours the world
 advocating Irish unification
21 December
Republic of Ireland Act: Éire becomes the
 Republic of Ireland and leaves the British
 Commonwealth, 18 April 1949

1949
2 June
Ireland Act passed at Westminster,
 declaring special relationship of Irish
 citizens to the United Kingdom and
 guaranteeing Northern Ireland will
 remain within UK unless its parliament
 decides otherwise

1951
11 March
Ian Paisley forms Free Presbyterian Church
4 April
Catholic hierarchy condemns coalition
 government's "Mother and Child"
 scheme
30 May
General election: Fianna Fáil regains power;
 de Valera again becomes prime minister

1952
Samuel Beckett publishes Waiting for Godot

1954
6 April
Flags and Emblems Act in Northern Ireland

legislates against interference with Union
 Jack and effectively prohibits display of
 tricolor
18 May
General election: Fianna Fáil loses power to
 coalition government led by Fine Gael

1955
14 December
Republic of Ireland admitted to United
 Nations
Unemployment and emigration levels again
 surging

1956–62
IRA campaign of violence on Northern
 Ireland border

1957
5 March
General election returns Fianna Fáil with
 large majority (they retain power until
 1973); de Valera is again prime minister

1958
2 July
Industrial Development Act, to encourage
 inflow of foreign capital

1959
17 June
De Valera retires from Fianna Fáil and is
 elected President of the Republic

1961
31 December
National television service, RTE, begins
 broadcasting

1963
Formal state visit to the Irish Republic by
 US President John F. Kennedy, a Catholic
 of Irish descent

1964
January
Campaign for Social Justice founded in
 Northern Ireland
July
Publication of Second Programme for
 Economic Expansion in the Republic
Film Appeal Board established to appeal
 decisions of censor

1965
14 December
Anglo-Irish free trade agreement signed

1966
April
Commemoration of 1916 rising
26 June
Three sectarian murders by UVF
19 July
Ian Paisley convicted of unlawful assembly
and breach of peace; imprisoned 20 July

1967
January
Northern Ireland Civil Rights Association
founded on the model of Martin Luther
King's non-violence movement
11 July
Censorship Act limits ban on books
prohibited to twelve years (although
they can be banned for another twelve)

1968
First performance of Tom Murphy's play
Famine
24 August
Northern Ireland Civil Rights Association
organize march from Coalisland to
Dungannon
5 October
Police clash with Derry civil rights
marchers, marking re-emergence of the
"Troubles"
9 October
Origins of People's Democracy in Belfast
student demonstrations

1969
4 January
People's Democracy march from Belfast to
Derry attacked by Protestants at
Burntollet Bridge
19 April
Riots in Derry: police enter Bogside
28 April
Northern Irish Prime Minister O'Neill
resigns after failure of mild reforms
prohibiting discrimination against
Catholics in housing, local government,
and the franchise
12–16 July
Derry riots, first death in the "Troubles" (at
Dungiven, Co. Londonderry, 14 July)

13 August
Bogside under siege; government in Belfast
requests UN intervention
14–15 Aug
Riots in Derry and Belfast; British Army
troops enter and assume control
25 Nov
Electoral reform in Northern Ireland
universalizes the vote

1970
11 January
IRA splits into Official and Provisional
(guerilla) wings; Sinn Féin follows suit
Protestant paramilitary groups formed in
response
16 April
Paisley elected to Northern Irish parliament
at Stormont
6 May
Charles Haughey and Neil Blaney dismissed
from Dublin government; arrested for
conspiracy to import arms, 28 May;
Blaney discharged, 2 July; Haughey
acquitted, 23 October
3 July
Riots in Belfast (six killed)
21 August
Foundation of Social Democratic Labour
Party (SDLP) in Northern Ireland, from
moderate nationalist groups

1971
Francis Stuart publishes *Black list Section H*
6 February
Following a month of rioting, first British
soldier killed by Provisionals
16 July
SDLP withdraws from Northern Ireland
parliament in protest at failure to inquire
into deaths of two civilians killed by
Army (8 July)
9 August
Internment reintroduced in Northern
Ireland
5 October
Paisley founds Democratic Unionist Party

1972
22 January
Irish Republic joins European Economic
Community (EEC)
30 January
"Bloody Sunday": thirteen civilians killed

in Derry during civil rights march
2 February
British Embassy burned in Dublin
24 March
Northern Ireland parliament and
government suspended by British Prime
Minister Edward Heath; direct rule over
Northern Ireland imposed from London,
under Secretary of State William
Whitelaw
26 May
Republic establishes special criminal court
for offences against the state
7 July
Abortive negotiations between Provisional
leaders and Whitelaw in London
30 October
Whitelaw's Green Paper, "The Future of
Northern Ireland," declares no UK
opposition to unity by consent
7 December
Special position accorded Catholic Church
in Irish constitution of 1937 is removed
by popular consent
467 people killed, including 321 civilians;
political scientist Richard Rose
pronounces the Northern Ireland
problem "intractable"

1973
Fine Gael-Labour coalition defeats Fianna
Fáil government
Sunningdale Agreement passed, creating a
power-sharing executive of Unionist
politicians and nationalist Social
Democratic and Labour Party (SDLP),
only to collapse the following year in the
face of a Loyalist workers' strike
Over thirty killed in the Republic by UVF
bombs

1974
Guildford and Birmingham pub bombings
by IRA

1975
Internment in Northern Ireland suspended
(abolished in 1980)

1976
British Ambassador to Dublin murdered
Seamus Heaney publishes *North*

1977
Jack Lynch and Fianna Fáil reelected to
 office

1979
Charles Haughey succeeds Jack Lynch as
 Fianna Fáil prime minister
Pope John Paul II visits Ireland and
 denounces the IRA, abortion, divorce,
 and contraception
August
Earl Mountbatten killed by IRA in Co. Sligo

1980
First performance of Brian Friel's play
 Translations

1981
Ten IRA men starve themselves to death in
 Maze Prison in attempt to gain political
 status within prison system
Sinn Féin emerges as modern political
 party, wins 42 per cent of nationalist
 vote in Northern Ireland; Gerry Adams
 enters Parliament for West Belfast

1982
February and November
Government in Dublin changes hands
 twice, between Fianna Fáil and Fine
 Gael/Labour coalition
Neil Jordan's film *Angels* opens

1983
Referendum confirms constitutional ban on
 abortion

1985
Anglo-Irish Agreement signed by Irish
 Prime Minister Garrett FitzGerald (Fine
 Gael/Labour) and British Prime Minister
 Margaret Thatcher, giving Dublin
 government a consultative voice in
 conduct of northern policy and outraging
 Unionists

1986
FitzGerald's government attempts to rescind
 ban on divorce but is defeated by
 conservative-led referendum
First performance of Tom Murphy's play
 Bailegangaire

1987
February
Fianna Fáil reelected, led once again by
 Charles Haughey
May
Single European Act ratified, confirming
 Irish participation in European
 Community (since 1993 the European
 Union)
November
Eleven Protestants killed by a bomb at
 Remembrance Day service in Enniskillen,
 Northern Ireland

1990
Civil rights lawyer and feminist Mary
 Robinson elected President of the Irish
 Republic, the first woman to hold the
 office

1992
Albert Reynolds replaces Charles Haughey
 as leader of Fianna Fáil; Fianna Fáil-
 Labour coalition wins general election;
 Reynolds becomes Prime Minister

1993
Downing Street Declaration signed, a joint
 peace initiative betwen the Irish and
 British governments
Homosexuality decriminalized in the Irish
 Republic
Irish government proposal to establish
 Irish-language television stations wins
 popular support

1994
IRA and Unionist paramilitary groups
 declare ceasefire
Ruling government coalition collapses,
 replaced by a coalition of Fine Gael,
 Labour, and Democratic Left, with John
 Bruton as Prime Minister

1995
Referendum lifting ban on divorce passes,
 takes effect in 1997
US President Bill Clinton visits Northern
 Ireland, the first sitting president to do
 so during the Troubles

1996
9 February
IRA ceasefire collapses with bombing in
 Canary Wharf district, London
June
All-party peace talks begin; Sinn Féin
 barred from participating
7 October
IRA resumes bombing campaign inside
 Northern Ireland with bomb explosion at
 the British Army's headquarters in
 Lisburn, Co. Antrim
22 December
Protestant Loyalists retaliate with car
 bombing, ending their own two-year
 ceasefire

1997
June
Fianna Fáil wins control, with Bertie Ahern
 as Prime Minister
September
Sinn Féin and Ulster Unionists enter all-
 party talks

1998
10 April
Good Friday Agreement signed, proposing
 new self-governance for Northern Ireland
 along with cross-border cooperation;
 Northern Ireland officially remains
 within the United Kingdom and the Irish
 Republic renounces territorial claims to
 the North
22 May
Referenda in Northern Ireland and the
 Republic of Ireland confirm acceptance of
 Good Friday Agreement
25 June
Elections held to select members of newly
 formed Assembly in the North of Ireland

The Irishness of Irish Painting

JAMES CHRISTEN STEWARD

"The ghosts of a nation sometimes ask very big things and they must be appeased, whatever the cost." So wrote Patrick Pearse, hero and martyr of the Easter Rising, executed for his part in it, in the pamphlet *Ghosts* on Christmas Day, 1915.[1] Never could this sense of an oppressive history be said to be truer in Ireland than in the early years of the twentieth century when the cultural nationalist movement took root and led inexorably first to the War of Independence (1919 to 1921) and then to civil war (1922 to 1923). It is against this backdrop that we must place the Protestant poet William Butler Yeats when he came to write "To Ireland in the Coming Times," the poem from which this exhibition and catalogue take their name. By the 1890s, after more than 200 years of dominance by the English – codified by the Act of Union of 1800 that incorporated Ireland into the United Kingdom – a history of defeat by the Celtically-descended Catholics at the hands of English Protestants had created a remarkable sense of solidarity among Irish Catholics. Such solidarity had lead to political action before, notably the rebellion of 1798, led by Theobald Wolfe Tone and the "United Irish." Modern Irish Republicanism can be said to claim descent from Tone, whose arrest and subsequent suicide was condemned by Catholic authorities at the time and made him unpopular among Catholic nationalists of the nineteenth century. By the 1890s and the first years of the twentieth century, however, Tone's status as hero and martyr was revived: he was sacralised by nationalists such as Patrick Pearse for being automatically saved, despite his suicide, because he had died for Ireland.

All of this is deeply revealing. The status of Catholicism and its moral positions remained enormously important into the twentieth century and the years when Yeats was writing. The fall of Charles Parnell, a Protestant, in 1889 and with it of his Irish National Party may explicitly have come because he was implicated in a notorious divorce suit. But the larger meaning of this stemmed from the fact that the divorce was hateful to Irish Catholics. Yeats had such background in mind when he came to write "To Ireland in the Coming Times" four years later, and when he published it in 1895. By contrast to Parnell, whose defeat set back the cause of Irish nationalism by a decade, Yeats offered the possibility of a cultural nationalism. Beyond the aesthetic and sentimental charms of Yeats's position, appealing to a cultural nostalgia for Ireland's ancient and

therefore pre-English history, the movement he championed was embraced in part because it was condemned by Church authorities.[2] Ultimately the movement, with George Russell, known as AE, as its other leader, came to be known as the Irish Literary Movement, and was itself attacked by certain elements of the Church as a "West British" movement – that is to say, one that actually adhered to unionist values. Such an attack was easily made against W.B. Yeats and AE as Protestants, whose loyalty could be thought to be with the Protestant English, despite the fact that Yeats had himself been an avowed nationalist since 1887.

This conflict is important to an understanding of Yeats's poem, and by extension to the underpinnings of the present exhibition. When Yeats writes that he "would accounted be/True brother of a company/That sang, to sweeten Ireland's wrong . . ." he is self-consciously proclaiming himself a member of the nationalist movement who wishes to be seen as such. Such a motivation is also clearly behind Yeats's play *Cathleen ni Houlihan*, written – possibly in collaboration with Lady Gregory – and first performed, with Maud Gonne in the title role, in 1902. Set at the time of the rebellion of 1798, the play literally embodies Cathleen – whose name was a Gaelic personification of Ireland – in the form of an old woman who cancels a marriage and replaces it with a blood sacrifice in a nationalist revolution. When the old woman is asked, "What was it put you wandering?" she answers, "Too many strangers in the house," meaning the presence of the British in the house of Ireland. Cathleen thus has taken human form to rectify the troubles visited on her "four beautiful green fields," the Four Provinces of Ireland, one of which is modern-day Ulster.

But even with writings such as these, Yeats's reputation and standing as a nationalist was never cemented. When he produced J.M. Synge's *The Playboy of the Western World* at the Abbey Theatre in 1906, Yeats was seen as impugning the sexual purity of a woman and thus both Catholicism and Irish nationhood. When he called in the police to quell a calculated nationalist riot that broke out at the Theatre, he destroyed his nationalist standing. With this, and with his later production of Sean O'Casey's play *The Plough and the Stars* – the work of a working-class Protestant – in 1926, only three years after the end of the Civil War, Yeats was seen, in short, as being insufficiently Irish.

This is a question that emerges not only in looking at W.B. Yeats, but in looking at Irish heroes – including Pearse, the son of an Englishman, schooled by the Christian Brothers – and indeed many of the artists in the present exhibition. What did it take to be seen as sufficiently Irish or indeed to be a truly Irish painter? That the present exhibition takes its title from Yeats thus asks that we see in the project not merely a survey investigation into Irish painting, a field itself little understood or known outside Ireland, but that we see it as a particular investigation into the Irishness of Irish painting, including the possibility of a wide range of response in which artists might equally choose to explore a specifically Irish subject matter or idiom or to participate in internationalist trends. Indeed, this range of response helps to determine the starting point of the exhibition at the dawn of the twentieth century, prior to which it is arguably difficult to find a truly Irish thread in Irish painting.

Equally, however, the exhibition takes the year 1900 as its opening point for the extent to which it marked a rise in nationalist tendencies, a coalescing of energies that had long vented themselves on an occasional but ultimately frustrated basis. Nationalist energies had begun to heat up in the 1870s with a movement toward home rule and, in the 1880s, with the introduction of the Government of Ireland bill in the English Parliament – a bill that was to be defeated in both 1886 and 1893. The temporary failure of Irish political nationalism, however, brought with it a cultural nationalism that revived interest in the Irish language and in Irish cultural traditions, and helped lead to a revival in the Irish visual arts.

The artists who open the present exhibition must be seen as transitional figures, continuing to look outside of Ireland for their artistic influences and often for their clients. Walter Frederick Osborne, for example, began his artistic training in Dublin, at the Royal Hibernian Academy – the traditional guardian of Ireland's visual arts traditions – and at the Metropolitan School of Art, but the more consequential influences on his style came from the continent, including a period of formal study in Antwerp and more informal apprenticeship in northwestern France. Specifically, his exposure there to plein air painting was something he could not have had in Dublin and overturned his stylistic development. The work by Osborne included here, *Tea in the Garden* – painted in 1902, the same year in

which Yeats premiered his *Cathleen* – is pointedly retardataire, a beautifully painted throwback to High Impressionism a quarter of a century or more after the style was most clearly articulated in the 1870s by Claude Monet, Camille Pissarro, and others. But its subject is Irish – specifically a scene in the Dublin garden of the artist's neighbor – and dates to the last years of the artist's life when he had returned to Ireland after an extended stay in England. This was a pattern repeated in various permutations by most of the Irish artists in the opening section of the exhibition, "Echoes of the Belle Epoque." Sir William Orpen looked to England rather than to France, both studying at London's Slade School of Art and allying himself to a group of English artists that included Augustus John (who was himself Welsh born). At the same time, Orpen's best painting participated in the experimentation of avant garde European painting, including that of Edgar Degas. And in addition to his own work as a painter, Orpen became perhaps the most influential art teacher in twentiety-century Ireland, instructing a generation of artists who turned more to Ireland and Irishness even while adhering to his painterly tenets.

Sir John Lavery was perhaps the most internationally successful Irish artist of this generation, and like Orpen was rewarded with a British knighthood for his achievement. Unlike Orpen, Lavery maintained close ties with Ireland for the rest of his life, returning frequently and exhibiting at home, even if he resided primarily in London or, later, in the south of France. Lavery ultimately rose to become, after the American-born John Singer Sargent, perhaps the second most sought-after society portraitist of his day, and became the social peer, friend, and confidant to many in England's highest social circles, including H.H. Asquith, British Prime Minister from 1908 to 1916, whose daughters Lavery painted in 1917 (see Plate 9). Yet as the course of Irish politics evolved through the first quarter of the century, Lavery walked an increasingly fine line, maintaining his close friendships with English aristocrats while involving himself in the Irish independence movement. He was equally capable of painting the golden moments of a nostalgic Edwardian idyll even in the face of the horrors of World War I, and of painting the political leaders at an Anglo-Irish peace conference whose logistics he facilitated. When in 1928 he

was commissioned to paint a portrait of his wife that became the central figure of the bank note of the newly formed Irish Free State (an image still used in watermark form), Lavery was returning to the mythology of his native land. He painted the American-born Hazel as the figure of Éire, the embodiment of Ireland, with her arm on a harp, the national symbol of independent Ireland.

Lavery may, then, have been the most hybridized of the Irish artists born in the nineteenth century, merging international influences, success in England, and an abiding commitment to his Irish background and the cause of an independent Irish state. But he was not alone in exhibiting an interest in the latter. Perhaps the most individualistic expression of this came from an unexpected quarter, a painting by an upper middle-class Dublin woman, Beatrice Elvery (later Lady Glenavy). Elvery was otherwise an accomplished stained glass artist and a somewhat indifferent painter, but her *Éire* of 1907 (Plate 4) is a landmark achievement, a depiction of Mother Ireland that merges the stylistic influences of Byzantine mosaics with the devotional simplicity of fifteenth-century Italian while invoking the iconography of Ireland's Celtic past and the history of Irish Catholicism. Most tellingly, perhaps, Elvery herself admitted that the painting was inspired by a viewing of Yeats's play *Cathleen ni Houlihan* with Maud Gonne in the title role (indeed Gonne later bought Elvery's painting).

The memories of Edwardian splendor and of nineteenth-century plein air luxuriance co-existed, from about 1910, with another thread in Irish painting that was in many ways a response to the question of Irishness, and this was a new realism. Itself perhaps loosely derived from the realism of an earlier generation of French artists – that of Gustave Courbet and Théodore Rousseau – and of their English counterparts, such as Samuel Palmer, this realism was part of a larger movement to rediscover and reclaim distinctly Irish subjects. It was generally advanced by artists such as Paul Henry and Seán Keating who maintained stronger physical and emotional links to the Irish land than did their more . internationalist counterparts. Like Lavery, Henry was a native of Belfast; he too travelled to Paris to study, and settled for a time in London to work. But the lure of Ireland and of Irish subject matter proved strong. Keating was perhaps the most ardently Irish of the group, having studied painting at the

hand of Orpen in Dublin and ultimately assuming the chair in painting at the National College of Art and Design. Orpen had also taught Leo Whelan and Patrick Tuohy, whose work is also characterized by strong technical skills and an interest in the everyday. For Irish artists of this generation the everyday often focussed on economic impoverishment – leading to the final solution represented by Eileen Murray's *This or Emigration* (Plate 29) – or stifling domesticity (surely a by-product of the former). Realism also crept into the work of the Edwardians, notably Lavery and Orpen, both of whom made paintings that depicted the First World War – Lavery from a certain distance capturing a sense of nobility, Orpen closer to the front itself and therefore revealing a more sinister aspect in often grotesque coloring. These war paintings are problematic in their own ways, observations of an international war into which Ireland was drawn by its relationship with Britain and made by Irish artists just at the moment that nationalism was literally exploding at home.

In stylistic counterpoint to the work of Lavery and Orpen, certainly, but also to the work of younger artists such as Henry and Keating, came the lightning rod of Jack B. Yeats, without question the best known Irish artist of the century and a figure on whom any investigation into twentieth-century Irish painting – including this one – must pivot. Yeats, born in 1871, was only fifteen years younger than Lavery and actually eight years older than Orpen, but his painting made a kind of revolution in Irish visual expression. Born in London the younger son of the painter John Butler Yeats, Jack Yeats had as older brother W.B. Yeats whose role we have already briefly seen. Jack was himself connected to the Irish literary community, touring the region of Connemara, for example, with the writer John M. Synge in 1905, the year before Synge's *Playboy of the Western World* caused such an uproar at W.B.'s Abbey Theatre. This trip to the West, along with Jack's upbringing in Sligo with his maternal grandparents, made indelible impressions on the artist, whose wide-ranging interests led him to depict subjects ranging from street scenes in Dublin to horse races, boxing matches, and funerals. From 1898 he devoted himself almost entirely to Irish subject matter, emerging in the late teens as a painter of the first order with works such as *The Funeral* and *On Drumcliffe Strand* (Plates 19 and 20). These subjects – a

country funeral and a horse race respectively – derive from a close observation of Irish life wedded to an inclusion of specifically Irish icons and focus on Irish identity in a way we have not previously seen.

As these examples suggest, Irish realism in the teens and twenties was not exclusively focussed on Irish subjects and took a variety of forms. Perhaps the most common, though, and the one that ultimately had the greatest legacy, were those that participated in the articulation of a peculiarly Irish landscape, language, and mentality in the West of Ireland. The West was regarded by both writers and painters as a land of fundamental difference, articulated against the Englishness of the colonial power as well as, to a lesser extent, constructed as different, a primitive other within Ireland. The West thus provided a way of access to the true Irish past through its language, its folklore, its antiquities, and its way of life. This movement first came about in the early years of the twentieth century, as part of the Celtic revival and the "Irish-Ireland" movement. As early as the 1890s the West had been thought of as a "problem" region, one without sufficient resources to support its population. But with the rise of nationalist sentiments, the colonial construction of the Celtic as feminine was rejected in favor of a masculine and Gaelic West in the hands of the Irish Ireland movement. With independence and the establishment of the Irish Free State in 1922, national identity was increasingly attached to the landscape. As Catherine Nash has written, in the context not only of cultural politics but of tourism:

"The celebration of the West as an archetypal Irish landscape was part of an attempt to identify with a landscape which was a confirmation of cultural identity. It was not simply or only that the West was farthest from England and therefore most isolated from the cultural influences of anglicisation, but that its physical landscape provided the greatest contrast to the landscape of Englishness."[3]

Paul Henry, Seán Keating, and Jack Yeats all turned to the West to find landscape and subject matter that would be defined first and foremost as Irish, by contrast with the English and Continental influences of their forebears. Charles Lamb's *Dancing at a Northern Crossroads* (Plate 23), depicting peasants engaged in a traditional Irish dance in

the out of doors, might be seen as the perfect embodiment of this desire. It is a vision of rural virtue and a pastoral ideal far removed from the reality of rural poverty but nevertheless suggestive of uncorrupted Irishness. But did this mean that to be Irish was to be non-urban, poor? Such an equation sought to rehabilitate the reality of Irish poverty that had led to massive emigration in the nineteenth century and to ennoble those who had remained behind, even as the Irish government in the years after independence would begin to tackle this seemingly intransigent social plague. Yet even those artists who embraced the West did not deny economic reality: Keating's *Economic Pressure* of 1936 (Plate 34) describes the tragedy of families torn apart by a land that could not give them the means of survival.

This desire expressed by Henry, Keating, Yeats and others to associate themselves with the archetypally Irish, coming just at the time of the struggle for independence, civil war, and early nationhood, was clearly a desire to redefine the visual arts in Ireland. Like the Celtic Revival movement of the late nineteenth century, they sought to create an Irish School apart from the more traditional influences of the Royal Hibernian Academy, drawing on international influences to create an up-to-date painting of their own. And it was a movement in which other forms of the visual arts and literature also participated: the 1934 film *Man of Aran* embodied this sense of the "typical" to be found in the West, a landscape in which the elemental formed the natural strength of its people. The West was equally ennobled in literature, and was championed in anti-emigration tracts of the time, as, for example, "The best country for Irish men and women in the 20th century is Ireland itself."[4] Yet even in the hands of these writers, painters, and other cultural nationalists, one could not escape the discourses of earlier writing and of colonial influences; the painting of Henry and Keating is defined as much by the English influence it implicitly rejects as by its choice of a landscape thought to be resistant to foreign corruption.

Within this reclamation of Irishness, we also find works that adopt inescapably political subject matter, that go beyond the more coded politics of the Western landscape or Western peasant scenes. Keating's *Men of the South* (1921; Plate 24), for example, depicts a "flying column" of the Irish Republican Brotherhood, an antecedent of the

Irish Republican Army. Using guerrilla tactics, such groups fought the notorious Black and Tans, the extra-police force recruited by the British in their waning days of power in southern Ireland. Keating depicts these men as heroes in the struggle for independence, as the idealized representatives of watchful nationhood. *Men of the South* is thus an updating of traditional history painting. Yet the painting is ultimately problematic, ennobling their role by distancing them representationally from the violent combat at the core of their fight. By invoking the clarity of their ideals rather than the contradictions of war, the image sets up a kind of romanticized notion of the fight for freedom that remains troubling in the 1990s as ideals continue to come into conflict with brutal reality after more than thirty years of renewed violence in Northern Ireland. Lavery's portrait of an Irish hero on his deathbed, *Michael Collins (Love of Ireland)* (Plate 26), is perhaps less proselytizing and speaks to the artist's role as mediator between the British Government and the Republicans. The emphasis seems to lie on the tragedy of loss, here the loss of a charismatic hero of the Easter Rising of 1916 and the War of Independence now himself shot down. If less inherently a call to arms, this painting is not distant – one senses the artist's admiration for his subject. Jack Yeats, too, could invoke Irish heroism while distancing himself from its overt political manifestation: his *Going to Wolfe Tone's Grave* of 1929 (Plate 35) is inscribed in the politics of Republicanism by its reference to the "father" of Irish nationalism, the hero of a failed uprising in 1798. Yet the politics here reside in memory, in the selflessness of a long-dead hero, rather than in present-day violence.

Independence came in 1922 in the form of partition, in which the "Fourth Province" of Protestant dominated Ulster remained part of the United Kingdom. Partition was itself viewed either as insufficient for the more extreme Republicans or equally as a failure of will on the part or extreme Unionists. Divided opinion even in the newly independent Ireland (divided between the so-called Treatyites and those who opposed partition) led to years of civil war as violent as anything that had preceded them. The resolution of the border and acceptance of partition inaugurated a new era, an era with its own parallels in painting. Yeats's painting *Going to Wolfe Tone's Grave* of 1929 also marks a new beginning of sorts, a return to internationalism on stylistic terms. His palette is less

restrained, the treatment of the paint in its thick impasto and deep incisions is expressionistic in a way that looks back to the art of interwar German painters but also proves to be enormously influential for a later generation of Irish painters in the 1970s and 80s. In this way it is not atypical of a number of Irish painters working in the middle part of the century who experimented with a variety of international influences and then adapted them to Irish subjects. Amongst these is Louis Le Brocquy, whose early work drew heavily on the radical compositional techniques of Edouard Manet or Edgar Degas, adapted heavily to Irish settings. Such work was, as before, intended to insert progressive Irish painting in the mainstream of international production. Mainie Jellett, one of a number of influential mid-century Irish women artists, must also be seen in this light, and must largely be credited with bringing European Modernism – the modernism of Picasso and other Cubists such as Albert Gleizes – to Ireland. Her particular conception of Modernism saw it as a serious attempt by a new century to create an identity for itself – unlike Keating's interest in the art and identity of a New Ireland.[5] In this, Jellett's goal was perhaps more revolutionary, as opposed to reforming, than Keating's. Her work often verges on abstraction and thus moves beyond the focus of this project, but the works chosen for inclusion here merge the internationalist influences that characterize her achievement with a distinct return to Irish subject matter, specifically the religious iconography that marks a number of Irish women artists (including Beatrice Elvery and Mary Swanzy). Jellett's *Virgin and Child* (Plate 38) marks this artist's turn to subjects suggestive of the historical prevalence of Roman Catholicism in Ireland, and to a continuing interest in the role of women. Indeed, this latter subject is particularly potent – for Jellett and Swanzy, and for Elvery before them, as well as for male artists such as Maurice MacGonigal. Woman often appears as the embodiment of the nation, as a kind of national mother, even as the role of women in Irish society tended to be among the most retardataire in Europe, a victim of Irish Catholicism's tight hold on the country and its insistence on woman's domestic role.

Despite the pivotal role of Jellett, and the continuing output of Jack Yeats, Irish painting at mid-century was at something of a crossroads, marked by moves in different directions. The work of Colin Middleton, for example, derives its greatest power from a sense of post-war angst, from a flirtation with the emotional tones of Surrealism and the unsettling juxtaposition of disparate objects. Related to Middleton is the work of Patrick Hennessy, who in works such as *Exiles* of 1943 (Plate 42) merges an air of mysticism with allusions to the continuing legacy of emigration, with its deep psychological and ideological meaning. One senses in such works that exile was a state seen as the natural condition for a generation of Irish artists worn down by war and a continuing sense of dislocation and alienation, in which their Irishness must be seen as a contributing factor. Dan O'Neill's work from the 1950s often suggests a similar sense of alienation. Even as a work such as *Birth* from 1952 (Plate 47) celebrates the central role of women in Irish society and the selflessness of childbirth, it is an oppressive scene in which life itself seems squeezed, forlorn. When Irish subject matter itself appears, as in Nano Reid's *Tinkers at Slieve Breagh* (Plate 51), it often identifies Irishness with rural poverty, as in Reid's depiction of a band of Irish gypsies whose name derived from the livelihood of making cups and cans out of tin. Cumulatively, such work seems to speak to the difficult economic situation in Ireland at this time, when artists could not but have observed their country seemingly being left behind – and isolated – by postwar economic prosperity. Ireland as an island nation, separate from Europe and divided in itself, continues to assert itself.

The heroism of Irish painting and Irish history gradually reemerges in the later 1960s as already prominent artists such as Louis le Brocquy turned to new subject matter that could be more firmly associated with a virtuous tradition. Le Brocquy's work with skeletal or "evoked" heads derives ultimately from the discovery of a Celtic sculpture, which the artist then adapts to the loose portraiture of Irish heroes both past and present. Likewise, Robert Ballagh turned to a series of portraits of Irish literary and artistic celebrities living and dead that insist on their cultural standing, often allied coloristically with Irish Republicanism. The most potent move in this direction, however, came in 1977 with Micheal Farrell's *Madonna Irlanda* (Plate 56), subtitled "The Very First Real Irish Political Picture." This controversial picture unites disparate elements drawn from the history of art – with overt references to both Leonardo da Vinci and François Boucher – to suggest an Ireland after the fall, corrupted

into a state of quasi prostitution by its continuing partition and what the artist clearly sees as subservience. It is a powerful image produced nearly a decade into the modern "Troubles," the period of extreme violence and unrest that began in 1968 and that led to the dissolution of the parliament in Northern Ireland in 1972.

Paintings dating from the period of the Troubles – which must loosely be said to continue today even after cease fires, all-party talks, and the so-called "Good Friday Agreement" of 1998 because of the continuing violence in Northern Ireland – must almost without exception be seen as political, if for no other reason than the fact that the painters in question have for the most part chosen to stay in Ireland or Northern Ireland and thus to remain within a society in which politically motivated violence has played such a great role. Such a decision has often come with a cost, in a country in which commercial opportunities for artists were minimal until the last decade. But the immediacy of the Troubles, the poverty that continued to exert a strong hold on the country until the last decade, and the resulting isolation has provided rich fodder for expression in both North and South. Whether in the work of David Crone, who for many years painted scenes of violence observed directly outside his Belfast studio window, that of Rita Duffy, who has often painted autobiographic scenes depicting the oppression of Irish women or indeed all the Irish at the hands of bitter segregation, or of Dermot Seymour, who describes the ever present military in the bucolic Irish countryside, much of Irish painting of the last thirty years has an energy rarely seen in Europe and the United States. The youngest artist in the present exhibition, James Hanley, also invests his painting with a powerful combination of icons drawn from the Church yet conveyed in a distinctly contemporary sensibility, drawing out the weight of Ireland's history on its present. The work of Patrick Graham may be said to summarize many of these tendencies, merging an expressionistic use of paint that harkens back to interwar German painting and to Jack Yeats with the use of politically potent icons of Irishness and references to Irish heroes. For Graham, Ireland is a country that can be and has been bought, like Farrell's prostitute, simultaneously worthy of love and hate in a mixture of affection, contempt and embarrassment that is reminiscent of the writings of James Joyce.

As it has been throughout the century, internationalism in Irish painting can still be seen as emotionally fraught, the adoption of foreign influence as a form of emigration signifying Ireland's colonization (specifically as a colonized woman). Those artists who have resisted internationalism have often sought consciously to invoke links between the individual, the community, and the Irish landscape to assert a sense of distinct identity, and this remains the case for Irish painters working in the landscape idiom. Yet the search for what has been termed the "Holy Grail of Irishness"[6] can be seen as equally limiting, as deriving out of mere opposition to an English culture it has often politically resisted. The non-English culture of Ireland is older than is the English, but for most of Ireland's modern history it has also been weaker – even as it exercises an imaginative influence on writers and to a lesser extent painters and sculptors. Perhaps these failings in either direction are inevitable in a land that has been defined by opposition, by the fact that when we speak of Ireland we continue to speak of two lands, two regions, and two peoples. This duality of concerns and contexts makes it to address or identify a specifically Irish aesthetic in twentieth-century and particularly contemporary art, as Ireland's recent economic successes seem to suggest that its distinct culture can only become more vestigial. Yet even as interest continues to mount in Irish national and cultural identities, especially in the cultural politics of postcolonialism – an interest that might also rather contradictorily desire to keep Irish culture at the margins – this dialogue between the Irish and the Other, an inescapable legacy of Irish history, may come to signify the Irishness of Irish painting.

NOTES

1 In *Collected Works of Padraic H. Pearse: Political Writings and Speeches* (Dublin: Phoenix Park Ltd., undated), pp. 223–255.

2 See Conor Cruise O'Brien, *Ancestral Voices: Religion and Nationalism in Ireland* (Dublin: Poolbeg Press Ltd., 1994), p. 30.

3 Catherine Nash, "'Embodying the Nation': The West of Ireland Landscape and National Identity," in Michael Cronin and Barbara O'Connor, edd., *Tourism in Ireland: A Cultural Analysis* (Cork, Ireland: Cork University Press, 1993), p. 91. See also D. Cairns and S. Richards, *Writing Ireland: Colonialism, Nationalism and Culture* (Manchester: Manchester University Press, 1988).

4 G. McCarthy, "Emigration, Climate and Race," in *The Irish Review* 1 (July 1911), pp. 209–214.

5 See for a fuller discussion of this point Ciaran Benson, "Modernism and Ireland's Selves," in *Circa* 61 (January/February 1992), pp. 18–23.

6 Seamus Deane, "The Artist in Ireland," in A Sense of Ireland, 1980, p. 36.

Public, Private, and a National Spirit

C O L M T O Í B Í N

"The most important thing we have done is that we have made a modern art, taking our traditional arts as a basis, adorning it with new material, solving contemporary problems with a national spirit," the Catalan architect Josep Puig i Cadafalch wrote in 1903.[1] By the turn of the century in Catalonia the national spirit had taken over most cultural activities so that art, architecture, and the Catalan language had become more powerful weapons in the politics of Catalonia than resentment about Madrid's handling of foreign or economic policy. The architects who worked on the new apartment blocks and public buildings in Barcelona between 1880 and 1910 began to play with a dual mandate, not merely innovative but Catalan as well, in an effort to create a national spirit in their buildings. They used the most modern methods available: in 1888 the architect Domenech i Montaner used unadorned brick and industrial iron for his café-restaurant in the Parc de la Ciutadella; sixteen years later he used a steel frame for his concert hall, El Palau de la Música, making it the first curtain wall building in Spain and one of the first in the world. Thus both buildings sought to establish the progressive nature of the Catalan enterprise. But both buildings are also laden with medieval references and motifs; they sit there still as constant reminders of former greatness, of the time before 1492, when Catalonia was a serious power in the Mediterranean, America had not been plundered, and Castilian imperialism had not begun. As in most turn-of-the-century buildings in Barcelona, they used Gothic and Romanesque references, spiky shapes, cave-like entrances, floral motifs in wrought iron, on colored glass and ceramic tiles; they used ornate sculpture and a sense of craft, opulence, and wealth.

These were intensely political buildings, and two of the most important architects in the city, Domenech i Montaner and Puig i Cadafalch, became leading politicians: Domenech i Montaner was one of the founders of the Lliga de Catalunya in 1887. Both were elected to the Cortes in Madrid to represent the Catalan cause. Like other Catalan architects of the time, such as Gaudí, they consciously set out to invent Catalonia in their buildings, creating a focus for the emotions which surrounded Catalan identity.

I spent a year in Barcelona at the end of the 1980s looking at these buildings, reading about these architects, and thinking about their efforts to construct a nation. Sometimes as I sat in the Biblioteca de Catalunya in the fourteenth-century hospital building I had to blink to make sure that I was

not in the National Library in Dublin. Some of the connections between Catalonia and Ireland during this thirty-year period of nation-building were obvious: the Catalans founded a political party in the early 1920s called Nosaltres Sols, a direct translation of Sinn Féin, Ourselves Alone. There were poems written in Catalan on the death of Terence MacSwiney on hunger strike in 1921. A stirring poem was written in Catalan in 1848 and this, historians agree, inspired a generation of nationalists; in the same year in Ireland Thomas Davis wrote the song "A Nation Once Again."

But it is the general shape and atmosphere of Catalan cultural politics between 1890 and 1910 which constantly reminded me of Ireland. The foundation of the Barca football club and its function in creating waves of Catalan emotion were close to the function of the Gaelic Athletic Association in Ireland, founded in the same period. The fetishization of certain parts of the Catalan landscape – Montseny, for example, or the Canigó – bore a great resemblance to the sanctity of the Aran Islands and the Blasket Islands in Ireland. The attempt by W.B. Yeats, Lady Gregory, and Douglas Hyde to surround the Gaelic past with holiness had loud echoes in the efforts by Catalan architects and artists, from Gaudí to Miró, to establish the Romanesque tradition as quintessentially Catalan while the rest of Spain was Moorish. And the attempt, too, by Yeats and Synge, and indeed Joyce, to embrace modernity and Europe as a way of keeping England at bay was close to Domenech's use of iron and steel and modern systems, while Spain slept. And there were echoes, too, between the careers of Joyce and Picasso who found all this rhetoric and dreamy nationalism too much for them, who viewed Dublin and Barcelona respectively as centers of paralysis, and got the hell out as early as they could. And other echoes between the careers of the visionaries Yeats and Gaudí – one embraced magic and the other extreme Catholicism – in a fraught political and emotional climate. And between Beckett and Miró, who flirted with minimalism and abstraction, who utilized a deeply personal and surreal iconography, who favored solitude and loved France, and were deeply opposed to fascism, and lived to be old.

It seems that if you introduced Ireland to Catalonia, the two countries would recognize each other and get on like a house on fire.

But what did this mean for the artists and writers who followed, this atmosphere in which art was a weapon in the battle which a small fragile society waged in order to create itself? It is easy to understand why Beckett and Miró evaded the issue, invented a language pared down to lines and surreal signs and grunts and groans and odd silences. Everyone who wrote or painted in Ireland or in Catalonia in the twentieth century has had to deal not simply with the tension between tradition, the individual talent and modernity, but also with the notion that novels and plays and paintings – even drawings and poems – filled a gap that was somehow left between public rhetoric and private life and could not be viewed as merely aesthetic objects.

The Irish poet Derek Mahon has a poem about this inheritance called "The Last of the Fire Kings," about a man who wants to be the figure who drops "at night/ From a moving train// And strikes out over the fields/ Where fireflies glow,/ Not knowing a word of the language.// Either way, I am/ Through with history." His character has a problem, however: "But the fire-loving/ People, rightly perhaps,/ Will not countenance this,// Demanding that I inhabit,/ Like them, a world of/ Sirens, bin-lids/ And bricked-up windows."[2]

This urge to be "through with history" is something that the Catalan painter Antoni Tàpies understood when he was interviewed in 1988 for the catalogue of a large show of new work. "There was a time when the Franco regime was at its height," he said, "that I believed that certain political messages [in his paintings] could contribute to a general revulsion for the regime. These messages have not reappeared for some years now." Politics had freed him then from having to paint about politics; now he was free to be playful and obscure, if he so wished. But one of the essays in the catalogue wanted to claim him, in all his guises, as a Catalan artist, with the emphasis on the Catalan: "Many motifs appearing in the work of Tàpies have been recognized as references to his Catalan roots, but his Catalan identity has also been explained on a deeper technical and formal level. . . . Ultimately, Tàpies's intellectual attitude towards mysticism, the esoteric and the magical has been explained by his Catalan identity."[3]

For some writers and painters in Ireland, this way of being claimed for the nation, and a close involvement with the public world, with politics, history, and the possibility of social change, has been deeply enabling, has helped to steady and to strengthen the hand. Writers such as Paul Durcan, Dermot Bolger, and Sebastian Barry, and painters such as Dermot Seymour, Patrick Graham, and Brian

Maguire conjure up a world in which the private and the public are not separate and the attempt to make them so is part of a conspiracy against the powerless. They make you feel in their work that their responsibility is to make connections, that they would not have it any other way. For other writers and painters, however, the task has been to follow Beckett and Miró and to evade all of this responsibility, to inhabit an entirely private universe, a free space. In my first novel, *The South*, this was the central drama: the painter Katherine Proctor leaves Ireland for Spain to find a space that has no politics in it, no Protestants and Catholics, no colonists and dispossessed. She goes, of course, to the wrong place. But her dilemma is not simply political: it is artistic and, perhaps more than anything, it is technical. "She watched the oppressive sky, sensing the moisture in the air outside, knowing that no matter how intensely she watched this scene, and studied it, and thought about the colours, she would never get it right."[4] She does not know what colors to mix, she does not know how you could paint this landscape.

The Irish painter Tony O'Malley lived nearby – Katherine in the novel lives outside the town of Enniscorthy in County Wexford in the south-east of Ireland – in the late 1940s and early 1950s. Years later, he realized that there was a gap in his work, that he could not find anything he had done in Enniscorthy. But in the late 1970s, as he was walking through the town for the first time in decades, he met the daughter of his former landlady who told him that one of his suitcases was still in their attic. It was full of drawings and sketches and small paintings.

Tony O'Malley had worked in out-of-the-way places, old backwaters, mills, and ponds, but he had also done drawings of Vinegar Hill above Enniscorthy, which was the last battlefield in the 1798 Rebellion. The Hill is famous; there are songs about it. No one, so far as I know, had ever painted it. And it struck me, as I saw some of these paintings and drawings and heard the story about the suitcase, that painting this hill and other sites in the surrounding landscape was an immensely political act, more political than any number of paintings about overtly political subjects. No one had ever believed that this poor landscape of ours had been worth painting. It was not the West of Ireland; it was not glamorous or romantic. O'Malley had been brave in his use of color; he had taken full possession of this place, transformed it. He had found enough in this small place to sat-isfy his imagination and his palette. There were no peasants in the paintings, no locals standing around; no messages; just lines, colors, contours, shades; nothing national or heroic. This was part of the real story of Ireland as a free state or indeed a republic: a painter could find colors with which to paint a landscape, which others in previous generations had been too poor to paint. The painter would not play with stereotypes, the paintings would not be "Irish" in any way recognizable to an outside audience. The painter was free. Somehow the pure act of art done in a place where art was unknown and unheard of had immense implications.

In poetry in the same years a similar struggle was being fought in the mind and imagination of Patrick Kavanagh (1906-67). Kavanagh, like Tony O'Malley (and indeed others of O'Malley's class and generation such as Patrick Collins), had a difficult inheritance. What came before in poetry was W.B. Yeats, a poetry, like the paintings of Jack B. Yeats, full of grand statement, rhetorical flourish, and national sentiment, poems which insisted that Ireland was one place, that its heritage and destiny could be confidently described.

Kavanagh inherited these ideas that poetry in Ireland should be national, that its rhythms should reflect the rhythms of Gaelic poetry, and its themes that of the simple peasant life, or the great myths and stories that gave life to the Irish fireside. He inherited ideas of art as part of the national movement, a way of inventing a nation. But his imagination was essentially anti-heroic and his experience limited to the parish. He did not live in a place as grand as Yeats's Ireland, he lived in a world of small hills and narrow roads, of smallholdings. He knew this world in detail, and it was in the detail of his poems that their genius lay, in Kavanagh's inability to deal with ideas like "Ireland" or "nation" or "colony" or "tradition." His work reclaimed the real world as a site for poetry, the ordinary movements of Catholic Ireland, nothing glamorous, nothing linked to history – there is no history in Kavanagh's poems; Kavanagh was genuinely "through with history" – nothing that an outsider would recognize as particularly Irish. Close, then, to Tony O'Malley's Wexford landscapes, a way of reclaiming for art what had been seen before as dull, establishing for the first time the idea that common experience in the new state could be made into poetry.

In the early 1960s, Seamus Heaney recognized this in Kavanagh and later wrote about it in his book *The Government of the Tongue*:

"And then came this revelation and confirmation of reading Kavanagh. When I found 'Spraying the Potatoes' in the old *Oxford Book of Irish Verse*, I was excited to find details of a life which I knew intimately – but which I had always considered to be below or beyond books – being presented in a book. The barrels of blue potato spray which had stood in my own childhood like holidays of pure colour in an otherwise grey field-life – there they were, standing their ground in print. And there too was the word 'headland', which I guessed was to Kavanagh as local a word as was 'headrig' to me. Here too was the strange stillness and heat and solitude of the sun-lit fields, the inexplicable melancholy of distant work-sounds, all caught in a language that was both familiar and odd."[5]

There is always a strange beauty about poems written and paintings made in places where these things did not occur before, not just in the aura around the occasion but in the very core of the work itself. One of Kavanagh's quatrains in "Spraying the Potatoes" goes:

> And over that potato-field
> A lazy veil of woven sun.
> Dandelions growing on headlands, showing
> Their unloved hearts to everyone.[6]

Kavanagh loved making an awkward music – watch how the third line breaks the iambic rhythms of the other three, how the stanza sways between the pure sounds of a ballad and the sound of an ordinary voice speaking. This was written just a year after Yeats's death. There are no dandelions and no headlands (nor headrigs, for that matter) in Yeats. Kavanagh deliberately set out to invent a poetics based on the local and the parochial, on what he knew and what he heard. There is a supreme self-confidence in his work ("I have lived in important places," begins his poem "Epic"[7]; in "Advent" he could write of "the spirit-shocking/ Wonder in a black shining Ulster hill"[8]). The national question had been shrugged off, the spirit was free then to make a halo around what was to hand, the here-and-now. This work became, then, despite itself, deeply political – the first fruits of independence.

Kavanagh did not inherit a tradition; he destroyed one. For a painter starting to look at Paul Henry's skies and Seán Keating's peasants (or indeed Jack B. Yeats's peasants, or those of George Russell, or Charles Lamb, or James Humbert Craig, not to speak of their skies) in the same year that Kavanagh wrote "Spraying the Potatoes," or twenty-five years later when Seamus Heaney read the poem for the first time, the dilemma is just as real as that facing Kavanagh. How should you paint in Ireland now that the country is a free state?

Patrick Collins called the Irish tradition in painting "an unmuddied stream." There was no tradition; the idea that anyone in, say, the sixteenth century could have painted the Irish midlands is a sour joke. Muddying the stream, then, became immensely important and powerful. The landscapes that Tony O'Malley painted in Wexford and South Wicklow in the late 1940s and early 1950s have enormous emotional resonance for me. I was brought up there. Even to hear the names of the places is enough to get me imagining and remembering. But the paintings themselves are different: they are so startling and original in their use of color, so painterly in their conception, that they do not make me think about the places I know so well. Instead, they surprise and delight me just as Kavanagh's poem delighted Heaney and surprised him: I simply did not know that these landscapes could be rendered in these colors; they stand their ground, as Heaney said, not in print but in paint. They have about them that strange awkward beauty that you find in the best of Kavanagh.

Just as painters like O'Malley and Patrick Collins, and later Seán McSweeney, Brian Bourke, and Mary Lohan, had to invent an Irish light, with no Old Masters to help them, so too Irish figurative painters had to re-imagine everything in the years after independence, when the idea of a national art that glorified the high skies and barren landscape of the West of Ireland and the noble peasantry had to be abandoned.

With all of the Irish poets who came after Kavanagh, you find an outsider who helped them get their bearings. In the early work of Thomas Kinsella or Anthony Cronin, you hear echoes of Auden. In the early work of Seamus Heaney, you hear echoes of Kavanagh and Robert Frost and Thomas Hardy. In Derek Mahon, you hear echoes of Louis MacNeice. It is true also with figurative painters such as Gerard Dillon, Colin Middleton, Mainie Jellett, Dan O'Neill, Norah McGuinness, Brian Bourke, and even the early Louis le Brocquy. They looked to Europe where they found colors

and systems they could adapt: they were more interested in Cubism and Surrealism than in creating a national art or an Ireland of western peasants and fishermen. They learned nothing from their Irish predecessors. In all of their work, there is a feeling that they were, like Kavanagh, starting from scratch in Ireland, but, unlike Kavanagh, they were looking outwards for technical assistance.

The example of Kavanagh remains instructive. In his poem "Memory of Brother Michael" he wrote:

> Culture is always something that was,
> Something pedants can measure,
> Skull of bard, thigh of chief,
> Depth of dried up river.
> Shall we be thus for ever?
>
> Shall we be thus for ever?[9]

His own poems which dealt with the world he knew answered that question. He ended his poem "Kerr's Ass" with the lines:

> Morning, the silent bog,
> And the god of imagination waking
> In a Mucker fog.[10]

Mucker was the townland where he was born. It had not been mentioned in a poem before. And when you look at, say, a Gerard Dillon interior, you realize that no one before had ever painted the small spaces in which we all grew up in Ireland and where most of us still live. Irish interiors in painting had always been opulent, and to do this now, to create an interior space that was ordinary, that indulged in no cliché about big house or peasant cabin, was an important moment. Dillon and others of his generation had something else in common with Kavanagh: they were not social realists, not interested in charting how people lived. Rather, they were interested in the luminous aura around ordinary things, in floating color and light. Seamus Heaney, in his essay on Kavanagh, understood this:

"Where Kavanagh had once painted Monaghan like a Millet, with a thick and faithful pigment in which men rose from the puddled ground, all wattled in potato mould, he now paints like a Chagall, afloat above his native domain, airborne in the midst of his own dream-place rather than earthbound in a literal field."[11]

This "dream-place" became the site where Irish painting pitched its tent for thirty years, say from 1940 to 1970. From the strange, haunting, haunted canvases of the later Jack B. Yeats to the isolated figures in a dream-landscape in Colin Middleton, Patrick Hennessy, or Louis le Brocquy, Irish painters looked inwards to the self, the unconscious. The paintings played with mystery as an earlier generation had played with nationhood and romantic Ireland.

It is almost uncanny to watch this "dream-place" slowly emerging as the central landscape in the poetry of Thomas Kinsella, the most interesting and talented Irish poet to come after Kavanagh (Kinsella was born in 1928). In books such as *Nightwalker and Other Poems* (1968) and *Notes from the Land of the Dead* (1972), what is dreamed has more intensity and power than what is lived; what is half-remembered, half-hinted at, half-understood finds in the poems a broken music to match it, a poetry that deals with solitude and disarray and an inhospitable landscape:

> When I came to,
> the air I drifted in trembled about me
> to a vast distance with sighs
> – not from any great grief, but disturbed
> by countless forms drifting as I did,
> wavery albumen bodies
> each burdered with an eye. Poor spirits![12]

This, then, is the tone of Irish art in the years when independence had been consolidated. Freud and Jung, Picasso and Braque took the place of various national icons. The soul replaced the body as the subject for art and poetry; private life replaced public life; the mystery of the world around us replaced the heroic. European colors replaced high Irish skies.

The prose written in these years tended to use the short-story form. The best-known writers were Frank O'Connor, Sean O'Faolain, Mary Lavin, Michael MacLaverty. Some took the view that the Irish experience, so fragmented and uncertain, could best be dealt with in stories that used a single character and a short space of time, that took their power from a luminous moment of revelation or a mysterious ending, that mixed anecdote and epiphany, but avoided

serious portraits of the society or formal experiment. There were exceptions to this: notably Beckett and Flann O'Brien and Kate O'Brien, but each of these, through exile, censorship or silence, managed to become marginalized figures in the new state.

By the early 1960s a new generation of novelists had emerged who were prepared to deal with the darkness of Irish society, an authoritarian church and an insecure state, and the deep isolation in which many individuals lived. Notable among these was John McGahern (born in 1934), whose novels *The Barracks* (1963) and *The Dark* (1965) remain seminal works. Both McGahern and John Banville (born in 1945) wrote a beautiful, clear prose, and became known for their style as much as their subjects. But in the 1980s a number of younger novelists emerged in both Dublin and Belfast whose tone was rougher, angrier, more raw, more socially aware, interested in producing a cinematic, deeply realist fictional universe.

And this reflects very accurately what happened in painting in Dublin and Belfast during the same period. Some painters such as Felim Egan and Clement McAleer remained interested in tone and texture; their paintings became, like certain John Banville novels, exercises in pure style. For others, what was happening in the outside world governed their work: the new materialism in the Republic of Ireland, the conflict in the North, the sense of dispossession in the ghettos of Dublin and Belfast. Some of the work was raw, but in many cases – Brian Maguire, Patrick Graham, Michael Kane, for example – primacy was given to the paint. There was a sense that they believed in paint in the same way that, say, Dermot Bolger and Roddy Doyle, two novelists who wrote about working-class Dublin, believed in sentences. These connections between what was happening in prose fiction and painting in Ireland in the 1980s are not absolute or watertight, but it is nonetheless interesting that a group of novelists and a group of painters with left-wing politics and a deep social concern emerged in the same years, and produced work that is formidable because of the ten-

sion between the way the material was used and the way the message was being conveyed. Dermot Bolger's prose could be poetic and lyrical, just as a Brian Maguire painting could be as concerned with tone and texture as that of any formalist. But the impact arose from the world which was being described, a world inhabited by the marginalized and the powerless.

In a century, then, Irish painting has moved from the national, the heroic, and the public to the private and internal – the existential dream – and back once more to the public arena where the idea of a nation is a bitter joke and paint becomes a medium for expressing dissent or exploring the surreal nature of Ireland in the late twentieth century. "The fire-loving people" in Derek Mahon's poem who demand that his character inhabits "Like them, a world of/ Sirens, bin-lids/ And bricked-up windows"[13] have come back to haunt us. For painters and writers in Ireland still, despite our best efforts, the battle between the public and the private, between dreams and responsibilities, continues to haunt us.

NOTES

1 Quoted from "L'oeuvre de Pais i Cadafalch architecte 1896–1904" in David Mackay, *Modern Architecture in Barcelona* (Sheffield: The Anglo-Catalan Society, 1885).

2 Derek Mahon, *Selected Poems* (London: Viking, 1991), p. 58.

3 Tàpies, *Els Anys 80* (Barcelona: Ajuntament de Barcelona, 1988), p. 244.

4 Colm Toíbín, *The South* (London: Picador, 1990), p. 37.

5 Seamus Heaney, *The Government of the Tongue* (London: Penguin, 1990), p. 7.

6 Patrick Kavanagh, *Selected Poems* (London: Faber and Faber, 1996), p. 11.

7 Ibid, p. 73.

8 Ibid, p. 101.

9 Ibid.

10 Ibid.

11 Seamus Heaney, *The Government of the Tongue*, p. 13.

12 Thomas Kinsella, *Notes from the Land of the Dead* (Dublin: The Cuala Press, 1972) p. 3.

13 Mahon, *Selected Poems*.

Some Men
and a Picture

K E N N E T H M C C O N K E Y

An odd collision of ideas caught the imagination of artists and writers in Ireland in the early years of the twentieth century. As the Celtic renascence in literature broadened to embrace a revival of national consciousness, the possibility of a national school of painting emerged. Almost nowhere else in western Europe did new nationhood go hand in hand with questions to do with form and content in the visual arts. The extraordinary idea of those who led the discussions around 1905 was that a closer engagement with modern French painting would pave the way to something distinctly Irish. This audacious claim was not, however, universally accepted, and to many of the Dublin intelligentsia, faced with a *fait accompli* at the opening of the Municipal Gallery of Modern Art in 1908, it must have seemed untenable. Hugh Lane had placed on loan a recently acquired collection of Impressionist pictures, which, by their very presence, were intended to cause controversy. The English critic Frank Rutter, invited to lecture on Impressionism after the opening of the Gallery, recalled "the utter incredulity on the part of the citizens of Dublin that the pictures given to them could be of any real value. The view generally entertained was expressed by some Irish cousins of mine who came to see me after my lecture. 'Of course,' said they, 'we understand you've got to crack them up in public . . . But you can tell us. They aren't really any good, are they? They can't be. If they were any good they wouldn't be in Dublin.'"[1] This cautious probing stood next to philistine outrage on the part of some members of the Dublin city council. Alderman Murphy's oft-quoted sound-bite – "fresh air is a more desirable asset for the people than French art" – expresses the populist rejection.[2] If this is not surprising, given the tardy acceptance of modern painting elsewhere in Europe, the conceptual connection between social and cultural revolution was extraordinary. It arose in the minds of three men – George Moore, the novelist and critic, Hugh Lane, the collector, and William Orpen, the painter – at a significant moment in time, commemorated in one of Orpen's most imposing canvases, *Homage to Manet* (fig. 1).

With hindsight, the workings of this society of three seem merely to confirm a familiar modernist paradigm. As elsewhere in western Europe and North America, the identification of a strand of painting which contained possibilities unconstrained by academic formulae attracted young painters, critics, and collectors. While the emergence of Irish Impressionists and Post-Impressionists has been noted,

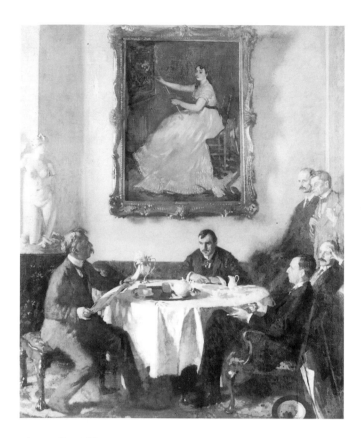

Fig. 1. Sir William Orpen, *Homage to Manet*, 1909, oil on canvas, 62 × 51 in. (157.5 × 129.5 cm), Manchester City Art Galleries

the sense of the relationship of this reflection of modernist practice to the specific context of the nascent Irish school has not been tackled.[3] Yet Orpen's early isolation of Manet within the modernist caucus led to the possibility, not simply of a new syntax, but more fundamentally of a new, distinctly "Irish" visual language. In the years up to 1916, a national identity, emerging from radical visual sources, underpinned by critics, collectors, and British artists in Orpen's circle, led to a remarkable suite of works. At the center of this group is *Homage to Manet*, a picture that reflects upon and attempts to take stock of the modern movement. Ironically this painting is one of the least overtly modernist and least overtly "Irish" of Orpen's works of the period. Its visual analysis, its codes and complex references, reveal evidence of conflicts and resolutions, temporary alliances and fundamental allegiances, sewn up together into a group portrait.

Homage to Manet is one of a small, fascinating group of modern pictures specifically produced to record a stage in the debate about matters of art. They gather a group of

artists and literati together and imply a common consensus. Henri Fantin-Latour's *Homage to Delacroix*, Maurice Denis's *Homage to Cézanne*, and Max Ernst's *Rendez-vous des amis* would all be examples from this select genre. These pictures are motivated less by formal or stylistic exploration, or by new subject matter, than by the desire to take stock of the shaping of taste and sensibility. They may not have been commissioned; they may evince no conscious speculation about the market; they seem to have been simply motivated by the desire to note who was talking to whom at a moment in time. They isolate a particular grouping and in so doing underwrite its status. Possibly they emphasize the notion of "art made out of art," in a kind of sealed self-generating process in which a new body of opinion validates itself by selective use of the recent past. Beyond this, it is probably unnecessary to theorize their existence, apart from noting that they hold an obvious fascination for historians. As images, they furnish convenient illustrations, implying a social world from which a particular history sprang. They get us into thinking that these people came together and that out of their conversation the history of Impressionism, Post-Impressionism, Surrealism mystically emerged.

When Orpen embarked upon a *Group Portrait* in 1906 the crucial question was who should be listening to whom.[4] He wrote to Lane, "the people I thought of were Lane, Moore, Sargent, Steer, MacColl, Tonks . . . another set rather nice to paint would be Lane, John, Max, Sickert, Nicholson, Pryde"[5] In line with the precedents set by Fantin and Denis, all of the characters eventually included in Orpen's work had been actively engaged in the debate about progressive painting and Hugh Lane's efforts to see it installed in a special gallery in Dublin. Comparisons were made by critics when the picture was eventually shown with *Homage to Delacroix,* in which the characters – Whistler, Manet, Champfleury, Baudelaire, and others – were lined up around a portrait of Delacroix as in a school photograph.[6] P.G. Konody felt that Fantin's composite series of heads, each derived from separate individual portraits, made his work far less satisfactory than Orpen's. He wrote, ". . . in his *Homage to Delacroix* the artists and literary celebrities . . . have without exception an air of conscious posing, and are either staring out of the canvas or fixing their gaze upon one point of interest, whilst in Orpen's group they are seen at perfect ease, each in his most characteristic natural attitude, as though they were wholly unaware of being under the

artist's watchful eye."[7] Readers are therefore recommended to verify Orpen's picture by the laws of probability. It seems authentic. The room and its fittings seem convincing: this conjunction of individuals could actually have occurred: the picture appears to be a faithful naturalistic rendering of a moment in time. That there appears to be no documentary evidence for such an occasion does not detract from the persuasive authority of the work. Elementary reading would confirm that these men knew one another well and shared overlapping circles of friends. Research would also reveal that Manet's *Portrait of Eva Gonzales* (fig. 2) actually did hang on the wall of 5 South Bolton Gardens, the house Orpen rented from Hugh Lane around the time when *Group Portrait*, now known as *Homage to Manet*, was being painted. We are not simply remarking upon the bourgeois pleasure of possession – we are also concerned with the pleasure taken in enclosed familiar interior spaces. Orpen eventually took over the house and it remained his studio until the time of his death.[8] But it is not wholly from this circumstantial authenticity that *Group Portrait* draws its persuasive power.

While it is clear that it purports to represent history being made, even though it was not made by these particular people in this coming together at a specific moment in time, knowledge of the activities of those present in Orpen's picture and their view of their experience complies with what we know of the picture's present – that is, the period 1906 to 1909. The work, at one level, fixes the emergence of a coherent British and Irish view of French Impressionism. It was painted at a time when this history was being manufactured, when the composite picture of the linear development of modern French painting was being isolated within the time continuum and being formed.[9] This taxonomy and genealogy was as thoroughly artificial a fabrication as *Homage to Manet*, but, in essence, it owes a great deal to those who, after doubts and delays, came to be represented in it. George Moore on the left of the painting turns to address the group.[10] Philip Wilson Steer, who leans forward attentively in the middle of the picture, is a sort of chairman.[11] Behind him stand D.S. MacColl and Walter Sickert.[12] In the foreground is Henry Tonks, and seated to the far right is Hugh Lane.[13] Each of the *dramatis personae* has a particular significance in the debate about Impressionism. In support of Lane's Dublin collection each of the artists had donated works.[14] D.S. MacColl was, of all

Fig. 2. Edouard Manet, *Portrait of Eva Gonzales*, 1870, oil on canvas, 75¼ × 52½ in. (191.1 × 133.4 cm), National Gallery, London

of those depicted, most vocal in his support of the project in the English press.[15]

The clear *raison d'être* of Orpen's composition is to do with acquisition and appreciation. In this, Hugh Lane, George Moore, and Orpen, the unseen author of *Homage to Manet*, had most significant roles, the latter two contributing crucially to the education of the former. The idea to bring into being an Irish School of painting first began to take shape at Coole in 1901 when Lane visited his aunt, Lady Gregory, in company with W.B. Yeats, Douglas Hyde, and Edward Martyn.[16] With the Nathaniel Hone/John B. Yeats exhibition in that year at the Royal Society of Antiquaries, however, he began to take an interest in contemporary painting.[17] Other shows – the Walter Osborne memorial exhibition in 1903, for instance – increased his commitment. With the Guildhall Loan Exhibition of works

Fig. 3. Edouard Manet, *Vieux musicien*, 1862, oil on canvas, 73¾ × 97¾ in. (187.4 × 248.3 cm), National Gallery of Art, Washington, Chester Dale Collection

by Irish painters in 1904, Lane took the opportunity to issue a manifesto for the formation of an Irish school of painting for which the permanent display of the best modern art would be essential.[18] He declared himself for "raising a standard of taste and a feeling for the relative importance of painters" and envisaged a great permanent collection installed in Dublin as "necessary to the student if we are to have a distinct school of painting in Ireland."[19] Read carefully, this was an admission that Ireland did not have its own distinctive tradition in the visual arts, a point which seemed to be underscored by the appropriation of Scots-Irish, Irish-American, and other artists of doubtful provenance on the roster. Critics were quick to pick this up, and there was a serious debate about what ought to constitute an Irish school and how this could be achieved.[20] In this Lane was swept along, refining his judgment as he went. He immediately embroiled himself in the selection of the Royal Hibernian Academy winter exhibition which contained key loans from Durand-Ruel and from the executors of the late James Staats Forbes.[21] He went to Paris with Orpen in September 1904 to negotiate these loans and immersed himself in modern French painting.[22] D.S. MacColl gave him fulsome endorsement and complimented Dublin for bowing to his judgment. "For once," he declared, ". . . a public collection is chosen

by methods of judicious private collectors and not by the blind and unlucky rushes for safety made by the committee-sheep."[23]

For the present the Dublin burghers rested content to allow Hugh Lane to amass pictures on their behalf, at his expense. When Durand-Ruel brought 277 French Impressionist pictures to the Grafton Gallery in London the following spring, including many shown in the previous winter in Dublin, Lane was under renewed pressure to buy. Works by Monet and Pissarro were acquired in 1905 and Manet's *La musique aux Tuileries* and *Eva Gonzales* in 1906.[24] This private accumulation of a modern French collection was surrounded by diplomacy of a different order in Dublin City Hall.[25] At length the municipal gallery opened in temporary accommodation at Clonmell House in Harcourt Street in January 1908.[26] Again Lane was lionized by MacColl: ". . . born to surmount difficulties, [he] has succeeded in getting his splendid gift of modern pictures accepted by the city of Dublin An artistic project has actually been carried through without being smothered in compromise, with hardly a trace of the official sterilizing which is usefully applied to sewage but not to art."[27]

Orpen, who had begun work on *Homage to Manet* shortly after the acquisition of *Eva Gonzalez*, was now dismayed to

find that it might be removed from his studio – although, as the preparatory drawings indicate, the main characteristics of the composition were already established by the end of 1907.[28] Although the figures might change, the placing of *Eva Gonzales* did not alter. As this process of realization continued, Hugh Lane was a "Maecenas with a mission." His cultural program was broadly accepted by the leading painters who had been associated with the Guildhall exhibition.

Of greater significance, however, was the younger generation of Orpen pupils in the Metropolitan School of Art in Dublin. Orpen had begun his annual teaching sessions in Dublin in 1902 and he encouraged and in turn was supported by Irish students some of whom, like him, had gone to the Slade School of Fine Art in London.[29] Grace Gifford and Beatrice Elvery, who had Celtic Revival sympathies, featured in his work as Irish heroines, just as Seán Keating was later to take the mantle of the strong, brooding man of the West, upon whom the modern Ireland would be built.[30] As if to prove Lane's point that the Irish school could only emerge in rapport with the central thrust of European painting and not from forming a municipal collection along the lines of those of British cities, Orpen was, and always had been, strongly identified with Manet. His early drawings *The Absinthe Drinker* and *The Man with a Hat* demonstrate his affection for the *manière noire* of the early hispagnoliste Manet. It is clear that he had studied Manet's *Vieux musicien* (fig. 3), one of the pictures shown in Dublin and London and available to Hugh Lane for consideration. Manet's seemingly random collection of street characters contained a secret code. The frieze-like presentation of types admitted exciting possibilities. The musician could, in Orpen's eyes, become a pauper saint; the *buveur d'absinthe*, extracted from the background of Manet's canvas, was theatrically recast as a self-image in *A Young Man looking out on the World* (ca. 1904, fig. 4).[31] The very setting of Manet's figures – the *banlieue* – could serve as a metaphor for contemporary Ireland, a country which was more fundamentally at the periphery of the British Empire than India or the African colonies. Like Paris in the 1860s, it was prey to speculative redevelopment, the failure of which in the areas around its Georgian core was described by a contemporary visitor as "bankrupt magnificence," leading to poverty and starvation.[32] It was this which Walter Osborne represented in his powerful late canvases portraying the indigents of St Stephen's Green –

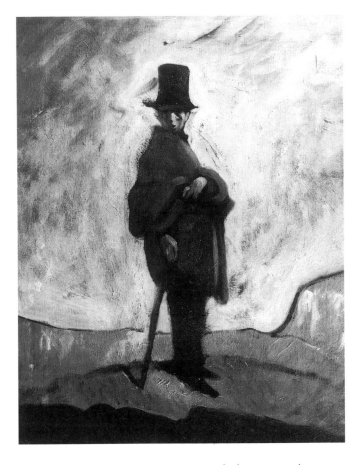

Fig. 4. Sir William Orpen, *A Young Man looking out on the World*, ca. 1904, oil on canvas, 26¼ × 20 in. (66.5 × 51 cm), Photo courtesy of Pyms Gallery, London

a world of barefoot children, pale, bloodless mothers and old men. Orpen intuitively grasped that the cultural space occupied by Manet's itinerants resonated with contemporary Dublin. The hinterland at the heart of this decaying preindustrial city was a world of mountebanks and malcontents. He allegorized it in *The Knacker's Yard*, a painting in which an old nag has been slaughtered under a gaunt stage-flat based upon the Merchant's Arch. From adjacent decaying buildings motionless sheets hang out on a pole, the sad pennants of poverty.

However, far beyond the crumbling façades of the Liffey, in the West of Ireland, lay an ancient kingdom in which the Catholic Irish had been corraled by Cromwell. It was to this region that Orpen had recourse in 1908 and it was there that he attended what was known as an "American wake," held to celebrate the departure of a young woman bound for New York and a career as a domestic.[33] The family sat around the ancient hearth boiling tea and poteen, occa-

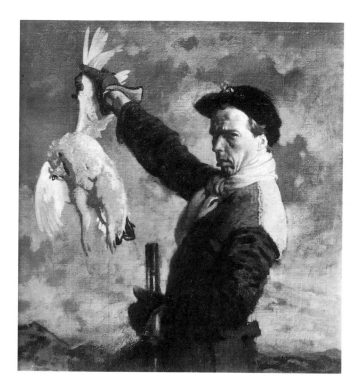

Fig. 5. Sir William Orpen, *The Dead Ptarmigan*, 1909, oil on canvas, 39⅛ × 35⅞ in. (100 × 91 cm), National Gallery of Ireland, Dublin

sionally getting up to dance in a mute, joyless way. As Orpen records it, the experience is one of dislocation and disenfranchisement.[34] From this source, as his later self-portraits demonstrated, the new, purer Celtic types would emerge.[35] The *Baldoyle Steeplechaser*, *The Man from Aran*, and *The Dead Ptarmigan* (fig. 5) are stereotypical characters of the kind that dominated the plays of Synge.[36] They are built into three large allegorical canvases in which Orpen attempted to disentangle old continuities and new idealisms.[37] The pictorial language – style and subject matter – of these works became the basis of the nationalist vision of modern Ireland in Orpen's pupils Keating, Lamb, Tuohy, and MacGonigal. Keating's *Aran Fisherman and his Wife* and Lamb's *Dancing at a Northern Crossroads* (Plate 23) would be impossible without this strand of Manet-derived realism flowing through Orpen.

As Orpen intuitively strove to express these evolving idealisms on canvas, Dublin was dithering over *Eva Gonzales*. Reviewing the New English Art Club in the spring of 1909, *The Studio* wove an atmosphere of uncertainty around the picture: "At the time that this picture was painted, Manet's canvas was temporarily housed in Mr.

Orpen's studio by its owner, Sir Hugh Lane, before it left England as part of Sir Hugh's splendid gift to the Dublin Gallery. In those days the fate of the picture was not quite certain; much rested with the action of the City of Dublin, and the picture – a symbol of all that is best in modern movements – was much in the mind of Orpen's sitters; they sit, as it were, in its atmosphere"[38] From the start, Orpen had a fixed idea about the format. In all of the drawings from 1906 onwards, Manet's portrait is centrally placed on the wall, parallel to the plane of the picture.[39] Under it was a settee, and in front of the settee, an octagonal table. The main problem concerned the grouping of the figures around the table. Orpen himself was deleted early in the process and eventually replaced by a cast of Venus. From the start, George Moore was seated on the left facing in the direction of his audience. A drawing of 1907 is inscribed with what may have been the original title, *Some Men and a Picture* (fig. 6).[40] At first there was no chair on the right, then an empty late-Jacobean square-backed chair appears. This was discarded for a Regency library "tub" chair and the figure of Tonks was introduced. The picture was then, although incomplete, photographed for *The Art Journal*.[41] After further changes it was again photographed for Frederick Wedmore's book *Some of the Moderns* before it left the studio.[42] Between these photographs Orpen had further hesitations and revisions. A cloth pulled back to reveal *Eva Gonzales* was put in and taken out. Steer is brought for-

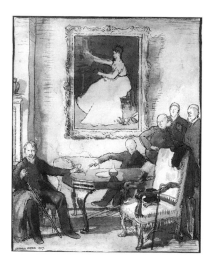

Fig. 6. Sir William Orpen, *Some Men and a Picture*, 1907, watercolor, 9 × 7 in. (22.8 × 17.8 cm), Photo courtesy of Pyms Gallery, London

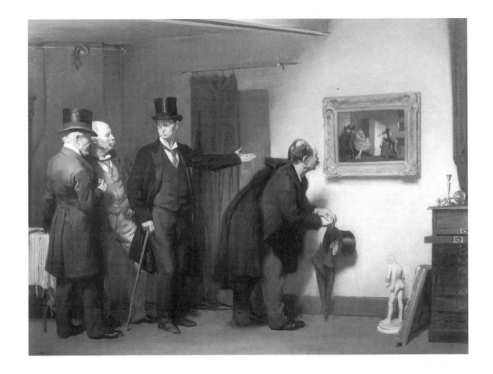

Fig. 7. Sir William Orpen, *The Valuers*,
1902, oil on canvas, 32¾ × 34 in.
(83 × 109 cm), Photo courtesy of Pyms
Gallery, London

ward to lean on the table.[43] The present late eighteenth-century carver appeared. Sickert was added to the background on the right, and the cast of Venus on the left – recalling his *Painter in his Studio* (1907).[44] Orpen had used this cast in his own slightly zany self-portraits.[45] More significant than these insertions and deletions was the fact that the table, which in *Some Men and a Picture* had a sherry, claret, or possibly even absinthe decanter upon it, is now covered up with a tablecloth and the irrefutable evidence of afternoon tea.

The drawings and studies are a commentary upon the conception of the work rather than genuine preparations for it. They illustrate in an important way that beginning from the roughest of ideas Orpen worked towards something naturalistically convincing. He was thinking visually, grouping and regrouping the figures, deciding upon the effect which Moore's words might create upon the faces of the listeners, the way in which they would be dressed, the way in which they would sit or stand. There was a whole history of this type of realization in western art, going back to English eighteenth-century conversation pieces. Framed in a carved Rococo section between the cast on the left and Sickert and MacColl on the right, Manet's *Eva Gonzales* becomes a reference point, a sign, and its presence is naturally reduced. It is the object to which the unheard words are directed. It becomes the background to a conversation piece which echoes the world of the Society of Dilettanti, of Zoffany, Wheatley and Mortimer, and it is the fundamental eighteenth-century Englishness of the ensemble which separates it from the school line-ups of Fantin and Denis.[46] In the nineteenth century there was a rich legacy of pictures of collectors and critics viewing works of art: Meissonier, Decamps, Tassaert, Stevens, Gérôme, Alma-Tadema, Degas, Sargent, and many others addressed the ambience of art consumption. Collectors live with pictures either by taking them out and studying them one by one, concealing them behind curtains, or by installing them for all to admire as part of the interior.[47]

How people behave in front of pictures, how they look – how they actually look, and how they look to an observer – these issues preoccupied Orpen throughout his career. In 1902 he reacted to a sketch in one of his father's letters in the painting of *The Valuers* (fig. 7). This shows three men studying a landscape and it comes in the context of a liquidation of assets, the kind of activity in which a Dublin solicitor might become involved.[48] The painting shows four frock-coated notaries' assistants examining household contents, below stairs. A silver chest has been opened on the right, some candlesticks have been left on top of it, and a picture and statuette by its side. The attention of the four has been caught by a genre painting in a gilt frame, which contains a dancer being engaged in conversation by a couple

of potential clients. Behind the stage-flat, their conversation is overheard by a male performer dressed as a harlequin. There are echoes of Degas, Forain, and Béraud.[49] The men are studying a painting, diverted by its subject from the serious task of putting a valuation upon it. One shabby assistant gingerly approaches, looking perhaps for a signature; one declaims its worth, two stand back to take it in. This object they have come upon is more than what one might traditionally expect in maids' and servants' quarters. All at once we see the commodification of art in the Edwardian period allied to an older form of commodity in the theme of the picture within the picture, drawing together sexual and cerebral desires.

People studying pictures, group portraits of cognoscenti, theatrical declamations of poetic substance – the sub-plots of *Homage to Manet* were Orpen's most frequent subjects –in the portrait-interiors of Charles Wertheimer, the Countess of Crawford and Balcarres, and in the extraordinary *Selecting Jury of the New English Art Club* – and he was to come back to these themes. To this group could be added the "artist and model" series of 1911–12, which culminates in *The Poet* (ca. 1915). Here was a deeply enigmatic work, perhaps debunking the renascence with which Orpen had been associated. The poet, based probably on Keating, is one of those motley characters described by Yeats, his motleyness accentuated by the dappled shade into which he is thrown. His solitary listener, reclining on Tarzan's pillows, is a blond vamp.[50] Over the whole proceedings flutters Verrocchio's *Putto with a Dolphin* – echoes of Browning, echoes of Alma-Tadema's *Catullus at Lesbia's.*

Alluding in passing to these pictures – and there could be others mentioned – helps to construct swiftly the image community around and from which *Homage to Manet* emerges – its particular visual culture, to borrow Svetlana Alpers's phrase. Reference to this material demonstrates that none of his other works of the period has the moment, the sustained concentration of purpose, of Orpen's *Homage to Manet.* For this reason it was a notable exception in John Rothenstein's mind when he published his essay on Orpen, his uncle, in 1952.[51] For the most part Rothenstein inherited the view that Orpen in spite of his prodigious talent, was so severely lacking in intellectual grasp as to be dismissable. As a portraitist it was "the golden treadmill for him," there was "no time for reflection."[52] This view was even being taken in the 1920s when Orpen had returned

embittered from the Western Front. Orpen in the 1920s, like Manet, hated vulgar theorizing – indeed, as he became more and more unbalanced he came to loathe all serious conversation. Sadly this makes bad copy with today's historians, who, if they consider artists at all, like them to be intellectually credible or at least able to state a doctrinal position. In the 1920s Orpen resorted to casual comedy with fiendish enthusiasm. Faced with the endless parade of the rich and famous who came to the studio at South Bolton Gardens to be painted, he could do nothing but suppress the deep feeling that the Great War had unleashed. At the end of his life, in a series of biblical pictures which Konody dismissed, he was to be seen groping like a gas-blinded "Tommy" towards incomprehensible goals. Nothing really mattered. He could not take himself or anything else seriously. Thus the little bourgeois joker incongruously painting *Eve in the Garden of Eden* in Sleator's late homage.[53]

It is clear that Orpen eventually attained, arguably to his detriment, what Manet always seemed to wish for – a successful Salon career based upon portraiture. It is nevertheless apparent that he must have been most affected by the very debate he was depicting in *Homage to Manet.* In the winter of 1904 Lane had invited Moore to lecture at the installation of the exhibition of French painting at the RHA. He was, as he was quick to point out, "The only one in Dublin . . . who knew them all [the Impressionists] at the Nouvelle Athènes." It is this which he is going over in front of Steer, Sickert and the others.[54] When the first studies of *Homage to Manet* were being drawn, Moore's lecture was published in Dublin in 1906 as *Reminiscences of the Impressionist Painters,* containing a dedication to Steer. Moore took it hot off the press, to Steer's studio. He wrote to AE (George Russell)". . .. I was dining with Steer and Tonks, MacColl, Rothenstein and others of the 'New English kin' were dining with Steer too; the circumstances were so fortuitous that it was impossible not to read the preface Everyone was delighted."[55] So there was a ritual reading in London, albeit in Cheyne Walk, not South Bolton Gardens. In this Moore recounts again his own sentimental education as an art student in Paris in the 1870s, when he gate-crashed on the Impressionist circle at the Nouvelle Athènes café. Like Reynolds's *Dilettanti* impressing one another with tales of digging up Athens in the Forum, Orpen is excavating the "new Athens" – in the process, of course, the noxious absinthe and crème de coca is distilled into afternoon tea.

However, none of this explains why the portrait of Manet's pupil, fashionably attired for the Salon and rhapsodically posed in the act of painting a flower piece, should be the chosen image. Would not a picture with a tougher program such as the *Vieux musicien* or *La musique aux Tuileries* provide a more appropriate paradigm? While in Orpen's terms, and perhaps in hindsight, this might be true, it was not so for George Moore and the particular view of Manet which he had come to represent. "Manet," he declared, "was a rich man, in dress and appearance, he was an aristocrat Manet was obliged for the sake of his genius to separate himself from his class"[56] While the notion of the "genius," deeply beloved of writers on painting at the turn of the century, is problematic, the rest of Moore's observation is acute. Manet's class background was not a feature of the early scholarship and has only relatively recently begun to seem important to writers such as Clark and Reff.[57] Manet's upbringing led him to be preoccupied with status. He was instinctive rather than intellectual, yet, despite his aspirations to public success, he was unable to turn his hand to meretricious society portraiture such as that practised by his friend Carolus-Duran. His attraction for Moore was that, being on the edge of this – what had become by the 1890s the central tradition of revived court painting – Manet defined it. These and other qualities made *Eva Gonzales* a necessity for the burghers of Dublin, if only they could see. Glancing up at her portrait, Moore is saying, "Mlle Gonzales' rounded white arm is courageously stated, for it is entirely without sexual appeal, and I am afraid the picture will to many people seem vulgar for that very reason. . . but one should not hesitate about saying anything – the portrait is Manet and nothing but Manet. That portrait is an article of faith. It says 'Be not ashamed of anything, but to be ashamed.' Never did Manet paint more unashamedly. There are Manets I like more, but the portrait of Mlle Gonzales is what Dublin needs. Is it not clear that whosoever paints like that confesses himself unashamed, he who admires that picture is already half free – the shackles are broken and will presently fall"[58]

How should one come to terms with this extraordinary utterance, which everyone who writes about Manet or Orpen declines to quote? The circumstances surrounding the acquisition and appreciation of Manet's picture are recounted, and through them the belief in the efficacy of Manet's facture explained on the level of the visual. The sub-sequent history of Manet's painting, a cultural property of which the ownership has been in dispute between Dublin and London, its containment in Orpen's canvas as an object of homage confirms its status as a holy relic, separated forever from the powder-puff complexions and bourgeois *politesse* of the Second Empire.

The crazy assumption that this painting is revolutionary, and that from this the relationship between social and artistic revolution can be extrapolated, remains. How can we accommodate the breathtaking assertion that the contemplation of *Eva Gonzales* will lead to freedom? Was this really a revolutionary picture, an unacknowledged inspiration of the Easter Rising? There is no apparent sense in the rambling of the aging novelist who had, in the front of his mind, the bizarre connection between the Irish cultural renascence and the fight to convert everyone to French art.

After London, *Homage to Manet* was shown in Glasgow and recommended for purchase by the city in the columns of a local newspaper. If Glasgow was contemplating acquisition it was gazumped by Manchester, which paid the asking price of £500.[59] It is likely that the picture would have appealed to the council's art committee because it was a modern work in an acceptable style, which also provided an efficient record of people and events. Anyone, like the burghers of Manchester, building a representative collection would be attracted to it. It did after all portray a committee of sorts, even if the words being spoken cannot now be heard.

NOTES

The present paper was delivered in embryonic form as a lecture at the University of Hull and the Ulster Museum, Belfast in 1991. Overhauled and updated, it was re-presented at the conference "Re-thinking Englishness" at the University of York in July 1997. Further refinement and reworking has occurred since that conference.

1 Frank Rutter, *Since I Was Twenty-Five* (London: Constable, 1927), p. 175.

2 Quoted from *The Evening Herald*, 3 March 1913, in Jeanne Sheehy, *The Rediscovery of Ireland's Past, The Celtic Revival, 1830–1930* (London: Thames and Hudson, 1980), p. 116.

3 For the Irish Impressionists see *The Irish Impressionists* (exh. cat. by Julian Campbell, National Gallery of Ireland, Dublin, 1984); for general discussions of the re-casting of modernist practice in terms of an Irish school see Kenneth McConkey, *A Free Spirit: Irish Art 1860–1960* (Woodbridge: Antique Collectors' Club in assoc. with Pyms Gallery, London, 1990) and S.B. Kennedy, *Irish Art and Modernism, 1880–1950* (Belfast: Published for the Hugh Lane Municipal Gallery of Modern Art, Dublin by the Institute of Irish Studies at the Queen's University of Belfast, 1991).

4 *Homage to Manet* was originally exhibited at the New English Art Club in London in the summer of 1909 (no. 13) as *Group Portrait*.

5 The second group of characters, not used in *Homage to Manet*, was deployed in *The Café Royal*, 1912 (Musée d'Orsay, Paris). It is clear from

study of the original manuscript that Bruce Arnold, in *Orpen, Mirror to An Age* (London: Jonathan Cape, 1981, p. 228), has misread "Max" for "Moore" in the second group. It is also clear from the context that Lane was actively involved in persuading sitters to cooperate.

6 Fantin's *Homage to Delacroix* was shown at the artist's posthumous retrospective in May-June 1906 at the Ecole des Beaux Arts, before its acquisition by the Musée du Louvre in 1907 as the gift of Etienne Moreau-Nélaton. It was temporarily displayed from 1907 onwards at the Musée des Arts Décoratifs (see *Fantin-Latour*, exhib. cat., Paris and National Gallery of Canada, Ottawa, 1983, entry by Douglas Druik, p. 180). Denis's *Homage to Cézanne*, which would at this date have been less visually appealing to Orpen, was in the collection of André Gide, having been shown at the Salon (Société Nationale des Beaux Arts) in 1901 see *Maurice Denis* (exhib. cat., Lyons, Cologne, Liverpool and Amsterdam, 1995, p. 258). Orpen is, for instance, likely to have been influenced, initially at least, by Moore and Sickert, both of whom failed to appreciate Cézanne.

7 P.G. Konody in P.G. Konody and S. Dark, *Sir William Orpen, Artist and Man* (London: Seeley, Service & Co., 1932), p. 213.

8 "Sir William Orpen's Studio, 8 South Bolton Gardens," *Country Life*, lxviii, 1930, p. 342.

9 For further discussion of the formation of this "history," see Kenneth McConkey, *Impressionism in Britain* (exhib. cat., London: Barbican Art Gallery, 1995).

10 For reference to George Moore (1852–1933), Irish novelist, critic and collector, see *inter alia* Joseph Hone, *The Life of George Moore* (London: Victor Gollancz., 1936); Tony Gray, *A Peculiar Man: A Life of George Moore* (London: Sinclair-Stevenson, 1996).

11 For reference to Philip Wilson Steer (1860–1942), British Impressionist painter, see *inter alia* D.S. MacColl, *Life, Work and Setting of Philip Wilson Steer* (London: Faber and Faber, 1945); Bruce Laughton, *Philip Wilson Steer, 1860–1942* (Oxford: Clarendon Press, 1971); Ysanne Holt, *Philip Wilson Steer* (Bridgend: Seren Books, 1993).

12 For D.S. MacColl (1859–1948), critic, historian, keeper of the Tate Gallery and the Wallace Collection, see Maureen Borland, *D.S. MacColl: Painter, Poet, Art Critic* (Harpenden: Lennard Publications., 1995); for Walter Sickert (1860–1942), British Impressionist painter, see *inter alia* Robert Emmons, *The Life and Opinions of Walter Richard Sickert* (London: Faber and Faber., 1941); Wendy Baron, *Sickert* (Oxford: Phaidon, 1973); and Richard Shone, *Walter Sickert* (Oxford: Phaidon, 1988).

13 For Henry Tonks (1862–1937), painter and Slade School of Fine Art professor, see Joseph Hone, *The Life of Henry Tonks* (London: W. Heinemann, 1939); for Hugh Lane, see Lady Gregory, *Sir Hugh Lane: His Life and Legacy* (Gerrards Cross: C. Smythe, 1973).

14 Steer presented *Landscape: Sunshine and Shadow*, Sickert presented Whistler's portrait of him. Other prominent British painters who contributed works were George Clausen, Henry Scott Tuke, Laura Knight, D.Y. Cameron, and Augustus John.

15 MacColl's principal articles appeared in *The Saturday Review*, see notes 23 and 27 below. For general reference to his support for Lane see Borland, pp. 198–99, 205–07.

16 Gregory, *Sir Hugh Lane*; Thomas Bodkin, *Hugh Lane and his Pictures* (Dublin: Published by the Stationery Office for an Chomhairle Ealaíon [The Arts Council], 1956); *idem*, "Memories of Sir Hugh Lane," in *Tribute to Sir Hugh Lane* (Cork: Cork University Press, 1961); see also Barbara Dawson, "Hugh Lane and the Origins of the Collection" in *Images and Insights* (exhib. cat., Dublin, Hugh Lane Municipal Gallery of Modern Art, 1993, pp. 13–31), for more recent research on Lane's early life. Born in Co. Cork in 1875, son of a Protestant clergyman, Lane worked in London with the firm of Colnaghi from the age of eighteen, before branching out as a "gentleman dealer." For further notes on his activities as a trader in pictures see Rutter, *Since I was Twenty-Five*. Lane lived at a time when Bernard Berenson's studies on Italian art were being published and he practiced the then current "scientific" connoisseurship to personal advantage, regularly spotting unattributed pictures. On the historic occasion at Coole we can expect that the young W.B. Yeats and Douglas Hyde, founder of the Gaelic League, pressed the case for Irish culture and nationality. In Edward Martyn, Lane also

encountered strongly held nationalist sympathies – mixed with a predilection for French painting cultivated by his friend George Moore. Martyn already owned two works by Degas at this point: see Denys Sutton, "George Moore and Degas," in Brian P. Kennedy, ed., *Art Is My Life, A Tribute to James White* (Dublin: National Gallery of Ireland), 1991, p. 187.

17 Lane was so impressed with John Butler Yeats's work that he immediately commissioned him to produce a series of portraits of distinguished Irishmen to form the basis of an Irish National Portrait Gallery: see Bodkin, *Hugh Lane*, p. 5.

18 For a discussion of Lane's attempts to raise aesthetic awareness of French art in Dublin see Sheehy, *Rediscovery*; Kenneth McConkey, "Cultural Identity in Irish Art," in *Irish Renascence* (exhib. cat.,) London, Pyms Gallery, 1986; McConkey, *A Free Spirit*, and Dawson, "Hugh Lane."

19 Lane effectively rescued paintings gathered for the Irish section of the St Louis World's Fair which for bureaucratic reasons had been canceled. At short notice he arranged through A.G. Temple for these to be shown at the Guildhall Art Gallery, London. In June 1904, when the exhibition opened, Lane declared his ambition to bring together specimens of work by Irish artists in order to "discover what common or race qualities appear through it" ("Prefatory Notice," in London *Catalogue of the Exhibition of Works by Irish Painters*, Art Gallery of the Corporation of London, 1904, p. x). The significance of this date, coinciding with James Joyce's "Bloomsday," has been noted. The idea of "race" and particular racial characteristics was current among European intellectuals at the time. Lane hoped, even at this stage, to form the collection which would stimulate the visual arts in Ireland: see Gregory, *Sir Hugh Lane*; Bodkin, *Hugh Lane*; Dawson, "Hugh Lane"; and Sheehy, *Rediscovery*, pp. 107–19, for fuller accounts of the formation of the Gallery of Modern Art in Dublin.

20 Recent writers, including the author, have not fully explored the contemporary debate about nationality in the arts and the discussion about what might qualify a painter for inclusion. In an interesting review of the exhibition, *The Athenaeum* (11 June 1904, p. 758) questioned Lane's belief that the flame of the Irish school would be ignited by the presence of a "Corot, a Watts, a Whistler and a Sargent in a Dublin gallery. The Irish should look to their own Celtic traditions . . . they must isolate themselves, and not, as they propose, get the English to build for them big galleries for the display of typical works of recent times from England, America and the Continent." *The Art Journal* (1904, p. 236) took a less isolationist line, while *The Academy* (1904, p. 620), opposed *The Athenaeum*, and looked for more, not less cosmopolitanism, commenting for instance upon Orpen's *Portrait of George Moore* that he was depicted "suffering from a severe colic supervening on the fever called the Irish Literary Revival after writing a play in Irish and realising the tomfolly of the achievement."

21 James Staats Forbes (1823–1904, born in Aberdeen) was a railway manager who amassed a huge private collection of Barbizon and Hague School pictures. Orpen's portrait of him (Manchester City Art Gallery) was shown at the New English Art Club in the summer of 1902 (no. 97). Orpen recalled that he was "a most kind gentleman, and he used to let me run *loose* in Garden Corner House, Chelsea, where he kept his collection, at any time I pleased, so I knew his pictures well": see William Orpen, *Stories of Old Ireland and Myself* (London: Williams & Norgate, 1924), p. 51.

22 Orpen later recalled to Lady Gregory, "I was with him at Durand-Ruel's and he would say to me behind his back, 'What is that? A Manet?' – he had never seen a Manet before – and what is that other? Is it one I should ask for to bring to Dublin?": Gregory, *Sir Hugh Lane*, p. 58, quoted in Arnold, p.143.

23 *The Saturday Review*, 3 December 1904, p. 696.

24 See Martin Davies, *French School* (London: National Gallery, 1970, pp. 89–94, 104, 111–12).

25 Sheehy, *Rediscovery*, pp. 111–13; Dawson, "Hugh Lane," pp. 21–24.

26 The tale of the subsequent search for a permanent site for the gallery, Lane's withdrawal of his collection and the extraordinary circumstances of his death on the Lusitania are recounted in Sheehy, *Rediscovery*, pp. 114-19, and Dawson, "Hugh Lane," pp. 24–30.

27 D.S. MacColl, "Lessons from Dublin," *The Saturday Review*, 8 February 1908, p. 168. MacColl praises individual purchases, citing the National Gallery, London, attempts to buy a French Impressionist picture a few years earlier: "the *Eva Gonzales* was too dear, the *Tuileries* not to be sold, Mr. Lane got them both The Monet even, the *Snow Scene at Vétheuil*, was too dear, and Mr. Lane got that. In the end a charming little Boudin was bought; that was all the subscribers could run to."

28 Arnold, pp. 228–29, reproduces the most comprehensive selection of these.

29 Orpen, *Stories*, pp. 68–69, refers to this generation as "the young of Ireland, men and women with the real gift and love of nature, together with the wish and energy to express their love both in line and color."

30 For a discussion of these works see *Celtic Splendour* Pyms Gallery, (exhib. cat., London, 1985, pp. 50–53); *Orpen and the Edwardian Era* Pyms Gallery, (exhib. cat., London, 1987, pp. 72–75).

31 In this regard it is interesting to compare the handling of *St Patrick* (City Museum and Art Gallery, Stoke-on-Trent) with the figure of the musician. I am grateful to my colleagues on the Orpen Research Project for the opportunity to discuss the interpretation of this picture. Into the comparison with Manet's frieze of miscellaneous characters should be added later works like *The Hungarians* and *The Fairy Ring*.

32 Frank Mathew, *Ireland* (London, 1905), p.35, quoted in McConkey, *A Free Spirit*, p. 51. See also R.F. Foster, *Modern Ireland, 1600–1972* (New York: Penguin Books, 1989), pp. 436–37, pointing out that Dublin had at this time the fifth highest death rate in the world.

33 Orpen, *Stories*, p. 34.

34 For reference to *Old John's cottage, Connemara*, Orpen's principal work from this journey, see McConkey, *A Free Spirit*, pp. 132–34.

35 "Difference" as an underpinning of nationalism at the turn of the century is considered in D.G. Boyce, "The Marginal Britons: The Irish," in Robert Colls and Philip Dodd, edd., *Englishness, Politics and Culture 1880–1920* (Dover NH: Croom Helm, 1986), pp. 230–53. This account concentrates upon the political polarization of Ulster Unionism and Sinn Féin. For a more culturally oriented account, F.S.L. Lyons, *Culture and Anarchy in Ireland, 1890–1939* (Oxford: Clarendon Press; New York: Oxford University Press, 1979), is seminal.

36 For a discussion of these works see *Orpen and the Edwardian Era*, 1987, pp. 78–81.

37 Arnold, pp. 289–96. Space does not permit detailed analysis of *Sowing New Seed . . .* (Mildura Arts Center), *The Western Wedding* (formerly Matsukata Collection, destroyed) and *The Holy Well* (National Gallery of Ireland), a sequence which, taken beside the "Irish" work of Augustus John, Cayley Robinson, John Currie, and Gerald Leslie Brockhurst, attempts to re-create for modern Ireland the grand manner of Renaissance mural cycles.

38 T.M.W. [T. Martin Wood], "The New English Art Club's Summer Exhibition," *The Studio*, XLVII, 1909, p. 180. See also notes 1 and 2 above.

39 Arnold, pp. 228–30.

40 For reference to this important drawing, not reproduced by Arnold, see *Orpen and the Edwardian Era*, 1987, pp. 82–85.

41 *The Art Journal*, 1909, p. 16.

42 Frederick Wedmore, *Some of the Moderns* (London: Virtue & Co., 1909), following p. 102. The sequence of these photographs is clear from the fact that Steer adopts his final position in the Wedmore photograph.

43 Close examination of the pentimenti in *Homage to Manet* confirms these changes. I am grateful to Philip Sykas of Manchester City Art Gallery for the opportunity to study the picture in detail.

44 Collection of the Art Gallery of Hamilton, Ontario (see Baron, cat. 258, p. 346). This picture was shown at the New English Art Club summer exhibition of 1907 and would have been seen by Orpen.

45 See for instance, *Self-Portrait with Venus*, Hugh Lane Municipal Art Gallery, Dublin, 1910.

46 In referring generally to these British sources I do not, of course, neglect my central argument of Orpen's dependency on Manet and, through him, on Spanish Caravaggesque painting. Like other Slade-educated painters such as Augustus John, Orpen had a prodigious visual memory and capacity to quote. In this particular regard, his trip to Madrid with Hugh Lane must have been seminal. The similarity of figure-to-field relationships between *Homage to Manet* and Velázquez's *Las Meninas* (Prado) is noteworthy.

47 The New English Art Club exhibitions of the years around 1909 were particularly rich in middle-class interiors containing works of art. With S.N. Simmons, *The Cosy Corner*, F.H.S Shepherd's *The Bach Player*, Philip Connard's *A May Morning* and Rothenstein's *A Family Group*, "portrait interiors" dominated the summer show of 1909.

48 Arnold, pp. 111–13; see also D.S. MacColl, "The New English Art Club," *The Saturday Review*, 12 April 1902, p. 461, which comments particularly on Orpen's ability to orchestrate a group of figures.

49 One of Martyn's Degas pastels, with which Orpen may well have been familiar, was, for instance, *Les deux arlequins* (National Gallery of Ireland, Dublin).

50 For reference to this work see *Irish Renascence*, pp. 72–75.

51 John Rothenstein, *Modern English Painters* (London: Eyre & Spottiswoode, [1952], 1962 edn.), pp. 239–56. For a consideration of Orpen and his critics see Kenneth McConkey, "Sir William Orpen: his contemporaries, critics and biographers," in *Orpen and the Edwardian Era*, 1987.

52 Rothenstein, p. 252.

53 For James Sleator's portrait of Sir William Orpen at work on an unfinished canvas entitled *Eve in the Garden of Eden*, see *Orpen and the Edwardian era*, 1987, p. 126. For further reference to James Sleator's career, see Brian Kennedy, *James Sinton Sleator, PRHA, 1885–1950* (exhib. cat., Belfast: Armagh County Museum, 1989).

54 Wedmore actually suggests, (*Some of the Moderns*, p. 100), that Moore might be reading "The Lovers of Oreley," a story published in 1906, to the others. This is possible but unlikely. Orpen clarifies this point in a letter of February–March 1907, "I have painted George Moore into the composition – great success – he is in front looking at the Manet and is supposed to be reading his paper on that gentleman to the eager listeners" (Arnold, p. 229).

55 Joseph Hone, *The Life of George Moore* (London: Victor Gollancz, 1936), p. 271.

56 George Moore, *Reminiscences of the Impressionist Painters* (Dublin: Maunsel, 1906), p. 17.

57 See, for instance, Theodore Reff, *Manet and Modern Paris: One Hundred Paintings, Drawings, Prints and Photographs by Manet and his Contemporaries* (exhib. cat., Washington, National Gallery of Art, 1982); T.J. Clark, *The Painting of Modern Life, Paris in the Art of Manet and His Followers* (Princeton: Princeton University Press, 1989).

58 Moore, *Reminiscences*, p. 20.

59 Arnold, p. 231.

Framing
Ireland's History

Art, Politics, and Representation

1914–1929

SIGHLE

BHREATHNACH-LYNCH

During Easter Week of 1916 a twelve-hundred-strong armed force of Irish Volunteers took over the center of Dublin. Their proclaimed aim was to rid Ireland of British Rule. It was an ill-fated action. Within weeks this Rising had been quashed, seven of its leaders executed, and many of those involved imprisoned. Yet in spite of its apparent military failure, it promoted a more widespread support for political independence. Within three years, Sinn Fein members who had been elected to the British Parliament refused to take their seats and opted instead to establish an independent Parliament in Ireland. They issued a declaration of independence. Two years of bloodshed followed after which a truce was declared between Britain and Ireland allowing for negotiations for a treaty. When finally agreed in 1921, this treaty gave Ireland "Dominion" status but permitted any of the thirty-two counties to secede within one month from the newly constituted Irish Free State. As expected, six of the Ulster counties opted out. The compromise did not please all the nationalist delegates and in spite of a general election in June 1922, which gave the Pro-Treatyites a majority, a short but bitter Civil War followed. By 1923, however, an uneasy peace had been restored and newly independent Ireland began a fresh chapter of its history.

For nationalists, these turbulent events represented an heroic modern movement in the age-old struggle with England, and they were documented as such by Irish historians of the period. Almost without exception, written accounts interpreted what had occurred in a triumphal way. The dead of 1916 and of the War of Independence were accorded the status of latter-day Christian martyrs and heroes. It was not only historians who concerned themselves with unfolding events. The literary and artistic world responded too. Sean O'Casey, for example, explored the immediate effects of these occurrences on ordinary men and women in some of his finest dramas, while W.B. Yeats gave expression to his own misgivings in poetic form. An art historian at the end of the twentieth century might ask what the visual response was to what was happening. Did Irish artists rush to capture in paint the stirring times in which they were living? The painting of history, both past and present, was after all a category held in great esteem for centuries.[1] Did the plastic arts reflect current political concerns in early twentieth-century Ireland?

If one were to rely on the conventional wisdom, nothing of consequence was produced by artists during this period.

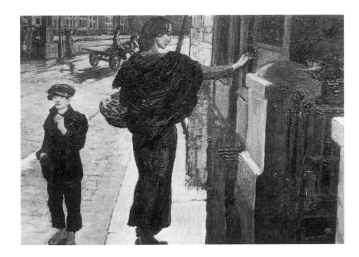

Fig. 8. Jack B. Yeats, *Bachelor's Walk – in Memory*, 1915, oil on canvas, 18 × 24 in. (46 × 61 cm), Whereabouts unknown

In the writing up of an Irish art history, the political art of the years 1916 to 1923 has tended to be either ignored or treated as relatively unimportant.[2] Instead, the principal issue tackled in such surveys has been the advent of modernism, with its emphasis on the concept of the autonomy of the work of art. Academic, realist art has rated less analysis precisely because it is grounded in the "real," and the "political real" does little to foster notions of timelessness and universality, attributes readily ascribed to Great Art.[3] Yet to accept this line of reasoning leaves an important difficulty. Uncomfortable as it may be to formalist art historians, artists live in the real world and there were artists who did respond to political events – descriptively, anecdotally, and, in some cases, in a frankly polemical manner. Among them were three artists who would become household names in the history of early twentieth-century Irish art: Jack B. Yeats, Seán Keating, and John Lavery. Other painters, now not so well remembered, also documented what was happening in Ireland, and there would be artists, born after this period, who continued to paint this political subject-matter for several decades to come. Sculptors, too, would be employed through the years on commemorative works in bronze and stone.[4] This essay sets out to examine the response of Irish painters over a period of fifteen years to unfolding political events, considering the motives of artists who chose to depict such happenings. More significantly, it examines how this history was interpreted by them. The public reception of the imagery at the time is discussed and the underlying ideological importance of such visual reportage is also analyzed.

The year 1914 saw efforts to bring about the collapse of Home Rule in Ireland. Ulster loyalists in particular had countered every move towards this goal and, as a result, a conference initiated by King George V fell apart. Many political meetings were held by Sinn Fein throughout Ireland. Present at some of the meetings, and experiencing at first hand the heady atmosphere and political passion of these occasions, was the artist Jack B. Yeats. It was he who was to lead the way in contemporary visual reportage.[5] Yeats's political sympathies were with the nationalist cause and his patriotic feelings were deep and intense. As a young man he had attended the celebrations marking the centenary of the 1798 Rebellion in Ireland, the historical and spiritual ancestor for the Rising of 1916. He joined the Gaelic League, an organization devoted to the restoration of the Irish language and one which was to become increasingly politicized under the influence of Patrick Pearse as 1916 approached. By 1914, as a middle-aged man of over forty years, Yeats's passionately held views had deepened with time. He fervently believed in an Ireland free from foreign domination. As an artist his natural inclination was to paint and sketch what was of interest to himself, and of abiding regard to him was the life of his own countrymen and women. Every aspect of that life fascinated him, from the humdrum and personal minutiae of everyday activities to major contemporary events affecting the very structures of Irish society. Not surprisingly, therefore, his art is one in which the personal and the political merge effortlessly and in which art and politics are inclusive.[6] Shaping and informing all of his images is Yeats's own sense of involvement in the events he describes. In no way did he believe that as an artist he must be at a remove from what was happening around him. Pictures, he believed, were a part of life; he argued that "the true painter must be a part of the land and the life he paints."[7]

Yeats's first major contemporary historical painting is *Bachelor's Walk – In Memory,* painted in 1915 (fig. 8). It records the artist's personal response to a skirmish between civilians and British soldiers in Dublin city the year before, in which three people were killed and at least thirty-eight injured. The event (an aftermath of a gun-running incident in Howth, Co. Dublin) caused widespread indignation throughout nationalist Ireland. Although the artist did not personally witness the event, some days later he visited the spot for himself. Young women selling flowers on the streets

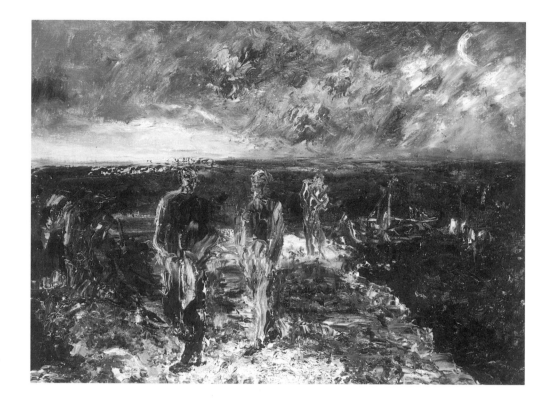

Fig. 9. Jack B. Yeats, *Men of Destiny*, 1946, oil on canvas, 20 × 27 in. (50.8 × 68.6 cm), National Gallery of Ireland, Dublin

nearby had placed flowers where the dead had fallen. Yeats sketched the scene and followed it up one year later with an oil painting, depicting a tall graceful flower girl in the act of throwing a rose from her basket though the gateway of a house. She is silhouetted in profile. The mood of the scene is quiet and somber. Significantly, the Dublin quayside does not bustle with life. Only a small boy walks by, a horse and cart trundles on its way, and one or two passersby can be seen on the opposite pavement. Although the street is well lit, the buildings on either side are cast in deep, almost menacing shadow. The rather dark palette, revealed only by small touches of pink and creamy white, serves to reinforce the mood. Yeats's choice as to which moment of the event to paint is revealing, for he notably does not portray the actual shooting. Instead, he concentrates on depicting the grief and protest eloquently registered by a single person after the event. The young woman's gesture is made all the more poignant by the fact that it is unnoticed by the others on the street.

The shooting at Bachelor's Walk in 1914 was not the first overtly political subject tackled by the artist. At a Volunteer meeting in Dundrum, Co. Dublin, that same year Yeats made several sketches of Patrick Pearse, who would lead the Easter Rising two years later, as he addressed the crowds. But

rather than forming the basis of a grand history painting or portrait, the drawings provided the basis for an everyday (genre) scene. Entitled *The Public Speaker* (private collection), the painting shows a young man, dramatically silhouetted against the sky, addressing an intent crowd. There are no clues as to the precise nature of the meeting and none of the figures is a portrayal of a recognizable person. Nevertheless, it provides a lively vignette of contemporary reportage. This scene heralds the artist's strategy in his chronicling of political events, in which, as John Turpin has noted, Yeats described "the larger historical tragedy through a small poetic detail."[8]

In spite of Jack Yeats's interest in depicting this kind of subject-matter, ironically it was not he who was to document that most pivotal of all historical occasions, the Easter Rising of 1916. Already the artist was ill and suffering from depression, a depression that would last for several years and during which time he would paint little. In fact it would be many years later before he expressed in paint his feelings about the men who had fought for Irish freedom, especially those of Easter Week. By then his art was based on his responses to earlier memories coming to mind unbidden. *Men of Destiny* (fig. 9), painted in 1946, is a visionary image based on memory and half-memory in which the flamelike

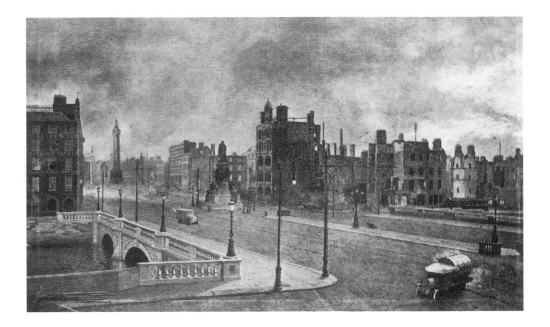

Fig. 10. Archibald McGoogan, *After the Bombardment*, 1916, oil on canvas, 19¼ × 27½ in. (50 × 70 cm), New Ireland Assurance Company, Dublin

glowing figures of the fishermen coming ashore are evocations of those involved in the struggle for national independence. The deep, vivid colors give the painting an intense mystical quality in keeping with Yeats's mature style of painting, a highly personal and expressive one.[9]

The artist who produced what was to become the icon of the Rising was the younger painter Seán Keating. His painting *Men of the West* (Plate 15) was initially inspired by a visit in 1914 to the Aran Islands, which exercised a powerful and lasting impression on the young student. Keating was not the first artist to be inspired by this part of the country. From the end of the nineteenth century the West of Ireland increasingly held an attraction for artists and writers. The separateness of the people living there from those living elsewhere in Ireland made them appear unique: they dressed in peasant costume, they spoke Gaelic, and their unchanging life-style, with its timeless customs and rituals, seemed to suggest that it was these people and this place which had retained the essence of the "real" Ireland.[10] In a period when independence was becoming the dream of an increasing number of Irish men and women, the West and what it came to stand for in the public imagination offered a distinctive sense of national identity, one very different from that associated with Great Britain. After independence the official construct of this identity was to center on an Irish-speaking, rural, Catholic people with a strong Gaelic cultural tradition. Seán Keating's art, with its concentration on images of the western peasant, reinforced this construct.

Men of the West, painted some time in 1916,[11] is a romanticized image of the Irish fighting men of the time. Dressed in Aran costume and bearing arms, their expressions heavy and solemn, they stand in heroic pose against a backdrop recalling the desolate landscape of Aran. Their commitment to the Republican cause is symbolized by the tricolor (the flag merging the Green of Ireland and the Orange of Ulster's Protestants) on the left of the picture. The visual message is clear: it is these men fighting for Irish freedom who are the new heroes of Ireland. But their quaint peasant clothes make it equally plain that they are the "true" representatives of the Irish race. In reality this was entirely out of keeping with the largely urban, Dublin-centered nature of the Rising, but the decision to present the men in this way served ideologically to link the remote West, with its distinctive, Gaelic way of life, to the emerging concept of national identity. Significantly, too, Keating incorporates his own features in the figure on the left, a declaration of his allegiance to the nationalist cause. In the year leading up to independence he was an ardent supporter of national politics, partly for family reasons: a relation of his, Mercedes Joyce, had fought in the General Post Office in the Rising of 1916.[12]

Keating's *Men of the West* stands out as a personal, visionary response to developing political events when compared with the paintings of Edmond Delrenne[13] and Archibald McGoogan.[14] Their canvases offer sweeping vistas of the destruction of the center of Dublin after the fighting, the compositional format recalling photographic illustrations.

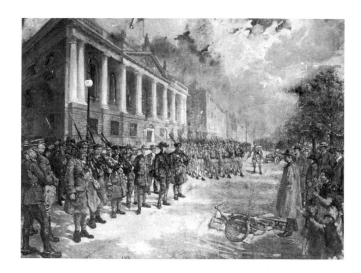

Fig. 11. Kathleen Fox, *The Arrest*, 1916, oil on canvas, 22 × 30 in. (56 × 76.5 cm), Sligo County Museum

Delrenne's *The G.P.O. in Flames* (private collection), which he painted in 1917, presents the scene from the back of ruined houses in a side street off Dublin's Sackville Street (later renamed O'Connell Street), where much of the fighting took place. Smoke and flames engulf the Post Office and enshroud nearby Nelson's Column, which somehow managed to survive the fighting.[15] McGoogan's painting *After the Bombardment* (fig. 10) shows Sackville Street and part of Eden Quay in ruins and on fire. It is a desolate scene in which, with the exception of two armored cars firing shots at snipers who remain hidden, there is no one to be seen. Its topographical accuracy, giving the scene veracity, is the result of a series of sketches the artist did at the time as well as his use of contemporary photographs.

Unusually for the time, one woman artist, Kathleen Fox,[16] chose to depict the Easter Rising, and at first glance her canvas appears to be an objective visual representation. *The Arrest* (fig. 11) shows Countess Markievicz,[17] second officer in command of St Stephen's Green during the Rising, surrendering to British troops outside the Royal College of Surgeons. Returning from abroad in 1916 after spending four years painting on the Continent, Fox openly went into some of the most dangerous centers in Dublin during Easter Week. On one occasion, attracted by gathering crowds outside the College of Surgeons, she drew nearer and discovered that she knew the woman being arrested. Fox was then a student at the Dublin School of Art and among those who came to evening classes were the Countess and her hus-

band. Thumbnail sketches were quickly executed on the spot. These provided the basis for the finished canvas completed some months later. As she worked on it Fox acquainted herself more fully with the events she was painting. She realized that she knew some others involved in the Rising through the art school, among them the sculptor Willie Pearse, brother of the rebel leader Patrick Pearse. When he and the other leaders were executed in the weeks after the Rising, Fox was appalled and as a result became more patriotically inclined. Recalling the executions many years later she declared, "I was horrified . . . They were friends of mine."[18] While the picture provides an excellent detailed visual account of what happened and fully conforms to the conventional demands of history painting, it is not entirely without personal input, for Fox included herself in the scene. Wearing a straw boater she represents herself as one of the onlookers. Unlike them, she stares out of the canvas as if to assert the documentary nature of the image.

The immediate fate of some of these "Rising" pictures is worth noting. In the aftermath of the event, particularly following the executions of the rebel leaders, Ireland went through a period of political tension during which nationalist sympathizers felt particularly vulnerable. Fox worked on her painting in secret lest it be confiscated by the British authorities, and when it was completed she sent it to a friend in New York for safe keeping.[19] Keating, however, openly declared his commitment to the cause by supporting an auction held in December 1916 by the National Aid and Volunteers Dependants Fund, an attempt to raise funds to help the dependents of those involved in the Rising. Many who fought had been interned and their families were in desperate need. Several artists supported the cause. Jack Yeats submitted a drawing while William Orpen and John Lavery offered to paint portraits of the highest bidders for blank canvases in their names. The sculptor Albert Power submitted a portrait bust of the writer James Stephens and W.B. Yeats gave a limited edition of *The King's Threshold*. Keating offered *Men of the West* but quickly changed his mind about its being raffled. Instead he suggested that the painting be reproduced as a print and offered to donate the copyright.[20] While the initial reaction to the Rising by most citizens had been one of bewilderment, bemusement, even impatience, after the executions the tide of public opinion changed. A growing pride in the rebels supplanted earlier

suspicions and Keating's image seemed to encapsulate that heroism and pride. Significantly the reproductions were subject to seizure and destruction by British forces, a measure of the perceived power of the image.[21] Meanwhile, Archibald McGoogan's painting, with its more impersonal focus on the destruction of the city center, seems to have been regarded as less seditious and was on offer to interested readers of the *Lady's House Journal* in its December issue as a Christmas plate.[22]

By 1919 Ireland was in turmoil. The War of Independence between Britain and Ireland which had begun with sporadic attacks against the army and police force was now one of continuous raids and ambushes. The armed guerrillas, known as "flying columns" for the speed at which they carried out their actions against the forces of the Crown, fought in civilian clothes, making their detection all the more difficult. The leaders of these columns became the new nationalist folk heroes. Several paintings document this increasingly ferocious war, the majority of these by Seán Keating. One of the most striking is *Men of the South* (Plate 24) painted late in 1921.[23] A flying column of six men from the second Battalion, 4th (North) Cork Brigade of the IRA, wait impassively to carry out an ambush. Partly hidden in trees and bushes, they are set against a backdrop of autumnal fields and hills. Keating's preparations for the painting were thorough. He began by assembling a group of leading officers from the North Cork Brigade and photographing them in an arrangement that is almost identical to the painted composition.[24] Several of them later traveled to Dublin, where they sat for Keating in his studio in the Metropolitan School of Art. The porters at the school were retired members of the Crown forces and were apparently terrified to encounter these men, armed with their rifles wrapped in brown paper.

It is Keating's arrangement of the figures across the canvas, in profile, that sets the tone of this painting. Recalling the great heroes of classical friezes of the past, it immediately establishes the men as representatives of Ireland's new heroic type. Their resolute expressions and alert poses, coupled with the accuracy of detail in their appearance and the arms they carry, create an image that demands to be valued for its historical authenticity. Yet it is not a wholly accurate representation: the implied cohesion of the group, united in a common purpose, was increasingly at odds with the real political situation. During the period in which the picture

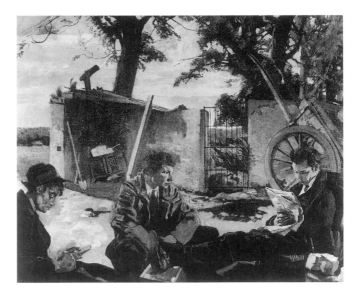

Fig. 12. Seán Keating, *On the Run – War of Independence*, ca. 1924, oil on canvas, 39⅛ × 47⅝ in. (100 × 121 cm), AIB Art Collection

was painted, a split between the pro- and anti-Treaty factions of the IRA was emerging. The treaty with Britain that guaranteed independence for twenty-six of the thirty-two counties of Ireland was believed by many to be the best that could be hoped for at the time. But for others, often hardline Republicans, the terms of the Treaty signified a betrayal of the ideals of a free and unified Ireland. Significantly, Keating's image does not deal with these political tensions. Instead he presents what he termed "a picture of men indivisible, illuminated by a cause."[25]

Men of the South is representative of a very direct form of nationalist propagandist art glorifying the recent military struggle and its participants.[26] As such it is a painting that actively constitutes the monumental heroic construct of contemporary history officially being promoted by the new State. Yet Keating cannot be dismissed as a mere propagandist. Not all his images of the War of Independence are heroic in treatment. *On the Run – War of Independence* (fig. 12), for example, painted about 1924, depicts the revolutionaries in a less glamorous role.[27] Three men sit in a country farmyard whiling away the time. One man is stretched out reading a newspaper, a second is engrossed in a book. While they seem relaxed and at ease in this situation, the third figure is a study in tension and anxiety. In comparing this composition with *Men of the West* and *Men of the South,* the lesser scale of the figures, failing to dominate the canvas, is striking. Psychologically, too, they

Fig. 13. Sir John Lavery, *The Ratification of the Irish Treaty in the English House of Lords*, 1921, oil on board, 14¹/₄ × 10¹/₄ in. (36 × 26 cm), National Gallery of Ireland, Dublin

convey a less united front in their differing responses. By these means the artist conveys a less than glorious view of war; the central focus of the painting is the reality of being on the run, its risks, its tedium, and the despondency of the participants.

While Keating is remembered as the artist of the War of Independence, the work of another Irish artist, Ulster-born Sir John Lavery, is associated with the Treaty and immediate post-Treaty period. In a number of paintings, both history paintings and portraits, it is he who documented some of the most significant events in Ireland's modern history and its central players. Unusually, his interest in contemporary political events was initiated by his American-born wife Hazel, who had become interested in Irish affairs prior to the Easter Rising.[28] As the situation between Ulster and the rest of Ireland deteriorated, Hazel had appealed to her

husband to do something for his country. In response the artist decided to make his studio neutral ground where the protagonists on all sides might meet. He began by painting portraits of political leaders, North and South, and then moved on to portray the hierarchy of both Churches in the North. Notably, Lavery was of the opinion that the Irish needed to sort out their differences by themselves. Replying to a request by Winston Churchill to proffer an opinion on the worsening Irish problem, Lavery wrote, "I believe that Ireland will never be governed by Westminster, the Vatican, or Ulster without continuous bloodshed."[29]

During the Treaty negotiations of 1921, the Laverys' home at Cromwell Place, London, was open house for the Irish negotiators. Hazel Lavery, anxious that they should meet Englishmen of importance concerned with the Irish Question, organized soirées and dinners for the delegates. Her husband, meanwhile, believed a painting documenting the signing of the Treaty would be important for posterity, but this proved difficult to arrange and he opted instead to do individual studies of the delegates. Portraits of the Irish team were later augmented by paintings of Lloyd George, F.E. Smith, Earl of Birkenhead and Austen Chamberlain of the British delegation.[30] The artist was, however, able to sketch the hastily convened debate on the Treaty in the House of Lords on 16 December 1921, a work which he entitled *The Ratification of the Irish Treaty* (fig. 13).[31] The sketch painted *in situ* from the spectators' gallery gives an impression of the proceedings, with a bird's-eye view emphasizing the impressive height of the chamber. Free touches of color indicating those present, and the warm illumination, result in a painting of mellow tonalities. Lavery exhibited the sketch at the Royal Academy early the following year, where one critic praised him for approaching his subject in a "purely pictorial way." Its historical content was not commented on.[32]

In June 1922, following the assassination of Sir Henry Wilson, the Ulster Unionists' military advisor, the new provisional government of the Irish Free State attacked the anti-Treaty IRA forces who had been occupying the Four Courts in Dublin (seat of the judiciary) since April. This attack launched the Civil War. Several paintings document this War, among them Kathleen Fox's painting *The Four Courts* (fig. 14). The view is from across river with the Courts dramatically outlined against a sky of ominous clouds and black smoke emanating from behind the dome. Fox depicts her

Fig. 14. Kathleen Fox, *The Four Courts*, ca. 1922, oil on canvas, 39¹/₈ × 58¹/₄ in. (99.5 × 148 cm), University College Dublin

scene almost devoid of human activity, its stillness reminiscent of Archibald McGoogan's *After the Bombardment*.[32] While Fox's painting is a reminder of the effects of war on a specific location, two of Jack Yeats's paintings provide poignant testimony of the war's consequences for those directly involved in the conflict. *The Funeral of Harry Boland* (Sligo County Museum), painted in 1922, commemorates a man who vehemently rejected the Treaty and who died of wounds sustained while he was being arrested in Co. Dublin. He was buried in the Republican plot in Glasnevin Cemetery, and his funeral was fraught with tension and danger. Indeed, Yeats later claimed that his picture represented the only visual document of the occasion, since all cameras were removed as mourners entered the cemetery. In spite of the risk of being arrested by Free State troops, the IRA attended the funeral and fired a salute of three volleys to the memory of the deceased. In Yeats's picture the IRA gunners can be seen beyond the bank of flowers, their hands resting on their rifles. Members of Cumann na mBan, the women's organization supporting the Republicans, were also present and are depicted holding wreaths. Behind the mourners stands the great Round Tower marking the grave of Daniel O'Connell, the great nineteenth-century nationalist hero. Headstones in the form of Celtic crosses are also visible. Yeats does not attempt to detail individuals in his picture, but the inclusion of tower and crosses, recognizable icons of national identity, indicate the historical importance of the event. Significantly the original title of the painting

when exhibited at the Royal Hibernian Academy (RHA) in 1923 was *A Funeral*. Nothing indicated that this was the funeral of a specific person, the choice of title thus reflecting the political climate in Dublin that year. The painting later became known as *The Funeral of a Republican* and finally it was given the title by which it is known today.[34]

Yeats's *Communicating with the Prisoners* (Plate 27), painted in 1924, is an unusual picture in that it registers the part played by women during the conflict. Although women had been playing a significant role in Irish politics since the beginning of the century, their contribution was often ignored or sidelined. Indeed within the decade following the Treaty they would find themselves discouraged from making any meaningful political or public contribution to the new State. Free State Ireland was rigidly patriarchal, and, backed by legislation, the role of women was reduced to the private sphere. Sadly, their invaluable contribution during the years of bitterest conflict between 1916 and 1923 would count for little.[35] Yet during the Civil War over two hundred and fifty women were arrested and jailed; most spent about one year in prison and were then released. In Yeats's painting a group of young women standing by an advertisement hoarding call up to the women in the tower in Kilmainham Jail, Dublin, who have broken the windows in order to communicate more easily with their friends and supporters. The sense of imprisonment is subtly conveyed in the treatment of space. The prisoners are contained within the tiny apertures high up in the tower. The animated

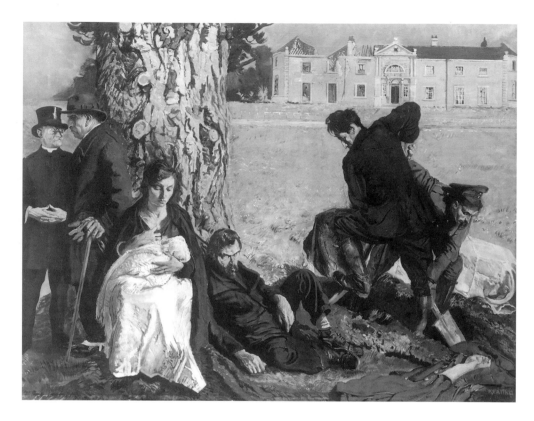

Fig. 15. Seán Keating, *An Allegory*, ca. 1922, oil on canvas, 40¹/₈ × 51¹/₈ in. (102 × 130 cm), National Gallery of Ireland, Dublin

women standing below, in sharp contrast, are out in the open, silhouetted against a panoramic sweep of nearby buildings. The viewpoint of the composition encourages the spectator to feel that he or she is standing directly behind the group, thus effectively joining in and showing support. In fact, the artist half-turns one of the figures in an inclusive gesture that further opens up the canvas for the viewer's participation.

While Yeats registers an essentially private gesture in his lively genre scene cum landscape, John Lavery, in *Michael Collins (Love of Ireland)* (Plate 26) records with due solemnity a pivotal public event, the death of Michael Collins, Commander-in-Chief of the National Army, who was killed in an ambush in Co. Cork. The artist's feelings about the killing were ones which went beyond mere grief for the man who had died. "I felt then," Lavery wrote later, "and feel still, that on that night the Irish slew the Irish, that the Irish killed Ireland as a force for good and greatness in the world of to-day, when every horror is committed in the name of nationalism."[36] Lavery recorded the death in two pictures, a painting of the Requiem Mass held for Collins (Hugh Lane Municipal Gallery, Dublin) and a close-up view of the body as it lay in the mortuary chapel.[37] Lavery recalled that in death Collins "might have been Napoleon

in marble as he lay in his uniform, covered by the Free State flag, with a crucifix on his breast."[38] It is not an earthly hero who is recalled in the finished painting but Christ as seen in a pietà, the image of mourning between Mary and her dead son. Lavery's painting is thus transformed into a religious icon commemorating a contemporary Christian martyr whose life was sacrificed for his country.

Perhaps the most unusual painting from the Civil War period is one by Seán Keating. For Keating, who had espoused violence as a necessary evil to gain independence, the new period of conflict was heartbreaking. "Like all the people of my time," he recalled later, "I couldn't believe we would split in the face of the British. I hated the breakdown in the Civil War."[39] Painted at the end of 1922,[40] *An Allegory* (fig. 16) depicts disparate groups of people connected with recent events but who, to all intents and purposes, seem to be unaware of each other's presence. In the foreground, dominated by the gnarled trunk of a tree, members of the regular and irregular army dig a grave. A tricolor-wrapped coffin lies on the ground beside them. Close by, a clergyman converses with a man in business attire. Two more figures are seated at the base of the great oak tree, a mother holding a child to her breast and a man reclining on the ground full of brooding intensity. The setting for the alle-

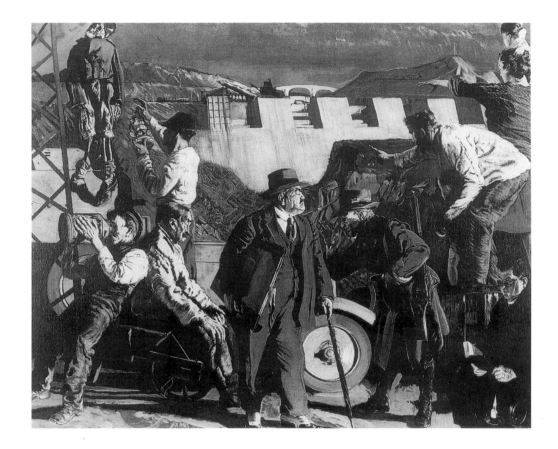

Fig. 16. Seán Keating, *Night's Candles are Burnt Out*, 1928/29, oil on canvas, 52 × 62 in. (132 × 157.5 cm), Oldham Art Gallery

gory is a park land before a large gutted old house. Not surprisingly, when reviewed at the RHA in 1925 it was declared to be a "problem picture."[41] The artist's allegorical message is twofold, the loss of ideals arising from the Civil War and his own response to it. After the valiant fight to gain independence, nationalistic ideals were ruthlessly sacrificed for radically different visions of freedom. The glowering, sprawling figure in the foreground is Keating himself, registering his disillusionment at this turn of events.

The Civil War ended in 1923 and its horrors ensured that peace would become a major priority. Although sporadic violence would erupt from time to time, during the next two decades the Irish Free State (and the successor Republic) remained a stable entity. Two paintings dating from 1929 and exhibited that year encapsulate the Irish nation's desire to move forward while unable fully to relinquish the past. Shown in Dublin, *Going to Wolfe Tone's Grave* (Plate 35) by Jack Yeats represents a crowd assembled in the vestibule of Kingsbridge Station, Dublin, on their way to Tone's burial place in Co. Kildare. Wolfe Tone was a leading figure in the ill-fated 1798 Rebellion, a figure who came to be seen as the father of Irish Republicanism. Since the centenary of his

death in 1878 his admirers have ceremonially visited his grave once a year. Yeats's modernist mature style does not allow for an easy reading of the image by the viewer. The figures, given form with urgent, calligraphic strokes of the brush, are presences rather than solid figures, the setting indistinct, almost mysterious. Color is used to create the mood, the black and gold redolent of what Kenneth McConkey has called "the solemnity of the ritual."[42]

While Yeats's painting is a reminder of the continuing homage to the past, Keating's allegorical painting *Night's Candles are Burnt Out* (fig. 16), exhibited at the Royal Academy in London in 1929, represents the future. The subject records a major milestone in the history of the Free State, the signing in 1925 of a contract between the Irish government and the German engineering firm Siemens-Schuckert for the construction of a hydro-electric scheme on the River Shannon. The building of a national electricity service was nothing less than an act of faith in the future for a country trying to recover from civil war and hampered by a worldwide economic recession. Keating, inspired by a personal interest, began to do some drawings and paintings of the project, and he was subsequently commissioned

by the Electricity Supply Board to record the work as it progressed.[43] It was a scheme that quickly assumed symbolic significance for the Cumann na nGaedhael government, and Keating's images both reflect and reinforce this view. It showed the world just how the new Free State was standing on its own two feet. Significantly, the heroes in Keating's paintings of the Shannon project are the engineers who made it all possible, his earlier fighting men giving way to this modern hero-type, men involved in state-building rather than war. Unlike the earlier allegory, here the figures represent the new order. The fawning gunman has given way to the engineer; the parents (Keating's own features are used for the father figure) point to the dam which testifies to the strength of the future, while an engineer holds an oil lamp to view a skeleton, both symbols of the past. The priest reading by candlelight also represents that past. Keating's message suggesting the possibility of a new beginning is powerfully portrayed in a strongly academic-realist style, recalling Soviet realist art. His clearly legible artistic language declares his intent that the image be immediately understood by the viewer, an empowering statement in the Ireland of 1929.

What emerges from this brief survey of Irish political art from 1914 to 1929 is that a number of Irish artists considered it vital to record visually contemporary political events. The results were to provide not only a valuable visual documentation but differing personal responses to the events of a tumultuous period that would serve as a register of the emotional climate of these years. The paintings of Keating and Yeats are strong individual statements, the former highly charged and visionary, the latter intense and private. While Lavery might purport impartiality in his work, a painting such as *Love of Ireland*, which portrays Michael Collins as a hero-martyr, is undoubtedly an expression of the artist's own admiration for the man. Interestingly, Fox, who so pointedly included herself in *The Arrest of the Countess*, was many years later to deny any emotional commitment in her earlier subject matter. Yet her political paintings were undeniably initially inspired by a desire to voice her growing nationalist sympathies.

This mix of personal responses offers a more complex visual record of the national narrative than is usually credited, because it constitutes not only an art which chronicles but one in which compassion, imagination, and commitment play a significant role. Yet in art historical surveys such

art has been largely ignored or repressed. The art critic Brian McAvera has, for example, stated categorically that, despite the bloody Home Rule struggle, the fighting of 1916, and Partition, "no body of art was produced such as that of the Weimar Republic: no one seemed interested in observing, recording and commenting, be it in anger, frustration or compassion."[44] The motives behind this refusal by McAvera and others to acknowledge the place of Irish political art of the past are various and outside the scope of this essay, but one argument put forward by Mary Stinson Cosgrove is worth considering briefly.[45] She points out that Romantic myth and a modernist theory of subjectivity have helped to create a climate in Irish art writing in which the notion of art being above politics has been encouraged. Thus the painted images of the period 1914 to 1929, shaped and informed as they were by contemporary events, have been cast aside in the zealous promotion of modernism instead of being appreciated as offering a rich and challenging aid to an understanding of Irish history.

NOTES

1 For an account of Irish history painting see John Turpin, "Irish History Painting," *Irish Arts Review* (1989–90), pp. 233–46.

2 For instance, in Kenneth McConkey's account of the development of a new national art in *A Free Spirit: Irish Art 1860–1960* (London: Antique Collectors' Club in association with Pyms Gallery, 1990). While he acknowledges the contribution by academic artists, those who embraced modernism are considered unreservedly to be more important.

3 Fintan Cullen discusses this topic more fully in *Visual Politics: The Representation of Ireland 1750–1930* (Cork: Cork University Press, 1997), ch. 5.

4 See Sighle Bhreathnach-Lynch, "Easter 1916: Constructing a Canon in Art and Artefacts," *History Ireland*, v, no. 1 (Spring 1997), pp. 37–42, for an assessment of artists' responses to the Easter Rising.

5 For the definitive account of the life and work of Jack B. Yeats, see Hilary Pyle, *Jack B. Yeats: A Biography* (Maryland: Barnes & Noble Books, 1989), and Pyle, *Jack B. Yeats: A Catalogue Raisonné of the Oil Paintings*, 3 vols. (London: Andre Deutsch, 1992).

6 Much of the discussion about the art of Jack B. Yeats over the years has centered on a formal analysis of his work. His luminous painterly qualities and the very personal later subject matter, based on half-memory and experience, have been stressed. This emphasis has served to ensure his place in the history of modernism, which insists on the primacy of form over content. As a result his subject matter, where it is overtly political, has tended to be marginalized.

7 See Pyle, *A Biography*, p. 104.

8 Turpin, p. 242.

9 Modernist criticism has traditionally focused on the formal qualities of this painting and evaded engaging with its nationalist content. For an interesting discussion on the modernist mystique surrounding Jack B. Yeats, see Tricia Cusack, "Neither Visionary nor Porpoise," *Circa*, no. 79 (Spring 1997), pp. 43–45.

10 For an account of artists' responses to the West of Ireland, see Sighle Bhreathnach-Lynch, "The Peasant at Work: Jack B. Yeats, Paul Henry and Life in the West of Ireland", *Irish Arts Review*, no. 13 (1997), pp. 143–51.

11 The date of this painting is problematic. It is sometimes dated 1915 but a major exhibition mounted to celebrate the Thomas Davis centenary within the lifetime of the artist dates it to 1916. See *Thomas Davis and the Young Ireland Movement Centenary Exhibition of Pictures of Irish Historical Interest* (Dublin: National College of Art, 1946), p. 16. For further discussion on this issue see Joan Fowler, "Men of the West," in *Critics Choice* (Dublin: International Association of Art Critics, 1988), pp. 16–17.

12 Information kindly supplied by Justin Keating, son of the artist, 11 July 1997.

13 Little is known of Delrenne. He is listed as exhibiting four canvases on themes of the Great War at the RHA in 1915 and 1916. See Ann M. Stewart, *Royal Hibernian Academy of Arts: Index of Exhibitors 1826–1979* (Dublin: Manton Publishing, 1985), p. 206.

14 McGoogan (1860–1931) was a landscape and portrait painter from Northern Ireland. He was also Assistant in the art section of the National Museum of Science and Art in Dublin and is responsible for the design of the Great Seal of Saorstat Eireann. See Theo Snoddy, *Dictionary of Irish Artists: 20th Century* (Dublin: Wolfhound Press, 1996), p. 290.

15 It was bombed by the IRA in 1966, on the fiftieth anniversary of the Rising. Partially damaged, it was subsequently destroyed in a controlled explosion by the Irish Army.

16 Fox (1880–1963) was a portrait, flower-piece and historical painter. She trained under William Orpen at the Dublin Metropolitan School of Art, where she was a distinguished pupil. Throughout her career she exhibited widely in Ireland and was represented in a number of official Irish exhibitions abroad.

17 Constance Markievicz (1863–1927) was born into an Anglo-Irish family in Co. Sligo. She trained as an artist in London and Paris and in 1900 married Casimir Markievicz, a Polish artist, by whom she had one daughter, Maeve. She became increasingly involved in nationalist politics, was a follower of Sinn Féin, founded a youth organization, Fianna Eireann, in 1909 and joined the Citizen Army where she held the rank of officer during the Rising. Following her arrest she was tried and sentenced to death but the sentence was commuted. In 1918 she was returned as a Sinn Féin member of Parliament, the first woman to be elected to the House of Commons. She became a member of the first Dail Eireann, and was vehemently opposed to the Treaty. During the Civil War she supported the anti-Treaty faction.

18 Recollections of Fox, taped interview with Nora Hiland, Curator, Sligo Museum, January 1963. I am grateful to Sunny Pym, granddaughter of the artist, for permission to use this material.

19 *Ibid.* The canvas was subsequently given to a friend, rolled up and stored in an attic for thirty years. It was returned to Fox at her request in 1946 and was exhibited at the Thomas Davis and Young Ireland Movement Centenary Exhibition that year.

20. See Laurence-Marie Gemma Bradely, *John Keating 1889–1989. His Life and Work*, diss. University College, Dublin, 1991. I should like to express my thanks to Ms Bradley for granting me permission to read her thesis.

21 See *Thomas Davis and the Young, Ireland Movement Centenary Exhibition of Pictures of Irish Historical Interest*, p. 16. The fate of the original canvas was less dramatic. It was exhibited at the RHA in 1917, where it received a favorable response. Interestingly, *The Studio*, a British art and crafts journal, while praising his West of Ireland types in the painting for their "vivid sense of personality," made no comment on the political context of the picture. See *The Studio*, no. 71 (July 1917), p. 73.

22 This journal styled itself as the house journal of Ireland and was aimed at women readers from every part of Ireland, north and south. Most of the articles were domestic in tone, but current events were covered, albeit with a light touch. Readers of the 15 December issue were offered the reproduction on special thick paper for the sum of 1/6d or per post 1/8d.

23 I am grateful to Ann O'Connor, Crawford Gallery, Cork, for access to information on the artist and this work.

24 This photograph was reproduced in Donie Murphy, *The Men of the South and Their Part in the Fight for Irish Freedom* (Cork. Inch Publications, 1991). Each man was identified by rank and by name. In all, seven officers were photographed, but Keating used six figures in the painting.

25 Quoted in Bradely, p. 90.

26 An earlier version of the subject is entitled *1921 – An IRA Column* (Collection Aras an Uachtarain). It is very similar in composition to the later painting, although eight men are figured rather than six and there is less emphasis on unity of gaze and pose. The background, too, is minimal. This earlier depiction was a commissioned work for Albert Wood QC, who was a great admirer of Sean Moylan and his Newmarket Battalion, 4th North Cork Brigade (Moylan features in the painting). All eight men went to Dublin to sit for Keating. While there, they stayed in the Clarence Hotel and had all expenses paid for by the patron. Information Ann O'Connor, Crawford Gallery, Cork.

27 An earlier version of this subject was painted in 1919, entitled *Ar a gGoimead*. The scene is set on the Aran islands and three figures frame the composition. Dejection is conveyed in the poses and expressions. The present location of the painting is unknown.

28 For an account of the life of Hazel Lavery, see Sinead McCoole, *Hazel: A Life of Lady Lavery 1880–1935* (Dublin: Lilliput Press, 1996).

29 Sir John Lavery, *The Life of a Painter* (London, Toronto, Melbourne and Sydney: Cassell and Company Ltd., 1940), p. 211.

30 The Irish portraits included Eamon de Valera, July 1921; Arthur Griffith, July 1921; Robert Barton, October 1921; Eamon J. Duggan, October 1921; George Gavan Duffy, October 1921; Michael Collins, October 1921 (Collection Hugh Lane Municipal Gallery, Dublin).

31 This is a preparatory study for a painting entitled *Earl Morley Addressing the House of Lords* (Glasgow Art Gallery and Museum).

32 James L. Caw, *The Scotsman*, 29 April 1922, p. 7; quoted in Kenneth McConkey, *Sir John Lavery 1856–1941* (Belfast: Ulster Museum and the Fine Art Society, 1984), p. 86.

33 A painting entitled *The Ruin of the Four Courts*, exhibited at the RHA in 1923, may be a second version of the subject.

34 Pyle, *Jack B. Yeats: A Catalogue Raisonné of the Oil Paintings*, p. lxii.

35 For an account of how women fared in the new State, see Maryann Gialnella Valiulis, "Power, Gender, and Identity in the Irish Free State," *Journal of Women's History*, VI, no. 4/.VII, no. 1 (Winter/Spring, 1994/1995), pp. 64–71 and Sighle Bhreathnach-Lynch, "Landscape, Space and Gender: Their Role in the Construction of Female Identity in Newly-Independent Ireland," *Canadian Woman Studies/Les Cahiers de la Femme Journal*, XVII, no. 3 (Summer/Fall, 1997), pp. 26–30.

36 Lavery, p. 217.

37 The sculptor Albert Power, on the instigation of the writer and senator Oliver St John Gogarty, made a death mask. See Sighle Bhreathnach-Lynch, "Face Value: Commemoration and Its Discontents," *Circa*, no. 65 (Autumn 1993), pp. 32–36.

38 Lavery, p. 217.

39 Gregory Allen, "Sean Keating Regrets," *Irish Press*, 20 October 1977, p. 9.

40 Justin Keating is certain that the painting dates from this period and not 1925 as listed by the National Gallery of Ireland.

41 See Bodkin, "The Hibernian Academy Exhibition," *Irish Statesman*, 18 April 1925, p. 177. Significantly, Bodkin makes no attempt to interpret the picture for himself or his readers.

42 McConkey, *A Free Spirit*, p. 183.

43 For an account of Keating's connection with the scheme, see Andy Bielenberg, "Keating, Siemens and the Shannon Scheme," *History Ireland*, v, no. 3 (Autumn 1997), pp. 43-47. See also Bradley, pp. 99–107.

44 See Brian McAvera, *Art, Politics and Ireland* (Dublin: Open Air, n.d.), p. 47.

45 Mary Stinson Cosgrove, "Irishness and Art Criticism," *Circa*, no. 52 (July/August 1990), pp. 14–19.

Jack Yeats and the Making of Irish Art in the Twentieth Century

BRUCE ARNOLD

In January 1912 the Russian dancer Anna Pavlova visited Dublin. Her worldwide fame carried no great weight in the city, and she received an indifferent critical response to her dancing. William Orpen was a personal friend and a great admirer, who painted two portraits of her. Recalling from memory the visit, he associates with it an occasion when W.B. Yeats "gave a discourse on dancing, rhythm, Pavlova's good points and bad, etc."[1] He objected to what he thought was "terrible rubbish" in the poet's remarks, made a few derisive comments himself, and left. It was, as he realized later, a terrible blunder to insult Ireland's greatest living poet. As for Pavlova, she was there for a week and then gone, and her feelings – which Orpen respected – were of less account than the collective susceptibilities of Ireland's "intellectuals," gathered to debate her merits over glasses of ginger beer and sandwiches. But Orpen chose the event, twelve years later, to demonstrate how much had changed in the intervening years. Such amateurism, he implied, would no longer be expressed in the new Ireland that had come after independence. "A new era has come to the land," he wrote in 1924. "No longer is the shamrock put to shame Ireland is face to face now with the working out of her own destiny, and all little jealousies and trifles are being washed out. There is work for all, and no time for idle criticism."[2]

Orpen's words were mocking and ironic. He did not believe, either in 1912 or in 1924, or indeed at any time in his life, in a separate Ireland from the cultural or artistic viewpoint. He mocked the idea of it, and in *Stories of Old Ireland and Myself* (1924) made lighthearted fun of individual episodes where supposedly the cultural life of the country was evolving. He did not accept the myth and symbol of W.B. Yeats's poetry, which was clearly an important part of this process, and clearly had no time for the man. He thought that George Russell painting fairies was slightly less ridiculous than George Russell under the influence of French Impressionism. And he believed that Dermod O'Brien would never be other than second-rate. He believed in the act of painting, not in its cultural impact. He taught the practicalities, of how to draw, of how to mix color, of what made a good composition. And he practised it.[3]

Orpen knew that he had come out of a British tradition in art, that of the South Kensington art schools, topped up by the abilities and talents of great teachers at the Slade School. He knew this worked. The Kensington system, when

he was a student, could stand comparison with art schools anywhere in the world. And the cumulative effect of his training was to undermine any belief in a separate, nationalist art collectively expressive of Ireland. If painters painted Irish landscape, or Irish genre scenes, or portraits, or events out of history, then by definition these were "Irish." But they were no more and no less Irish than the paintings which had been painted by Daniel Maclise and William Mulready in the nineteenth century, or by James Barry and George Barret in the eighteenth century, or by Thomas Cooley and James Gandy in the seventeenth century. They were Irish by location; it was an issue of geography, not one for cultural celebration.

It was a perfectly legitimate attitude to adopt, and was shared by other Irish writers and artists, men and women, some of whom, like George Moore, became tired of the whole "movement," and of the emergence of the Irish "nation" with its separate "culture." Moore deserted it. Others, like Susan Mitchell, at first skeptical, eventually joined it and enriched it.[4]

This division of attitude would not count for anything substantial in a survey here of Irish art as it developed during the twentieth century but for two significant facts: the first is that William Orpen, after establishing himself in London with early, brilliant works exhibited at the New English Art Club and elsewhere, returned to Ireland in order to teach. He did so during the crucial period 1900 to 1914, and taught with such success that his stamp as a figure in Irish art is overwhelmingly strong. Orpen set the tone and style in painting for his students and their generation; they in turn became the teachers and passed the same tradition on to a second, and even a third generation of artists in ways which have no comparison. No other major Irish painter in the twentieth century had a comparable impact. The second significant fact lay in the painting rather than the teaching: Orpen was a twentieth-century "master" in any accepted meaning of the phrase, and, good as his teaching was, his painting was even better. He left an array of jewel-like canvases, some of them Irish in theme, but the majority transcending any nationality or regional identity. *A Woman* (fig. 17), for example, in the view of the present writer one of the great nudes of the twentieth century, was painted by an Irishman, in Dublin, in 1906, and was, unsurprisingly, the subject of much comment there at the time. Even at the end of the century the work is difficult to place

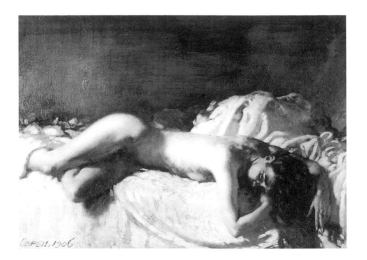

Fig. 17. Sir William Orpen, *A Woman*, 1906, oil on canvas, 22¹/₂ × 32 in. (57.1 × 81.3 cm), Leeds Museum and Galleries (City Art Gallery)

within any specifically Irish visual context. In contrast, another early masterpiece, *The Mirror*, belongs indubitably to the New English Art Club tradition; it is a "London" painting, the model, Emily Scobel, part of the Fitzroy Street set in which Orpen moved at the beginning of the century, in his post-Slade School days.

The point needs no further emphasis. What Orpen witnessed, at first hand, during the early years of the twentieth century, was the careful crafting of an Irish identity, in social, political and cultural terms. He treated it lightheartedly, as did most of those who came from the same tradition. Success in London allowed him to distance himself, from the professional point of view, and Dublin increasingly became a playground. Both as painter and in his ordinary life Orpen was a pragmatist; he believed in the reality of what is, and not in some imagined perfection. And this view, which included a powerful sense of his own worth and physical presence, exemplified in an extraordinary number of self-portraits, such as *Ready to Start* (Plate 18), governed his development, distancing him increasingly from the country of his birth. It did exactly the same to George Moore. He abhorred the second-rate. The way in which Orpen dealt with the combination of background and experience provides a distinctive concept of national art in Ireland in the modern period which has to be accommodated. It is one thing to recognize the heavily orchestrated creation of an Irish national identity in the early years of the twentieth century, even to admire it. But as the century

draws to its close, scholarship needs to be more objective in its acceptance of awkward strands of creative excellence which were not relentlessly tied to the evocation of a harmonious Irish world narrowly conforming to norms.

While it is clear from Orpen's own writing that he became quite shrewd about not speaking his mind on the national question, Orpen taught a series of visual lessons about the pre-eminence of the work over the place in which it is done, or the cultural demand it is meant to satisfy. He clearly detected, in the Ireland around him during the first two decades of the century, and emanating from numerous pundits whose names are bywords in the pantheon of the so-called "Irish Revival," a set of artistic and cultural guidelines about what being Irish meant. And he saw the fruits of this process in innumerable paintings, plays, poems, and other literary efforts which were falsely raised above the second-rate position they should have occupied by their deliberate support of a nationalist point of view.

Orpen had scant regard for this. The *faux monnayeurs* were there, in his view, to be mocked, laughed at, even if the price paid for this attitude was heavy. And in his letters, and in his own writing, particularly *Stories of Old Ireland and Myself*, there is a constant theme of mockery about Irish self-deception alleviated only by his disarming trick of belittling himself as much if not more than those whose acts he criticizes. But though Orpen lived this life of humorous doubt and indulgence towards the country of his birth, in his paintings, and in his teaching, there was quite another story being enacted. This was rigorous, professional adherence to the very best that could be done in pencil, chalk, crayon, watercolor, and oils.

Not only did Orpen perform exceptionally, as a painter of portraits, genre scenes, historical events, and perhaps most famously in his massive study and indictment of war, recorded in his book *An Onlooker in France*, but he was enormously successful at it as well. This habitually acts upon the Irish as a kind of cultural aphrodisiac. They fall about in amazed admiration when one of their number achieves success on the world stage, as Orpen did in his lifetime. And the conventional response is to take pride in the success, and accept that a little of it resulted from birth and upbringing. Orpen rarely played the Irish card except to make fun of those who treated it seriously. There was a departure from this frivolous attitude of mind in the period leading up to the First World War, when Orpen painted

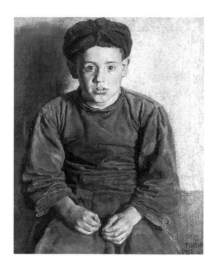

Fig. 18. Patrick Tuohy, *A Mayo Peasant Boy*, 1912, oil on canvas, 36 × 21 in. (91.5 × 53.4 cm), Hugh Lane Municipal Gallery of Modern Art, Dublin

several deliberately "Irish" canvases, including *Sowing New Seed*, *The Western Wedding*, and *The Holy Well*. The first is a deliberate allegory; all three are comments upon Irish life. But all are marred by the deployment of caricature, and this in the end is an accurate reflection of Orpen's own judgment about his country. At the peak of his success, in *Stories of Old Ireland and Myself*, he defines the position, drawing a clear line between himself and his country, and littering the pages with dismissive asides against a process he had never believed in, and also against its principal practitioners.

It was an act of supreme irony. Orpen had taught Irish painters. The best of them, when the State came into being in 1921, were his pupils. And his name was to remain central in Irish art well after his death in 1931. There was further irony in the fact that at least two of those students, Patrick Tuohy and Seán Keating, were strongly nationalist in their own views. This was not expressed as strongly in Tuohy's painting as it was in Keating's, or at least not in any obvious way. Tuohy's wonderful painting *A Mayo Peasant Boy* (fig. 18), in the best Orpen tradition, transcends all obvious symbols relating it to the West of Ireland. It is a uniquely powerful example of an international genre, that of the direct and innocent portrayal of youth.[5] *The Model* (Plate 14), which Tuohy regarded as his masterwork, is faithful to the principles taught by Orpen and is technically

brilliant. For Ireland it is a disturbing image, that of the adolescent girl posing in the nude against the kind of flamboyant draperies recommended and used by Orpen in his portraiture. And it is a mark of Tuohy's courage as an artist that he carried off the complex challenges presented by the subject. It is hard to imagine any other Orpen pupil painting a similar work as early as 1914, certainly not Keating. Keating was more overtly engaged in the business of creating paintings which were intended as historical icons, and these are found in public collections in Ireland, where they often conform to a nationalist ideal in visual art. But Keating had a natural and warm sense of domestic life, and his studies of Irish peasant interiors are often finer works at least in painterly terms than his ''flying columns'' or civil-war heroes. In this and related works we see Keating's instinctive response to the West of Ireland, to Irish peasants in domestic settings, to the romantic vision exemplified in Synge's writing, all of which Keating continued to paint throughout his life, despite the passing of much of the custom and dress. In the end, the relationship between Orpen and Keating pivoted on their conflict of views; Keating wanted Orpen to give up his life to Ireland, Orpen, wisely, saw his future in England.

This disdain, as it were, was offensive to nationalists. One of the more voluble of them was a fellow-painter, John Butler Yeats, more than fifty years Orpen's senior, who nevertheless saw himself in rivalry with the younger man. So powerful was Orpen's position, as early as 1906, that Yeats told his son, W.B. Yeats: "At present my object is to paint better than Orpen – that is the only path to salvation."[6] And he made the point that Orpen was the only Irish artist making a living out of his painting. But the old man never succeeded. He knew himself to be "imprisoned in an imperfect technique," and said as much. And he remained a captive until his death sixteen years later in New York.

It was different for those whom Orpen taught. They knew the technique. What Orpen could not do was to transfer the spirit and cohesion of his own artistic inspiration to his students and followers. An impressive number of painters in Ireland during the first half of the twentieth century drew and painted so very well, and seemed naturally in command of the requirements of form and composition. And to a degree they owed this to Orpen's teaching and the powerful shadow of his greatness as a painter. But a flatness intruded with the passage of time, and a pedestrian dependence on solid, safe teaching and conventional performance created an academic self-satisfaction which was increasingly mocked. The academic approach was presided over by Dermod O'Brien, President of the RHA from 1910 until his death in 1945. O'Brien, in the Nathaniel Hone tradition as a painter, was an agreeable and kindly man, who helped younger artists by buying their works, and trudged around different parts of Ireland painting generally indifferent landscapes when he was not painting portraits. In Orpen's absence – he never returned to Ireland after the First World War – the idea and the practice of academic painting settled around Dermod O'Brien. He and the main body of RHA painters became loosely, in some cases reluctantly, committed to the new nation, Éire, in their involvement with country life, urban scenes, political events, the painting of the Shannon Scheme (by Keating), and other expressions of patriotic art. And their output was generally worthy, solidly executed, conventional, but on the whole uninspired.

What had been originally inspired by Orpen's own mockery of the fervent revivalist thinking at the beginning of the century became in its turn all too open to mockery and more pungent criticism at the hands of modernist painters. At about the time when Orpen was metaphorically washing his hands of Ireland's cultural and nationalist pretensions, life and vigor in art was passing to a different group. And in the chronology of events it would be natural to turn to them in order to pick up the new strands in Irish painting during the period immediately after World War I. But something far more magical had already taken place in the life of quite another kind of artist, emerging almost from the shadow of Orpen's overwhelming presence at the beginning of the century, yet fully armed to take over the unfulfilled role in shaping a national ethos in terms of visual image and metaphor.

The figure in question is Jack Yeats. Yeats never had pupils. It is questionable whether he ever had teachers who made any impact on him, other than by example. He went through no rigorous art school training comparable to Orpen's studies under Henry Tonks and Philip Wilson Steer. He never taught art, and throughout his life had very little to say about it, though the argument that he never talked art at all seems an exaggerated one. He never wrote about art, still less did he make any comments on fellow artists. He was a mute, silent observer. For so powerful a painter, and a hugely respected presence on the artistic landscape,

it is odd that he never had followers, either. There are no painters in Ireland who relate to Yeats in a way comparable to the relationship with Orpen of Keating or Tuohy, or indeed a score of other painters whose style and technique can be directly traced to Orpen's teaching. Yeats, by comparison, stands alone.[7]

But he does so more by accident than design, more by the lateness of his development, and its uncertainty, than by virtue of qualities which can be seen as unique. Though seven years older than Orpen, he did not impinge in any comparable way as a painter until well into the 1920s. He had no serious reputation in England until after Orpen's death. And he struggled in his own country for many years against indifference and mockery. But he had a singleness of purpose from the outset which came to be allied with the evolution of Ireland in the twentieth century in a totally remarkable way. Yeats was seen for this capacity to represent Irish people and the life of the nation by a relatively small though influential group. Virtually from the outset of his career as an Irish artist he had the support of Lady Gregory, of his father and sisters, perhaps less so of his brother, of Synge, George Moore, Seamus O'Sullivan, James Stephens, and others who formed a nucleus for nationalism in art, including politicians such as Eamon de Valera. Though Yeats was almost thirty before he embarked on his career as an Irish artist, he did so in such an original and appealing way that it stamped his name and his work indelibly on their imaginations, and they occupied a key role in the development of the fledgling nation. Yeats did it by setting out to portray Irish life in everything he drew and painted in a way that was new, refreshing, and truthful. He sought to penetrate the national character, to understand it, to reveal it, to give it dignity, to raise it to self-respect and even to greatness. It would seem an obvious task for an Irish artist to impose on himself. And yet Irish art, and indeed British art, had created a conventional view of Ireland which was at best sentimental and at worst gross caricature. Peasants were the peasants of Erskine Nichol or of *Punch*. Provincial life was the life of Boucicault or Charles Lever. The majority accepted this. Even after the Irish Revival it lingered on. It needed the deadly purpose of John M. Synge's genius, or indeed that of Jack Yeats, to demonstrate that self-respect and truth required something different.

Having demonstrated, during his early years as an illustrator and cartoonist, as well as in his first serious paintings for exhibition in 1897, his capacity for action, character, and drama in art, Yeats turned his attention to Ireland, and to the holding of first one and then a succession of exhibitions broadly entitled *Life in the West of Ireland*. They were essentially modest in scope, made up of line drawings, wash drawings, watercolors, and prints. He put on the exhibitions himself in places like the Engineers' Hall in Dublin, and they sold modestly. He held exhibitions in England with the same title. He also made prints for his sisters' Cuala Press, and these were more widely bought and served as new and acceptable images of Irish life, truthful, full of energy, inspiring.

For much of the period during which he was laying down, as it were, his artistic credentials as a recorder of Irish life and character, Jack Yeats was living in Devon with his English wife, Cottie, and traveling to Ireland for periodic working holidays, and to keep up his friendships with those who were at the center of the literary revival, his brother W.B. Yeats, Lady Gregory, John M. Synge, and the American promoter of Irish painting and writing, John Quinn. In retrospect, his associations with the Irish Revival, and notably with Synge during their time in Connemara and Mayo, and with Lady Gregory, have been exaggerated. In reality, Jack Yeats was a minor figure in the movement, unsure of whether or not to live in Ireland, and lacking in confidence about his work to the point where he had a nervous breakdown in 1915 almost certainly caused by a sense of non-fulfillment as a painter. But he continued to range the West of Ireland, from Kerry to Donegal, drawing and painting people, events, and places, and putting an increasingly distinctive stamp upon the representation of a national identity.

Yeats's powerful early masterpiece, *The Circus Dwarf* (fig. 19), predates the breakdown, and follows his return to Ireland by only two years. It was rejected by the RHA in 1912, the year it was painted, but then exhibited in the Armory show in 1913 after its exhibition in London the previous year. It attracted early critical attention. There was perceptive identification of an important Jack Yeats characteristic: "The people Mr. Yeats is interested in are a rough, hard-bitten, unshaven, and generally disreputable lot of men. His broken-down actors practicing fencing, his 'Circus Dwarf'. . . are subjects no other artist would have chosen to paint."[8] Hilary Pyle takes a sentimental view of this work, referring to the dwarf looking "meditatively," having a

Fig. 19. Jack B. Yeats, *The Circus Dwarf*, 1912, oil on canvas, 36 × 24 in. (91.5 × 61 cm), Photo courtesy of Waddington Galleries, London

"sad, painted face," with "added poignancy," and the "vulnerability of the performer." But the subject of the painting is indulging in no self-pity; he is tough, devious, a survivor. His face is neither painted, nor is it sad. Jack clearly identified the painting as his own major exhibit for New York, and for that historically important event in twentieth-century art.

Jack Yeats's recovery from the breakdown, his growing accomplishment in the painting of oils, and the courage with which he tackled the aftermath of World War I and the setting up of an independent Irish state, moved him inexorably towards the center of the stage as an Irish artist of national significance. His alliance with the Society of Dublin Painters – a group established to promote modernist, especially Continental ideas – was an important act, even if his involvement was short-lived. He was in fact to remain always a solitary figure in art. But by the early 1920s, when he was already in his fifties, he had become a central voice on behalf of Irish art. It was Jack Yeats who gave the lecture on Irish art at the important Race Conference in Paris, early in 1922.[9] It was there that he came into contact with Eamon de Valera, and found himself increasingly allied to the Sinn Féin, or Republican side, in Irish politics. All the

things that Orpen mocked, Yeats took to his heart. He valued the national spirit in painting more than the exercise of the craft. Indeed, it could be said that he never mastered the craft in any conventional meaning of the words. He was self-taught in the handling of oils, using them to begin with as an illustrator might, laying down color within a linear frame. And his sense of the making and mixing of color is undoubtedly open to quite severe criticism, since all too often he ends up with shades of mauve in default of better contrasts, higher tonal values. Similar criticisms may be leveled against his control of composition and form. But Yeats had a magical reading of the national character, and was able, in many paintings, to translate it into a breathtaking piece of the drama of Irish life. By the mid 1920s he had established a number of major works which count as foundation stones in Irish art in the twentieth century.

Then came a break with even the limited traditions in his art of the first fifty years. Throwing all caution to the wind, Yeats began to paint with thick impasto, using fingers and palette-knife as well as brushes, and with the wide use of primary colors, brilliant reds, yellows, blues, and greens, bringing fire, sun, light, into unconventionally high-flown antagonisms and juxtapositions which verge often on the extraordinary, and are always challenging.[10] Yeats expressed for those around him how to be liberated in what they painted, and in how they executed their work. No-one followed the lead he gave. He presented Ireland with a series of stages on which its own history was enacted. The life of the ballad-singer, the public house performer, the theater entertainer, the political speech-maker, the jockey at a country race meeting, the circus clown, the story-teller, the poet, the soldier, the emigrant, the old sea-captain, all became emblematic and symbolic. Yeats built a tapestry around the nation; the unending presentation of the life of Ireland, no longer constrained by that original title, did more to create the cultural blood and tissue of the nation than almost anything else produced by Irish writers and artists.

It was both a pure and a mature expression of Irish nationalism in art. There was innate sensitivity and subtlety in what Yeats did; it was never obvious. Understanding what he was saying was never easy, nor did it always work. There are paintings which simply mean nothing at all, and there are paintings which technically, compositionally, are absolute disasters. But the general thread of Yeats's composition is a reflection of his life, and in his life through its

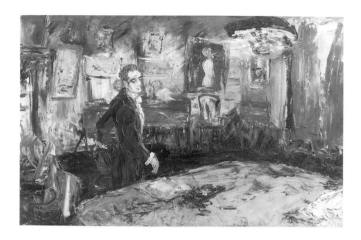

Fig. 20. Jack B. Yeats, *About to Write a Letter*, 1935, oil on canvas, 24 × 36 in. (61 × 91.5 cm), National Gallery of Ireland, Dublin

art he sought to reflect and create the life of the country, making credible and acceptable its diverse and rugged nature.

It is questionable how far Jack Yeats was accepted. He was never successful in the Orpen sense of success, not even at the end of his life. Recognition of his potential greatness as a painter came in England more than in Ireland, and only when the National Gallery exhibition in London took place with Kenneth Clark's inspiration behind it did Dublin respond with a measure of comparable enthusiasm, and begin working towards the 1945 retrospective exhibition which duly honored the doyen of Irish art, who was by then in his early seventies. But the hidden lessons of his life had been spread through the nation, among painters, of course, but also among ordinary people who equated Irish art with Jack Yeats in ways which no other artist inspired.

Yet there is a negative side to this. Jack Yeats achieved a preeminent position in Irish art in spite of, rather than because of, his qualities as a painter. He transcended imperfect technique with visionary capacities which at times are overwhelming. No one doubts the poignancy and compassion, for example, of *The Blood of Abel*; yet as a painting it is ill-conceived, its composition completely without discipline or internal structure, its colors and tone weak.

It is a form of critical suicide, in Ireland, to raise fundamental questions about this problem confronting us over Yeats's art. Worse still, bound up within it is the more widely spread difficulty over the extent to which bad art in Ireland gains endorsement from the existence at its very

heart of so complex, so unique, so instinctive a figure. Yeats swept aside the very idea of a worthwhile academic tradition. He belittled not just the idea that good art came from European cities like Paris, against which he had the strongest of prejudices, but that good art could be defined in such terms. Like de Valera, whom he greatly admired during a substantial part of his life, there was a tendency for Jack to look into his own heart and discover there what art was about, and why painting should be done in one way and not another.

Yeats is a giant in Irish art of the twentieth century, perhaps flawed by imperfect technique, but a giant figure nonetheless. He stands proud and solitary as the creator of a unique landscape which he peopled with men and women who frequently come in from the fringes of society – from the bogs, the fairs, the circuses and the markets – and who yet are able, through the power of his presentation, to take center stage positions with pride and confidence. They become, under his hand, substantial and haunting figures representative of a sad and violent history, of mythic values, powerful tales, apocalyptic achievements. He pushes them forward, transforming their human state into artistic statements that are breathtaking. The nationalist agenda is a wide one, however, and in no sense exclusive. In *About to Write a Letter* (fig. 20), for example, a patrician view is given of the unexplained episode. And the great painting *Now* (fig. 21) draws its inspiration from a visit Jack made to a newly opened London theater at the turn of the century, recreating from memory the excitement and flurry of a stage entry. The whole vast performance, spanning more than half the twentieth century and adding up to some 1,100 oil paintings and innumerable drawings and watercolors, holds together as a cohesive, complete expression of the man's imagined reality for Ireland. Nothing compares with it in Irish art.

Jack Yeats defied the very canons which mattered so centrally to William Orpen. And he was a skeptic towards another, and quite different seminal figure in Irish art of the twentieth century, Mainie Jellett. [11] Mainie Jellett was a product of the art tradition to which William Orpen had belonged, and for a short period was his pupil at the Metropolitan School of Art before moving to London and studying there with Walter Sickert at the Westminster School of Art. Accomplished in draftsmanship, in composition and form, in the painting of beautiful portraits and

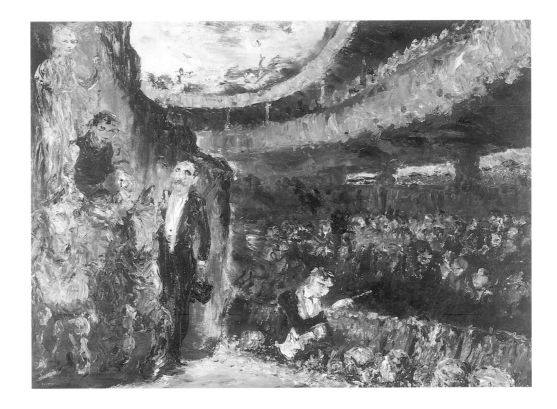

Fig. 21. Jack B. Yeats, *Now*, 1941, oil on canvas, 36 × 48 in. (91.5 × 122 cm), Photo courtesy of Waddington Galleries, London

nudes, she eventually turned her back on the English art school tradition, and followed French artists – first André Lhote, from whom she acquired the basic principles of Cubism, then Albert Gleizes, who taught her the principles of abstraction. By the mid-1920s, when Ireland was beginning to flex its cultural muscles in exploration of modernism, Jellett was ready to carry out a signal and unique service through teaching and artistic practice in the city of her birth. She believed, in sharp contrast to Jack Yeats, that the key to art in the future derived from Paris, and more specifically was contained within abstraction. This was the natural outcome of Cubism, and offered a key, not just to the future of painting, but to all the arts. Einstein, Stravinsky, Pound, Proust, Eliot, and Joyce, all were part of her artistic heritage. She read and lectured on abstraction in music. She had a competent grasp on Einstein. She attended Stravinsky concerts in Paris in the early 1920s. She read works by Joyce as they came out, and more widely was well read in the modernist literature of the period through which she lived.

Second only to Orpen, among Irish artists, Jellett was an outstanding painter of the female nude, from the period of study under Orpen, through the Sickert period at the Westminster School in London, and then with André Lhote,

as in *Seated Female Nude* (fig. 22). This accomplishment was not revisited again until late in her life, when she reverted to naturalism for a period.

Jellett believed in the importance of transmitting her knowledge and views of international modernism to the newly independent Ireland, and she brought to this task the skills of a teacher and considerable ability as a writer.[12] For the country to survive and flourish culturally, in her view, its artists needed to be international in their outlook, aware of world trends, and not confined either by a local authoritarianism based on lifeless academic painting or by a nationalism which subscribed to an equally local set of myths and symbols in art designed to trigger predictable, safe public reactions. To a remarkable extent she reconciled the two quite different traditions deriving from Orpen and Yeats. She was technically a brilliant painter, and a fine draftswoman. She admired the best in the academic tradition, so long as it had life. At the same time, she shared with Jack Yeats his desire for novelty and experiment, his determination to shock and challenge, his belief in the unique capacity of the individual artist to occupy a territory of influence and expression entirely his, or her own. Jellett and Yeats were members together of the Dublin Painters, and remained respectful of each other during the comparatively short

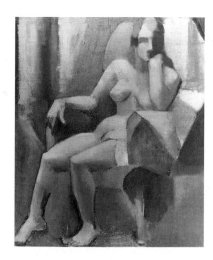

Fig. 22. Mainie Jellett, *Seated Female Nude*, 1921, oil on canvas, 22¹/₈ × 18¹/₈ in. (56.3 × 46.2 cm), Ulster Museum

period of time Mainie Jellett lived in Dublin, from her return from France in the mid-1920s to her early death in 1944.

But while Jack Yeats was essentially static as an artistic influence, lofty, aloof, isolated, solitary, Mainie Jellett was the undisputed leader of the modernist movement in Ireland, active, aggressive, confrontational.[13] And it really was a movement. She taught, argued, debated, challenged on issues of cultural direction, artistic philosophy, all the arts including architecture. Above all she painted, with great passion and inspiration, and produced a body of work very much ahead of its time. She engaged in pure abstraction, on the Cubist model, and produced a number of religious works, of which *Virgin and Child* is an outstanding example (see Plate 38). Towards the end of her life her work became more naturalistic, as in *Achill Horses* (fig. 23).

Jellett campaigned on the need for young painters to form themselves into a society or group able to take on the RHA and create an alternative venue for the display of modern paintings, which were regular refused by the selection committee of that august body. This gave birth to the Irish Exhibition of Living Art, an annual show of modern artists' work which was crucial to her contemporaries, although she did not herself live to enjoy the fruits of her work in setting it up. By the time she did so, in 1943, Jellett had already led a generation of painters, many of them women, including her lifelong friend Evie Hone, Mary Swanzy, whose art she greatly admired, May Guinness, who had

studied at the same time as herself and Evie in Paris, Nano Reid, and Norah McGuinness. And she had supported and encouraged younger artists, including those who exhibited with the White Stag Group, among them Patrick Scott, Kenneth Hall, and Basil Ráckóczi. Louis le Brocquy, whose mother was a close friend of Mainie's, came under her influence and was encouraged by her; and she helped the painters in Dublin who associated with Gerard Dillon, whose first solo exhibition she opened. Unlike Orpen, who surrounded himself with students whose work he admired and whose company he enjoyed, Mainie's relationships with fellow artists were more egalitarian, more cerebral, perhaps more formal, and more rigorously concerned with the theory and practice of a profession for which she had unlimited time and respect. She did not need to like what an artist did in order to support their determination to do it.

Nationalism, for Jellett, resided in the exercise of freeing painters from constraint and fashion, and allowing them, indeed encouraging them, to express themselves in language which had currency throughout the modern world. This, she believed, was how Irish artists would best serve any reliable concept of "Irish" art, and not by the representation of national life in terms of event or character set forth in panoramic tableaux. Hers was a revolutionary view. She did not teach abstraction except to a tiny group of painters who specifically wanted to understand its principles. She taught a disciplined freedom for the artist at a time – the late 1930s – when authoritarianism and nationalism were both tending to stifle independence of artistic thought and freedom of expression.

Jellett gave to Irish art an international frame of reference, and yet never lost the respect of the academic painters, such as Dermod O'Brien, with whom she enjoyed a relationship based in fundamental disagreement and conflict, or Seán Keating, the doyen of nationalist artists whose stamp on Irish art teaching was a reflection of his devotion to William Orpen. Inescapably, what she foreshadowed in her teaching, and even more significantly in her espousal of the Living Art idea, was her own desire to lead succeeding generations away from the concept of an identifiable Irishness in art, apart from the obvious components represented by Irish landscape or urban scenes or by new and modern interpretations in painting of Irish myth, legend, or history. Irish painters, after the Second World War, began slowly, uncertainly, to take their place within art outside Ireland, to have

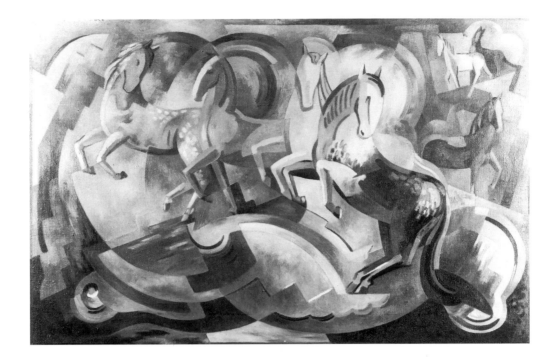

Fig. 23. Mainie Jellett, *Achill Horses*, 1939, oil on canvas, 24 × 36 in. (61 × 91.5 cm), National Gallery of Ireland, Dublin

shows in London and New York, to live and work abroad, to lose any sense of obligation, such as those felt by Yeats and Jellett, and perhaps sensibly denied by William Orpen in the earlier decades of the century.

Uniquely of their time, these painters defined and progressed concepts of what it meant to be Irish artists, what painters should be doing, how they should do it, in both the technical and visionary sense, and where it would lead. They charted a road by example, by teaching, and by writing, and others followed. They were markedly different in approach. William Orpen, perhaps responsive in a somewhat negative way to the historical events of the first two decades of the century, placed the emphasis on technique and excellence of performance.[14] A truly egalitarian person in human terms, he was professionally elitist, choosing the company of students who shone in their art and ignoring the second-rate. In his teaching and in his painting he summarized the period through which he lived in a series of masterpieces which rank as high as any works of art by an Irishman ever produced. Yet there is a question mark over using the term "Irish art" to describe the major part of Orpen's output, the glorious nudes, the genre scenes, the portraits, the domestic interiors, and the glowing landscapes painted at Howth or in the West of Ireland. And in his writing he betrays his position as that of a man who had limited belief in the collective, national purpose to be served

by developing art in Ireland as an extension of life in Ireland.

Jack Yeats was the opposite. He believed in the concept, and followed it for himself. But he promulgated nothing, he taught no one, his writings are deliberately obscure on art, and his only lecture on Irish art is consistently paradoxical, from beginning to end. He cared little for technique, he invented his own compositional rules, he developed a palette which is eccentric, and he plucked from the air some of the most handsome, vital, and witty titles we know for works of art. In terms of the national identity and the extent to which it derives from the work of artists, Yeats occupies a uniquely central position which few have ever been able to explain.

Mainie Jellett both believed in, and practised, an art which she related to the life of the country, and to the generations of painters who followed her. The major part of her work consists of abstract paintings, and they belong to a French tradition which she deployed in the education of artists in Ireland. It did not, in practical terms, catch on; no school of Irish abstraction developed under her guidance, and the best that can be said of her influence is that it opened hearts and minds to the world outside Ireland, and sowed the seeds for the internationalizing of Irish art during the final quarter of the twentieth century. The concept itself, "Irish art," is rendered redundant in the wake of what we have seen in our lives.

These were not the only figures to carry out this largely self-appointed task. Of course the academic painters, the traditionalists, the overtly nationalist artists, were engaged in something similar. But none, in my view, has that indefinable characteristic of greatness which I unquestionably associate with the three artists named. Each in his or her fashion made a quite prodigious impact on art in Ireland during the twentieth century. Each was entirely different in what they achieved. Taken together, the range of their accomplishments, as influences and as artists, is incalculable.

NOTES

1 William Orpen, *Stories of Old Ireland and Myself* (London: Williams and Norgate, 1924), p. 93.

2 Ibid.

3 See Bruce Arnold, *Orpen: Mirror to An Age* (London: Jonathan Cape, 1981). Fuller details are in the correspondence, part of which is lodged in the Orpen Archive in the National Gallery of Ireland.

4 See Susan Mitchell, *George Moore* (Dublin and London: Maunsel and Co., 1916) for a lively and penetrating picture of Moore's negative attitudes about Ireland and Irish cultural nationalism. George Moore references are too numerous to mention, but the best general account of himself and the period is to be found in his *Hail and Farewell* (London: Heinemann, 1911–14).

5 The painting was owned by the architect Joseph Holloway, who was a friend of Jack Yeats and keenly interested in the theater. He presented the work in 1934.

6 Undated letter, probably 1906, from Gurteen Dhas, Dundrum, published in *J.B. Yeats: Letters to his Son, W.B. Yeats and Others, 1869–1922* (London: Faber & Faber, 1944), p. 89. The age gap between the two men was forty years. The letters from John Butler Yeats contain many references to Orpen's ability and his focus on success.

7 There is a substantial literature, including Hilary Pyle, *Jack B. Yeats, Catalogue Raisonné*, 3 vols. (London:André Deutsch, 1992); *eadem* Jack B. Yeats, *A Biography* (London: Routledge and Kegan Paul, 1970) and her catalogues of watercolors and drawings. The author of this essay has a *Life* of the artist due to appear in September 1998.

8 A. J. Findberg, "'Art and Artist's Life in the West of Ireland," in *The Star*, 16 July 1912. The other works shown by Jack in the Armory Show were *The Political Meeting, A Stevedore, The Barrel Man, Strand Races*, and *The Last Corinthian*.

9 J.B. Yeats, *Modern Aspects of Irish Art* (Dublin: 1922). The booklet, one of an extensive series concerning Ireland, carried an introduction by Eamon de Valera. He claimed that their purpose was "to expose current first principles and to bring exact knowledge concerning correct [*sic; current?*] problems into every home in Ireland. A carefully thought out scheme of study is proposed."

10 His early work, technically, presented one set of problems. The late canvases, as Brian Kennedy has perceptively shown, present us with a totally different range of technical problems. See Brian Kennedy "The Oil Painting Technique of Jack B. Yeats," *Irish Arts Review Yearbook*, 1993, pp. 118–23.

11 See Bruce Arnold, *Mainie Jellett and the Modern Movement in Ireland* (New Haven and London: Yale University Press, 1991) for biographical details and a general discussion of the evolution of modernism in Ireland during the first half of the twentieth century.

12 Full details of her largely unpublished writing, mainly for lectures and addresses, but also for publication in journals, are given in Arnold, *Mainie Jellett*.

13 Both came to their positions through controversy. Yeats was gregarious by nature, and spoke freely about art in the early years; but adverse criticism made him increasingly taciturn with newspapermen and with the public generally. His gregariousness became increasingly limited to trusted friends and to those they recommended to him. Mainie Jellett had a more limited circle of friends, but was outspoken about art and fearless in the face of controversy. Sources, published and yet to be published, for these important aspects of character have already been cited.

14 He refers, both in *Stories of Old Ireland and Myself* and in *An Onlooker in France*, to his involvement as a war artist with the senior officers, up to and including Field Marshall Earl Haig, and to the process of personal alienation, attributing it at one point to a supposed or actual threat to his own personal safety in Ireland. For whatever reasons, apart from a brief, one-night visit in 1918, he never returned to the country between the end of the First World War and his death in 1931. The officers with whom he had contact, and whose portraits he painted, were the enemies of Irish independence, and had been responsible for the oppression after the 1916 Rising and the years leading up to independence in 1922.

Irish Women Painters
and the
Introduction of Modernism

MARIANNE HARTIGAN

"I think myself that the only means I ever had of knowing anything has been through painting. Anything I have known in life or known of life has been there . . ."[1]

Mary Swanzy

One of the most intriguing aspects of the introduction of modernism in Irish art was the key role played by women artists. Over a period of roughly thirty years a number of Irish women artists working independently brought about, through their direct experience of modern European art movements, their organizational ability, and their encouragement of avant-garde ideas in younger artists a quiet revolution in Irish painting.

To describe someone as a woman artist today does not conjure up a negative image. The only controversy one might encounter over such a label would be indignation that there should still be a need for such positive discrimination. Such strides have been made in the last few decades that it is difficult to understand the sensibilities of the situation in the early years of this century when women were known as the "weaker" and the "fairer" sex. One could not then easily describe someone as a "woman" without being thought offensive. "Lady" was the term in common usage for middle- and upper-class females and this subtly implied someone who did not have to work. A lady artist painted simply as a hobby, thereby denoting a lack of professionalism. Certainly those who had time and the facilities to paint were generally from the leisured classes. Being a competent painter was seen as a useful accomplishment for a woman but one was not expected – or encouraged – to make a career out of it. Many of the key figures in this essay – May Guinness (1863–1955), Grace Henry (1868–1953), Mary Swanzy (1882–1978), Mainie Jellett (1897–1944), Evie Hone (1894–1955), Norah McGuinness (1901–1980), and Nano Reid (1900–1981) – would have repudiated the idea of being a "woman artist" because that particular label did not carry the strength it does today.

The writer Terence de Vere White recalled the social system in which Mary Swanzy grew up in Dublin: "The daughters in intellectually distinguished families diffidently treated their accomplishments as hobbies. Their brothers in their brilliant scholastic or artistic careers were allowed to monopolize the family claim to seriousness."[2] Indeed Mary Swanzy recalled the low expectations placed on women painters in the early years of this century, remarking that

"Ladies have to paint pussy wussies and doggie woggies."[3] And Norah McGuinness, when asked if as a woman she felt that she ought to make a statement in her painting, replied that she never thought of herself "*just* as a woman as far as painting was concerned" (my italics).[4] One would not expect these women to make feminist statements in their art: they worked relatively early in this century in a strongly traditionally minded, rurally oriented society that considered a woman's place to be in the home, where in certain circumstances "lunatics and paupers" were allowed the vote but until 1918 women were not, and where higher education for women was only a fairly recent introduction. It was enough for women to attempt to compete on a par with men. Yet the women treated in this essay chose independent paths; they did not submit to the artistic fashions of their day but – despite lack of understanding – searched continually for authentic expression and the reflection of their experience through their works.

Artists, by their very nature as observers and recorders of life, are often slightly apart from society. Women artists in the early years of this century needed to be very determined to stick with their chosen profession, as the demand that they should play their role in society was strong. While there were increasing numbers of women going to art college, after training the majority put marriage and family life first, as was expected of them. Their talents and energies were meant to be devoted to looking after their husbands and children. If a career was to be fostered, it was to be his. The seven women we are concerned with, however, dedicated their lives to art. Although most of them had independent means that gave them a valuable degree of freedom, many of them developed the commercial side of their art, too. Mary Swanzy tried her hand at illustrative work as well as portraiture. Mainie Jellett advertised her drawing and painting classes and her rug designs in her exhibition catalogues.[5] Norah McGuinness, who vowed early on not to teach, did illustrations for magazines, books – including one for W.B. Yeats – and stage-set and costume designs, as well as stylish window displays for Brown Thomas, the major Dublin department store. Nano Reid painted portraits (until one person refused to pay her), murals, screens, *etc*, as well as religious commissions. And Evie Hone created a series of stained-glass works for churches.

Is it purely coincidental that all of them were childless and single (with the exception of Norah McGuinness and Grace Henry whose marriages did not last)? One must remember that broken marriages and separated women were not highly regarded in a state that rejected divorce and officially upheld the indissolubility and sanctity of marriage in the very decade that both these women parted from their husbands. There is no doubt that the lack of dependents left them free to work in a manner that would otherwise have been impossible. Perhaps unconsciously they forfeited the possibility of a certain kind of long-term relationship in order to fulfill their destiny as artists. Or was it a factor that a professional female artist was not seen as domestic or partnership material? Writer Frank O'Connor recollected that he began to doubt the wisdom of having advised poet Geoffrey Phibbs to marry Norah McGuinness: "On the first Sunday when I went to lunch there were no potatoes and I was scandalized when she went on with her painting and allowed Phibbs and myself to go into town for them. I had never met a girl who forgot things like potatoes."[6]

Evie Hone, who as a child was paralyzed for a year with polio and consequently suffered for the rest of her life, reflected, "I have been fortunate for through my ill health I learnt a long time ago that to be an artist one must have no personal responsibilities – no family ties – I can dedicate my life."[7] Mary Swanzy arrived at a similar conclusion: "I think myself that the only means I ever had of knowing anything has been through painting. Anything I have known in life or known of life has been there But if you give that entirely to other people's happiness by bringing them up and being dedicated to them, what have you got left then for the other thing which is your art, music or sculpture? Nothing, I think, nothing."[8] Grace Henry's more famous husband, Paul Henry, in later life wrote a two-volume autobiography that deliberately excluded any mention of her.

That it was women who were the catalysts for the introduction of modernism into Irish art was, undoubtedly due, in part, to their not being compelled to have a commercial career to support a partner and family, and therefore compromise their art. Coming, by and large, from comfortable backgrounds, they did not have to bow to academia to make a living as a painter, but could afford to experiment and explore new methods. Although exposed to a number of different movements abroad at a time when artistic fashion was changing quickly, most of them did not get caught up

inextricably in one particular movement but could select elements from various directions and incorporate them into their own artistic style. This multiplicity of styles could also be disadvantageous: Grace Henry, May Guinness, Mary Swanzy, and Norah McGuinness have only recently begun to be given the recognition they deserve, partly, I think, because of their experimentation with a number of styles. To the critic hoping to characterize their work under one particular label, an artist whose work appears to go in different directions, treating subject matter in certain styles but then occasionally reverting to an earlier style, serves often to confuse.

In early twentieth-century Irish art circles, realism was the order of the day - with a few notable exceptions, such as the expressionistic work of Jack Yeats. From the end of the nineteenth century there was a lot of talk of a new "national school of art" reflecting the values and symbols of the newly emerging Ireland. In the 1920s, when nationalism had finally triumphed over British imperialism and the Irish Free State was in its infancy, this new "school" created implicitly realist visions of an idealized Ireland. The strongly rural West of Ireland, presumed to be less corrupted by the "civilizing" influence of eight hundred years of British rule, was seen as the focus. Scenes akin to Eamon de Valera's future vision of comely maidens dancing at the crossroads with athletic youths were translated into imagery by exponents of the new school led by Seán Keating and Maurice MacGonigal. Women painters in particular, however, rejected both the subject matter and its treatment of the West of Ireland model and looked instead to the Continent. This was not simply a response to political disenchantment, for going abroad to "finishing school" was the done thing in certain upper-class circles. Also the late nineteenth and early twentieth century had seen many Irish women students, including the very considerable talents of Sarah Purser, Edith Somerville, Helen Mabel Trevor, Beatrice Glenavy, and May Manning, studying in Parisian studios. The French Cubist painter, André Lhote's studio, for example, was so popular with Irish women students around 1920 that in Dublin his pupils were jokingly referred to as "Lhote's wives."

Since painting was by and large restricted to the upper and middles classes in this country, most painters socialized together to some extent. It is well known that the literati of that time were acquainted, but many of these visual artists also talked to one another and on occasion worked with one another, even as they followed their own career paths. For instance, George Furling, Director of the National Gallery of Ireland from 1935 to 1950, recalled that Norah McGuinness, Nano Reid, Eva and Letitia Hamilton, Ruth Jameson, and Harriet Kirkwood attended many painting weekends either at Sutton House or Collinstown House during the Second World War years. He noted, "They were informal, fun but hard-working weekends, often with Mainie Jellett as the ringleader."[9] Ideas and methods encountered abroad or developed at home could be shared in this way. Each of these seven women was also a member of the Dublin Painters Society and despite their age differences are likely to have been in contact there as well.

Despite the inclusiveness advocated by certain leaders of Irish separatism since the 1790s, the Free State in the 1920s increasingly excluded any other ethos except the Gaelic and Catholic. The new Ireland was insular, rural, and Catholic. Why would these women artists, all of them, except Nano Reid, Protestant, look to the narrow vision of an artistic school from which they may well have felt excluded? Was it not more natural for them, like modernist writers such as Joyce and Beckett, to look to the wider scope of Europe in general and France in particular?

Most of these women responded instinctively and in some cases spiritually to their craft rather than adopting any one artistic creed. With the exception of Mainie Jellett's zeal for a deep understanding of her tutors' philosophies, they seem to have adopted characteristics of certain modern styles and adapted them to their own purposes rather than immersing themselves completely in the theory. While Mainie Jellett and Evie Hone spent years in France working with the Purist Albert Gleizes and perfecting his artistic theories, Mainie Jellett later questioned the validity of this work as anything more than part of the process: "I believe in the possibility of non-representational art being an end in itself, but I do not think the art of that very severe geometrical phase which I went through myself is an end in itself; however I believe it to be a vital means to an end."[10]

The groundwork for the introduction of modernism in Irish art was laid over a number of years and through a number of exhibitions held in Dublin.[11] The first significant exhibition in this regard was the tenth annual exhibition of the Dublin Sketching Club in December 1884, where James McNeill Whistler, John Singer Sargent, and two other U.S.

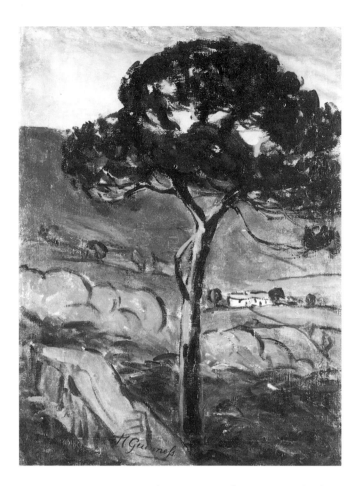

Fig. 24. May Guinness, *Mediterranean Landscape*, ca. 1928, oil on canvas, 27 × 19¾ in. (68.5 × 50.2 cm), Hugh Lane Municipal Gallery of Modern Art, Dublin

painters, Julian Story and Ralph Curtis, were invited to show their work. Whistler's twenty-six atmospheric paintings including *Portrait of the Painter's Mother* (1871, Musée du Louvre), so far removed from the anecdotal, sentimental pictures popular at the time, stirred up the Dublin art world. As S.B. Kennedy writes,[12] "This exhibition had no obvious lasting effect on the Dublin art scene. Most importantly for the future it implanted the idea that the best way to raise the standard of Irish art was to expose it to external influences and not to insulate it against them." Despite the turbulent political climate of the first few decades of the century, the Hugh Lane Municipal Gallery, the United Arts Club, and the Society of Dublin Painters became venues for significant exhibitions of Irish and Continental works.[13] Before the First World War Irish artists were able to see works by Cézanne, Derain, Van Gogh, Gauguin, Matisse, and Picasso at first hand.[14] Many of the women artists with

whom we are concerned frequently had work in both the RHA and the more avant-garde shows even while studying abroad, displaying to a Dublin public their increasing engagement with modernism. On their return to Ireland, many of them became involved in the organization of alternative exhibitions and through these, as well as through their solo shows, they brought back and disseminated much needed fresh ideas and the first tastes of modernism, often to a hostile reception.

May Guinness may well have seen the 1884 exhibition of the Dublin Sketching Club as a young woman, but her influences after 1905 were largely Continental artists – including Matisse, the Old Masters in the Louvre, the Post-Impressionists, as well as Picasso, Dufy, and Marie Laurencin – whose work she encountered abroad. Although a contemporary of Orpen and Lavery, she was one of the first proponents of modernist styles in Ireland, experimenting with Fauvism and Cubism before ultimately working in a highly individualistic, free, colorful manner. Her life is not well documented, she did not date many of her paintings and she exhibited later works along with early ones at solo shows, so a chronology is difficult to construct. Works that have survived show an artist with a vision very different from that which was currently fashionable in Ireland.

The influence of Fauvism is already evident in *Mediterranean Landscape* (fig. 24), a confident, assured, dramatic painting. The magnificent center-stage Scots pine, with brooding, black foliage and red and blue bark highlighted by the setting sun, stands firm against a flat background of muted color. The space is defined by the use of brighter colors and stronger definition in the foreground fading to increasingly abstract shapes in the background. A passionate, original interpretation of a landscape with deliberately simplified components, the composition has strong contrasts of color and texture and great intensity of expression. The energetic brushstrokes are very much in empathy with the Impressionists, yet recall the colors and simplification of the Fauves. Does the lone pine standing tall and defiant against the elements represent the painter's position in the world? Her walls flare and toss, her tree positively burns with color – as a painter she is outside the norm in society, as a woman painter searching for the way forward through innovation she is in danger of ostracizing herself further still. Undated, *Mediterranean Landscape* is a good example of her "early work," before she moved in

more Cubist directions.

May Guinness began painting seriously about 1905 when she went to Paris. She worked on and off with the Fauvist painters Anglada and Kees van Dongen for twenty years, and with the Cubist André Lhote from 1922 until 1925. Contemporary Continental influences, particularly that of Lhote, from her middle period are apparent in *Still Life* (1922–25), where a strong sense of pattern and flattened perspective remain in the semi-cubist stylization of bold yet still recognizable shapes. The simplified shapes of everyday domestic objects – a ewer, a dresser with plates and crocks, a table with a vase of flowers and an open book – are depicted in a controlled, stylized vitality lacking the depth of passion evident in both her earlier and later work. Form and color predominate as sunlight spills across this cut-off view, a device then fashionable and a legacy of the popularity of Japanese prints, to give a strong contrast of light and shade.

In her seventies, tired of the restrictions of Cubism, May Guinness announced that she had finished with experimentation and was returning to "flat rhythmic arrangements of line and color."[15] Some of her later works such as *Still Life with Tulips* (private collection) show a wonderfully joyous, free arrangement of form and color. The very vitality of the flowers, so often lost in over-polished still lifes, simply bursts off the canvas. The blues and greens of the floral arrangement reminiscent of the palettes of Marie Laurencin and Raoul Dufy (and reflected also in the abstract background) contrast strongly with the splashes of crimson of the flowers and the darker sweeps of color for the stems. Here, too, are painterly overtones of Matisse.

May Guinness gave a great deal of encouragement to younger artists and numbered Mary Swanzy, Evie Hone, Mainie Jellett, and Grace Henry among her disciples. Indeed, the colors of Grace Henry's *Evening Achill* (fig. 25), with its vast expanse of deep-blue sky over purple mountains in which nestle a boreen of purple heather-colored thatched cottages, while vastly different in composition, are reminiscent of the lustrous, somber brooding tones of Guiness's *Mediterranean Landscape*. Here, too, we find the same rich contrast of colors, as glints of orange firelight flicker through chinks of open doors and at the odd window, hinting at the goings-on within.

Emily Grace Henry (née Mitchell) exhibited with the Aberdeen Artists Society in 1898 and 1900 before studying

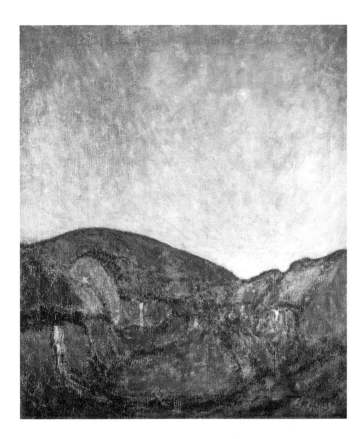

Fig. 25. Grace Henry, *Evening Achill*, ca. 1912–19, oil on canvas, 23 × 19¹/₂ in. (58.5 × 49.5 cm), Hugh Lane Municipal Gallery of Modern Art, Dublin

in Brussels and Paris, where she met and married Paul Henry in 1903 at the age of thirty-five. The Henrys returned to England for around seven years (moving almost every twelve months) before going to Achill in the West of Ireland, where they stayed for eight years. *The Girl in White* (fig. 26) is a beautiful example of her early work. Possibly a self-portrait, it is a difficult tonal exercise produced with controlled facility. To create these chalky whites the painter has used green grays, pinks and blues with subtlety. Not only Whistler but also Manet is evident here in the distinctive use of paint and the interplay of white upon white. While the hands and face are warm in contrast with the cool tones of the dress and background, even the hair contains umbers and cool shades of green. The use of contrasting pattern and texture between the geometric shapes of the Georgian door, the deep softness of the sofa and the diagonals of its design, and the great sweep of white lawn in the dress, creates a space that respects the picture surface. The construction of this serene and sensitively drawn portrait is timeless

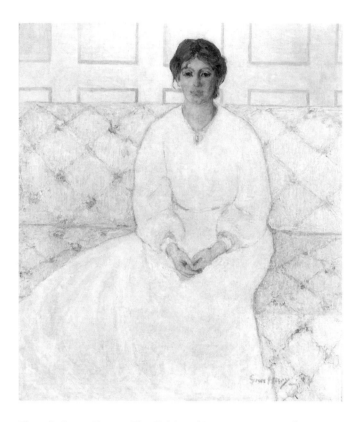

Fig. 26. Grace Henry, *The Girl in White*, ca. 1910–12, oil on canvas, 24 × 20 in. (61 × 51 cm), Hugh Lane Municipal Gallery of Modern Art, Dublin

After the move to Achill, Grace Henry's style changed immeasurably. For Paul Henry, Achill's rugged landscape, seascape, and peasant life provided the inspiration he was looking for. Grace however, already unsettled in her marriage, traveled regularly to Dublin and London. She began to experiment with various painting forms and to develop a bold, colorful style with fluid brushwork. While she and her husband shared similar subject-matter, their treatment of it could not be more different. Paul generally painted the landscape at dawn, she was drawn to the obscurity and mysticism of the night. His are tranquil (occasionally in later years almost static), atmospheric depictions of the landscape of rural Ireland while some of hers, created in thick colorful strokes of paint, are deeply felt responses pulsating with color, occasionally so simplified as to be almost abstract. Passion is a key note in her works. In Achill much of her work was done by moonlight, continuing the muted color and mood of Whistler, but with much greater reduction of form and an almost nocturnal palette of gray, lilac, purple, black, and Prussian blue. In *Evening Achill*, while Grace

shares her husband's interest in the depth of the sky, allocating almost two thirds of the picture space to its forceful presence, it is the depth of color and the very obscurity of the simple sculptural shapes that draw the viewer into the picture and evoke the mood of the Fauves or even Expressionists such as Edvard Munch or Emil Nolde. On a small canvas we glimpse both unlimited space and huddled claustrophobia, emotionally charged depth of color, shapes reduced almost to their bare essentials. These are undoubtedly early experiments in modernism.

These somber almost abstract landscapes continue up until 1916, when suddenly daylight colors and figures are reintroduced. *Top of the Hill* (fig. 27), for example, shows a brightening of the palette to predominant oranges and buffs, with blues and browns highlighted with white – colors that will remain in her later Achill landscapes and on through her Mediterranean works. The figures of gossiping women in traditional dress of headscarves, skirts, and shawls worn with colorful crios, are bulky and rotund, humorous, almost caricatures. Has this lightening of the palette and a new sense of artistic freedom evident also in her fluid, thick use of paint something to do with her liaison with Stephen Gwynne, whose portrait she painted around 1918? Was she beginning to break free artistically and personally?

One clue is certainly to be found in the Henrys return to Dublin in 1919, where they were involved in setting up the Society of Dublin Painters, a forum for innovative younger painters and an alternative venue to the RHA. Each member was entitled to hold an annual solo show as well as to submit work to a twice-yearly group show. A large number of women were involved from the beginning: founder-members included May Guinness, Eva and Letitia Hamilton, Harriet Kirkwood, Clare Marsh, Mary Swanzy, and Mainie Jellett, as well as Jack Yeats, Charles Lamb, and Harry Clarke. Here was a platform where artists whose work did not fit into the narrow academic groove could display their wares. In its early years the Society was an important lynchpin in the development of modernism. Grace Henry's original work in these shows did not go unnoticed. A critic commented on one of her works in a Society exhibition in 1923, "It is perhaps the best picture in the exhibition. This bold painting is not quite Mrs. Henry's usual style. It is far more 'modern' than most of her work; but it does not suffer from that."[16] Despite working abroad for considerable periods Grace remained actively involved with the Society

for many years even after Paul's departure from it in 1926.

In 1920 Grace Henry traveled to Italy and France with Stephen Gwynne, and in 1924–25, possibly on the advice of Mainie Jellett, went to study with André Lhote. His Cubist work does not seem to have had a huge influence on her, as she was already following her own agenda, in which Fauvism was perhaps the primary influence. Works such as *Spring in Winter No. 9* (ca. 1920–25, private collection) show her experimentation at embedding landscape with passion and emotion in vivid color allied with a simplification of form. The energy in this distinctly Expressionist painting of what could otherwise be a tranquil west of Ireland scene seems to reflect the fact that the 1920s were an unsettled period for her. Over the next few years she spent time in the south of France and in Italy, where the busy Mediterranean with its brilliant sunshine suited her painterly style. Her later works – landscapes, canals, sails, boats, and so on – are imbued with rich colors but are calmer in treatment, paying greater attention to detail. Her brushwork, however, remains full of life, her composition is even more confident, and her use of color evocative of particular moods.

Like Grace Henry, Mary Swanzy responded to the revolutionary changes brought about by the Fauves, studying art in Paris during those same years 1905 and 1906 when the Fauves were making headlines with their dramatically expressive use of color. She was already a skilled draftswoman, having attended childhood art classes with May Manning and trained under John Hughes in the Metropolitan School of Art in Dublin, when, on the advice of May Manning, she departed for Paris, studying under Delacluse and with Del la Grandera, attending too the studios of Colarossi and la Grande Chaumière. She also had access to works such as Matisse's *Bonheur de vivre* and *Woman with a Hat* and Picasso's *Jeune fille aux fleurs*, in Gertrude Stein's collection.[17] On her return to Ireland from her Parisian studies Swanzy pursued a successful career as an illustrator and a portraitist – she very much admired William Orpen. She felt that society militated against her, however, observing, "Most women artists cannot paint portraits . . . ladies don't like to be painted by ladies and gentlemen don't like to be painted by ladies."[18] So instead she resolutely pursued her own vision. Indeed *Young Woman with Flowers* (early 1920s, private collection) shows Swanzy's early experiments with Cubism – she exhibited

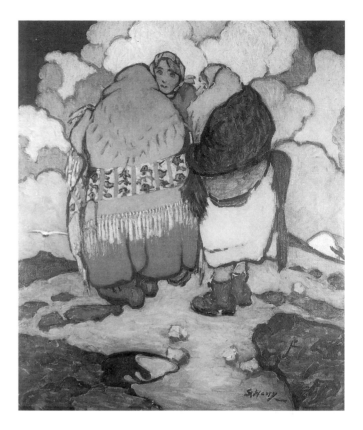

Fig. 27. Grace Henry, *Top of the Hill*, ca. 1918, oil on linen, 24 × 20 in. (61 × 51 cm), Limerick City Gallery of Art

with Delaunay and other avant-garde artists at the Salon des Indépendants in 1914, and may also have been influenced by the work of Picasso. In this picture the haunting image of a woman's head and chest is painted amidst a structured kaleidoscope of interlocking shapes. A stylized posy of flowers tumbles before the trance-like face, giving vitality to this carefully controlled composition, with a quiet dynamism of movement and energy.

Thomas McGreevy has suggested that it was through Mary Swanzy's works that the influence of Cézanne was first seen in Ireland.[19] Certainly an understanding of Cézanne's principles and treatment of subject-matter is immediately obvious in *Landscape with Red Gable* (fig. 28). Cézanne wanted to achieve the effect of nature's monumentality while retaining the intensity of the visual image. In this work there is a great sense of structure, fundamental to Cézanne's beliefs, and an attempt to observe nature in its component shapes, but there is also an overriding, innate lyricism. The trees are stylized hemispherical clumps of foliage atop sinuous energy-filled trunks. Atmospheric

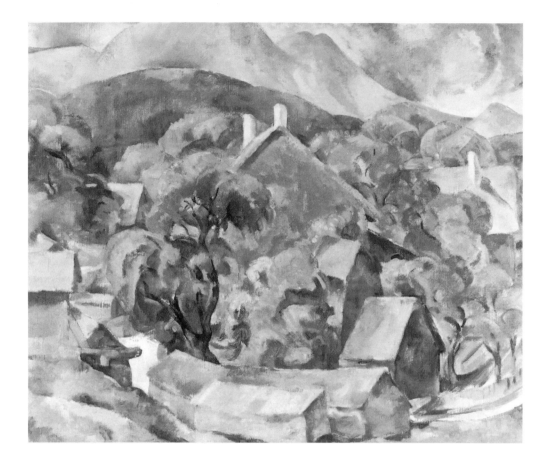

Fig. 28. Mary Swanzy, *Landscape with Red Gable*, ca. 1920s, oil on canvas, 18 × 21 in. (45.5 × 53 cm), Hugh Lane Municipal Gallery of Modern Art, Dublin

watery blues, greens, and grays make up the background hills and turbulent sky. To the right the picture space becomes flattened and perspective almost disappears, creating a tension, a slightly disquieting union of styles - that of Cubism and her own more rhythmically lyrical one.

Some of Swanzy's later works such as *The Message* (Plate 40), likely to have been painted as a response to her deep distress at the Second World War, show the influences of Cézanne and the Cubists merging with a new understanding of Italian Early Renaissance painting to which they led her. There is a strong focus on the structure underlying the natural features of the stylized landscape, as well as a monumental quality about the figures of the Virgin and Child typical of the Early Renaissance. The treatment of the folds of the Madonna's dress has more in common with that of the robe in Cézanne's *Woman with a Coffee-Pot* than, for example, with the sensuous treatment of textiles in portraits by her immediate Irish contemporary Leech (see Plate 11). In this symbolic painting, the Madonna is huge, impassive, almost stonelike. While gazing at the baby gurgling in her lap, the Virgin's mind seems to be elsewhere.

Her hands are clasped together – are they clapping to amuse the baby, or praying for the horrors of the world which she knows lie before him and which her fellow countrymen are facing in the turmoil of war?

Swanzy was an unconventional, independent woman, traveling to Czechoslovakia after the First World War and later to the South Seas – considerable trips in those pre-airplane days – where she took every opportunity to paint. Her paintings, exhibited at home and abroad, were not always favorably received; for example Stephen Gwynne writing in *The Irish Times* on the Painter's Gallery Exhibition in 1921 observed: "I can neither recognize shape or color . . . nor can I see any beauty in this vision of hers."[20] Despite this kind of response, there is no doubt that Swanzy's works – which, although occasionally rejected by the RHA, were included in many of the annual shows in Ireland up until the late 1940s – exposed Irish artists to a new way of looking and thinking. She exhibited in Dublin and London and in 1946 at the St George Gallery London, alongside Braque, Vlaminck, Dufy, Chagall, Henry Moore, and William Scott. For much of the rest of her life she lived in London and

exhibited rarely, although a critically acclaimed retrospective of her work was held at the Hugh Lane Municipal Gallery in Dublin 1968. She painted in a variety of styles from Impressionist and Fauve landscapes to Cubist nature studies to surreal allegorical paintings as well as, in her final phase, dreamlike, joyously colored Chagall-like assemblages. Her artistic influences were many over her long career and she was constantly experimenting with new ideas, determined to perfect her art. Late in life she recalled, "At one point I was dotty about Velásquez. After that I found Manet, Monet and others. We need these great spirits. My ambition is to pitch a little tent in the outermost court of the temple where the great ones dwell."[21]

For Mary Swanzy, working abroad for much of her life, showing pictures in annual Irish exhibitions was a vital link with other Irish artists. The two most important organizations for the development of modernism were the Dublin Painters' Society – in which each of these key women artists exhibited – followed more than twenty years later by the Irish Exhibition of Living Art. These were venues where artists could show work among like-minded artists; where they did not feel the need to tone down their subject matter or its treatment in order to get in; where they could meet other artists experimenting with new methods and approaches. But even so they were subject to change: while in 1942 Stephen Rynne wrote that the Dublin Painters were "the liveliest of the living painters, the explorers and experimentalists,"[22] various artists felt it necessary to set up another alternative venue for more avant-garde works in that same year. Though it is often assumed that Ireland was isolated artistically by the Second World War, in reality it meant the return of many of its artists from abroad and a cross-fertilization of new ideas. The Irish Exhibition of Living Art – a vital forum for modern art in Ireland – initially came about as a sort of Salon des Refusés. Sybil le Brocquy was so incensed at the RHA's rejection of her son Louis's work *White Shawl* in 1942 that she felt something had to be done. This, compounded by the RHA's almost complete rejection of modern work in 1943, led to the establishment of a new alternative venue by a group of artists – Louis le Brocquy, Mainie Jellett, Norah McGuinness, Evie Hone, Ralph Cusack, Elizabeth Curran, Margaret Clarke, Laurence Campbell and the Reverend Jack Hanlon – with Mainie Jellett elected chairwoman.

That she was elected chairwoman was an indication of

Mainie Jellett's standing within the artistic community – a position for which she had worked quite hard. In Irish art circles Mainie Jellett and Evie Hone are often talked about almost as a single entity, and credited jointly with having introduced modernism into Irish art. Indeed, they have much in common: before their career paths diverged Mainie Jellett and Evie Hone spent the best part of ten years with Albert Gleizes in France researching, developing, and creating a Cubist method of painting which they brought back to Ireland to initial cries of derision. There is no doubt that their work, and particularly that of Mainie Jellett, stretched the boundaries of Ireland's perceptions of art. Yet they were also quite distinct artistic personalities.

Christened Mary Harriet Jellett but known throughout her life as Mainie, Jellett determined upon being an artist at a young age. It was not to be an easy option, and Mainie recalled in later years, "My voyage of discovery from student to professional painter was stormy and varied. At least three times I have gone through major revolutions in my work, style and ideas and more or less started afresh."[23] She was taught art by Sarah Cecilia Harrison, May Manning, and Elizabeth Yeats, and attended the Metropolitan School of Art, Dublin in 1915 and the Westminster School of Art in London from 1917 to 1919. There she studied under Walter Sickert – her first "revolution," a time of which she later said:

"Here for the first time drawing and composition came alive to me, and with Sickert's help I began to understand the Old Masters. Sickert being in the direct line of French Impressionist Painting was an excellent stepping stone to my next revolution, Paris and Lhote's studio."[24]

In André Lhote's studio, where she joined Evie Hone who had previously studied in London, the two women were introduced to Cubist theory based on realist form. However it did not fulfill their need for a complete understanding of non-representational art, so they abandoned his semi cubist teaching and persuaded Albert Gleizes to take them on. Thus began Mainie Jellett's third "revolution." Here Jellett and Hone created paintings that dispensed with subject matter and perspective and relied purely on line and color. Mainie Jellett's aim was, she wrote,

"To delve deeply into the inner rhythms and construction

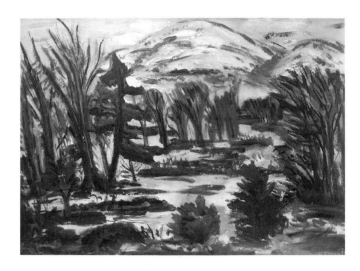

Fig. 29. Evie Hone, *Snow at Marley*, oil on board, 14¹/₂ × 19¹/₄ in. (37 × 49 cm), National Gallery of Ireland, Dublin

of natural forms to create on their pattern, to make a work of art a natural creation complete in itself like a flower or any natural organism, based on the eternal laws of harmony, balance and ordered movement (rhythm). We sought the inner principle and not the outward appearance."[25]

With Gleizes the two young Irish artists developed a system that involved placing a number of geometric shapes concentrically on the picture surface, shapes that were then "translated and rotated" – moved up and down and sideways or turned round – to produce the end result. Early works generally titled "Abstract" or "Composition," such as Mainie Jellett's *Abstract* (1922, Ulster Museum), are masterpieces of colorful simplicity using interconnected bold forms in translation and rotation. Many of the early works have single elements, while both artists later introduced patterning, groups of lines, dots, and dabs to add interest and vitality to the surface. Eventually they came to create multiple-element works containing three or four separate sets of translations and rotations on the one canvas. Jellett and Hone were swimming against the tide in exhibiting abstract works in an Ireland dominated, in the 1920s, by academic realism. A critic wrote of Mainie Jellett's work exhibited in the Dublin Painter's Exhibition in 1923: "I fear I did not in the least understand her two paintings. They are in squares, cubes, odd shapes and clashing colors. They may to the man who understands . . . modern art mean something

but to me they presented an insoluble puzzle."[26]

Unbowed, Mainie Jellett and Evie Hone battled on in their study of abstraction, although Evie Hone was never as committed to the theory as her friend and toward the end of the ten years with Gleizes became increasingly dissatisfied with the rather soulless works she and Mainie Jellett were producing. A friend later recalled,

"When I first met Evie in 1933 she was getting rather tired of Gleizes. There was a certain amount of resentment in her voice when she talked of him. She felt loyalty to him but it irked her Later she would deplore the fact that he never let her draw from nature and that she had not learned anatomy."[27]

In *Composition* (ca. 1924–30) we can already find a strongly intuitive element in Evie Hone's work and a softer, less mathematical appearance in the exercises of translation and rotation than in the early works. The vivid shapes and linear rhythms contain energy, vigor, and spontaneity, hinting at the influence of Juan Gris, whose work she admired, rather than exclusively at the experiments of Gleizes. In Paris Evie Hone bought pictures by Gris and Picasso but was deeply impressed by the work of Rouault as well as the stained glass windows of Le Mans and Chartres, combining her fervent admiration for Irish Early Christian art with an enthusiasm for modern art. From the mid 1930s onwards Hone's own inspirations took over and she abandoned the Cubist influence for a more personal interpretation of her subject matter. And when in 1933 she began to work in An Tur Gloine, the Irish stained glass studios set up by Sarah Purser, her earlier abstract work helped her create a newly simplified style of stained glass where superfluous detail was removed and pure colors and shapes soared. Her later gouache landscapes such as *Snow at Marley* (fig. 29) are full of evocative atmosphere, vigor, and freely expressive brushwork that pay tribute to her Parisian influences but are primarily her own vision. Interestingly, among the numerous works in Norah McGuinness's studio after her death were gouache paintings of trees in snow-covered hills approached in a manner similar to *Snow at Marley*, with the same rapid brushwork, freely expressive use of paint, and range of colors used to depict wintry trees against a flattened picture surface.

Mainie Jellett meanwhile remained dedicated to new prin-

ciples in art and determined upon her methodical voyage of discovery. A deeply religious person, in the late 1920s and 1930s she introduced semi-abstract figures and strongly religious themes, moving away from the initial austerity of her earliest works by incorporating a wider range of color. A series on the theme of Madonna and Child continued these stylistic developments but had a strong, caressing and curvilinear element in which abstracted figurative shapes multiplied in facets of harmonious color, sometimes bordered by a painted frame. The semicircular echoing forms suggest the soft maternal shape and protective embrace of the Virgin.

For a number of reasons, not least of which was the Second World War, Jellett's contact with Gleizes diminished in the 1940s, leading to the gradual emergence of a more confidently personal style. She continued with figurative subjects, treating them in a softer way that resulted in a greater fluidity in the thinly painted, gently faceted surface, reminiscent of the work of Mary Swanzy. A distinctive assuredness pervades her late works, including the ambiguously titled *I Have Trodden the Winepress Alone* (fig. 30) with its reference to the biblical prefiguration of Christ as one suffering and disowned by his own people. The interlocking blocks of solid color found in her early works, including those that incensed the critics in 1924, have here become a fluid, multifaceted decorative background from which a triumphant figure emerges, a figure that, heralded in a blaze of color, appears more female than male. Surely this represents the artist, so that the winepress refers not only to Jellett's struggle for recognition in the face of her native country's hostility to modern art, but also her search for her own way forward independent of her masters. Finally, like Grace Henry and Nano Reid, Jellett, too, was drawn to the West of Ireland, where Achill in particular provided the subject-matter for much of this late period. *The Western Procession* (Plate 43) has all the cadence and rhythm, the interest in surface pattern and harmonious color of her earlier abstract paintings. But the rolling clouds of the West, the strength of rural traditions, and the deep spirituality of the islanders are easily discernible in this carefully structured composition – her final painting – of a graveyard procession.

Slowly – partly prompted by Mainie Jellett's endeavors to educate the wider public in modern art through lectures, exhibitions, radio broadcasts, and later by the establish-

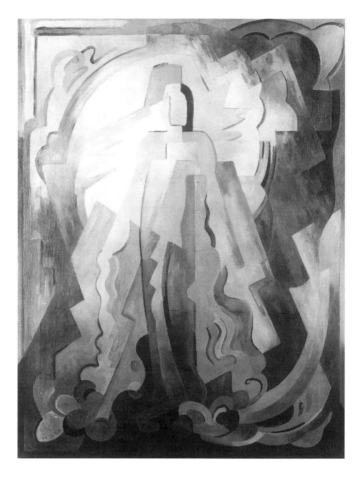

Fig. 30. Mainie Jellett, *I Have Trodden the Winepress Alone*, 1943, oil on canvas, 30 × 22 in. (76 × 56 cm), National Gallery of Ireland, Dublin

ment of the Irish exhibition of Living Art – the walls of prejudice against modern art in Ireland came down. In 1938 Evie Hone was commissioned to design windows for the Irish Pavilion at the New York World's Fair; later her designs for a new window at Eton College brought her international recognition. In 1938 and 1939 Mainie Jellett was asked to represent Ireland in the World's Fairs in Glasgow and New York. Of these critical breakthroughs Thomas McGreevy, then Director of the National Gallery of Ireland, later wrote, "It would seem to be incontrovertible historical fact that Evie Hone and Mainie Jellett jointly were the first Irish artists not merely to study but fully to master and then to introduce into the practice of painting in Ireland the principle and the idiom of the modern French approach to the painter's problem"[28] And they certainly paved the way for other artists to come. Among these was Norah McGuinness, who, after Jellett's untimely death in 1944,

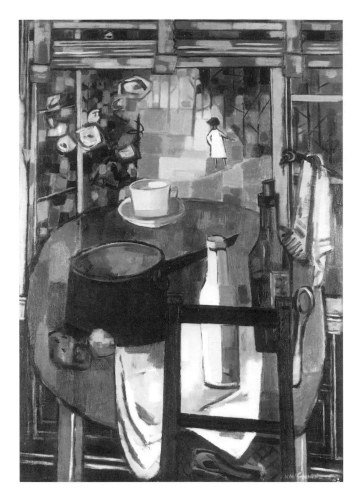

Fig. 31. Norah McGuinness, *Garden Green*, 1962, oil on canvas, 40 × 28 in. (101.6 × 71.1 cm), Hugh Lane Municipal Gallery of Modern Art, Dublin

was elected chairman of the Irish Exhibition of Living Art, where she carried on Jellett's commitment to make it a platform for new ideas. McGuinness had gone to study with André Lhote in France on Jellett's advice after her marriage broke up. Although, after studying first in Dublin, she had come across Impressionist and Cubist influences at the Chelsea Polytechnic, McGuinness was liberated by her sojourn in Paris, writing of it, "I painted all the time and saw marvelous pictures and wonderful galleries."[29] Her style moved from the decorative to the formally charged, in a series of still lifes and spontaneous portraits in fat black brushstrokes contrasting with glowing color. After two years in Paris she spent some months in India then returned to London where she remained until 1937. The early months in London were not easy, as she knew few people and her divorce hit the headlines as a scandal – "I was for eight

months so lonely," she recalled.[30] McGuinness's *Thames* series – somber, brooding paintings executed with thick swabs of murky colors, predominantly greens and browns – hint strongly at her emotional state.[31] The artist herself saw this when she admitted, "I had an exhibition of paintings around that time and it was as black as night. The gloom came out."[32] *The Thames* (1932–34, private collection), for example, is created in bold, thick strokes of dark greens, blues and browns unrelieved by any hint of gaiety. Gone are the jewel-like colors of her Parisian works. The thick lines of her French still lives are retained, yet the color contrast is dimmed immeasurably. Details of the riverscape are omitted, the objects reduced to simplified forms, the background mere sweeps of paint, the houses standing in an ominous row. Instead we find a vitality in the vigorous, deeply felt brushstrokes, a modernity about the massing of tones and shapes, and an unconventional viewpoint, allied with an emphasis on tonal relationships and the flatness of the picture plane, that is unmistakably contemporary.

After spending two years in New York – where she exhibited at the Paul Reinhardt Gallery and did window displays at Altmans, Lord & Taylor, and for Helena Rubinstein after being impressed by Salvador Dali's Surrealist fur-lined bathtub in a Fifth Avenue shop window, McGuinness returned to Dublin at the outbreak of war. Her work developed into a lyrical Fauvist phase in the landscapes, still lifes and informal portraits of the 1940s, where her palette is predominantly green and blue but highlighted with sunny reds and yellows, all in stark contrast to the somber colors of her London years. Her landscapes and figure studies of the 1950s exhibit a renewed interest in a form of asymmetric Cubism, while by the 1960s and 1970s she consolidates a confident style of semi-abstraction. *Garden Green* (fig. 31) is in classic late McGuinness hues of strong greens highlighted with black and white. The setting is rigidly structured, the semi-abstracted figure outside defining the multifaceted surface of the picture space. It is a kind of summation of the artist's interest in the flattened perspective and multiple viewpoints of Cubism of her Parisian years, melded with the coloristic and design strengths of the British School of the 1940s and 1950s.

In 1957 Norah McGuinness was elected an honorary member of the RHA, an accomplishment indeed when one remembers that in the 1920s, when she began her career, no woman was allowed the letters RHA or ARHA after her name. In 1968

a retrspective of her work was held at Trinity College Dublin, and in 1973, much to her delight, she was awarded an honorary D. Litt. degree. And so we see another artist whose experience abroad, interest in new ideas, and experimentation were vital to the development of modern art in Ireland. The painter Edward McGuire wrote of her, "She made us [young painters] feel important when the visual arts was at a low. She was aware of what constitutes a good picture, and was always giving her advice in a gentle manner for those who would listen. Without her help I would not have started painting."[33] Nor was McGuinness the last Irish woman artist in the middle years of the century to play such a role. A contemporary, chosen to represent Ireland with her at the 1950 Venice Biennale, was the highly original Co. Louth artist Anne Margaret (Nano) Reid, who took the intimacy of McGuinness's everyday subject matter – still lifes from the kitchen, quick gouache portraits of her friends putting on make-up, smoking, or at work sewing – to a new depth. Initially trained as a nurse before winning a scholarship to the Metropolitan School of Art in 1920, where she was taught by Patrick Tuohy, Seán Keating, and Harry Clarke, Reid went to La Grand Chaumière in Paris in 1927 where she encountered the Argentinian painter Antonio Berni. "He was a smashing painter. Oh My God!" she recalled. "It was a revelation to me compared with the weak stuff being done in Dublin. He put the paint on with such gusto."[34] After studying in Chelsea and London she was showing with the Society of Dublin Painters by 1930, and in 1934 had her first one-woman show at The Gallery, No. 7 St Stephen's Green. Throughout her life she painted her beloved Boyne Valley, with its rich prehistoric Celtic heritage, while also painting the landscapes of Donegal, Connemara, and Achill in a simplified style not entirely unlike the early work of Paul Henry. A good example of Reid's work from this time, *Galway Peasant* (1929, Ulster Museum), was painted while she lived in the sitter's cottage in Letterfrack, Co. Galway, for two months. Like many of Reid's portraits, the portrait of her landlady, Mrs Conboy, is strong on personality with perhaps a hint of caricature, a slightly larger-than-life rendition of the subject, whose head and shoulders almost fill the picture space. There is no flattery or softening of natural features here, as the slightly quizzical expression of the ruddy faced woman in her traditional garb is caught in carefully layered brushstrokes with bold simplicity and forthrightness. In some of her other portraits, this directness did not always

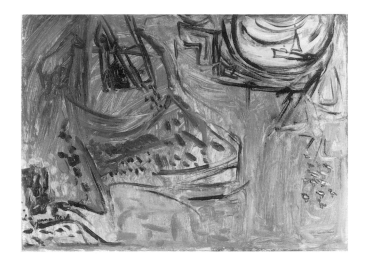

Fig. 32. Nano Reid, *Rubbish Heap*, 1958, oil on canvas, 18 × 24 in. (45.8 × 61 cm), Hugh Lane Municipal Gallery of Modern Art, Dublin

meet with the sitter's approval.

An exhibition of works by the Belgian painter Marie Howet held in Dublin in 1934 caused Reid to reappraise her entire approach to painting, discovering new, liberating expressive possibilities. Vigorous line then took over and color came to the fore as her work developed an idiosyncratic viewpoint. Later work such as *Rubbish Heap* (fig. 32), with objects seen from a bird's-eye view, shows her mastery of free and expressive use of paint and a completely individual style that is almost anarchic. The artist has taken what is discarded and, with wit and irony, made a satisfying and harmonious composition of painterly rubbish in which the viewer must hunt. In other works of this period, such as *The Backyard* (fig. 33), the whole picture surface is alive with objects and activity, with barrels and boxes, collections of miscellaneous objects, a fleet-footed cat, a sleeping cat, and a figure hanging out washing, all combined in an everyday domestic scene viewed, probably, from the back of the family pub. All the elements, seen from different angles, are arranged on a strictly two-dimensional surface. Shades of gold, browns, and reds contrast with blues, applied in vital, expressive, almost childlike manner.

Certain themes – water, megalithic tombs, Celtic crosses, and animals – recur throughout Reid's increasingly abstract work, although the artist felt her work was never completely abstract. She stated, "I don't like pure abstraction, just as I don't like pure representation. When you get pure

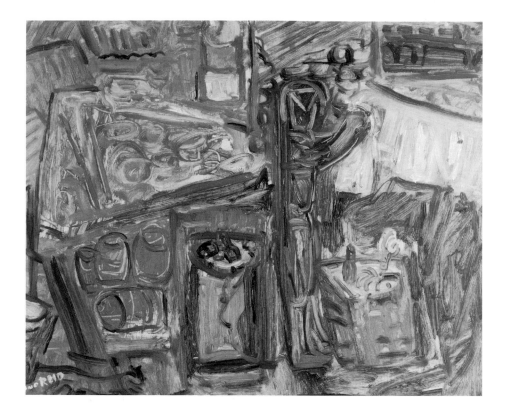

Fig. 33. Nano Reid, *The Backyard*, 1959, oil on board, 20 × 24 in. (51 × 61 cm), AIB Art Collection

abstract painting you often get a mechanical thing, an imitative thing – like the way some people slavishly follow a painter like Picasso, say. All my influences were personal influences. The big names don't appeal to me."[35] Reid's work met with decidedly mixed critical response. In 1942 Thomas McGreevy wrote, "There seems to be no help for it. This young artist from Drogheda has to be saluted as a genius."[36] When she and Norah McGuinness represented Ireland at the Venice Biennale, James White, later director of the National Gallery, noted, "critics were amazed to learn that she was a woman,"[37] so surprised were they by the vigor and urgency in her work. But she also suffered adverse comments, one critic remarking,"I still cannot see what she gains by her murky colors, her graceless lumpy forms"[38] Even in the late 1960s she did not feel her work was really accepted in her home town: "When you say you paint up where I live, they are puzzled and uninterested."[39]

Even so, artists such as these changed the face of art in Ireland, not through an orchestrated, deliberate crusade but rather by each striving to reach the pinnacle of her artistic ability and to explore whatever contemporary methods and styles might assist her in doing so. It was at times a daunt-

ing task, as adverse criticism greeted almost each new phase of work exhibited in Dublin. In most cases it was many years before official recognition of any sort was given. While with hindsight and in a broader international context their works may not appear extraordinarily avant-garde, in insular, nationalist Ireland they were wildly modern and set important precedents. The artistic institutions in which they were involved – the Society of Dublin Painters and the Irish Exhibition of Living Art – became important fora for the display of new works, for exposure and interaction. And it was through these fora that younger artists, male and female, came in contact with the latest developments in Irish art and the contemporary European avant-garde. Anecdotal evidence suggests that these were formidable, independent women, yet women who were not unaware of what they had given up in order to carve out their careers. While due attention has begun to be given to some of this group, notably Evie Hone and Mainie Jellett, much must still be done to credit the rich and diverse contribution of all these groundbreaking women – May Guinness, Grace Henry, Mary Swanzy, Norah McGuinness, and Nano Reid – to the development of modern Irish art.

NOTES

I wish to thank the National Visual Arts Library, 100 Thomas Street, Dublin 8, for their invaluable assistance with this research.

1 Mary Swanzy in an interview with Andy O'Mahony, RTE Radio, "The Arts Show," 5 May 1977.

2 Terence de Vere White, "Arts and Studies," *The Irish Times*, 30 April 1976.

3 Swanzy, interview.

4 In an interview entitled "Water is a Stirring Image," Eavan Boland, *The Arts*, 1971, press cutting from the artist's studio.

5 On the bottom of a number of catalogues, including one from The Gallery, 7 St Stephen's Green, November 1939: "Miss Jellett holds classes for Drawing and Painting at her studio, 36 Fitzwilliam Square, W Dublin. Subjects Still life, life, composition, landscape. Special classes for children." Or, from a "Catalogue of Cubist Paintings by Mainie H Jellett," 1931: "Orders taken for Cubist Rugs designed by MH Jellett"

6 Frank O'Connor, *My Father's Son* (London: Pan Books in association with Macmillan, 1968).

7 Evie Hone to Winnifred Nicholson, quoted in an essay on Evie Hone by W. Nicholson in Stella Frost, ed., *A Tribute to Evie Hone and Mainie Jellett* (Dublin: Browne and Nolan, 1957).

8 Swanzy, interview.

9 George Furlong in an interview with the author, London, June 1983.

10 Mainie Jellett in Eileen MacCarvill, ed., *The Artist's Vision* (Dundalk: Dun Dealgan Press, 1958).

11 For a comprehensive text on this see S.B. Kennedy, *Irish Art and Modernism 1880–1950* (Belfast: The Institute of Irish Studies, 1991).

12 Kennedy,

13 See the essay by Kenneth McConkey elsewhere in this volume.

14 For example, "An Exhibition of Post Impressionist Painters" held in the United Arts Club in 1911 had eight works by Gauguin, four by Van Gogh, one by Cézanne, one by Signac, three by Vlaminck, three by Derain, three paintings and two drawings by Picasso, two drawings and a painting by Matisse, and two landscapes by Rouault.

15 Quoted in *Images and Insights,* exhibition catalogue (Dublin: Hugh Lane Municipal Gallery of Modern Art, 1993, p. 76).

16 *The Irish Times*, 20 October 1923.

17 Fionnuala Brennan, "An Independent Eye," introduction to catalogue.

19 Thomas McGreevy, "Fifty Years of Irish Painting", *Capuchin Annual*, 1949.

20 Stephen Gwynne, *The Irish Times*, 13 April 1921.

21 Interview with Terence de Vere White, *The Irish Times*, 24 October 1973.

22 *The Leader*, 21 February 1942.

23 Mainie Jellett, "Definition of My Art," in Eileen MacCarvill, ed., *The Artist's Vision* (Dundalk: Dun Dealgan Press, 1958).

24 Ibid.

25 Ibid.

26 *The Irish Times*, 20 October 1923.

27 Hilda Von Stockhom, "Evie Hone as I knew her," *Martello Arts Review*, Winter 1992.

28 Thomas McGreevy, "Evie Hone and Mainie Jellett," in Stella Frost, ed., *Evie Hone* (Dublin: Browne and Nolan, 1958).

29 Norah McGuinness, unpublished manuscript notes prepared for an undated speech delivered to a meeting of the Irish Countrywoman's Association. Likely to be from the mid 1970s.

30 Eavan Boland, "Water is a Stirring Image," in *The Arts* 1971, press cutting from the artist's studio.

31 Critics have attributed this somberness to political instability and the impending war but it seems more likely to reflect her personal feelings.

32 Eavan Boland, "Water is a Stirring Image," in *The Arts,* 1971, press cutting from the artist's studio.

33 Personal letter to the artist's sister, Rhoda McGuinness, February 1982.

34 Quoted in *Nano Reid 1900–1981*, exhibition catalogue (Drogheda: Droichead Arts Centre, 1991).

35 Nano Reid to Marion Fitzgerald, *The Irish Times*, 1965, undated press cutting from the National Visual Arts Library.

36 *The Irish Times*, 27 November 1942.

37 Quoted in *Nano Reid 1900–1981*.

38 Ibid.

39 Nano Reid in an interview with Harriet Cook, *The Irish Times*, 14 April 1969.

Irish Painting, Tradition, and Post-War Internationalism

PETER MURRAY

On 19 January 1950, the painter James Sinton Sleator died at Academy House in Dublin. A quiet and retiring man, Sleator had succeeded Dermod O'Brien five years previously as President of the RHA. His portraits (fig. 34) and still lifes show him to have been a gentle and sensitive colorist. On his death, an artist's palette – a gift from his mentor Sir William Orpen many years before – passed to Sleator's friend Maurice MacGonigal, the painter who in turn was to succeed him as President of the Academy. At MacGonigal's funeral in 1979, in Roundstone, Connemara, Orpen's palette was placed on the coffin.[1] This gesture might be taken as symbolizing the waning of that academic tradition, so ably revitalized in the early years of the twentieth century by William Orpen, a pupil of Henry Tonks at London's Slade School of Art, and so stoutly defended through the ensuing decades by Orpen's own pupils.

As Professor at the Metropolitan School of Art in Dublin in the early years of the century, Orpen had taught a generation of students whose names were to become synonymous with the Irish art of their time – Seán Keating, Patrick Tuohy, Leo Whelan and others. MacGonigal, who attended the Metropolitan School in 1923, was not tutored by Orpen personally, but by Tuohy and Keating. However, through his thirty-five years' teaching at that same school (renamed the National College of Art (NCAD)), MacGonigal maintained Orpen's traditional approach, an approach based on the atelier system and maintaining at its core the primacy of the life-drawing class. It was this style, which can be called academic realism, which came to be adopted as the "official" artistic style of the new Irish Free State, a relationship that ultimately helped neither the state nor the artists it professed pride in supporting. The paradox was, of course, that the immediate source of this style – adopted by a country which had just broken centuries of political connection with Britain – was one of the most prominent British art schools, the Slade. Increasing student agitation and resistance to these academic teaching methods ultimately forced MacGonigal's resignation from the NCAD in 1969, and should also have signalled the end of the dominance of the academic tradition which he had inherited from Orpen, but such was not the case. The opportunities presented to that radical student generation of the late 1960s were never fully exploited, nor were the rifts exposed ever properly addressed, and so an uneasy relationship in Ireland between progressive and conservative traditions in art education

lingers even today.

The year 1950 was not the most auspicious in twentieth-century Irish art, either for the academic or for the avant-garde movements. A number of the great names of Irish academic painting – William Orpen, John Lavery, Dermod O'Brien, Sarah Cecilia Harrison, and Sarah Purser – had died in the past decade. There had been few new developments since the founding of the Irish Exhibition of Living Art in 1943 (see further below). Those artists who had come to maturity in the difficult but electrifying years of the founding of the Irish Free State – Keating and MacGonigal, as well as Mary Swanzy, Evie Hone, Estella Solomons, Charles Lamb, Paul Henry, and Harry Kernoff – were still working, but in most cases they had established their styles in the 1920s and since then had been content, for the most part, to settle into a pattern of producing paintings that broke little new ground. The social and political instability of the early 1920s had acted as a stimulus on the production of art, but in the 1930s a sense of disillusionment grew among artists about the role they were being asked to play in the cultural life of the country. The Irish government displayed increasing intolerance towards artistic freedom of expression. In 1930, Harry Clarke's stained-glass window, commissioned as a gift to the League of Nations' headquarters in Geneva, was rejected on the grounds that some of the literary works that had inspired it were officially banned. The main obstacle during this period, however, was a lack of wealth and patronage. Some artists, such as Cecil Salkeld ffrench, a student at the Metropolitan School in 1919 (and afterwards at Kassel, where he exhibited with Otto Dix and other members of the Neue Sachlichkeit movement), managed to establish an adequately comfortable niche in Dublin's artistic bohemia. Arthur Power, a friend of Modigliani, Zadkine, and Pascin in Paris in the 1920s, returned to Ireland in 1930 and settled back into life at his family home in Waterford.[2] Others looked for exhibition and work opportunities overseas. Patrick Tuohy emigrated to New York in 1927 and, although he achieved some success, painting portraits of Claudette Colbert and other movie stars, he died, aged just thirty-six, in his Riverside Drive studio in 1930. Just a year before, Tuohy had helped organize an exhibition of contemporary Irish art in the New York gallery of Helen Byrne Hackett. The Hackett Gallery showed work by Jack B. Yeats (whose life and work are discussed elsewhere in this volume), James Humbert Craig, Seán Keating,

Fig. 34. James Sleator, *Portrait of William Orpen*, oil on canvas, 38⅛ × 36⅛ in. (96.8 × 91.8 cm), Crawford Municipal Art Gallery, Cork

Estella Solomons, Charles Lamb and others. That same year, along with Seán O'Sullivan, Power O'Malley, Margaret Clarke, and others, Keating was represented in an exhibition of Irish art held in Brussels. However, by 1950, much of the youthful energy of this generation had been dissipated and artists such as Paul Henry, Keating, and MacGonigal, although still working steadily, were no longer producing their best work.

Like Sleator, who had been first a pupil of, and later a studio assistant to Orpen, Keating, a scholarship student at the Metropolitan School of Art from 1911, became Orpen's close associate: he had been held in such high regard by Orpen that he was given free tuition at the School for a year. Keating in turn was Professor of Painting at that same institution from 1934 through to the 1960s, then President of the RHA from 1948 to 1962, and during that period his trenchant opposition to modernism and other recent art movements grew steadily, to such an extent that it hindered the development of the contemporary visual arts in Ireland and, ultimately, encouraged much that was second-rate, simply because it followed academic precepts. Keating's growing intolerance was all the more unfortunate as he had

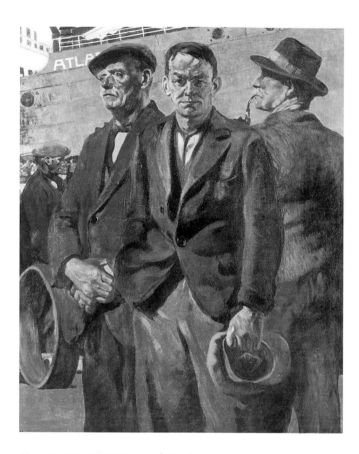

Fig. 35. Maurice MacGonigal, *Dockers*, 1933–34, oil on canvas, 49³/₈ × 39¹/₂ in. (125.4 × 100 cm), Hugh Lane Municipal Gallery of Modern Art, Dublin

displayed, in a giant mural painting commissioned by architect Michael Scott for the Irish Pavilion at the 1939 New York World's Fair, a zest for the modern world and a strong sense of design and abstract composition that was in no way retrogressive.

The public, however, on both sides of the Atlantic, seemed to prefer Keating's traditionalist approach. His *Race of the Gael*, a prizewinner at an exhibition organized by IBM in New York, also in 1939, showing a group of Irishmen in profile, has something of the feeling of a Norman Rockwell setpiece. Maurice MacGonigal trod a more ambiguous path, occasionally experimenting with modernist styles – adventures that were welcomed neither by his admirers nor by his colleagues at the Academy. In retrospect, the artistic output of Keating and MacGonigal is uneven; both had moments in their lives when every encomium showered upon them was deserved. Both also produced flawed, theatrical, and unconvincing paintings, a situation aggravated by

the keen rivalry that existed between them.

MacGonigal had done some of his finest work during the 1930s – landscapes at Renvyle, laid quickly on the canvas, *en plein air*, with a fluid command of color and paint handling reminiscent of John Lavery or John Singer Sargent. He also painted at this time superb figure studies such as *The Irish Captain* (1933, McKee Barracks, Dublin), and *Dockers* (fig. 35), as well as painting sets for the 1936 Abbey Theatre production of *The Silver Tassie* by Sean O'Casey. However, by the mid 1940s MacGonigal was producing views of Connemara which have an informal charm but which seem almost amateurish when set against his taut, visionary, and well balanced paintings of the previous decade. He was appointed Assistant Professor of Painting at NCAD in 1937, where he met his future wife Aida, the daughter of a Republican family whose three brothers were active trade unionists. Aida herself was a supporter of the Republicans in the Spanish Civil War and a fundraiser for Emma Goldman. MacGonigal, who along with Keating had been commissioned by Michael Scott to paint murals for the Irish Pavilion at the 1939 World's Fair, used Aida as the model for the personification of America in his large painting depicting famous Irishmen in American history.[3] Around this time also, in a series of ambitious paintings, Aida was portrayed as a traditional Aran Islander by her new husband. In *Cois na Farraige* (1938, private collection) she sits demurely but with a somewhat melancholic air, eyes downcast, beside a turf creel, with, beyond her, a pier, the blue sea, a currach being launched and others rising on the waves. Her red petticoat, black boots, and heavy shawl are traditional Aran Island garb. In *Bean agus a Naoidheanan* (*Mother and Child*, Plate 39) Aida is a mother, holding a young child, again dressed in traditional manner with a black shawl around her shoulders. In contrast with the portrait of four years before, here she appears more careworn and indeed, in the years between the two paintings, much had happened. The world had been at war for three years, but Irish Prime Minister Eamon de Valera had, with popular assent, kept Ireland out of the conflict. In a neutral country, cut off from the outside world, food, fuel, and other essentials were rationed; the students in the art college experimented with making their own paints. The heady days of the World's Fair in 1939 must have seemed a different age.

Beside the (mainly) male academic painters and their rival-

ries, much of the vitality in Irish art between the wars was provided by a group of talented women who dominated the annual exhibitions of the Society of Dublin Painters. The Dublin Painters, founded in 1920 by Paul Henry and the ardent Cubist painter Mainie Jellett, exhibited the work of moderately progressive artists such as Hilda Roberts, Lilian Davidson, Mary Swanzy, Stella Frost, Joan Jameson, Brigid Ganly, and Beatrice Glenavy. In many cases, these women had independent means or were married to prominent men: Jellett and Swanzy both came from wealthy Dublin medical families; Glenavy's husband was a director of the Bank of Ireland; Joan Jameson's, a director of the family distillery; Roberts's, the headmaster of Newtown School. As much as these circumstances abetted them materially, the artistic careers of these women were hampered inevitably by social constraints, and, while they were resolute in their commitment to painting, the fact that they were not dependent on sales to support themselves had a defining influence on their self-esteem as artists. Mary Swanzy remarked, with some justification, that if her name had been Henry she would have been taken far more seriously as an artist in Ireland, for the academic realists of the RHA (over which MacGonigal and Sleator presided) regarded themselves as "professional" artists and, in general, greeted the experimental progressive art styles of the Dublin Painters, with derision. Sleator had been a founding member of the Dublin Painters but had withdrawn after the first exhibition, presumably because of the non-academic approach of most of the members.

The era of the independently wealthy woman artist drew to a close with World War II, when the funds that had sustained the affluence of Edwardian upper-middle-class life in Ireland began to peter out. In the 1950s, when women such as Camille Souter and Nano Reid opted to become full-time painters, they were more often obliged to rely for a meager income on the sale of their work. The early death of the proselytizing Mainie Jellett, whose lantern-slide talks to the Irish Countrywomen's Association on the virtues of Synthetic Cubism had been influential in changing public opinion, was a blow to those who wanted to promote modern art in Ireland. Her friend and companion, Evie Hone, who had also studied with André Lhote and Albert Gleizes, lived until 1955 but was less influential.

The second generation of progressive artists that had emerged in the 1930s – painters such as Anne Yeats, Fr. Jack Hanlon, Ralph Cusack, and Patrick Hennessy – were far less influential and merged quickly with the artists of the 1920s. Intimidated by the powerful social and political changes that swept Europe in the 1930s, the Irish government had pursued an increasingly isolationist and xenophobic policy, culminating in Ireland's neutrality in World War II, a period known as "The Emergency." This policy had a silent, insidious, and ultimately damaging effect on the country's cultural and artistic life, the years after the war being something of a doldrums. There were some unexpected benefits, however: sales at the Irish Exhibition of Living Art in 1943 were brisk; as the war progressed, people found they had little opportunity to spend money on imported goods. Fleeing the Blitz in London, a group of progressive British and European artists who called themselves the White Stag Group formed an expatriate community in the safe haven of Ireland. Despite several exhibitions held in Dublin during the war years, their presence does not seem to have had a lasting effect, apart from launching the career of one important progressive Irish artist, Patrick Scott. Scott had worked for fifteen years as an assistant to architect Michael Scott (no relation) before deciding to become a full-time painter in 1960. His influence and presence in the visual arts in Ireland should have been considerable in the decades following, but, as Brian O'Doherty has pointed out, because of the hegemony enjoyed by MacGonigal and Keating at the NCAD, Scott was never invited to teach and so has remained a respected but somewhat isolated figure in the contemporary Irish art world.[4]

The inspiration of the White Stag exhibitions led to the establishment in 1943 of the Irish Exhibition of Living Art by Louis le Brocquy, Norah McGuinness, Mainie Jellett, and Jack Hanlon. The rejection of le Brocquy's painting *Spanish Shawl* by the selectors of the annual RHA exhibition in 1942 had shocked even supporters of the Academy and had led to a public controversy about its continuing hostility to new forms of art. (The rejection was all the more surprising as a painting by le Brocquy which was more radical, *A Picnic* (Plate 37), had been accepted by the RHA selection committee the previous year.) The first Irish Exhibition of Living Art was held at the NCAD in September 1943 and included nearly two hundred works of art. Owing to the destruction of their original premises on Middle Abbey Street during the Rising of 1916, the annual exhibitions of the RHA were also held at this time in the NCAD. Presumably Maurice MacGonigal must have been tacitly

supportive of this initiative, as he was Professor of Painting at the NCAD at this time. Seán Keating, surprisingly, participated in the first Living Art exhibition, and his *Tip Wagons at Poulaphouca* (ESB Collection) received critical praise. The Irish Exhibition of Living Art, of which Norah McGuinness was to remain chairwoman until 1972, demonstrated that there were many artists working in Ireland outside of the academic realist tradition. The initial exhibitions included Ralph Cusack, Nano Reid, Patrick Scott, Gerard Dillon, the Fauvist inspiration of Norah McGuinness, the Cubist styles of Doreen Vanston and Mainie Jellett, the Surrealism of Colin Middleton and Nick Nicholls.[5]

After the war, with a struggling economy and state censorship of the arts that reached risible levels, it is not surprising that the arts were somewhat moribund. These were the years in which emigration to Britain or the United States was not a choice for young people in Ireland seeking employment, but a necessity, though artists fled not from poverty but from a repressive and repressed society. The year 1950, however, saw some efforts to improve opportunities for artists. An exhibition, including works by Raymond McGrath, Gerard Dillon, and others, was organized by the Institute of Contemporary Art in Boston and toured the United States. Back in Ireland, in November of the same year, the government debated a new Arts Bill, which passed into law in 1951 and provided for the establishment of an Arts Council to dispense funds to the arts. The first Arts Council was appointed in 1951, and while it predictably enough included the directors of several arts institutions, such as Thomas McGreevy of the National Gallery, it also, and more interestingly, included Muriel Gahan, founder of the Irish Countrywomen's Association and the Country Shop on St Stephen's Green. While Dublin's famous pubs such as McDaid's and the Palace Bar had long served Ireland's writers well, it was in the back room of the Country Shop, furnished by Gahan with chairs by Alvar Aalto and Cubist paintings by Mainie Jellett, that discussions on new movements in the visual arts took place between Louis le Brocquy, Patrick Scott, and other avant-garde artists. Gahan was an important patron of the arts, commissioning Elizabeth Rivers and others to produce works depicting everyday lives in the West of Ireland. The Country Shop had also been a favourite meeting place of White Stag artists Basil Rákóczi and Kenneth Hall, their colorful clothes and conversations on creative psychology contrasting with the tweed suits and sedate demeanor of the other customers.[6]

The establishment of the Arts Council came paradoxically at the beginning of one of the most depressed decades in twentieth-century Irish history. For many artists there seemed little point in remaining in the country, as both the economy and repressive attitudes toward contemporary art continued to provide powerful disincentives. In 1942, and again in 1954, the Advisory Committee of the Hugh Lane Municipal Gallery of Modern Art in Dublin, of which Seán Keating was a member, had rejected a Georges Rouault *Christ and the Soldiers*, offered as a gift by the Friends of the National Collections. Louis le Brocquy wrote a letter of protest to the *The Irish Times* and shortly afterward left Dublin for London, beginning years of a peripatetic existence that led through London, with many visits to the European mainland, and finally, in 1960, to a house in Carros in the Alpes Maritimes, which has remained his principal home since. (The South of France had also been the chosen domicile of the other great Irish modernist painter of the twentieth century, Roderic O'Conor, who died at his home near Cassis in 1940). Le Brocquy's letter of protest may have been instrumental in the Hugh Lane Gallery refusing, in 1951, the gift of one of his most important paintings, *The Family*, which had been shown at the Gimpel Fils Gallery in London and at the Victor Waddington Gallery in Dublin. It emerged that Dublin Corporation would happily have accepted the painting but was overruled by the Arts Advisory Committee, composed mainly of academicians. The painting later won a major prize in at the 1956 Venice Biennale.[7]

Louis le Brocquy was born in Dublin in 1907. His initial training was as a chemist and until 1938 he worked in the family business, a small oil company. Largely self-taught as an artist (he spent much time studying in museums in London and Paris), le Brocquy has evolved a style that is sparing and delicate, his early training as a scientist still evident in the careful, controlled, experimental use of paint. Although his early paintings were inspired by Cézanne and the Cubists, his more recent work counterpoints precise brushwork with elusive, inspired mark-making. The artist's obsession with the head as the central, and indeed only, subject matter in many of his paintings began in 1964, when he saw Polynesian decorated heads in the Musée de l'Homme in Paris and linked this Pacific art form with the cult of the head evident in Celtic art in Ireland and France. His paint-

ing *Reconstructed Head of an Irish Martyr* (Plate 53) dates from 1967. Eight years later, working from a commission from the Galerie Borjeson in Malmö intended to focus on an Irish Nobel Prize winner, le Brocquy began his series of portraits of W.B. Yeats. This was the starting point of a whole series of charcoal sketches, watercolors, and oil paintings of Yeats exhibited in the Musée de l'Art Moderne de la Ville de Paris in 1976. Le Brocquy affirms that Yeats's recurrent use of mask imagery, as in *A Vision*, was influential in the development of this series.[8]

Le Brocquy's fondness for France was shared by other Irish painters. William Leech had spent many years painting in Brittany, mainly in Concarneau, continuing a tradition among Irish artists that had reached its peak in the latter half of the nineteenth century. However, the 1939–45 war cut short many of these connections. The Cork painter William Gerard Barry, a friend of Augustus John, was killed at his home in St-Jean-de-Luz during a German bombing raid in 1941, while Micheal Farrell, an Irish artist who remained in Brittany, was continually harassed by the occupying forces. William Scott's fledgling summer school for painters in Pont-Aven had closed at the outbreak of war, with Scott escaping to England. Born in Scotland, but raised and educated in Northern Ireland, Scott's still lifes (a genre he returned to throughout his life) are essays in the pure tactile and visceral qualities of oil paint. Skirting warily the domains of abstraction and representational art, Scott remained, in his own words, an "individualist." His works nonetheless retain a strong sense of the simple furnishings and puritan ethics of his Northern background. Perhaps more than any other Irish artist this century, Scott has been exhibited worldwide since the early 1930s. In 1953, as well as showing at the São Paulo Bienal, he was introduced by Martha Jackson (at whose New York gallery he had several exhibitions) to Jackson Pollock, Franz Kline, and Mark Rothko. Five years later, he represented Britain at the Venice Biennale, and showed also at galleries in Turin, Milan, Munich, and other cities.

In spite of their having quit Ireland, both William Scott and Louis le Brocquy continued to exhibit in Dublin – unlike Ralph Cusack, a co-founder with le Brocquy of the Irish Exhibition of Living Art, who, suffering from that mix of arrogance and self-loathing which seems to have reached a peak with Irish artists and writers during these years, emigrated with his family to France in 1954, vowing never to set foot in Ireland again. Le Brocquy and Cusack left behind their friends and family – a closed society, mainly Protestant, in which devotion to European culture had become almost a fetish. And this devotion vented itself in the form of gramophone evenings and even concerts before private audiences, discussions on art, accompanied by tea and scones, in the back room of the Country Shop on St Stephen's Green, and the works of Schopenhauer and Kirkegaard being held as a talisman against the scholastic Jesuits.[9] It was a world, too, in which there was a significant contribution by Irish artists of Jewish faith or background, including Harry Kernoff's animated cityscapes and portraits, the strange surreal tableau paintings of Beatrice Glenavy, prints by Stella Steyn (one of the few Irish artists to have studied at the Bauhaus), and skillful portraits and landscapes by Estella Solomons, who, like Jellett and Swanzy, had come from a leading Dublin medical family.

Like Louis le Brocquy and Cusack, Micheal Farrell also settled in France, over a decade later (there were two Irish artists in France named Michael Farrell; the first returned to Ireland after the war, while the younger Micheal Farrell left Ireland in the 1970s). Patrick Swift, one of the most interesting Irish émigré painters of the period, settled in Portugal. Swift, born in 1928, gave up his job in the Dublin Gas Company to become a full-time painter in the late 1940s. His first paintings were simple and honestly felt, of trees and gardens in and around Baggot Street and Pembroke Road in Dublin, areas immortalized in literature by the poet Patrick Kavanagh, whose portrait Swift painted shortly before leaving Ireland in the mid 1950s. Swift was a considerable loss to the local vitality of the Irish art scene, although he continued to exhibit regularly at the RHA and the Living Art exhibitions. In London he settled easily into the artistic and bohemian life of Soho, where he was friendly with Lucian Freud and Francis Bacon and edited an influential literary magazine called *X*. He left London for Portugal in the early 1960s where he played an important role in the revival of the traditional pottery industry of the Algarve. Swift continued to paint throughout his life, and a retrospective exhibition held at the Irish Museum of Modern Art after his death revealed him to have been a painter of consistent strength and vision.[10]

Fewer artists chose to emigrate to America. Seán O'Sullivan, a fine and sensitive portrait painter whose inability to surmount his academic training may have contributed

to his early death from alcoholism, made a tentative foray to New York and Philadelphia in 1955. Two years later, with the aid of a Fulbright scholarship, a young medical student and painter from Roscommon, Brian O'Doherty, moved to the United States, where he quickly began to make a name for himself as a progressive artist and art critic. Along with Sol Le Witt and Joseph Kosuth, O'Doherty (who changed his name to Patrick Ireland in 1969, in response to the onset of the modern-day "Troubles") was one of the pioneers of the Conceptual art movement in New York in the 1960s. His friendships with Edward Hopper, Marcel Duchamp, and other leading artists influenced his own development, while the enthusiasm evident in his writings on Hopper, Pollock, De Kooning, Rothko, and Rauschenberg was undoubtedly driven by memories of the rather insular art scene he had left behind in Dublin. Commenting on the efforts of the Society of Dublin Painters and the Irish Exhibition of Living Art, O'Doherty wrote:

"The Academy controlled . . . the National College of Art, where the teaching was, and is, splendidly irrelevant to its students' needs. The floating complex of dealers (Waddington was joined by the Dawson Gallery in 1944 and by the Hendriks Gallery in 1956), artists and collectors thus had no access to the institutions. This explains the peculiar lack of influence by many of the best artists, such as Patrick Scott – they never got the opportunity to teach. One would have expected Jellett's demanding ideas to affect some of the younger artists, but the only painter who shared her tough-mindedness was Thurloe Connolly. His loss – he abandoned painting for design and went to live in England – further testifies to the lack of response to anti-romantic ideas in Irish art. Jellett's failure to give Irish art a firm cubist underpinning (apart from the work of Nano Reid) is easily understood. A suggestive form of painting with a particular atmospheric complexion, a product of the interaction of the artists and the audience created by and for their art in the forties and fifties, gathered force. Owing to the war, something 'local' in the best sense had the opportunity to develop. To call it a national quality could be an exaggeration, though all the paradoxes and misunderstanding of that idea were in operation."[11]

The painters O'Doherty was referring to in this revealing text, written in 1971 – Nano Reid, Patrick Collins, and Camille Souter – had each evolved an art that was in no way "International" but which also clearly avoided the cul-de-sac of academic realism. He praised these painters' success in evolving an art practice that, on the surface at any rate, appeared to reject the precepts of the New York School (which found ready imitators in most European cities) but was in no way provincial as a result. The paintings of these artists were inspired, internally, by a poetic imagination and, externally, by the atmosphere of Irish skies and landscapes, unkempt, untamed, and somewhat damp.

A student of Keating at the Metropolitan School of Art in the same years as Maurice MacGonigal, Nano Reid had gone on to study in Paris. She exhibited with the White Stag Group in 1941 and represented Ireland at the 1950 Venice Biennale. Her paintings, for the most part quasi-abstract landscapes and interiors with figures, loosely painted in tones of browns and greens, have nowadays become emblematic of that somewhat dismal era in Irish life. The recurring motifs of glasses, bottles on tables, dark pub interiors, rain-sodden landscapes, and tinkers are presented in her work with a sense of humour and lack of pretentiousness that is honest and appealing.[12] Patrick Collins, for his part, made the decision to become a full-time painter in the 1940s, after working for twenty-two years in an insurance company. Apart from some part-time classes at the NCAD, he was largely self-taught. In some ways Collins was the inheritor of the tradition of Jack Yeats – indeed, both artists hailed from Co. Sligo. However, the literary and autobiographical strains which recur frequently in the works of Yeats remain muted in Collins's soft and evanescent landscapes hovering on the fringes of figuration. Although Collins could clearly articulate what he set out to achieve in his paintings, the works themselves, in spite of a fragile beauty, often appear indecisive and lacking a sense of structure. Not long after painting *Travelling Tinkers* in 1968 (Plate 54), Collins spent nearly a year in Connemara digging ditches, which led in turn a series of taut paintings inspired by bog landscapes. In the early 1970s he spent six years living in Paris, although his work remained determinedly Irish in subject matter.[13]

Although born in England, Camille Souter grew up in Ireland. She embarked initially on a nursing career, as had Nano Reid, but contracted tuberculosis and returned from London's Guy's Hospital to Ireland in the early 1950s.

Inspired by paintings of Pierre Bonnard she had seen in London in 1947, Souter decided to become a full-time painter and in the face of many difficulties worked steadily at developing a lyrical and painterly style. Painting only in natural light, and requesting that owners of her paintings view them only in that light, Souter achieved quasi-abstract views of Irish landscapes and scenes of everyday life that are among the finest works of art created in Ireland this century. Souter's subject matter tends to invert hierarchies, so that she is more at home portraying a discarded and rusting bed in a ditch than the interior of a neat bedroom.[14] She celebrates the power station chimney that would have appalled the aesthetic sensibilities of most traditional Irish landscape painters. In 1978 she rented a flat in Shannon, close to the international airport. Her paintings of aeroplanes in the Irish landscape provided a perfect opportunity to counterpoise small areas of vivid color against the greys and greens of the fields and skies at Shannon (fig. 36). Added to this unexpected subject matter is an inherent optimism and sense of humanity in her work.

In many ways, Souter's career and style of painting can be compared to that of Kilkenny artist Tony O'Malley, also forced by tuberculosis to quit his job as a bank clerk before electing to become a full-time painter. His early paintings, generally on panel, became increasingly abstract as he came into contact with the work of Ben Nicholson, Peter Lanyon, and other artists in Cornwall in the 1950s. These early works are often sombre and dark, while in more recent years O'Malley has combined these formative elements with a lyrical abstract quality in which color, tone, shape, and form are laid, incised, and scratched into the surface of the panels on which he almost invariably works (fig. 37). These recent paintings, with their sure and elegant sense of balance and harmony, contain a quality reminiscent of Monet's Giverny canvases. Since his return to his place of birth, Callan, Co. Kilkenny, and his creation there, with his wife Jane O'Malley, also a painter, of a delightful garden, the comparison is not inapposite.

Although the annual exhibitions of the RHA continued to provoke debate about the essentially conservative nature of the visual arts in Ireland, another annual show, An tOireachtas (an assembly, or festival), while including much the same fare as the RHA – academic portraits by Seán O'Sullivan, quiet landscapes and still lifes by Barbara Warren and David Hone, views of Connemara by George

Fig. 36. Camille Souter, *Turn on to Base Leg*, 1980, oil and aluminum paint on paper, 23³/₄ × 22¹/₄ in. (60.2 × 56.4 cm), private collection

Fig. 37. Tony O'Malley, *Hawk and Quarry in Winter, in memory of Peter Lanyon*, 1964, oil on board, 20⁷/₈ × 28³/₈ in. (53 × 72 cm), Crawford Municipal Art Gallery, Cork

Campbell and Charles Lamb, landscapes by the Cork painter Diarmuid O'Ceallachain – achieved a reputation for being more open to new and diverse trends. The Exhibition of Living Art also continued its policy of being open and progressive, although in time it came to be dominated by a group of Northern painters including George Campbell, Gerard Dillon, Nevill Johnson, and Daniel O'Neill. O'Neill,[15] born in Belfast in 1920, trained as an electrician and worked in the Belfast shipyards. Essentially self-taught as an artist, he took up painting in 1939 with encouragement from his friends Gerard Dillon and Sidney Smith. O'Neill had a joint exhibition with Dillon, who had introduced him to the work of Cézanne and Rouault, at the Contemporary Picture Galleries in Dublin in 1943. His painting *Birth* (Plate 47) dates from 1952 and is filled with the strong sense of morbidity and foreboding that characterizes his work. Dillon, born in Belfast, had left school in 1930 at the age of fourteen. His keen interest in art led to his becoming a full-time artist, but, from time to time, in order to earn a living, he returned to his trade as a house painter. During the war years he worked in Belfast, where he was friends with Nevill Johnson and Daniel O'Neill, and also in Dublin, where he showed with the White Stag Group and with the Irish Exhibition of Living Art. Dillon's first one-man exhibition was held at the Country Shop in 1942. He was greatly inspired by Chagall's paintings and by Keating's illustrations for Synge's *The Playboy of the Western World*, the influential and controversial play set on the Aran Islands. Dillon's painting *Island People* (Plate 45) probably dates from this period, when he traveled around Ireland painting landscapes. From the beginning of his career Dillon's art portrayed aspects of life in Connemara and the Aran Islands where, like Keating and Charles Lamb, Dillon was interested as much in the life of the people of the West of Ireland as in the landscape itself. His style of painting is personal and idiosyncratic, deriving inspiration from the work of Gauguin and Chagall – a sort of magic realism, with dreamlike landscapes and interiors peopled by farmers and fishermen but also by pierrots and strange hallucinatory figures. In 1958 Dillon represented Ireland at the Guggenheim International, and Great Britain at the Pittsburg International Exhibition. During these years he traveled and exhibited widely in Europe, taught for brief periods in the London art schools, and even exhibited twice in New York, in 1952 and 1963, in displays at Macy's and Lord & Taylor respec-

tively. His *Self-contained Flat* (Plate 50), painted around 1955, is a complex work inspired by Gauguin and Van Gogh, containing clues to the artist's troubled sexuality. In 1968 Dillon was back in Dublin, designing sets and costumes for a revival of Sean O'Casey's play *Juno and the Paycock,* again speaking to his interest in the West.

One of the most outstanding painters in the next generation of Northern artists is Basil Blackshaw,[16] born in Belfast in 1932 and trained in the art college of that city. *Men, Sea and Moon* (Plate 48) was painted in 1952, when the artist had recently returned to Ireland from Paris where he had continued his art studies. In the years that followed, Blackshaw traveled rarely, preferring to paint local landscapes of Co. Down, horses and other animals, and the occasional portrait. What comes through most strongly in Blackshaw's work is an honesty and lack of pretension, qualities he shares with Patrick Collins and Souter. Like these artists, Blackshaw has been greatly inspired by the Irish countryside and climate. A soft gentleness permeates his work, but, like the Sligo artist, his paintings are also sometimes characterized by a sense of uncertainty and lack of resolution.

These landscape and figurative painters were to dominate the artistic life of the country through the decade of the 1950s, but were somewhat overshadowed by the arrival in the 1960s of an internationalism that made great claims to be the true art of its day. In general, it is true, there were few enough Irish artists who consciously set out to adopt the "international" look. Common sense dictated that, with limited building and few gigantic corporate lobbies or skyscrapers requiring a clean hard-edged art on a large scale, such art was unlikely to be found a home. But when a number of modernist office blocks, banks and new university buildings did come to be built in the late 1960s and early 1970s (many of the best designed by architects Scott Tallon Walker), there was an immediate response from artists and these buildings were fitted out with art of a type and scale that accorded well with their impressive modernist surroundings, by painters such as Brian Henderson, Jonathan Wade, Micheal Farrell, Ann Madden, Patrick Scott and Eric Van Der Grijn, whose large, abstract hard-edge paintings that were partly inspired by the vivid yellow and black diagonals of road signs. Patrick Scott, for example, whose early training as an architect is clearly evident in his carefully constructed canvases, won a considerable number of commissions for the new bank and university buildings that

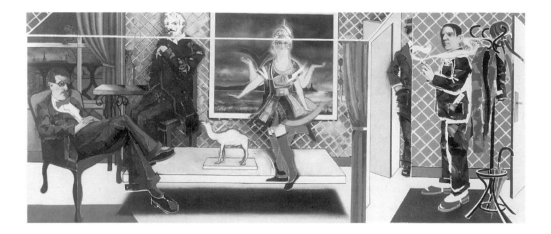

Fig. 38. Micheal Farrell,
La Fête, 1984, oil on canvas,
66⅛ × 153½ in.
(168 × 390 cm),
Collection of Fitzwilton plc

were springing up all over Dublin. In retrospect, some of the creative potential in his work was restricted by his strong sense of design, the elegance consequent on his use of raw linen with goldleaf overlaid, holding his work in an aesthetic sense close to the world of Japanese interiors and furnishings.

Micheal Farrell, who studied at St Martin's School of Art in London, is one of the most interesting of this group which emerged in the 1960s. His early abstract paintings and sculptures combined geometric and organic elements, and were perfectly in tune with the hard-edged abstraction then current internationally. One of the finest of these works was a large mural commissioned by the Bank of Ireland in 1967. Like Robert Ballagh (see below), Farrell found himself in hostile opposition to many social and political aspects of life in Ireland in the 1960s. Speaking at the opening of a Living Art exhibition in Cork in 1969, he declared his intention of never exhibiting in Northern Ireland until the political situation there had been resolved. Perhaps prompted by this new-felt need to express his personal convictions, Farrell's work moved away from purely formal concerns and towards figuration. In 1971 he emigrated to France. Although Farrell's career flourished there and he continued to exhibit regularly in Ireland, in some ways he fell victim to that cultural paradox of moving from a gradually liberalizing social agenda to seek intellectual freedom in a country where conservatism is less acknowledged, but equally pervasive. His response in the ensuing years was to withdraw from the international stream of art to a more personal style, in which figurative elements again reappear, but in which, predictably, the dominant consciousness is of his own particular status and condition, linked with that of his native coun-

try.[17] This attitude is expressed clearly in the painting *Madonna Irlanda, or, The Very First Real Irish Political Picture* (Plate 56), painted in 1977, in which the artist borrows from François Boucher's famously erotic portrait of Louise O'Murphy, the Irish mistress of Louis XV. This seminal work satirizes the burgeoning commercialization of Ireland, the voyeuristic role of much figurative art, and the dilemma of a committed modernist seeking some sort of détente with the academic tradition (fig. 38).

Another Irish artist who studied at this time (albeit briefly) at St Martin's School of Art was Brian Bourke, whose figurative portraits and landscapes, first shown in Dublin in 1965, gained an immediate following. The painting *Seated Nude* (Plate 52) dates from this year. Bourke's style, combining elements of German Expressionism, an appreciation of African sculpture, and literary influences such as *Don Quixote*, is individualistic and energetic, but the artist's development since the 1960s has been curiously tentative.[18] Expressionism as a style has fitted well into the Irish cultural psyche, the most outstanding of Brian Bourke's generation being the painters Patrick Graham, Brian Maguire, and Michael Kane, a group who generally came into their own during the 1980s. Their work shares a sense of extreme emotional introspection, a characteristic less evident in the work of the younger generation of expressionist painters such as Eithne Jordan or Cecily Brennan. Graham's childhood was marked by his mother's illness from tuberculosis, and the latent anger always evident in his paintings has not diminished over the years. They have a strong emotional quality, and are marked by sadness and an awareness of the self-destructive capacities of human beings.

The initial enthusiasm of a number of Irish artists for

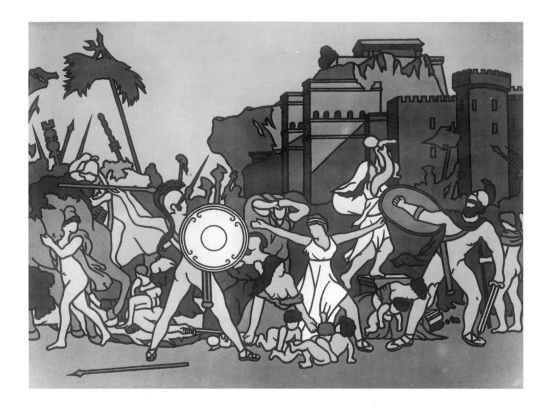

Fig. 39. Robert Ballagh,
Rape of the Sabine Women,
1969, acrylic on canvas,
66⅛ × 88⅛ in.
(168 × 224 cm), Crawford
Municipal Art Gallery, Cork

international modernism in the 1960s was quickly tempered by the realization that it was a style that married uneasily into the Irish experience. This group included Robert Ballagh, born in Dublin in 1943 and initially trained as an architect, who, apart from his paintings, has produced since the mid 1960s a wide range of theater designs, stamp and currency designs for the Irish Government (including the present banknotes), and various public art projects. Ballagh's firmly held political views require that his works, in whatever media, contain little mystery and leave little to the imagination. In 1969 he began a series of paintings which, while stylisically paying homage to the appropriations of Roy Lichtenstein and the black-edged interiors of British Pop artist Patrick Caulfield, draw their iconography from the great history paintings of the nineteenth century. One of the most important of this series, the *Rape of the Sabine Women* (fig. 39), is based on the famous work by Jacques-Louis David in the Louvre. The excessively simplified motifs and evident Pop Art origins lend an uneasy ambivalence to these works, however, intended by the artist to be read both by art critics and by the general public as serious commentaries on the political situation in Northern Ireland. The artist's response to this ambivalence was to paint a work, *My Studio 1969* (Gorry Gallery, Dublin, 1992),[19] which

explicitly juxtaposes on the artist's drawing table a simplified image of Delacroix's *Liberty at the Barricades* with a contemporary Irish newspaper bearing the news of rioting in Derry. The "Starry Plough," the flag of Irish socialism, has replaced the French tricolor in the hands of Liberty. From the outset Ballagh consciously fettered himself in this way to the world of outward appearances and material possessions. His photo-realist portraits and urban interiors, such as *Portrait of Bernadette Greevy* (Plate 57), can be seen as late twentieth-century transpositions of the proto-Marxist paintings of Ford Madox Brown, a Victorian sensibility revealed most tellingly in the profusion of objects and possessions that clutter the paintings. *Portrait of Laurence Sterne* (Plate 55) is one of the more successful of these didactic paintings, as Ballagh lets his imagination run in sympathy with the wild surrealist wit of the eighteenth-century Anglo-Irish writer.

To conclude, in the mid to late nineteenth century, the visual arts in Ireland were increasingly used in the creation of a national identity for a newly affluent middle class, as indeed was also the case in Scotland, England, and many other European countries at the time. The visual arts became in many cases identified with the quest for political independence, and images that reinforced the creation of a

national identity were highly popular. The visual arts in late nineteenth-century Ireland became overtly politicized, with interlace motifs from Celtic manuscripts reappearing in a variety of forms, decorating the bindings of books of Irish literature, stained-glass windows in churches and furniture and jewelry. Such mimetic attempts to revive a tradition which had died a thousand years before often resulted in works of art and architecture that oscillate uneasily between bathos and kitsch.

In Ireland the interconnection between the visual arts and politics has always been a complex one. The works of the greatest Irish artists of the twentieth century – Jack B. Yeats, Louis le Brocquy, William Scott – are practically devoid of overt (as opposed to covert or encoded) political comment. Perhaps this is because in Ireland the visual arts have traditionally been the preserve of an essentially conservative section of the population, the minority Protestant Anglo-Irish community that felt itself on a knife-edge in the uncertain years after the Civil War of the early 1920s and found its voice in the relatively neutral areas of painting and literature. Perhaps the greatest paradox of Ireland's recent cultural history has been that the visual arts tradition of an ancient Celtic (and pre-Celtic) nation, cited so often as the exemplar of the new Irish Republic, was almost entirely based on an abstract model. Among the carvings, illuminations, and castings that form the material record of the visual arts in Ireland throughout the first millennia, there are virtually no works of art that can be described as realist. Official and popular support for academic realism in early twentieth-century Ireland therefore points up the dilemma facing the founding fathers of the Irish Republic, whose assertion that Ireland was a separate, indivisible, and unique state, entirely separate from its nearest neighbor, England, is flatly contradicted in their own portraits by Tuohy, Roberts, Whelan, and O'Sullivan that line the corridors of the Dáil, the seat of government in Ireland. Those twentieth-century European art movements genuinely drawing inspiration from Celtic and Nordic civilizations – Art Nouveau, Jugenstil, the Bauhaus – had virtually no impact on the visual arts in Ireland, which remained, in its official institutions, up to the time of Patrick Scott, steadfast in its preservation of a proud and provincial British tradition in art.

NOTES

1 Katharine Crouan, *Maurice MacGonigal RHA 1900–1979* (exhib. cat., Dublin: Hugh Lane Municipal Gallery, 1991), p. 31; see also Brian Kennedy, "James Sinton Sleator PRHA (1885–1950)," in *An Exhibition of Irish Paintings* (Dublin: Gorry Gallery, 1992), p. 3.

2 Theo Snoddy, *Dictionary of Irish Artists: Twentieth Century* (Dublin: Wolfhound Press, 1996), p. 400.

3 Aida had done much of the historical research for this project. See Crouan, pp. 14–21.

4 Brian O'Doherty, introductory essay, *The Irish Imagination 1959–1971* (exhib. cat., Dublin: Hugh Lane Municipal Gallery of Modern Art, 1971), pp. 10–11.

5 Brian Kennedy, *Irish Art and Modernism* (Belfast: Institute of Irish Studies, Queen's University of Belfast, 1991), pp. 115–46.

6 Conversation with Patrick Scott, January 1998; Snoddy, p. 161.

7 Anne Madden le Brocquy, *Seeing His Way* (Dublin: Gill & Macmillan, 1994), p. 82.

8 *Louis le Brocquy, The Head Image: Interviews with the Artist* (Kinsale: Gandon Editions, 1996).

9 James Plunkett, "Ralph Cusack in Exile," in *The Recorder: The Journal of the American Irish Historical Society*, nos. 1–2, 1997.

10 John Ryan, "Patrick Swift," in *The Irish Imagination*, p. 100.

11 Brian O'Doherty, introductory essay, *The Irish Imagination*, pp. 10–11.

12 Pearce Hutchinson, "Nano Reid," in *The Irish Imagination*, p. 90. See also Frances Ruane, *The Allied Irish Bank Collection: Twentieth-Century Irish Art* (exhib. cat., Dublin: Douglas Hyde Gallery, 1986), p. 46, which gives Reid's birth date as 1905.

13 Ruane, *The Allied Irish Bank Collection*, p. 47. See also Frances Ruane, *AIB Art* (Dublin, 1997), p. 136.

14 Gerry Dukes, "What are you doing there with that pencil?: The Integrity of Camille Souter," in *Irish Arts Review Yearbook 1997*, XIII, pp. 159–68.

15 Hilary Pyle, *Irish Art 1900–1950* (exhib. cat., Cork: Crawford Municipal Art Gallery, 1976), p. 24.

16 Mercy Hunter, "Basil Blackshaw," in *The Irish Imagination 1959–1971*, p. 40.

17 Cyril Barrett, *Micheal Farrell* (exhib. cat., Dublin: Douglas Hyde Gallery, 1979).

18 John Hunt, *Brian Bourke* (exhib. cat., Dublin: Arts Council, 1989), p. 5.

19 *Irish Paintings* (exhib. cat., Dublin: Gorry Gallery 1992), p. 17.

Madonna and Maiden, Mistress and Mother

Woman as Symbol of Ireland and Spirit of the Nation

PAULA MURPHY

The secondary place of woman in Ireland in the last one hundred years is readily revealed in the imagery employed by her visual artists across the century: powerless heroine, peasant worker, submissive whore, religious icon, enduring mother. An image of woman serves as national allegorical figure in many countries in the western world and woman has a traditional association with the land. The position appears more complex in Ireland, however, as the allegory shifts from Virgin Mother to Celtic goddess to earth mother, three symbols synonymous with the image of Irish religious motherhood. The Irish Constitution, enacted in 1937, enshrines such a position, with woman singled out in Article 41 in her role as mother:

2. 1. In particular, the State recognizes that, by her life within the home, woman gives to the State a support without which the common good cannot be achieved.

2. 2. The State shall, therefore, endeavour to ensure that mothers shall not be obliged by economic necessity to engage in labour to the neglect of their duties in the home.[1]

As Ireland and Irish artists take their place beyond parochial nationalism at the close of the millennium, change is evident from the specific identity-related message inherent in the imagery of earlier decades to the more universal status of woman and mother and all that it implies in the late 1990s.

In 1991, for an installation/site-specific exhibition in Dublin's Kilmainham Gaol, Rita Duffy painted an image of Mother Ireland that might be considered to mark the end of the political and religious symbolism that has dominated such imagery through the century. Employing the triptych format of traditional altarpiece painting, *Emerging from the Shamrock* (fig. 40) represents woman, liberated from religious control and social restraints, walking independently and with confidence into the new century, with babies and bishops, politics and powerlessness confined to the side panels. The three ages of life are indicated, reading from right to left, with infancy and old age on either side framing and projecting the strength of womanhood centrally positioned. Depicted in the role of model or beauty queen, Duffy's woman strides a catwalk strewn with lilies. There is a marked absence of artifice as the woman is unadorned,

Fig. 40. Rita Duffy, *Emerging from the Shamrock*, 1991, oil on canvas, 72½ × 108⅝ in. (184 × 276 cm), Collection of the artist

untitivated, and surely tramples on the lilies, those symbols of virginity which she, as certainly many others have done, might have carried in procession as a young girl.

In the light of an observation by Luke Gibbons that "the function of art is not simply to represent people but to empower people, to make people agents of their own representation,"[2] it is interesting that Rita Duffy sees this image as something of a self-portrait,[3] of woman beyond idealized Irishness. As such she is one of a circle of artists projecting a new sense of woman/motherhood in Irish art at the close of the twentieth century. Kilmainham Gaol is also, however, the site of a traditional Madonna image, painted in situ in 1923. Grace Gifford,[4] artist and revolutionary, was imprisoned in the Gaol during the War of Independence, and while incarcerated painted a Madonna and Child in a mandorla on the wall of her cell. This image became known as the Kilmainham *Madonna*.[5]

Images of the Madonna as a symbol of Ireland or, as in the case of Gifford's work, identified with a particular location in Ireland have been numerous over the last hundred years, from the *Éire* of Beatrice Elvery in 1907 (Plate 4) to the *Goddess of Temple Bar* by Seán Hillen (born 1961) in 1995. Elvery's Madonna is a multilayered disguise, in which the Madonna is in fact the Irish heroine Kathleen ní Houlihan who, in turn and in reality, is Maud Gonne, who, in 1902 played the leading role in the eponymous nationalist play

by W.B. Yeats. Hillen, more straightforwardly but perhaps more incongruously, depicts the Madonna standing on a crescent moon, with more than a suggestion of the compositional arrangement of seventeenth-century Spanish paintings of the Immaculate Conception. Hillen's Madonna is overlooking, or perhaps watching over, the artistic/bohemian/trendy center of Dublin that is Temple Bar; in other works Hillen places the Madonna in other locations in contemporary Ireland.

The Virgin Mother has had, and continues to have, a special and significant place in the heart of Irish people: witness the number of Irish women who are given the first name of Mary at birth and the way she is revered across the country in the form of public statues. Viewers of RTE, the national broadcasting station, are confronted daily by an image of the Virgin: tuning into the main television station at 6:00 p.m. for the main evening news program, when the immediacy of news headlines might be expected, the solemn tone of a bell is instead encountered. The bell rings, not to announce some contemporary world catastrophe, but rather to recall the Incarnation. The expectation of real information is replaced by spiritual hypothesis. The sonorous note encourages reflection, which is further visually stimulated by a religious image, frequently one of the Madonna and Child in the form of an icon executed in the Celtic style.

John Kindness (born 1951) has recognized the power of

the Virgin in Ireland in his work *Sectarian Armour* (1995). Images of two queens representing Britain and Ireland are etched on either side of the front of a metal jacket. The English queen is head of both State and Church, and the Queen of Heaven is afforded similar dual authority in Ireland, as the State, since Independence, has been governed by Catholic rather than secular laws. It is perhaps inevitable that the Virgin would have a special place in a country of fixers and favors, as it is she who is expected to intercede with her Son on behalf of the faithful – in other words, to "fix" things in heaven. And in a country where sex was considered for a long time to be something vulgar and dirty that was more suitably practiced in foreign and pagan places, the idea of a Virgin (that is, sexless) birth must have been somewhat comforting. One wonders how many young Irish girls were encouraged to "close their eyes and think of" Ireland and/or the Church.

Few of the images of the Madonna in the role of Mother Ireland are without some political inference. Mainie Jellett's *Madonna of Éire* (1943, National Gallery of Ireland), however, appears unencumbered by politics or even by overt Irishness. The "Éire" indication in the title can reflect the presence of Irish saints, Patrick and Brigid, in the painting. The work is more concerned with style than symbolism and as such was fittingly included in the first Irish Exhibition of Living Art in 1943, of which Jellett was president. Jellett's oeuvre was somewhat unusual for its time in that it included a considerable number of religious images painted from a strong religious conviction. Her particular focus of interest was the pursuit of a modernist style in art for Ireland. This image has the abstract patterning and fusion of late Cubism and Orphism so typical of her work.

An interesting secular variant of this nonpolitical Madonna imagery is seen in *Mother and Child* by Maurice MacGonigal (Plate 38), in which a robustly healthy mother and her equally sturdy offspring are presented in the traditional pose of the Madonna and Child. The religious undertone is even heightened in the rich blue of the mother's shawl. By contrast, both the red petticoat and the landscape backdrop suggest the West of Ireland, while the practical nature of the dribbler worn by the child draws the image back from the lofty symbols of church and nation into one of simple domesticity. It is not surprising to discover that this is a portrait of the artist's wife and her first born, a son. However, the symbolic female figure within the framework of the West of Ireland is not without its many antecedents in visual imagery in the twentieth century and earlier, although she is more usually depicted with the primitive beauty of the Irish *cailín* or the rugged strength of the peasant. In fact, with the gaining of Independence, artists were encouraged to paint images of the western seaboard. It became the official visual language of the State, viewed as the real Ireland, untainted by capitalist and sectarian imperialism.

Other religious images carry an often explicit political reference. Beatrice Elvery's *Éire* is an unusual representation of the Madonna and Child, with the mother seated rigidly upright against a Celtic cross, her face partially shrouded, almost in the manner of a weeper on a medieval tomb. This is not, in fact, the Virgin Mother, but rather an allegorical image of Maud Gonne with the symbol of Young Ireland on her knee.[6] Maud Gonne was the president of *Inghinidhe na hEireann* (Daughters of Erin), an Irish women's group inaugurated in 1900 that concerned itself with Irish independence and related cultural and educational matters. Their cultural commitment encouraged the development of an Irish theater in Dublin at the beginning of the century and it was for this forum that W.B.Yeats (perhaps with Lady Gregory) wrote *Kathleen ní Houlihan*, with the intention that Maud Gonne would play the title role. This she did in April 1902 in a portrayal that was considered queen-like and described as "symbolizing the image of a free nation."[7] Irishness is projected in the painting by the inclusion of Celtic objects and the presence of saints and scholars; nationalism is promoted by the active gesture of the child and in the color range employed. That Maud Gonne purchased this work for Patrick Pearse's school, St Enda's, seems entirely appropriate and indicates the way in which the image was considered suitable for educational purposes.

If Elvery's *Éire* suggests vehemence and determination in the cause of nationalism at the beginning of the century, Diarmuid Delargy (born 1958), in his etching *Madonna I* (1993, fig. 41), employs a mourning image of the Virgin holding two infant boys to reflect the conflict in Northern Ireland. While traditionally images of the Madonna mourning suggest her knowledge of the future suffering of her son, Delargy's work reveals the pain of contemporary reality, with the violent inclusion of a gun that one child points at the other. These are surely not representations of John the Baptist and the Child Jesus, but rather the children of the

North who have known nothing but conflict and for whom a gun is not a plaything. The mother is saddened by her children who fight in her name. Tellingly, Delargy is not alone in working the Madonna into the northern subject. Marie Barrett (born 1964) painted an image she entitled *Madonna with Helicopters* (1989) in which we see an emaciated woman troubled by the sound and surveillance of helicopters.

The least religious among the symbolic images employing the Madonna, and also the best known among them, is one painted by Micheal Farrell in 1977. *Madonna Irlanda* (Plate 56) reveals a naked whore blatantly displaying herself on a couch, adorned only by a halo perched above her head like a floating piece of jewelry. Seemingly in possession of an inner calm, she is oblivious of the fiery chaos around her; even the detail of the Vitruvian Man hiding his genitals escapes her notice. Quoting from François Boucher's famous image (now in the Alte Pinakothek, Munich) of Louise O'Murphy, one of Louis XV's favorite concubines, the symbolism enshrined in the Irish whore servicing a foreign king does not pass unnoticed. In variants of this painting the artist has sectioned, and identified by words, the different parts of the woman's body. Subtitled *The Very First Real Irish Political Picture*, the carving up of the body in this manner is as much a reference to animal instincts as it is to the political situation. Is the artist, who watches her intently from behind, his gaze directed at her reddened buttocks, lusting after the woman, the whore, the modern-day Mother Ireland? When asked about Louise O'Murphy, Farrell said, "She is my Mother Ireland. Why? Because she was a whore!" [8]

The depiction of Ireland in the guise of a whore was further explored by Patrick Graham in the 1980s. Working in the aggressively neo-expressionist style resurgent in this period, Graham presents a strident image not of a mistress of kings, but of a prostitute of the people. *My Darkish Rosaleen* (1982, Plate 59), subtitled *Mother Ireland as a Young Whore*, wears the identifying garb of black gloves and black stockings, with suspenders framing her pubis, a backdrop of shamrocks strategically projecting a wholly functional and commercial nakedness. Micheal Farrell has indicated the way in which his series of images comments on the religious, cultural, and political situation in the country; Patrick Graham actually includes such references in his painting, with symbolic objects and textual labeling lining the top of the composition. These works, therefore, encompass a

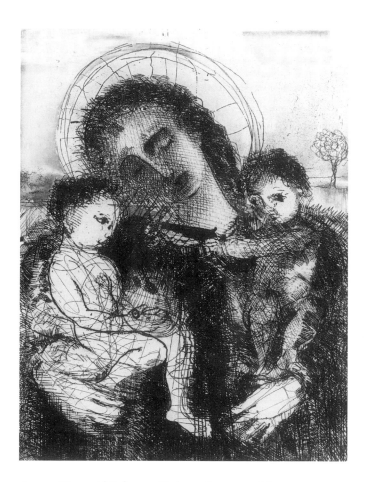

Fig. 41 Diarmuid Delargy, *Madonna I*, 1993, etching, 22½ × 15 in. (57 × 38 cm), Collection of the artist

breadth of expression similar to, for example, the bronze figure of Éire executed by John Henry Foley (1818–1874) for the O'Connell Monument in Dublin more than a hundred years earlier. While Foley's figure is unmistakable, presented, as she is, with the trappings of allegory in the form of identifying accessories such as shamrock and harp, and in Graham's case the symbolism has relative clarity, Farrell's personification is considerably less overt. Irish name, Irish exile, and Irish whore are uncovered with a knowledge of history or art history, as is the pun on butchering/Boucher. In the use of the nude to represent Ireland, Farrell emphatically breaks with tradition. In a country where the nude has not had a marked artistic presence, his image rejects coyness and covering for naked allegory, and in so doing appears to comment on the role of censorship in Ireland. The Censorship of Publications Act of 1929 deemed unlawful the exposition or sale in the country of "any indecent picture." [9] While this would instantly suggest pornographic

Fig. 42. Mick O'Kelly, *Imagined Identity*, 1993, dimensions variable, detail of slide installation, Collection of the artist

material, the term "'indecent' is construed to mean suggestive of, or inciting to, sexual immorality."[10] In this context, Farrell's image might be considered shocking. With contempt for the Act, or perhaps in ignorance of it, Farrell's naked *Madonna Irlanda* suggests an Ireland liberated sexually if not politically.

A sculptural work by James McKenna (born 1933), *A Woman of the West* (1972) – from the same decade as Farrell's *Madonna Irlanda* – has none of the suggestiveness of the painted image. McKenna's heroic nude figure is clothed in dignity and uprightness; this carved monumental female will not go whoring with kings but rather remain unsullied in her primitive environment, restrained by the power of the stone that adheres to her body. Representations of women of the West of Ireland are more usually, it must be said, clothed in more than their dignity. Rather than depicted in the full-blown maturity of adulthood, they are frequently shown at one extreme, either beautiful and youthful or haggard and old. Examples are to be found in Charles Lamb's *Young Connemara Girl* (1924, private collection) and Paul Henry's *Old Woman* (Limerick City Gallery of Art), painted about ten years earlier. Read in the broader Irish context and considered within the framework of Irish identity, the former suggests hope for the future, while the latter indicates the abuse of the past.

Sir John Lavery was to make the younger variant assume something of national passport status. He painted both of his wives in the guise of Irishness, although neither was strictly Irish. *An Irish Girl* (1890, private collection), a portrait of his first wife painted in the year of their marriage, suggests an acquired or perhaps imposed maturity, the arrival at adulthood, and reveals a sophistication beyond her early supposed life as a flower girl.[11] Adopting a more insistent position of Irishness for the portrait of his second wife, he depicted her in the role of Kathleen ní Houlihan (1928, collection of The Central Bank of Ireland, fig. 68). The knowing beauty of the woman in question is not readily camouflaged in her representation as a wild Irish *cailín* purposefully posed with her harp. But then Kathleen ní Houlihan was also, or perhaps more correctly, ultimately a legendary beauty and not without the knowledge of how to employ her looks to needful ends. The portrait was commissioned from Lavery in 1927 by the Note Committee, which had been established to organize the design of the new paper currency for the State.[12] The Committee requested a likeness of Lady Lavery for the notes (where it is still to be found in the form of a watermark), and thus Lavery's portrait of his wife as Kathleen ní Houlihan became the face of Ireland, an image of Éire, familiarly known to the widest possible number of people, both Irish and foreign.

Ireland personified by the beautiful Lady Lavery has been transformed in a photomontage by Mick O'Kelly (born 1954) entitled *Imagined Identity* (1993, fig. 42). Taking the image of an Irish twenty pound note, where Lady Lavery is still faintly visible in watermark form, O'Kelly superimposed a photograph of a traveling woman with her infant child and thus deconstructed the artifice of the earlier image. That a sophisticated society lady, albeit one with a keen interest in Ireland, should have been selected to represent the nation is not without irony or meaning. Yet the traveler suggests a more telling face of Ireland, a face in which the harsh reality of life is fully expressed. The lines of a W.B.

Yeats poem, also superimposed on the bank note, equally indicate a lifestyle very different from that of Lady Lavery: "I, being poor, have only my dreams." This is Mother Ireland, representative of the vast number of the country's mothers caring for large families while living below the poverty line. The image of the traveling mother and child set against a bank note seems a destitute echo of medieval imagery in which the Madonna and Child are presented in a gold setting. In a contemporary context, the work takes on the visual impact of a newspaper advertisement making a charitable appeal. Yet an image of poverty was not the form of advertisement for Ireland that was most desired in the 1990s, a period marked by aggressive economic success, often described by the term "Celtic tiger." The extent to which it was considered inappropriate is evident in the removal of the work from public display before the exhibition for which it was created, 'EV+A 1993' (the annual Exhibition of Visual+ Art in Limerick), had ended.[13]

Advertising Ireland was an issue of considerable importance across the century and not least in the aftermath of Independence in 1922. The first major opportunity to advertise the country publicly came at the New York World's Fair in 1939. Ireland, having for so long been represented as a colony at these Universal Exhibitions, was to have its own pavilion and, in the tradition of World's Fair construction, sculpture was to play a significant promotional role. A figure of Éire, inspired by a line from a Yeats poem, "Your Mother Éire is always young," was commissioned to stand on a pedestal in front of the building (fig. 43). The commission was won in a limited competition by a Bohemian sculptor, Frederick Herkner (1902–1986), newly appointed Professor of Sculpture at the NCAD in Dublin. Herkner spoke no English when he came to Dublin in 1937[14] and he had scant experience of Ireland by the time he undertook the commission. There was little about the monumental figure, standing eighteen feet tall, that suggested Ireland. Other submissions, such as that from Peter Grant, certainly included greater symbolic reference.[15] Grant's maquette (collection of the artist) reveals a figure worked in the highly linear style of Art Deco. His *Éire*, who stands on leaping flames, wears an ancient Celtic collar as a headdress, with a harp placed beside her. The stylized nature of Grant's figure contrasts with Herkner's image, which was at once vigorous and gentle, exuding calm and control. In the bold generalized carving of *Mother Éire*,[16] Herkner revealed a

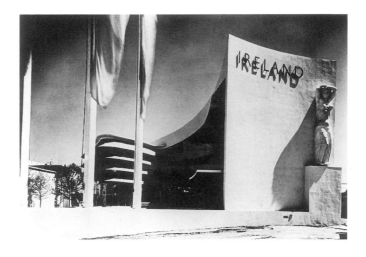

Fig. 43. Photograph of the Irish Pavilion at the 1939 New York World's Fair showing the sculpture of Éire by Frederick Herkner. Photo courtesy of the Irish Architectural Archive

style akin to the smooth, rounded treatment found in Aristide Maillol's colossal figures, linear clarity reflecting classical (even universalizing) concerns on the part of the sculptor. The universal position of woman as symbol of nation was suggested rather than the more specific reference to Mother Ireland that might have been expected. The somewhat unusual positioning of the arms, raised to rest on her head, indicated a protective openness, a cautious confidence. In this alone perhaps something of the spirit of the young state was captured.

Jerome Connor's figure of *Éire* (Merrion Square, Dublin), likewise executed in the 1930s, could not have been more different from Herkner's sculpture. Connor, an Irish American, (1874–1943) had strong emotional ties with Ireland, often worked on subject matter of Irish interest, and returned to Ireland to work in 1925. While his *Éire* was not cast in bronze until 1974, the design was executed in 1931–32 and was intended for the Kerry Poets Memorial to be erected at Killarney.[17] The composition includes the trappings of Irishness one associates with similar works modeled in the nineteenth century, most obviously in the unstrung medieval Irish harp but also in the costume detailing suggestive of armored battle-dress. This sad, thoughtful, but strong and statuesque woman seems to reflect something of the imagery of Ireland as described in a poem by Walt Whitman, "Old Ireland," written about seventy years earlier:

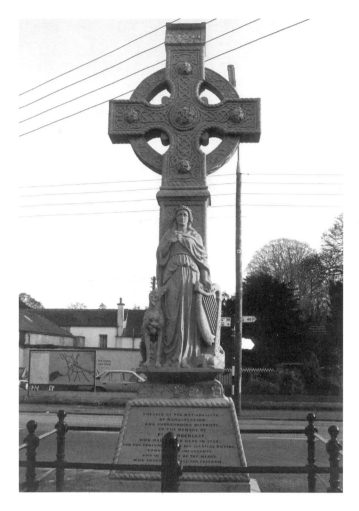

Fig. 44. *Maid of Erin Monument*, erected by the Nationalists of Monasterevan and surrounding districts to the memory of Fr. Prendergast who was slayed there in 1798.

Far hence amid an isle of wondrous beauty,
Crouching over a grave an ancient sorrowful mother,
Once a queen, now lean and tatter'd, seated on the
ground,
Her old white hair drooping dishevel'd round her
shoulders,
At her feet fallen an unused royal harp,[18]

The head of the figure reveals a brooding, introverted expression, an introspection that is also to be found in the face of Herkner's *Mother Éire*. [19]

If Éire appears sorrowful and dejected in Connor's proposed literary commemoration, standing variants of the figure employing the same symbolism, executed at the beginning of the century, in contrast reveal a proud, con-

fident – even defiant – image. Indeed the century opens with a proliferation of Maid of Erin monuments across Ireland (fig. 44). These monuments, erected in cities and towns as far apart as Sligo, Monasterevin, and Cork, in the period from 1898 into the early years of the new century, commemorated the centenary of the 1798 Rebellion. The sculptural work on the whole has little artistic merit, often being executed by mason firms, but, like poor religious statuary, the imagery was less about art and more about inspiration, intended to inspire heroism, courage, and sacrifice. The message, therefore, is singularly apparent, the symbolism immediate. If these works appear to have a certain similarity, this is the result of the dryness of the carving. Closer examination reveals that the sculptors have selected from a variety of different symbols: Erin may be found clasping a crucifix, a sword, or a flag, and may be accompanied by a Celtic cross, a harp, an Irish wolfhound, or, less specifically Irish, an anchor. Shamrock and broken chains may also feature. The figure, draped in classically flowing garments or more militaristic garb, is sometimes represented marching, to convey a fighting spirit, or at other times stationary, confident in her repose. A tradition of such imagery exists outside of Ireland, perhaps most particularly in French Revolution figures. The 1798 memorial designed for Bandon in Co. Cork (December 1898) reveals something of the spirit of such imagery, presenting a figure of liberty on top of a cropped column, readapted to serve the Irish nationalist cause by the addition of a harp. While the embodiment of liberty is of the utmost importance, the spiritual element is not overlooked and once more the image of woman combines the representation of politics, religion, and culture.

Having inspired courageous deeds, the Maid of Erin had to confront the sacrificial outcome of such heroism and transform herself into a protective and proud mother offering support and succor to the wounded and the dying, or serving as a mourning presence for the dead. Mothering representations of Éire appear on monuments as disparate as the commemoration by John Hughes (1865-1941) of *Queen Victoria* (1908)[20] and the Custom House Memorial (1953) by Yann Goulet (born 1914).[21] Hughes adopts a naturalistic approach in his sculpture group, with an attentive and caring Mother Ireland holding a laurel wreath as she mourns the dead soldier whose body is slumped at her side. Goulet's work (fig. 45) is more vigorous: fiercely upright, she proudly presents the dying hero for all to acclaim. The rounded

forms of her body are clearly delineated by clinging draperies which, coupled with her flowing tresses and the vertical thrust of her vast sword, presents a sensually powerful image of Mother Ireland – and a suggestion that while the men will die, continuity is maintained through the female.

Woman power and continuity take on a more forceful position in the context of Northern Ireland. "Women are the republican tradition," suggests Luke Gibbons, while Conor Cruise O'Brien lays the blame with these same mothers for the acts of violence carried out by their sons.[22] This supposed power does not, however, emerge in the visual imagery of Republican motherhood. In fact, Rita Duffy has, in her paintings *Mother Ireland* (key. 14) and *Mother Ulster* contrasted the forcefulness and dominant nature of Loyalist motherhood with the ineffectual and put-upon woman that is *Mother Ireland*. To represent Éire, Duffy depicts a rather fraught woman holding a large and discontented group of small children; the allegory refers to the way in which she is controlled in her actions by the Catholic Church and curtailed in her ambitions by domesticity. *Mother Ulster*, on the other hand, is supported rather than controlled by the Protestant Church, and the trappings and outcome of that support surround her. Duffy also conveys the fierceness of intransigence in the powerful imprint of the red hand of Ulster stamped in repeat pattern across this mother's apron.

It is more usual in imagery of women of Northern Ireland to depict them as victims of the Troubles directly, as wounded figures, or, indirectly, as sorrowing mothers. F.E. McWilliam (1909 1992), who was often to explore the legendary aspect and political positioning of Irishness in his work, is perhaps best known for his work in the latter context. His series of bronze figurines, *Women of Belfast* (1972), depicts the vulnerability of women going about their lives in a city of conflict, emphasizing the effect of bomb blasts, for so long a part of daily life, on innocent passers-by. McWilliam conveys the immediate and uncontrolled reaction of the body to the impact of the explosion. While the theme would appear to suggest that it is the men who plant the bombs and the women who are the victims, this is an unsatisfactory reading, as the women are undoubtedly equally capable of such violent activity. It is perhaps more accurately the suffering of woman as mother that is at issue here, with some mother's child planting the bomb and some child's mother caught in the explosion. "A mother bore

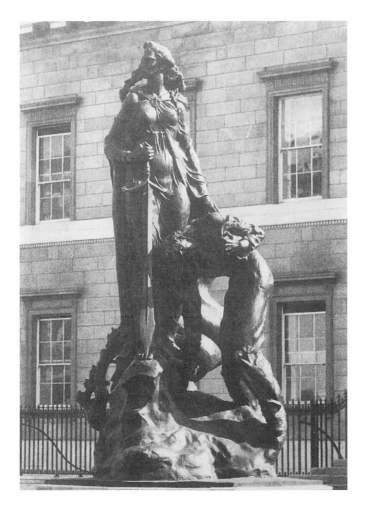

Fig. 45. Jean Renard Goulet, Memorial to the Custom House Dead, Dublin, 1953

each one of you," cried Queen Macha, the legendary Irish goddess, in other circumstances, inviting an assembled group to consider their relationship with their mothers in the midst of their destructive actions.[23]

If McWilliam has visualized the suffering of women generally, not prioritizing one community over another, Brian Maguire (born 1951) aligns himself with the Republican movement in depicting the pain of motherhood in *Mother with Head of Dead Hunger Striker* (fig. 46). The hunger striker is Patrick (Patsy) O'Hara, who died in 1981. Sacrifice is at the core of this painting, recognizing the wider implications of such an image. Where a *pietà* composition might have been employed,[24] Maguire has chosen instead to relate the work to the beheading of John the Baptist, who was also "some mother's son."[25] Several other severed heads – the Medusa, Goliath, Holofernes – appear throughout the his-

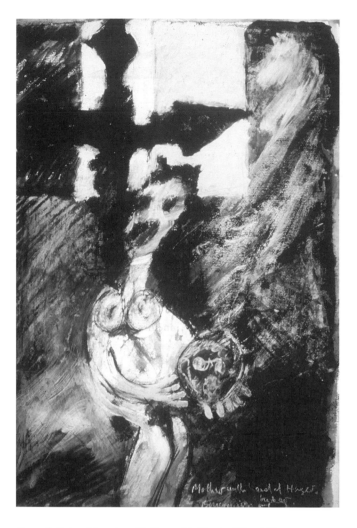

Fig. 46. Brian Maguire, *Mother with Head of Dead Hunger Striker*, 1981, acrylic on paper, 30 × 20 in. (76.2 × 50.8 cm), Photo courtesy of the artist

tory of art, and so the sacrificial nature of the work might be lost to some viewers. In Celtic legend, however, a link between decapitation and feminine vengeance is suggested,[26] which in turn would appear to support the Conor Cruise O'Brien theory of Republican mothers as "carriers" of the killing strain. But this openness in reading the image distorts the artist's original intention. Maguire, in fact, presents more than simply a moving depiction of a mother grieving over her dead son, and creates here a further variation of Mother Ireland: the mother as personification of Ireland presenting the head of her son who has died for her sake. Maguire is interested in the power and pain of motherhood, and has often had recourse to creating images of his own mother. One such image visualizes a memory of his

mother having a nervous breakdown when he was aged eleven, a work the artist has described as a "universal image of pain."[27] Similar pain is evident in an early small drawing of a woman screaming in which Maguire suggests the way in which his mother answered for her sons and took their sins to herself. The image becomes a universal representation of the willing burden undertaken in motherhood.

In an earlier stone carving McWilliam adopts a calmer, less vehement position. His *Irish Head* (1949, AIB Art Collection) is neither male nor female but simply Irish, and is carved in two separate pieces to represent the partition of Ireland, the segregation and separation of the mind and soul of a people. This silent, statuesque image appears simply to bide its time. More than twenty-five years had passed when another Irish artist depicted a head in order to address the country's political situation. Louis le Brocquy's *Northern Image Head and Hand* (1975, private collection) reflects the mid-1970s as much as McWilliam's had the late 1940s. While both images utilize the power of silence, le Brocquy presents a silent scream – a depth of pain reaching farther than would the actual sound. Le Brocquy appears to retain the absence of gender specificity in this image, reaching for the universal pain of a people rather than individual male or female suffering. Yet his heads are more usually male, and the artist has admitted to finding it difficult to paint a woman's head because it is "more vulnerable to distortion."[28] Are we, therefore, somewhat unusually, in the presence of troubled father (Ire)land?

While female political and religious symbolism continues to be employed at the end of the twentieth century, contemporary symbolic images of women by women artists focus more particularly, and with wider reference, on issues of motherhood, sexuality, and woman's traditional association with the land/earth/nature. An examination of the position of woman in society – independent woman and woman within her different roles – is the concern of many contemporary female artists. The need to replace woman as patronized, powerless and propagandist symbol with an exploration of woman as an emotional, living being is evident in much recent work. If earlier symbolism was more suggestive, even artificially, of triumph and glory, and clearly resulted from a male dominated culture and society, the new imagery is more questioning, recognizing the need to explore the reality and endeavoring to "find the strength to open up."[29] Alanna O'Kelly (born 1955) speaks of the

way in which our culture enforces a position in which we have been holding ourselves back "by being so highly embarrassed by feelings and emotions."[30] Louise Walsh (born 1962) indicates how the treatment of the female as "other" in Ireland has led to a defensive self-repression that inhibits women from indulging in real expression.[31] Alice Maher (born 1956) reveals the way in which an Irish Catholic upbringing lays down "many layers of intellectual repression".[32] Employing the female Irish dancing costume as a metaphor for Irishness in *Irish Dancers* (Plate 72) Maher visualizes the way in which an aspect of Irish culture, that many young girls experience, appears never to fit properly. She suggests that, even more importantly, what might be expected to facilitate and stimulate expression actually inhibits it.

Woman's relationship with the land is most clinically explored in the Body Maps series of Kathy Prendergast (born 1958), *Enclosed World in Open Spaces*, *To Control a Landscape*, and *To Alter a Landscape* (1983, Irish Museum of Modern Art). Female bodies are mapped and mined, no longer specifically representing Ireland but a much broader horizon. Alice Maher employs details of nature to create female imagery. In 1994, working with honey bees and rose-hips, she created *Berry Dress* (Irish Museum of Modern Art) and *Bee Dress*, two small girl's dresses in which the respective staining and stinging, poison and protection can be interpreted in different ways, while at root female vulnerability, sexual and physical, remains the issue. Louise Walsh similarly utilized fragments of nature to execute her *Harvest Queen* in 1986. Interweaving natural materials and found objects she depicted a woman/horse, transforming the ancient Celtic goddess symbol into a beast of burden. She interrelates her interest in pagan cultures in Ireland with contemporary attitudes to women that can only be considered primitive. Her particular concern with the place of woman in society found expression in her *Monument to the Unknown Woman Worker*, erected in Great Victoria Street, Belfast, in 1992. The absence of power and position is explored in a bronze two-figure group of a mother and daughter with the symbols of their different working environments attached to their bodies, and fragments of text speaking of the way in which women carry out low-pay/no-pay jobs.

". . . it'd be much better for the world to be governed by the women in it." Thus declared Molly Bloom, and Dublin

Fig. 47. Frances Hegarty & Andrew Stones, *For Dublin*, 1997. A temporary artwork comprising nine neon signs presenting phrases from Molly Bloom's unspoken monologue in James Joyce's *Ulysses* on display in Dublin City Centre from July to August 1997. Shown, *Site No. 1 – Portico of City Hall, head of Parliament Street*. Quotations from *Ulysses* by James Joyce, Photo courtesy of the Irish Museum of Modern Art

bore witness to this statement throughout the summer of 1997 in a pink neon installation positioned in the tympanum of the City Hall (fig. 47). The work of Frances Hegarty (born 1948) and Andrew Stones (born 1960), this was one of nine such text fragments taken from Molly Bloom's soliloquy in James Joyce's *Ulysses* and placed throughout the city, coloring the gray stone and red brick of Dublin with the words of a woman (written by a man) written in pink light.[33] Shane Cullen (born 1957) has also used text in imaging Irish womanhood in his carved plaster tablet entitled *Párliament na mBan* (1992). Even if this artist had no committed feminist interest in executing the work, it is difficult to ignore it in this transcription of a fragment of a late seventeenth-century text which gives an account of a medieval parliament of women. While Cullen worked with a minuscule portion of the original, the text in its entirety covers a wide range of subjects, from social etiquette to fashion to the education of daughters. An early feminist work, the text is also critical of women remaining in the home and advocates the establishment of a women's parliament.[34]

While politics and positioning remain issues in the dual context of visualizing Irishness and womanhood, mother-

Fig. 48. Alanna O'Kelly,
installation view of *A'Beathú*,
1994, video installation,
courtesy of the artist

hood – in its initial stages of pregnancy and labor, its rejection in abortion, and most particularly its ultimate expression in the relationship between mother and child – is also a concern. There is no longer the closed parochialism of Irish nationalism but an open attempt to comprehend what it is to be Irish on a bigger stage, in a global context. Alanna O'Kelly, describing herself as woman, mother, and artist, searches in the stories of the past for meaning with regard to Irishness, less in the historical events themselves and more in the individual incidents that express the period's horror. If much of her work, such as *No colouring can deepen . . . the darkness of truth* (*A'Beathú*; fig. 48), is located within the tragedy of the famine, she does not permit the pain to overwhelm. Beautiful, haunting, and occasionally chilling details of land and body are projected on three monitors to the accompanying but distorted sounds of birth. The work opens and closes with the image of a breast from which milk flows, but it is less specifically about breast-feeding and more about the abundance of spirit. The breast and its milk serve as a metaphor for the relationship between mother and child, for something that comes from deep within. O'Kelly is quick to point out that she has never intended to exclude men, but that she can only express her own experience – in this instance reading about the famine when she was pregnant, and reaching a new understanding of her

position as an Irish mother.[35] O'Kelly is currently exploring images of herself and her daughter.

If the century opened with emphatic nationalistic depictions of woman as the image of Ireland, developments that have taken place in art and symbolism across the last hundred years reveal that related images of womanhood and Irishness at the close of the century are questioning rather than accepting, exploratory rather than declamatory. And if tradition had established that in mother and child imagery – in its lineage from the Madonna and Child – the child was usually male, artists are now concerned to visualize the mother/daughter relationship. Beyond the Virgin Mother, Celtic goddess, and Earth Mother, badges of identity have been recognized for the controlling and delimiting purpose that they serve.

It has been suggested that "the state is invisible; it must be personified before it can be seen, symbolized before it can be loved, imagined before it can be conceived."[36] Perhaps confusion rather than invisibility would more appropriately describe the state of Ireland. Nonetheless, it will continue to be personified, symbolized, and imagined as Irish artists try to position themselves beyond the confines of nationalism while retaining their sense of Irishness – doing so in the context of being "not Irish merely . . . but Irish as well."[37]

NOTES

1 *Bunreacht na hEireann* (Constitution of Ireland), 1937, Government Publications, 1990, pp. 136, 138.

2 Luke Gibbons, "Censorship and the Arts," in Patrick Smyth and Ellen Hazelkorn, edd., *Let In the Light: Censorship, Secrecy and Democracy* (Kerry: Brandon Books, 1993), p. 123.

3 *In a State*, an exhibition in Kilmainham Gaol on national identity (exhib. cat., Dublin: Project Press, 1991), p. 31.

4 Grace Gifford, 1888–1955.

5 Over the years the image deteriorated badly and in the 1960s, when the cell was replastered, Thomas Ryan, then President of the Royal Hibernian Academy, repainted the image: *In a State*, p. 86.

6 See Nicola Gordon Bowe, "The Art of Beatrice Elvery, Lady Glenavy (1883–1970)," *Irish Arts Review*, xi, 1995, p. 171.

7 Margaret Ward, *Unmanageable Revolutionaries, Women and Irish Nationalism* (London: Pluto Press, 1983), p. 56.

8 Simon Oliver, ed., *A Sense of Ireland* (Dublin: A Sense of Ireland, 1980), p. 51.

9 *Public Statutes of the Oireachtas*, No. 21, Censorship of Publications Act, 1929, article 18.

10 Ibid.

11 Lavery also executed a posthumous portrait of his first wife, *Kathleen, the Flower Girl*, (private collection), in the late 1930s.

12 See Brian P. Kennedy, "The Irish Free State 1922–49: A Visual Perspective," in Raymond Gillespie and Brian P. Kennedy, edd., *Ireland: Art into History* (Dublin: Town House, and Niwot, Colorado: Roberts Tinehart Publishers, 1994), pp. 138–39.

13 John Logan, "All About EV+A," *Circa*, no. 64, Summer 1993, p. 47.

14 John Turpin, *A School of Art in Dublin since the Eighteenth Century: A History of the National College of Art and Design* (Dublin: Gill & Macmillan, 1995), p. 349.

15 Peter Grant, (born 1915), executed a figure of an Ancient Irish warrior for the Irish Pavilion at the New York World's Fair in 1939. However, in conversation in August 1997, he indicated that while the original design for the figure of *Éire* as executed was by Herkner and the design for the *Warrior* figure as executed was his, Herkner and he collaborated on the modeling of both figures.

16 *Mother Éire* was executed in plaster and was in high relief rather than fully in the round. The statue no longer exists. As was frequently the case with work carried out for World's Fairs and Universal Exhibitions, the sculpture, along with the architecture, was ephemeral.

17 The Kerry Poets Memorial at Killarney was commissioned to commemorate four seventeenth- and eighteenth-century Gaelic poets. Connor's design was not realized for the memorial. See Giollamuire O'Murchú, *Jerome Connor* (Dublin: National Gallery of Ireland, 1993).

18 Walt Whitman, "Old Ireland" in *Complete Poetry and Collected Prose* (New York: The Library of America, 1982), p. 493.

19 The head was cast in 1991 from Connor's original wax fragment of 1932 and exists as an independent work in the collection of the National Gallery of Ireland.

20 The Queen Victoria Monument was erected in the grounds of Leinster House, Dublin, in 1908. It remained in place until 1948 when it was removed to storage in the Royal Hospital at Kilmainham. The fragmented monument is once more on display in three different locations: Queen Victoria in Sydney, Australia; the three allegorical groupings, including Erin with the dead soldier from the base of the monument, in the roof garden of Dublin Castle; the four *putti* in the formal garden at the Irish Museum of Modern Art (formerly the Royal Hospital, Kilmainham).

21 Yann Goulet's memorial is located in the grounds of the Custom House in Dublin and commemorates those who died in the Battle of the Custom House in 1921.

22 Gibbons, p. 121.

23 McWilliam executed a bronze statue of *Queen Macha*, 1957-58, Londonderry, Altnagelvin Hospital. See also Mary Condren, *The Serpent and the Goddess, Women, Religion and Power in Celtic Ireland* (San Francisco: Harper & Row, 1989), p. 32.

24 Rita Duffy executed a work entitled *Belfast Pietà* in 1991.

25 Condren, p. 209. The story is told of the aftermath of a funeral in the North during which two soldiers were beaten to death, and a woman covered one of the naked bodies saying, "Sure God loves him. He's some mother's son."

26 Jean Markale, *Women of the Celts* (London: Gordon Cremonesi, 1975), p. 186.

27 Conversation with the artist, September 1997.

28 Le Brocquy in an interview with George Morgan in *Louis le Brocquy, The Head Image: Interviews with the Artist* (Kinsale: Gandon Editions, 1996), p. 16.

29 Louise Walsh in Moira Roth and Hilary Robinson, *Sounding the Depths* (Dublin: Irish Museum of Modern Art, 1992), p. 6.

30 "Intimate Spaces," Alanna O'Kelly interviewed by Medb Ruane, *Circa*, no. 77, Autumn 1996, pp. 20–23.

31 Roth and Robinson, p. 6.

32 Fionna Barber and Cécile Bourne, *familiar: Alice Maher, New Works* (Derry: Orchard Gallery, and Dublin: Douglas Hyde Gallery, 1995), p. 27.

33 *For Dublin* was the 1997 Nissan Art Project, a temporary installation.

34 See Brian O'Cuiv, *Párliament na mBan* (Dublin: Institute for Advanced Studies, 1977), pp. xxxi–xxxiv.

35 Conversation with the artist, December 1997.

36 "On the role of symbolism in political thought," *Political Science Quarterly*, lxxxii, 1967, p. 194. Quoted in Gary Owens, "Nationalist Monuments in Ireland, c. 1870–1914: Symbolism and Ritual," in Gillespie and Kennedy, p. 104.

37 With apologies to Paul Durcan.

Politics

AIDAN DUNNE

The personal is political, a truism amplified in a small country where the Catholic Church has traditionally been inextricably linked to the apparatus of the secular state as the arbiter of moral and social behavior, and where personal actions have proved, time and again, to have major public consequences. If we look for the areas of political concern that intersect with Irish painting since 1980, four immediately suggest themselves, but they merge and overlap at many points, and the Church is a recurring presence. The areas are, broadly, Northern Ireland, relations between Church and State in the South, women's issues, and economic and demographic changes that have had a significant impact on Irish society. The most recent manifestation of these changes is the economic boom of the "Celtic Tiger", and even here Northern Ireland has been the specter at the feast.

It is at least partly true to say that the Troubles kick-started a generation of Northern artists. Whereas the dominant visual arts tradition in Northern Ireland prior to this latest eruption of violence was largely remote from political concerns, rooted in the pastoral and a flirtation with varieties of modernism, younger artists and art students were increasingly reluctant to ignore the reality of a divided society and violence happening on the streets around them. This is not to say that prior to the Civil Rights movement Northern Ireland produced no artists of note. On the contrary. The work of Basil Blackshaw, for example, which could be categorized as conservative and conventional, faithfully and effectively describes, even crystallizes, an entire rural culture. Equally it is not to claim that events on the ground were the sole determinant of the direction of art in the North. Rather, the tragedy of unfolding events was a natural source of subject matter for a generation of artists who, in line with international developments, had begun to question the dominance of a formalist definition of artistic practice. This was precisely the sort of definition, furthermore, that was regarded as symptomatic of the failure of the artistic establishment in Northern Ireland to address the political crisis.

The effect of events in the North on art in the South has been more subtle. Initially, in the heated atmosphere of the late 1960s and early 1970s, there was a flurry of activity. When violence re-entered the politics of Northern Ireland with the suppression of the Civil Rights movement, the impact on the South was remarkable. In October 1968

Northern Ireland police baton-charged a Civil Rights march that was being filmed by a television crew. The brutality meted out to unarmed protesters was seen not only in the Republic but all over the world. Public opinion was galvanized. Within a year, the Provisional IRA had emerged as defenders of the Catholic community. In circumstances that are still unclear, the South came close to armed intervention in defense of the North's nationalist community. Bloody Sunday, the day in January 1972 when British paratroopers killed thirteen unarmed protesters in Derry city, seemed merely to confirm an inexorable slide into conflict.

These traumatic events drew responses from such artists as Robert Ballagh, Micheal Farrell and the expatriate Brian O'Doherty, who changed his name to Patrick Ireland as a way of drawing attention to the situation in the North. Part of a sequence of otherwise abstract work, Ireland's *Big H*, a combination of rope drawing and wall painting, exhibited in Belfast in 1989,[1] referred to the so-called H-blocks that housed political and paramilitary prisoners. Micheal Farrell had established his reputation as an abstract painter in the 1960s, but his desire to comment directly on the political situation in Northern Ireland prompted him first to withhold his work from exhibition north of the border, and then to introduce progressively more overt references to events there in his paintings. His figurative work is characterized by a bitter, sarcastic humor, directed as much at himself as others.

It is true to say, though, that as the Troubles settled into a grisly routine in a way that impinged only infrequently or indirectly on the South – the bombing of Dublin, or the hunger strikes, being notable interruptions – the North faded from prominence as a subject of direct concern in the work of Southern artists. There were exceptions. A series of textual paintings by Shane Cullen reproduced in formal, hand-painted lettering, on a monumental scale, the notes exchanged by Republican prisoners during the hunger strikes.[2] The relative diminution of involvement had partly to do with the emerging complexities of the situation in the North and sheer weariness with the continuing conflict. A rising toll of atrocities made it impossible to see things simply in terms of good and bad, right and wrong – indeed the temptation to do so might be said to preclude the possibility of any settlement. The problem of partisanship was of course even more acute for Northern artists.

One of the questions Northern artists had to face was whether the traumatizing rush of current events could be incorporated within the framework of traditional artistic practice. Some artists certainly thought, and continue to think, that it could, as several pertinent examples show. Veteran sculptor F.E. McWilliam, long resident in London, felt impelled to deal with the violence in his homeland. His response was a series of sculptures, *Women of Belfast*, which took as their subject figures in the midst of bomb blasts. But McWilliam's approach was not analytical: his sculptures describe the suffering of people innocently involved in a war that is not theirs; his stance is that of a liberal humanist. Other works he made embody the desire for peace, but without imparting any sense of how that peace might be achieved, or the political framework that would deliver it, or the circumstances that had led to violence.

Certain similarities to McWilliam's work can be found in Jack Pakenham's approach. In his expressionist paintings, we are placed in the position of observers witnessing the tragedy of history, spectators at allegorical dramas that portray the brutality and suffering of hapless players. Pakenham clearly, and reasonably, regards it as the artist's duty to bear witness. He sides with the common person, the cog in the machine. In response to the most appalling sectarian savagery – of the kind that is routinely reported and as quickly forgotten by those not directly involved, but that scars families and communities for generations – Pakenham wanted, he said, "to produce a kind of collective scream and comment that would work directly on the nervous system."[3] He is primarily a decent, humanist observer, and his work is descriptive but not prescriptive. At the same time, it has to be said that an expressionist howl of outrage does not advance the situation. As Seamus Heaney laconically put it, "The 'voice of sanity' is getting hoarse."[4]

The problem with the by no means atypical approach exemplified by the work of both F.E. McWilliam and Jack Pakenham is that the notion of reasonable, liberal consensus to which they implicitly appeal cannot exist in Northern Ireland given the existing political, religious and cultural priorities of the two communities. These two communities share a land while harboring mutually exclusive conceptions of what that land is; they are both conceptions rooted in an at times strikingly similar historical precedent, but they are essentially two alternative realities, societies with, as Herder would put it, different centers of gravity. The exclusive identity of each gains definition in proportion to the threat

Fig. 49. John Kindness, *A Monkey Town Besieged by Dogs*, 1985, fresco panels, Collection Irish Museum of Modern Art

seen to be posed by the other. Such a situation can be seen to pertain until the political will exists among the leadership to reach a pragmatic accommodation, something lacking in nearly thirty years of conflict. Before the current Peace Process, the one radical attempt at a constitutional power-sharing arrangement, following the Sunningdale agreement in 1973, ended in tears when the British government backed down in the face of a Loyalist strike. In any event, accommodation will not dissolve incompatibilities, and division appears ingrained.

It was perhaps the need to approach the realities of this evidently intractable situation that prompted artists to test alternative ways of presenting and using information. Many contemporary Irish artists felt that it was not enough to comment on states of affairs when that commentary was effectively contained within an insulated environment of cultural production and reception. What was needed was an entirely new model of cultural practice, or failing that, the renewal, subversion, reinvention, or simply redefinition of the standard model. A variety of strategies was employed to those ends, and the art magazine *Circa* became a forum for such debate.

Largely for these reasons, it is impossible to deal with this

subject solely in terms of representational painting. It was during this time, for example, that photography became an important medium in Irish art practice, partly usurping a role that had traditionally been filled by painting. An artist such as John Kindness, while making a great deal of painting, has also worked in many other areas. From the beginning of his career he has ensured that his work is extremely accessible and addresses subjects of immediate relevance to his audience. His *Belfast Frescoes* are a remarkably mellow, nostalgic account of his childhood in the city,[5] but in enormous works such as *A Monkey Town Besieged by Dogs* (1985, fig. 49), or *Night Canvas* (1987), he has treated violent subjects in, respectively, allegorical and darkly satirical ways. The latter, for example, posits the interchangeability of Loyalist and Republican violence in the idiom of a grimly humorous comic strip.

Perhaps the most widely seen work by a Northern artist is that of Willie Doherty, which uses text and photography and, latterly, just photography. A piece such as *Stone upon Stone* (1986), which juxtaposes views of opposite banks of the River Foyle, suggests the mutual exclusivity of Loyalist and Nationalist perspectives, and also their interconnectedness. Opposed meanings can coexist in a single image. Much of Doherty's work refers to the problematic role of landscape in Northern Ireland. If the Nationalist myth of the West of Ireland indicates a distrust of towns as a colonial imposition, the Loyalist identification with organized, defensible territory is apparent in a distrust of the amorphous, threatening wilderness. It is interesting in this context that the favored icons of natural landscape used to promote tourism in Northern Ireland are the orderly hexagonal basalt columns of the Giant's Causeway, a structure that echoes man-made architectonic forms, whereas in the South the vague, unbounded expanses of the Atlantic seaboard have traditionally been the dominant representative landscape.

One of the most graphic illustrations of the way a pastoral or formalist approach to the landscape was not just inadequate but effectively precluded by the Troubles is provided in another photo-text series by a younger photographer, Paul Seawright. In his *Sectarian Murder Series* (1987–88, fig. 50), Seawright visited and photographed the locations of sectarian murders using an old diary as a guide. Various locations are depicted: wasteland and mountains, a lakeside, a row of shops. But each image is accompanied by a brief caption with a date and a brief description of the mur-

der committed on the spot, information that inevitably colors our response to the image. The apparent innocence of the landscape is undercut by the text and by history.

Less baldly, another photographic artist, Victor Sloan, produces images that are halfway between photography and painting by directly attacking negatives, scratching and piercing them, and laying on chemicals and pigments to produce records of Orange ceremonies on July 12th. The Twelfth is an important date in the political calendar, when Orangemen take part in marches that function as dramatic reassertions of their cultural identity and, more contentiously, of their dominance over the Catholic population. The finished images are scarred, disfigured, and partially obscured. The results function as a metaphor for the corrosive effects of history, tradition, sectarianism and violence on an agreed, contrived "normality." Similarly, in his composite paintings Joe McWilliams has subjected nationalist and Loyalist icons to distorting, corrosive processes.

The surfaces of Sloan's work also bear comparison to the layered complexity of David Crone's paintings (see Plates 58 and 69). These often contain references to looking – a common preoccupation, understandably, given the ubiquity of surveillance in the North for the past generation. Crone stands aside, however, from Pakenham's moralistic involvement. In fact he continually denies us any commanding viewpoint, thrusting us into a confusion of overlapping spaces. Figures occupy distinct if interpenetrating spatial frameworks, initially inspired by the patterns of division established to segregate Belfast's communities, and the cages and barriers that guard against bombing in the city center. His subject is not the terrible deeds themselves but, in a sense like Sloan, the veneer of normality, the way daily life is constructed from a patchwork of divergent realities and interests. Though he offers only an oblique take on political context and events, Crone has consistently produced complex, compelling paintings that are remarkably true to their time and place. In his 1993 exhibition, *City Reformed*,[6] Ronnie Hughes also looked at the strange composite quality of an urban environment ravaged by systematic bombing on the one hand and, with the injection of enormous financial resources, reconstructed as a kind of model contemporary city on the other, again with the aim of projecting an image of normality that was anything but.

Dermot Seymour's unlikely images synthesize a fragmented reality in another way. His harshly lit, garishly col-

Fig. 50. Paul Seawright, *Sectarian Murder Series*, Monday 30th December 1974, "A 17-year old boy was duck shooting on the shores of Belfast Lough. Four men approached him demanding he hand his shotgun over. They shot him in the head before leaving with the weapon," 1988, color C-type print, 20 × 20 in. (51 × 51 cm) plus text, Courtesy of the Kerlin Gallery, Dublin

ored pictures approximate to photorealism, but the jarring incongruity of the motifs combined within individual paintings suggest otherwise. Seymour uses the implied seamlessness of the photographic image to persuade us to accept impossible situations. But they are, he is at pains to point out, a reflection of the incongruities thrown up by the bizarre circumstances that pertain in Northern Ireland. It is not just that things in Northern Ireland are objectively strange, that the environment has been heavily militarized, for example, and is strewn with the often surreal apparatus of defense and surveillance. There is also the level of watchfulness that exists within communities, the constant alertness to innocuous-seeming details because they are in fact badges of identity. Animals feature extensively in Seymour's pictures (see Plates 62 and 66), mostly domesticated farm animals such as sheep and cows, but also badgers and foxes. They are there to some extent because Seymour spends his time in the countryside, but it is impossible not to see the passive, placid, ultimately sacrificial beasts as representative of the Northern population, nurtured and perhaps misused

Fig. 51. Cecily Brennan, *Mud Pool*, 1988, oil on canvas,
13 × 16 in. (33 × 40.6 cm), Photo courtesy of Taylor Galleries

by their political leaders. Diarmuid Delargy, the painter and printmaker, has also used animals in a symbolic role in his work, visualizing the North as a disrupted classical landscape, populated by estranged, rootless masses.

Dermot Seymour is typical of a significant number of his contemporaries in that he moved South – in fact in his case he moved southwest, to the Mayo coast, where he has lived since 1990. He frequently visits the North, but found it uncomfortable to live and work there. "They say Northern Ireland is obsessed by its own history, but there's no history in Northern Ireland," he said in an interview in 1997,[7] reiterating a point often made. "We've never been detached enough to allow the past to become history. What happened 400 years ago in the North has the same currency as what happened last week. How many anniversaries and commemorations and re-enactments do you need before you let something belong to the past?"

A large number of Northern artists have similarly moved elsewhere, both to the South and further afield, notably to Britain; Paul Seawright, for example, runs an MA course in Wales. The move has inevitably influenced the shape of their work and raises another question. It is probably true to say that Seawright's best work to date was based on Northern Ireland, but he has thrown himself fruitfully into several projects abroad and shows every sign of thriving, whereas someone like Willie Doherty seems strongly identified with his native Derry, which continues to provide an apparently inexhaustible store of subject matter.

In the 1980s, while sections of Irish society in the Republic were asserting their resistance to moves towards liberalization, a number of Irish artists were creating revised images of women in a specifically Irish context. Conservative resistance manifested itself in two notable referendum results. The first, in 1983, was to decide whether an existing ban on abortion should be incorporated in the Irish constitution – notwithstanding the constant traffic of Irish women to Britain to have abortions. It was overwhelmingly passed. Ironically, the wording of the constitutional amendment was later judged by the Supreme Court to have the effect of making abortion legal in certain circumstances in Ireland. By a particularly cruel irony, within a few months of the referendum, a teenage girl died while giving birth, in secret, in an open-air grotto in her home town in Co. Longford. There could be no more graphic demonstration of the disparity between public piety and the private reality of women's lives in Ireland. Then, in 1986, the culmination of Taoiseach Garret Fitzgerald's constitutional crusade, a liberalization program, was a referendum on the legalization of divorce in certain circumstances. In a bitterly divisive campaign, the Catholic Church expressed its vehement opposition, and was criticized for playing on fears of inheritance rights to land.

There is another, specifically Irish twist to representations of women in art. Ironically, given that de Valera's Ireland was a patriarchal state in which the social and moral arbiters were largely the local representatives of a patriarchal Catholic hierarchy, the country itself has been habitually personified as female, as has its defining landscape in the West. Hence Rita Duffy sardonically portrays *Mother Ireland* (1989, Plate 68) not as an ethereal Kathleen ní Houlihan, but as a harassed mother beset by the mundane problems of survival and the strictures of religious doctrine. Hence, too, Micheal Farrell's savagely allegorical series, from the late 1970s, of *Madonna Irlanda* (see Plate 56), based on François Boucher's nude portrait of Louise O'Murphy, an Irishwoman who was a mistress of Louis XV. [8]

Against this background of moral battles fought largely, as feminist commentators pointed out, over the territory of women's bodies, Eithne Jordan made several series of works in which a woman was visualized as a kind of terrain, marked out in a peculiarly liquid, mutable skin of paint, invaded, enveloped, and pulled apart by external forces.

These paintings developed from her earlier *Swimmers*, in which the figures blend with the rhythmic patterns of the water, and they included a *Beauty and the Beast* series, in which the woman is the prey of the beast. As one critic has noted, "In some of these paintings the beast represents the child, the clinging male child, in others the courtship of the adult male."[9] Yet the woman is not a victim. Rather, Jordan has in mind the public and private role of woman as a locus of demands, something underlined in paintings in which an individual female figure literally splits in two. The paintings are an assertion of autonomous identity, a statement that woman exists for herself outside of these imposed – and, it is worth saying, not necessarily rejected – roles.

Luke Gibbons has argued that in Cecily Brennan's paintings – based variously on the County Wicklow landscape, the rhododendron garden at Howth, her own garden and then the raw, volcanic interior of Iceland – bodily experience is displaced onto the landscape (fig. 51).[10] Gibbons suggests that the geophysical processes in the landscape function as signifiers for bodily processes, and that our immersion in the landscape breaks down the customary distance of pictorial convention. Furthermore, in Brennan's various explorations of nature untamed and nature controlled, it is reasonable to see a metaphor for the question of woman's control of her own body. As it happens, this view is bolstered by Brennan's more recent work, which has moved on to a treatment of body narration in a much more explicit and even disturbing way, with images of pain and loss.

As a teacher, Patrick Graham encouraged students to mine their own experiences as a means to explore, analyze, and represent their identities. While this strategy inevitably engendered a substantial amount of dark, introspective and undeniably self-indulgent painting that aped the trappings of his own style and was largely superficial, it did produce some worthwhile results as well. After seventeen years as a wife and mother, Patricia Hurl, for example, returned to art college determined to pursue just such a course in her painting. In the process of making an intensely felt series of autobiographical paintings that she called *The Living Room*,[11] apparently settled within the context of a conventional family life, she embarked on a fundamental reappraisal of her role as wife and mother (fig. 52). The work that made up *The Living Room* was almost cursory in delivery, but it spoke so directly and urgently that it was quite compelling,

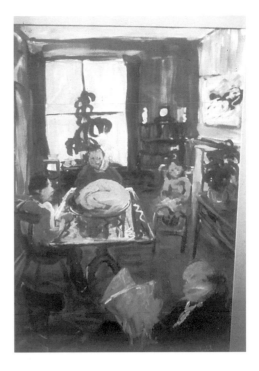

Fig. 52. Patricia Hurl, *Sunday Rituals*, 1988, oil on board, 36 × 24 in. (91.5 × 61 cm), courtesy of the artist

and imparted the excitement of personal discovery. Hurl has gone on to produce much more sophisticated work, rigorously honest explorations of her own identity and relationships.

In a broadly similar vein, many Irish women artists have produced autobiographical drawings and paintings that have attempted to foreground their own experience. Their work can be seen in the general context of a feminist re-appropriation of images of the female body and an assertion of the legitimacy of female experience as subject matter. Some of that work, in the realm of sculpture, performance and video as well as painting, is very good. Inevitably, much is less successful. The greatest weakness is one that afflicts Irish figurative painting generally: an expressionist self-indulgence engendered by the assumption that the release or display of emotion is sufficient in itself.

Two early works by an outstanding artist of her generation, Kathy Prendergast, specifically addressed the notion of woman as landscape (fig. 53). *Sea Bed* (1980) is a sculptural installation in which a life-size female figure, lying on a bed, is inscribed with contour markings, perhaps a metaphor for control. *Enclosed Worlds in Open Spaces* (1983)

Fig. 53. Kathy Prendergast, *To Control a Landscape – Irrigation* (from *Body Map Series*), 1983, watercolor, 30 × 21¹/₂ in. (76 × 56 cm), Collection Irish Museum of Modern Art

which followed is a series of watercolors offering a set of rigorously calculated maps and diagrams of a woman's body, much like surveyors' reports on a piece of land to be exploited for its resources. The brutality of the concept is offset by the exceptional delicacy of the treatment, which mimics the style of nineteenth-century mapmaking, incidentally recalling the brash self-confidence of Victorian engineers. Prendergast has consistently denied any overtly feminist intent in the piece, although it stands as one of the most powerful artistic representations yet made of the position of women in Irish society entailed by the pious idealizations of Church and State.

Alice Maher's work always seems to contain autobiographical elements that symbolically chronicle the construction of her own identity. From early drawings that cast her as a strong Alice in Wonderland figure, she has moved on to a huge variety of media, making deliberately problematic works that defy conventional categorization but that prioritize female experience. In her exhibition "familiar,"[12] for example, she paired a number of large paintings with sculptural objects, perhaps questioning the modernist principle of painting's purity and autonomy. Furthermore, in physically approaching these large paintings, the viewer realized that they confounded expectations of large museum works: their anecdotal content was casually deployed on a small scale; figures when they appeared were tiny. Their concerns, literally or symbolically autobiographical, were domestic, personal, intimate, not "appropriate" fine-art

material at all.

There is a male equivalent of this self-analysis. Working initially in a magic-realist and latterly in a harshly realist manner, James Hanley (see Plate 75) has set about a comparable exploration of masculinity starting from an autobiographical basis. His work articulates an anxiety underlying conventional models of masculinity against a background of changing values and roles, a concern evident as well in the work of such artists as Brian Maguire, Patrick Graham, and Michael Kane (see Plates 33, 39, 59, 60, 61, and 70).

Over the last decade, the Catholic Church in Ireland, already struggling to cope with a decline in the numbers of its congregation[5] and vocations to the priesthood, was rocked by a seemingly endless series of scandals. These included a bishop being identified as the father of a teenage son and his subsequent flight, an episode that formed the subject matter for an acerbic series of work by Micheal Farrell. It is a mark of the passage of time that the tone of this work was widely regarded as excessive, not because it attacked the Church, but because it seemed that the expatriate Farrell was still fighting battles that had been not so much won as rendered irrelevant by the Church's own palpable failures. Other scandals included a vociferously conservative cleric being revealed, posthumously, as having lived with and fathered children with a woman he never publicly acknowledged, and several cases of child sexual abuse in which the Church authorities were generally thought to have responded inadequately and inappropriately. Most commentators have suggested that such cases have irrevocably undermined the image and authority of the Church.

It is against and indeed in anticipation of this background that Patrick Graham's work (Plates 59, 60, and 61) should be viewed. Its raw honesty in chronicling a troubled relationship with the world, and in dealing with problems of faith, sexuality and identity exposes the very fault lines along which the Church eventually split. The penitential, almost flagellate, quality of Graham's work is unmistakably rooted in Catholic guilt, but it is also passionately critical of the institutional impulse to regulate and control the lives of others. His paintings have an exhausted, spent quality, often like the aftermath of an all-night discussion, or some other grueling emotional experience. Often, through layer on layer of overpainting, color is virtually worn out of them. At times at war with his own representational facility, Graham

has virtually obliterated images in exasperation and scrawled words across the canvas.

The crisis in the Catholic Church makes the case of Hughie O'Donoghue all the more intriguing. His mother's family lived in one of the bleakest, most remote corners of the country, the rain-swept bogland of Erris in northwest County Mayo. Born and brought up in Manchester, he developed an extraordinarily strong identification with the Irish landscape during summer visits as a child. In fact, the starkly beautiful upland landscape characteristic of much of the West, can readily be recognized in the paintings that established O'Donoghue's reputation. There is something willfully anachronistic in his embarking on a hugely ambitious series of paintings on the theme of the Passion of Christ,[13] a project that has occupied him for the best part of the last decade and which he has approached with the utmost seriousness. But it would be wrong to see the paintings (see Plate 74) as a simple reaffirmation of religious faith. In attempting a concerted treatment of one of the central, more enduring themes of Western art, they are certainly an expression of faith in the practice of painting. It is reasonable to surmise, as well, that they suggest a faith in the ability of paint to embody human presence without the disclaimers of irony. The several metaphors and approaches O'Donoghue has used in this regard – the unearthing of long-buried bog figures, the flame of passion, the evocation of figures *in* extremis, his imaginative, reconstituent treatment of an episode of his father's life – reinforce this impression.

The habitual view of Ireland as a bastion of conservative values has taken a pounding on several fronts in the last two decades. It is hardly surprising, then, that after a second referendum divorce was legalized in the Irish Republic in 1996, even if the result was decided on the slenderest of margins. But in Ireland the dissection of poll results can be a national pastime, and on the day analysts were quick to point out that the real significance of the vote lay not in the bald figures, decided on a fraction of a percentage point, but in two other points: the reversal that had occurred since the last divorce referendum was resoundingly defeated, and the underlying demographic shift that has seen a growth in the number of young voters and the inexorable migration of the population to the major urban centers. A full one-third of the Republic's population now lives in Dublin. These factors were much more profound than the marginal result in

itself and once again underline the urban-rural divide. It was yet another milestone in a process that really began with the retirement of Eamonn de Valera as Taoiseach and his replacement by Sean Lemass in 1959, initiating a wave of economic and social change unmatched until the 1990s economic boom. Since that time, and significantly in the last two decades, Irish identity has been substantially recast. The thrust of the revisionist case is a dismantling of the old nationalist ideology, which was homogeneously Gaelic, Catholic, Anglophobic, insular, and rural. In its place are offered various heterogeneous models, broadly emphasizing the country in a European context and viewing the society as increasingly liberal, pluralist, urban, and cosmopolitan.

Artists have been vulnerable to the criticism that they were slow to adapt to these changes, although that is much less the case now than it might have been in the 1970s. Publisher and writer Dermot Bolger has argued that, almost without the literary establishment noticing, a new generation of Irish novelists – and their readers – stemmed from a new, urban world and could not be presumed to share the references of their predecessors.[14] In paintings, one early exponent of a representative urban landscape is Michael Kane, who continues to situate most of his coarsely brushed, figurative paintings in a recognizable part of Dublin and has long expressed a dislike of landscape painting. Charles Cullen, equally, locates most of his work in a night-time Dublin setting, with its own distinctive ambience of mystery and threat, its shadowy comings and goings. The atmosphere of his work is picked up in that of a younger painter, Oliver Comerford, also a nighthawk. He offers glimpses into a transient urban world of late nights, parties, and car journeys in a built environment at once alien and familiar. Equally, Brian Maguire has consistently identified with the marginalized sections of urban society, the by-products of a problematic urbanization. His spare, explosive, gestural, descriptive style matches a range of subjects that are often quite bleak. But his work is also distinguished by a surprising vein of gentle lyricism that derives largely from his openness to character and his sense of compassion. Maguire's interest in the marginalized of Irish society has carried over from work to action: he was involved in the establishment of the Art in Prison scheme and has been politically active in a number of other areas.

Yet, despite the fact the most of the Irish population now lives in large towns and cities, if one regularly visits exhi-

Fig. 54. Martin Gale, *The Flyer*, 1997–98, oil on canvas, 48 × 48 in. (122 × 122 cm), Photo courtesy of Taylor Galleries, Dublin

Fig. 55. Barrie Cooke, *Sewage Outlet, River Nore*, 1992, oil on canvas, 38 × 40 in. (97 × 102 cm), Courtesy of the Kerlin Gallery, Dublin

bitions of painting in Ireland, or the annual graduation shows mounted by art schools, it is readily apparent that landscape remains the dominant genre of Irish painting. It holds an unwavering fascination for Irish artists. And for many of them the West still provides the representative landscape. Yet apart from art that directly employs the conventions of landscape painting, a number of options are presently available to Irish painters. There is, of course, the possibility of accurately reflecting the realities of rural life, and Martin Gale is one artist who chooses to do this (fig. 54). Having made highly formalized, stylized paintings of an imagined, essentially Anglophile landscape of rural demesnes as an art student, Gale was taken aback to discover that he knew very little about the real countryside when he moved out of town. His best work since then has been an exploration of that largely rural environment in a style that is close to photo-realism. This does not rule out celebratory evocations of natural splendor, but Gale's Ireland is really a place of agricultural industry, of European Union subsidies, headage payments, drainage schemes, bungalows, adolescent restlessness, greed for land, monotonous conifer plantations, Japanese cars, isolation, cold winter light, moisture-laden air, and melancholy autumn evenings. Although a great deal of his painting is in many respects as resolutely downbeat as Brian Maguire's, it too is remarkably popular, perhaps because it is so atmospherically true: anyone with experience of the Irish countryside recognizes it. Yet Gale's paintings are abrasive in that they recognize problems in the received view of rural Ireland. The rural idyll promoted by Bord Failte (the tourism board) overlooks a virtual absence of planning strategy in rural areas which has allowed the eclipse of vernacular architectural style by incongruous bungalows and indiscriminate ribbon development ignorant of existing settlement patterns.

Another painter who takes an unblinking view of the problems afflicting the rural landscape is Barrie Cooke (fig. 55). Born in Cheshire, he came to Ireland in 1956 and has remained there since, based not in Dublin, but in Clare, Kilkenny, and latterly in County Sligo. His involvement with angling and his views on conservation have led him to address issues of rural planning and environmental degradation directly in his work, including specific problems like eutrophication, water pollution and other manifestations of the impact of human activity on the natural world. The fact that Cooke does so as a countryman is vital.

Fig. 56. Seán McSweeney, *Along the Shore,*
Sligo, 1983, oil on board,
31¼ × 20¾ in. (79⅜ × 52¾ in.), Photo
courtesy of Taylor Galleries, Dublin

Still, many Irish people, painters among them, strongly identify with the rural environment as an essentially natural space. They are often criticized for doing so, but in a telling reply to an interviewer who seemed disparaging of the romanticism implicit in such an approach, Dermot Seymour – a country dweller who, as we have seen, does not paint landscape in that way himself – remarked: "To comment on the romantic artists – the place is romantic. It's a magical place, and you will look out and say how could it be painted in any other way. And Paul Henry's paintings – himself a Belfast man, lived in Achill – are real gems, and I would never be critical of the work that he was doing. It is actually like that."[15] Like Seymour, Seán McSweeney, for example, consciously embraced country life. Born and raised

in Dublin's inner city, when he began to work as a painter he opted to live first in Wicklow, latterly in a remote part of County Sligo, close to Lissadell, where he has family connections. McSweeney's work is an obsessive exploration of this low, shoreline bogland, based on a close, intimate knowledge of the terrain and the progression of the seasons (fig. 56). One could add other, younger painters of substantial ability who have sought out the wild landscapes of the Atlantic seaboard, including Helen Richmond, Mary Lohan, Nick Miller and Gwen O'Dowd. Perhaps their activity should be seen not as a throwback to a notional romantic past but as a reappropriation of their own landscape, a reappropriation of what it means to speak of Ireland.

NOTES

1 Exhibited, Orpheus Gallery Belfast, 1989, one of a series of site-specific "rope drawings" made with rope and paint.

2 *Fragments sur les Institutions Républicaines IV* by Shane Cullen comprises eighty-eight eight-by-four-foot paintings consisting of textual transcriptions of letters written by Republican prisoners during their hunger strike in Long Kesh in 1981. The edited texts were taken from David Beresford's book, *Ten Men Dead: The Story of the 1981 Hunger Strike* (Dublin: Grafton, 1987).

3 Statement for *Art for Society*, Whitechapel Art Gallery, London, 1976, reproduced in Jack Pakenham, *Works 75–89*, Orchard Gallery, Derry, 1990.

4 Seamus Heaney, "Whatever You Say, Say Nothing," in *North* (London: Faber & Faber, 1975).

5 First exhibited at the Kerlin Gallery, Dublin in December 1994, the frescos are in the collection of the Ulster Museum, Belfast.

6 The Rubicon Gallery, Dublin.

7 Interview with Aidan Dunne, *Sunday Tribune*, 28 September 1997.

8 Cat. X, *Madonna Irlanda, or The Very First Real Irish Political Picture* (1977), in the collection of the Hugh Lane Municipal Gallery of Modern Art, Dublin, and is the first painting in the series.

9 Leland Bardwell, text in exhibition catalogue, *Eithne Jordan: Faces and Other Paintings* (Dublin: Hendriks Gallery, 1988).

10 Luke Gibbons, "Displacing Landscape," essay in exhibition catalogue, *Cecily Brennan* (Dublin: Douglas Hyde Gallery, 1991).

11 *The Living Room – Myths and Legends*, Garter Lane Arts Center, Wexford, 1989.

12 *familiar*, The Douglas Hyde Gallery, Dublin, 1995.

13 Works from the series were shown in the exhibition *Via Crucis* at the Haus der Kunst, Munich, and a smaller number in Kilkenny, Ireland, in 1997.

14 In the Introduction to *The Picador Book of Contemporary Irish Fiction*, ed. Dermot Bolger (London: Picador, 1993).

15 Dermot Seymour in conversation with Liam Kelly, *Dermot Seymour* (Co. Cork: Gandon Editions, 1995).

Strategic Representations

Notes on Irish Art
Since the 1980s

CAOIMHÍN
MAC GIOLLA LÉITH

This essay makes little attempt to chart the development of Irish art in general during the course of the 1980s and the 1990s. Rather it offers two "snapshots" from the period in question, separated by less than five years, in the form of an examination of two key moments in the recent history of the public presentation of Irish art. It is hoped that a consideration of some of the continuities and disjunctions evidenced by the two exhibitions addressed, some of the art they showcased, and some attendant critical commentary and exegesis, may contribute to the debate concerning the intersection between art and politics in contemporary Ireland.[1]

The first of these two exhibitions was, by the domestic standards of the recent past, a relatively lavish presentation of contemporary Irish art to a predominantly Irish public.[2] Between September 1990 and March 1991 the Douglas Hyde Gallery, a publicly funded exhibition space attached to Trinity College, Dublin, in the heart of the city, mounted a series of exhibitions collectively titled *A New Tradition: Irish Art in the Eighties*. This ambitious attempt to survey what an introductory essay in the substantial accompanying catalogue described as "a decade of unparalleled productivity and diversity in Irish art" comprised five consecutive shows.[3] The shows were presented under the following rubrics: "Nature and Culture," "Sexuality and Gender," "Myth and Mystification," "Abstraction," and "Politics and Polemics," each of which was introduced by a separate essay in the catalogue. The work of more than thirty artists was dispersed over (or, in a very few cases, manhandled into) these categories, with a small number of artists appearing in more than one section. While most of these sections featured some sculpture or work in three dimensions there was a notable predominance of two-dimensional work: painting, drawing and, to a lesser extent, photography. The exhibition series provoked a certain, perhaps predictable, amount of local debate. Yet it was an exercise in stocktaking undertaken largely behind invisible protectionist barriers which at the time left the Irish art world relatively unaffected by the extremes and excesses of the international art world during the preceding decade (though the actual art produced during the period was by no means immune to outside influence). It was, in effect, a big fish in a little pond.

The second exhibition was quite different. This was potentially an all but invisible fish in a great ocean. The two-

person exhibition which constituted Ireland's participation in the 1995 centenary Venice Biennale was a modestly financed, unobtrusive contribution to the most venerable gala event in the international art calendar. In the event, however, it was seen by many as a significant marker of the arrival of contemporary Irish art on the international stage. At the very least it heralded a markedly increased degree of visibility for Irish art on the international scene. It was not that Irish artists had never before exhibited at Venice. They had. Official Irish representation at the Biennale, however, had been allowed to lapse for thirty years before its resurrection in 1993. In that year a photographic work by Willie Doherty and a Dorothy Cross sculpture gamely, and not unsuccessfully, fought for attention in a crowded Italian pavilion at the heart of the Biennale's core venue, the Giardini di Venezia. By 1995 the Irish had removed to an oasis of calm at the Nuova Icona gallery on the island of Giudecca, an awkward boat ride from the sites of most of the major (and infinitely better funded) exhibitions. The obscurity and relative inaccessibility of the venue resulted in poor attendance on the press days. All this changed, however, when the Biennale's international jury dutifully paid a visit which resulted in one of the two Irish participants, Kathy Prendergast, being awarded the prestigious Premio Duemila, the award for the best artist under forty years of age.

Prendergast had been one of the few artists to be included in more than one section of *A New Tradition* five years earlier. In Venice the main body of work she presented was a selection from what remains her most ambitious and best known project to date, the *City Drawings* (1992–97, fig. 57).[4] At the time this work was incomplete. In fact, in one sense at least, it will always remain incomplete. In 1992 Prendergast began a series of small pencil drawings of all of the world's capital cities, which were then approximately 180 in number. Three years later, she had finished over eighty of these drawings. They are exquisitely realized and minutely detailed maps. They are also, however, entirely free of annotation. The bewitching delicacy of their ravelling gossamer is untrammelled by the apparatus of conventional mapmaking. They are undeniably beautiful and of no practical use whatsoever. The artist brought to this work all the skill and commitment of a medieval illustrator painstakingly copying and embellishing a precious manuscript his age had lost the power to decipher. She could, in

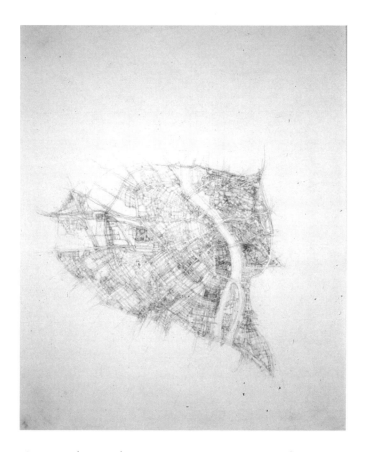

Fig. 57. Kathy Prendergast, *City Drawing*, 1994, pencil on paper, 12⅝ × 9½ in. (32.1 × 24.1 cm), Irish Museum of Modern Art

theory, continue this series of drawings indefinitely. The constant appearance and disappearance of capital cities, as new nation-states emerge and old ones are dissolved, ensures the possibility of, if not the necessity for, constant revision. Her fragile cartography is not only mute but mutable.

Prendergast's austerely unadorned maps point suggestively to the essential indecipherability of the physical world. Yet she clearly realizes that there are many different ways to misread the world, and that a surfeit of information can be as misleading as its lack. For any one of her reticent, uninterpreted cities might provide the perfect mirror image of the tantalizing city of Tamara, city of abundant signs, in Italo Calvino's *Invisible Cities*. In an imagined encounter between Kublai Khan and Marco Polo – those twin emblems of medieval imperial expansionism – Tamara is described by the latter as follows:

"Your gaze scans the streets as if they were written pages: the city says everything you must think, makes you

repeat her discourse, and while you believe you are visiting Tamara you are only recording the names with which she defines herself and all her parts.

However the city may really be, beneath this thick coating of signs, whatever it may contain or conceal, you leave Tamara without having discovered it."[5]

A clear continuity of concerns can be traced between *City Drawings*, first shown in Venice, and the map drawings earlier exhibited by Prendergast in *A New Tradition*, such as *To Control a Landscape – Irrigation* (1983, see fig. 53) and *Enclosed Worlds in Open Spaces* (1983). In fact, Prendergast's earliest "map work," the precocious mixed media sculptural tableau *Sea Bed* (1980), dates back to the year of her graduation from art college. It might be argued that the many map works produced by Prendergast since *Sea Bed* conspire to resist the covetousness and rapacity implied in the fictionalized Marco Polo's account of ill-concealed, frustrated desire. They certainly draw attention to such rapacious desire, though they take some risks in doing so. One is the considerable risk of mapping the female body in an attempt to render it intelligible to itself, despite the fact that one problem with maps is that they often fall into the wrong hands, and are used for ends contrary to the intentions of those who draft them.[6] Some of the most compelling of these works, however – *To Control a Landscape – Oasis* and *To Alter a Landscape*, for instance, or her 1990 series of wall sculptures in Bath stone and paint – are effective examples of what Caren Kaplan, borrowing and adapting from Deleuze and Guattari, calls "reterritorialization."[7] "Deterritorialization," for Deleuze and Guattari, refers to that state of exile and alienation familiar to all who inhabit the margins of a dominant culture. Deterritorialization, however, also has its merits. Simultaneously debilitating and liberating, it enables the imagination "to express another potential community, to forge the means for another consciousness and another sensibility."[8] It thus implies the possibility of subsequent reterritorialization in a terrain more amenable to radical, oppositional thinking. That is to say, a shifting, flexible location such as that tentatively described by Kaplan as "a space in the imagination which allows for the inside, the outside and the liminal elements of in between." With their deft balancing of the external and the internal, the carnal and the mechanical, plan and elevation, universality and specificity, Prendergast's maps in paper

and stone provide a valuable preliminary guide to just such a space.

Prendergast's entire oeuvre may be said to revolve around a potent cluster of issues, chief among which are sexuality, identity, landscape, mapping and power. In this she is by no means unusual. This cluster of issues has sustained and animated the work of numerous Irish artists throughout the past two decades. Yet the dominant methods and media used to address them have varied considerably, both from artist to artist and, perhaps even more significantly, over the duration of the period. This may be best illustrated by first returning to the 1990–91 survey exhibition at the Hyde Gallery before tracing subsequent developments in the work of a few of its more prominent participants, and making a brief examination of the work presented by Prendergast's co-exhibitor at Venice, Shane Cullen.

Prendergast was included in two sections of *A New Tradition*, "Nature and Culture" and "Sexuality and Gender." "Nature and Culture" was a strangely, if consciously conflicted, multigenerational selection. It included a number of Prendergast's contemporaries, such as Mickey Donnelly, Willie Doherty and Mick O'Kelly, who shared a critical, even subversive approach to the romantic depiction of a "poeticized" Irish landscape favored by many of the senior painters of an earlier generation. Yet it pitted them against three of the principal proponents of that tradition, Patrick Collins, Camille Souter and Barrie Cooke. In fact, the "Nature and Culture" and "Abstraction" sections of *A New Tradition* seemed, in 1990–91, less coherent and less timely, respectively, than the remaining three sections, though hindsight need not necessarily view these as failings. Of the five categories "Abstraction" was potentially the most quarantined affair. As Aidan Dunne pointed out at the time, 1980s Irish abstraction had its roots in a modernist formalism which arrived relatively late in Ireland under the aegis of the Living Art group in the 1940s and only gradually acquired the privileged status in "advanced" art circles it enjoyed by the early 1970s. It did so only to face the prospect of having this status swept away again by the tidal wave of figurative and narrative painting which washed over Ireland, as it did elsewhere, a mere decade later.[9]

A New Tradition marked the apotheosis of a strain in Irish painting during the 1980s which, wherever its disparate roots may be located within the individual development of its leading lights, was clearly allied to the "New

Painting" then taking the world by storm. The work of painters such as Patrick Graham, Brian Maguire, Patrick Hall, Michael Cullen, Eithne Jordan and Anita Groener showed clear affinities with that of the German Neo-Expressionists.[10] Some of Hall's work on a smaller scale could also be related to that of the Italian Transavantguardia. The influence of painters such as Clemente and Palladino could similarly be detected, during the early to mid 1980s, in the work of Michael Mulcahy (fig. 58), one of whose paintings adorned the cover of the *New Tradition* catalogue. The prevailing sense given by the *New Tradition* package as a whole – *i.e.* the series of exhibitions and the landmark catalogue, which was expressly presented as a potential "basis for the study of Irish Art in the eighties"[11] – was of the dominance of expressionist figuration in Irish art during the period covered. This art's primary concerns were in turn appropriately expressed by the abbreviated headings "Sexuality," "Myth," and "Politics" suggested by *A New Tradition*'s three core categories. Both this mode of address and this subject-matter enjoyed ascendant status despite the gestures toward inclusiveness made by a survey which conscientiously attempted to give their due to the claims of competing or alternative practices. This predominance was partly due to the imposing physical presence and clamor of powerful, large-scale paintings by artists such as Graham, Maguire and Mulcahy which, in group shows, tended to drown out less obviously strident voices. However, the claims made by this art on the gallery-going public's attention were, during the same period, being strengthened at a more discursive level by an impressive array of critical *imprimaturs*, both within Ireland and from without.

Less than two years earlier, Brian Maguire's 1988 solo exhibition, also at the Hyde Gallery, was presented with an enthusiastic endorsement by Donald Kuspit, arguably the most influential champion of Neo-Expressionism internationally. In the vigorous opening paragraph of his catalogue essay, which is worth quoting at some length, Kuspit explicitly tied Maguire's colors to the Neo-Expressionist mast:

"A Maguire picture is produced not reproduced – roughly hewn handmade [sic] rather than smoothly manufactured, indeed made with a hand so vehemently assertive as to seem unsusceptible to mechanical control, unsubservient to any system of control. The sense of abandonment to paint, or of wild painterliness, and of

Fig. 58. Michael Mulcahy, *Gate Ways 1*, 1987, oil on paper, 28 × 40 in. (71.1 × 101.6 cm), Photo courtesy of Taylor Galleries, Dublin

imagery more fantastic than descriptive – freely transformative of a subject matter rather than transcriptive of its common appearance – and a certain sense of confrontal alienation: all these are signs of Expressionism, or rather, in the 1980s, of Neo-Expressionism. That a strong Expressionism, such as Maguire's, is still viable, indicates that the storm-and-stress mentality inseparable from it – an art expressive of rage and determined to outrage – still makes socio-emotional sense at this time in Western history."[12]

Two large paintings included in that exhibition, *Divis Flats* (1985, Plate 63) and *Child and Self (Remembering)* (1986, Plate 64) are also included in this volume. The first of these depicts a lone figure, viewed from the back, who is anchored uneasily in a ground ominously rendered in violent daubs of dirty red. He stands helplessly at the forbidding mouth of a ruined gray canyon which dwarfs his puny presence. Bereft of its title this painting might be read as an anguished depiction of existential despair, inviting the viewer to share in a generalized sense of "confrontal alienation," as described by Kuspit. The towering, brutalist architecture by which the figure is hemmed in echoes a formal device frequently used in Maguire's earlier portraits. In a gesture reminiscent of Francis Bacon, Maguire enclosed his subjects in cagelike structures which emphasized their isolation. "Every time I did a portrait I would lock it in, enclose it in an architec-

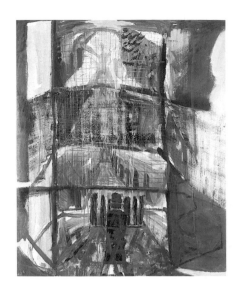

Fig. 59. Brian Maguire, *The Big House*,
acrylic on canvas 65 × 81 in.
(165 × 206 cm), 1990, Kerlin Gallery,
Dublin

ture in the picture. I used to invent that architecture in the earlier work to show how people were isolated and divided from each other in their tiny boxes."[13]

The title *Divis Flats*, however, refers explicitly to a once notorious block of flats in the heart of war-torn Belfast. It thus reflects Maguire's deep engagement with the politics of Northern Ireland. Formally, it is closely related to a series of paintings produced by Maguire a few years later in direct response to his experience of working and teaching in Port Laoise prison, a Southern prison in which many Republican paramilitaries active in the Northern Irish conflict were detained. In the prison buildings Maguire found an architecture which did not need to be invented or added to imaginatively, an architecture, as he put it, "which expressed its purpose and defined its emotional reality in itself." Following an initial period during which he felt entirely incapable of adequately responding to the situation in which he found himself Maguire began to paint the prison interiors. At first he painted them devoid of inmates. Only gradually did the prisoners find their way into the paintings. In responding to the prison environment Maguire was also thrown back on early memories of institutional architecture. *The Foundation Stones (Mental Home)* (1990), for instance, relates to a childhood experience of St James Hospital in Dublin. *The Big House* (1990, fig. 59), painted in the same year, evokes more directly the anguish of incar-

ceration. The overpowering architecture of the last named painting echoes that of *The Foundation Stones* and *Divis Flats*, while the splayed figure just off-center at the top of the image harks back to Maguire's *Homage to Orwell's 1984* (1985), a large diptych which had figured prominently in the "Sexuality and Gender" section of *A New Tradition*.

Maguire's work as a whole, and *Homage to Orwell's 1984* (fig. 60) in particular, perfectly illustrates the troubled intersection of politics and sexuality highlighted by *A New Tradition* as crucial to Irish art in the 1980s. Yet the selection of works exhibited in the relevant sections of the exhibition series was both unsubtle and unimaginative. Maguire was one of only two male artists included in "Sexuality and Gender," whereas "Politics and Polemics" was entirely dominated by art which addressed the Northern Irish troubles. The choice of works appeared to reflect a crude curatorial assumption that "sexuality" was what women made art about, while "politics" was what Northern Irish artists made art about. Explicitly sexual imagery had, for instance, for long been a staple of the paintings and drawings of Patrick Graham. Yet Graham did not feature under this particular rubric, though he was a powerful presence elsewhere in the exhibition series.

Graham was arguably the most influential figure in Irish painting in the 1980s and an early friend and mentor of Maguire's. Six years after his first paean in praise of Maguire Donald Kuspit was to pen an even more grandiloquent appraisal of the Graham's paintings and what he believed was their epoch-defining importance. The fact that by 1994 Neo-Expressionism was considerably more embattled internationally than it had been in the late 1980s is evident in the belligerent tone Kuspit adopted for his defense of Graham's work:

"[At] a time when the cognoscenti want to discard painting — when they think it has collapsed from the weight of its own tradition, and is beside the point of modernity — Graham's paintings persuade me that it is still possible to make convincingly grand paintings, about modernity no less . . . *Song of the Yellow Bittern* and *The Life and Death of Hopalong Cassidy*, both 1988, and *The Lark in the Morning* and *Native Home*, both 1993, are works of consummate ambition as well as depressing modernity. They are paintings that tell us, on a grand physical, emotional, and intellectual scale, a good deal about the unfortunate

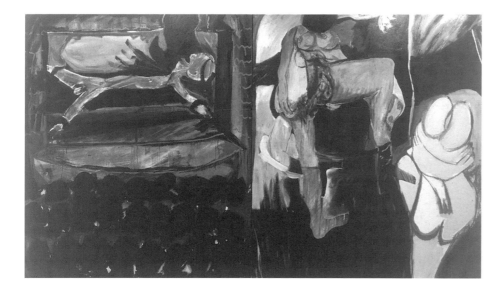

Fig. 60. Brian Maguire, *Homage to Orwell's 1984*, 1985, acrylic on canvas, 67¾ × 113⅜ in. (172 × 288 cm), Irish Museum of Modern Art Collection

effects of modernity on the individual psyche – on the modern subject They are among the most complicated, salient reflections on modern existence that have been made in the last decade."[14]

While stressing the significance of Graham's paintings as both reflections and critiques of "modern life," Kuspit simultaneously argues, on the one hand, that these paintings are "medieval in spirit" (he rather recklessly adds "as emotionally medieval as Ireland?") and, on the other, that Graham is ultimately "a postmodernist." The pre-modern, the modern and the post-modern meld giddily in this account of the artist's furious attempts "to freely synthesise whatever elements from the past, recent and remote" he chooses to mobilize "in order to find a form for the anguish of the present."[15] Religious and sexual imagery loom large here. Among the works Kuspit describes curiously as "abstract expressionist Triumphs of Death" is *The Lark in the Morning I* (1991–93, fig. 61). One of the elements which punctures the tortured, lacerated surface of this gigantic ruin of a painting is a rude rendition of an exposed vagina. The labia of slashed canvas enfold a clitoral pearl bead and are presided over by the outline of a small gold heart while the patch of canvas from which they extrude is fringed by cartoonish sprigs of pubic shrubbery. Here Eros and Thanatos meet, though it is difficult to disagree with Kuspit as to which is triumphant. While this painting post-dates *A New Tradition* by some years, one of the questions it raises was addressed by Joan Fowler in her introduction to the "Sexuality and Gender" section of the series. In an

extended patchwork of quotations from Graham himself and from Roger Cardinal's 1984 book on Expressionism Fowler suggests that Cardinal's account of the original Expressionists serves also as a persuasive description of Graham's work. In this regard she finds it telling that Cardinal avoids referring to Freud's analysis of Eros and Thanatos and restricts himself to "the more traditionally Christian concept of the mystical." Fowler argues that the adoption by Graham, and to a lesser extent by Michael Mulcahy, of an Expressionist ethos which elevates intensity of experience to an artistic imperative tends to collapse sexual experience into the experience of art and art making, thereby precluding an engagement with the social or political aspects of sexuality.[16] Brian Maguire's evident interest in social and political issues is, for Fowler, a saving grace, though she describes his art as operating "down a fine line between self-indulgence and a statement about the individual in modern society."[17]

Graham, Mulcahy and Maguire had participated in the 1983 exhibition *Making Sense: Ten Painters 1963–1983* at Dublin's Project Arts Centre, which marked the triumphant coming of age of Neo-Expressionism in Ireland. No women were included in the exhibition. Alice Maher is one of a number of women artists whose early work in the 1980s had to contend with the fact that the predominant mode of expression was one with a history inextricably bound up with masculinist notions of the primacy of gesture, genius and authenticity. Maher's initial response to expressionism, as Fionna Barber has pointed out, took the form not of outright rejection but of negotiation, retaining certain pictor-

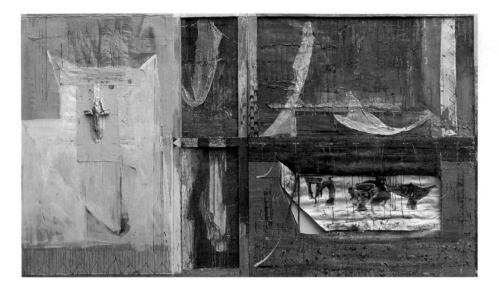

Fig. 61. Patrick Graham, *The Lark in the Morning I*, 1991–93, oil and mixed media on canvas, 84¹/₄ × 144 in. (214 × 366 cm), Jack Rutberg Fine Arts, Los Angeles

ial strategies of expressionism while at the same time attempting to subvert them.[18] Barber's list of the ingredients which constitute Maher's painting – a mixture of mythology and memories of a rural Irish childhood enriched by an active engagement with various aspects of modernist, postmodernist and medievalist representational painting – seems remarkably similar to Kuspit's account of Patrick Graham. Yet for all the seething chaos of a typical Graham canvas, its fractured sadness or despair, it exists primarily as a vehicle for articulating the wildness or woundedness of a transcendent male ego. The orchestration of its disparate elements, including renditions of the female nude derived from traditional, academic life-drawing, gives voice to the artist's inchoate feelings of rage or mourning. Barber reads Maher's superficially expressionist works on paper from the late 1980s very differently. They are "highly confrontational in their depiction of gender imagery" and operate "as a means of doing violence to the stereotype and articulating an anger at its power."[19] A feminist critique of Graham's confrontationalism would most likely see it as a means of doing violence with stereotypes rather than to them, and of harnessing their power in order to articulate a far more generalized sense of anger.

A reading of Maher's work up to and including the nine drawings that make up *The Thicket* (1990, fig. 62) which seeks to disassociate it entirely from an otherwise inimical expressionism will always involve a degree of special pleading. In her most recent work, however, an engagement with expressionism has given way to invocations of a Surrealist inheritance more obviously amenable to her needs. Despite

the fact, noted by Barber, that "the sign of 'Woman' ultimately functioned as a catalyst for the emotional response of the male Surrealists" and that, historically, Surrealism "effectively contained and marginalized the position of women Surrealist practitioners",[20] an increasing number of contemporary women artists have drawn considerable sustenance from the legacy of once marginalized figures such as Meret Oppenheim and Louise Bourgeois. In Ireland these include Maher, the sculptor Dorothy Cross and, to a lesser extent, Kathy Prendergast. This was most evident in Maher's 1995 exhibition *familiar* at the Hyde Gallery, where each of her large-scale paintings was accompanied by a three-dimensional object (fig. 63), a number of which were formally evocative of Minimalist sculpture. Instead of the solid industrial materials and streamlined finish typically associated with Minimalism, however, Maher's objects were handwoven in flax, a natural, organic material. She thus also aligns herself with the critical reappraisal of Minimalism evident in the work of so many of her contemporaries internationally.[21]

Maher's gradual turn away from a densely energetic expressionism toward a more coolly enigmatic painting augmented by sculpture has resulted in an opening up of interpretational space, both between individual, related works and between those works and the viewer. It is intriguing that this should have coincided with a recent development in Brian Maguire's work which has a comparable import. Maguire's allegiance to expressionism, which he has referred to as "an extremely honourable tradition of Northern European painting," remains intact. In 1993, however, he

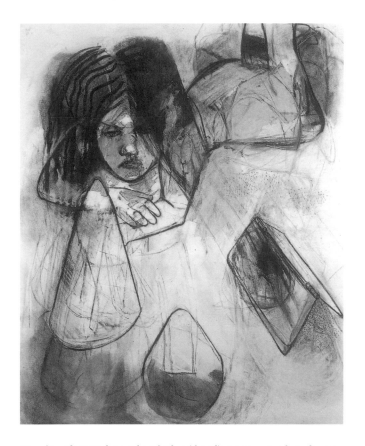

Fig. 62. Alice Maher, *The Thicket* (detail), 1990, mixed media on paper, 55 × 44 in. (140 × 112 cm), courtesy of the artist/Green on Red Gallery, Dublin

Fig. 63. Alice Maher, *Familiar IV*, 1994, oil and acrylic on canvas and flax on light steel, 78³/₄ × 98¹/₂ in. (200 × 250 cm), Irish Museum of Modern Art Collection

exhibited a series of photographic works and a short film in the Irish Museum of Modern Art as one of the artists shortlisted that year for the prestigious Glen Dimplex Award. While working within the Irish prison system Maguire found that there already existed a small cottage-industry in portrait-painting served by a few artistically minded prisoners. Maguire's response to this was to paint his own portraits of various prisoners which he then gave to the sitters (fig. 64). When he subsequently thought of exhibiting them he struggled with the problem of how best to portray the intense humanity of an institutionalized individual in what he deemed a relatively debased art form. Given that most contemporary portraitists trade in the hidden intimacies of the private commission or the aggrandizement of a public personage, how does an artist who has always divided his loyalties equally between the personal and the political come to terms with a genre increasingly forced into the extremes of one domain or the other? Maguire decided upon two, complementary solutions.

Filming with a rostrum camera set up in front of one of his portraits, he attempted to retrace with the camera's movements the painterly gestures by which the image was originally constituted. The film was then shown with an accompanying soundtrack on which a woman's voice read monotonously from *The Rules for the Government of Irish Prisons*. The viewer was thus invited to participate in the intimate surveillance of a representation of a prisoner while simultaneously being exposed to some of the thinking behind the prison system. Maguire also exhibited a series of backlit photographs of portraits of individual prisoners taken in the surroundings of their own homes, thereby emphasizing the domestic comforts, however meager, of which the subjects had been forcibly deprived.

To invoke Kuspit once more, this is how a Maguire picture that is *reproduced* rather than *produced* operates. Despite its traditional associations with a notion of documentary truth-telling, photography (both still and moving) here functions as a distancing mechanism which crucially tempers

Fig. 64. Brian Maguire, *Portrait of Brian O'Hara*, 1994, photographic lightbox, 48 × 48 in. (121.9 × 121.9 cm), Photo courtesy of Irish Museum of Modern Art

the sense of an immediate, visceral encounter with captive, suffering humanity suggested by the conventions of Expressionism. It offers the viewer the space to reflect on the mediated nature of the imagery without necessarily diminishing its power. The opening up of just such a space has been a key concern of some of the most interesting Irish art of recent years. A similar strategy was employed in the very different work made in response to the plight of political prisoners which was exhibited by Shane Cullen alongside Kathy Prendergast's *City Drawings* at the 1995 Venice Biennale. Cullen, who was not included in *A New Tradition*, is something of a maverick figure in contemporary Irish art. The pairing of Cullen with Prendergast, when first announced, had caused a few raised eyebrows in the Irish art world, not least because their respective sensibilities did not seem immediately compatible. Yet points of comparison between the two principal works exhibited by them in Venice were not difficult to find. In the first instance, both were incomplete projects though, as was noted in the case of *City Drawings*, in one sense they were no less complete a moment after their initial conception than they would be when they drew to a natural close. One trait both artists

shared was a quiet obsessiveness. In 1993 Shane Cullen had embarked on a project every bit as ambitious as Prendergast's, one that eventually resulted in a monumental wall made up of 96 large painted panels bearing documentary witness to the 1981 Irish hunger strike: *Fragments sur les Institutions Républicaines IV* (1993–97, fig. 65). By the summer of 1995 just over a quarter of these panels had been completed. The laborious task the artist set himself was to paint by hand a text of some 35,000 words comprising an intermittent series of letters from Irish Republican prisoners. These were the communications – known as "comms" – to the external leadership of the IRA which were smuggled out of the Maze prison during the course of the 1981 hunger strike.[22] The result was a gradually unfolding testament to one of the most emotionally charged moments in the recent Irish past, meticulously painted in reversed white-on-green Bodoni font with the pride and precision of a master signwriter. The combination of Prendergast and Cullen at Venice offered the international art world tantalizing glimpses of work in (potentially perpetual) progress: interim evidence of an attempt to come to some, necessarily provisional, understanding of the convoluted geography of the contemporary world and of the contested history of contemporary Ireland, respectively. Both works provided the opportunity to see things from a different perspective, a novel point of view. Prendergast took vast metropolises of teeming millions and shrunk them to the size of the tiny anatomical illustrations they so strangely resemble. Cullen took urgent messages written on cigarette papers (to be crushed into minute pellets, wrapped in cellophane and secreted in the body's various orifices) and blew them up to the size of a billboard. Both artists exploited, as did Swift before them, the dramatic and revelatory power of distortions of scale, as they invited the viewer to peer through opposite ends of an imaginary telescope at these Brobdignagian missives and Lilliputian cities. The condescending admonition "not to blow things out of all proportion" is one of the more familiar gestures by which authority – colonial, patriarchal, familial, etc. – attempts to mask its own operations and reassert the status quo. It is an admonition both artists resolutely chose to ignore.

Deleuze and Guattari's concept of "deterritorialization" has already been deployed in discussing Prendergast's subversive cartography. One crucial manifestation of deterritorialization in what Deleuze and Guattari term "minor

literature," writing which is by definition oppositional, is the attention drawn to the disjunction between eating and writing (perceived as an intensified form of speaking). For, as they argue, "to speak, and above all to write, is to fast."[23] This disjunction is dramatically underlined by Shane Cullen's work. Maud Ellmann has noted the curious complicity between starvation and garrulity implied by the frequently loquacious nature of the writings of the Irish hunger strikers: "The bodies of the starvers dwindle as their texts expand, as if they were devoured by their prose."[24] Given the difficulty of acquiring writing materials and the danger and discomfort of exchanging written messages we might expect such communications to be terse and to the point. Yet to read through the texts re-presented here by Cullen is to be surprised by their range and variety, the shift and clash of registers as they move through analytic agonizing to incredulous outrage to abashed intimacy to the stirring rhetoric of the public communiqué. Obviously the need to maintain group morale was at least as important as the exchange of vital information. The consolidation of fraternity was crucial as the hunger strikers' flesh gradually became words. For, as Ellmann notes, "the starving body is itself a text, the living dossier of its discontents, for the injustices of power are encoded in the savage hieroglyphics of its suffering."[25]

The brutal eloquence of these absent bodies, these bodies become text, provides a cruel counterpoint to the poignancy of the reconfigured body presented in much of Kathy Prendergast's work. Yet this eloquence is refracted through a complex of strategies employed by Cullen in order to re-present the prisoners' words in a very different form and context to that in which they were originally produced. Mick Wilson has listed some of these strategies: "[Cullen's] choice of Bodoni typeface with its specific associations of Republican Virtue, the deliberate re-ordering of the typography [of Beresford's book] to conform to the format of the newspaper, the uneven trace of manual touch within the constraints of the chosen mechanical standard, the use of paint, the monumental format and the contemporary art-gallery context."[26] *Fragments* is clearly the result of a genuine attempt to come to a greater understanding of an especially painful episode in recent Irish history; an episode to which many observers reacted at the time with a mixture

Fig. 65. Shane Cullen, *Fragments sur les Institutions Républicaines IV*, 1993–97, acrylic on polystyrene board, 96 panels, each panel 23⅝ × 96 in. (60 × 244 cm), Orchard Gallery, Derry

of distanced bafflement and guilty feelings of complicity, especially those south of the Irish border. Cullen, moreover, has indicated that he views this work to some extent as a contribution to "the noble tradition of the documentary." Yet the range and nature of Cullen's strategic interventions between his raw material and the viewer, and the fact that in other works he has subjected a wide variety of very different material, from labor legislation to train timetables, to a similar process of meticulous reproduction, precludes an interpretation of any of these works as a simple endorsement of the content of the chosen texts. As Wilson notes,

"The complex of strategic traces in the *Fragments* . . . demands of the viewer that they forego any simple and unambiguous connection between the representation and the represented. However, the work also refuses the viewer the comfort of abandoning the referent altogether in the name of the free play of signs."[27]

In their different ways, Cullen's textual redeployments, Maher's sculptural augments, Maguire's foray into photography and film (however brief or ancillary to his normal practice), and Prendergast's persistent remappings have contributed to an expansion of the range of Irish art and an increase in the demands it makes on its public in the closing decade of the century.

1 It is worth noting that in 1975 Conor Cruise O'Brien, in a subsequently much quoted phrase, referred to the area where literature and politics overlap in Ireland as an "unhealthy intersection" which tended, through a surfeit of romanticism, to produce bad and blinkered politics.

2 The exhibition predated the long awaited opening of the Irish Museum of Modern Art by just over a year.

3 Aidan Dunne, "Back to the Future: A Context for Irish Art of the 1980s," *A New Tradition: Irish Art in the Eighties* (Dublin: The Douglas Hyde Gallery, 1990), p. 21.

4 A selection from *City Drawings* was shown at the Tate Gallery, London, in 1997. The work in its entirety was acquired by the Irish Museum of Modern Art the same year. In the following discussion and in the concluding discussion of the work of Shane Cullen I draw extensively on my catalogue essay for the Venice exhibition, *Reterritorializations: Finding the Words and Drawing the Picture* (1995).

5 Italo Calvino, *Invisible Cities*, trans. William Weaver (New York: Harcourt Brace, 1974), p. 14. Maité Lores, in a recent article, has noted that a reference to Calvino's work in relation to the *City Drawings* has become almost de rigeur in commentary on the work: "Kathy Prendergast: City Drawings," *Contemporary Visual Arts*, no. 15 (1997), pp. 70–71.

6 For somewhat different interpretations of Prendergast's cartography see Catherine Nash, "Remapping the Body/Land: New Cartographies of Identity, Gender, and Landscape in Ireland," in *Feminist Review*, no. 444 (1993), pp. 39–57; and James M. Smith, "Retelling Stories: Exposing Mother Ireland in Kathy Prendergast's *Body Map Series* and Mary Leland's *The Killeen*," in Alston Conley and Jennifer Grinnell, edd., *Re/Dressing Cathleen: Contemporary Works from Irish Women Artists* (McMullen Museum of Art, Boston College, 1997), pp. 43–51.

7 Caren Kaplan, "Deterritorializations: The Rewriting of Home and Exile in Western Feminist Discourse", in Abdul R. JanMohamed and David Lloyd, edd.), *The Nature and Context of Minority Discourse* (New York: Oxford University Press, 1990), p. 358.

8 Gilles Deleuze and Félix Guattari, "What Is a Minor Literature", in *Kafka: Towards a Minor Literature*, trans. Dana Polan (University of Minneapolis Press, 1986), p. 17.

9 Aidan Dunne, "Saving the Phenomena: Formalist Painting in the 1980s," in *A New Tradition*, p. 97. Dunne suggests a reading of certain maneuvers made by Irish abstract painters during the 1980s either as a progressive attempt "to transcend the boundaries of a constricting creed" of modernist formalism or as a conservative (and arguably opportunistic) bolstering of its credibility by incorporating within it "a few additional postmodern epicycles." The latter reading emphasizes the gravitational force of the "new" figuration – and of the "postmodern turn" it was frequently deemed to reflect – which tended to pull otherwise incompatible works into its discursive ambit.

10 Joan Fowler noted the resistance of a number of these artists to this categorization and their insistence that their work be seen as a continuation of the principles established by the Independent Artists group in Ireland, which was originally formed in 1960: "Speaking of Gender...: Expressionism, Feminism and Sexuality," in *A New Tradition*, p. 53.

11 Medb Ruane, "Introduction," *A New Tradition*, p. 5.

12 Donald Kuspit, *Brian Maguire* (Dublin: The Douglas Hyde Gallery, 1988), unpaginated. Kuspit had made the case for the importance of Neo-Expressionism most famously in his 1983 essay "Flak from the 'Radicals': The American Case against Current German Painting," reprinted in Brian Wallis (ed.), *Art After Modernism: Rethinking Representation* (New York and Boston: The New Museum of Contemporary Art David R. Godine, 1984), pp. 137–52. Kuspit returned to Maguire's work in a subsequent catalogue essay, "Brian Maguire's Primitivism," *Brian Maguire: Paintings '90–'93* (Dublin and Derry: Kerlin Gallery/ Orchard Gallery, 1994), pp. 7–13.

13 This and subsequent quotations are from an unpublished conversation with the author in 1996.

14 Donald Kuspit, "Patrick Graham: Painting as Dirge,"in *The Lark in the Morning: Patrick Graham* (Dublin: The Douglas Hyde Gallery, 1994), p. 7.

15 Ibid., p. 8.

16 Fowler, "Speaking of Gender," *A New Tradition*, p. 54.

17 Ibid., p. 56.

18 Fionna Barber, "Unfamiliar Distillations," in *familiar: Alice Maher* (Dublin: The Douglas Hyde Gallery, 1995), pp. 16–17.

19 Ibid., p. 13.

20 Ibid., p. 11.

21 Evidence for this may be found in exhibitions such as *Sense and Sensibility: Women and Minimalism in the Nineties* at the Museum of Modern Art in New York in 1994 and the growing recognition of the centrality of Eva Hesse in the canon of post-war art.

22 They were systematically transcribed from David Beresford's *Ten Men Dead: The Story of the 1981 Irish Hunger Strike* (Dublin: Grafton Books, 1987) in the order in which they appear embedded in Beresford's narrative account.

23 Deleuze and Guattari, p. 20.

24 Maud Ellman, *The Hunger Artists: Starving, Writing and Imprisonment* (London: Virago, 1993), p. 70.

25 Ellman, pp. 16–17.

26 Mick Wilson, "Fragments and Responses," in Liam Kelly, ed., *Shane Cullen: Fragments sur les Institutions Républicaines IV* (Derry: Orchard Gallery/ Centre d'art contemporain de Vassevière en Limousin), p. 17.

27 Ibid., p. 19.

CATALOGUE

JOHN LOSITO
JAMES STEWARD

1 WALTER FREDERICK OSBORNE (born 1859, Dublin – died 1903, Dublin)

Tea in the Garden

1902
oil on canvas
52 × 85½ in. (132 × 217 cm)
Collection Hugh Lane Municipal Gallery of Modern Art, Dublin

Walter Osborne was one of a number of Irish artists who emigrated under the auspices of artistic education and subsequently maintained a geographical distance from their homeland. His training on the Continent opened his eyes to new styles and subjects. Throughout his time abroad, Osborne maintained ties with Ireland by exhibiting his work in Dublin, but he found his artistic niche outside of Ireland and ultimately returned only because of familial obligations.

Osborne's consequential art education began in 1881 when he left Ireland and enrolled at the Académie Royale des Beaux Arts, Antwerp, where he became a pupil of Charles Verlat (1824–1890), who later directed the artistic education of Irish artist Roderic O'Conor (see Plate 21). After a year of Verlat's tutelage, Osborne went to Brittany in the west of France where he joined the league of painters lured to artists' colonies in such towns as Pont-Aven and Quimperlé. Here he pursued an interest in plein air painting – a method that was not taught to him in Dublin or Antwerp. He met numerous artists and experimented with a diversity of styles while in Brittany. In 1884 he departed for England where he remained until 1892. His decision not to return to Dublin seems deliberate but its reasons remain unclear. One scholar has speculated that he wished to paint with a group of British artists with whom he had developed friendships while in Belgium, pointing out that the Royal Hibernian Academy had strong ties with the Walker Art Gallery in Liverpool (where the present exhibition will, coincidentally, premiere), where Osborne could exhibit his work.[1] Although he made regular visits to Dublin to show his work and was a founding member of the Dublin Art Club, it is reasonable to suspect that Osborne's decision to live in England stemmed from a desire to be less isolated than he might have been in Ireland, although he would still have retained his residency in the United Kingdom (since 1800 and the Act of Union Ireland had been formally incorporated into the United Kingdom). Deeply committed to his painting as he was, Osborne was certainly not so preoccupied as to be oblivious of the growing strength of Irish nationalism;

his refusal of a British knighthood offered in 1900 – as opposed to William Orpen and John Lavery who accepted theirs – perhaps speaks to his politics, although this is unclear.

Tea in the Garden is one of the last paintings done by Osborne and was left unfinished at his death. It is typical of the outdoor genre paintings Osborne carried out in the last ten years of his life, showing a shift from the more linear artistic progression espoused by Verlat in Antwerp – a factual approach – to one that was more spontaneous and utilized a wider range of color. *Tea in the Garden* thus demonstrates this change to a more Impressionistic style, albeit a quarter century after the heyday of French Impressionism in the 1870s. The outdoor scene shows Osborne's neighbor, a Miss Crawford, pouring herself a cup of tea in her family's garden in Dublin. A younger girl, presumably Miss Crawford's sister, stands behind assisting with the pouring of the tea. Osborne's niece is seated on the grass with another child, while seated on the bench in the background is a barely discernible elderly woman, possibly the artist's mother. As an unfinished work, the painting offers wonderful insight into Osborne's mature style and process. One can view the quickly rendered, initial layer of paint on the right side of the work from which the figures begin to emerge. Their ultimate appearance can be compared to the finished figures on the left that show the final application of paint, giving them a real presence. The painting is testimony to the influence of the French Impressionists on Osborne in the free handling of the brushwork and bright palette, adapted to serve an Irish subject. His interest in experimenting with the effect of light through trees and a range of saturated colors in his last years has prompted Julian Campbell to comment that Osborne is probably the only artist who can properly be termed "an Irish Impressionist."[2]

1 Jeanne Sheehy, *Walter Osborne* (Dublin: The National Gallery of Ireland, 1983), p. 25.
2 Julian Campbell, *The Irish Impressionists: Irish Artists in France and Belgium, 1850–1914* (Dublin: The National Gallery of Ireland, 1984), p. 88

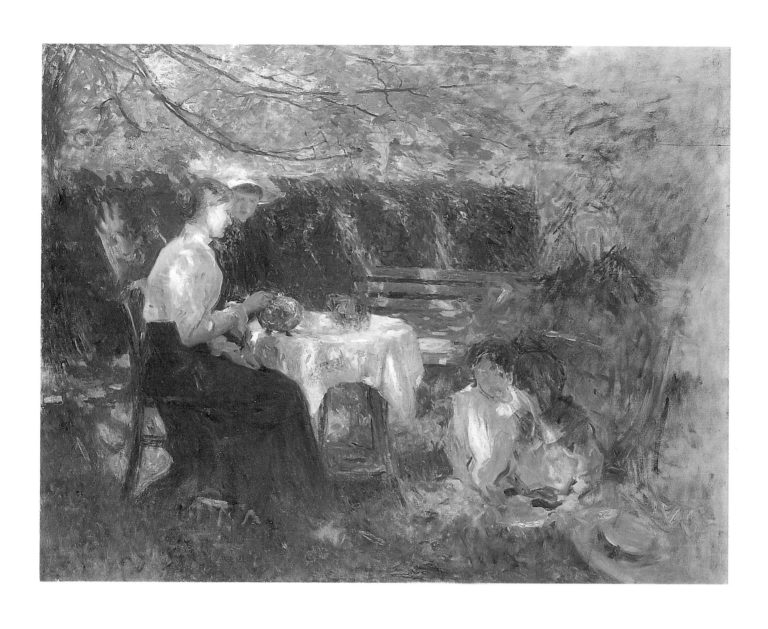

2 SIR WILLIAM ORPEN (born 1878, Stillorgan, Co. Dublin – died 1931, London)

The Wash House

1905
oil on canvas
35⅞ × 28¾ in. (91 × 73 cm)
The National Gallery of Ireland
(Not exhibited at Walker Art Gallery, Liverpool)

Sir William Orpen was born in Stillorgan, Co. Dublin, the sixth and youngest child of staunch Unionist parents. He entered the Metropolitan School of Art, Dublin at age thirteen. During Orpen's second year of schooling, the administration introduced the use of a nude model for life drawing class; Orpen showed exceptional skill at rendering form and proportion – a hallmark of his later work. In 1897 he moved to London to attend the Slade School of Art where he studied for four years. He was hired to teach part time in the evening at his alma mater in Dublin in 1902 and was an influential figure for a group of young artists enrolled at the school including Patrick Tuohy and Seán Keating, both of whom are also represented in the present exhibition.

While Orpen's influence on successive generations of Irish artists has long been recognized, it is clear that this influence was restricted mainly to technical issues. For Orpen, although born in Ireland, was really an English artist and as such a throwback to eighteenth- and nineteenth-century traditions in which Irish-born artists emigrated and became English, to all practical purposes, in order to find success. In Orpen's case, this was in part due to his family's religious beliefs but more principally to his own personality and beliefs and to the continuing economic realities of the prevailing art market. In London, Orpen found numerous patrons, many within the upper echelons of society, who were responsible for his economic success. Orpen's lifestyle in London might also be seen as a motivation for staying in his adopted city: although married, he often lived the life of a well-to-do bachelor, frequenting clubs and keeping a mistress – both of which might not have been possible in the economic, social, and political reality of Dublin in the first years of the century.

An interesting comparison can be made between Orpen and his contemporary Jack B. Yeats. Orpen's artistic identification went in another direction, one that paired him with the Welsh-born artist Augustus John (1878–1961). John and Orpen met while students at the Slade School of

Art. Like Orpen, John won a reputation as one of the most brilliant draughtsmen in England, and his portraits and other paintings done around 1900 gained attention for the vigor and originality of their approach and technique. The two artists embarked on a business venture in 1903, the Chelsea Art School, that ultimately failed in 1905 just as Orpen was painting *The Wash House*.

Orpen's model in *The Wash House* was a woman named Lottie Stafford who reappears in a number of works by Orpen, including *Lottie and the Baby* (see Plate 3).[1] Lottie was a wash woman who lived and worked in the London slum neighborhood called Paradise Walk. Along with other artists, Orpen found her to be a remarkable model owing to her facial features, body type, and the manner in which she carried herself. The model's neck was of particular interest to Orpen and figures prominently in both paintings of Lottie in the current exhibition. Here, she pauses momentarily and looks up from her washboard to see the female figure descending the stairs, bringing a new load of laundry to be cleaned. Turning away from the viewer, Lottie exposes her neck, which Orpen has cleverly accented with a burst of light in order to emphasize the fact that this attitude is a particular moment in time caught by the artist, rather like the unusual poses and vantage points of Edgar Degas's paintings of women at work. Like Degas or the American painter John Singer Sargent in his Venetian genre scenes, Orpen has painted a woman whose life is toilsome and harsh, yet he softens this hard edge with the luminosity and delicate femininity of the neck, painted with a flourish of light color. Through the contrast of pitiless reality and underlying beauty, Orpen creates a powerful work that reflects his consummate skill for understanding and rendering the human form.

1 Another version of *The Wash House* is in the collection of the National Gallery of Canada, Ottawa, and is entitled *Lottie of Paradise Walk*.

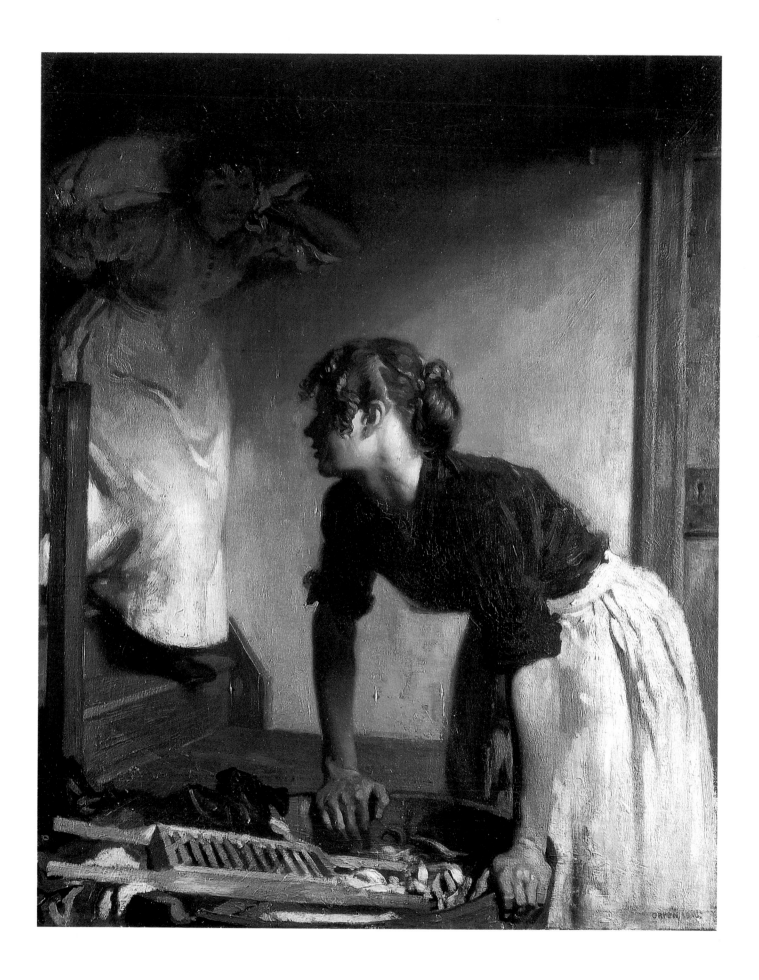

3 SIR WILLIAM ORPEN

Lottie and the Baby

1907
oil on canvas
24 × 20 in. (61 × 51 cm)
Board of Trustees of the National Museums and Galleries on Merseyside (Walker Art Gallery)
(Exhibited only at Walker Art Gallery, Liverpool)

After the failure of his art school business in 1905 (see previous page), Sir William Orpen continued to receive portrait commissions and to teach art. His reputation in both areas was stellar and he reaped the financial rewards of success: for an artist of his day, he enjoyed great material comfort, something that would not have been realized had he stayed in Dublin. His paintings from the late 1890s firmly established him as an artist of merit and led directly to his becoming a prolific painter of society portraits. His career after art school was similar to that of John Lavery's (see Plates 7, 9, 10, 17, and 26), who also enjoyed the favor of upper-class patrons in London. Like Orpen, Lavery was born on the island of Ireland and set up a prosperous portrait business, but at the same time they differed both stylistically and politically. Lavery took a non-partisan view of the conflict in Ireland after 1916 and, along with his wife Hazel, assumed the role of political mediator, espousing a sincere belief in reconciliation between Unionists and Republicans. Orpen, on the other hand, showed little interest in Irish political affairs and unceremoniously resigned from the Royal Hibernian Academy in 1915. Orpen's legacy to Irish history can be seen rather in the work of a number of prominent Irish artists who had the good fortune of being instructed by him at the Metropolitan School of Art in Dublin from 1902 to 1914. Orpen was an artist's artist, generally not concerned with politics at a highly political time; his passion was for art, and the practicalities of drawing and painting garnered all of his attention.

Along with commissioned works, Orpen painted allegorical and interior genre scenes relying on paid models and family and friends as sitters. One of his preferred models was a woman named Lottie Stafford who worked as a wash woman in the slum neighborhood of Paradise Walk in London. From 1905 to 1907, Orpen used her in a series of paintings including *The Wash House* (see Plate 2) and *Lottie and the Baby*. In the latter, Lottie is seated in a chair, drinking from a large tin cup, a baby resting on her lap. She wears an apron and the same dress she has on in *The Wash House*, but here Orpen shows her taking a break from the drudgery of laundering clothes. Her baby's face is sickly looking and full of pathos, suggesting the impoverishment of life in the slums. Indeed, the baby bears a greater resemblance to one of the monkeys that Orpen saw as a child at the Dublin Zoo than to a young child. The child's swollen facial features and chunky limbs are in stark contrast to the delicacy and grace accorded the drinking figure of Lottie who, even in her state of poverty, is invested with exuberance and vitality. The young child, however, reflects Orpen's perceptible discomfort in rendering children – even his own three daughters – throughout his career. The babies and children in his paintings bear, for the most part, strange expressions and awkward poses, lacking the refinement and natural human beauty found in his depictions of adults.

In addition to being withdrawn from politics, Orpen was not a religious man in his personal life nor did he carry out many works containing elements of religious iconography. With *Lottie and the Baby*, he seems to allude to the tradition of mother and child representations that derive from the Madonna and Child, even though his more obvious interest is Lottie and her physical appearance. As in *The Wash House*, Lottie is shown in profile, a pose that enables Orpen to draw particular attention to her neck. The scene shows unsentimentally the reality of a working mother needing sustenance to continue her job while trying to provide love and comfort to her baby child.

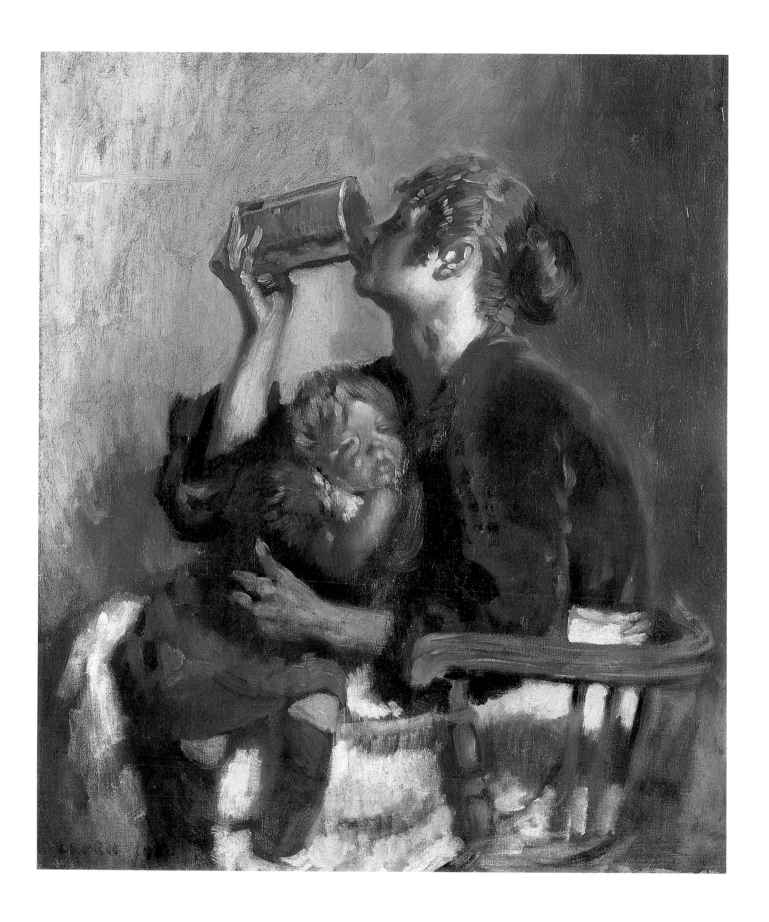

4 LADY GLENAVY (BEATRICE MOSS ELVERY)

(born 1881, Co. Dublin – died 1970, Rockall, Sandycove, Co. Dublin)

Éire

1907
oil on canvas
35⅞ × 28 in. (91 × 71 cm)
Lady Davis-Goff

Raised in an upper middle-class family that included six artistically and musically talented brothers and sisters, Beatrice Elvery in her youth befriended the artist William Orpen and the writer Samuel Beckett, who modeled as a kneeling child in an early painting by her sister Dorothy. Elvery herself served as a model both for Orpen and for Sarah Purser (1848–1943). Elvery attended the Metropolitan School of Art in Dublin with her sister Dorothy and studied with the Irish sculptor John Hughes. She was invited by Purser in 1905 to join and do design work at An Túr Gloine (The Tower of Glass), a workshop specializing in stained glass window design and fabrication which had been launched by Purser in 1903. Although in her own words she "never got the right feeling for glass or the detached, austere quality necessary for ecclesiastical art," she worked there until 1912.[1]

The subject matter of Elvery's *Éire* was drawn both from her childhood memories and, significantly, from viewing *Cathleen ni Houlihan*, a one-act play written by W.B. Yeats with Lady Gregory's help, as Yeats acknowledges in his book *Autobiographies*, and performed by Maud Gonne in 1902.[2] As told by Yeats, the story of Cathleen ni Houlihan – one of the traditional embodiments of Mother Ireland – revolves around a peasant cottage that is visited by an old woman in a long cloak who laments that her "four green fields" have been taken, and exhorts a young man to give up earthly love for, symbolically, love of the motherland. The old woman later reveals herself as a beautiful maiden, symbolically reborn by the young man's sacrifice. Gonne, who formed the revolutionary woman's society Daughters of Erin, was deeply involved in Irish politics at the turn of the century, and with her performance confirmed herself as the personification of the legendary Cathleen ni Houlihan or Mother Ireland. *Éire* was later purchased by Gonne and given to St. Edna's College in Dublin, where it elicited strong patriotic reactions from some of the students.[3]

The composition of *Éire* draws directly from Elvery's formal training and work as a sculptress and stained glass

designer and, in fact, was painted while she was employed at An Túr Gloine. The seated, hooded central figure shows considerable mass beneath the folds of cloth. The diffusion of light gives the impression of her being illuminated from behind, as if in a cathedral clerestory. The entire scene blends the color and two-dimensionality of Byzantine mosaic with the religious, devotional significance of a fifthteenth-century Italian altarpiece – influences merged within the context of the nationalist fervor prevalent in turn-of-the-century Ireland. Mother Ireland is seated, reminiscent of medieval images of the Madonna Enthroned, while the blond Child's assertive reach, and the painting's somber tones, suggest it must be read as a picture of the Second Coming – which may be the coming of the Irish fight for freedom.[4] The Celtic cross serving as the seat back for the central figure, the green *cucullus* or hooded cloak (dating from the pre-Christian era in Ireland) clasped by a brooch, and the rows of differentiated saints (presumably including the Irish saints Patrick and Bridget) all revive and extoll the Celtic past against a backdrop of brewing political upheaval. In her patriotic exuberance and naïveté, Elvery created a work displaying religious and secular metaphors – Madonna as Mother Ireland, the Christ child as young Ireland – that championed the cause of Irish independence.

1 Beatrice Lady Glenavy, *Today we will only Gossip* (London: Constable, 1964), p. 40.
2 Marjorie Reynolds, ed., *The Elvery Family: A Memory* (Cape Town: Carrefour Press, 1991), p. 8. Lady Glenavy's sister recounts how "Beatty [Lady Glenavy], in Grandmama Moss' great, black cloak (a garment which, even when hanging harmlessly behind a door, had power to frighten us), would come floating down the steep stairs from the ghost-filled tank room, moaning and waving her arms and with hooded head like a great black bat, would enter the darkened nursery, flapping the cloak and circling amongst us with moans and wails, disappearing as suddenly as she had entered."
3 Lady Glenavy, p. 91. Lady Glenavy relates how "Some time later I met one of the boys from the school and he told me that this picture had inspired him 'to die for Ireland'! I was shocked at the thought that my rather banal and sentimental picture might, like Helen's face, launch ships and burn towers!"
4 This iconographic reading was posited by Phoebe Cowles in her work at the Graduate Theological Union, Berkeley, California.

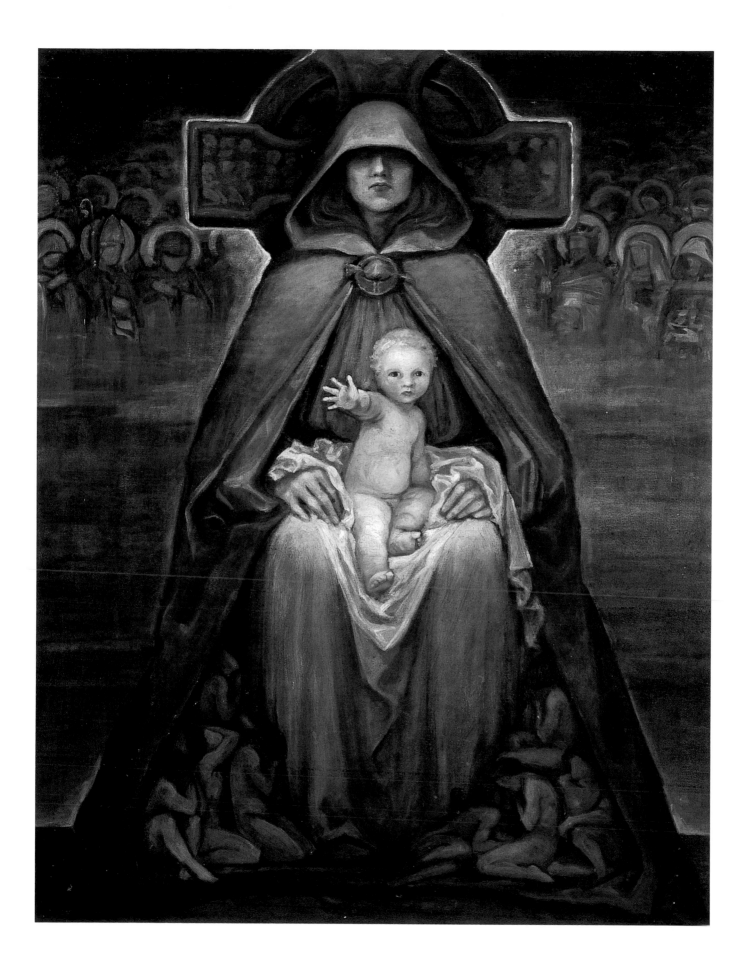

5 WILLIAM LEECH (born 1881, Dublin – died 1968, West Clandon, Surrey, England)

Interior of a Café

ca. 1908
oil on canvas
18 × 21½ in. (45.7 × 54.6 cm)
Pyms Gallery, London

William Leech was born in Dublin and began his artistic training in 1899 at the Metropolitan School of Art in Dublin but decided after one year to transfer to the Royal Hibernian Academy School, where he came under the tutelage of Walter Osborne (see Plate 1). Osborne greatly influenced Leech and taught him to work freely and quickly; after one year of study, Osborne encouraged him to go to Paris. Leech enrolled at the Académie Julian and worked under French artists William-Adolphe Bouguereau, Gabriel Ferrier, and Jean-Paul Laurens. His stay in Paris not only helped to develop his technical skills, but exposed him to other art students and to the art collections housed in Parisian museums. In 1903 Leech moved to Concarneau in Brittany, an area then dense with thriving artist colonies. His painting flourished in Brittany as Leech, like his fellow Irishmen John Lavery (Plates 7, 9, 10, 17, and 26) and Roderic O'Conor (Plate 21), found the open landscapes and seascapes – and the abundance of natural light – an ideal environment in which to work.

Leech remained in Concarneau until 1906 when he returned to Dublin. He left Ireland in 1910 and settled in England, making periodic trips to France to paint and to Ireland to exhibit his work. His close familial ties and later his relationship with May Botterell, who was to become his second wife, warranted his move to England, where he established a studio. Although Leech presented a selection of his paintings annually to the Royal Hibernian Academy in Dublin, his work was seldom purchased by collectors during his lifetime. This was obviously discouraging to the struggling artist and necessitated continued financial support from his parents and later, after their deaths, from his brother and sister. The lack of attention Leech received from Dublin art circles was no doubt due both to the skills and techniques he developed in France and his choice of subject matter; his predilection for plein air painting, with its loose brushwork and vivid coloring, was in strong contrast with the formal, academic approach espoused in Dublin art schools. And although artists such as Osborne and Lavery were able to incorporate the education received abroad and still achieve artistic success in Dublin, Leech's subject matter lacked the local flavor that was evident in the work of his countrymen.

Regardless of their marketability, Leech's paintings, such as *Interior of a Café,* display a strong handling of line and composition. Leech painted a number of interior scenes of cafés and barber shops in a palette of warm browns and green while in Concarneau. The choice of subject was predicated by the fact that cafes and barber shops functioned as the primary meeting places in town for resident artists and locals. Another work painted around the same time as *Interior of a Café*, titled *Interior of a Barber's Shop*, shares stylistic and compositional elements with the café scene to create the same sense of easy intimacy. The most noticeable is the use of a mirror, a device also employed in paintings by Orpen and Lavery, both of whom were fascinated by its visual effects and greatly admired its subtle yet powerful presence in Velázquez's *Las Meninas*. Here, Leech paints from the rear of the café facing the large mirror that covers the back wall. The reflection affords the viewer an unobstructed view of the interior from the furthest recesses to beyond the front windows and the luminous crowd outside on the street. The oblique angle at which Leech faces the mirror cleverly hides him from view and, aside from the implied wiping movement of the barkeep in the lower right, creates a scene of cool calm. The tonal variations and technical skill shown in the sure brushwork give an early indication of Leech's artistic talent, along with the same interest in turn-of-the-century internationalism that prevented his success at home.

6 SIR WILLIAM ORPEN

On the Beach at Howth

1910
oil on canvas
34¹/₂ × 46¹/₂ in. (87.6 × 118.1 cm)
Private collection, courtesy of Pyms Gallery, London

From approximately 1909 to 1913, Sir William Orpen painted a number of outdoor scenes at Howth, a port town just outside Dublin where Orpen, his wife Grace (whom he had married in London in 1901), and their two daughters, Mary ("Bunnie") and Christine ("Kit"), spent summer holidays. A third daughter, Diana, was born in 1914 just before Orpen left to work as a war artist in France. *On the Beach at Howth*[1] is one of the paintings done during this period and shows Grace and Kit lying under a parasol on the rocky shoreline. It represents a departure from the type of paintings that Orpen was known for up to that time, which had been characterized by an emphasis on the subject rather than technical experimentation. Since his earliest days as an artist, Orpen demonstrated extraordinary skills as a draughtsman which enabled him to create a harmonious synthesis of line and form evident in paintings such as *The Wash House* (Plate 2) and *Ready to Start – Self-portrait* (Plate 18).

On the Beach contains the deft line and form typical of Orpen's mature painting style, but also reveals his interest in *plein-airisme* or outdoor painting. This is the closest any of Orpen's later paintings come to the style of French Impressionism and its fascination with passing light effects; its uniqueness makes it clear that this was an area in which Orpen did not feel most comfortable. Unlike other Irish painters at the turn of the century, notably Osborne (Plate 1), Lavery (Plates 7, 9, 10, 17, and 26), and O'Conor (Plate 21), all of whom received at least some of their artistic education either in France or in Belgium and adopted to a certain extent the principles of outdoor painting, Orpen – who did travel to France after leaving the Slade School of Art in London – never adopted this style. He was influenced by Osborne in his early career at the Metropolitan School in Dublin and paintings from that period showed fledgling Impressionist qualities. Later in his career, Orpen was, how-

ever, disinclined to experiment with the effects of natural light, owing perhaps to the fact that he was a technical purist – that is to say, he was heavily steeped in traditional forms of painting relying primarily on his drawing ability. Certainly his skill allowed for tremendous flexibility of subject: portraiture, genre, and allegorical types are all to be found within his oeuvre.

The beach at Howth was for Orpen and others a bucolic site for relaxation and a close-by respite from the squalor of Dublin city life.[2] He was drawn to idyllic rural settings and wrote nostalgically:

"The chief memories of my early life in Ireland were the beauty of the mountains and the bay, the songs of the birds and the noise of the waves breaking on the shore, and the smells of the gorse and sea."[3]

These fond recollections were a motivating force in Orpen's decision to spend his summer holidays at Howth. His daughters also enjoyed the beach, and their time together there allowed him to paint a number of outdoor scenes, drawing his inspiration from his family and surrounding environment. Retrospectively, scenes such as this speak to the Edwardian idyll as a period of calm before the outbreak of war and before the storm of rebellion was unleashed in Ireland. *On the Beach* shows that Orpen was able to master the Impressionist style that was so perfectly suited to this atmosphere of benevolent relaxation, even if he never fully embraced it.

1 Also referred to as *Midday on the Beach* and *By the Sea Shore, Howth*.
2 The site later became infamous for the gun smuggling incident in 1914 that, through an arrangement by Roger Casement, brought guns from Germany to the Irish Volunteers, an event that was witnessed by Orpen.
3 Sir William Orpen, *Stories of Old Ireland and Myself* (London: Williams and Norgate, 1924), p. 43.

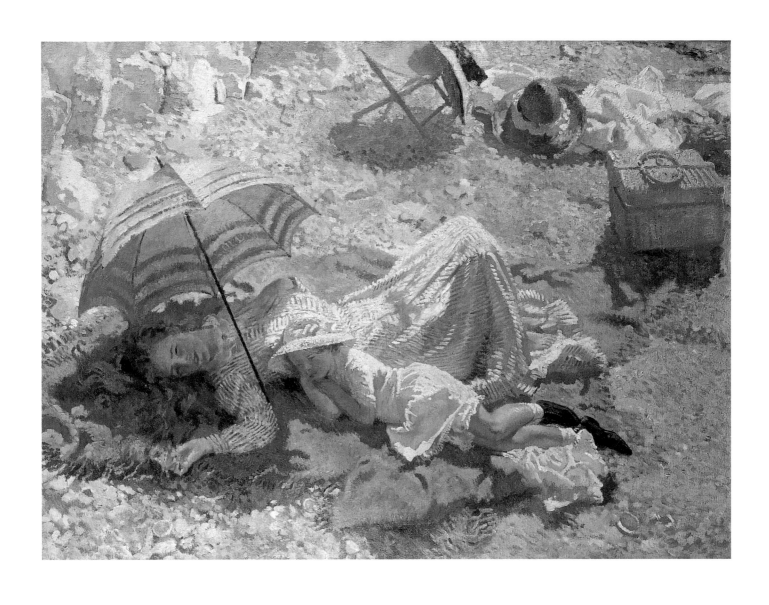

7 SIR JOHN LAVERY (born 1856, Belfast – died 1941, Kilmaganny, Co. Kilkenny)

The Greyhound

1910

oil on canvas

25 × 30¼ in. (63.5 × 76.8 cm)

Reproduced with kind permission of the Trustees of National Museums and Galleries of Northern Ireland

Sir John Lavery's *The Greyhound* represents a fine example of his mature work painted while in Tangiers, Morocco, and shows evidence of new ideas acquired from his travels and associations with established European artists. The technical skills and plein air painting method that characterize his earlier work such as *The Bridge at Grez*, 1901 (fig. 67) are evident in this interior scene. It was just after the turn of the century that Lavery began to be acknowledged as a distinguished artist, marked by selection as the Irish representative at the Venice Biennale in 1910, where he exhibited 53 works. His selection as the Irish delegate is somewhat ironic in light of the perception of him by some art critics as a British artist, disregarding his birthplace.[1] Yet Lavery himself maintained strong ties with Ireland throughout his lifetime, even through periods of prolonged foreign residency.

After leaving Belfast as a young boy, Lavery received his artistic training first in Glasgow, Scotland, where he was apprenticed to a photographer. His job entailed retouching negatives and hand-painting photographs – a task that served to develop his attention to detail and to the effect of color in enlivening a composition. After a brief sojourn in London around 1880, Lavery studied in France where he was a pupil of both William Adolphe Bouguereau and Jules Bastien-Lepage. It was Bastien-Lepage who exerted the greatest influence on Lavery, particularly by introducing him to the principles of *pleinairisme* or painting out of doors. In addition to these French artists, Lavery admired the work of James Abbott McNeill Whistler, whom he met in 1886 when both were members of the Society of British Artists.[2]

Armed with the artistic knowledge he had gained in Scotland and France and escaping the drab London winter, Lavery traveled to Tangiers in the fall of 1890, at which time he established ties with the artist community there. Tangiers offered Lavery not only access to a foreign cultural environment, but the change in geography brought with it a different atmosphere of light and shade in contrast to the predominantly dull, wintry gloom in London. In this setting, Lavery was able to develop a broader palette and experimented with new effects of color in rendering his compositions. Lavery ultimately established a residence outside of Tangiers, where he and his daughter Eileen spent time (Eileen's mother and Lavery's first wife, Kathleen, had died shortly after Eileen's birth in 1891).

The Greyhound depicts Sir Reginald Lister, the British envoy in Tangiers, and Eileen conversing in the finely decorated drawing-room of the British Legation. The Laverys had befriended Sir Reginald, and both he and Eileen were favorite models for Lavery during his residency in Tangiers, as was the Lavery's greyhound, Rodney Stone. Eileen stands leaning against the mantle dressed in riding attire, as she and her father had become accomplished equestrians during their visits to Morocco. The stateliness of the room and Sir Reginald's relaxed yet dignified posture reflect the prevailing image of colonial power.[3] Morocco in the early twentieth century was under the divided protectorate of France and Spain, which gave the Arab city a certain European aura. Lavery's ability to render interior portrait scenes calls to mind the work of Velázquez, which Lavery had seen during a visit to Madrid in 1891. Lavery was a great admirer of the Spanish master; another painting from 1910, *The Artist's Studio*, pays homage to Velázquez's great masterpiece *Las Meninas*. *The Greyhound* reflects the mature style of painting that secured for Lavery a position as society painter for an international clientele that persisted throughout the remainder of his career.

1 See for example Selwyn Brinton, "Some Recent Paintings by John Lavery, R.S.A., R.H.A," in *The Studio* (XLV, no. 189, December 1908), p. 171, and James Stanley Little, "A Cosmopolitan Painter: John Lavery," *The Studio* (XXVII, no. 115, October 1902), p. 115.
2 Walter Shaw Sparrow, *John Lavery and his Work* (London: Kegan Paul, Trench, Trübner & Co., Ltd, n.d. [1911]), p. 157.
3 Kenneth McConkey, *Sir John Lavery* (Edinburgh: Canongate Press, 1993), p. 98.

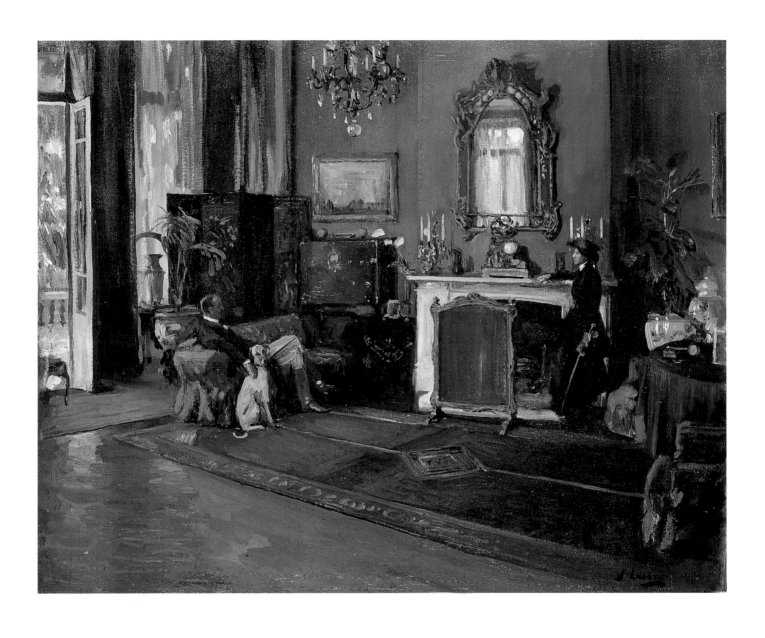

8 WILLIAM LEECH

Les Soeurs du Saint-Esprit, Concarneau

ca. 1910–12
oil on board
20¹/₂ × 29 in. (52 × 73.5 cm)
Private collection, courtesy of Pyms Gallery, London

William Leech was born into a prominent Protestant Dublin family; his father was a highly regarded lawyer who was a staunch Unionist and published several articles on the advantages of a continued relationship with Great Britain and in opposition to Home Rule. In this politically charged environment Leech was raised with his five brothers and one sister, all of whom achieved academic success. The death of his youngest brother, Frederick, in 1906 just after Leech had returned from a three-year stay in Concarneau had lasting repercussions on his entire family. But it must have been the rising tide of nationalist fervor then building in Ireland that was the determining factor in the elder Leech's decision to move from Dublin to London in 1910. The younger Leech was deeply involved in his work and made no reference to politics in his actions or art. His status as an expatriate of sorts was due primarily to his inability to support himself by his art; he lived with his parents both in Dublin and in London until as late as 1912.[1]

Les Soeurs du Saint-Esprit (The Sisters of the Holy Spirit) depicts an order of nuns who lived in a convent and ran the hospital in Concarneau where Leech recovered from typhoid fever in 1904. A resident in the town for three years as well as a patient in the hospital, Leech was able to make daily observations of the activities of the nuns. In this particular scene, Leech shows them in procession as they walk in the light of the setting sun outside the fortified walls of the *ville close* (walled city). Concarneau was an ideal location for painting as it offered both a myriad of subjects – ranging from the nuns in their traditional white habits, to the traditional Breton peasant dress as seen in contemporary postcards, to the fish market located in the center of town – and inexpensive lodgings for a struggling artist. In this environment, Leech displayed a mature handling of plein-air painting that rivals the work of French Post-Impressionists such as Jules Bastien-Lepage. Indeed, there is a particular quality of light here that is especially reminiscent of Bastien-Lepage, with a clarity in the light effects absent from their French predecessors, including Claude Monet.

The scene of a procession is reminiscent of a number of paintings employing a similar subject, such as *Corpus Christi Procession* (fig. 66) painted about 1880 by Aloysius O'Kelly (1853–1926). O'Kelly was one of the first Irish artists to paint in Brittany, having arrived in the 1870s, and Leech spent time with him in Concarneau from 1903 to 1909. Leech may have been specifically influenced by O'Kelly's work in the treatment of light on the white headdresses and capes of the figures and on background surfaces such as the walls visible in both paintings. Unlike O'Kelly, Leech renders a more polished painting, one that demonstrates an understanding of the interplay of light and shade, as in the diaphanous fabric of the capes flowing behind the nuns, as well as compositional devices that provide rhythm to an otherwise conventional genre scene. In this instance the meditative tranquillity of the religious figures is interrupted by the tree in the foreground visually dividing the group.

Fig. 66. Aloysius O'Kelly, *Corpus Christi Procession*, ca. 1880, oil on canvas, 23¹/₄ × 15³/₈ in. (59 × 39 cm), AIB Art Collection

1 Denise Ferran, *William John Leech: An Irish Painter Abroad* (London: Merrell Holberton, 1996), p. 13.

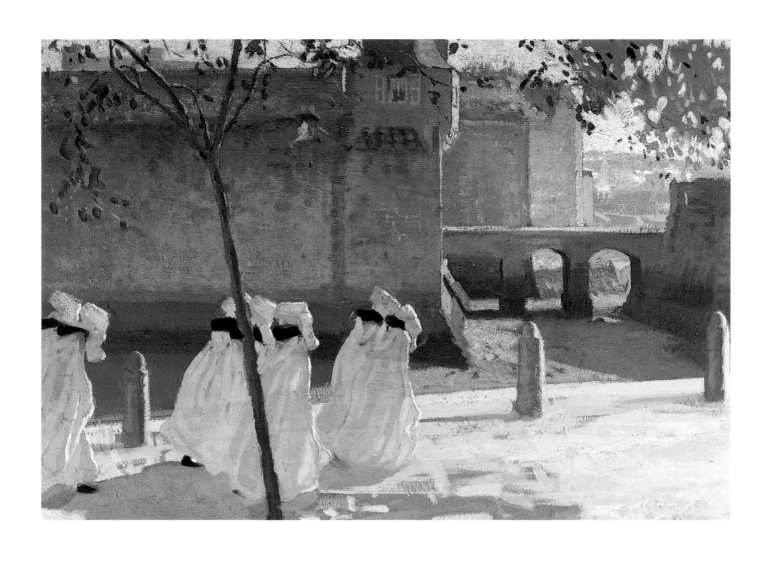

9 SIR JOHN LAVERY

Sutton Courtenay

1917
oil on canvas
40 × 50 in. (101.6 × 127 cm)
Collection Hugh Lane Municipal Gallery of Modern Art, Dublin

Although he was born and spent the first ten years of his life in Belfast, Sir John Lavery spent the majority of his artistic life in Scotland, Paris, and London. Because of his international ties and his ability to paint glamorous portraits in the taste of High Edwardianism, Lavery was a favorite artist of both Irish and British society. In *Sutton Courtenay* Lavery has painted an idyllic scene of boaters resting near the home of Lord Asquith in Sutton Courtenay, a town located on the River Thames west of London. The two women shown are Lady Violet Bonham Carter and Elizabeth Asquith (with their names inscribed, along with that of Harry Boulton, on the verso of the painting). The male figure's identity is not clearly known as other sources have referred to him as being Stephen McKenna or Mr. Pollond. The two women were half-sisters who shared as their father H.H. Asquith, Prime Minister of England from 1908 to 1916. Both women were accomplished writers during their lifetimes: Lady Bonham Carter wrote a biography of Winston Churchill, while Elizabeth, who later became Elizabeth Bibesco, wrote novels and poetry.

The theme is one that Lavery had previously explored with his *Bridge at Grez* (see fig. 67), a subject that he painted on several occasions at the turn of the century. His time spent in Grez-sur-Loing, south of Fontainebleau, from 1883 to 1884 and on subsequent visits in 1897 and 1900 left an indelible mark because of its idyllic setting and the opportunity to experiment with plein air painting. This seminal period in Grez represented some of Lavery's happiest days in France, where he developed a keen understanding of how to create a harmonious balance of light and shade – a basic component of his later portraits and interior scenes.

During the height of World War I, Lavery did a series of paintings of scenes on the Thames. These works transcend the existence of any sort of savage conflict in Europe as well as the upheaval in the international art world caused by the work of Cubist, Futurist, and Vorticist artists.[1] Lavery continued to espouse a traditional style of painting learned as a student of Bouguereau and Bastien-Lepage in France and most closely aligned with that of the French Impressionists. Like his pre-war painting, in which Lavery became an international celebrity in his own right, helping to define notions of Edwardian opulence, his painting style here directly reflects the social positions of his sitters. Lavery's choice of subject matter, emphasizing the continuation of the pre-war Edwardian idyll, a sense of endless summer, suggests a denial of global realities in keeping with his inherent conservatism and the tastes of his clients, a denial that both the artistic and political worlds were changing beyond recognition – a reality that seems particularly ironic here given the identity of the sitters.

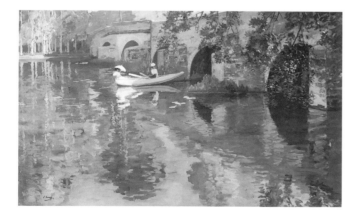

Fig. 67. Sir John Lavery, *The Bridge at Grez*, 1901, oil on canvas, 35¼ × 58½ in. (89.1 × 148.3 cm), Ulster Museum

1 Kenneth McConkey, *Sir John Lavery* (Edinburgh: Canongate Press, 1993), p. 127.

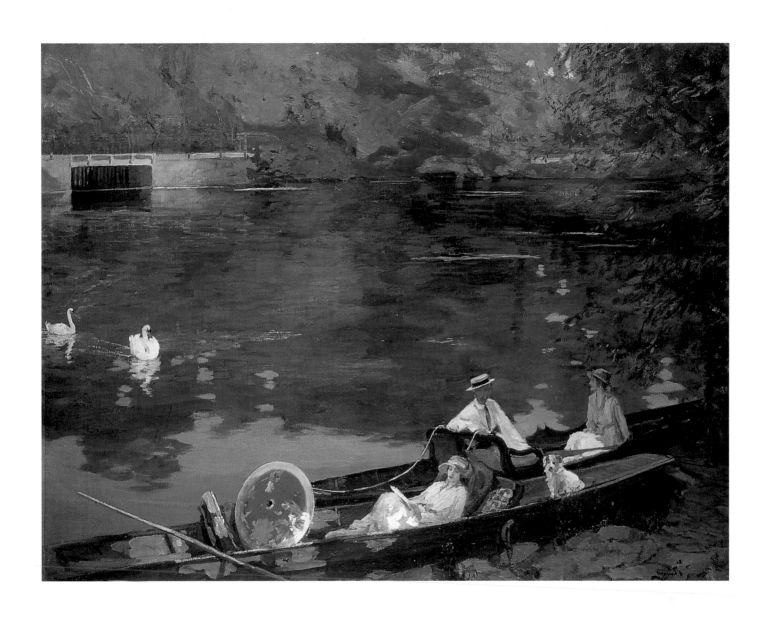

10 SIR JOHN LAVERY

Hazel in Rose and Gold

1918
oil on canvas
79¹/₂ × 39¹/₂ in. (201.3 × 100.3 cm)
Board of Trustees of the National Museums and Galleries on Merseyside (Walker Art Gallery)
(Exhibited only at the Walker Art Gallery, Liverpool)

Although Sir John Lavery was born and died on the island of Ireland, his artistic education was received in Glasgow, London, and Paris. He initially went to Glasgow around 1876 as an apprentice to a photographer, then to London to attend Heatherly's School briefly before moving on to Paris. There he enrolled at the Académie Julian, where he studied under Adolphe Bouguereau (1825–1905). During his repeated visits to France, Lavery developed a fondness for plein air landscape painting. His return to Scotland in 1884 marked the establishment of the "Glasgow Boys", a group of artists working in the city that established a new tradition of painting gained from their collective artistic experiences in France. The success of the Glasgow Boys led to Lavery's acceptance in Europe as an artist of merit; while continuing to travel, primarily to Morocco and France, he began to receive numerous commissions.

In 1903 Lavery returned to the artists' colony of Beg-Meil in Brittany where he met his future wife Hazel Martyn, an artist as well, who was visiting with her mother and sister from Chicago. This was the beginning of a courtship that lasted until 1909 when Hazel, whose ancestors were of Irish descent, returned to Europe from America and married Lavery in London.[1] Hazel became Lavery's muse and model until her death in 1935, appearing in numerous portraits, of which *Hazel in Rose and Gold* is an example. Lavery's most notable depiction of her came in 1928 when he was commissioned by William T. Cosgrave, president of the newly formed Irish Free State, and the Currency Commission to paint a portrait of Hazel to be used as the central image on banknotes of the Irish Free State. The final product, *Lady Lavery as Kathleen ní Houlihan* (fig. 68), depicts Hazel as the seated figure of Éire resting her arm on a harp, the national symbol of Ireland. Through this medium, Hazel's face became one of the most widely known in Ireland; indeed, although banknote designs have changed, Hazel's visage continues to grace Irish banknotes in the form of a watermark. *Hazel in Rose and Gold* did not enjoy the same widespread dissemination as the banknote portrait but had similar political and cultural ramifications, since by 1918 Lavery and Hazel were established figures in society.

Lavery's early work depicting outdoor landscape scenes finds its interior counterpart in a work such as the full-length portrait *Hazel in Rose and Gold*. The play of light and shade to create depth and the sumptuous palette that characterized his work in Brittany are both evident, and ennoble the painting. Yet Hazel's striking facial features and lavish dress are the distinguishing components of the portrait. The dress, wrapped around Hazel's slender body, unfolds in rich cascades of tactile cloth – the layering made clear by Lavery's subtle shifts from light to dark. Hazel's face is radiant, illuminating an interior space otherwise void of natural light sources. Lavery has captured the elegance and stature of his wife while demonstrating the artistic prowess that made him one of the leading portrait painters exhibiting in Ireland and the United Kingdom, where he was thought to rival the talents of John Singer Sargent.

Fig. 68. Sir John Lavery, *Lady Lavery as Kathleen ní Houlihan*, 1928, oil on canvas, 30 × 25 in. (76.2 × 63.5 cm), Central Bank of Ireland, Dublin

1 Sinéad McCoole, *Hazel: A Life of Lady Lavery, 1880–1935* (Dublin: Lilliput Press, 1996), p. 36.

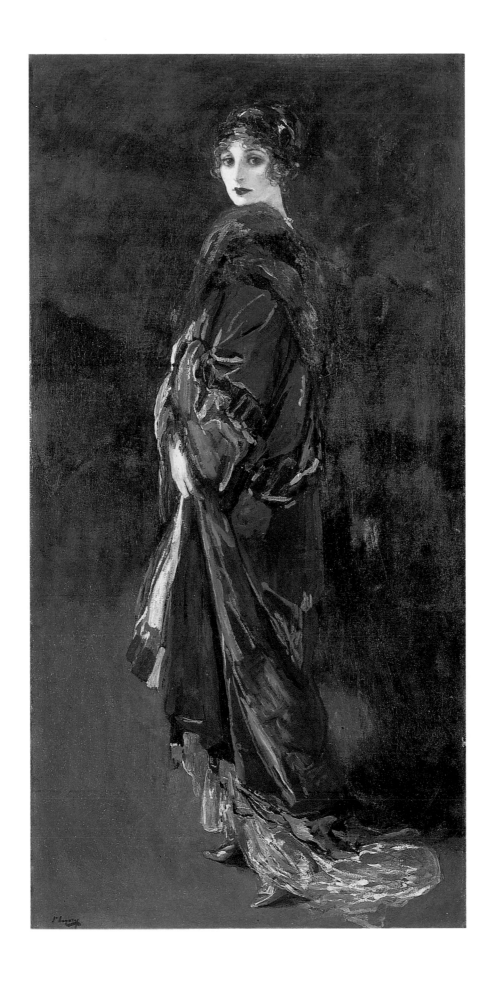

143

II WILLIAM LEECH

The Sunshade

ca. 1919
oil on canvas
31⅞ × 25⅝ in. (81 × 65 cm)
The National Gallery of Ireland

William Leech's position in the canon of Irish painting is difficult to assess. Although he was born into a Dublin family that firmly believed in the Unionist cause, Leech himself did not show an inclination toward politics. His education in Dublin at the Metropolitan School of Art under the direction of Walter Osborne and his continued artistic education in France followed a pattern of training that was common for artists of his generation. Leech benefited greatly from a time of study and work in Paris and Brittany, and upon his return to Dublin in 1906 it appeared he was ready to settle and paint in his native country. With the death of his youngest brother and his father's decision to leave Ireland, however, Leech found himself bound to his family and moved with them to London in 1910. As Denise Ferran has noted, "We can only surmise what his direction might have been had he stayed in Dublin and continued to exhibit with other Irish painters and to attract the attention of the critics."[1] This question of Irishness aside, Leech's work in the early part of the century evoked the beauty and grace of the late nineteenth-century Belle Époque and demonstrates his undeniable talent as a painter, reminiscent of international contemporaries including Jules Bastien-Lepage and John Singer Sargent.

Leech's oeuvre is divided primarily between paintings made in France, constituting his early career, and those done in England, which were a radical departure from the sun-drenched canvases of his French period. *The Sunshade* is one of the last paintings Leech made in France and almost reads as the painter's homage to the sun. The model was Leech's first wife Elizabeth Kerlin, whom the artist had married in 1912. She served as model for a number of paintings, most notably a painting related to *Les Soeurs du Saint Esprit*

(see Plate 8) entitled *A Convent Garden, Brittany,* in which he painted Elizabeth dressed in traditional Breton wedding costume, standing in a convent garden. Leech's marriage with Elizabeth was to dissolve in 1919; coincidentally *The Sunshade* was purchased by Percy Botterell, the husband of May Botterell whom Leech befriended and later married. *The Sunshade* and Leech's divorce from Elizabeth marked the end of a fruitful period in his artistic life during which his life in the Breton village of Concarneau introduced him to other artists and allowed him to develop fully his interest in plein air painting.

The Sunshade reflects Leech's interest in and ability to reproduce the effects of sunlight through and on various surfaces. The light of the sun is partially broken by the thin green membrane of the parasol, which casts an unusual green glow on Elizabeth's face and upper body. The diffused light softens the picture and contrasts with the vibrancy of the direct sunlight on her sweater. Leech has created an impasto that gives the cardigan a tactile, woolly appearance both in shaded areas and in those that appear in direct light. The deft handling of line in modeling the contours of Elizabeth's neck and face show skill equal to that of William Orpen (see Plate 2). Leech's masterful style was almost a throwback to pre-war days, a paean to a simple, sun-filled outdoor life that reflected an apolitical response to the world quite different from that taken by contemporaries such as Orpen and Lavery. Again, one can only speculate how Leech would have transformed painting in Ireland with his masterful skills had he chosen to remain in or return to his native land.

1 Denise Ferran, *William John Leech: An Irish Painter Abroad* (London: Merrell Holberton, 1996), p. 51.

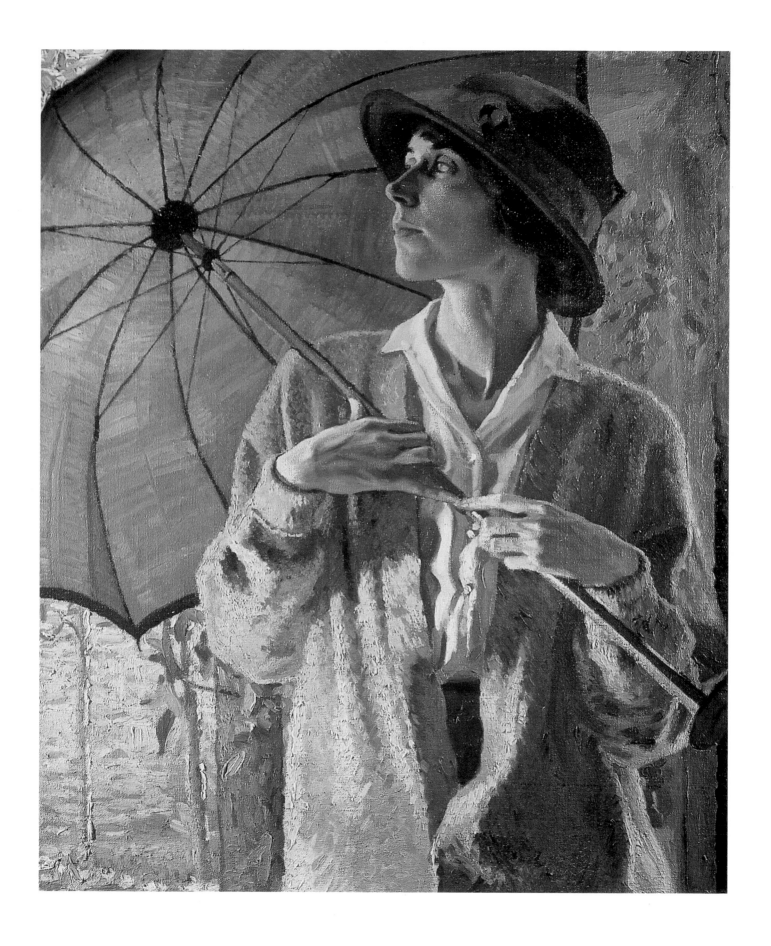

12 PAUL HENRY (born 1876, Belfast – died 1958, Bray, Co. Wicklow)

Launching the Currach

1910–11
oil on canvas
16⅛ × 23⅝ in. (41 × 60 cm)
The National Gallery of Ireland

Launching the Currach shows a common image of life on Achill Island as five men push a currach (or curragh) into the sea. The currach is a small boat of wickerwork and hide traditionally used by fishermen specifically in western Ireland due to the scarcity of wood in the area, the currach's minimal cost of construction, and its ability to negotiate both shallow waters and rough seas. It is light enough to be carried by a single man while another carries accessories such as oars and lobster pots; crewmen sit directly on the floor as there are no seats.

This painting demonstrates Paul Henry's ability to merge harmoniously figures and landscape: the fishermen here appear to be an extension of the beach on which they labor. Henry records a daily occurrence on Achill – man versus the sea – in a subtle and deft manner that minimizes the drama and draws attention to the natural beauty of man's interaction with nature.

After studying in his native Belfast, Henry continued his artistic training in Paris and then went to London, in 1900. While in London, he was influenced by his Belfast compatriot and friend, the essayist and journalist Robert Wilson Lynd, to return to Ireland and vacation on Achill Island off the coast of Co. Mayo in the west of Ireland, which Lynd had recently visited. Henry and his wife, Grace, travelled to the island in 1910 for a month; two years later they returned and remained off and on for the next seven years. Prior to his settling on Achill, Henry had read John M. Synge's one-act play *Riders to the Sea*, written in 1902, a tragic tale of a mother losing her six sons to the sea. Although *Riders* is set on Inishmaan, one of the three Aran Islands located off the west coast of Ireland in Galway Bay, south of Achill, Henry was attracted by the rustic, yet dignified lifestyle pervasive in the West as described by Synge.[1] When Henry turned to his adopted region for his subject matter, he provided the visual equivalent to Synge in his ability to capture and convey the essence of life in the West of Ireland.

Prior to his stay on Achill, Henry was primarily a figurative painter, but he soon realized that the local residents were not receptive to his sketching scenes that included them. They felt that by drawing or painting their likeness Henry was removing part of their souls, and so were unwilling to model for him. Both *Launching the Currach* and *The Watcher* (see Plate 13) were probably painted from memory or done stealthily. Henry was intrigued by the distinct dress and physiognomy of the islanders and was equally fascinated with the geography. Given the problems encountered in painting figurative scenes, Henry instead focussed his attention on the landscape, and this marked the genesis of his reputation as one of the greatest Irish landscape painters. His formal landscapes, usually depicting lush mountains, cloud-filled skies, and a traditional thatched cottage, came to represent the quintessential essence of Ireland on postcards and in other types of travel brochures and posters. His images were used in particular by the London Midland and Scottish Railway Company to entice tourists to Ireland, as the tourist industry discovered that the West played well to the market for a pure and unspoiled Ireland. Henry's paintings, particularly his later landscapes, offered a visual counterpart to literary commentaries, such as works by Synge, providing vivid descriptions of the West of Ireland and establishing a link between Irish cultural identity and the land.[2]

1 Paul Henry, *An Irish Portrait* (London: B.T. Batsford, 1951), p. 48. "There was something in Synge that appealed to me very deeply. He touched some chord which resounded as no other music ever had done."
2 Brian P. Kennedy, "The Traditional Irish Thatched House: Image and Reality, 1793–1993" in Adele M. Dalsimer, ed., *Visualizing Ireland: National Identity and the Pictorial Tradition* (Boston: Faber and Faber, 1993), pp. 165–79, links the work of Henry to 18th-century representations of rural Ireland, specifically the thatched cottage and its significance as an icon of Irishness. See also Catherine Nash, "'Embodying the Nation' – The West of Ireland Landscape and Irish Identity," in Michael Cronin and Barbara O'Connor, eds., *Tourism in Ireland: A Critical Analysis* (Cork, Ireland: Cork University Press, 1993), pp. 86–112.

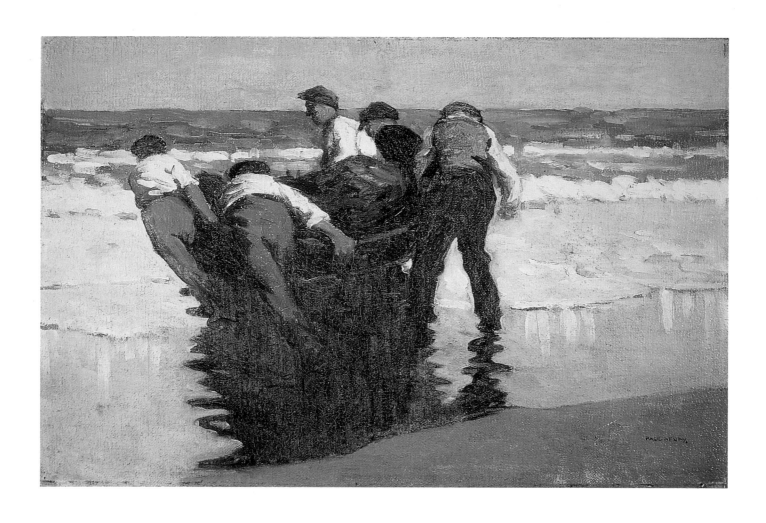

13 PAUL HENRY

The Watcher

ca. 1914
oil on canvas
23⅞ × 19⅞ in. (60.5 × 50.5 cm)
Private collection, courtesy of Pyms Gallery, London

The son of a fundamentalist Protestant clergyman, Paul Henry was raised in a disciplined and restrictive environment. He attended Methodist College, Belfast, before moving on to the Royal Belfast Academical Institution, where he decided to pursue a career as an artist. In 1898, Henry was offered financial support by a generous cousin and went to Paris, where he enrolled at the Académie Julian, but left after a couple of years to study at the Académie Carmen under the direction of the American artist James Abbott McNeill Whistler (1834–1903). Henry was an ardent pupil of Whistler and was influenced by his emphasis on technique. He also gained an appreciation for the work of the French artist Jean-François Millet (1814–1875), particularly his representations of peasants working in the fields. Henry painted a number of compositions depicting workers, such as *The Potato Diggers* (fig. 69) that, while intended

to document life in the West and the natural beauty of the landscape there, served to create an enduring stereotype of Irish life – one that exists even today.

Henry left Paris in 1900 and moved to London to work as an illustrator. There, in 1903, he married Grace Mitchell, a fellow artist whom he had met in France. Throughout their artistic careers, the Henrys were involved in promoting and developing avant-garde painting in England and Ireland; while living in London they helped to form the Allied Artists Association, an independent group of progressive artists. Later, in 1920, he and Grace helped to form the Society of Dublin Painters with eight other artists including Jack B. Yeats and Mary Swanzy (see p. 57).

The Watcher was painted while Henry was living in the village of Keel on Achill Island, located off the west coast of Ireland. Henry admired the simple life of the local people and was particularly inspired by the countryside, commenting: "But what attracted me above all these things was the wild beauty of the landscape, of the colour and variety of the cloud formations, one of the especial glories of the West of Ireland."[1] *The Watcher*, as well as *The Potato Diggers*, gives credence to this remark, as both canvases are dominated by a cloud-filled sky that seems to billow from the horizon. Here, the figure of the young girl looking out to sea while standing on an outcropping of rock, most likely waiting to catch sight of the men returning from a day of fishing, is silhouetted by the majestic forms of sky and sea. Henry created spatial recession by contrasting the clouds with the girl's dress, a traditional garment worn on Achill which, Henry noted, ". . . always supplied a rich note of colour; most of them wore flannel homespun. This coarse material dyed vermilion, after wear and weather and washing, turned to a variety of tones . . ."[2] The basic elements of Henry's composition are the land, sea, and the young girl, echoing the simplicity of life on Achill yet made vital by a reliance on quick brushstrokes and rich coloring.

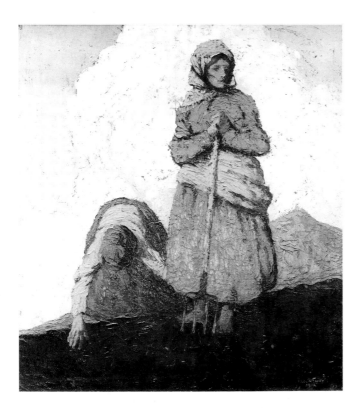

Fig. 69. Paul Henry, *The Potato Diggers*, 1912, oil on canvas, 20 × 18 in. (51 × 46 cm), National Gallery of Ireland, Dublin

1 Paul Henry, *An Irish Portrait* (London: B.T. Batsford, 1951), p. 51.
2 Henry, p. 51.

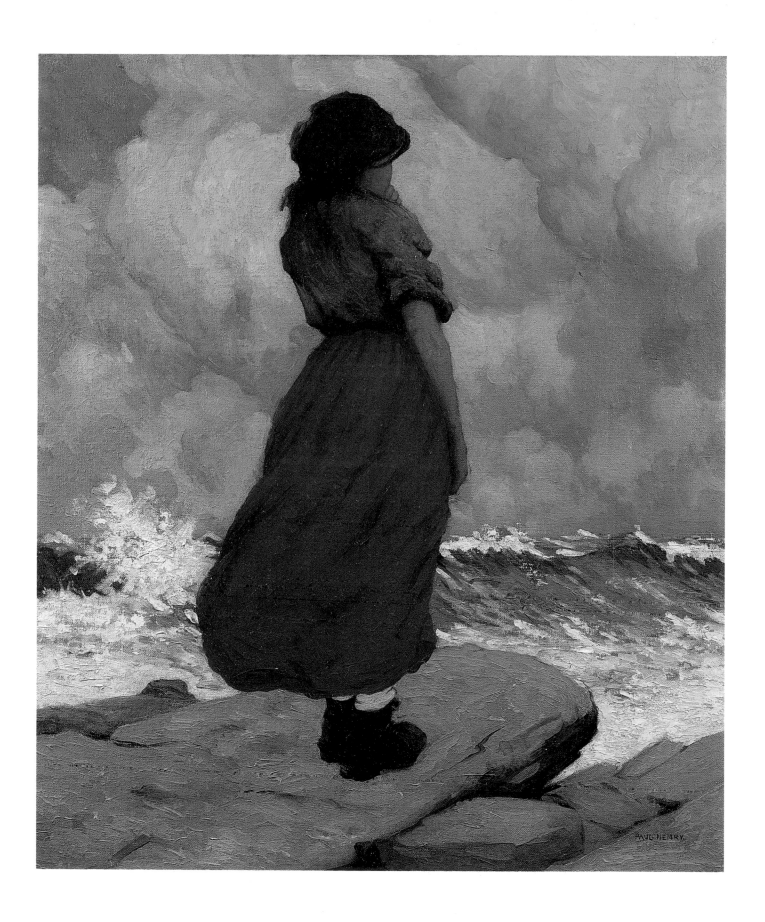

14 PATRICK TUOHY (born 1894, Dublin – died 1930, New York)

The Model

1914
oil on canvas
36¹/₄ × 30 in. (92 × 76.5 cm)
Private collection

Patrick Tuohy was born in Dublin, the son of a surgeon who, along with his wife, was a strong supporter of the Nationalist movement in Ireland. Not surprisingly, then, Tuohy began his education at St. Edna's in Co. Dublin, a school founded by Patrick Pearse, a fervent nationalist leader who was later hanged for his participation in the Easter Rising of 1916. It was at St. Edna's that Tuohy showed an aptitude for drawing and was encouraged to begin taking art classes at night at the Metropolitan School of Art. There he came under the tutelage of William Orpen, whose predilection for life drawing profoundly influenced Tuohy's work. Tuohy proved to be a precocious student, overcoming the physical challenge of being born without a left hand, and was singled out for his ability at his first exhibition at the age of seventeen. Tuohy rounded out his artistic education with a trip to Spain in 1916, where he frequented the Prado, examining the work of the Spanish masters Velázquez and Goya.

After returning to Ireland, Tuohy began teaching at the Metropolitan School of Art in Dublin. His legacy of a relatively small but masterfully executed body of paintings and works on paper is matched by the enduring impression he made on a number of artists including Christopher Campbell, Maurice MacGonigal, and Norah McGuinness, and on their subsequent contributions to the development of art in Ireland. Tuohy favored portraiture and religious imagery and received commissions throughout the 1920s. During this period he was successful in convincing the writer James Joyce to sit for a portrait that now hangs at the State University of New York at Buffalo. Tuohy exhibited regularly at the Royal Hibernian Academy (RHA), beginning in 1918, and his work continued to be recognized within art circles, eliciting comments such as those of the art critic writing for *The Irish Statesman* who observed, in reviewing the RHA exhibition in 1924, that "in Patrick Tuohy we have an obstinate artist who may come to do very fine things

in portraiture . . . but the exhibition has revealed the real talent of Mr. Tuohy and I will remember it for that if nothing else."[1] Tuohy departed for the United States in 1927 never to return to Ireland. While living in New York, he died tragically, the victim of an apparent suicide, in 1930 at age thirty-six.

The Model offers a fine example of Tuohy's precocity as an artist and the perpetuation of the technical skills taught by Orpen. Much like Orpen, Tuohy refrained from political themes during an historic period in Irish history. This detachment represents his preoccupation with the act of painting, underscoring a belief in the visual arts in Ireland as a part of the cultural heritage that was outside the realm of politics. Ironically, Tuohy came from a family of ardent Nationalists but seems to have used his art to disassociate himself from such issues.

This seminal work was painted at the age of eighteen and shows evidence of Tuohy's understanding of anatomy and his versatility as a draughtsman. The sitter is a young seated girl nude but for a cloth cap on her head and a bolt of white cloth lying across her midsection. The luminosity of the body is striking and has been described as "brilliantly lit and given the quality of marble sculpture."[2] The marble-like quality is achieved not only through Tuohy's handling of color and light, but through the soft modulation of line that reveals all the nuances of an adolescent body. Tuohy's versatility is clear in the differentiation of folds in the skin of the sitter with the fabric cascading to the floor. To achieve this realistic distinction takes first a cerebral understanding of the materials – flesh and fabric – and then the technical skill to render them in a convincing manner, giving both a tactile presence.

1 Y.O., "The Hibernian Academy," *The Irish Statesman*, April 19, 1924, p. 166.
2 Rosemarie Mulcahy, "Patrick J. Tuohy 1894–1930," *Irish Arts Review* 5 (1989–90), p. 110.

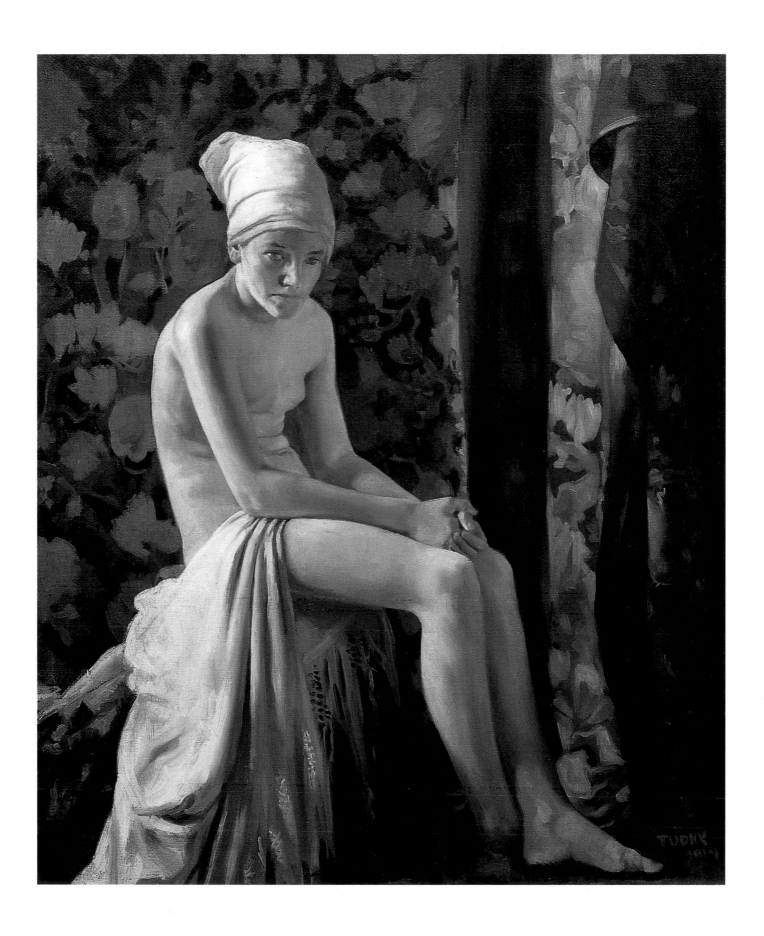

151

15 SEÁN KEATING (born 1889, Limerick – died 1977, Dublin)

Men of the West

1915
oil on canvas
35⁷/₈ × 49¹/₄ in. (91 × 125 cm)
Collection Hugh Lane Municipal Gallery of Modern Art, Dublin

*M*en of the West was painted at an auspicious time in the course of modern Irish history: the following year saw the Easter Rising of 1916 in Dublin that led to the execution of Irish rebel leaders including Patrick Pearse and ultimately the War of Independence in which British and Republican forces fought until the signing of the Anglo-Irish Treaty in 1922. The agreement of this treaty in turn initiated a bloody civil war within the Republic that endured until 1923. Keating's painting heroically personifies the men who fought to save the cultural and ethnic heritage of Ireland. As James White has written in his introduction to the Keating retrospective held in 1963, "Attitudes, conditions, states of mind are reflected there. Above all the state of mind of a large circle of young men who were growing up when Pearse was teaching, and when he and his contemporaries were steeling themselves for action."[1]

Seán Keating was born in Limerick, and after spending time at the Limerick Technical School went to Dublin to attend the Metropolitan School of Art. As a pupil of William Orpen, Keating learned to draw and paint with precision and directness – a hallmark of Keating's work throughout his career. He later went to London to assist Orpen. On returning to Ireland he soon established himself as the premier painter for the newly created Irish Free State (precursor to the present Republic). Keating painted subjects that were based on current themes and concerns, imbued with a personal vision of Ireland steeped in traditional values and culture. His emphasis on nationalist sentiment heavily based on the culture of the West of Ireland was supported in the visual arts by his contemporaries Jack B. Yeats and Paul Henry and in literature by W.B. Yeats and John M. Synge. Keating was appointed Professor of Painting at the National College of Art and Design in Dublin and passed on the lessons he had learned from Orpen to a new generation of Irish artists including Charles Lamb (see Plates 23 and 44) and Maurice MacGonigal (see Plate 33).

Ostensibly *Men of the West* depicts a different sort of Irish hero figure – compared, for instance, to images of Mother Ireland – demonstrating greater conviction, resiliency, and resistance. The painting – in which the artist, his brother, and a friend served as models – has, however, met with criticism in recent years owing to its overtly nationalistic message. In an essay examining the cultural transformation occurring in the West of Ireland, Luke Gibbons has noted:

"In one of Keating's pictures, a romantic portrayal of a group of armed republicans entitled "Men of the West", the artist's imagination runs away with him to such an extent that the gunmen, in Robert Ballagh's words, 'Are more reminiscent of being west of the Rio Grande than west of the Shannon.'"[2]

Gibbons thus raises the question of whether Keating accurately reflects the reality of Ireland between 1910 and 1930 or whether he is merely painting political propaganda for the New Ireland. Both seem to be true. His work can be viewed as representing the spirit of the time (*Zeitgeist*), conveying the sense of enormous change occuring during the period in politics, industry, and culture. Simultaneously, one can read images such as this as social realist paintings, expressing idealized notions of the new Ireland for the purpose of declaring that Ireland was changing for the better by exposure to and dissemination of traditional Celtic culture. As the Ballagh quotation suggests, Keating may have felt that the conquest of the American West by fearless explorers was an appropriate model for the expansion of traditional ideals from the West of Ireland to the other parts of the country.

1 *John Keating: Paintings–Drawings* (Dublin: Municipal Gallery of Modern Art, 1963), p. 7.
2 Robert Ballagh, "The Irishness of Irish Art" (1980), unpublished lecture, p. 2, reprinted in Luke Gibbons, *Transformations in Irish Culture* (Notre Dame, IN: University of Notre Dame Press, 1996), p. 23.

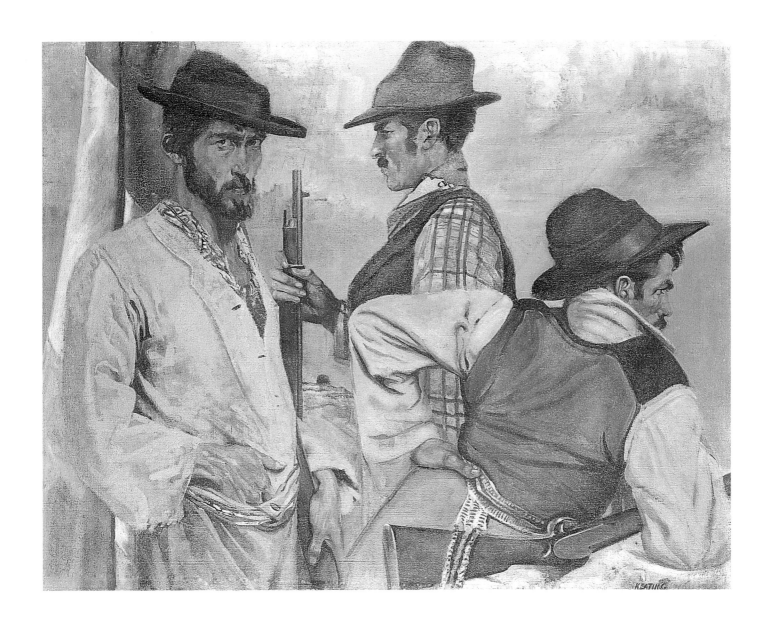

16 LEO WHELAN (born 1892, Dublin – died 1956, Dublin)

The Doctor's Visit

ca. 1916
oil on canvas
36¹/₄ × 28 in. (92 × 71 cm)
The National Gallery of Ireland

The work of Leo Whelan typifies the style of painting that was the hallmark of the Royal Hibernian Academy (RHA) in the first decades of the century, one that was characterized by the importance of line in composition and of experience in drawing from live models. Whelan specialized in portrait and genre painting, two areas in which he proved himself to be an accomplished artist in the academic tradition. Under the direction of William Orpen at the Metropolitan School of Art in Dublin, Whelan developed a keen understanding of the technical methods endorsed by the RHA. Although Whelan matured into an artist of a caliber equal to Orpen's in technical skill, his work often lacks the vitality associated with Orpen, and this may be in part due to Whelan's close family ties, his resultant reluctance to travel, and a certain inexperience with international art movements. Nonetheless, as a student he earned the respect of Orpen, who commented, "The school was really turning out good work, and there was a lot of promising youth – James Slater, John Keating, Miss Crilly, Miss Fox, Miss O'Kelly, and young Whelan and Touey, all with talent."[1] These artists were the first generation of Irish painters who benefited from Orpen's influence, not only studying his technique but the way in which he set about to change the structure of fine art education in Ireland. Whelan was a precocious student and began showing at the RHA in 1911 while still attending art school. He was awarded the Taylor Art Scholarship of the Royal Dublin Society in 1916 for *The Doctor's Visit*.

The painting depicts a room in Whelan's house in Dublin where his cousin lay sick in bed. Whelan's mother sits with her back to the viewer; his sister Frances (who served as his model in a number of pictures) stands on the other side of the bed dressed in the uniform of a nurse from Mater Hospital in Dublin. She has just opened the door for the doctor to enter. It is a simple genre scene that shows

Whelan's ability as a draughtsman and his understanding of interior light. His rendering of line and form is clear and distinct to the point of creating an air of sterility, which, coupled with a sense of withdrawal from the world, builds an atmosphere of domestic repression, of near claustrophobia. Particularly in the fabric of the duvet and the towering canopy, one can admire the precision of detail and the reality of their texture. The interior is reminiscent of the work of Orpen (see Plate 2, *The Wash House*) and John Lavery (see Plate 7, *The Greyhound*) where the light source seems to radiate from within the picture. Like his predecessors, Whelan is concerned with technical issues, but consciously retains a static quality to reinforce the listless and reposeful scene of a person resting in bed. The figures within the painting occupy a clever compositional arrangement leading the viewer from the foreground to the mid-plane and then to the background, disposed to make the entire scene a still-life with figures. In his later work, particularly in his portrait painting, Whelan demonstrates not only his superior technical expertise but shows a new refinement in his capacity to infuse life into his subjects and to bring forth their individual character.

Whelan's rigorous academic standards and strong technical skills provided him with the necessary tools to become one of Ireland's most accomplished portrait painters. His repertoire of portrait subjects ranged from political luminaries such as Michael Collins and Arthur Griffith to prominent literary figures and a number of religious dignitaries. Whelan's work is as much a testimony to his artistic talent as it is a revealing paradigm of a stifling domesticity not only in Whelan's personal life but generally prevalent in Ireland just as the Irish nationalist movement was bursting forth.

1 Sir William Orpen, *Stories of Old Ireland and Myself* (London: Williams and Norgate, 1924), p. 78.

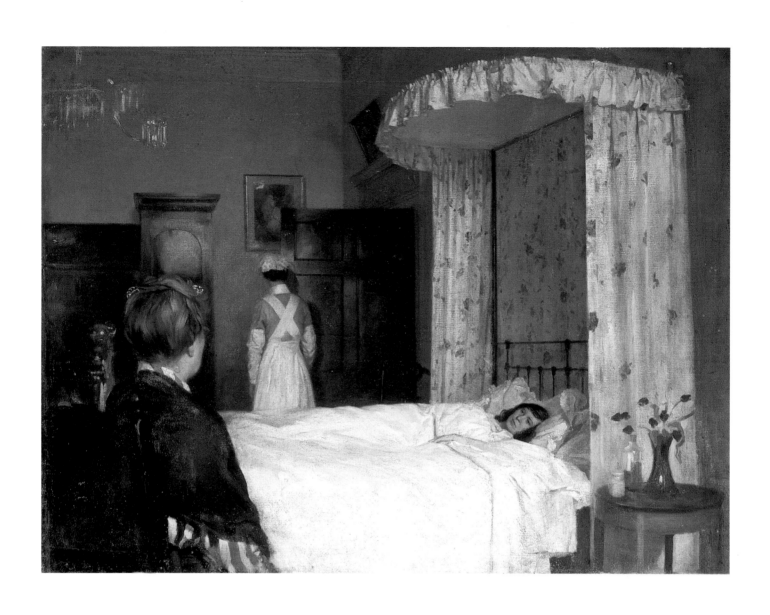

17 SIR JOHN LAVERY

The Studio Window, 7 July 1917

1917

oil on canvas

55¾ × 35½ in. (141.5 × 89.9 cm)

Reproduced with kind permission of the Trustees of National Museums and Galleries of Northern Ireland

Painted in the same year as *Sutton Courtenay* (Plate 9), *The Studio Window, 7 July 1917* offers a thematic contrast to the idyllically tranquil boating scene. Here far more direct and confrontational, Sir John Lavery has rendered a dramatic and tension-filled composition capturing the second air attack on London made by German forces. Although the German and British aircraft engaging in combat bear greater semblance to a flock of birds, the apprehension and concern conveyed by the posture of Lavery's wife Hazel looking out the window and the somber tonal qualities indicate to the viewer that a serious drama is unfolding in the sky.[1] The framing of the window with the black-out curtains serves to create a stage for the aerial performance, an impromptu theatrical device that both focusses and heightens the drama. Lavery's treatment of this painting is similar to his method of rendering landscape scenes, where gradations in light and dark define figures and objects and are then given vitality through the application of color.

Lavery's ability to work quickly and spontaneously served him well as an official war artist attached to the British Navy from 1917 to 1918. He was able to capture memorable images both of beauty and of the harsh reality associated with war. His technical skill in rendering images quickly was enhanced by his apprenticeship to Jules Bastien-Lepage, with whom he studied while in Grez, France, in 1882. Lavery recounts in his autobiography,

I had never forgotten his [Bastien-Lepage's] advice on figures in motion. Pointing to people passing he said: 'Always carry a sketch-book. Select a person – watch him – then put down as much as you remember. Never look twice. At first you will remember very little, but continue and you will soon get complete action'.[2]

The war scene painted by Lavery from his studio in London less explicitly raises the question of his native country's involvement in the First World War. Lavery's interest in supporting the Allied cause in any way possible could not have diminished his awareness of events in Dublin the preceding year and their ongoing after-effects. The Easter Rising of 1916 can be viewed as a byproduct of the War, given that Irish Nationalists with strong socialist beliefs such as Joseph Connolly (1868–1916) felt that the War would end only with a global uprising of workers, including those in Ireland. With what the Nationalists felt to be the oppression of British imperialism, and the preoccupation of the British with the offensive waged by the Germans making them vulnerable to an internal attack, insurrection was perhaps unavoidable. It is not surprising then that the rallying cries of the Easter Rising were, "Down with the War! Down with British Imperialism! All hail a free Irish Republic!"

Lavery was anxious to participate in the First World War and initially enlisted to serve as a soldier; although he felt just as able as the younger men, he was given a position as a war artist rather than actual combat duty.[3] William Orpen, who, like Lavery, was an accomplished portraitist, served in a similar capacity, although he was stationed closer to the front; his work from that period offers an interesting counterpoint to Lavery's, not only stylistically but in the treatment of the subject matter (see Plate 18 and fig. 7). While Lavery's work, in keeping with his High Edwardian style, seems to reflect the nobility of war and its aftermath, Orpen reveals a more sinister and surreal perception.

1 Kenneth McConkey, *Sir John Lavery* (Edinburgh: Canongate Press, 1993), p. 130, notes that originally Hazel was shown kneeling before a votive statue of the Madonna, but that Lavery, perhaps to play down the anxiety expressed by his wife, painted out the statue before giving the painting to the Ulster Museum in 1929.

2 John Lavery, *The Life of a Painter* (London, Toronto, Melbourne and Sydney: Cassell and Company, 1940), p. 57.

3 Lavery, pp. 138–39.

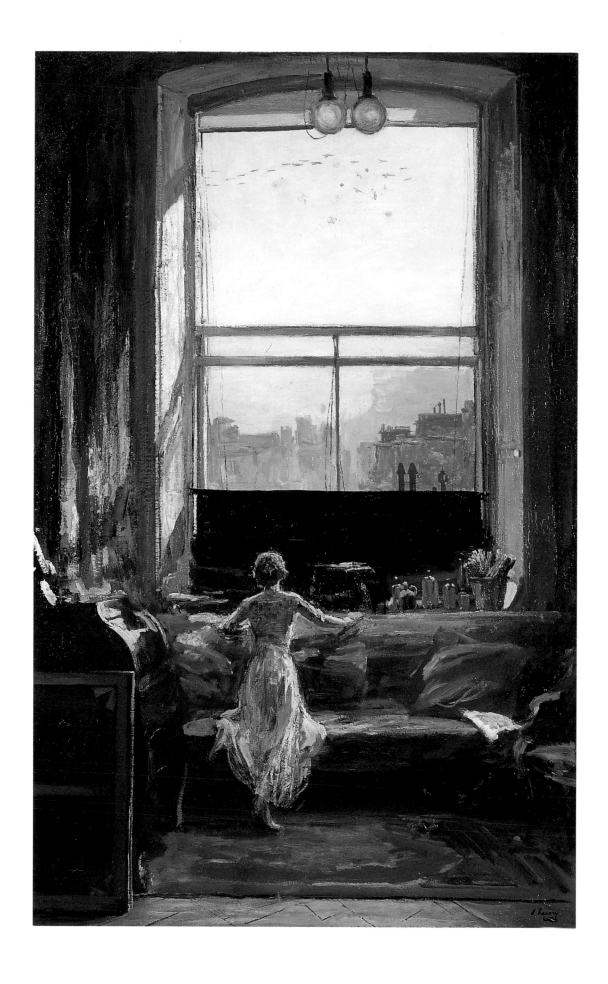

18 SIR WILLIAM ORPEN

Ready to Start – Self-portrait

1917
oil on canvas
24 × 20 in. (60.9 × 50.8 cm)
Imperial War Museum, London
(Not exhibited at Walker Art Gallery, Liverpool)

In contrast to the ardent nationalism of his pupil Seán Keating, Orpen professed limited interest in politics, although his signing on for military service at the end of 1915 into the British Army must have been based on his loyalties to the patrons who had made him the successful artist that he was – the English.

Orpen was not a soldier and never made any pretensions to be one; he was an artist who would exercise his talents in support of the British war effort. This led to his appointment as an official artist with the Army in France in 1917. During his tour of duty with the Army, Orpen painted and drew over a hundred images graphically illustrating all aspects of the war, from life in the trenches to scarred battlefields, to the psychological isolation and weariness of the soldier. In the preface to his written recollections published in 1921 as *An Onlooker in France, 1917–1919*, Orpen wrote: "This book must not be considered as a serious work on life in France behind the lines, it is merely an attempt to record some certain little incidents that occurred in my own life there."[1] Although Orpen appears to have shown little regard

for military procedure and protocol, his writing suggests that his exposure to the devastation and desolation created by the armed conflict left an indelible mark on his psyche. This scar became visible in his work in its often lurid coloring and a sense of emotional trauma; even work done after the conclusion of the War lacks the subtle order and beauty of his earlier painting such as *The Wash House* (see Plate 2).

Ready to Start – Self-portrait is one of an interesting array of portraits of military men, self-portraits, and battlefield landscapes painted by Orpen in France. The painting depicts Orpen, his image reflected in a mirror, his countenance bearing the determination and resolve fitting a soldier ready for battle. Instead of being armed with a gun, Orpen has at his side the accoutrements of an artist: brush, cigarettes, books, and whiskey and soda water. It is an idealized portrait presenting Orpen in the duel role of soldier and artist. Orpen was not, however, one of the fighting men risking his life for his country, and despite a sense of wary readiness his self-portrait reveals his true self – a young man dressed up in military garb witness to events beyond his calling. In this and other works including *Harvest* (fig. 70), Orpen introduces a surreal element to his work that appears to be initiated by his exposure to war. In *Harvest*, two women harvest wheat behind a barbed wire fence near a beach that was the site of a recent invasion, during which soldiers were killed and subsequently buried. A mother holding a child and baring her breast to feed the baby stands near two women busily harvesting. The strange, unreal juxtaposition of birth and death; the earth both as a burial ground and a source of food: both reflect the disruption that war wrought on Orpen's psyche and his art. In *Ready to Start*, Orpen creates another unusual association – that of painter to the aristocracy dressed for battle, appropriately placing himself in the midst of a conflict he viewed as an utter waste of human life and property.

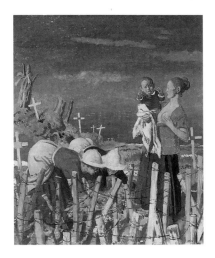

Fig. 70. Sir William Orpen, *Harvest*,
1918, oil on canvas,
30 × 25 in. (76.2 × 63.5 cm),
Imperial War Museum, London

1 Sir William Orpen. *An Onlooker in France, 1917–1919*. (London: Williams and Norgate, 1921).

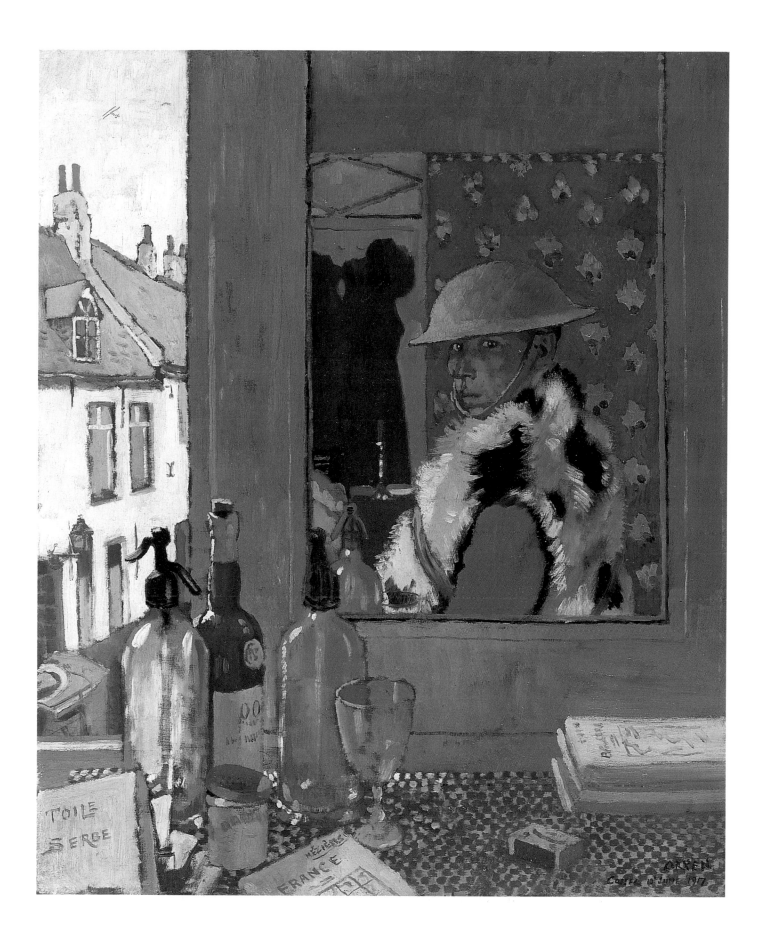

19 JACK B. YEATS (born 1871, London – died 1957, Dublin)

The Funeral

1918
oil on canvas
9⅛ × 14¼ in. (23.2 × 36.1 cm)
The Walters Art Gallery, Baltimore, Maryland
(Exhibited only at Walker Art Gallery, Liverpool, and Berkeley Art Museum)

According to his father, painter John Butler Yeats (1839–1922), Jack B. Yeats began drawing as a young child and never stopped. There were two facets of Jack's drawing that his father remembered: that he never showed his work to anyone and that "his drawings were never of one object, one person or one animal, but of groups engaged in some kind of drama."[1] This sense of drama indeed permeates the best of Yeats's prodigious output.

Yeats was born in London, but spent the greater part of his childhood in Sligo with his maternal grandparents. It was in Sligo that he drew constantly and developed his keen sense of observation – one that, combined with his remarkable memory, enabled him to paint figures later in his career whose faces were learned many years earlier. In 1905 Yeats toured Connemara, the westernmost area in the Connaght province, with the writer John M. Synge, who was asked to compose a series of articles for *The Manchester Guardian* on life in the West of Ireland. Together they roamed the West, observing the hard life endured by many of the residents that went hand in hand with the isolation and exotic remoteness that kept it the most "un-English" part of Ireland. The poor economic situation in Ireland at the time was particularly egregious in the West, and was the principal reason for the exceedingly high emigration rate as people went to England and America to find work.

The Funeral, painted in 1918, is derived from a sketch made by Yeats during his travels with Synge. An excerpt from one of Synge's articles published in *The Manchester Guardian* provides a written description of the scene:

"Turning out of Winford, soon after our arrival, we were met almost at once by a country funeral coming towards the town, with a large crowd, mostly of women, walking after it. The coffin was tied on one side of an outside car, and two old women probably the chief mourners, were sitting on the other side. In the crowd itself we could see a few men leading horses or bicycles, and several young women who seemed by their dress to be returned Americans."[2]

Aside from slight variations, Yeats has recreated the same scene in paint. Interestingly, Yeats has inserted two figures standing by the roadside watching the procession pass by – perhaps the two chroniclers, himself and Synge.

Yeats's interest in all aspects of humanity led him to explore a wide range of subjects, from funerals to boxing matches. He often relied on his artistic skill and his knowledge of things Irish (gained through his own direct experience) to convey a distinctly Irish sensibility, while at other times this Irishness was communicated by the inclusion of icons, features ostensibly unique to Ireland. One such icon commonly found in Yeats's work was the "outside car" or cart seen here carrying mourners and the casket. Its frequent appearance owes partly to Yeats's attraction to horses, but primarily to his childhood memories of life in Sligo, where the car was the predominant mode of transportation. The traditional outside car, or jaunting car, was superseded by the long car owing to the demand for vehicles that could carry more passengers. The long car was developed by an Italian, Charles Bianconi, who established a public transportation system in Ireland in 1815. By 1845, Bianconi had created a network of "Bian" routes that, along with the railroads, connected most of Ireland.[3] Yeats recognized the contribution of Bianconi not only to his childhood memories, but to the economic development of Ireland, through his ubiquitous usage of the outside car and the long car in his art – there are many such references in his work such as *The Sea Captain's Car* (Plate 25) or *A Lift on the Long Car*. Yeats made explicit the nation's reliance on this mode of transport in 1937 when he painted a work he titled *In Memory of Boucicault and Bianconi*, merging his interest in movement and traditional Irish transport.

1 John Butler Yeats, "The Education of Jack B. Yeats," *The Christian Science Monitor*, November 2, 1920, p. 5.
2 Hilary Pyle, *Jack B. Yeats: A Catalogue Raisonne of the Oil Paintings* (London: Deutsch, 1992), p. 98.
3 Mary Anne Bianconi O'Connell, *Charles Bianconi: A Biography 1786–1875* (London: Chapman and Hall, 1878).

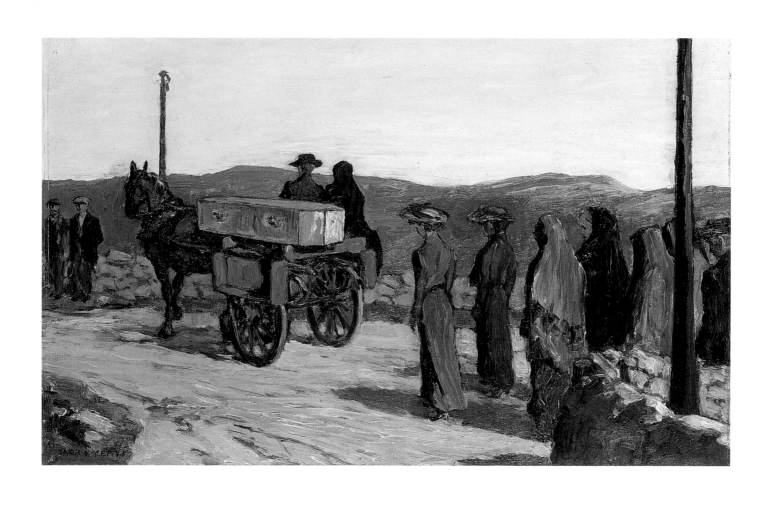

20 JACK B. YEATS

On Drumcliffe Strand

ca. 1918
oil on canvas
24¼ × 36 in. (61.5 × 91.5 cm)
National Gallery of Canada, Ottawa

Both of Jack's parents had familial ties to Sligo in the northwest of Ireland, where Yeats spent the greater part of his youth from 1879 to 1887 with his maternal grandparents William and Elizabeth Pollexfen. Yeats felt this had a lasting effect on his artistic vision, as he was encouraged to pursue his innate aptitude for drawing and given the freedom to investigate the shipping docks and other public sites from which he gathered material for his work. His older brother, the poet William Butler Yeats, later confirmed the impact of this seminal period on his younger brother by commenting:

"Besides he had begun to amuse everybody with his drawings, and in half the pictures he paints to-day I recognize faces that I have met at Rosses or the Sligo quays. It is long since he has lived there, but his memory seems as accurate as the sight of the eye."[1]

Yeats began producing the first of many illustrations for publication while still enrolled in art school in London. His work appeared in periodicals, books, and on posters. After 1898, he devoted himself almost entirely to Irish subject matter.

The painting *On Drumcliffe Strand* (also known as *Drumcliffe Races*) refers to the location of a horse race held in Co. Sligo. Yeats was fascinated with horses and regularly attended, and later used as subject matter, events such as the circus, races, and sporting activities at which horses were the principal attraction. And in so doing, Yeats was participating in a spectator sport of phenomenal popularity in Ireland, where horse racing and breeding continue to hold exceptional appeal. His early interest in horses certainly exposed him to pastimes and traditional forms of Irish entertainment where he became more aware of the lives of common Irish people. In Sligo, Yeats preferred to "live the life of Sligo and to 'learn' the characters and the skies and the hills."[2] *On Drumcliffe Strand* represents the pictorial synthesis of this philosophy with its emphasis on the distinct facial features of the figures, the outline of Benbulben

against the horizon, and the cloud-filled evening sky.

Of the Sligo races Yeats noted:

"I see races on strands, on the shores of the Atlantic at low water spring tide, when there is a flat plain of sand like a country so large it dwarfs the little brown and black turf-coloured crowd about the tents and the winning post, with the green flag flapping in the ocean air. When I am close enough to hear the voices, I know I am where excitement dwells."[3]

The races held four times a year in Sligo were of special interest to Yeats and, even after he settled in Dublin in 1917, he returned often to attend the event. *On Drumcliffe Strand* shows the abundance of subject matter available to Yeats at these communal gatherings – including jaunting cars carrying people home in the background, and tents with banners where spectators imbibed poitín, illegally distilled Irish whiskey – but also exposes an underlying political subtext. In 1918, when this painting was done, conflict abounded in Ireland. World War I had only just been settled and the hostility between Nationalists and Unionists was increasing. Although Ireland had maintained neutrality in the global conflict, many Irishmen went to fight for Great Britain. The distrust and uneasiness that prevailed under these conditions is reflected in the foreground group of men and women who convey a mixed range of feelings as they stare at the two men with their backs to the viewer. The two men, one of whom is an Irish Volunteer (Nationalist), return their looks. Through this unspoken exchange, Yeats creates a scene charged with emotion between those with Nationalist and Unionist ties. *On Drumcliffe Strand* allowed Yeats to observe this current of conflict in the guise of a popular, and Irish, sporting event.

1 W.B. Yeats, *Autobiographies* (London: Macmillan, 1955), p. 68.
2 Hilary Pyle, *Jack B. Yeats: A Biography* (London: Routledge & Kegan Paul, 1970), p. 15.
3 Jack B. Yeats, *Sligo* (London: Wishart & Company, 1930), p. 16.

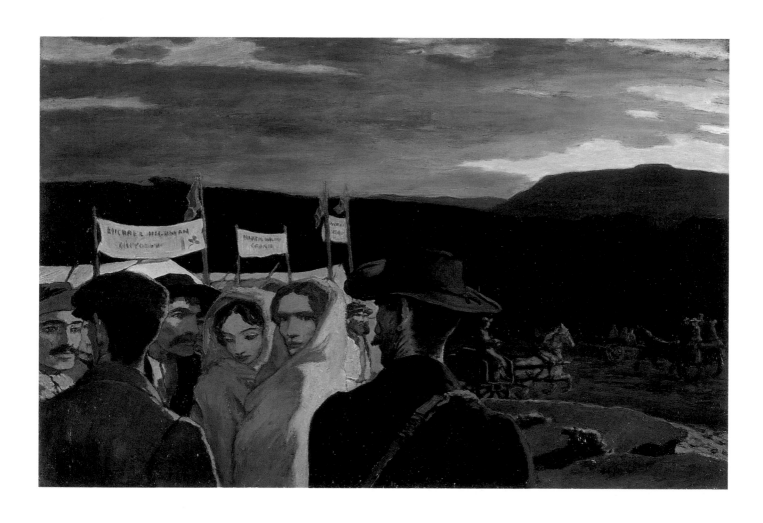

21 RODERIC O'CONOR

(born 1860, Milltown, Co. Roscommon - died 1940, Nueil-sur-Layon, France)

Self-portrait holding Palette

1919
oil on canvas
36 × 28¾ in. (92 × 73 cm)
Private collection

Roderic O'Conor was an Irish artist whose work went largely unnoticed until recent scholarship revealed him to be an accomplished and versatile artist adept in painting, drawing, and printmaking. From an upper-middle-class family with substantial land holdings in Co. Roscommon, O'Conor was able to pursue his interest in painting free of financial concerns. The open, rural landscape of Roscommon provided O'Conor with his earliest artistic inspiration.

After completing his art education in Ireland, O'Conor, like some of his compatriots such as Walter Osborne, opted to continue his studies abroad. In 1883, he went to Antwerp, Belgium, where he studied under Charles Verlat. Verlat emphasized the development of drawing skills and a vigorous handling of paint – hallmarks of O'Conor's artistic oeuvre. O'Conor decided to move to France where, in Brittany, he was introduced to plein air painting that used natural light and weather conditions to enliven and give immediacy to its subjects. O'Conor's early influences in France included the work of the Impressionist masters Claude Monet and Alfred

Sisley. Some of his earliest works from this period included colorful landscapes painted at Grez-sur-Loing, including *The Bridge at Grez* (ca. 1900), a popular subject that was treated by other artists including Sir John Lavery, whose acquaintance O'Conor made at nearby Marlotte.

With the death of his father in 1894 and the subsequent sale of his inherited land in 1903, O'Conor effectively broke any remaining ties with Ireland. The art market in France was a stark contrast to what many artists saw as a cultural void in Ireland. O'Conor's interaction with leading members of the French avant-garde fostered a personal investigation into new methods of painting, leading to the introduction of a new style employing parallel "stripes" of color that perhaps was prompted by the pointillist technique employed by Seurat.[1] *Breton Boy in Profile* (fig. 71) demonstrates the bold striation of brushstrokes that effectively created contrasting tones of light and dark while giving texture and depth to the painted surface.

O'Conor moved to Paris in 1904 where he continued to paint for many years. The *Self-portrait holding Palette* provides an interesting counterpoint to the *Breton Boy* from both artistic and psychological perspectives. O'Conor is seen in the dark confines of his Montparnasse studio. Much had changed since the *Breton Boy* was painted; O'Conor was now almost sixty years old and alone, having endured World War I in Paris. His painting during this time returned to a more academic tone with emphasis on modeled figures and less vibrancy of color. He paints himself as an artist pure and simple with the tools of his trade in hand; the painting is a kind of calling card for the aging artist, whose greatest works often involved brilliantly colored female figures. O'Conor's posthumous emergence from years of obscurity provides evidence that here was an artist who emigrated as much to find a community of like minds, and to participate in international artistic endeavors, as to find practical financial support for his work.

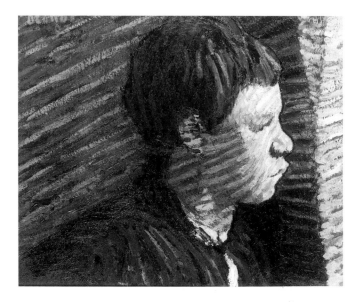

Fig. 71. Roderic O'Conor, *Breton Boy in Profile*, 1893, oil on board, 15 × 17½ in. (38.1 × 44.5 cm), whereabouts unknown, photo courtesy of the Victoria Art Gallery, Bath

1 Denys Sutton, "Roderic O'Conor: Little-known member of the Pont-Aven Circle," *The Studio*, 160, no. 811 (November 1960), p. 173.

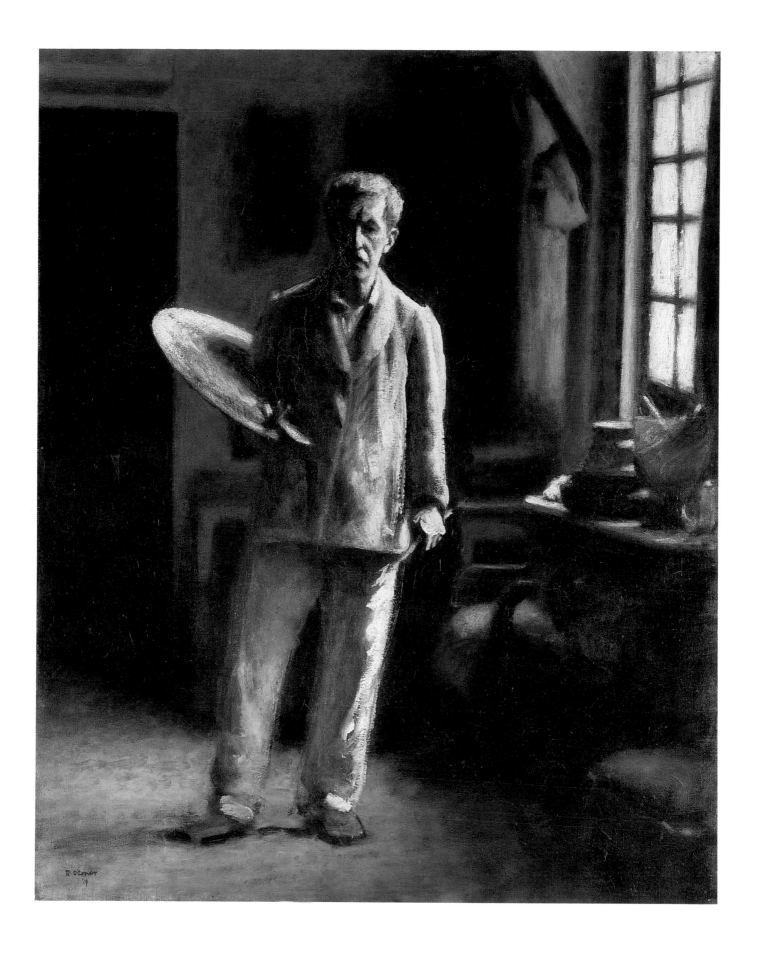

22 LEO WHELAN

Reverie

ca. 1920
oil on canvas
30 × 25 in. (76.2 × 63.5 cm)
Joseph M. and JoAnn Murphy

After studying at Belvedere College in Dublin, Leo Whelan attended the Metropolitan School of Art where he showed great artistic promise under the guidance of William Orpen. He was one of a handful of students deemed by Orpen to be worthy of instruction. In 1911, Whelan showed for the first time at the Royal Hibernian Academy and went on to make annual contributions to the exhibition until his death in 1956. *Reverie*, ehixibted in 1920, was one of the more than 200 paintings showed by Whelan at the RHA during his lifetime. His strong, traditional academic ties did not prompt him to explore original subject matter, but enabled him to paint remarkable portraits and true-to-life interior scenes – of which *Reverie* is an example – that exposed intimate moments of contemplation and revealed facets of the sitter's personality.

The sitter is Whelan's sister Lily playing the piano in the family home in Dublin. The scene calls to mind images made by the seventeenth-century Dutch painter Johannes Vermeer in which women were painted conversing with a gentleman, writing a letter, or playing a musical instrument in a room illuminated by a window to the side. More or less disregarding Vermeer's fascination with the construction of space and spatial illusions, Whelan seems interested only in the manner in which Vermeer composes a genre scene, in light effects, and in the opportunity to show his ability to render detail, a talent that was also the hallmark of the Dutch master. Whelan thus creates a picture that is both still-life and portrait. The details of the patterned curtain and the sheet music illuminated by outside light provide evidence of Whelan's ability as a draughtsman. The soft light diffused by the lace curtains comes through the window to accentuate the sitter's profile, defining more precisely the contours of her face and upper body. The effect of the dark, somber coloring is contemplative and well suited to a moment of quiet meditation. Lily seems unaware of the presence of the painter and remains focussed on her music.

The ambiance of repose permeating this interior scene contrasts with the volatile conditions existing in Dublin in 1920. Social and political unrest was reaching a peak as fighting between sectarian groups escalated, leading to the signing of the Anglo-Irish Treaty in the following year that many hoped would bring a peaceful resolution to the conflict. This larger reality seems far removed from Whelan's peaceful drawing-room. The work of Whelan reflects his rigid academic training and, in harkening back to High Edwardian portrait painting, presents a counterbalance to the work of artists whose primary interest was in creating paintings that addressed greater social and political concerns. Whelan's contemporaries such as Seán Keating, Jack B. Yeats, and John Lavery offer examples of this more politically engaged approach to subject matter. Indeed, these political realities might suggest an escapist market for Whelan's redolently atmospheric artistic output. While Whelan's artistic agenda perhaps was more conservative than that of some of his contemporaries, it is evidence of the varied methodologies applied to figurative painting in Ireland around 1920.

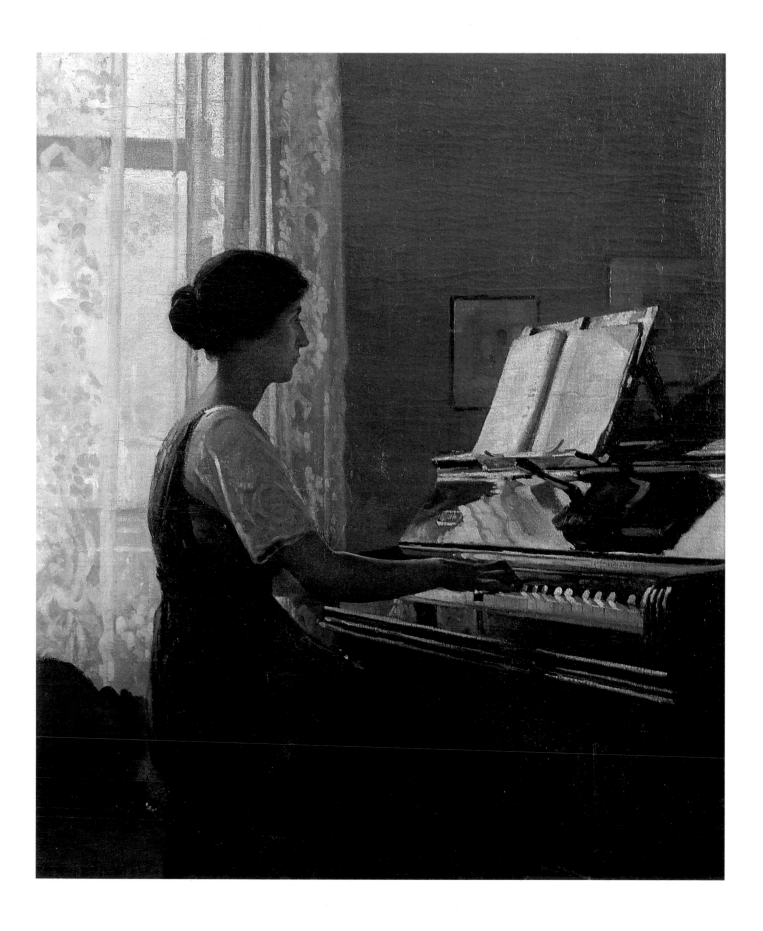

23 CHARLES LAMB (born 1893, Portadown, Co. Armagh – died 1964, Carraroe, Co. Galway)

Dancing at a Northern Crossroads

1920
oil on canvas
52¹/₂ × 75 in. (133 × 190.5 cm)
Private collection, courtesy of Pyms Gallery, London

In the 1920s a vision of rustic dignity and rural virtue emerged in Ireland, extolling the merits of country life in literature, painting, and folk songs. In painting, the whitewashed, thatched cottages as depicted in works by, most notably, Paul Henry, but also to be found in works dating even from the 1940s such as Maurice MacGonigal's *Mother and Child* (see Plate 39), were viewed as a pastoral ideal. The reality of rural life was far different for the majority living in rural Ireland, however, particularly in the West, and included severely overcrowded housing and poor nutrition.[1] Charles Lamb, although born in the North, was also drawn to the West of Ireland and painted scenes of daily life in rural areas. His *Dancing at a Northern Crossroads* is emblematic of the role of dancing in Irish culture, and of the extent to which artists equated the "quaint" customs of the West with a true sense of uncorrupted Irishness. Equally telling is the subject's perhaps unwitting representation of the idleness existing in economically impoverished communities. Like the depictions of the white thatched cottages, the dancing scene may have seemed a quaint, bucolic custom for artists and their urban clients, yet it masked the reality plaguing much of Ireland, especially in the years of the War of Independence. Rectification of this problem became the life's work of individuals such as Sir Horace Plunkett and George Russell (Æ), both of whom recognized the importance of improving agrarian living if Ireland was to establish economic independence and stem the tide of emigration.

Lamb was born in 1893, the same year in which the Gaelic League (Conradh na Gaeilge) was founded. The League encouraged the revival of Irish culture and set about generating enthusiasm by initiating the Feis. Initially, Feiseanna were held primarily in the open air and were organized all over the country, consisting, as some still do today, of competitions in traditional aspects of Irish culture, including dancing. The type of dancing depicted in *Dancing at a Northern Crossroads* is set dancing, a popular form derived largely from dances such as quadrilles and lancers that had been learned by Irishmen fighting in Continental armies in the nineteenth century and then brought home. It remained principally a rural phenomenon. The crossroads gatherings at which these were performed became hugely popular all over the country, set in such sites as a way of bringing together a scattered rural population. The Feiseanna were, however, much frowned on by the clergy of the time, who saw them as opportunities for immoral behavior and who eventually succeeded in having them stopped. Irish dance has evolved in terms of locations, costumes, and dance technique throughout the twentieth century, from its early performance on table tops or, as here, at rural crossroads. It is not surprising, then, to see references to dancing as "tripping the sod."

Other representations of Lamb's theme were carried out by artists including Seán Keating who, along with William Orpen, greatly influenced Lamb's artistic development. Keating's *Dun Aengus: Fisherfolk on a Galway Quay*, from the early 1920s, depicts a similar scene of rural dancing in which, like Lamb's work, the act of dancing and local costume are emphasized. Lamb presents two couples dancing to the accompaniment of two musicians; another couple sits absorbed in conversation in front of a signpost. It is a scene that could be found in any popular dance hall, only here the traditional dress and open landscape show that we are out of doors. Lamb seizes the occasion to exhibit his great technical abilities, relishing the opportunity to depict detailed patterns and colors in the figures' clothing. Their facial features indicate the zeal with which the participants engaged in this informal recreational ritual, part of the country life that Lamb himself embraced, living for the last thirty years of his life in Carraroe, Co. Galway.

1 As Terence Brown has pointed out, the greatest irony of the rural housing problem was that it was somewhat ameliorated by emigration. In *Ireland: A Social and Cultural History, 1922–1979* (London: Fontana, 1981), p. 85.

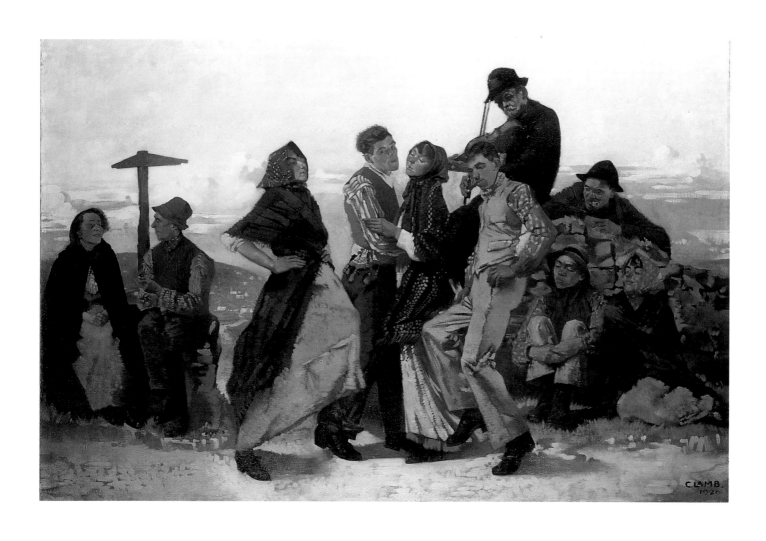

24 SEÁN KEATING

Men of the South

1921
oil on canvas
50 × 80 in. (127 × 203.4 cm)
Crawford Municipal Art Gallery, Cork (Ireland)

Seán Keating's painting *Men of the South* depicts a "flying column" of the Irish Republican Brotherhood (IRB), an antecedent for the Irish Republican Army (IRA). These groups of Irish volunteers performed ambushes and raids on the Black and Tans – the extra-police force recruited by the British during the War of Independence (1919–21) to combat the guerrilla tactics employed by groups such as the IRB – and on the Royal Irish Constabulary, the British police force in Ireland. The role of the IRB in the south was to disrupt the presence of British forces by bombing police barracks and initiating ambushes on police patrols. The IRB itself was a loosely connected, quasi-grassroots effort that lacked the leadership and arms to inflict real damage. Often, when the IRB succeeded in destroying police property or confiscating weapons, the Black and Tans – who were ruthless in their tactics and remain a hated memory in much of Ireland – would mount indiscriminate reprisals that led to many civilian deaths and to the destruction of property across the island.[1]

The figures in Keating's work evoke images of the heroic struggle for independence then occurring in the south of

Ireland and that resulted in the creation of the Irish Free State in 1922. What appears to be a group of men waiting in ambush also becomes a series of individual portrait studies of actual freedom fighters, albeit removed from a combative environment. The men depicted are far too casual in their poses to convey a sense of the restlessness and anxiety one associates with men lying in wait to do battle, particularly in a guerilla war. The painting was, in fact, derived from a number of drawings and photographs done in Keating's studio, with leading members of the local volunteer force posing for these studies (fig. 72). Keating has altered the composition considerably by reducing the number of men from nine to six, allowing for greater emphasis to be placed on each man's facial expression and weaponry. His first visit in 1914 to the Aran Islands off the west coast of Ireland, along with his experiences of living through the War of Independence, may have catechized Keating with the idealized notion of Irishness evident in *Men of the South*. Here, as elsewhere in his work, Keating displays precise technical ability as a realist painter, but ultimately, ". . . it is the clarity of ideals – courage, resolve, self-sufficiency – which are evoked, rather than the confusion and contradictions of guerrilla war."[2]

Keating was a student of William Orpen (see Plates 2, 3, 6, and 18) at the Metropolitan School of Art in Dublin and later acted as a model and assistant to him in London. Although their views of Irish identity and nationalism were diametrically opposed, Orpen greatly influenced Keating's development as an artist. Keating may have viewed the War of Independence as an opportunity to emulate his mentor while lending his support to the Nationalist cause – allowing him to work in the genre of history painting, one that lent itself to Keating's figurative style.

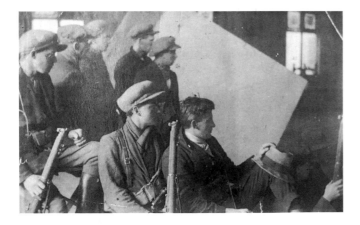

Fig. 72. Photograph taken by Seán Keating of a group of men posing for Keating's *Men of the South*, 1921. The men were the leading officers in the south fighting for independence. Photo courtesy of the Crawford Municipal Art Gallery, Cork

1 For futher first-hand accounts of the IRB's work in West Limerick see Donie Murphy, *"The Men of the South" in the War of Independence* (Newmarket, Co. Cork: Inch Publications, 1991).
2 William Gallagher in *Irish Art, 1770–1995: History and Society. A Touring Exhibition from the Collection of the Crawford Municipal Art Gallery, Cork* (Cork: City of Cork, VEC, 1995), p. 34.

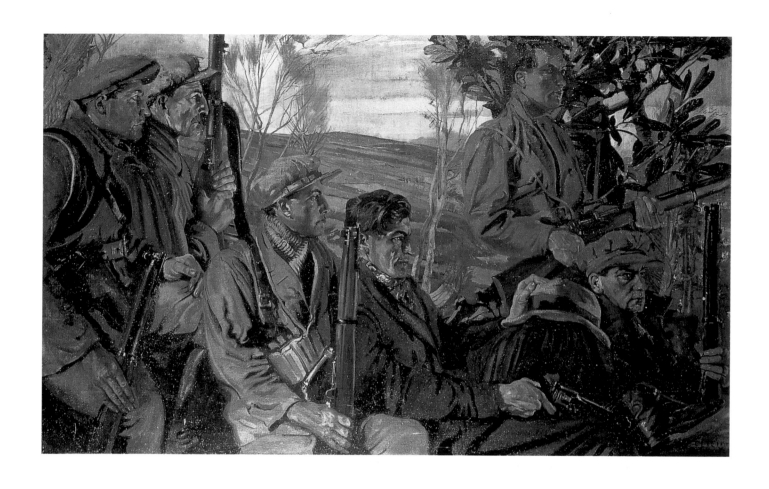

25 JACK B. YEATS

The Sea Captain's Car

1922

oil on canvas

18 × 24 in. (46 × 61 cm)

Private collection, courtesy of Pyms Gallery, London

Jack Yeats once wrote, "I want to say here that 'Captain,' the Captain of a Ship, any Ship, and any size, is the grandest title in the world to me."[1] Yeats's admiration for the sea and the men who earned their livelihood onboard ships began when he was a child, spending most of his early youth at his maternal grandparents home in Sligo in the West of Ireland. His grandfather, William Pollexfen, was a ship owner who devoted his life to the sea; his wayfaring character has been aptly conveyed by Yeats scholar Hilary Pyle who wrote:

"His background was a mystery, except for a few details which revealed glimpses of a life of adventure: an ugly scar on his hand; pieces of coral in a cabinet, beside a jar of water from the Jordan; Chinese paintings; an ivory walking-stick that had come from India; the late learnt knowledge from a chance visitor that he had won the freedom of a Spanish city, perhaps for saving a life."[2]

One can feel the pride and respect given the Captain by Yeats in *The Sea Captain's Car* and how it reflected Yeats's own personal sentiment. The influence of his grandfather and his formative years in Sligo were sources of tremendous inspiration, and in some respect this painting can viewed as an homage to his grandfather, not only as a man of the sea, but for instilling in Yeats a sense of adventure – a facet that clearly reveals itself in his numerous depictions of outdoor sporting events.

The Captain pictured here rides aboard a jaunting car, a popular mode of transportation that is to be found in many of Yeats's paintings. Its common appearance owes much to Yeats's infatuation with horses, used not only to pull the jaunting cars but also figuring centrally in one of Yeats's favorite sporting events – horse racing. The jaunting car, unique to Ireland, developed from the block-wheel cart, a cart that had wheels fashioned out of three solid pieces of wood and joined together by dowels to make a circle. This was modified in the nineteenth century by creating bench seats over the wheels that allowed passengers to sit back to back facing out (leading to the term "Irish outside car") and by outfitting the carts with spoked wheels. The jaunting car was described by an early nineteenth-century traveler to Ireland in this way:

Although there are carriages of all descriptions in Ireland and coaches, too, on many of the principal roads, the jaunting car is the national vehicle and Ireland would scarcely be Ireland without it. It may be said to completely supersede as a private vehicle the whole of the gig tribe – dennet, tilbury, cariolet, etc. – and to be a formidable rival to the coach as a public conveyance.[3]

Yeats was acutely aware of subject matter that was distinctly Irish and made a point of incorporating it into his artwork. But what is most precisely Irish in Yeats's work is the particular coalescence of iconic imagery with a fluid painterly skill that is almost narrational in its layered brushwork. In works such as *The Sea Captain's Car*, Yeats portrays a scene of life in a western Irish seaside town using a palette that elicits a visual sensation appropriate to its subject – the colors alone are sufficient to convey the type of setting, while the trademark variations in the brushwork confirm the sense of movement and action. One can feel the pounding hoofs of the steed galloping at full speed and see the road rushing under the wheels of the car. Even amidst this action, Yeats portrays the Captain – the "grandest title in the world" – in a state of dignified calm.

1 Jack B. Yeats, *Sligo* (London: Wishart & Company, 1930), p. 74.
2 Hilary Pyle, *Jack B. Yeats: A Biography* (London: Routledge & Kegan Paul, 1970), p. 5.
3 Henry D. Inglis, *Ireland in 1834: A Journey throughout Ireland during the Spring, Summer, and Autumn of 1834* (2 vols, London: Whittaker, 1834), I, p. 24.

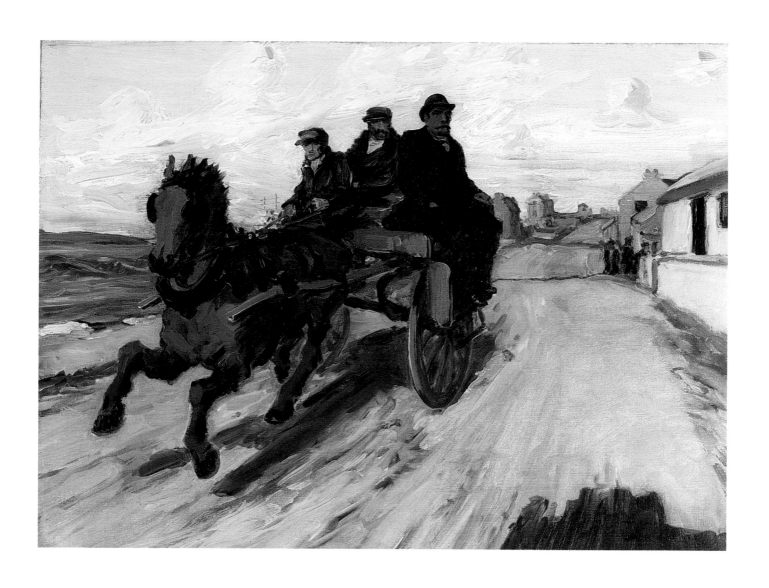

26 SIR JOHN LAVERY

Michael Collins (Love of Ireland)
1922
oil on canvas
25⅛ × 30¼ in. (63.8 × 76.8 cm)
Collection Hugh Lane Municipal Gallery of Modern Art, Dublin

While Sir John Lavery's paintings provide visible evidence of his artistic abilities, what is often less apparent was the role Lavery assumed as a facilitator and promoter of interaction between the British and Irish governments at a crucial period in the history of both countries. In the years surrounding the Irish War of Independence, Lavery was encouraged by his American wife Hazel, Lady Lavery, to become more involved with Irish politics, and he proved equal to the task. Through his ties to both countries (born in Ulster and knighted by the British king), his position in society, and the respect accorded his artistic and social stature, he was able to work at breaking down barriers toward peace through both his diplomacy and his art. As a Catholic born in Belfast, he was championed by both the British government and the Republicans, and while this and other paintings may lead to the perception that Lavery was partial to the nationalist cause, his true commitment was to peace throughout the isle.

Lavery's subject here, Michael Collins (1890–1922), was an Irish revolutionary and statesman who early in his life dedicated himself to Ireland. A member of the nationalist Gaelic League as well as a member of the Irish Republican Brotherhood, he was a hero of the Easter Rising of 1916 in which Irish rebels challenged British rule, and fought in the War of Independence (1919–21). Because of his elevated status within Nationalist ranks, Collins was part of the delegation sent to London to negotiate a settlement with the British government. Collins signed the Anglo-Irish Treaty in 1921 that created the Irish Free State; its ratification was made in January of the following year, when Collins was named Commander-in-Chief of the forces of the new State. Collins felt the Treaty was a step toward total independence, but it involved partition between North and South, and

Collins's action was viewed as treachery by staunch Irish Republicans. In 1922, after returning to Ireland and forming a provisional government, Collins was assassinated in an ambush while on a visit to Cork, his birthplace. For many in Ireland, Collins is remembered as a charismatic figure deeply committed to his country; Lavery and his wife Hazel ardently admired Collins and his work.

During treaty negotiations in London in 1921, Lavery painted portraits of a number of the delegates, including Collins. This, Lavery's second portrait of Collins, shows him lying in the chapel of St. Vincent's Hospital in Dublin prior to his lying in state at City Hall. His body is covered by the green, white, and gold flag of the newly established Free State of Ireland. *Michael Collins (Love of Ireland)* shows the same technical refinement and control that Lavery used in his work as a society painter. The style renders Collins in dignified repose, capturing Collins's youthful vitality, and emphasizing a sense of what might have been, not only for Collins but for his country. Lavery later recounted in his memoirs that while he sat painting the slain leader lying in state, "All day I strove to record the mystery that seemed to play about that mouth, the lips appearing to move at times."[1] Lavery's painting inspired the British-born, Irish Nationalist poet Sir Shane Leslie (1885–1971) to write:

Good luck be with you, Michael Collins,
Or stay or go you far away;
Or stay you with the folk or fairy,
Or come with ghosts another day.

1 Sir John Lavery, *The Life of a Painter* (London: Cassell and Co., 1940), p. 217.

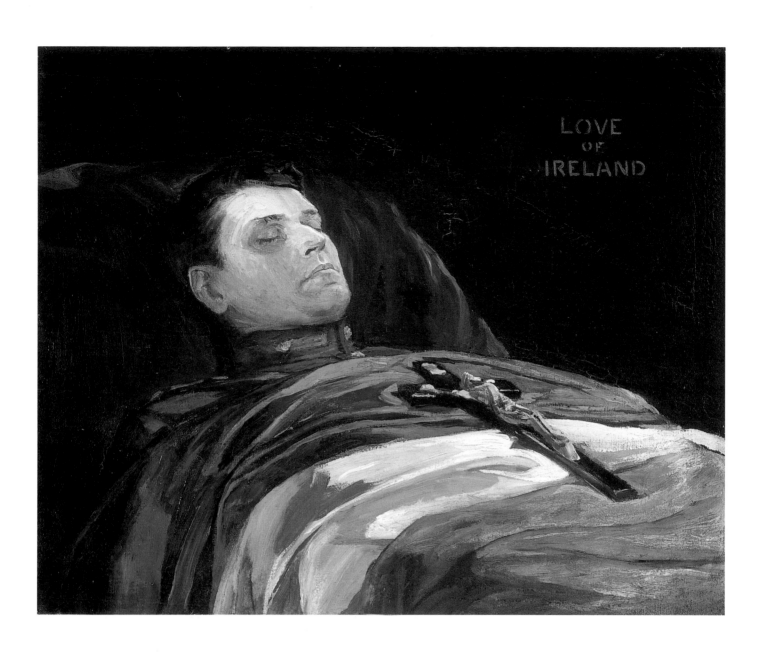

27 JACK B. YEATS

Communicating with Prisoners

1924
oil on canvas
18 × 24 in. (46 × 61 cm)
Sligo County Library

Throughout his career Jack B. Yeats captured scenes of life in Ireland through his illustrations, paintings, and even in literature, with his book *Sligo*. His artistic training at the South Kensington School of Art in London prepared him with technical skills well suited for the work which he did as an illustrator in the 1890s. This formal education combined with his innate drawing ability enabled him to create a unique style that was a synthesis of documentation and painterliness. *Communicating with Prisoners* from 1924 shows the merger of these two traits and represents a stylistic turning point in Yeats's career: it is one of the last works to show clarity and smoothness in the brushwork, soon to be replaced by a more gestural impasto (see Plate 35).

Yeats paints a group of women standing outside Kilmainham Gaol in Dublin, yelling to their captive republican sisters who in turn have broken the windows in the tower and are responding – one of the central figures in gaol has her hands near her mouth to amplify her voice – to their supporters.[1] The painting is important historically as it represents the end of the bloody civil war that polarized the newly created Irish Free State (Saorstát Éireann), yet the violence associated with the event is subdued by the soft coloring and smooth surface of the painting. Yeats has painted an ominous looking prison that dominates half of the canvas and takes on the air of a medieval castle with damsels in distress locked in the tower. Indeed, the work may have had a somewhat parodic intent – such a reading is possible given Yeats's prolific work as an illustrator of humorous cartoons and political parodies.

Yet the work has a more serious edge in commemorating the political role played by women during the War of Independence and the Civil War. As evident in Yeats's work, such women were sometimes incarcerated for their actions. One of the most outspoken of the women activists during the first quarter of the century was Maud Gonne MacBride (1866–1953), who formed the revolutionary woman's society "Daughters of Erin." Gonne's participation in 1902 as the lead character in *Cathleen ni Houlihan*, a play written by W.B. Yeats with assistance from Lady Gregory, indelibly forged her status as the personification of the mythical Mother Ireland (see the introductory essay to this volume). In his autobiography W.B. Yeats commented, "Her beauty, backed by her great stature, could instantly affect an assembly"[2] Her activities after independence confirmed her status as the literal and figurative widow of the War for Independence. In 1923 she was imprisoned in Mountjoy Gaol for planning a poster parade to protest the imprisonment of Republicans through the auspices of the newly formed Women Prisoners' Defense League; from prison she initiated a hunger strike that lasted for twenty days. Once she was freed she continued to assist the families of political prisoners, taking part in demonstrations and vigils at prison gates as she had done in previous years.

With the onset of the modern Troubles, the role of prisons and the prisoners inside have elicited responses similar to those depicted by Yeats and led by Maud Gonne. The most historic incident signifying the role of prisons as a fertile ground for paramilitary political action occurred on March 1, 1981, when Bobby Sands, an Irish Republican Army (IRA) prisoner, began a hunger strike, documented in the recent film *Some Mother's Son*. His action was intended to restore prisoner-of-war status to paramilitary inmates against the wishes of British Prime Minister Margaret Thatcher. His subsequent death while on hunger strike and those of six other IRA members, as well as three from a republican splinter group, initiated a violent reaction outside the infamous Maze prison and effectively strengthened the IRA. Likewise, contemporary artists such as Brian Maguire have rekindled the Yeatsian flame by addressing politically sensitive themes of incarceration (see fig. 46 accompanying the essay by Paula Murphy).

1 Thomas MacGreevy, *Jack B. Yeats: An Appreciation and an Interpretation* (Dublin: Victor Waddington Publications, 1945), pp. 25–26.
2 W.B. Yeats, *Autobiographies* (London: Macmillan & Co., 1955), p. 364.

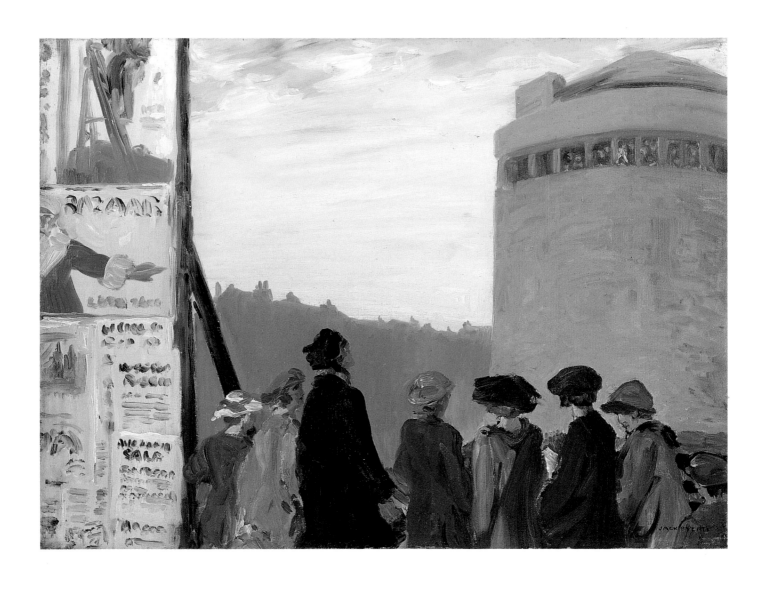

28 JACK B. YEATS

O'Connell Bridge

1925
oil on canvas
18 × 24 in. (46 × 61 cm)
Pyms Gallery, London

After living in Co. Wicklow from 1910, Jack B. Yeats moved to Dublin in 1917. Although he continued to travel throughout the country, particularly to the south of Ireland, Dublin and its surroundings provided the source material for much of his work from this time on. Yeats moved from the rural area south of Dublin into Dublin proper with his wife, Mary Cottenham White, a woman he had met as a fellow student in art school. "Cottie", as she was called, and Yeats were married in 1894; by 1917 they had tired of the isolation of rural living and opted to live in an urban setting. Once in Dublin, Yeats continued to draw from his rural experiences, specifically his childhood in Sligo, but as his style changed to a freer, more lyrical expression of painting, so too did his need for daily interaction with the people and places that reflected the mainstream of change occurring in the Irish Free State in the 1920s. Not coincidentally, this change in subject matter, Yeats's participation in the avant-garde exhibitions at the Armory in New York, his complete abandonment of illustration work in favor of oil painting, and his interest in learning Gaelic, all came at the time of widespread cultural and political transformation in Ireland. It can be argued, then, that Yeats shared such an intimate link with the country and its inhabitants that his personal shifts in thought and artistic style were deeply interwoven with those of the country. Just as Yeats adapted his work to suit the tenor of the times, so too did he hope to instill in Ireland a will to change comparable to that emerging in other industrialized countries.

O'Connell Bridge is one of a number of urban narrative paintings by Yeats in the mid-1920s that were generated by the activity happening on and near the wharves of the River Liffey and the bridges spanning it in Dublin. Yeats was absorbed with the vitality of the waterway and surrounding areas, and the plethora of meanings, both metaphorical and real, that could be attached to it. The Liffey was the life-blood flowing through the heart of Dublin, establishing a link to the sea that provided Yeats with a psychological connection to his childhood in Sligo. More specifically, the O'Connell Bridge (named after the nineteenth-century statesman Daniel O'Connell) was a major byway within the city, and also near the General Post Office where the rebels of the Easter Rising of 1916 had barricaded themselves before ultimately being overtaken by British forces. The bridge resonated with the sort of distinctly Irish sensibility that stimulated Yeats to paint, and brought out the deep attachment to the nation that is evident in much of his work. This attachment has long been remarked on: in a review of Yeats's painting from the early 1920s, one critic wrote, "Too many pictures, though painted in Ireland, have no nationality. We are never in doubt about Jack Yeats' country."[1]

In 1916 the psychological strain of civil strife in Ireland and the years of producing a high volume of hand-colored illustrations for his publication *A Broadside* caused Yeats, exhausted and depressed, to fall ill. Along with the other events in his life already noted, this depression marked a turning point in Yeats's career. His painting style not only changed but became imbued with a deeper understanding of himself and of humanity. *O'Connell Bridge* reveals this change in perception through the inclusion of Yeats himself in the painting: the painter and his wife are at the left of the picture moving across the bridge. Yeats, wearing a broad-rimmed hat and a tight-lipped countenance, pays little heed to the advance of the shadowy figure next to him; instead, he directs his gaze at the bundled, impoverished-looking woman ahead of him. The painting is a radical departure from earlier work such as *The Funeral* (see Plate 19), injecting a real sense of both tension and vivacity through rapid, effusive brushstrokes. The thick application of paint gives the work a richness that was to become a standard feature of Yeats's later work. This glimpse of the artist within the bustling milieu of Dublin divests him of the role of casual observer and makes him instead an active participant in the life of the city.

1 Y.O., "Pictures of Life in the West of Ireland," *The Irish Statesman*, April 5, 1924, p. 104.

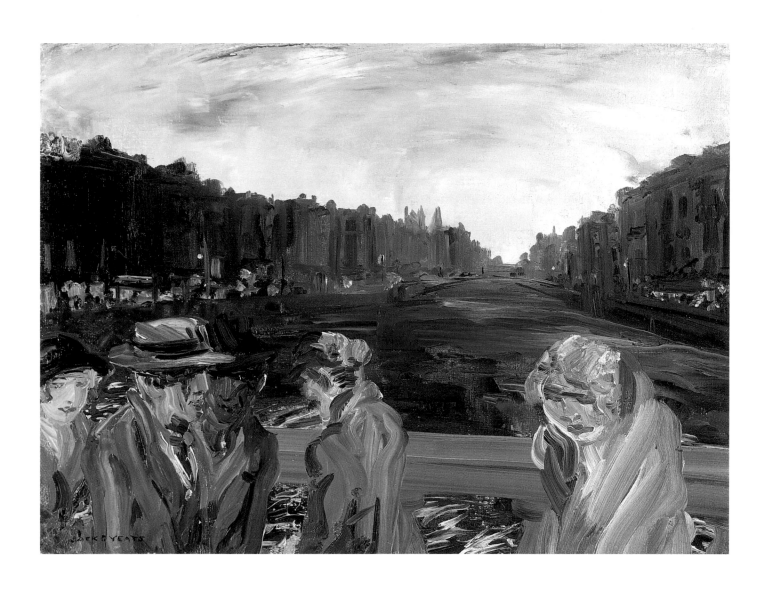

29 EILEEN MURRAY (born 1885, Templemore, Co. Cork – died 1962, The Balcony, Killiney)

This or Emigration

ca. 1926
oil on canvas
36 × 24 in. (91.5 × 61 cm)
Reproduced with kind permission of the Trustees of National Museums and Galleries of Northern Ireland

Y ou brave Irish heroes wherever you be,
I pray stand a moment and listen to me,
Your sons and fair daughters are now going away,
And thousands are sailing to Americay.[1]

Little is known of Eileen Murray, born into a military family in Co. Cork. Although she showed a number of times at the Royal Hibernian Academy's annual exhibitions, little suggests that she exhibited elsewhere. She was educated privately in Ireland before traveling to England to study under the Irish-born British artist Stanhope Forbes (1857–1947) at Newlyn, Cornwall. This area in the southwest corner of England had established a reputation as a British counterpart to the artists' colonies located in Brittany, France. Murray learned plein-air painting techniques from Forbes, who had also spent time in Brittany. She further developed the lessons learned from Forbes in India, where she went to live after her marriage to Major F.S.J. Murray of the Indian Army. She returned to Ireland in 1920 and continued to paint a variety of subjects throughout her life, focussing primarily on figurative and portrait painting.

This or Emigration addresses a theme with political and economic implications that persist to the present day. Murray paints a portrait of a young man after a meager day of hunting – the hares resting on his shoulders like the proverbial albatross. There is sad resignation in his face as he is torn between remaining at home or leaving and facing the uncertainty of life abroad. In both cases, he is called upon to provide for his family either from hunting and bringing home food or by sending monthly contributions of money from wherever he may be working. From her training in outdoor painting, Murray learned to create nuances of light and shade that she uses here to focus on the hapless face of the boy, whose figure is rendered with broad brushstrokes awash in somber grey tones. It is interesting to compare this painting with Lavery's *Hazel in Rose and Gold* (see Plate 10). Despite their difference of subject matter, and the economic station of their sitters, the use of minimal light for maximum effect is comparable in both works.

The message conveyed by *This or Emigration* is made clear and simple by Murray's fine painterly skills, economy of composition, and the work's charged title. Murray suggests that the choices, a meager existence at home or emigration to a foreign land, are equally unappetizing. Unfortunately, the solution to the problem presented here was not so clearly addressed by Ireland's social and political leaders early in the century. At the turn of the century, with the advent of what was to be termed the Celtic Revival, emigration – of terrible proportions, particularly since the potato famine of the nineteenth century – was given serious attention because of its relation to economic troubles which inhibited the development of a truly independent – economically, politically, and socially – Ireland. The lack of economic opportunity at home appeared to make emigration inevitable; emigration in turn made economic success ever less likely. Sir Horace Plunkett (1854–1932), born in England, was an outspoken social reformer who in his book *Ireland in the New Century* appealed for change. He wrote:

"We must recognize that emigration is but the chief symptom of a low national vitality, and that the first result of our effects to stay the tide may increase the outflow. We cannot fit the people to stay without fitting them to go. Before we can keep the people at home we have got to construct a national life with, in the first place, a secure basis of physical comfort and decency."[2]

Even in the 1980s, arguably little had changed, as Fintan O'Toole has candidly observed:

"We will never even begin to face up to emigration until we stop taking a certain surreptitious pleasure in it as the one thing which unifies us as a nation, which establishes our continuity with our ancestors and our history."[3]

1 Excerpt from *You Brave Irish Heroes*, a traditional Irish ballad written some time after the famine when the mass emigration to American began.
2 Sir Horace Plunkett, *Ireland in the New Century* (New York: E.P. Dutton & Company, 1908), p. 39.
3 Fintan O'Toole, *A Mass for Jesse James: A Journey through 1980's Ireland* (Dublin: Raven Arts Press, 1990), p. 124.

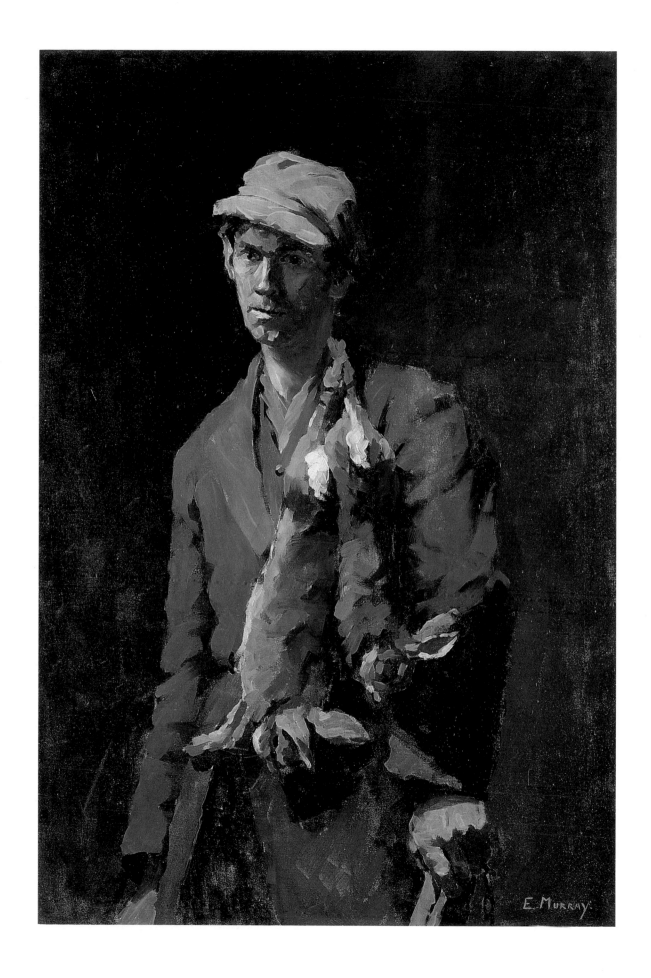

30 HILDA ROBERTS (born 1901, Dublin – died 1982, Dublin)

Portrait of George Russell (Æ)

1929
oil on canvas
30 × 25 in. (76.2 × 63.8 cm)
Reproduced with kind permission of the Trustees of National Museums and Galleries of Northern Ireland

Hilda Roberts was a student of Patrick Tuohy at the Metropolitan School of Art in Dublin who specialized in portraiture from 1925 onward. Roberts's chosen subject for this portrait remains a revered figure in the Republic of Ireland for his contributions to its cultural development. Artist, poet, playwright, journalist, editor, activist, and mystic, George Russell (1867–1935) represents the quintessential Irish Renaissance man. His efforts to revitalize Ireland from its post-famine stupor through his visual and literary contributions, as well as his work to establish agrarian reform, were important to the social and political change that took place at the turn of the century. He attended the Metropolitan School of Art but his ideas and visions moved far beyond the studio and the life model posing before him. As one of his classmates, the poet William Butler Yeats, remarked at the time, "Some other image rose always before his eyes (a St. John in the Desert I remember), and already he spoke to us of his visions."[1] Such visions manifested themselves in paintings such as *The Winged Horse* (fig. 73), which in its style and subject reflect a spiritual revelation. Russell further explored his visionary calling by becoming a member of the Theosophical Society, an organization that promoted a doctrine related to deity, the cosmos, and self

that would lead man to guide his own destiny through mysticism. From 1893 on, Russell was known by his pseudonym, Æ, which was derived from Aeon, a word that had come to Russell during a spiritual vision.

Russell was a strong supporter of cooperative agriculture in Ireland, working with Sir Horace Plunkett (1854–1932) for the Irish Agricultural Organization Society (IAOS) which he had joined in 1897 at Plunkett's invitation. He later expressed his outspoken views on all aspects of Irish cultural life as editor of *The Irish Statesman* (formerly *The Irish Homestead)*, which was the published voice of the IAOS. Throughout his career, Russell promoted socioeconomic change in Ireland that would lead to prosperity and stability. His work was outside the purview of party politics, but had a lasting effect on the country at a time of particular transition marked by the Easter Rising in 1916, the Civil War, and formation of the Irish Free State in 1922.

The *Portrait of George Russell (Æ)* was painted at Russell's home in Dublin over the course of six Sunday morning sittings in 1929. He is shown at the age of 61 having received honorary degrees in the United States from Yale University and in Ireland from Trinity College in Dublin. Behind the figure of Russell are the tools of his trade, books reflecting his scholarship and one of his own mystic/poetic paintings. Roberts has captured Russell's taciturn nature brilliantly, exposing his penetrating gaze, and suggesting his vibrant energy by showing him pulling at the lapel of his jacket. One feels the anxiety Roberts must have experienced at having to work quickly under the pressure of Russell's unwillingness to sit still. Given her time restrictions, it is clear that Roberts felt that it was imperative to focus attention on the head, while rendering the background and Russell's attire with quick strokes of paint. The end result is a brilliant portrait capturing the essence of a man who committed his life to the improvement of Ireland.

Fig. 73. George Russell (Æ), *The Winged Horse*, 1904, oil on board, 12³⁄₈ × 18 in. (31.5 × 45.8 cm), Hugh Lane Municipal Gallery of Modern Art, Dublin

1 W.B. Yeats, *Autobiographies* (London: Macmillan & Co., 1955), p. 80.

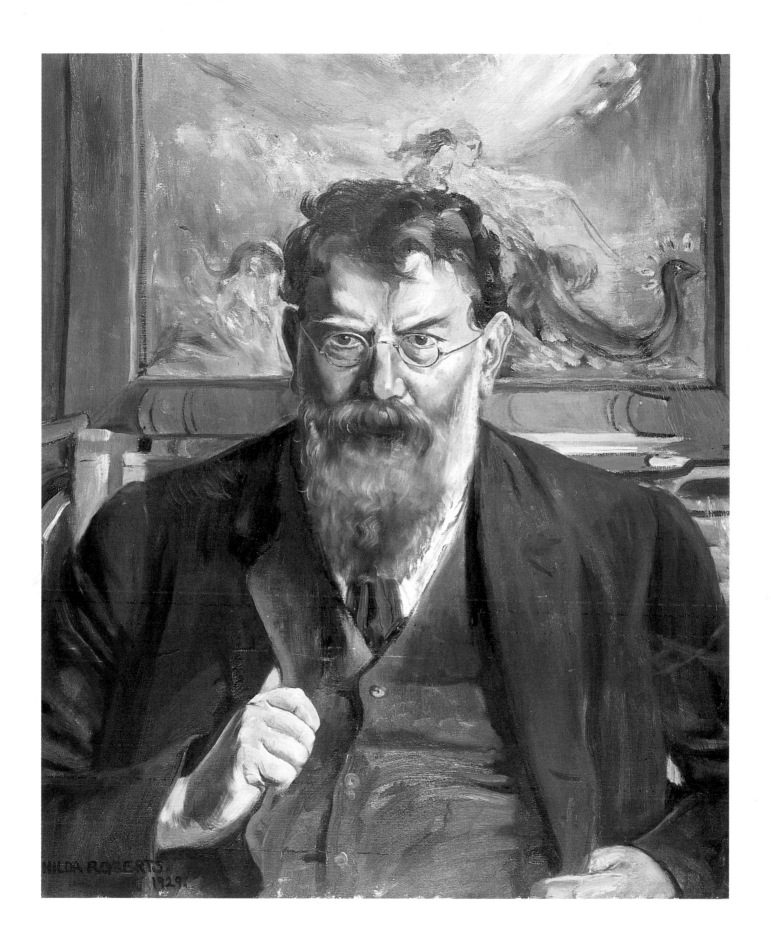

183

31 JAMES HUMBERT CRAIG (born 1877, Belfast – died 1944, Cushendun, Co. Antrim)

Going to Mass

ca. 1935
oil on board
14⁷/₈ × 19⁷/₈ in. (37.7 × 50.5 cm)
Crawford Municipal Art Gallery, Cork, (Ireland)

James Humbert Craig figures more prominently as a painter of landscapes rather than of figures in the history of Irish art. The son of an Irish tea importer and a Swiss mother, Craig began his career working in his father's business and later pursued his own commercial affairs. As a youth he enjoyed drawing and painting, and he eventually decided to devote his life to his childhood passion. Craig was for the most part self-taught, although he was enrolled at the Belfast College of Art for a short time. He first exhibited at the Royal Hibernian Academy in 1915, showing a pair of coastal scenes near his home at Ballyholme in Co. Down. Craig's work as a landscape painter ultimately achieved a popularity equal to that of Paul Henry (see Plates 12 and 13). Craig exhibited regularly in Belfast and Dublin as well as in London. He concentrated on representing landscapes of the north and west of Ireland, including depictions of the Glens of Antrim, Donegal, and the Connemara countryside, the areas that were most familiar to him and that offered what he felt to be the most scenic and picturesque views of Ireland.

As early as 1923, Craig was recognized as one of the best painters in the north of Ireland who were, in the words of a contemporary critic, "almost without exception, engrossed in landscape."[1] *Going to Mass* hints at the realism of rural life, capturing the ritual pilgrimage to mass. The small number of clergy and churches combined with the dispersal of families throughout the countryside predicated the need to travel to a centrally located site for religious services; the journey comes to symbolize the importance of religion as a bond within the community. Craig, showing his preference for natural scenery, has relegated the figures to the status of landscape elements of a piece with their setting, render-

ing them with the same broad brushstrokes and attention to detail that he uses to create the clouds and mountains. He seems primarily interested in presenting the effects of light through clouds, perhaps after a recent rain, by using soft colors that reflect and absorb, giving vibrancy to the scene. The prominence given to the sky and clouds is particularly reminiscent of paintings by Paul Henry, such as *The Watcher* (Plate 13).

Going to Mass offers through its title an ostensible reference to religion but more importantly for Craig it signifies the sacred experience found outside of the physical church and associated with the natural world. One thinks of the eighteenth-century landscapes of the German artist Caspar David Friedrich and the notion of the Sublime – the word used to describe the gamut of emotions felt upon viewing a landscape or a work of art – with its modern reading of landscape painting.[2] For Craig, as for Friedrich, landscape painting offered a personal testimony to the expression of spirituality in nature. The figures and the act in which they participate are subordinated to the emotive power of the Irish landscape but provide a means of entry for the viewer into the spirituality of landscape itself. Whether or not the painting was seen as representing a scene of Catholic devotion, it was embraced by the Irish public in the years after independence – and commonly reproduced – as characterizing an important aspect of Irish public identity.

1 T.B., "Art Reviews," *The Studio*, LXXXVI, no. 369 (December 1923), p. 341. The same reviewer, just a year after the ratification of the Anglo-Irish Treaty, offers numerous comparisons and generalizations between artists in the north and the south, underscoring the pre-existing division.
2 Robert Rosenblum, *Modern Painting and the Northern Romantic Tradition: Friedrich to Rothko* (New York: Harper & Row, 1975).

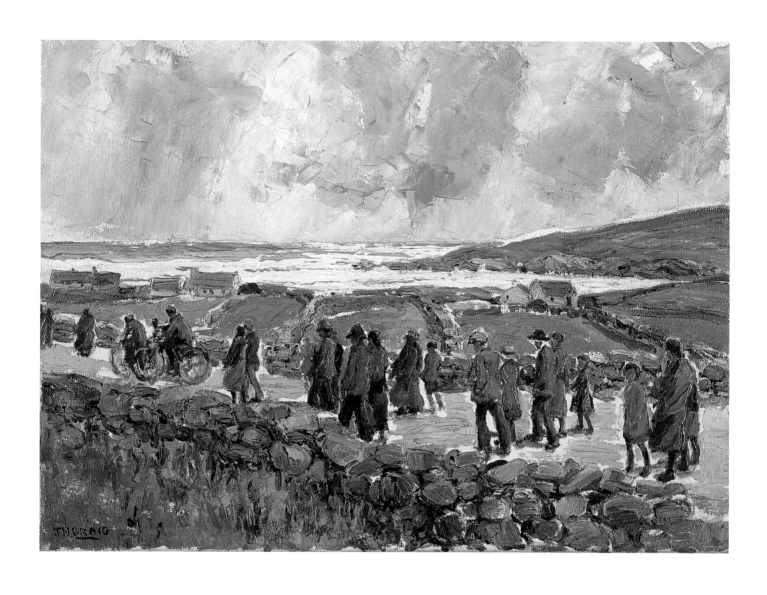

32 SEÁN KEATING

Slán Leat, a Athair (Goodbye, Father)

1935
oil on canvas
69 × 68¾ in. (175.9 × 175 cm)
Reproduced with kind permission of the Trustees of National Museums and Galleries of Northern Ireland

Seán Keating's *Slán Leat, a Athair (Goodbye, Father)* presents a scene from the Aran Islands in which a group of islanders sees off a departing priest. The priest who served such distant communities would visit them periodically while living on the mainland. The islanders epitomized what Keating believed was the true essence of Irish culture – espousing a simple yet rugged and fulfilling life, perpetuating century-old customs, and retaining their Gaelic dialect. Keating, like his former student and contemporary Charles Lamb (see Plates 23 and 24), made a conscious effort to extol the virtues of rural life in his work, feeling that a return to traditional Celtic customs and speech would lead to a more unified Ireland. The veneration of the past was a prevailing sentiment throughout the 1930s and instilled a somewhat xenophobic attitude among the Irish, supported by a zealous Censorship Board.

As an ardent supporter of the Nationalist movement, Keating condoned the activities of groups such as the Gaelic League, founded in 1893. The League was the principal driving force behind the national revival occurring in Ireland at the turn of the century, attempting to revive nationalism through linguistic efforts. The League had limited success with the advancement of Gaelic in everyday life, however, which Nationalists like Keating believed led to the resumption of pre-existing cultural poverty.

Equally important to Keating was the promotion of Irish industry, and in 1927 he was commissioned by the newly formed Electricity Supply Board (ESB) to document the construction of the hydro-electric facility on the Shannon River at Ardnacrusha that took place from 1926 to 1929. The ESB initiated this project to help develop agriculture and brighten rural life in Ireland. The more than twenty paintings Keating did for the ESB also include *Night's Candles are Burnt Out*, an allegorical portrayal of the socio-economic impact of the facility at Ardnacrusha. Keating actually lived on the site with the workers and through his paintings captured this important construction that ". . . was seen both at home and abroad as a concrete, tangible proof of Ireland's independence and separate statehood."[1] Stylistically the paintings for the ESB are similar to other work done in the 1930s and are linked thematically by their reference to social and economic issues that both underscore Keating's infatuation with tradition (exemplified by his partiality to subject matter from the Aran Islands) and document the advancement of Irish economy and industry.

Slán Leat, a Athair owes something to the landscapes of Paul Henry (see Plates 12 and 13) with their dramatically cloud-filled skies, while the technical skill in rendering each of the men shows, like his earlier work (Plates 15 and 24), the influence of William Orpen. Keating's work throughout his career can be viewed as a form of documentary painting that, because of a stubborn parochialism, offers a somewhat anachronistic image of Ireland. Keating was openly hostile to modernism, which he felt lacked skill and craftsmanship and only served to undermine traditional development of art as something passed on from master to pupil. Keating saw himself as part of the perpetuation of traditional values and training, and viewed the work of Mainie Jellett (see Plates 38 and 43) as detrimental not only to Irish art, but to the country. Yet Keating maintained a conservatively progressive position, wanting to see cultural and economic development in Ireland but unwilling to accept change orginating outside the confines of Ireland – in some respects resembling the position taken by George Russell (Æ) (see Plate 30). Keating's unwillingness to compromise garnered him the admiration of some critics as a man of conviction, but his unrealistic and even archaic way of thinking was not in keeping with his hope for change in Ireland. Later in his life he seemed to see this contradiction when he wrote, "But life – of which art is a part – is dynamic and changing continually. That which is not changing is dying, and that which cannot change is already dead."[2]

1 Maurice Manning and Moore McDowell, *Electricity Supply in Ireland: The History of the ESB* (Dublin: Gill and Macmillan, 1984), p. 51.
2 Seán Keating, "Reflections," in *Irish Art Handbook* (Dublin: Cahill and Company, 1943), p. 29.

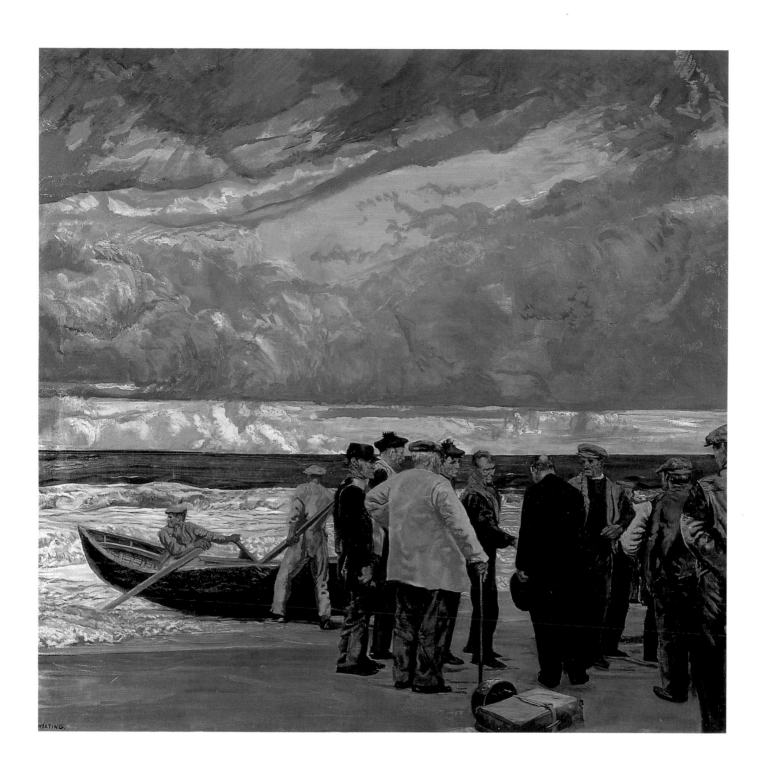

187

33 MAURICE MACGONIGAL (born 1900, Dublin – died 1979, Dublin)

The Olympia, Dublin

ca. 1935–36
oil on canvas
25 × 30 in. (63.6 × 76.5 cm)
Reproduced with kind permission of the Trustees of National Museums and Galleries of Northern Ireland

Maurice MacGonigal was born at the turn of the century in Dublin, just as nationalist fervor was spreading throughout the country. It is not surprising, then, given the political climate, that after working in the stained glass studio of his uncle, Joshua Clarke, he joined Na Fianna Éireann, an Irish Nationalist secret society that derived its name from the legendary band of Irish warriors led by the mythical hero Finn MacCumhaill (MacCool). Na Fianna Éireann was sometimes referred to as the Irish Republican Brotherhood, precursor to the Irish Republican Army. MacGonigal was arrested for his political affiliations and interned at Dublin's Kilmainham Gaol and Ballykinlar Camp. After his release in 1921, he returned to his uncle's studio and was encouraged to pursue art by his cousin Harry Clarke, who later established himself as an internationally recognized stained glass artist. Upon winning an art scholarship in 1923, MacGonigal enrolled at the Metropolitan School of Art where he was influenced by, among others, Seán Keating and Patrick Tuohy (see Plates 14, 15, 24, 32, and 34). MacGonigal later joined Keating as a member of the faculty at the National College of Art where they offered a contrast in teaching methods and painting styles.[1]

The Olympia deals not with overtly political subject matter, but with everyday life and a Dublin landmark; the title refers to the Olympia Theater in Dublin, one of the only remaining nineteenth-century theaters in the city, which originally opened as Dan Lowery's Music Hall and was later renamed the Empire Palace. MacGonigal painted it from a series of pencil drawings executed over a long series of visits. The figure standing on the right in the foreground is another Irish artist, Harry Kernoff (1900–1974), a good friend of MacGonigal's who frequently attended the theater with him. Although MacGonigal began his artistic career after art school by leaving Dublin and moving to the west of Ireland in order to paint, he was equally adept at book illustration and stage design. Later in his career he produced posters and sets for the Abbey Theater in Dublin and enjoyed attending performances there and at the Olympia.

The Olympia offers a clandestine snapshot of a performance (likely a rehearsal) inside the theater. The composition is somewhat unusual as the center of the painting focusses on the head of a standing figure watching the performers on stage from the orchestra pit. The upper portion of a contrabass is seen on the left side of the painting and partially obscures the two figures on stage. MacGonigal has broken from academic convention by placing the central figure directly in line with the massive architectural element that frames one side of the stage. In addition, the gaze of the painted audience directs the viewer to the performers standing at the far edge of the picture. These compositional details and the vivid coloring create a lively scene that is, appropriately enough, inherently theatrical. MacGonigal's fondness for theater and his experience with set design made him the ideal artist to document a traditionally popular form of entertainment in Ireland and to capture the spirit of an historic edifice. Although the interior scene is a departure from MacGonigal's figure paintings set outdoors and the later landscape painting for which he is better known, he renders *The Olympia* with the same immediacy and control that characterizes his other work.

1 For a more complete description see John Turpin, "The National College of Art under Keating & MacGonigal," *Irish Arts Review*, 5 (1988), pp. 201–11.

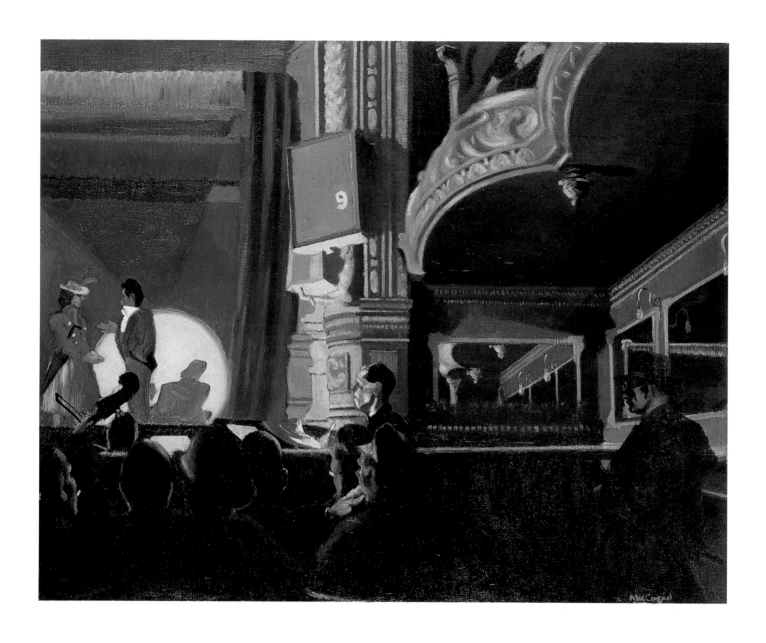

34 SEÁN KEATING

Economic Pressure

1936
oil on board
48 × 48 in. (122 × 122 cm)
Crawford Municipal Art Gallery, Cork (Ireland)

Seán Keating was encouraged by the stained-glass artist Harry Clarke to visit the Aran Islands in 1914, where he became fascinated by the lifestyle of the islanders which he felt represented the essence of true Irishness. Other artists such as Paul Henry (see Plates 12 and 13) and writers including W.B. Yeats and John M. Synge also developed an appreciation of the culture existing on the islands off the west coast, from which they drew for their work. Keating was so affected by his experience of island culture that he learned the Aran dialect of Gaelic and was said to be the first man in Dublin seen wearing a *crios* (a traditional Aran belt) and *báinín* (a type of wool produced in Aran). Keating found the Islands to be a fertile ground for painting, offering a variety of subjects for figure studies and depictions of the rugged and barren landscape. He was among the first of many Irish artists to travel to the islands and paint the local people; along with the paintings of Henry and the 1934 film *Man of Aran*, by the Irish filmmaker Robert Flaherty, Keating's representations of the Aran people such as *Economic Pressure* heroicized the islanders and their simple life.

Similar in many respects to the painting *Slán leat, a Athair (Goodbye, Father)* (Plate 32), *Economic Pressure* portrays another sort of departure, one that reflected a serious malaise affecting Ireland in the wake of the famine of 1845: emigration. Rampant emigration reflected the economic woes in Ireland, particularly in the 1930s, that led to political measures such as the Conditions of Employment Bill in 1935, intended by the government to improve working conditions and, as a result, to entice people to remain in Ireland.

Unfortunately, the Bill was viewed by many as merely an attempt to displace women from the workplace and give their jobs to men. Keating here depicts a woman saying good-bye to a young man, most likely her son. Two other men stand patiently near a currach, the traditional small boat (the oars of which lie on the rocks) of the Aran Islands, waiting to take the man to the waiting hooker, a larger sea vessel common in Galway Bay. The man would then disembark on the mainland of Ireland and board a steamer for the United States. Keating, who throughout his career used his painting skills to extoll industrial and agrarian advances even as he promoted the virtue of traditional Irish customs to the point of propagandizing, had to see emigration as an undeniable reality, even in the self-sustaining rural isolation of the West.

Keating's composition is a classic example of the sort of staged arrangement found throughout his work; its theatrical aspect was learned from Keating's teacher William Orpen, who used his technical skill to produce tight compositional frameworks. Both artists employed a precise handling of line and skillful composition in space, even if their work lacks the spontaneity of artists such as Henry and William Conor. Another painting by Keating, *Ulysses in Connemara*, uses virtually the same setting as *Economic Pressure* but changes the placement of the figures and their dress. Keating actually translated his expertise in creating stage-like settings within his paintings into theater design, producing the background scenery paintings and designing the costumes for a production of Synge's *Playboy of the Western World* at Dublin's Abbey Theatre in the 1940s.

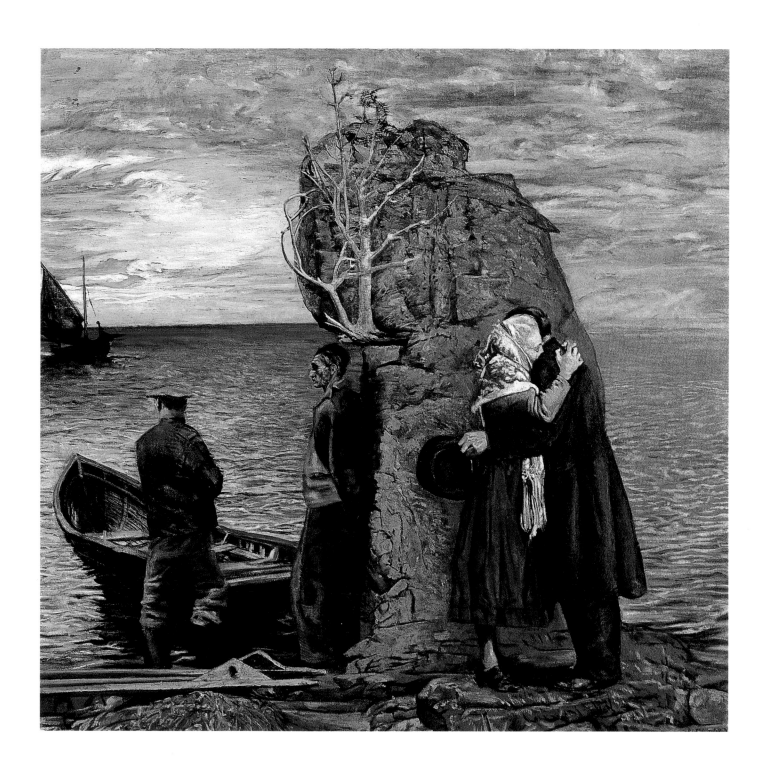

35 JACK B. YEATS

Going to Wolfe Tone's Grave

1929
oil on canvas
24 × 36 in. (61 × 91.5 cm)
Private collection

Jack B. Yeats helped craft a national spirit through his interpretation of events that comprised the drama of Irish life at the conception of the new Free State, Éire.[1] Through his choice of subject matter he conveyed a distinctly Irish sensibility that was consistent throughout his career. Despite this constant, one change did occur in his work around 1925, and that was a change in style marked by a less restrained palette, an expressionistic treatment of figures, and the frequent use of a palette knife for applying and incising paint. This evolution is made evident by comparing *Communicating with Prisoners* from 1924 (Plate 27), *O'Connell Bridge* painted in 1925 (Plate 28), and this work, *Going to Wolfe Tone's Grave*, dated 1929. The latest work is rendered with a rich and sensuously textured surface that inspires a more vivid drama. In this instance, the painting describes an annual event for Irish Nationalists – a pilgrimage (rendered in the form of a group of people waiting in a station house to take the train) to the burial site of one of the preeminent Irish freedom fighters, Wolfe Tone.

Theobald Wolfe Tone (1763–1798) is considered the "father" of Irish republican Nationalism. He was one of the founders of the Society of the United Irishmen in Belfast in 1791, originally formed to defend the rights of Catholics in Ireland, but which was disbanded and reformed as an illegal, clandestine group that sought to make Ireland a republic (following the lines of the French system) and sever all connections with England. Tone was captured on a French ship during the failed rebellion in 1798. As a Protestant member of this group, he was tried as a traitor and sentenced to be hanged. He wrote these words that were stricken from his speech before the court, but give justification for his venerable status among Irishmen:

"I have labored to abolish the infernal spirit of religious persecution, by uniting the Catholics and Dissenters; to the former I owe more than ever can be repaid; the services I was so fortunate as to render them they rewarded munificently; but they did more; when the public cry was raised against me, when the friends of my youth swarmed off and left me alone, the Catholics did not desert me; they had the virtue even to sacrifice their own interests to a rigid principle of honor."[2]

Tone committed suicide in prison while awaiting his execution, assuring his status as one of the first, and greatest, Irish "martyrs" to the cause of independence – despite condemnation of his suicide by his Catholic brethren. He was buried in Bodenstown, Co. Kildare. A ceremony held in 1898 marked the centenary of his death, initiating subsequent gatherings in Bodenstown, most notably one in 1913 at which Patrick Pearse delivered a speech that placed Tone above St. Patrick in the roster of Irish heroes. The scene painted by Yeats shows a crowd gathering at Kingsbridge Station (now Heuston Station) in Dublin purchasing train tickets for the annual pilgrimage.

Going to Wolfe Tone's Grave is a celebration of Tone and his efforts to reconcile the religious differences plaguing Ireland. Yeats's own appreciation of Tone as an Irish martyr was initiated with the centenary celebrations of 1898. His ties with the growing cult surrounding Tone were also familial: his brother W.B. Yeats was president of the English committee of the Wolfe Tone Memorial Association. The two brothers were far apart in their ideology of Irish politics, however, with Jack believing that only with complete independence from Great Britain would the Irish people truly be free. Jack's vision of a free Ireland derived from his open humanitarian nature rather than from strong political conviction. As Hilary Pyle has pointed out, "His [Jack's] patriotism had nothing to do with war or the practicalities of the situation, but was rather a dedication to perfect life, without blemish, where no man was subject to another."[3] One can see, then, what drew him to the mystique of political selflessness associated with Wolfe Tone.

1 See Bruce Arnold's essay, "Jack Yeats and the Making of Irish Art in the Twentieth Century," in this volume.
2 Reprinted in Marianne Elliott, *Wolfe Tone: Prophet of Irish Independence* (New Haven: Yale University Press, 1989), p. 394.
3 Hilary Pyle. *Jack B. Yeats: A Biography*. (London: Routledge & Kegan Paul, 1970), p. 119.

36 JACK B. YEATS

The Small Ring

1930
oil on canvas
24 × 36 in. (61 × 91.5 cm)
Crawford Municipal Art Gallery, Cork (Ireland)

The subject of *The Small Ring* was one that Jack B. Yeats had explored as an illustrator in the 1890s, when he carried out a number of drawings depicting boxing scenes. After working for a variety of illustrated journals, Yeats embarked with his friend and fellow artist Pamela Coleman Smith on a graphic venture in 1902 with the publication of *A Broadsheet*, a monthly periodical published for two years. In 1908, encouraged by his friend the British poet John Masefield (1878–1967) and his sister Elizabeth Yeats, Jack Yeats returned to serial publication with *A Broadside*, published monthly until 1915. Through the hundreds of illustrations drawn for these two periodicals, Yeats demonstrated an acute power of observation and ability to translate quickly what he saw into a graphic image. In this respect Yeats's work can be compared to that of American illustrators/painters at the turn of the century such as George Bellows (1882–1925), a painter and lithographer noted for his paintings of action scenes and for his expressive portraits and seascapes. Bellows, like Yeats, created dramatic, evocative paintings of prizefights, such as *Stag at Sharkey's* and *Both Members of This Club*, both 1909, as well as *Dempsey and Firpo* from 1924. Bellows studied at the New York School of Art under Robert Henri (1865–1929), whose ideas attracted a group of young illustrators from the Philadelphia press. Bellows's early works show the influence of Henri in their dark, tonal palette, vigorous brushwork, and urban subject matter, all of which resemble Yeats's work in Ireland. While not tracing lines of influence, the comparison serves to underscore the progressive, modernist sensibility inherent in Yeats's work, placing him out of the context of many of his Irish contemporaries tied to academic traditions.

Yeats' involvement with international modernism also relates to his first trip to New York in 1904. At that point in his career he was not yet painting in oils, but had shifted his focus from graphic illustration to watercolor painting. In fact, the reason for his travel was to show a selection of recent watercolors at a solo exhibition arranged by the wealthy Irish-American lawyer and art collector John Quinn. Quinn was a strong ally and generous patron of Yeats and

later was influential in Yeats's selection to contribute five paintings to the Armory Show in 1913, a groundbreaking international exhibition of modern painting and sculpture held at the Sixty-ninth Regiment Armory in New York City. The Armory exhibition traveled to Chicago and Boston and was seen by approximately 300,000 viewers. Of the 1,600 works included in the show, those that garnered the greatest attention – and accounted for about one third of the total on view – were European. Yeats's participation in the Armory Show came at another key transitional moment in his artistic career, as he took up oil painting with a keen devotion. The vitality and energy Yeats applied to his subject matter in this new medium, whether a boxing match in London or a walk across a Dublin bridge, helped to re-energize the arts in Ireland.

Yeats was a veteran observer of prize fights, having attended his first in London as a young man, and one senses the depth of experience bound in his painting. As he wrote in his book *Sligo*, "By many ring sides I have sat. But still I am no hardened veteran. I still give and receive in imagination the blows, bobbing up and down, and wincing , and setting my teeth and crushing forward."[1] In *The Small Ring* the crowd seems to mirror Yeats's own sentiments as it surges forward from behind the ropes as if to descend upon the fallen fighter. The onlookers' gazes are frozen momentarily, betraying a mix of emotions ranging from that of the fallen fighter's trainer, clinging to a white towel in disbelief, to those of a woman rushing in to embrace her champion. The title suggests that the physical space of the site has been compressed into a miniature boxing hall, its diminutive size heightened by the crowd pressing directly against the ropes and literally climbing on the backs of other patrons. Yeats further diminishes the size of the ring by enlarging the figure of the standing fighter who has just sent his opponent to the canvas, a victor embodying the energy of the ring and of Yeats's painting style.

1 Jack B. Yeats, *Sligo* (London: Wishart & Company, 1930), p. 22.

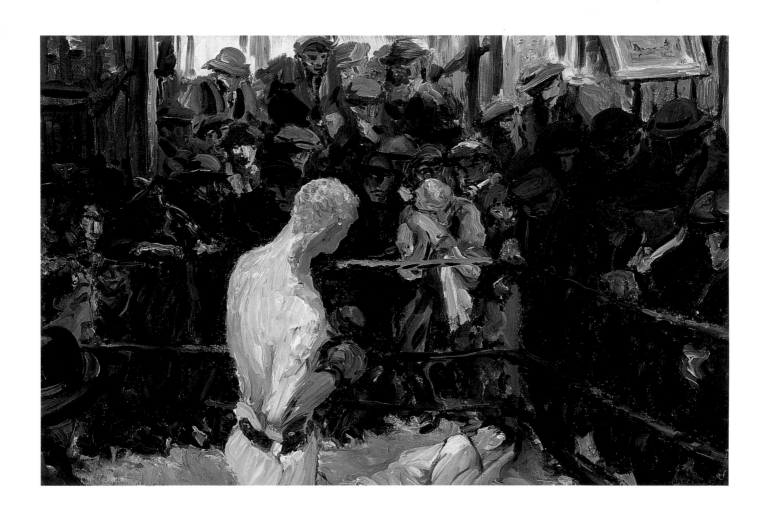

37 LOUIS LE BROCQUY (born 1916, Dublin)

A Picnic

1940
wax-resin medium on canvas mounted on board
15¾ × 15¾ in. (40 × 40 cm)
Private collection

Louis le Brocquy left Ireland in 1938 to study in London and has continued to reside outside Ireland, primarily in France, for much of his life. The year after his departure from Ireland he traveled to art museums throughout Europe where "Alone among the great artists of the past, in these strange related cities, I became vividly aware for the first time of my Irish identity to which I have remained attached all my life."[1] Le Brocquy has stated that he has an aversion to "self-conscious nationalism" and believes that there exists instead a latent Irishness in his work – a sentiment shared by other artists such as Robert Ballagh. Le Brocquy's earliest paintings reflect his European art experiences and can often be traced to a specific source such as Edouard Manet, James McNeill Whistler, or, in the case of *A Picnic*, Edgar Degas. This painting was inspired by Degas's *Beach Scene (Bains de mer: Petite fille peignée par sa bonne)* (fig. 74) a painting that also seems to have influenced William Orpen's *On the Beach, Howth* (see Plate 6). Degas's painting was part of the collection acquired by Hugh Lane (see pp. 29–36).

Le Brocquy painted *A Picnic* in pursuance of his interest in the art of painting as demonstrated by Degas and the picture making of Japanese ukiyo-e artists, who mixed native and foreign realism. It was not until later that le Brocquy recognized the surreal nature of the work.[2] The painting depicts two women and a man sitting on the ground, each pensively gazing in a different direction. The composition reads as three separate figure studies showing different perspectives of a single model in a reclining pose. What is apparent in this early work is le Brocquy's interest in the human figure and his desire to move beyond the physical to expose inner thoughts, conveyed in the introspective visages of the figures. The importance of this was to be made manifest in the series of head images that he began in 1964, of which *Reconstructed Head of an Irish Martyr* (Plate 53) is an early example.

Like Degas, le Brocquy paints with a palette of predominately neutral tones and shows great precision in the handling of line and detail within the composition. At the same time, there is an element of flatness in the picture plane that renders figures and objects at angles and in positions that appear unreal. The folded umbrella and outfit lying on the sand in Degas's work, much like the foreground female figure in le Brocquy's, are awkward; their spatial rendering seems out of place within the context of the picture. The "modern" arrangement and psychological interplay between le Brocquy's figures hints at the move toward a kind of figurative abstraction that has characterized his later work and was, in 1940, a departure from the academic-based painting promoted in Ireland by the principal arbiter of the visual arts, the Royal Hibernian Academy. This led le Brocquy and other artists to establish a new venue, the Irish Exhibition of Living Art, where they could exhibit work that reflected a more progressive view – one that they hoped would lead to the greater development of the visual arts in Ireland.

Fig. 74. Edgar Degas, *Beach Scene (Bains de mer: Petite fille peignée par sa bonne)*, ca. 1868, oil on paper, three pieces, mounted on canvas, 18½ × 32½ in. (47 × 82.6 cm), National Gallery, London/Hugh Lane Gallery, Dublin

1 Introduction by Kevin M. Cahill MD in *Louis le Brocquy and the Celtic Head Image* (Albany, NY: New York State Museum, 1981), p. 9.
2 *Louis le Brocquy: The Head Image* (Kinsale, Co. Cork: Gandon Editions, 1995), p. 14.

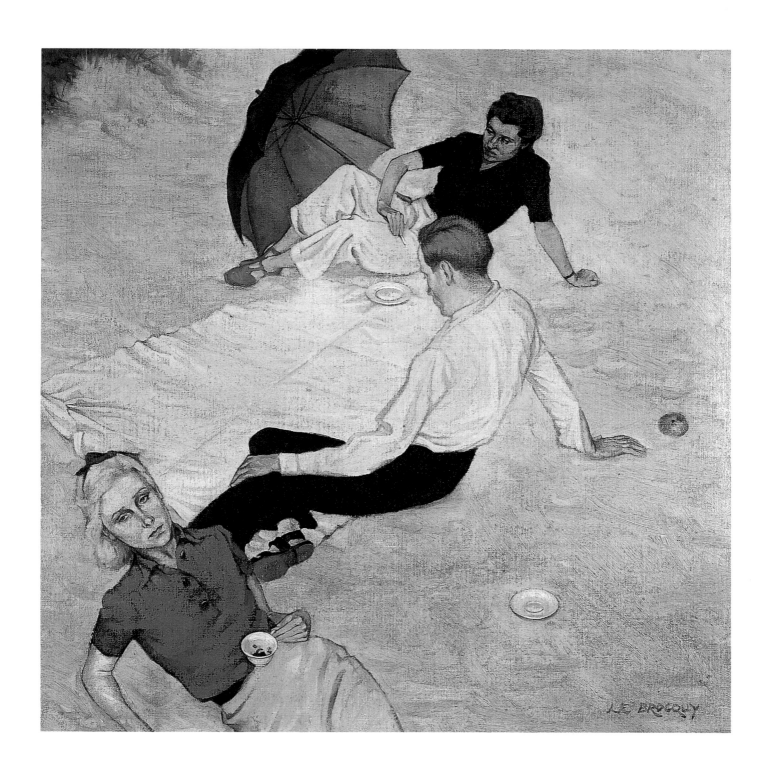

38 MAINIE JELLETT (born 1897, Dublin – died 1944, Dublin)

Virgin and Child

ca. 1936–37
oil on canvas
24 × 18 in. (61 × 46 cm)
Private collection

Mainie Jellett was born into an affluent Protestant family, her father a lawyer and her mother an accomplished musician. She showed a natural proclivity for art while taking her first art lessons with Elizabeth Yeats, the sister of artist Jack and poet W.B. Her inquisitive mind and technical ability ultimately led her to Paris where she firmly embraced non-representational art as a new means of expression. This led to her belief in the importance of keeping abreast of international trends and developments and the correlation of international modernism to Ireland's emergence as a modern nation (see pp. 63–77).

The turning point in Jellett's career came in 1921 when she returned to Paris to study under the French artist, critic, and educator André Lhote (1885–1962). At Lhote's studio, Jellett received her introduction to Cubist principles and philosophies that enabled her to understand better the work of the Old Masters as well as later Celtic art. Also at Lhote's studio, she became life-long friends with fellow student Evie Hone (1894–1955), an Irish artist who later achieved fame as a stained glass maker. At the end of that year she began studying with Albert Gleizes (1881–1953), a relationship that greatly affected her artistic development. Gleizes was an original member of the Cubist movement begun in France around 1907, who continued to espouse Cubism with an increasingly religious and philosophical zeal even after his Cubist associates had moved on stylistically. In Gleizes, Jellett found an instructor firmly immersed in the sort of analytical questioning that would aid her exploration of new artistic ideas focussing on the scientific application of color and its relationship to the picture plane.

It is uncertain whether Jellett was aware of the article published by Gleizes in *Montjoie!* in 1913 entitled "Cubisme et la tradition" in which he re-examined France's cultural heritage and argued for its Celtic basis (rather than a basis in Greco-Latin art). Gleizes was not alone in this: Robert Pellctier, another French artist, founded in 1911 the *Ligue Celtique Française* (Celtic League), that encouraged French artists to abandon "the Latin cult of form, matter, and force" and embrace "the idea of spirituality and justice" innate to their "common Celtic heritage."[1] Perhaps unknowingly, she aligned herself with a group arguing for an international transformation in art that derived from her native land.

The tradition of Celtic art and influence of religion on Irish society provided the impetus for works such as *Virgin and Child*. Jellett acknowledged the establishment of a verifiably Irish identity in Irish art dating from the fifth to the twelfth century, and used that as a reference point for the renewal of a modern-day equivalent. This source invested her work with an intangible quality, one that she referred to when she wrote:

"We never as a group turned from Nature – we could not; our aim was to delve deeply into the inner rhythms and constructions of natural forms to create on their pattern, to make a work of art a natural creation complete in itself like a flower or any other natural organism, based on the eternal laws of harmony, balance and ordered movement (rhythm). We sought the inner principle and not the outer appearance."[2]

The spirituality that Jellett felt was imbued in Cubist philosophies of color, form, and space was translated into religious imagery that meshed harmoniously with her Irish culture. Like the work of Beatrice Elvery or Mary Swanzy, paintings such as *Virgin and Child* – admittedly something of an anomaly in a career more driven by abstaction than narrative – speak to the strong role of iconographically motivated painting in twentieth-century Ireland. Subject matter for Jellett only goes so far: the rhythm of curved bands encircling the central images and the vibrancy of the multiple colors suggest that Jellett's religiosity stemmed from her beliefs as a practising artist, not as a practitioner of a particular religion.

1 Mark Antliff, *Inventing Bergson: Cultural Politics and the Parisian Avant-Garde* (Princeton, NJ: Princeton University Press, 1993), p. 121.
2 Mainie H. Jellett, "An Approach to Painting," *Irish Art Handbook* (Dublin: Cahill and Company, 1943), p. 18.

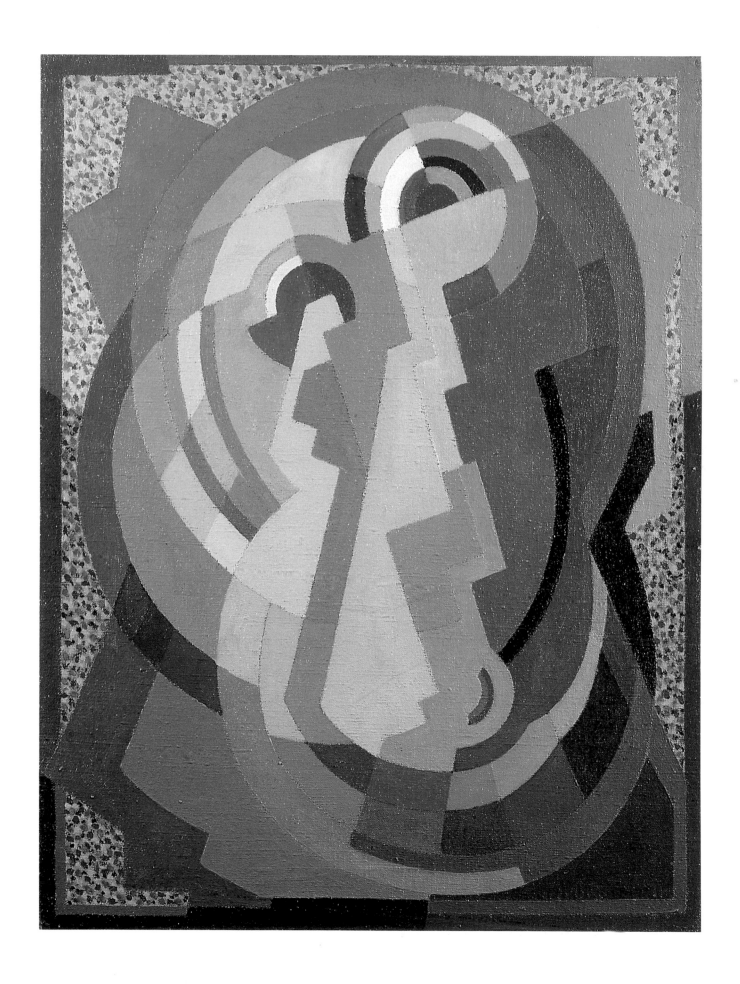

39 MAURICE MACGONIGAL

Mother and Child

1942
oil on canvas
40 × 30 in. (101,8 × 76.5 cm)
Crawford Municipal Art Gallery, Cork (Ireland)

Maurice MacGonigal first travelled to the Aran Islands in 1924, not long after his release from prison after being incarcerated for his involvement with the Irish Republican Army. His decision to paint in the West was one that many of his predecessors made, including one of his art professors, Seán Keating. His work during this period was influenced not only by the new geography, but by his strong nationalist sentiment and his desire to extoll the virtues of life in the new Irish Free State, established in 1922. After his initial visit to the west of Ireland, he returned throughout his life to Connemara, a district in the province of Connacht. His paintings, particularly the depictions of the West, supported the ideals of Irish Premier Eamon de Valera, who espoused traditional values and the primacy of rural life as the basis for sustaining Irish culture.[1]

Mother and Child depicts MacGonigal's wife, Aida, with their oldest son, Muiris, as a baby. MacGonigal used Aida as his model for an entire series of paintings from the late 1930s and 1940s depicting women in the west of Ireland. The painting is divided into distinct planes with the seated figures in the foreground followed by a progression of planes creating depth as they recede. The frontality and stiff pose are reminiscent of Byzantine mosaic images (a tradition he consciously invokes to ennoble his own painting), while the secular nature of the painting and its natural setting reflect a handling of the theme closer to that of the Italian Renaissance. MacGonigal seems to blend this interest in conveying a specific message, paramount to Byzantine artists, with the Renaissance convention of placing sitters in contemporary dress to personalize the relationship between the artwork and the viewer.

MacGonigal was certainly aware of the religious contexts for presenting a mother and child in this format. The subject was most certainly learned during his stained glass training at the Clarke Studios, a craft that often involved religious iconography in its conception and was frequently executed for secular sites. MacGonigal has chosen, however, not to instill a sense of piety or sacredness common in mother-and-child portrayals, but rather to focus on the human dignity and natural beauty of the landscape, extolling the way of life for which the West of Ireland was becoming famous but which paradoxically seemed to be fading into history. This mother, with her simple costume evocative of Irish woolen traditions, possesses a quietude and grace, while the child in his traditional bib and diaper serves more as a prop. Yet the two, taken together, serve to ennoble the role of modern-day motherhood by association with Biblical and art historical tradition, particularly appropriate to a land in which the domestic role of women has historically been much praised – even as this domestic value could be seen as limiting in other spheres. Motherhood occupied a central role in government action during this time as well, with the passage of the Health Act in 1947 providing guaranteed maternity care to Irish women for the first time.

Contrasted to the unusual composition MacGonigal used in *The Olympia, Dublin* (see Plate 33), this work suggests a more academic approach on the artist's part. This may have been a result of his return to the National College of Art in Dublin, where he was appointed Assistant Professor of Painting in 1937. His approach at the school, like that of his former instructor and then colleague Seán Keating, was based on a formal academic tradition that emphasized life drawing and composition. The evidence of Keating's influence can be seen by comparing MacGonigal's *Mother and Child* with *The Race of the Gael* which exhibits the same formal rendering of the figures dressed in traditional garb from the West of Ireland. Keating and MacGonigal were, from 1937, the leading faculty members at the College, and were acknowledged as the primary national painters of Ireland from the 1930s through the 1950s. Their artistic vision and traditional principles influenced generations of Irish art students, although their legacy was ultimately undermined by influences counter to the official College curriculum.

1 For further reading on de Valera see Owen Dudley Edwards, *Eamon de Valera* (Cardiff: GPC Books, 1987.)

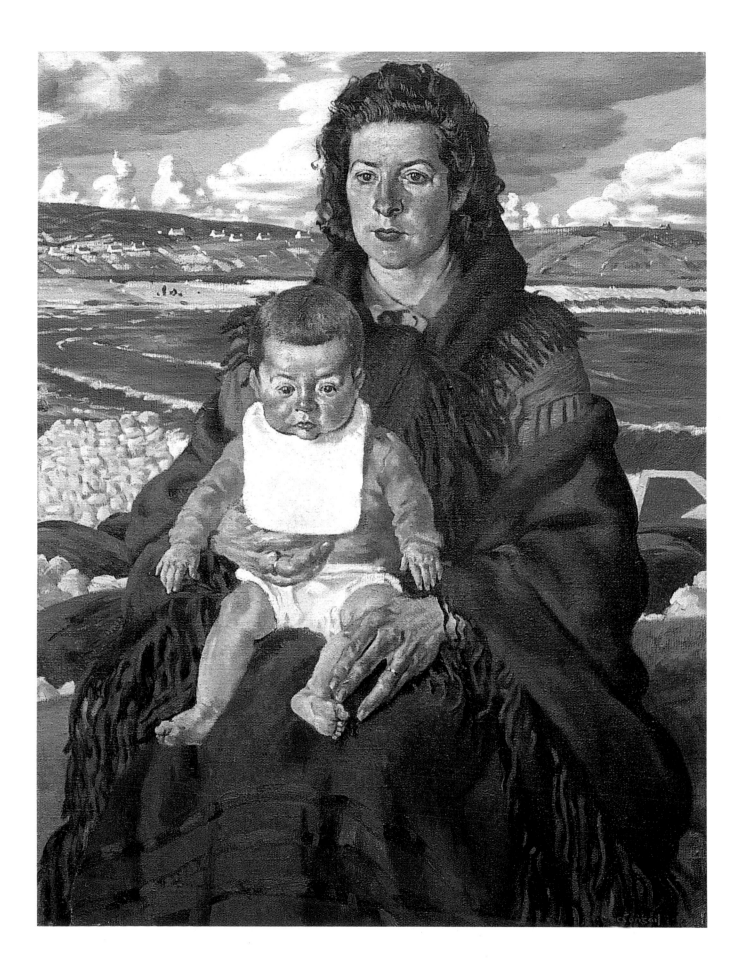

40 MARY SWANZY (born 1882, Dublin - died 1978, London)

The Message

ca. 1940–45
oil on board
17¾ × 21 in. (45.1 × 53.3 cm)
Collection Hugh Lane Municipal Gallery of Modern Art, Dublin

As a child growing up in Dublin at the turn of the century, Mary Swanzy felt that her earliest training as an artist came from simply living in a Georgian city where proportion and order were the rule. She has commented, "I am quite sure that being brought up here [in Dublin] laid the foundations of my feeling of structure in everything of discipline."[1] This early exposure to spatial relationships, along with her rigorous training in life drawing, ultimately allowed her to work in a plethora of styles throughout a long career that established her as one of Ireland's most versatile artists (see pp. 63–64).

Swanzy's stylistic experimentations ranged from Cubist to figurative work, and can be linked both to her restless nature and to the international social and political transformations that took place early in her career. She returned to Ireland from study in Italy in 1914 at the onset of World War I and was in Dublin at the time of the Easter Rising in 1916, an attempt on the part of Irish Republicans to overturn British rule which led to mass destruction in Dublin. These events, along with the Irish Civil War and the destruc-

tion and carnage observed in the course of World War II, led Swanzy to create allegorical paintings reflecting both destruction and, as in *The Message*, hope and salvation. Further, her extensive travels often paralleled shifts from one artistic style to another. One of her most important trips was to Samoa in 1923 – reminiscent of Gauguin's famous sojourns to Tahiti, of which Swanzy knew the results influencing her own compositions and use of color, from her extended visits to Paris.

The Message shows that Swanzy had learned both the iconography and the spatial recession of Italian Renaissance art, mixed with the loose compositional methods developed during her travels to the South Seas. The mother and child and adoring shepherds derive from devotional paintings that Swanzy saw while in Italy, but lack the austere piety of a strictly religious painting (bearing in mind that she was a Protestant painting in a largely Catholic country and working with subject matter derived from pre-Reformation Europe). She places the figures on a plateau (made desolate by bombs?) that recedes to a central point against an outcropping of rocks where shepherds focus their attention on what must be an angel wearing a fanciful headdress. Swanzy has broken with convention and placed the mother and child not in the center of the painting but to one side in the foreground, much closer to the viewer. This arrangement emphasizes the mother and child, adds to the illusion of depth, and gives the painting an unreal, dream-like quality. This type of flexible composition contrasts with Swanzy's earlier cubist work (see fig. 75) and is closer to her Samoan paintings in the lack of detail and loose brushwork. The shepherds are hastily painted and display exaggerated facial expressions and musculature that makes them seem somewhat cartoonish. *The Message* was painted at the height of World War II and can be read as Swanzy's personal interpretation of a religious theme – Jesus representing hope in the midst of chaos.

Fig. 75. Mary Swanzy, *Two Peasants at Work in Landscape*, ca. 1924, oil on canvas, 16½ × 20 in. (42 × 51 cm), Courtesy of Pyms Gallery, London

1 Una Lehane, "Mary Swanzy," *The Irish Times*, March 29, 1974, p. 12.

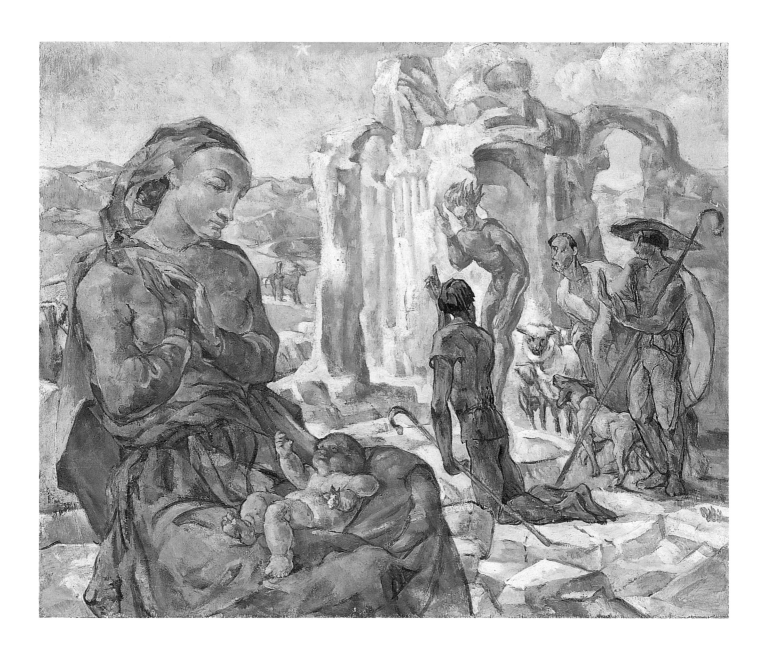

41 COLIN MIDDLETON (born 1910, Belfast – died 1983, Belfast)

Thinking of Antwerp

1942
oil on board
24 × 29¹/₂ in. (61 × 75 cm)
Kate Middleton

Colin Middleton was an artist who at mid-century experienced the uncertainty and disillusionment that was shared by many people throughout the world in response to the horrors of World War II. The war made an indelible impression on Middleton, and his desire to escape from the reality of the war's atrocities was reflected in the development of an eclectic art, as he searched for elusive meaning. In his search for stability, Middleton and his wife Kate moved to John Middleton Murry's community farm in Suffolk, England in 1947. Murry (1889–1957) was a British writer and pacifist who became interested in agriculture later in his life. Ironically the Middletons arrived at the time Murry was beginning to change his philosophy in a way that prompted the departure of farm members and ultimately led to the abandonment of the venture in 1948. Middleton returned to Northern Ireland owing to illness and disillusionment, and turned increasingly to painting religious themes in works such as *Jacob Wrestling with the Angel* (1948), a painting that mirrors both Middleton's personal struggle with the unrest and angst caused by the war, and his subsequent personal pursuits.

Middleton's mother was of Belgian ancestry and he visited Belgium around 1930 with his father, who owned a firm that designed damask linen. His father died in 1935 and the younger Middleton took over the family business. In his work as a damask designer he learned how to create pattern and to work quickly. The former is evident in Middleton's paintings from this period, which can typically be broken down into a variety of forms and lines craftily pieced together. *Thinking of Antwerp* is a notable example of this type of design. Middleton devoted more time to painting after leaving the damask business, and with the concurrent outbreak of World War II and the death of his first wife in 1939, he began to explore Surrealism – an international style that employed juxtapositions of disparate objects in often unreal or dreamlike combinations. The work of Salvador Dali (1904–1989) served as inspiration for Middleton, as did paintings by British avant-garde artists Paul Nash

(1889–1946) and Edward Wadsworth (1889–1949), both of whom were influenced by a number of styles including Surrealism. *Thinking of Antwerp* was painted only a few years after Middleton began to adopt Surrealist conventions in his art, and shows a linkage of his own fluidity of pattern with the emotional undertones distinctive of Surrealist style.

Thinking of Antwerp is painted predominately in reds with accents of other equally strong, bright colors, and this color palette seems to have been a response to the violence of war. Middleton later commented that the violence in Belfast in the 1980s elicited the same reaction from him as a painter as had the bombardment on his native city during World War II, in 1941, saying:

"The tension, the repressed anxiety . . . all the things that build up and push in on the emotional side . . . I find that it builds up, it's re-activated the old surrealist bug, and it's coming up. This strong colour, this is emotional colour."[1]

Certainly there is abundant vibrancy in the café scene depicted in *Thinking of Antwerp*, due in large part to the coloration. Middleton plays the strength of his palette off a unique composition in which two background figures are shown in profile seated at tables while a foreground, mannequin-like figure stands facing out in a pose that suggests she is greeting the viewer and offering a seat at her table. Middleton has turned the table tops on end so that one can see the various sundries – a tall glass, some olives, a small pizza – that now seem to be floating in front of a large disk. On the chair opposite the standing woman rests a book waiting to be read. The entire scene is perhaps an evocation of a moment in the life of his mother or a memory from his trip to Antwerp with his father, painted as a way of removing himself from the reality of life in the embattled Europe of 1942.

1 Harriet Cooke, "Colin Middleton," *The Irish Times*, January 25, 1973, p. 8.

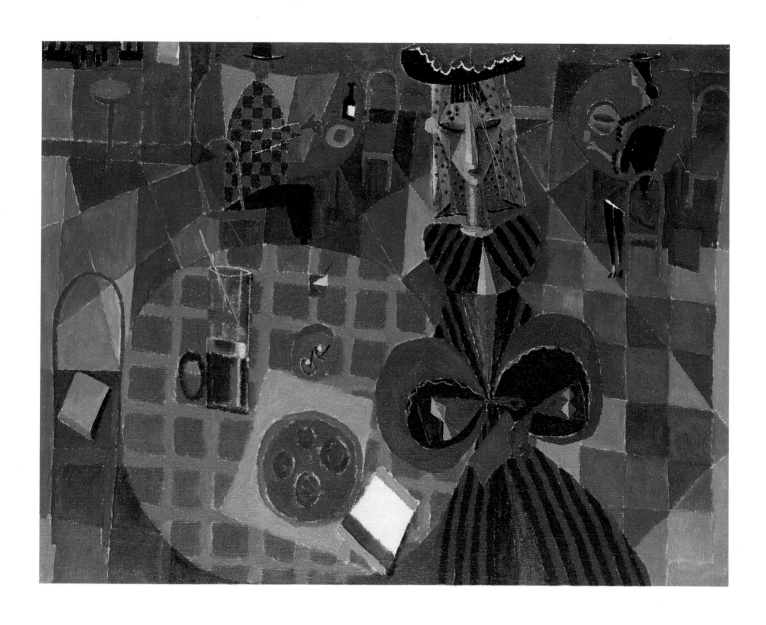

42 PATRICK HENNESSY (born 1915, Cork – died 1980, London)

Exiles

1943
oil on canvas
39 × 23¹/₂ in. (99 × 59.5 cm)
Collection Hugh Lane Municipal Gallery of Modern Art, Dublin

Patrick Hennessy's *Exiles* presents the viewer with a complex picture influenced by his childhood, his artistic training, island life, and perceptions of war. It is as much about emigration as it is about isolation whether forced or self-imposed. Hennessy had an early experience with emigration when his family moved from his birthplace in Cork to Angus, Scotland, for reasons that remain uncertain, whether economic hardship or familial issues. This painting makes it clear, however, that this dislocation had a lasting effect on the artist.

Hennessy gained his formal artistic training in Scotland at the Dundee College of Art, training that was augmented by winning scholarships that allowed him to study in Paris and Rome. Hennessy clearly spent time visiting modern art collections in both cities, where he was exposed to the metaphysical works of the Italian artist Giorgio di Chirico and the French surrealist painters. Indeed, the psychological tension created by the anonymity of the figures within the context of an indeterminate landscape in *Exiles* is reminiscent of the mysticism pervading the work of Di Chirico just prior to World War I.

In *Exiles*, Hennessy has placed a man stripped to the waist with his back to the viewer in the center of the picture. He looks out over a shoreline void of any distinguishable imagery save for the cloaked woman in the background closer to the water's edge. Hennessy perhaps is making a reference to Ireland, specifically its geographical identity as an island. Hennessy equates life on the island as a sort of perpetual exile – banished without clothes on his back, without hope. This type of painting was typical of Hennessy's work during the 1940s, prompting one contemporary art critic to comment that Hennessy "combines a not-too-exacting realism, a low-keyed and consistent palette with a morbid pessimism which sees flesh as something very much less healthy than grass . . . And it is the doom of cancer rather than of cataclysm."[1] *Exiles* was painted in 1943, at the height of World War II; the barren landscape resembles a wasteland ravaged by war, looking back to the apocalyptic landscapes of Georg Grosz and even seeming to anticipate the nuclear annihilation that occurred in Japan at the conclusion of the war. Hennessy's narrow range of color and the sparseness of the scene are in keeping with the economy of brushstrokes, rendering a simple composition fraught with ambiguity.

Emigration has, of course, been an issue for centuries in Ireland and the theme is addressed in works as diverse as those by Eileen Murray (see Plate 29) and Seán Keating (see Plates 15, 24, 32, and 34). While historically emigration has provided a potential means of mitigating economic woes such as those that followed the famine of 1845, for many it has also carried deeper psychological and ideological meanings. Hennessy's work calls to mind a telling exchange between two characters in Colm Tóibín's novel *The South*:

> "'Why did you leave Ireland?'
> 'I was sick,' he said. 'I was sick of Ireland,' he laughed.
> 'Seriously Michael.'
> 'Seriously, if you knew anything about the country you wouldn't ask me why I left.'"[2]

The implication of the passage is that it is not solely for economic reasons that many have chosen to leave Ireland. For some it has been the sectarian violence and conflicts with religious ideologies; for others it has been the opportunity denied them at home. Only in recent years has the trend diminished as the economic strength of the "Celtic tiger" has encouraged Irishmen and women to return. Hennessy shared an unusual relationship with Ireland, one that left him unsettled and constantly on the move. His peripatetic lifestyle found him making regular visits to the Continent, and ultimately led to his establishing residence in Morocco, as an exile, until his death in 1980.

1 Edward Sheehy, "Art Notes," *The Dublin Magazine* xx, no. 1 (January–March 1945), pp. 41–42.
2 Colm Tóibín, *The South* (New York: Viking, 1991), p. 74.

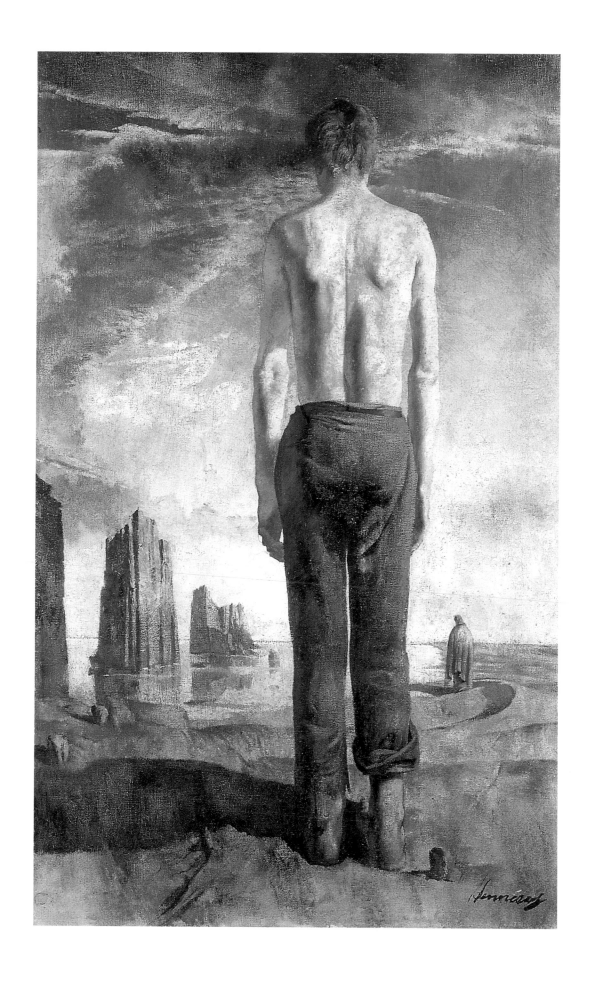

43 MAINIE JELLETT

Western Procession
1943
oil on canvas
17 × 34 in. (43 × 86.5 cm)
Niall and Dorothea MacCarvill

Left as her last painting at her death from cancer in 1944, Mainie Jellett's *Western Procession* embodies the synthesis of movement and color that was at the core of her artistic aesthetic and philosophy. Jellett challenged conventional notions of what constituted art and in the process brought to Ireland perceptions of the world that were far more progressive than those generally dominating the newly established Irish Free State. At a time when a new identity was being forged, her art reflected the possibilities of a radical shift. By contrast, the Ireland of the future perceived by the leaders of the Free State such as Eamon de Valera looked to the past and a return to Gaelic traditions to provide the base for a new identity, rather than to the future for notions of modernity.

Jellett's outspoken demeanor, reflected in her art and actions, was, unsurprisingly, challenged and refuted by many in mid-century Ireland. Her position as a woman artist espousing a new form of art in a male dominated society tightly controlled by the Catholic Church, one in which artistic standards were dictated by the academically-bound Royal Hibernian Academy, made her an extremely marginalized figure. Many early critics dismissed her work, placing it outside the canon of art by writing, for example, "In fact, what Miss Jellett says in one of her decorations she says in the other and that is nothing."[1] In spite of this opposition, Jellett persevered and continued to show her work and spread her gospel of an internationalist style of painting. Jellett's work gained additional notoriety in 1940 when she aligned herself with the White Stag Group, one of the two groups that most profoundly broke from the established traditions of art exhibitions in Ireland. The White Stag Group was formed in London in 1935 by a Hungarian psychoanalyst, Basil Rákóczi, who moved to Ireland at the outbreak of World War II. The group merged creative psychology with art (the White Stag being a symbol of creativity in Hungary) and in addition to Jellett included Nano Reid (see Plate 51) as one of its exhibiting artists. The other outlet for expressing non-traditional views in art was through the Irish Exhibition of Living Art, which stated as its mission the making of "a wider survey of contemporary Irish art than has hitherto been made."[2] Jellett was one of the founders of the IELA and showed in the inaugural exhibition in 1943 along with Hone, Louis le Brocquy (see Plates 37 and 53), and others who felt the repression of the Royal Hibernian Academy stifling the development of the visual arts in Ireland.

Jellett was equally adept at painting landscapes, portraits, and genre and religious scenes. *Western Procession*, fittingly, as her last work, seems to encapsulate all of these. Jellett's source of inspiration for her landscape work was an exhibition of Chinese art held at the Royal Academy of Arts in London in 1935 and 1936, and one can see here the merger of a natural setting with the lyrical rhythm of abstract forms. The resulting painting reflects the harmony and spirituality of Chinese art with the tension and modern fusion of Cubist ideas and Futurist force-lines. The painting harks back to her trip to the West of Ireland in 1936, a landscape that evoked the same feeling as the one she experienced on entering the Chinese art exhibition – being moved along by the natural rhythm emanating from a painting or the land itself. The West became more important to Jellett at the end of her life than it had ever been before, taking her back to the Celtic artistic influences and religiosity that had so captivated her teacher Albert Gleizes. She painted canvases at this time in which subject matter held an unusually important position relative to the body of her work. In *Western Procession*, figures, coloration, and a Cubist fracturing of light and form merge to imbue the painting with a sense of motion. In this case, Jellett pays her last pictorial homage to the West of Ireland as a site of freedom and purity – one that elegantly and subtly relates to Jellett's impending journey beyond the temporal.

1 "The Dublin Painters," *The Irish Statesman* (October 27, 1923), p. 206.
2 Quoted in A.J. Leventhal, "The Living Art Exhibition," *Irish Art: A Volume of Articles and Illustrations* (Dublin: The Parkside Press, 1944), p. 82.

44 CHARLES LAMB

Taking in the Lobster Pots

1947
oil on canvas
19 × 23¼ in. (48 × 59 cm)
Collection Armagh County Museum

The oldest son of a painter and decorator, Charles Lamb received his earliest art instruction at Portadown Technical School. In 1913 he concurrently began taking evening classes in life drawing at the Belfast School of Art. His artistic ability was rewarded in 1917 when he won a scholarship to attend the Metropolitan School of Art in Dublin. He studied there for four years during which he was most profoundly influenced by the work of Seán Keating. As a young man in Dublin just after the Easter Rising in 1916, Lamb was affected by the nationalist fervor rampant in the city and this, combined with his high regard for Keating who championed the return of traditional Irish customs and culture, led to his interest in the West of Ireland. In the West, Lamb discovered what was for many the "national essence," an Irishness of language and custom unspoiled by modern influences in general and English influences in particular; he committed his career to painting scenes drawn from this rural environment. He first visited Carraroe, a remote Gaelic area of Connemara, the westernmost region in Co. Galway, in 1921; Lamb was so enamored by the area that in 1935 he built a home and settled there.

Taking in the Lobster Pots is one of a number of works painted by Lamb depicting the activities of fishing fleets near Carraroe. The small town located on Galway Bay is typical of the small-scale communal living centers that can still be found throughout the area. The port, as shown in Lamb's painting, lacked any of the equipment such as hoists or motorized transportation generally associated with even simple port operations. The Carraroe economy was, like much of the rural areas of the Irish Republic in the 1940s, largely self-sustaining, relying little on the major economic centers; the lobsters caught here were most likely for local consumption. The scene is quaint, capturing a moment in daily rustic life. But as in the case of Lamb's earlier work

Dancing at a Northern Crossroads (Plate 23), the rural idyll belies the economic woes that have historically troubled the West of Ireland, leading it to have the highest emigration rate in the Republic. Even in the 1980s, the rate of emigration from Ireland greatly exceeded that of any other country in Europe; the number of Irish-born people living outside their native land is thought to approximate half the population of the Republic.

Lamb's decision to extol the virtues of rural life was a choice made by a number of artists included in this exhibition. Paul Henry, Maurice MacGonigal, and Keating viewed their work as vital to the cause of Irish Independence, in which their artistic skills would be employed to create a visual identity built on the inherent strength and beauty of the people and the land. Keating's influence can be felt here in the choice of subject matter, while the attention to detail and the handling of the figures reflect Lamb's partiality to the work of William Orpen, under whose influence he also came while a student at the Metropolitan School of Art. Lamb was a talented draughtsman, relishing the opportunity for detail and verisimilitude provided by the small boat and its tethering lines, successfully linking the foreground figures with a wide perspective. Like the landscapes Lamb painted in the 1940s along the River Bann and at Rostrevor, Co. Down, in Northern Ireland, the soft tones and deft handling of early afternoon light in *Taking in the Lobster Pots* successfully captures the rustic and natural atmosphere of the event. Lamb's choice of subject matter was based on both pleasure and strong convictions, as a critic pointed out in 1924: "We believe Mr. Lamb has talent, and however dispiriting it may be to follow art in a country like Ireland, we urge him to put every ounce of himself into his work"[1]

1 Y.O. [Robert Wilson Lynd], "The Stephen's Green Gallery," *The Irish Statesman* (March 22, 1924), p. 48.

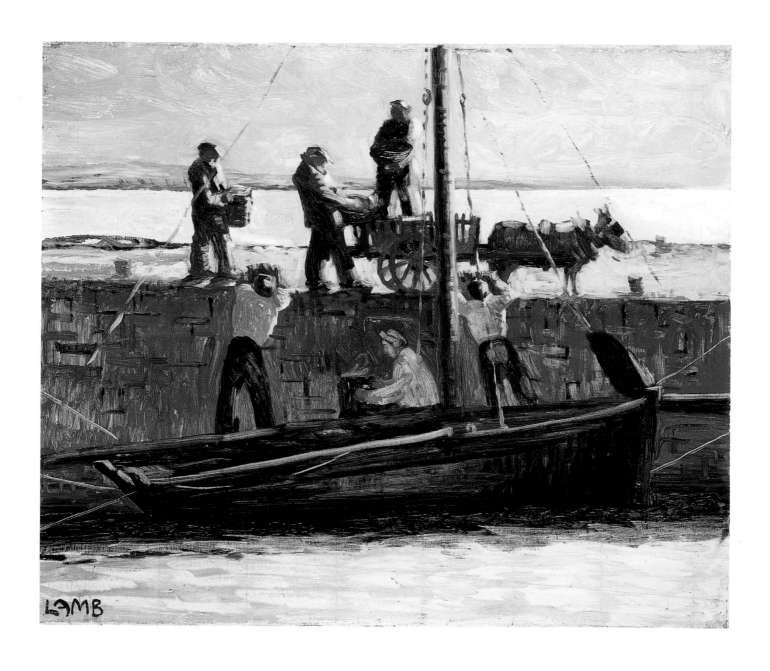

45 GERARD DILLON (born 1916, Belfast – died 1971, Dublin)

Island People

ca. 1950
oil on board
23 × 26¾ in. (58.4 × 67.8 cm)
Crawford Municipal Art Gallery, Cork

Gerard Dillon was born in Belfast, where he also studied art for a brief period of time before moving to London in 1934 to work as a painter and decorator. It was a trip to the West of Ireland in 1939 that inspired Dillon to pursue a career as an artist and that led to his first exhibition in 1941. He returned to London in 1945 to work on a demolition gang. Dillon continued to paint and was able to exhibit with some frequency in Belfast, Dublin, and London. He continued to live in London for the majority of his life, returning to Dublin in 1968, just three years before his death.

Dillon once remarked that "Sean Keating's illustrations for *The Playboy of the Western World* and the pictures of Marc Chagall were the first things that made me want to paint."[1] It was perhaps the former that inspired him to investigate the rural landscape and traditional lifestyle prevalent in the west of Ireland, and certainly the latter that proved to have the greatest stylistic influence on him. Dillon's *Island People* can be compared, for example, to Chagall's *The Red House or The Street* from 1922 (fig. 76). In Chagall's painting, the Russian-born artist has captured one of the quotidian scenes of life in his home town of Vitebsk,

drawn from memories of childhood. The subject is not unlike the one Dillon presents in *Island People* where he depicts, from memory, his daily jaunt out to what was his favorite painting site while resident on one of the Aran Islands, located off the coast of Co. Galway in western Ireland. The most telling stylistic similarities are the flattened picture plane and the elevated perspective, the composition lacking depth as figures and objects are layered onto the surface to create a two-dimensional scene. It is unclear whether two wheels of the cart, for example, shown in the left background are actually attached to the main body of the cart. Much like the windows in the building painted by Chagall, which seem to point in a number of different directions, Dillon creates imbalances that make the painting less realistic, more stylized, and thus more like a recollection. Dillon's work, like Chagall's, is less concerned with technical issues of perspective and architectural veracity, and more with conveying a narrative based on real and imagined, often dream-like memories.

Dillon was involved in rural life, particularly in Connemara and the Aran Islands, and his painting reflects an interest in the people and customs as well as the beauty of the landscape. Dillon has noted the stark contrast of growing up in urban Belfast and then experiencing the open beauty of the country, a contrast that strongly affected his perception of the West as a strangely wonderful place – a place that was somehow antithetical to rational urbanity. Yet his presence, like Paul Henry's, in a provincial community was almost certainly met with suspicion by the local people: in *Island People*, two islanders peer from behind a stone wall as Dillon heads off down a path with canvases tucked under his arm, carrying his paint and brushes in a case. The simplicity of the pastoral setting with donkey, chickens, cart, and currach reflects the uncorrupted isolation of the West even at mid-century, underscoring the region's status of iconic simplicity for a number of urban artists.

Fig. 76. Marc Chagall, *The Red House or The Street*, 1922, tempera and gouache on paper, 20½ × 26 in. (52 × 66 cm), Musée d'Art Moderne de la Ville de Paris

1 Gerard Dillon, "The Artist Speaks," *Envoy* 4, no. 15 (February 1951), pp. 39–40.

46 CHRISTOPHER CAMPBELL (born 1908, Dublin – died 1972, Dublin)

Self-portrait

1950
oil on canvas
36 × 28 in. (91.5 × 71 cm)
Private collection

In the introduction to what was the first solo exhibition of the work of Christopher Campbell, the art historian Bruce Arnold summarized Campbell as follows: "Introverted, self-conscious, shy, dominated by his mother, overshadowed by his brother, unsuccessful in selling his work, increasingly bewildered about the direction in which he was going, yet with a firm and lasting belief in his basic skills and his vision, Christopher Campbell presents himself as an enigmatic figure in Irish art."[1] His father died when Campbell was young and he was raised by his mother. His early education was under the supervision of the Christian Brothers at St. Mary's Place, Dublin. Campbell showed regularly at the Royal Hibernian Academy and has had work exhibited in the United States, Belgium, and Australia. His brother Laurence attended art school with him and later gained a reputation as an accomplished sculptor. Christopher Campbell had penchants both for portraiture, for which his mother served as model on numerous occasions, and for religious subject matter, painting devotional pieces such as a triptych showing the three apparitions of Our Blessed Lady to Catherine Labouré and a series of Stations of the Cross. He was a student of Patrick Tuohy's (see Plate 14) at the Metropolitan School of Art in Dublin. Although Campbell studied under Tuohy for only a brief time, he was said to be an ardent pupil, mastering not only some of the techniques employed by his mentor, but inheriting shared interests in subject matter as well.

Campbell taught at the Kilkenny Technical School from 1947 to 1951 and was employed for a period of time as an artist at Harry Clarke Stained Glass, Ltd. (an important Irish workshop that produced much of the twentieth century's finest stained glass). Campbell's parochial education and reserved, introspective personality seem to indicate a spiritual sensibility. Indeed, his choice of subject matter, his work with stained glass – a form with traditionally ecclesiastical associations – and his repeated contributions of illustrations to the *Capuchin Annual*, a magazine published by the Capuchin Brothers promoting Catholic doctrine, all point to his latent piety. His *Self-portrait* presents no ostensible signs of his religious beliefs but shows Campbell's extraordinary ability as a portraitist, clearly exposing the uncertainty and disquietude of the artist. The uneasy facial expression and awkward posture of the sitter are in keeping with his mismatched attire and blemished complexion. Campbell conveys his enigmatic personality via a painting style that makes use of sure and confident brushstrokes, yet the color is thickly and loosely applied, giving the entire image a subdued vibrancy. The patchwork of colors may owe something to Campbell's experience as a stained glass designer.

Campbell's work at mid-century, though rather overlooked historically, provides evidence of the continuation of a developing painting style in Ireland initiated in the 1920s by Tuohy and others at the Metropolitan School of Art in Dublin characterized by strong technical skills and, with respect to figurative work, an interest in conveying the personality of the sitter. Like the work of Francis Bacon and Lucian Freud in England, the portraits of Tuohy and then of Campbell and Edward McGuire speak to the vibrancy of the portrait tradition in twentieth-century Ireland.

1 Bruce Arnold, *Christopher Campbell, 1908–1972* (Dublin: Neptune Gallery, 1976), unpaginated.

47 DANIEL O'NEILL (born 1920, Belfast – died 1974, Belfast)

Birth

1952
oil on canvas
19³/₄ × 23⁵/₈ in. (50 × 60 cm)
Collection of the Arts Council of Northern Ireland

The son of a Belfast electrician, Daniel O'Neill did not receive formal artistic training aside from attending a few art classes at the Belfast College of Art. In the early phase of his career, O'Neill divided his time between a night job as an electrician for the Belfast Corporation Transport Department and painting during the day – until Victor Waddington, a Dublin art gallery owner, saw his work, realized his potential, and gave O'Neill financial assistance so that he could devote himself to painting full-time. His talent as a painter soon earned him praise from critics who described him, after his participation in 1945 at the Irish Exhibition of Living Art, as a newcomer who "... promises to figure largely in Irish painting of the future. His sensuous handling of paint, his rich use of colour, and dramatic compositions, are used to express an individual vision which is essentially Romantic."[1] O'Neill developed an early friendship with Gerard Dillon (see Plate 50) in which both artists benefited by providing one another with motivation and encouragement.

Birth exemplifies the ease with which O'Neill creates a composition that, in its simplicity of line and cool palette, masks a deep psychological tension. The central figure of the mother lies in exhaustion after enduring labor and the birth of her child, now held by one of the attendants. O'Neill was interested in the work of thirteenth- and fourteenth-century Italian painters, and one can see *Birth* as a devotional work calling to mind not only Madonna and Child images, but also, in the woman's exposed, foreshortened feet, Andrea Mantegna's *Dead Christ*. O'Neill makes such influences modern by also attaching a psychological tension that is bizarre, unreal, to an otherwise common event. This is manifested primarily in the sinister-looking boy (an older brother to the newborn?) standing at the foot of the bed. Is he brooding over the lost attention of his mother or is he

representative of a more serious malaise afflicting Ireland? The Mother and Child Scheme debacle of 1951 in Ireland – a scheme that involved government administration of medical services related to the care of children, including births, and that was ultimately rejected by the government – could have supplied inspiration for the picture. Likewise, the subject no doubt derives from the centrality of birth as the primary role of women in a conservative, predominately Catholic country that was not afraid, at this time, to turn to repressive measures, including censorship, to maintain the social status quo. O'Neill, a father himself, pays homage to the act of childbirth and the selfless role of women, while giving this a sinister tension.

Along with his contemporaries Christopher Campbell and Colin Middleton, O'Neill was an important figure in the mid-century development of Irish art. Only with the work of Evie Hone and Mainie Jellett (see Plates 38 and 43) in the 1920s and 1930s – often marginalized at the time – does one see evidence of an emerging modern style of painting in Ireland. Whereas the style of the period's more widely accepted artists, contemporaries of Hone and Jellett such as Seán Keating and Maurice MacGonigal, was overtly influenced by political events, O'Neill, although not immune to social and economic changes occurring in the 1950s, displays a more covert interest in social issues, emphasizing the importance of painting the subtleties of the commonplace. One senses here not so much a proselytizing role as a mood of unease. A later generation of Irish artists, including David Crone and Patrick Graham, has drawn from the work of O'Neill, Campbell, and Middleton in the 1950s in developing their own styles based on both technical and psychological exploration.

1 Edward Sheehy, "Art Notes," *The Dublin Magazine* XX, no. 3 (October-December 1945), p. 42.

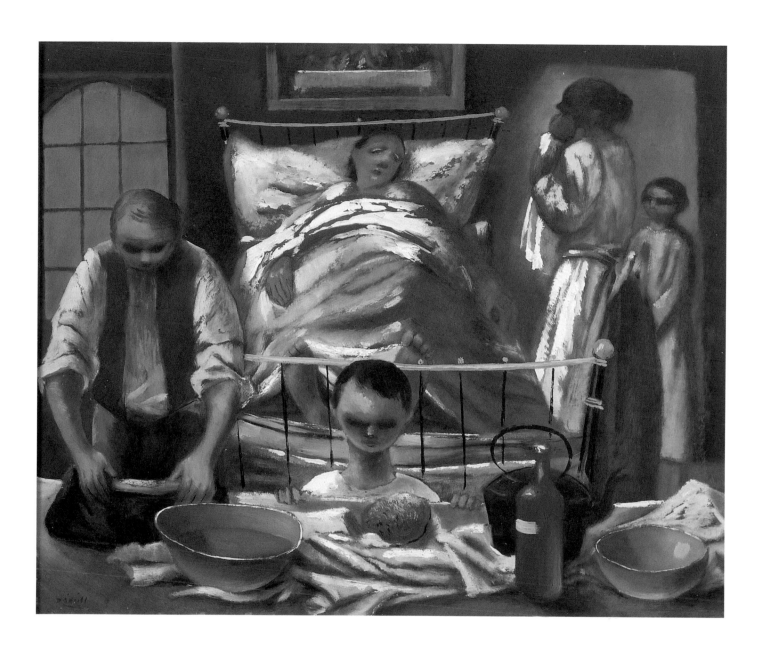

48 BASIL BLACKSHAW (born 1932, Glengormley, Co. Antrim, Northern Ireland)

Men, Sea and Moon

1952
oil on board
40¹/₂ × 30 in. (103 × 76 cm)
Collection of the Arts Council of Northern Ireland

Born in a rural area of Co. Antrim, Northern Ireland, Basil Blackshaw has drawn frequently from his country experiences. This provincial environment was complemented by his formal art training at the Belfast College of Art, two trips to London in 1948 and 1951, and a travel scholarship which allowed him to visit Paris in 1951. There he was able to see the works of two artists in particular who had a profound impact on his work, Paul Cézanne and Alberto Giacometti. One can see these early influences in *Men, Sea and Moon*, one of the seminal works from his "Blue Road" series of the early 1950s, characterized by the prevalence of blue and grey. The isolation of the figures near the sea invokes thoughts of the solitude found in the country, while the foreground figure strikes a pose similar to one of the several "types" that have been established for the bathing figures painted by Cézanne (fig. 77).[1] The background figure, in particular, can easily be compared to the thin, attenuated sculptures of Giacometti, where the emo-

tional impact of the embattled form is similar.

Men, Sea and Moon prompted one reviewer to write: "Basil Blackshaw is inclined to be more modernistic in treatment as in *Men, Sea and Moon* and *Man* 1952."[2] This criticism, whether meant as a compliment or pejoratively, indicates how provincial the nature of art in Ireland was up to that time. It is with artists such as Blackshaw, Christopher Campbell, and Daniel O'Neill (all included in the present exhibition) that one can isolate a significant change in style from what had come to be viewed as traditional Irish painting of the twentieth century – such as the work of Seán Keating and Paul Henry. Artists such as Blackshaw began painting subjects that conveyed psychological tension and elicited strong emotional reactions in response to the social, political, and economic changes occurring throughout the world. In the first half of the century in Ireland an attitude of art for art's sake largely dominated, as artists experimented with styles developed abroad. In the second half of the century, Irish artists have continued to adapt international styles, but the stylistic issues have become subordinate to the meaning (often emotional) infused in the work.

Blackshaw's *Men, Sea and Moon* offers an example of the evolution in Irish painting at mid-century. He has borrowed stylistic elements from modernist masters to create his figures, but the focus of the work lies in the psychological tension generated through the ambiguous interplay of the two figures. Is it merely an evocation of man and nature? A recollection of his youth? Are the two men brothers, friends, or lovers? The narrative present seems indeterminate, and the neutral blues and greys Blackshaw uses only add to the picture's ambiguity through a subdued tonality.

Fig. 77. Paul Cezanne, *Bathers*, ca. 1880, oil on canvas, 13⁵/₈ × 15 in. (34.6 × 38.1 cm), The Detroit Institute of Arts, Bequest of Robert H. Tannahill

1 Mary Louise Krumrine, *Paul Cézanne: The Bathers* (Basel: Öffentliche Kunstsammlung, 1989), p. 253. Based on Krumrine's classification of types, Blackshaw's figure is most closely associated with the posture of a tempted figure (male type).
2 *Belfast Newsletter*, September 29, 1952, cited in *Basil Blackshaw – Painter* (Belfast: Nicholson & Bass, 1995), p. 90.

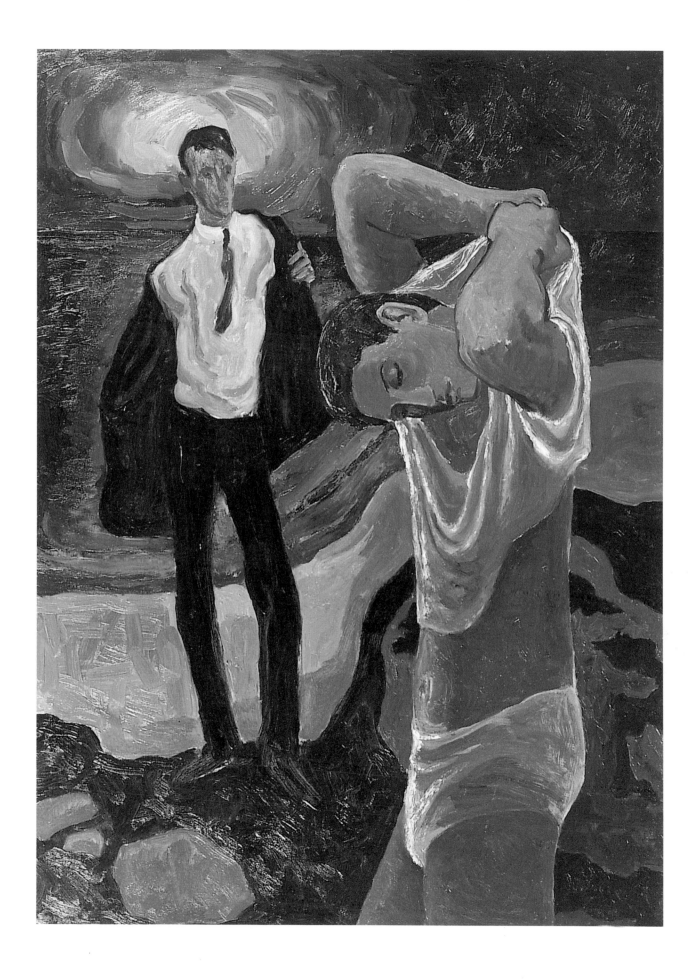

49 EDWARD MCGUIRE (born 1932, Dublin – died 1986, Dublin)

Portrait of Matti Klarwein

1953
oil on canvas
26 × 16 in. (66 × 41 cm)
Private collection

An artist influenced by such painters as Lucian Freud, Francis Bacon, Patrick Swift, and René Magritte, Edward McGuire's œuvre primarily consists of literary portraits and still-lifes. In both, he demonstrated technical virtuosity as a draughtsman and a liberal palette with which he animated his subjects. McGuire always adhered to the belief that technical skill was necessary to achieve success as an artist, and has been quoted as saying, "The vision is of great importance, but without the craftsmanship you can do nothing, and we really are a profession of craftsmen and it's been like that for thousands of years."[1] This artistic philosophy was undoubtedly solidified in McGuire's training in Italy, where he not only admired the work of Italian masters such as Giotto and Piero della Francesca, but also witnessed the persistence of craft in the daily production of artisans such as leather-workers or stonemasons.

McGuire was raised in a wealthy family, benefitting from the luxuries provided by his father's money, such as a private tutor and the opportunity to further his education in Italy. At the same time, he exhibited a modest and reserved personality, shying away from the limelight and focusing his attention on his art. As a young art student, he even went by the name Edward Augustine (his middle name) to avoid being confused with his father, whose name he shared and who also exhibited art on occasion. One critic speculated that the younger McGuire also adopted this pseudonym because of his reserved nature.[2] *Portrait of Matti Klarwein* is a product of McGuire's formative trip to Italy, which served as the point of departure for his career as a painter, one that ultimately led to his standing as the finest portraitist of his generation in Ireland.

The sitter, Matti Klarwein, was a Palestinian art-school friend of McGuire's during his stay in Rome from 1952 to 1953. Together with a group of other expatriates and art students, they frequented Rome's cafés and trattorias. His portrait is one of McGuire's seminal works, prefiguring the precise line and stark frontality that characterize his later work, such as the *Portrait of Seamus Heaney* (fig. 78), in which Maguire places the Nobel laureate poet seated at a table looking up from a book. The sparse interior setting and lush vegetation with bird are clearly rendered and reflect Heaney's simple, rural lifestyle in the early 1970s. In McGuire's paintings, one is always struck by the quietude and dignity of the sitter and its equation to the detailed exactitude of the artist's rendering. This portrait demonstrates the artist's early preference for stylization, in Klarwein's face – rather elongated and angular – lacking modulation and fullness, the treatment of the sweater's folds, and the rendering of the awkward hands. One senses here a projection of the young artist onto his sitter: it is easy to imagine McGuire himself as the young, lanky sitter fidgeting and restless to socialize with friends.

Fig. 78. Edward McGuire, *Portrait of Seamus Heaney*, 1974, oil on canvas, 56 × 44⅛ in. (142 × 112.1 cm), Ulster Museum

1 Harriet Cooke, "Harriet Cooke talks to the painter Edward McGuire,." *The Irish Times*, April 17, 1973, p. 10.
2 Brian Fallon. *Edward McGuire, RHA*. (Dublin: Irish Academic Press, 1991), p. 31. The portrait of Matti Klarwein is, in fact, signed "EA 53".

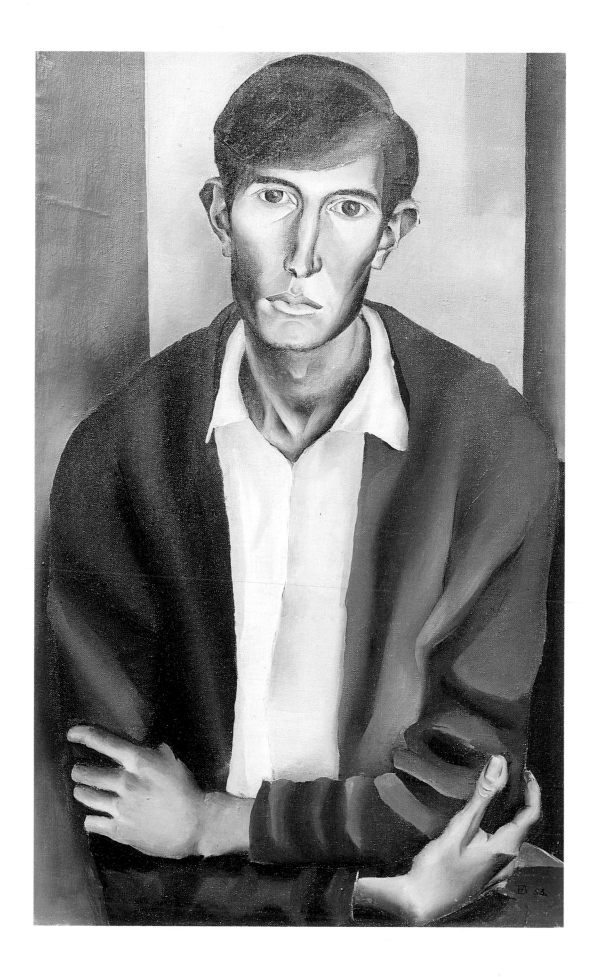

50 GERARD DILLON

Self-contained Flat

ca. 1955
oil on canvas
48 × 72 in. (122 × 183 cm)
Reproduced with kind permission of the Trustees of National Museums and Galleries of Northern Ireland

After attending the Christian Brother's School in Belfast and a brief stay at the Belfast College of Art, Gerard Dillon left his formal education behind and was apprenticed to a painting and decorating firm. He continued to pursue informal studies in art and was interested in the work of two artists in particular: Seán Keating and the Russian artist Marc Chagall. He held a variety of jobs in London after leaving Belfast in 1934; upon his return to Ireland in 1939, he took a formative trip to Connemara in the province of Connaght with another Irish artist, George Campbell. This proved to be the impetus for his career as an artist, drawing inspiration from his travels in rural Ireland. Dillon did not embrace the legacy of landscape painting in Northern Ireland, eschewing traditional depictions in favor of a more narrative, figurative form of landscape and genre painting. Dillon showed at the first Irish Exhibition of Living Art in 1943 and was a frequent exhibitor in the following years. He was much admired and liked by his fellow painters such as Daniel O'Neill, with whom he exhibited early in his career, and Nano Reid, with whom he painted in the countryside of her native Drogheda, north of Dublin. He returned to London in 1945 and took up long-term residence there, living in the basement of his sister's home on Abbey Road. His basement flat became a destination of sorts for Dillon's Belfast artist and writer friends.

Self-contained Flat not only reflects Dillon's personality and tastes, but also indicates stylistically an urban distancing from the West of Ireland scenes and Celtic associations made in Dillon's earlier works such as *Island People*. Dillon's flat was vividly described by the Irish writer Gerard Keenan in a novel that involved a character named Francie Gent who was based on Dillon. In this text, Keenan was critical of Dillon and his work, although in reality he admired Dillon's paintings and even wrote the catalogue introduction for one of his later exhibitions. In the novel, published in installments in *The Honest Ulsterman*, Keenan at one point describes a painting that is:

"a large, ambitious, successful canvas portraying multiple facets of Gent's London flat, a sort of massive *bande-dessinée* of One Day in The Life of Francie Gent, the nude figure lying face-down on his bed as a delicious reward at the end of the day was the nude figure from the painting Gauguin called Manao Tupapau... Francie had divided his living room with bookcases into foyer, sitting-room and bedroom. Furniture and furnishings, carpets and curtains, were shabby, clean and colourful. The walls were covered with paintings, some framed, many unframed. The tools of Francie's trade were sitting around on mantlepiece and cupboard, and there they were also in the paintings on the wall."[1]

Indeed, *Self-contained Flat* presents an autobiographical look at Dillon and the objects and activities he treasured most: artwork, his pliers, screwdriver, and blow-torch, his cat, his interest in Gauguin, entertaining friends, and, outside the kitchen door, an image of a man working the soil that derives from Dillon's fond memories of rural life in Connemara. Dillon's paintings of this period were a definite departure from his scenes of the West of Ireland; his facial expression seems to indicate his satisfaction with life in London, where he has created a private, "self-contained" flat, a self-contained world that provides him with all the necessary comforts while still invoking the legacy of Ireland.

1 Gerard Keenan, "Farset and Gomorrah," *The Honest Ulsterman* 57 (July 1977), pp. 84–85.

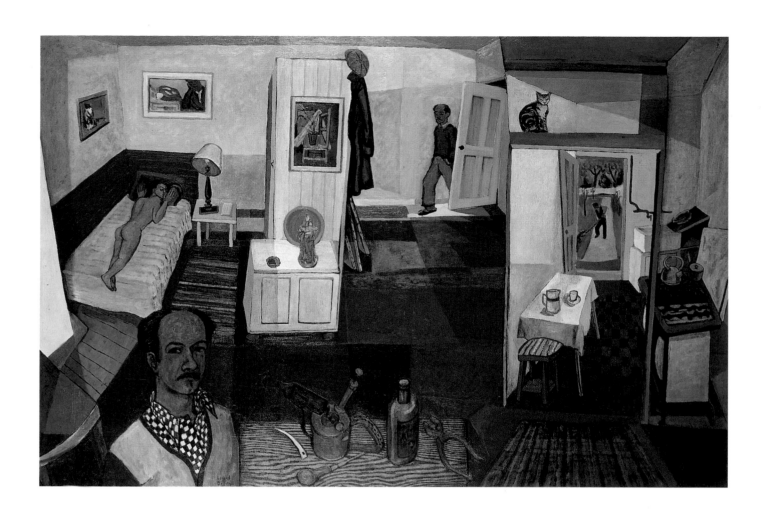

51 NANO REID (born 1900, Drogheda, Co. Louth – died 1981, Drogheda)

Tinkers at Slieve Breagh

1962
oil on board
23⅝ × 29½ in. (60 × 76 cm)
The Collection of The Arts Council/An Chomhairle Ealaíon

Born at the turn of the century, Nano Reid had the opportunity to work throughout the greater part of the twentieth century and thus experienced the political, artistic, and cultural fluxes that transformed the island of Ireland into its modern condition. She drew from this wide exposure, over time reducing its multiple meanings to what she found most essential to her work as an artist. This included an appreciation of the land and the simple lifestyle of rural inhabitants, particularly in her native Drogheda, located in Co. Louth, north of Dublin.

Reid won a scholarship in 1920 to attend the Metropolitan School of Art in Dublin. In 1927 she further expanded her artistic horizons by going to Paris to study at La Grande Chaumière. Reid briefly returned to Dublin before going abroad once more to study at the Central School of Arts and Crafts in London. This, too, was a short stay, and she returned to Ireland to paint in rural locations, although she often showed at international venues, notably in 1950, when she and Norah McGuinness shared the honor of representing Ireland at the Venice Biennale and in 1964 as an exhibitor at the New York World's Fair where *Tinkers at Slieve Breagh* was on view.

Tinkers at Slieve Breagh epitomizes Reid's preferred subject matter and style. *Tinkers* was painted in 1962, just after Reid returned to Drogheda to live with her two sisters above the family-owned pub. This afforded her the ability to paint in the surrounding countryside, including drives out to the more rural areas of Co. Louth with her close friend Gerard Dillon (see Plates 45 and 50). There, she encountered the country folk and sights that served as her greatest inspiration. In an early work such as *The Galway Peasant* of 1929 (fig. 79), Reid shows her skill at capturing the ruddy, earthy complexion and traditional attire of the countrywomen that provided a tonal link to the land. The portrait was painted while Reid was living in a small town in Co. Galway in the West of Ireland and recalls Keating's portraits of Irish peasantry. The subject of tinkers to which Reid turned some thirty years later refers to Irish gypsies whose name derived from the livelihood of making cups and cans out of tin.

The character and sense of humanity present in the painting of tinkers is borne out in a lyrical pattern of broad brushstrokes, much different from the stylized yet traditional early portrait. Reid's richly layered application of predominately green and brown paint is true to the tonal realities of Irish bogland. Reid's abstract approach to figures in a landscape and her earthy palette are much like those of another artist on view here, Patrick Collins (see Plate 54), whose work, like Reid's, has close affinities with the land. Reid makes figurative incisions in the landscape to create the figure of a woman holding a child opposite a seated man working on a tin cup. Their presence is both distinct and in harmony with the surrounding landscape and creates a religious tone reminiscent of depictions of the rest on the flight to Egypt – the three figures taking on the personages of the Virgin and Child and Joseph. Although it may not be Reid's express intention to create a religious scene, it points to the latent piety inherent in the Irish landscape.

Fig. 79. Nano Reid, *The Galway Peasant*, 1929, oil on canvas, 16⅛ × 12 in. (41 × 30.7 cm), Ulster Museum

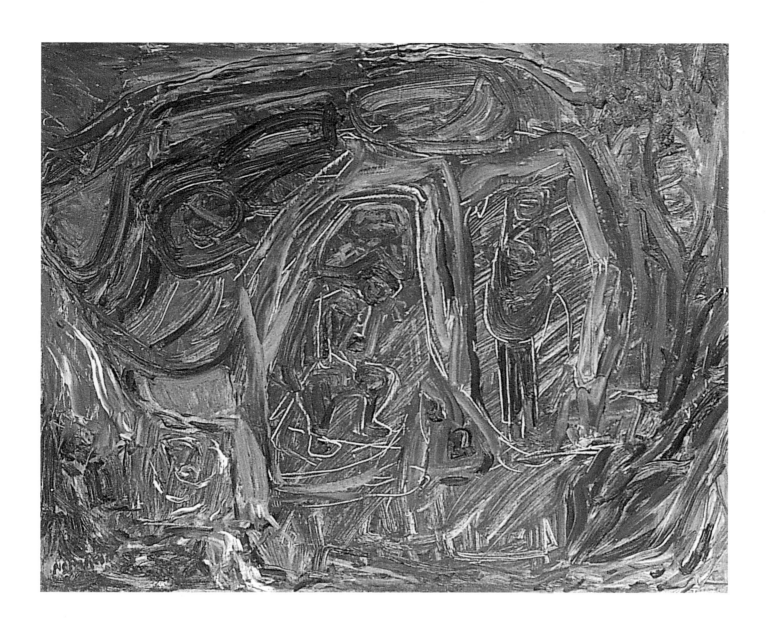

52 BRIAN BOURKE (born 1936, Dublin)

Seated Nude

1965
oil on canvas
40 × 38 in. (101.6 × 96.5 cm)
Private collection

Brian Bourke is something of an iconoclastic figure in Irish art history. He has abstained from popular trends and styles, pursuing a more personal vision that has manifested itself in various ways such as the revealingly nude self-portraits in the 1960s and incorporating the story of Don Quixote in a series of paintings from the 1980s. Bourke's identification with the fabled tilter of windmills was precipitated by his admiration for the clever and descriptive language used by Cervantes – components that find translation in Bourke's art. Although he did spend a year at the National College of Art in Dublin and briefly received further instruction at St. Martin's School of Art and at the Goldsmith School of Art in London, where he worked as a bartender and in various other jobs for six years, Bourke dismissed formal art instruction. He found his trips to museums and galleries, where he was exposed to a wide range of styles and individual artists, more beneficial to his development as an artist. Bourke particularly admired the handling of color and composition by fifteenth-century Italian and German painters and was impressed by the richness and sensuous quality of work by Roderic O'Conor (see Plate 21) and Francis Bacon.

An early corporealization of ideas gleaned from his informal education in museums is present in *Seated Nude* – one of a series of nude pictures Bourke carried out in the mid-1960s. Many of the works done during this period are self-portraits in which he wears different hats to elicit changes in mood from one picture to another. This series is characterized by the stark simplicity of the work, which func-

tions as a counter-reaction to traditional subject matter and avoids references to prevailing political events or other extraneous happenings. In these works, Bourke does not deny a larger societal reality, but makes a concerted and conscious effort to focus his attention exclusively on his subject – a body in space. The depicted female figure is isolated, stripped of her self and left within a vacant space, and the artist makes no pretense of revealing the personality of the sitter. By contrast, many of Bourke's contemporaries were experimenting with abstraction during this period, particularly in response to the work of American artists in the post-war era, while he, in his unfailing iconoclasm, remained committed to the figurative.

Bourke's success in creating a work that exudes vitality has much to do with his understanding of color and space. The brown and beige hues that comprise the body give dimension and form while contrasting with the darker tones applied to the constructed space. The depth and substance of the recessed space is attributable to Bourke's appreciation of the linear perspective developed by Italian Renaissance artists, but he is not alone in this: his rendering of a figure within such a simply composed framework is similar to portraits painted by Francis Bacon (an artist who, while Irish born, must otherwise be seen as an English painter). Bourke, however, gives a more tactile quality to the walls by creating individual panels differentiated by alternating brushstrokes. The brushstrokes, which appear as long dashes or stripes, are reminiscent of O'Conor's use of bold stripes of paint to heighten contrast and definition.

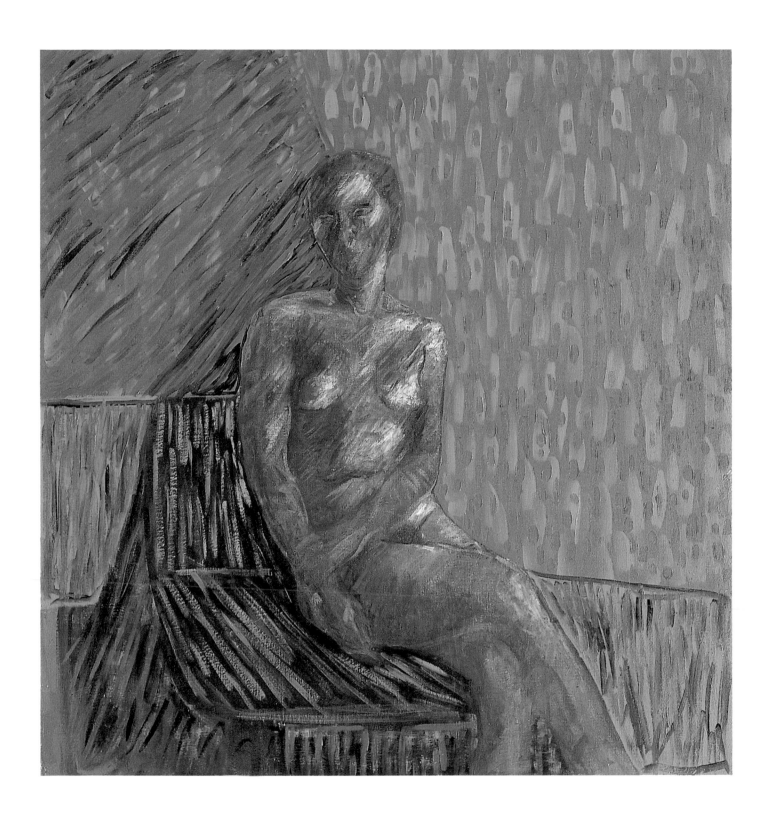

53 LOUIS LE BROCQUY

Reconstructed Head of an Irish Martyr

1967
oil on canvas
51¼ × 38¼ in. (130.2 × 97.2 cm)
Hirshhorn Museum and Sculpture Garden, Smithsonian Institution.
Joseph H. Hirshhorn Bequest, 1981

After having studied chemistry in Dublin, le Brocquy left Ireland to embark on a career as an artist, visiting major European art museums to educate himself. He returned to Ireland, where he went to work in Dublin as an illustrator for a neurosurgeon, attending operations and recording the appearance of diseased pituitary glands in the hidden recesses of the brain. His attempt to enter behind the face and into the recesses of the skull to discover another interior landscape foreshadowed his later work, including the *Reconstructed Head of an Irish Martyr*.

In 1943, after the rejection of his recent work by the Royal Hibernian Academy, le Brocquy, along with Mainie Jellett, Evie Hone, and others, helped to form the Irish Exhibition of Living Art to give greater exposure to contemporary art in Ireland. During this period he attended lectures by the Austrian physicist Dr. Erwin Schrödinger, who spoke on the connection between matter and consciousness. These lectures and le Brocquy's own scientific education were important components in his artistic development, specifically in the conception of the head images that he began to paint in 1964 and for which he is best known.

In 1963 le Brocquy destroyed forty paintings he had done during the year, yet he almost immediately found a new and vital source of inspiration that was to send him in a new and enduring direction – the skeletal or "evoked" head images. Le Brocquy stated in an interview that "The origin of this long series of head images was the Musée de l'Homme in Paris. It was there in 1964 I discovered the Polynesian decorated heads – skulls over-modelled in clay and painted ritualistically to contain the spirit."[1] Le Brocquy was aware of early head cults in Ireland, of which the Corlech head, a Celtic sculpture discovered in Co. Cavan, is a reminder, and this also served as inspiration. The Corlech head was the product of a culture that believed that the spirit continued to reside in the head after death; le Brocquy's painted heads are evocations of this past life. Le Brocquy has also drawn from such sources as the standing stones and severed votive heads found at ancient Celtic-Ligurian sanctuaries in France such as Entremont and Roquepertuse. Le Brocquy has stated of these merged influences and philosophies that:

"You cannot paint consciousness. You start with the knowledge we all have that the most significant human reality lies beneath material appearance. So, in order to recognize this, to touch this as a painter, I try to paint the head image from the inside out, as it were, working in layers or planes, implying a certain flickering transparency."[2]

With the *Reconstructed Head of an Irish Martyr*, le Brocquy applies this method of recreating both the physical appearance and the inner spirit to a painting of an anonymous martyr, assumed to be Wolfe Tone, the rebel leader executed in 1798 (see Plate 35).

Le Brocquy's *Reconstructed Head of an Irish Martyr* had particular significance in 1967 as tension mounted in Northern Ireland that was to culminate in the outbreak of renewed violence in the following year. To invoke the memory of the great Irish martyr was therefore particularly laden with meaning – as, too, are his "evoked heads" of Irish literary heroes, including W.B. Yeats, James Joyce, and Samuel Beckett (where the heads usually hover on a bone-colored white background). Le Brocquy's painterly interest, derived from his scientific work and historical examination of head cults, merges with the politics of identity in the eery image of a partially fractured skull emerging from a cool blue-grey background. The illusory effect is heightened by the inclusion of daubs of red paint alluding to the final rite of martyrdom – death.

1 *Louis le Brocquy: The Head Image* (Kinsale, Co. Cork: Gandon Editions, 1995), p. 7.
2 *Louis le Brocquy*, p. 13.

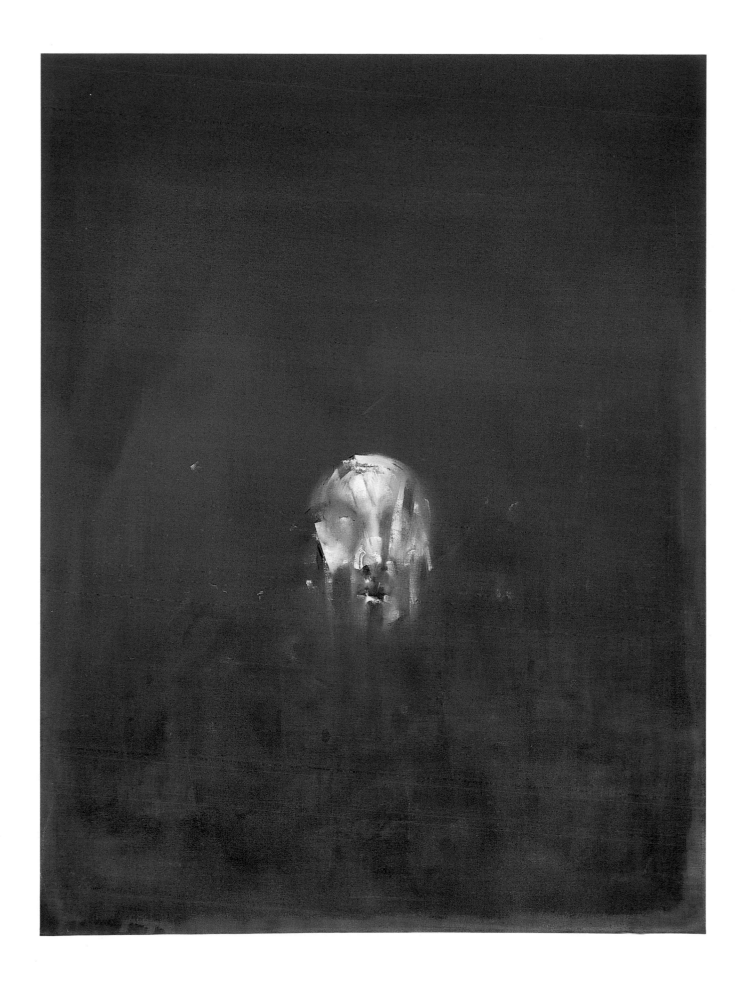

PATRICK COLLINS (born 1911, Dromore West, Co. Sligo – died 1994, Dublin)

Travelling Tinkers

1968
oil on board
24 × 29½ in. (60 × 75 cm)
AIB Art Collection

The work and career of Patrick Collins defy traditional notions of an artist's development. At the age of 14, he was sent to St. Vincent's Orphanage in Glasnevin, Co. Dublin, after the death of his parents; in the same year he began to take evening classes at the National College of Art. After leaving the orphanage, he took a position with a life insurance company in Dublin and remained there for twenty years, during which time his interest in art grew. With only a limited formal art education, Collins drew inspiration primarily from his exposure to the countryside as a youth in the West of Ireland. His paintings such as *Travelling Tinkers*, with its earthy palette punctuated by color, convey the deep affinity Collins had for the Irish landscape.

In addition to his recollections and experiences in the West of Ireland, Collins was influenced by the work of Paul Henry (see Plates 12 and 13) and by Irish literature, in particular by the writers W.B. Yeats, John M. Synge, and James Joyce.[1] The subject depicted in *Travelling Tinkers* was derived partially from Collins's familiarity with tinker paintings by both Jack B. Yeats and Louis le Brocquy, as well as from his own recollections of a tinker camp near his home as a young boy in Co. Sligo. It is not surprising to learn that Collins cited Henry, who visually championed the West as the seat of true Irishness and extolled the nobility of its landscape and inhabitants, as one of the two artists who most influenced his career. Collins described Henry as "a modest man who painted Ireland like an Irishman,"[2] meaning that he possessed the insight to convey the spirit of Ireland in his work. And like Henry, Collins had a keen interest in the Irish landscape and felt that the essence of Ireland was to be found in the land.

The theme of the tinker, a gypsy in Ireland whose name derived from his livelihood making cups and cans out of tin, first appeared in Collins's work in 1957. The *Travelling Tinkers* represented the culmination of the theme and shows a horse-drawn cart upon which sit a mother holding a child, and two other figures. The cart emerges from a veil of fog that seems to obscure everything else save a tree or rock outcrop to the left and the indistinct glow of the sun or moon in the sky. Objects and facial features are defined by flecks of color added to an otherwise somber canvas. Collins frames the central images with a dark-colored band running around the edge of the canvas, a common element in his work that gives the viewer the impression of witnessing a sort of vision or revelation that relates the painting to the spiritual traditions and myth-making of the Celtic past, as well as to the omnipresence of Catholic spirituality in more modern times. In the case of the *Travelling Tinkers*, the band is made up of the ground, trunks of trees, and the sky.

Collins's work pushed the figure to the brink of abstraction with various layers of paint hinting at a deeper, hidden meaning. Frances Ruane has accurately summarized this by writing that Collins's art "goes beyond recording the surfaces so frequently identified with the archaeological remains of the Celtic past. It is rather more profoundly found in aspects that include a fascination with the mystical, a fix on the past, a sense of isolation, a brooding spirituality and an intense love of the land."[3] *Travelling Tinkers* was painted in 1968 at the onset of the present-day troubles. Unlike le Brocquy (see Plates 37 and 53), or the work of Robert Ballagh and Michael Farrell in the 1960s, Collins refrained from overtly politicizing his art and remained steadfast to his interest in the land and memories of his youth in the West of Ireland. Perhaps Collins's politics are to be found in one of the many layers of paint – firmly embedded in the earth even as they insist on the observed Irishness of that earth.

1 Synge's play entitled *The Tinker's Wedding* (1902–07) may have been of specific interest.
2 Harriet Cooke, "Harriet Cooke talks to the Painter Patrick Collins," *The Irish Times* (June 28, 1972), p. 8.
3 Frances Ruane, *Patrick Collins* (Dublin: An Chomhairle Ealaíon/The Arts Council, 1982), pp. 28–29.

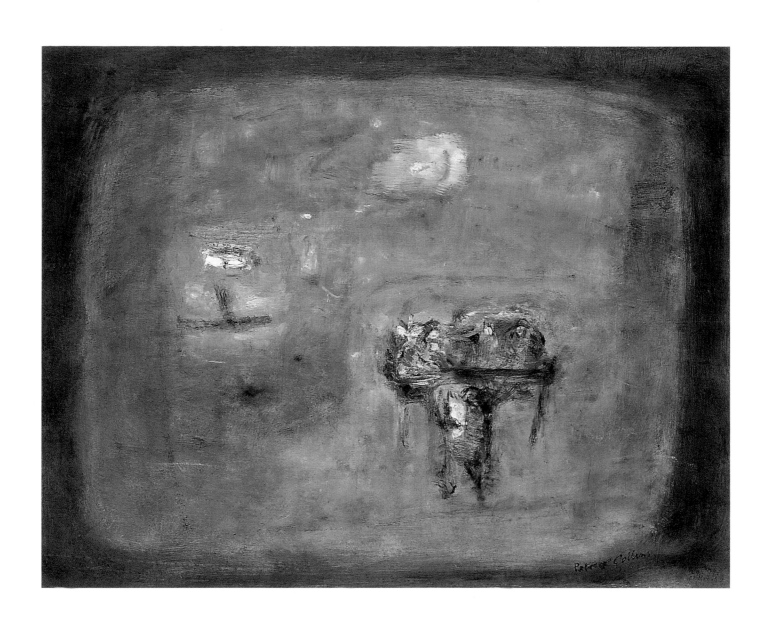

55 ROBERT BALLAGH (born 1943, Dublin)

Portrait of Laurence Sterne

1975
oil and acrylic on canvas
35$^{1}/_{2}$ × 70 in. (90 × 180 cm)
Elizabeth Ballagh

While much of his work is recognizably Irish in its subject matter, Robert Ballagh does not consciously attempt to evoke a sense of Irish identity in his painting. On the contrary, he rebukes those who "prattle on incessantly about definitions of cultural identity" and feels that the "Irishness" evident in his work is inherent and difficult to define. "It could be summarized possibly as an attitude to life or more accurately a way of dealing with life, consisting of, perhaps, a preponderance to irony, satire or metaphor, a sense of humour (often dark), an enjoyment of parody and above all a healthy skepticism."[1] Ballagh's choice of subject matter often draws from his experience of his home city of Dublin, including chance encounters with subjects or individuals that relate to his own sensibilities or beliefs. Such is the case with the subject of his painting *Portrait of Laurence Sterne*.

The painting was commissioned by the D.E. Williams Company in Clonmel, Co. Tipperary, that solicited Ballagh to do a series of paintings for a restaurant owned by the company. The only stipulation was that the subject matter had to have a local connection. Ballagh was unable to find a subject that engaged him until a friend suggested the eighteenth-century writer Laurence Sterne (1713–1768). Ballagh thought Sterne was British, but his friend told him that Sterne had been born in Clonmel. That was all Ballagh needed to hear and he began reading Sterne's famous multivolume novel *Tristram Shandy*, the first two volumes of which were published in 1760. Ballagh made an immediate connection with Sterne's style of writing, one that combined humor and sentiment delivered with apparent spontaneity. It is precisely to this impression of quickness that

Ballagh pays homage in his portrait. Ballagh drew his inspiration from the Walt Disney *True Life* movies that he had seen as a child, when he was fascinated by the way each episode began with an animated paintbrush bringing to life an entire landscape (depicted on a revolving globe) with just a few quick strokes. These scenes left such an impression that Ballagh has always thought "... a painting should look like that. It should never seem laboured. I think Sterne, like myself, was anything but spontaneous. But he gave the impression of spontaneity. That's the important thing."[2]

The image used by Ballagh is taken directly from a portrait of Sterne painted in 1760 by the British artist Sir Joshua Reynolds. Ballagh went to the National Portrait Gallery in London to view it and doubtlessly appreciated Sterne's "subtle evanescent expression of satire around the lips."[3] In his reading of Sterne, Ballagh identified with what he perceived as "an Irish sensibility." This intangible quality, as defined by Ballagh, was also responsible for the choice of green as a background color. It was originally conceived as being red, but Ballagh decided on green for aesthetic reasons while unconsciously making an ironic gesture to Irishness – green being one of the three colors comprising the national flag of the Republic and referring to the "four green fields" or four provinces that constitute the land of Northern Ireland and the Republic of Ireland. Green has also been adopted as the color of Irish Republicanism, by contrast to the Orange favored by Protestant Unionists.

1 Robert Ballagh, "Responding" in Richard Kearney, ed., *Across the Frontiers: Ireland in the 1990s* (Dublin: Wolfhound Press, 1988), p. 204.
2 Ciaran Carty, *Robert Ballagh* (Dublin: Magill, 1986), p. 124.
3 Nicholas Penny, ed., *Reynolds* (New York: Harry N. Abrams, Inc., 1986), p. 200.

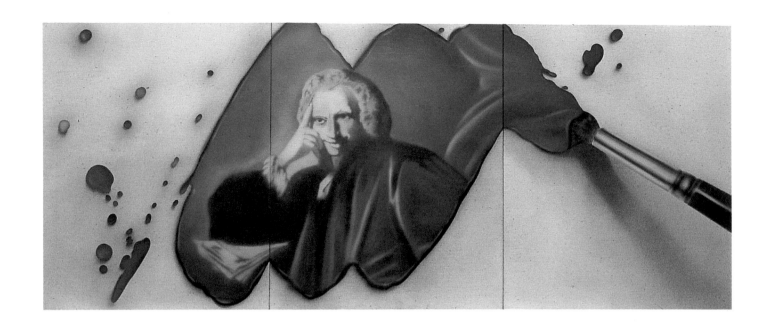

56 MICHEAL FARRELL (born 1940, Kells, Co. Meath)

Madonna Irlanda, or, The Very First Real Irish Political Picture

1977
acrylic on canvas
68'/₂ × 73 in. (174 × 185.5 cm)
Collection Hugh Lane Municipal Gallery of Modern Art, Dublin

While born in Co. Meath, Micheal Farrell received his formal artistic training in Great Britain at St. Martin's College of Art in London and at Colchester College of Art. He then returned to Ireland and did work that was marked by experimentation with both soft- and hard-edged abstraction. Since 1971, however, Farrell has lived and worked in Paris, with a geographical distance from his homeland that has allowed him greater perspective on his experience as an Irishman and spurred him on to create a more politically motivated art. In Paris, Farrell began a series he called *Pressé* after *citron pressé*, a drink made from squeezed lemons. His first *Pressé* works continued to explore abstraction, but soon evolved into abstraction combined with text that ultimately became increasingly figurative. In explaining his artistic development Farrell said, "I found in my big abstract works that I couldn't say things that I felt like saying. I had arrived at a totally aesthetic art with no literary connotations. I wanted to make statements, using sarcasm, or puns, and wit, and all of these things I couldn't do before because of the limited means of expression I had adopted."[1] Farrell's trajectory underscores the vitality of the representational and the figurative for contemporary Irish painters.

Farrell was one of the first artists in the 1970s to challenge stereotypical perceptions of Ireland inherited from earlier generations of Nationalist artists whose portrayal of the country consisted of thatched cottages, drumlin hills, and pastoral peasantry. *Madonna Irlanda, or, The Very First Real Irish Political Picture* was part of this volley waged at accepted notions of "Irish" painting. From a series entitled *Madonna Irlanda*, it formed part of Farrell's exploration of a key painting by the eighteenth-century French master François Boucher entitled *The Blonde Odalisque*. Through the misinterpretation of historical documents, the identity of Boucher's nude model has traditionally been attributed to Louise O'Murphy (1737-1815), an Irishwoman living in Paris who served as a mistress to King Louis XV. Although it has been shown that Ms. O'Murphy was almost certainly not the model used for Boucher's painting, more importantly for Farrell's purposes she was a prostitute and it is this that drew Farrell to the subject.[2] Farrell feels the paintings from this series are effective because "They make every possible statement on the Irish situation, religion, cultural, political, the cruelty, the horror, every aspect of it." With regard to this image from the series, the artist has flatly stated "She is my Mother Ireland. Why? Because she was a whore."[3]

As an allegorical image of Mother Ireland, the nude female figure lounging on the couch represents a radical departure from traditional depictions including both the heroic, militant type (the warrior Mother seen largely in sculpture and discussed by Paula Murphy in the present volume) or the nurturing, maternal savior represented by Lady Glenavy (see Plate 4). Instead, Farrell's less than reverential painting of Ireland as a harlot exposes what the artist saw as a culturally and politically repressed society void of both morality and humanity. She is, for Farrell, the symbol of the nation turned whore by virtue of 300 years of colonial servitude to Great Britain. His provocative attack leaves nothing unscathed in covering a large front ranging from religious to gender issues to Western art history: even Leonardo da Vinci's famous illustration of Vitruvius's code of human proportions suffers an ignominious fate. The figure's normally outstretched arms now cover his genitalia, a mark of shame that suggests Eden after the Fall and Ireland after corruption. The sacred is rendered profane as Farrell metaphorically dispels notions of both proportion and propriety in Ireland. Farrell himself appears in the upper right-hand corner of the picture voyeuristically peering in, his gaze directed as Ms. O'Murphy's/Mother Ireland's reddened buttocks. His presence, much like the hovering helicopters in the work of Dermot Seymour (see Plates 62 and 66), places Ireland as if under scrutiny on the world stage and restates Farrell's position as an outsider (expatriate) scrutinizing his homeland and finding it wanting.

1 Maev Kennedy, "Maev Kennedy talks to the painter Michael Farrell," *The Irish Times*, August 27, 1977, p. 12.
2 *François Boucher 1703-1770* (New York: The Metropolitan Museum of Art, 1986), pp. 258-61.
3 Kennedy, p. 12.

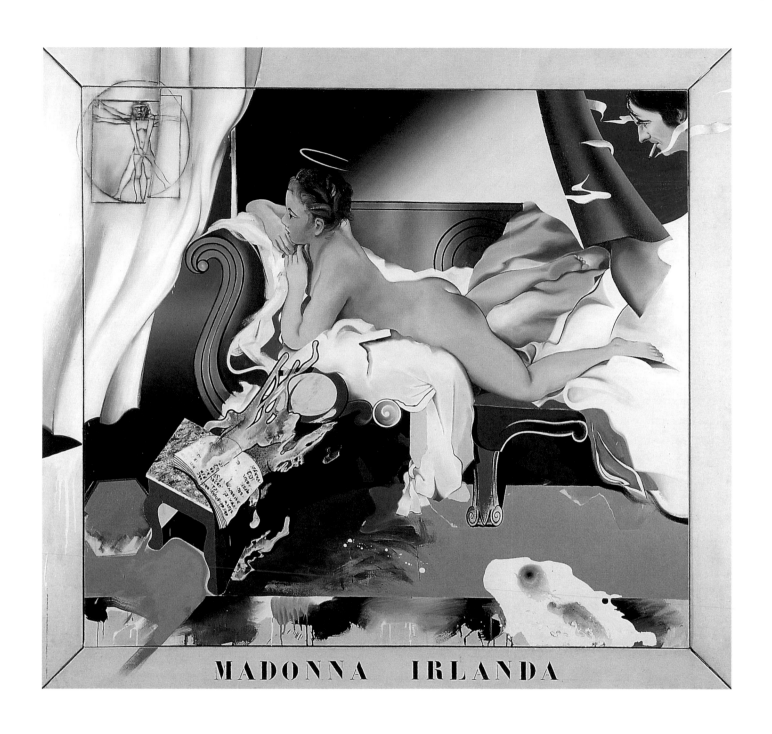

MADONNA IRLANDA

57 ROBERT BALLAGH

Portrait of Bernadette Greevy

1978
acrylic on canvas with tape recorder and soundtrack
42¾ × 42¾ × 6 in. (108.5 × 108.6 × 15.4 cm)
Collection Irish Museum of Modern Art, Gordon Lambert Trust

Robert Ballagh, who lives and works in Dublin, has been outspoken in his attempts to redefine stereotypical notions of what constitutes Irishness, particularly in the visual arts. Ballagh explains, "I never had any access to the culture that many people think is the Irish culture, the rural Gaelic tradition. I can't paint Connemara fishermen My experience of Ireland is an urban one and I paint that. It would be dishonest of me to paint anything else. But being Dublin is being Irish." Ballagh has resisted the temptation to leave Ireland to which many other Irish artists have succumbed since at least the eighteenth century, and has committed himself to making his statements from home. In recent work, such as *The Bogman* (fig. 80), Ballagh has satirized features particular to the Irish landscape and people. In this example he paints himself shoveling pieces of turf framed in a niche bordered by the inscription, in Gaelic, "briseann an dúcas tré súilib an cait," which translates literally as

Fig. 80. Robert Ballagh, *The Bogman*,
1997, oil on canvas,
78¾ × 48 in. (200 × 122 cm),
Collection of the artist.

"Heritage shines out of the eyes of a cat" or more colloquially "You can take the man from the bog but you can't take the bog from the man." Ballagh's Portrait of Bernadette Greevy is a different type of work, one that pays tribute to a gifted Irish vocalist and exemplifies the artist's technical innovation and skill.

The portrait of the Irish mezzo-soprano Bernadette Greevy was commissioned by Gordon Lambert, an important Irish patron of the arts. Ballagh has always used photographs as source material for his paintings; this portrait was no exception and was based on photographs that Ballagh himself took of Greevy. After being enlisted by Lambert, who wished to recognize Greevy for achieving international stature as an Irish singer (thus championing Irish cultural achievement), Ballagh became interested in painting more than merely a traditional portrait, wanting to invest it with something more probing so that, years later, people would have a greater understanding of the sitter and her life. To this end, Ballagh incorporated a technical component in the painting by installing an open microphone, which, when triggered by any noise made in front of the work, would activate a sound recording of Greevy singing a tune by Brahms.

Ballagh's treatment of the painting as a sort of performance on stage – marked by the painted curtain and audio element – complements not only Greevy's vocation as a singer, but also Ballagh's interest in rendering space in a veritable theatrical atmosphere. The curtain is pulled back to unveil Greevy, the star of her own private stage in a tradition with antecedents in Renaissance and Baroque painting, both secular and non-secular, in which the potential for theatricality in the painted space was fully exploited. The bookshelf-as-stage serves as a receptacle for the various mementos that distinguish Greevy's life as a singer including programs from international performances, cassettes of her recordings, a bust of Beethoven (in whose august company Ballagh suggests she belongs), and a manuscript sheet of her favorite song, *Chanson Triste*, by Henri Duparc.

58 DAVID CRONE (born 1937, Belfast)

Demolished Building

1979
oil on canvas
35½ × 35½ in. (90 × 90 cm)
AIB Art Collection

David Crone, currently in the faculty of art and design at the University of Ulster, has enjoyed a prolific career in his native Belfast, where he continues to paint. Crone's work from the mid-1970s to the present has focused primarily in two areas: the technical art of painting and the representation of the everyday routine of Belfast life. They are distinct preoccupations for Crone, who fuses them in his work to evoke a feeling for the physical and mental state of people.

Demolished Building has a literary counterpart in the Italian writer Italo Calvino's novel *Invisible Cities*, which presents a fictional Marco Polo describing to Kubla Khan each of the various cities he has visited in the course of his travels. Khan relies on the vivid descriptions recounted by Polo to conjure up a unique image for each of the many fantastical places. Crone, too, is describing a city, but instead of multiple images there is but one, and instead of words he uses form and color to convey meaning. Crone blurs his imagery, inviting the viewer to look closer and more intently. He deliberately obfuscates what he paints so that the meaning cannot be grasped immediately, arguing that the latter ". . .will be news and not art."[1] Crone's intention to elicit a different interpretation from each viewer is mirrored in Marco Polo's response to Khan who asks whether Polo will give the same description each time. Polo replies "It is not the voice that commands the story: it is the ear."

Crone has, from his earliest works, used grids to frame his subjects. In these early works, the grid was not clearly defined but loosely provided spaces in which to place gestural applications of paint. In *Demolished Building*, the grid pattern is more articulated, creating spaces for the figures as well as serving as latticework or chain-link fencing as it rises towards the top of the picture. In both instances boundaries are established that work centripetally to convey meaning inward within the confines of the painting.[2] The boxes or "windows" produced by the grid pattern contain heads of figures that in some instances actually look back into the picture. The fence divides the work and directs the viewers gaze further into the picture to explore beyond the barrier. Such partition of space is very much a reality in modern-day Belfast, where metal fences and concrete walls are visible in certain areas to separate Protestant and Catholic neighborhoods – an architectural legacy brought about with the onset of the Troubles in the late 1960s. Indeed, such "peace-walls" continue to be erected in the 1990s, even as the brokered peace process unfolds.

Crone uses browns, reds, and whites in the foreground of his canvas to create a swirling cloud of debris as the building appears to be in the process of collapse. The figures in the "windows" watch over the demolition process without revealing much emotion through gesture or facial features, so the impact on them of the collapse is ambiguous. Is this incipient collapse indicative of the society of Northern Ireland, or is it a sense of barriers and boundaries that is also demolished? As is characteristic of all his work, Crone asks each viewer to arrive at his or her own conclusion.

1 *David Crone* (Belfast: The Fenderesky Gallery at Queen's, 1991), p. 3.
2 Rosalind E. Krauss, *The Originality of the Avant-Garde and Other Modernist Myths* (Cambridge, MA: The MIT Press, 1994), p. 18. Krauss posits this as one of two readings for grids, the other being outward or centrifugal.

59 PATRICK GRAHAM (born 1943, Mullingar, Co. Westmeath)

My Darkish Rosaleen (Ireland as a Young Whore)

1982
oil on canvas
72 × 48 in. (183 × 122 cm)
Michael H. Traynor and Orlaith Traynor

Patrick Graham's painting takes its title from the ancient song *The Dark Rosaleen*, in which love for Ireland is disguised in the form of a love song. In the case of *My Darkish Rosaleen (Ireland as a Young Whore)*, Graham's love of his country is mingled with a statement of contempt and embarrassment for his homeland, a Joycean love/hate relationship that is at the heart of much of Graham's work. The reference to Ireland as a harlot, like that in Micheal Farrell's *Madonna Irlanda* from five years earlier and also included in this exhibition, is an artistic response to Irish identity — an identity that can, in the artist's view, be bought.

The visual and textual iconography employed by Graham derives from popular imagery and beliefs. The emotional meaning Graham attached to the shamrock in the 1980s contrasts significantly with its prominence at the 1939 World's Fair in New York (see Paula Murphy's essay in this volume).

The banner of icons across the top of Graham's painting satirically juxtaposes symbols of an Irish identity fractured between two groups that have shared a similar ideology of a united Ireland. The dominant political parties in the Republic of Ireland at the time this work was painted in 1982 were (and indeed remain) Fine Gael ("Gaelic Nation") and Fianna Fáil ("Warriors of Ireland"). Each is represented by the same tri-colored image but with the colors oriented differently. While they preach a common philosophy of republicanism, they draw from two distinct constituencies: Fine Gael supporters are generally more conservative and have a higher economic standing, and are represented here by the knickers and turnips; Fianna Fáil supporters tend to be small farmers, laborers, and factory workers, represented by the less refined icons of bum and spuds. The final two icons — one that merges the American and English flags and the other a question mark that appears above the text "something beautiful for god" — refer to the influence of America and Great Britain in forming Irish culture and the latter to the historical and modern-day influence of the Catholic Church on Irish politics.

The central image of *My Darkish Rosaleen* is, however, the female figure standing immodestly before the viewer wearing a sleeveless top, garter belt and stockings, and gloves. Graham's reference to her as a young whore in his subtitle suggests the Republic's youth even in 1982 as well as its malleability and inexperience, and also, in Graham's view, "selling out". In style she is reminiscent of the female types created by the American artist Willem de Kooning, whose *Woman* (fig. 81) from 1950 is a comparative prototype. Similarities in the immediacy and expressiveness of the figure, in the unflattering, even violent depiction of the female form, are striking. We are a long way here from the beauty and stature of the mythical Celtic heroine as depicted by John Lavery (see fig. 68) or the maternal protectress as presented by Beatrice Elvery (see Plate 4). Instead, the artist explosively shatters the tenderness and idealized beauty of these earlier models to take aim at stereotypical notions of Irish identity as conveyed by the mother figure and the nation's leading political parties.

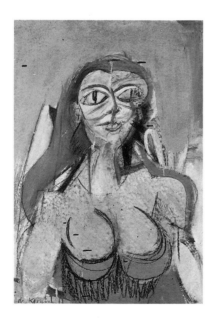

Fig. 81. Willem de Kooning, *Woman*, 1950, oil on paper mounted on Masonite, 36⅝ × 24½ in. (93.1 × 62.3 cm), San Francisco Museum of Modern Art

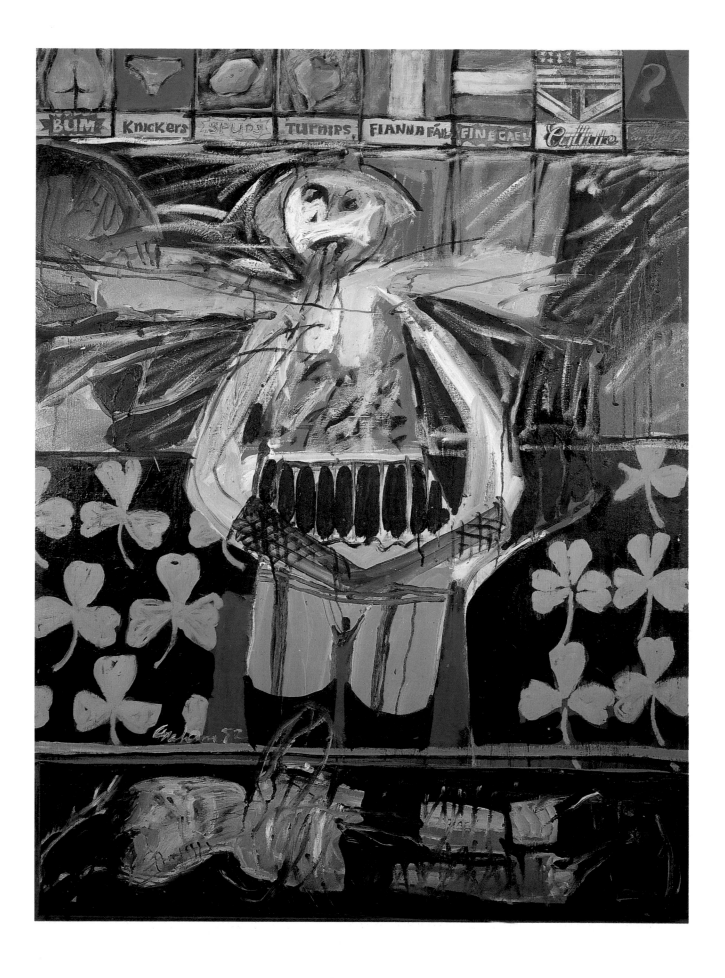

60 PATRICK GRAHAM

Ire/land III

1982
oil and paper on canvas
72 × 48 in. (183 × 122 cm)
Collection Hugh Lane Municipal Gallery of Modern Art, Dublin

Patrick Graham grew up in the boglands of central Ireland and showed an innate aptitude for drawing and painting at an early age. He studied at the National College of Art in Dublin from 1960 to 1964 and upon his graduation worked both as an art instructor and in an advertising firm. The pressure of work and life was too much for him throughout the 1960s; he was unhappy with the art he was producing and ultimately ceased making art for a time, dabbling for only short periods to counter bouts of depression. He was hospitalized to treat the alcoholism that had deteriorated him both physically and mentally.

Medical treatment aided Graham's recovery, as did his exposure to an exhibition of works by the German Expressionist artist Emil Nolde (1867–1956), whose style of painting employed contorted brushwork and raw colors intended to give the viewer a visual and emotional shock – much of which can also be said to describe Graham's painting. Nolde's work gave Graham the notion that an artist could give personal expression to his work and provided an outlet for his emotions. Graham used this new-found freedom in his painting to point out the hypocrisy in contemporary Ireland surrounding religious practice – specifically the Catholic Church – and sectarian violence. It was not until 1974 that Graham began exhibiting his work again. Commenting on his meteoric rise as a young artist, Graham has said, "I had become that most realized of things in the Irish art psyche, a tragedy of unfilled potential."[1]

Ire/land III was originally part of a triptych that was dismantled into its three component paintings and sold to private collectors. As is indicated by the title, Graham here reveals his own entomological source for the name "Ireland," one that signifies a land of anger and wrath. His painting depicts a body on a bier that is decorated with a shamrock, the national flower of Ireland and the object that, according to legend, was used by St. Patrick – a medieval king and the patron saint of Ireland – to explain to an unbeliever the concept of the Holy Trinity (three persons in one God) by showing him the flower with three leaves emanating from a single stalk. Graham thus draws an analogy between himself and the skeptic/unbeliever, inscribing on the painting the text "Ah Sweet Jesus This Is Another Way To Love…And I Understand" – an ironic implication that the religiously motivated violence and death then occurring in Ireland was to be construed as a form of love. The figure lying on the funeral bier becomes a victim of love, not of sectarian hatred. Graham's visual parody of the violence and its effects thus becomes an expression of his opposition through art.

Beneath the image on the bier are six "portraits," juxtaposing religious figures such as the Sacred Heart and the Virgin Mary with Nationalist leaders including Robert Emmet and Padraic Pearse, both of whom employed violence as a means to overcome British rule in Ireland and were executed for their participation in insurrections. Graham grew up in a Catholic family that firmly believed in Irish nationalism. But at the onset of the recent Troubles in the early 1970s, Graham was repulsed by the violence and renounced his earlier beliefs. In *Ire/land III* Graham plays on the ties between Church and state, between past and present, to suggest that the perpetuation of this status quo has not improved the state of affairs in Ireland. As one of the leading painters of the 1980s working in an Expressionist vein, Graham evokes powerful emotion through the heavy application of paint, the use of poignant symbols and expressive images, and a somber yet varied palette.

1 "A Letter from the Artist," in *Patrick Graham*. (Los Angeles, CA: Jack Rutberg Fine Art, 1989), p. 5.

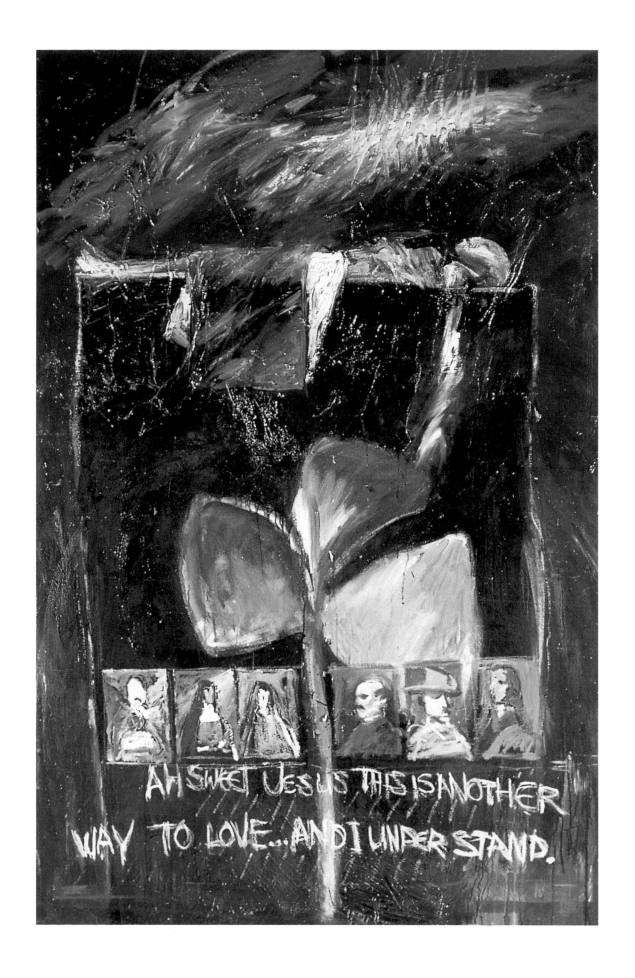

61 PATRICK GRAHAM

Scenes from the Life of Christ

1983/1984
oil on canvas
66 × 204 in. (167.5 × 518.5 cm)
Blaise and Dolores O'Carroll

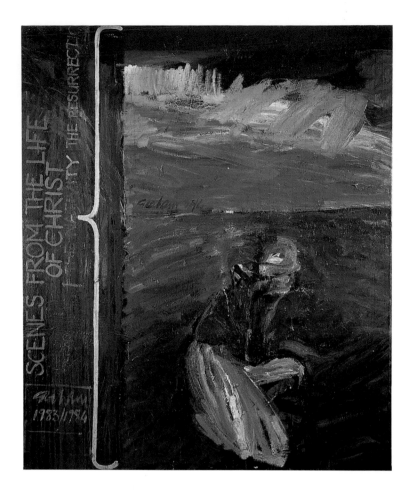

Patrick Graham's early indoctrination into two principal components of life in the Republic of Ireland – religion and politics – has made him profoundly responsive to both issues. Born to Catholic parents who were ardent nationalists, Graham subscribed to their beliefs until the age when he realized he had an opinion of his own – one that has since surfaced many times in his art. In *Scenes from the Life of Christ* Graham draws on Catholic doctrine to make a frank statement about life in contemporary Ireland. The painting can be read as a religious timeline showing the major components of the life of Christ: the Agony in the Garden, the Nativity, and the Resurrection. The work is thus highly narrational, divided into three distinct parts that refer not only to the Holy Trinity but also to the tradition of triptychs, three-paneled paintings made as devotional images, a form that was popularized in fourteenth- and fifteenth-century Italian painting. The religious implications are explicit, but Graham goes further in making a link to politics, specifically the tri-colored flag of the Irish Republic. The two are inextricably bound together, as the flag of nationalism and the triptych of Catholicism merge to symbolize Irishness.

The Nativity representing the birth of Christ – the key event that led to both the Agony in the Garden and to the Resurrection – is placed in the center of the painting. There, the infant lies between two figures, Mary and Joseph, amidst a stark and barren landscape devoid of the usual cast of shepherds, animals, and the entourage of kings so often depicted in representations of the birth of Jesus. Graham has reduced the scene to just the principal figures, painted in the same somber earth tones as the surrounding landscape and delineated only by subtle daubs of white and red paint. The Agony in the Garden and the Resurrection share the same spareness and economy, again reducing events that are traditionally depicted with a supporting cast to a single image of Christ. The reverentially kneeling figure is seen in the same barren landscape, barren of any greenery associated with a garden setting, praying for support from God. On the other side of the painting the apotheiatic image of Christ is presented in a manner that suggests the spirit of Christ is being borne aloft before the body is deposed from the cross.

Graham has created a cogent narrative in which the

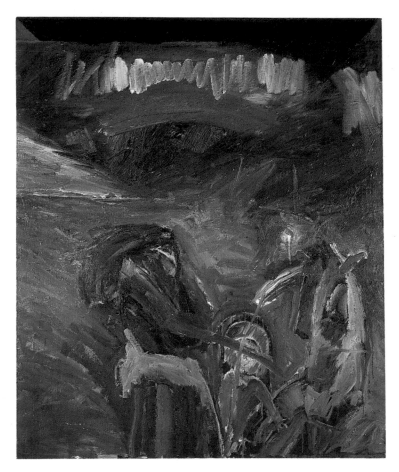 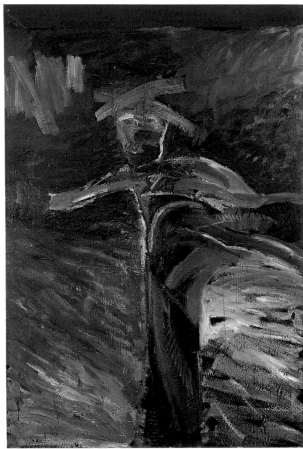

central theme has been stripped down to a bare essential: the spirit of Christ. The three scenes depict Christ's physical emergence, presence, and disappearance, emphasizing the importance of the legacy left by his actions, in the form of his spirit. Much like the flag that is the tangible symbol of the Republic yet represents unseen centuries of history, Graham's painting symbolizes the expression of a deeper emotional sentiment, one that is characterized by disillusionment. And by omitting the extraneous supporting figures and scenery, Graham is able to make a more focused presentation of the three events in keeping with the impassioned, Expressionistic brushwork that has dominated his work since the 1980s. Graham has commented that "The

only knowledge, wit or wisdom I have for now is that my paintings come from silence and a world of abandonment."[1] Graham's own sense of isolation allows him to reinterpret traditional representations of Jesus's life, pairing solace and despair to suggest the history of the Church in Graham's homeland. Ultimately it does not appear to be so much a painting about traditional belief or the lack thereof, but one in which the Bible stories Graham knew as a child become the vehicle for the artist to communicate a deeply felt, violently represented sense of cultural baggage.

1 "Patrick Graham on Patrick Graham" in *Patrick Graham* (Dublin: Gandon Editions, 1992), p. 17.

62 DERMOT SEYMOUR (born 1956, Belfast)

The Russians will Water their Horses on the Shores of Lough Neagh

1984
oil on board
30¹/₄ × 42¹/₈ in. (77 × 107 cm)
Dr. Patricia Noone

In *The Russians will Water their Horses on the Shores of Lough Neagh*, Dermot Seymour produces a landscape devoid of the elements described in the title: there is no lough (the Celtic term for lake), no horses, and, it could be argued, no Russians. Instead, he presents a sharply divided picture – one half showing a cow in the foreground with an armed military helicopter hovering in the background; the other with a half-submerged fish (in a field of grass) near a young bearded man in the foreground with a bird flying overhead in the background. Seymour has departed from the standard conventions associated with Irish landscape painting, in which the land is depicted in an idealized and romantic manner. The land has for Seymour been transformed from a visual representation to a cultural image representing two co-existing cultural traditions: the Republic of Ireland and Northern Ireland.[1]

Seymour was born and raised in Belfast and has drawn from his experiences amidst the charged political atmosphere, religious conflict, and cultural changes that have occurred in the province of Ulster in the past thirty years. Throughout his work he has drawn on a wide range of images and redefined them to communicate his personal views. In this instance the helicopter and cows, recurring icons in Seymour's work, are both "grazing" and assume specific roles. The helicopter connotes force and surveillance, echoing the British military presence in Northern Ireland across the last thirty years and their broader political presence there for centuries, while the cows symbolize for Seymour the steadfast Irishman, bound to the land yet attentive to the intrusion above. The telephone pole severs the picture into a sort of diptych and serves to delineate the religious boundaries of Roman Catholic versus Protestant, of Celt versus Anglo-Saxon. Seymour paints what he has

witnessed in terms of the political, social, and cultural events in Ireland and merges them to create an unreal reality – one that, for Seymour, positions two cultures vying to establish their identities on common ground.

The redefining of landscape painting is a significant aspect of Seymour's work. He has broken from traditional Irish landscape genre painting – of which Paul Henry's *In the West of Ireland* and James Humbert Craig's *Going to Mass* (Plate 31) are examples – to create a new type of artistic interaction with the environment. The painted interpretation Seymour produces deals less with the natural beauty that captivated Henry and Craig and more with the connotation of the Irish landscape as a means to a political end, a place burgeoning with meaning. His juxtaposition of ostensibly unrelated figures and images confounds and confronts the viewer by creating a paradoxical picture that, although clear in its representation (in a style approaching photorealism), creates a bizarre, almost surreal atmosphere. As for the title, Seymour has said that "The title comes from a prophecy of some Irish saint. You get tired looking at British Army helicopters in the sky, so this [is] a Russian helicopter juxtaposed with a little anecdote that at the turn of the century, around Lough Neagh, fisherman used to bury salmon, head-first, along the shoreline to enhance the flavour."[2] The cryptic nature of the title – invoking Irish storytelling, history, and present-day political reality – only serves to reinforce Seymour's painted observation of the conflicting nature(s) of Ireland and its people.

1 See John Hutchinson, "The Nature of Landscape," in *A New Tradition: Irish Art of the Eighties* (Dublin: The Douglas Hyde Gallery, 1990), pp. 37–44, who discusses the change in perception of landscape in Irish painting .
2 Dermot Seymour in conversation with Liam Kelly, December 1994, in *Dermot Seymour* (Dublin: Gandon Editions, 1995), p. 8.

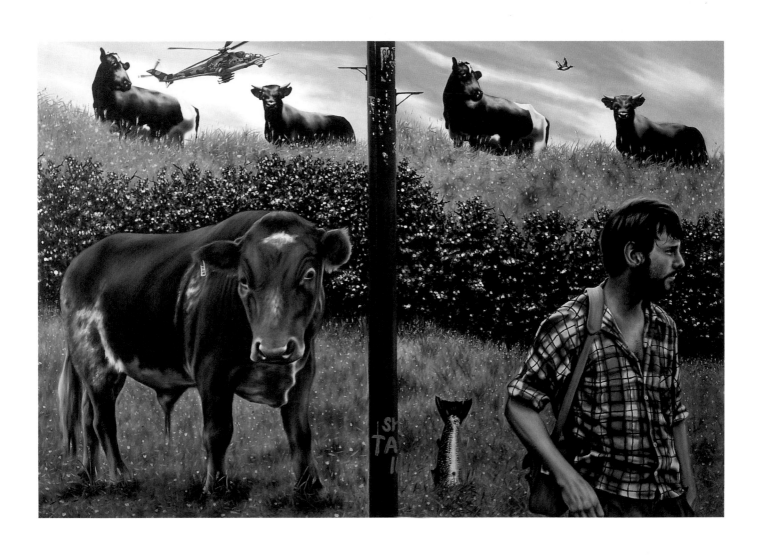

63 BRIAN MAGUIRE (born 1951, Dublin)

Divis Flats

1985
acrylic on canvas
67¾ × 45¼ in. (172 × 115 cm)
Collection Irish Museum of Modern Art,
Noeleen and Vincent Ferguson Donation

Brian Maguire was born and educated in Dublin but, like many artists of his generation such as Rita Duffy and Dermot Seymour, has found Belfast, as the axis of political tension, to be an abounding source of inspiration. Taking its title from one of the poorest and most deprived neighborhoods in the city, Maguire's *Divis Flats* presents a dramatic commentary on social conditions in contemporary Belfast and the ramifications of instability in an urban setting. The somber patches of color created by Maguire symbolize the fragility and instability of the housing project and underscore the potential collapse of both structure and spirit. *Divis Flats* offers little hope, but implores the viewer to take positive action to avoid failure. The poet and writer Seamus Deane, in an article on the relationship between the role of the artist and political aggression, writes, "To imagine what it is like to live in Divis Flats, in Turf Lodge or in Andersontown is to imagine what the whole society could become – poor, oppressed, debased, insanitary, numbed into the acceptance of violence as part of the daily round."[1] Maguire has effectively captured a moment of human deprivation, that is to say one lacking a sense of security within and belonging to a community, and isolation that were common features of Irish society in the 1980s.

In *Divis Flats* a solitary figure stands amidst a drab, muted backdrop of imposing architecture that recedes to create a gauntlet offering no alternative path other than straight ahead. It is a rigid, crudely rendered picture and one that epitomizes the work of Brian Maguire, who, as art historian Donald Kuspit has written, creates work that is "...roughly hewn hand-made rather than smoothly manufactured, indeed, made with a hand so vehemently assertive as to seem unsusceptible to mechanical control..."[2] Maguire's *Divis Flats* captures the artist's predilection to address social and economic issues in a manner that is utterly convincing because of the harmonic combination of his tough "expressionist" style and choice of subject matter. His feelings are expressed in a style employing loose brushwork and gestural applications of paint, conveying precise memories of his youth and perceptions of the state of humanity.

The psychological tension of isolation, expressed by the solitary figure and the confining nature of the architecture, gives Maguire's work a disturbing edge. The image of a figure lurking in the foreground suggests the inevitability of a crime. Maguire has lured the viewer into the picture by positing the possibility of violence, and has relegated him to the role of passive witness. The relationship of architectural space to man and the sensory reactions created by the union moved beyond the painted surface when, in 1991, Maguire collaborated with the architects Sheila O'Donnell and John Tuomey to construct a Pavilion for the courtyard at the Irish Museum of Modern Art. The Pavilion was a built environment created specifically to trigger meaning in the paintings by Maguire that were hung inside. The Pavilion came to represent a sort of prison within a prison where Maguire was able to construct meaning through the installation of a selection of his works. In discussing the Pavilion, Maguire articulated a difference in conception between him and his architect collaborators, stating "Where I saw a dismal, grey reality – a stage for the repetitive struggle of life and death, or their lesser equivalents, with the greyness counterpointed by individuality and erotic expression – where the city is, in ways, akin to the architecture of the prison, you [O'Donnell and Tuomey] said something like, 'If we saw the world the way you see it, or if we saw the city the way you see it, we wouldn't be able to work.'"[3]

1 Seamus Deane, "The Artist and the Troubles," in *Ireland and the Arts* (London: Newgate Press Ltd., n.d.), p. 42.
2 Donald Kuspit, *Brian Maguire: An Essay* (Dublin: Douglas Hyde Gallery, 1988), n.p.
3 Brian Maguire in conversation with Shane O'Toole in *The Irish Pavilion/Brian Maguire | Sheila O'Donnell and John Tuomey* (Dublin: Gandon Editions, 1992), p. 20.

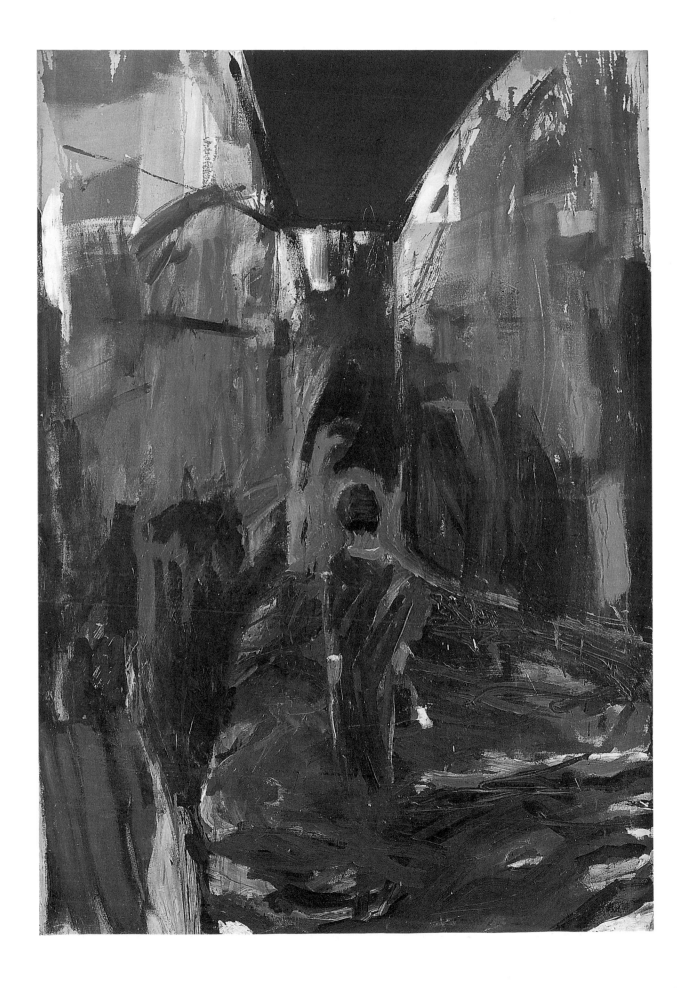

64 BRIAN MAGUIRE

Children and Self (Remembering)

1986
mixed media on canvas
67³/₄ × 68¹/₂ in. (183 × 174 cm)
The Collection of The Arts Council/An Chomhairle Ealaíon

In reference to his painting from the 1980s, Brian Maguire has said, "The work contains images of sexual frustration, parental matters, intoxication, guilt from political violence, from separation, dependency, loneliness, ordinary things where I was coming from."[1] For Maguire, the basic human conditions he describes have been negatively sustained by the conservative and traditional environment maintained by the Irish government and mandated to a certain extent by the Catholic Church. Along with other Irish artists, Maguire began to question secular and religious dogma in the 1980s through painting that used the body as a point of reference to re-examine the established beliefs that have formed and informed Irish identity. In *Children and Self (Remembering)* Maguire evokes recollections of childhood and self-identity to address such broader questions.

As a child growing up in Ireland, Maguire was forced to struggle not only with the normal vicissitudes of adolescence but also with what he viewed as the constraints imposed by Irish history and religion. In this view, the individual in Ireland has stood aside for centuries for the good of the group. Nobel Prize-winning Irish poet Seamus Heaney has pointedly remarked, "In Ireland the very idea that you would set out to seek individual fulfillment has something slightly affronting about it."[2] For Maguire, then, this auto-biographical painting – capturing a moment of self-expression that marks him as a non-conformist in the group-centric Irish culture – comes to symbolize not only an episode in his life, but one that could be applied to a large portion of the Irish people and thus speaks to the artist's conception of the Irish condition.

As much as Maguire touches on specific issues such as childhood memories and self-expression, a certain ambiguity remains surrounding the composition, particularly in the reclining foreground figure. One of the boy's hands modestly covers (or holds) his genitals while the other rests near his head. Maguire does not make it clear if the boy has been discovered by his family in the act of sexual self-fulfillment or if the background figures represent his conscience admonishing him for his act. Might the scene behind the foreground figure also represent part of a childhood dream as he sleeps? His nudity and awkward posture bear out the innocence and trustful nature of childhood and the loneliness and vulnerability of young adulthood in a moment of presumed (but violated) privacy. Here, the group is the victor.

Maguire gives expression to his painting through his choice of intimate subject manner and his liberal application of color. The background group lacks specific detail, but is made prominent by the use of orange and yellow paint, the mother figure cloaked in whiteish blue-grey in contrast to the primarily indigo background. The largest figure extends his arms to give cohesion to the family. Maguire clearly delineates these figures and renders them vital through the use of strong color. Another form is slightly detached from the main group and is painted in white, creating a ghost-like image that may be read as the shadow of the former self now isolated in the foreground, detached from his family. Maguire's paintings typically convey a wide range of emotion; sentiments such as loneliness, alienation, and rejection confront the viewer to create a visual forum in which the social and political issues of Ireland – in this case, the family and sexuality – are contested.

1 Brian Maguire, "On Irish Expressionist Painting," *The Irish Review*, 3 (1988), p. 26.
2 Seamus Heaney, "On Irish," p. 35.

65 JACK PAKENHAM (born 1938, Dublin)

The Raft of the Medusa, Ulster Version

1987
acrylic on canvas
48 × 48 in. (122 × 122 cm)
Private collection

The Raft of the Medusa, Ulster Version by Jack Pakenham is based on the story of the French government frigate, *La Méduse*, that sailed as the flagship for a convoy carrying French soldiers and settlers to the colony of Senegal in Africa. On 2 July 1816 the ship went aground owing to the incompetence of the ship's captain. There were not enough lifeboats to accommodate all the passengers, so the remaining group fashioned a crude raft from the masts and beams of the sinking ship. A group of approximately 150 people, comprised primarily of lower ranks and soldiers, including one woman, climbed aboard the raft, where they were abandoned by the other lifeboats and left to the mercy of the currents and the wind. Without means of navigation and sufficient food or drink, these survivors ultimately resorted to cannibalism; of the original group, only fifteen survived. The political opponents of the French monarchy seized on this tragedy to make a broad attack on the government; the gruesome first-hand accounts provided by the survivors inspired the painter Théodore Géricault to render his famous version *The Raft of the Medusa* in 1819 (fig. 82).[1]

Certainly the political implications of this catastrophic event have not been lost on Pakenham, who uses Géricault's historical model to make a similar statement about the modern situation in Ireland. Pakenham has said, "Over the

years, I have tried to convey through a poetic language of metaphor, symbol, allegory and ambiguous narrative some of my concerns and anxieties, to use visual language to expose and comment; the resulting paintings are my 'accusing and condemning finger'."[2] This language involves the use of recurrent motif's: the head of the ventriloquist's doll, appearing to grow out of the central female figure (Mother Ireland?), has been a ubiquitous feature of Pakenham's work since 1975, when he created the motif "as a metaphor for all the people caught up in the civil strife."[3] The masks worn by figures and hanging on the line allude to the deceit and immorality hidden from view, as does the black-hooded figure, resembling the stereotype of the terrorist, giving a one-eyed, cold-blooded stare from the lower left corner. Over the raft is scrawled graffiti ranging from the inane (a tic-tac-toe game carried out on the ennui of the raft) to the more menacing "provo," which, in contemporary parlance, refers to the ultra-militant faction of the Irish Republican Army.

In the lower right-hand corner of the painting a face emerges from the edge of the canvas peering in on the chaos displayed on the raft. This is almost certainly Pakenham's self-portrait as a voyeur, symbolizing the artist's daily existence as observer and chronicler – both as a visual artist and a poet – of the destructive and inhumane conditions prevalent in Belfast in the 1970s and 80s, where Pakenham has lived since leaving his native Dublin.

Originally conceived as a ship of fools, Pakenham's raft in *The Raft of the Medusa, Ulster Version* functions metaphorically as an island, the island of Ireland, isolated in turmoil.

Fig. 82. Théodore Géricault, *The Raft of the Medusa*, 1819, oil on canvas, 193¼ × 281⅞ in. (491 × 716 cm), Musée du Louvre, Paris

1 See Lorenz Eitner, *Géricault's Raft of the Medusa* (London: Phaidon Press Limited, 1972).
2 *Art Beyond Conflict: An Exhibition of Work by Eight Belfast Artists* (Belfast: Crescent Arts Centre, 1996), u.p.
3 The image was drawn from a doll formerly owned by Pakenham's son David that found its way into Pakenham's studio one day where he found it "...lying on the floor, one arm twisted half way up his back, legs twisted under his body. He looked so much like an assassination victim." Taken from a conversation between Paul Yates and the artist printed in *Jack Pakenham: Selected Works 1961-1978* (Belfast: Fenderesky Gallery, 1988), u.p.

66 DERMOT SEYMOUR

The Queen's Own Scottish Borderers observe the King of the Jews appearing behind Sean McGuigan's Sheep on the Fourth Sunday after Epiphany

1988
oil on linen
44 × 60¹/₄ in. (112 × 153 cm)
Sandra Leibbrand and Mícheál O'Brolacháin

"You look around you and there's lumps of Ireland breaking off and standing like islets on their own – sometimes with sheep stranded on them – while the tide swirls in behind them."[1]

With this remark, Seymour metaphorically describes his view of the situation of Irish Catholics living in Northern Ireland – a people disjointed from the Republic of Ireland by the territorial partition of the island of Ireland accomplished in 1922. Seymour, having spent the majority of his life in Belfast, moved to Co. Mayo on the west coast of Ireland in 1992, both to distance himself from the turmoil of urban life in Northern Ireland and to gain a better perspective on landscape painting in the West – long mythically perceived as the essence of Ireland because of its rugged, vital, and rural environment. The propagation of this image was due in large part to the work of Irish painters such as Paul Henry, Jack B. Yeats, and Seán Keating and of writers including W.B. Yeats and John M. Synge. In the presence of conflicting ideologies, Seymour draws on these sources to depict the erosion he saw occurring throughout Ireland.

In this painting, Seymour uses a farm animal to symbolize the Irish people, while also drawing from his repertoire of icons to include surveillance and religious images as recurring signs of military presence and religious conflict in Northern Ireland. The combination of dark tones and forceful imagery creates a threatening and foreboding picture. He positions the Crucifixion scene poignantly in the center of the picture, between the sheep in the foreground and the helicopter hovering over the drumlin hills in the background. The position of the crucifix clearly conveys Seymour's view that religion is at the center of the divide between Unionists and Irish Nationalists. The crucifix also serves to demarcate territory that is emphatically Catholic, the predominant religion in the Republic of Ireland and the minority, but growing population in Northern Ireland. The helicopter alludes to the military aggression and violence that often claims the lives of the passive, non-extremists, who take the form of the grazing sheep.

The photo-realistic veneer creates an ostensibly clear and straightforward picture but simultaneously conceals the tension and unease that is at the heart of the work. It is this mixing of the commonplace with the extraordinary that makes Seymour's work provocative, not only calling into question the changing and varied complexion of what is Ireland, but also invoking a sense of fragmented identity. Yet in the confusion of conflicting religious beliefs and territorial power struggles, there exists something that can be seen as uniquely Irish. The noted literary theorist Terry Eagleton has written "Identity is at once at the precondition of unity, and its potential disruption; without a degree of identity there is nothing to amalgamate, and with too much identity no possibility of accord."[2] Seymour recognizes the need to bridge the wide chasm that separates each of the polarized groups as the central problem facing Ireland. Through his painting, he offers no solutions but combines seemingly disparate parts to form a cogent narrative.

1 Dermot Seymour in conversation with Liam Kelly, December 1994, in *Dermot Seymour* (Kinsale, Co. Cork, Ireland: Gandon Editions, 1995), p. 24.
2 Terry Eagleton, *Heathcliff and the Great Hunger: Studies in Irish Culture* (London and New York: Verso, 1995), p. 129.

67 RITA DUFFY (born 1959, Belfast)

Segregation

1989
oil on gesso panel
47$\frac{1}{4}$ × 35$\frac{1}{4}$ in. (120 × 90 cm)
Crawford Municipal Art Gallery, Cork (Ireland)

"Having spent most of my life to date in Belfast, it has been inevitable for me that my art reflects the experiences and memories of my formative years."[1]

As a woman who grew up in Belfast, Rita Duffy has experienced first-hand the gender and religious divisions that exist in her native city and their influence on broader social issues such as education. In *Segregation* Duffy paints a clear and symbolic message of separation. For a nation attempting to achieve cohesion and some form of reconciliation, division based on gender and religious affiliation is not, according to Duffy, an answer. The people who inhabit this constructed world are not pretty, but border on the grotesque: distorted limbs and the gritty faces of anger and fear worn by women, men, and children confront the viewer. This type of explicit and life-based narrative is characteristic of Duffy's work, whose distorted figures convey a sense of reality that is truer for Duffy by revealing life's imperfections and blemishes.

Duffy's composition functions rather ironically like a diptych (a picture made up of two parts), a format often associated with religious altarpieces. The two opposing groups – Roman Catholics and Protestants – are separated by an androgynous and non-denominational figure in clerical black whose head has been cropped out of view. The absence of a face dehumanizes and degenders the figure, placing more emphasis on the victims separated by two oversized, bony hands. Derisive looks and gestures abound as each side pushes forward, either resisting segregation or insisting on their separate and unequal natures. Through a sense of unreal, even tragicomic exaggeration, Duffy insists on the divided nature of society in Northern Ireland, with its roots in both ethnic conflict and religious opposition, arguing in visual terms that this divisiveness is perpetuated by a non-integrated system of education. This is a form of ethnic separation that seems particular to the region: as the artist and critic Brian O'Doherty has pointed out, "Northern Ireland is not unique in its conflicts and emotions.

It is unique in the way they shape themselves into a particular profile."[2]

The question of establishing a secular curriculum in the Irish educational system amidst the prevailing religious tensions remains unresolved. In the 1830s an effort was made to set up a National Board of Education that would teach, as Robert Foster said, ". . . a utilitarian diet of values that . . . might be seen as a rather crude attempt at social control, but were at least secular. They therefore pleased nobody."[3] The majority of Protestant children currently attend state-run schools in Northern Ireland, while most Catholic parents prefer to send their children to grant-aided schools run by the Roman Catholic Church. Attempts to integrate education have been made repeatedly, but these generally met with little success until recent years, when a small number of schools found an increased willingness on the part of parents to cross the religious divide.

This rift is made explicit through Duffy's considerable bravura in her handling of the composition. In *Segregation* the men, women, and children swarm around the central figure creating a sort of restless equilibrium. As in other works such as *Mother Ireland*, she again grounds one figure to give stability while auxiliary images play off the central anchor. Her figures derive great emotional power from their expressionistic exaggerations and distortions to become a kind of satire, while Duffy's technical ability to create what are in fact caricatures that can be read like characters in a cartoon strip makes her an effective narrator. Babies wail, arms are raised, fingers are pointed – all combining for a dynamically impassioned narrative, one that derives from an artist whose entire adult experience, to date, has been lived during the Troubles.

1 Duffy, quoted in *On the Balcony of the Nation* (Belfast: The Arts Council of Northern Ireland, 1990), n.p.
2 Brian O'Doherty, introductory essay in Liam Kelly, *Thinking Long: Contemporary Art in the North of Ireland* (Kinsale, Co. Cork: Gandon, 1996), p. 7.
3 Robert F. Foster, *Modern Ireland 1600–1972* (London: Allen Lane The Penguin Press, 1988), p. 304.

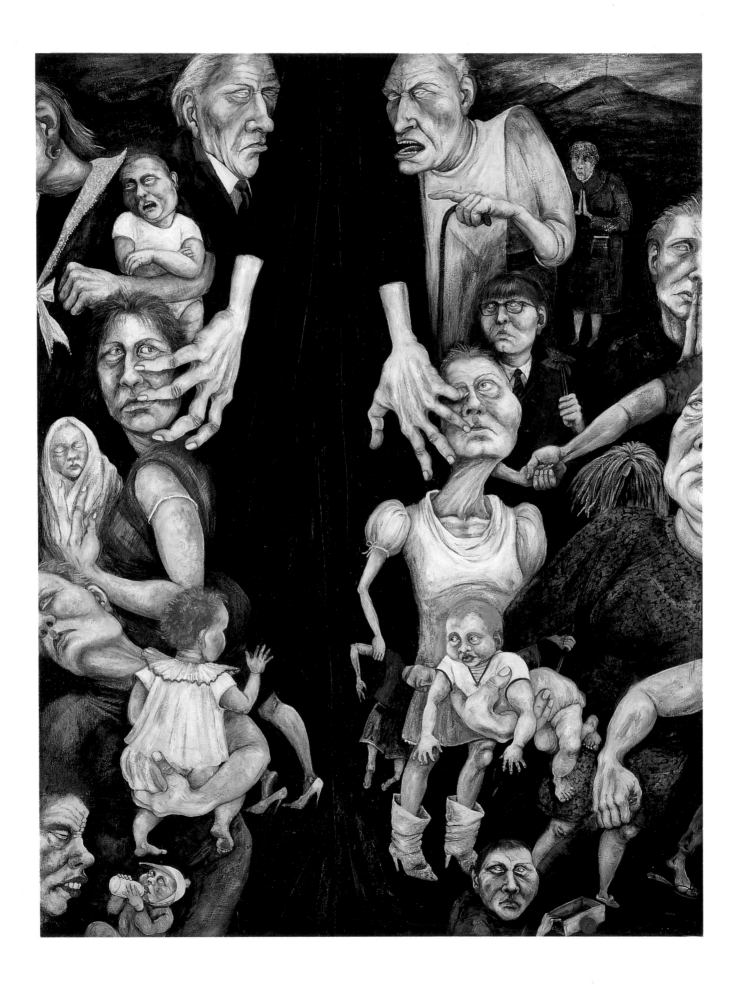

Mother Ireland

1989
oil on canvas
48 × 35¹/₂ in. (122 × 90 cm)
Peter F.J. Macdonald

Born and raised in Belfast, a focal point of the Troubles in Northern Ireland, Rita Duffy has charged her work with political tension on multiple levels. Rather than focussing on the conflict between loyalists and Irish republicans, Duffy's work examines more internalized Irish issues such as the role of women, religion, and cultural identity. Her style of painting and intent to convey a direct and clear message – the content of which borders on political satire but is imbued with personal emotions and experiences – shares an affinity with German Expressionist artists such as Otto Dix and Max Beckmann, most notably in their work produced during the 1920s and 30s. In particular, Dix's ability to make visible unsentimentally the realities of political and cultural issues in a language of contortion, exaggeration, even grotesquery is rekindled in Duffy's work.

Mother Ireland explores the role of women and the Catholic church in Irish society. The figure of Mother Ireland holds on her knees the "four strong sons" or the four provinces of Ireland referred to in the nationalist ballad "Four Green Fields" (often taken to represent a united Ireland). Duffy's woman represents a contemporary perception of the mythical Mother figure attempting to anchor a restless nation. Her weathered complexion and weary countenance bear testimony to her will and tenacity. Duffy's choice of the female serves not only to expose the onus placed on women to offer stability and solace, but also functions as a metaphor for the land itself and the friction surrounding her as two opposing factions vie to establish territorial and cultural preeminence. As David Brett has pointed out, "There is nothing that more compresses the tensions between 'land' and territory than this Oedipal struggle for the possession of the symbolic mother."[1]

While gender plays a significant role in Duffy's work, she is also concerned with identity, specifically the development of a distinctive identity within the context of modern-day Belfast. As Whitney Chadwick has noted, Duffy draws from her "marginalized" position as a woman artist working in a volatile urban environment to produce "new narrative cycles which emphasize identity as continually in process of formation, open-ended rather than determined."[2] Duffy thrusts forward the Mother here as the focal figure of her composition, while the figure of the Catholic bishop of Belfast is subjugated to the background. Specifically, in taking on the role of women as suggested by the Church Duffy is questioning established beliefs and systems that are at the core both of the Troubles and of gender-based identities.

Mother Ireland thus goes beyond merely commenting on the role of the Church to address the issue of women's rights in Ireland. Not only is Mother Ireland charged with the duty of maintaining the four provinces within the rules of the Church, but she must maintain the home. The clothing iron she wears here as an oppressive headdress signifies this domesticity, its electric cord leashing her to a kind of servitude. The women's movement came late to Ireland, held back by the historically poor economy and the power of a patriarchal Church, still sufficiently powerful in the 1980s to quash attempted reform concerning divorce and abortion. Ailbhe Smyth has posited that the single most restrictive factor preventing or delaying reform on the rights and status of women in Ireland has been the obsessive concern over national identity. Smyth has argued that this preoccupation with identity derived from the nationalist/unionist conflict must indeed be set aside for feminism to succeed in Ireland.[3] Yet even under these historically adverse conditions, the role of women in both Northern Ireland and the Republic has changed – not coincidentally even as Ireland has experienced the greatest economic prosperity it has seen in 300 years – a change perhaps best embodied by the election of Mary Robinson in 1990 as the first woman President of the Republic of Ireland.

1 David Brett, "Poetic Land and Political Territory· Points to Consider," in *Poetic Land Political Territory* (Sunderland, U.K: Northern Centre for Contemporary Art, 1995), n.p.
2 Whitney Chadwick, "Crossing Boundaries: Belfast," in *Crossing Boundaries: Belfast* (San Francisco: San Francisco State University, 1996), p. 7
3 Ailbhe Smyth, "Feminism in the South of Ireland – A Discussion," *The Honest Ulsterman* 83 (Summer 1987), p. 53.

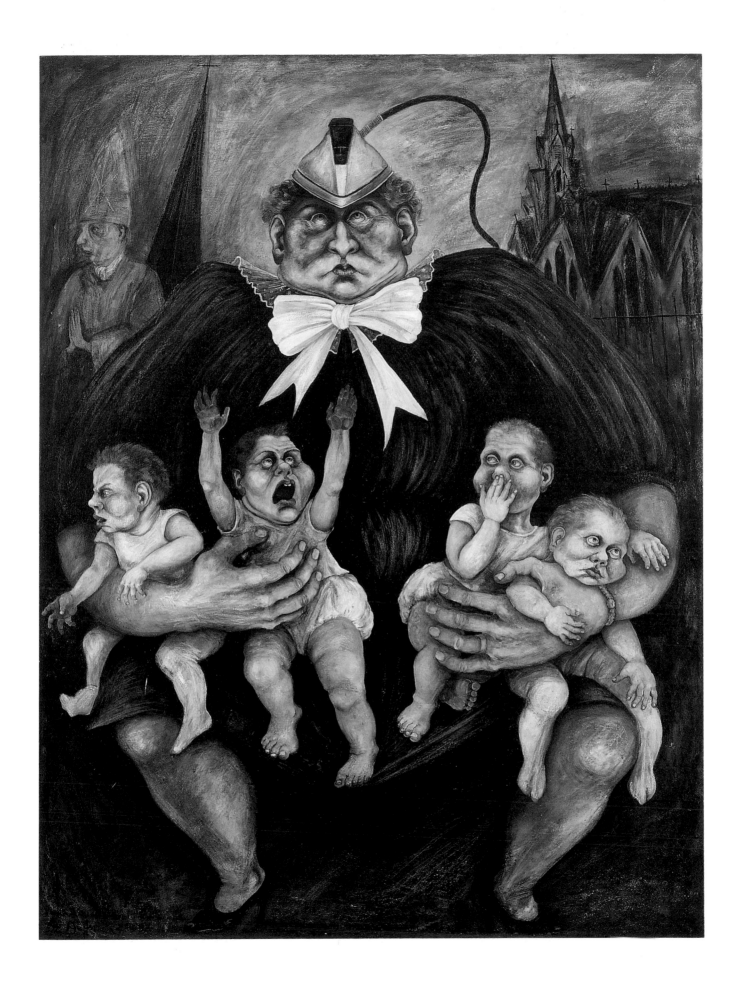

259

69 DAVID CRONE

Victim, Tourist and Model

1990
oil on canvas
80 × 96 in. (203 × 244 cm)
University of Ulster Permanent Works of Art Collection

David Crone draws on the artistic legacy of William Conor, James Humbert Craig, Colin Middleton, and other Belfast artists of previous generations with whom he shares an interest in landscape painting – a genre that Crone explored at the onset of his career. His subsequent exposure to the changing social, political, and environmental conditions in Ireland beginning in the late 1960s caused him to reassess his work and contributed to the evolution of his artistic style. In the mid-1970s, Crone's painting took on a more figurative aspect, although he remained disinclined to imbue it with an ostensible narrative, preferring the viewer to "feel" the meaning rather than read it more literally. Crone concentrated his efforts on scenes related to urban life characterized by paintings such as *Demolished Building* from 1979 (see Plate 58), paintings that examined the physical destruction occurring throughout Belfast during that period. His more recent work has remained within the rubric of urban subject matter, but is less concerned with the built environment and instead focuses more exclusively on the human condition. Crone's work loosely parallels the shift from the physical destruction of the 1970s to an emphasis on the social decay that took place in Belfast in the late 1980s and the sense of emotional fatigue that set in after years of the Troubles.

Victim, Tourist and Model began as a painting of a table covered with a paisley-patterned cloth and subsequently metamorphosed into a tour de force revealing Crone's visual interpretation of decadence and decay. It does not seem to be meant as a definitive socio-political commentary on the state of affairs in Belfast, but as an exploration into the power of paint to evoke thought and reveal human character. To emphasize the point, Crone has provided little detailed imagery, stating, "I don't think that painting should present vicarious experience for the viewer. I do not want to limit the viewer's experience to my own."[1] Even so, it is worth noting that much of Crone's painting from this period derived from the scenes of politically motivated violence he observed directly outside his studio window in central Belfast.

In *Victim, Tourist and Model* Crone has created a work of roughly life-sized proportions full of dynamic movement. The pell-mell action of figures walking, swaying, glancing, or falling creates a mesmerizing and enticing visual cadence. As a viewer, one is torn between entering into the fray or remaining safely outside its cacophonous interior, whose sense of unrest is created by the layering of paint and the use of line. The application of paint is reminiscent of the tension and ebb and flow created by American Abstract Expressionist artists such as Jackson Pollock and Mark Rothko, where the layering combines with color to initiate both a physical and mental state of motion. Crone has commented that the paint admits several layers of experience or perception.[2] He combines this with an understanding of line and an energy and propulsion that emanate from diagonals in the farthest recesses of the picture plane to produce a lively stage for the foreground figures. The lines creating the framework are subtly highlighted by light oranges and whites and contrast with the rich umber tones that provide the painting's foundation. Crone's technical ability allows him to engage the viewer on a variety of levels and to elucidate more fully a subtle and sophisticated sense of narrative.

1 *David Crone* (Belfast: The Fenderesky Gallery at Queen's, 1991), p. 3.
2 Taken from a conversation with the artist in February 1998.

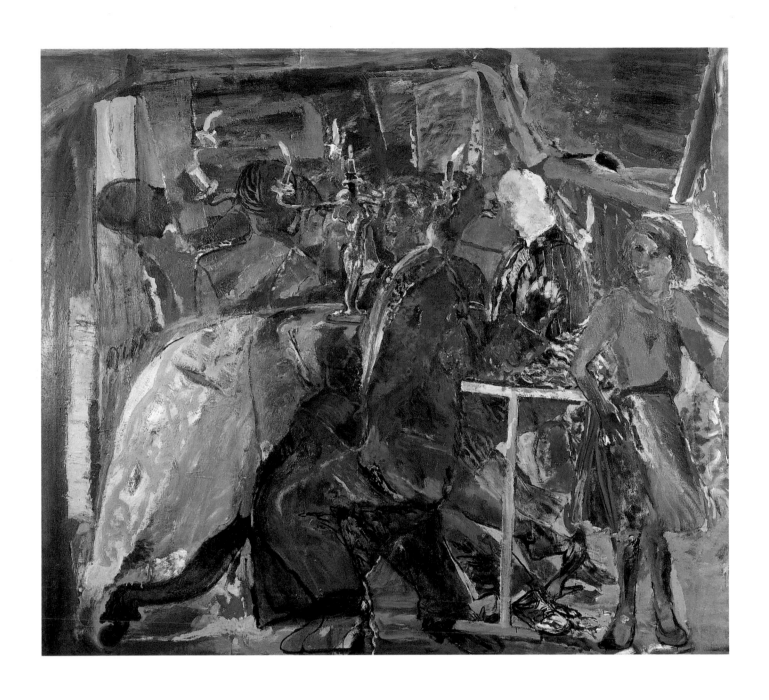

70 MICHAEL KANE (born 1935, Dublin)

A Vision Over Baggot Street (from the series *The Temptations of St. Anthony*)

1990–95
oil on canvas
101½ × 74 in. (257.8 × 187.9 cm)
Collection of the artist

As a poet and artist, Michael Kane has throughout his career used text and visual material to convey his views. Born in Dublin, he has been outspoken about the state of the arts in Ireland, in his native city in particular. In the course of his sometimes vitriolic attacks he has not endeared himself to members of the Irish art establishment, yet is firm in his convictions and has been an important advocate of Irish art and culture. Among his early contributions in this regard were the Project Arts Centre in Dublin, which he co-founded as an alternative art space in 1967, and *Structure*, an Irish art magazine focusing on art currents in Ireland and abroad, for which he was founder and editor in 1972 and which published quarterly for five years.

After studying art at the National School of Art in Dublin, Kane traveled extensively in Spain, France, and Italy, and lived for a few years in London, where he befriended the Irish painter Gerard Dillon (see Plates 45 and 50). His exposure to a variety of art throughout Europe convinced him of the need to energize the Irish art scene and led to his participation in the above-mentioned ventures.

Kane's work has a distinct graphic sensibility that is not surprising given his studies and employment at the Graphic Studio in Dublin in the early 1960s. After this indoctrination into illustration and printing techniques, Kane continued to make prints through the mid-1970s and worked on numerous illustrations for books and posters. He has drawn inspiration from German Expressionist printmakers such as Max Beckmann and Käthe Kollwitz, particularly influenced by their ability to convey human character and elicit emotive reactions through the printed medium. Kane's paintings reflect his background in illustration and are often made up of large patches of bold color calling to mind the contrast of solid impressions of black ink on white paper. His painting style and subject matter are often lyrical but direct, and mirror his work as a poet and activist.

A Vision over Baggott Street comes from the series of paintings Kane called *The Temptations of St. Anthony*, based on the life of the Irish writer and poet Anthony Cronin. In this painting the bespectacled protagonist gazes up into the sky while walking down Baggott Street, a major thoroughfare in central Dublin which in the 1950s was a favorite haunt for Cronin and his group of writer/beatnik friends. As Ulick O'Connor has described this group, "Between betting shops, the pub and absence of money, the life they led was poorly rewarded and unpredictable . . . One characteristic they did share in common with each other was that they were strollers. They used the town and the crowd as sustenance."[1] Instead of one of the everyday scenes of Dublin life, Kane depicts Cronin visited by a voluptuous naked female flying in the sky. Kane's tribute to his friend and colleague is perhaps a sacriligious one, equating Cronin with St. Anthony, a Christian saint and hermit who was subjected to vivid hallucinations resulting from his ascetic life in the desert. Kane's elevation of Cronin to that of a saint speaks metaphorically for Kane's high regard for Cronin. For St. Anthony, the two forms of temptation were attacks by demons and erotic visions; Cronin is the recipient of the latter but shows no signs of warding off the hovering temptress as St. Anthony did with a crucifix and prayer.

1 Ulick O'Connor in *Michael Kane: 'Where the Poet has been'*. (Dublin: Irish Museum of Modern Art, 1995), p. 5.

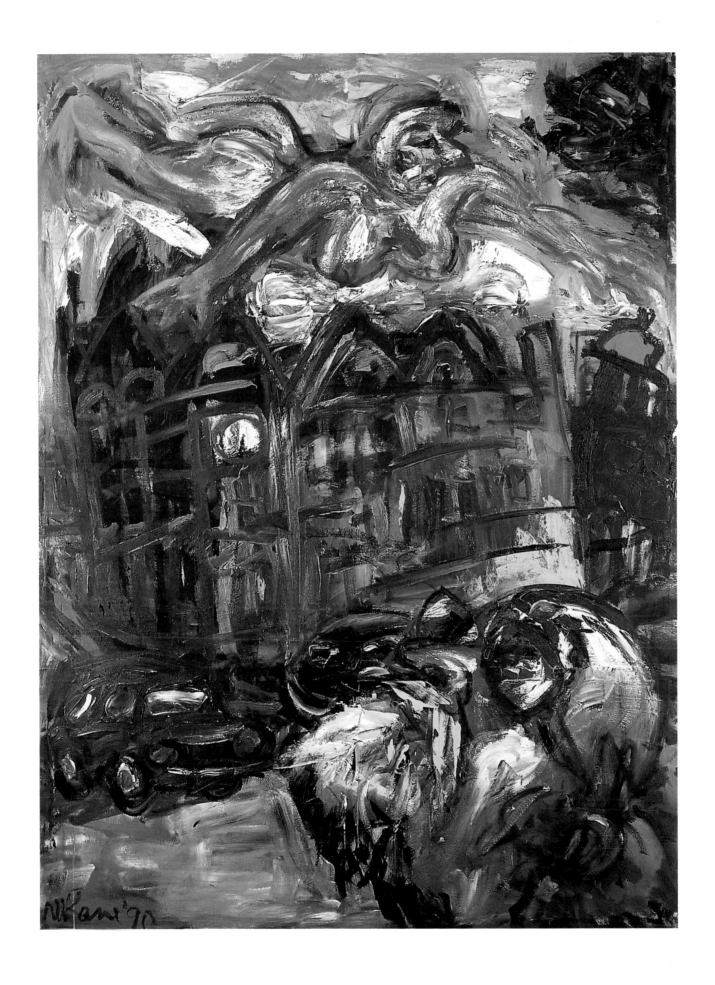

71 EITHNE JORDAN (born 1954, Dublin)

Figure in the Midday Sun

1992
oil on canvas
63 × 51 in. (160 × 130 cm)
Eithne Jordan, courtesy of the Rubicon Gallery

Eithne Jordan views her development as an artist as an innate progression: her mother was a painter, Eithne was encouraged by her parents to paint as a child, and she went on to receive her formal art education at Dun Laoghaire School of Art in Co. Dublin. Jordan's involvement in promoting the livelihood of artists in Ireland emerged in the 1980s when she and other artists founded the Visual Arts Centre in Dublin, a group studio/work space funded by the Arts Council of Ireland. She was awarded a Deutscher Akademischer Austauschdienst (DAAD) scholarship to study in Berlin, which turned into an extended stay from 1984 to 1987. The lure of the myriad artistic experiences available on the Continent and a need to distance herself from Ireland has led Jordan to divide her time between Dublin and the Languedoc region in the south of France.

At the outset of her artistic career Eithne Jordan did primarily abstract work, turning to the figurative only in the 1980s. She is particularly concerned with the female body, integrating myths and literary references with traditional subjects such as the theme of the mother and child. She injects a new perspective, at times drawn from her personal experience, at others shaped by her handling of the composition or use of color. In the case of mother-and-child imagery, she paints from a vantage point that, as a mother and female artist, allows her to conceive her subject from the inside out rather than as an outsider attempting to work her way in. Her perception of this particular subject and her rationale for choosing it are in stark contrast to earlier depictions of the same theme also included in the present exhibition: Mainie Jellet's *Virgin and Child* (see Plate 38), although also painted by a woman, has more to do with Catholicism than with actual maternity; Maurice MacGonigal's *Mother and Child* (see Plate 39), while ennobling the mother figure, stands as a testament to Irish Free State propaganda.

While her experience as a mother has influenced her choice of subject matter, Jordan's time in Berlin has affected her palette and manner of expression. Observing that colors were sober and bleak and the people in the street bordered on the grotesque, Jordan's exposure to the atmosphere in Berlin prevailing in the mid-1980s, before the removal of the Wall, profoundly influenced her work at the time, focused on the head, which Jordan felt was the most immediate site of human expression. Her more recent move from Germany to France has, not surprisingly, led to a palette loaded with lighter colors and an interest in full figuration.

Of her recent work Jordan has commented, "I like to work into wet paint. I like to wipe things away and let images underneath emerge. I like to mix my colours on the canvas. . . ."[1] *Figure in the Midday Sun* reflects this sentiment completely, with a richness of paint, repeated brushstrokes, and a layering of painted planes. A deep resonance emanates from the work due to the application of broad, expressive brushstrokes – strokes made with a fully loaded brush. The figure appears to be moving within the picture plane while the rays of the sun both penetrate and radiate. The earth tones and darker colors tie the figure to the landscape. *Figure in the Midday Sun* is one of a group of paintings done in the south of France showing a single figure silhouetted against a dramatic sky. Jordan has said her work from this period was influenced by the nineteenth-century French artist Eugène Delacroix, specifically his use of color and sense of drama and excess. At the same time, the bright yellows and oranges are evocative of the work of Vincent Van Gogh, who painted in the nearby town of Arles and who has come to define Provençal color for a global audience. All of Jordan's painting is done in the studio from images, such as the one in this painting, drawn from her perceptions and recollections of the landscape while on walks. Jordan has captured the brightness and clarity of southern France while combining it with an underlying basis in the land that sublimely draws its source from her life in Ireland.

1 From Eithne Jordan in conversation with Mairead Byrne in *Eithne Jordan* (Dublin: Gandon Editions, 1994), p. 17.

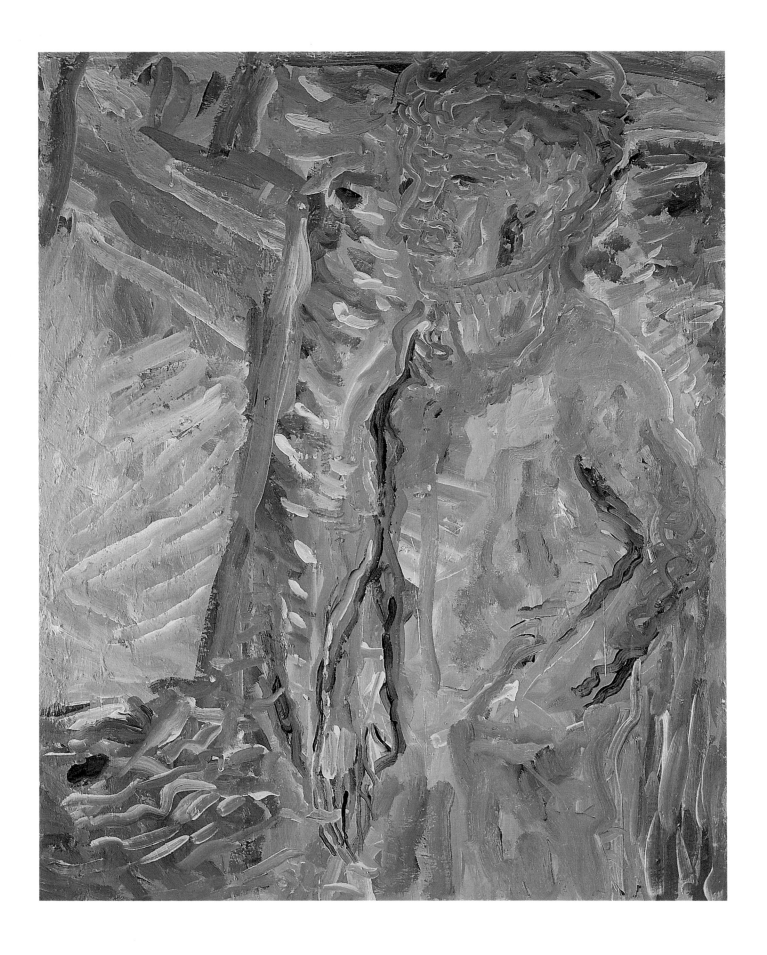

72 ALICE MAHER (born 1956, Cahir, Co. Tipperary)

Irish Dancers

1992
oil on paper
diptych, each panel 11½ × 7¾ in. (29 × 19.5 cm)
Crawford Municipal Art Gallery, Cork (Ireland)

Alice Maher is a Dublin-based artist whose work often deals with gender issues, exposing what she views as the dogma and oppression present in traditional beliefs. Her bold refutations often confront large audiences, as evident by an installation from 1988 in which Maher painted four scenes representing the Visitation, Birth, Annunciation and Coronation – events that center on the life of the Virgin – on old bedsheets, questioning the purity of Catholicism and its teachings while playing on the role of maternal figures in Irish society.

Irish dancing, as it is known today, has played a vital role in Irish cultural history since the eighteenth century, and has undergone several revivals, most recently in the 1990s as evident by the popularity of *Riverdance* and Michael Flatley's *Lord of the Dance*, which employ adaptations of traditional Irish step dancing. Beginning in the early years of the twentieth century, Irish dancing was viewed as a vital part of Irish culture and an important inheritance from the Celtic past, particularly in rural areas, as evident in Charles Lamb's *Dancing at a Northern Crossroads* (see Plate 23). The colorful costumes featured ancient and modern Celtic designs whose interlocking and continuous lines in the patterns symbolized the continuity of life and the concept of eternity. Maher's *Irish Dancers* is a contemporary reference to this tradition, a kind of static counterpart to an installation from 1989 entitled *TRYST* (fig. 83), in which four large tents with figures painted on the exteriors were suspended from the ceiling. Viewers were invited to step inside the intimate tents that functioned as trysts or meeting places, evocative of the cloistered world of childhood and adolescent intimacies. The exterior surfaces, with their images of dancing figures, swirled, setting the figures in motion.

Maher has observed that "Sometimes the 'Irish' costume that I wear doesn't fit me too well; either it's too big for me or I'm too big for it. I learned Irish dance as a child. I love dancing, but I don't love wearing stiff artificial garments as a badge of my Irishness."[1] Indeed, the painting on the left shows a girl or young woman inside an oversized dress, her eyes barely visible over the neckline. She is overwhelmed by the dress, which at the same time conveys a sense of safety within its massive confines. Like a child pretending she is invisible to the rest of the world, or a girl wearing her mother's clothing, she is secure, protected. By contrast, the flanking dancer seems perturbed and uncomfortable. She appears to thrash about, her hand clenched in a fist, her legs flailing, and her head twisted with a tense facial expression. The artificiality of the dress and its constricting fabric are too much for her to handle as she tries to set herself free. The anger exhibited by her body language is echoed in Maher's palette of taciturn tones of violet and ochre that contrasts with the sublime yellow and gold tones used for the other figure. Together, the two halves of *Irish Dancers* suggest the nurturing and confining characteristics of Irish culture and the Irish past, particularly for its young women.

Fig. 83. Alice Maher, *TRYST* (detail: "The Dancers"), 1989, mixed media on linen. 141¾ × 59 in. (360 × 150 cm), Courtesy of the artist/Green on Red Gallery

1 Taken from a conversation between Maher and Cécile Bourne in *Familiar: Alice Maher, New Works* (Dublin: The Douglas Hyde Gallery; Derry: The Orchard Gallery, 1995), p. 27.

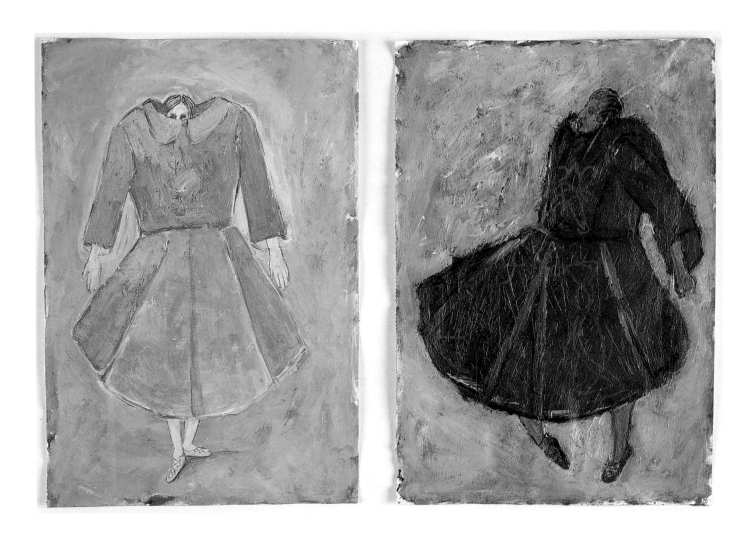

73 NICK MILLER (born 1962, London)

Patrick Hall

1994
oil on linen
34 × 34 in. (86 × 86 cm)
Irish Museum of Modern Art

Primarily self-taught as an artist, Nick Miller began painting as a teenager and relied on his instinct and exposure to work by artists such as Rembrandt and Van Gogh for inspiration. In this respect Miller differs from the conventional tradition of portrait painting in Ireland, lacking the academic training established at the National School of Art by William Orpen and continued by Seán Keating and Leo Whelan. Miller's painting reflects the continued vitality of Irish portrait painting that owes much to the work of Edward McGuire and Christopher Campbell in the 1950s in its ability to capture effectively the personality of the sitter. Far removed from the stylized or allegorical depictions of the 1920s and 30s, Miller concerns himself almost exclusively with the underlying psychological characteristics of the sitter. This inquiry into the temperament of the sitter is akin to the work of Austrian artist Oskar Kokoschka (1886–1980), who, in his early portraits, used gesture and miming to intensify the psychological penetration of

character, and of the British artist Lucian Freud. Freud, in particular, paints the raw physical characteristics and the inner tensions of his subjects that are also evident in Miller's work.

Miller's painting here depicts fellow artist Patrick Hall, who, like Miller, lives in the rural West of Ireland. Hall is shown in three-quarter profile wearing a shirt and simple blue jacket; his hands, a common outlet for expression in portraiture, are not visible. The muted grey background and the subdued coloration in Hall's figure place emphasis on the facial features; Miller has channeled all expression to the face, displaying a pensive, introspective countenance and averting the gaze of the artist/viewer. Hall's taut lips and penetrating stare provide insight into his temperament, one that is manifested in his own work as a painter, characterized by strong tension and direct messages.

Just as Miller represents the strength of portrait painting in contemporary Ireland, the *Portrait of Patrick Hall* is a stage in the development of Miller's own artistic career. Miller continues to explore figuration and the relationship of artist to model that serves as a prelude to the interaction of viewer and painting. His intent is to engage the viewer with the sitter on a deeper psychological level. This has led to numerous nude portraits that literally expose the sitter and in the process not only unveil the corporeal, but lay bare the spirit and personality. Miller has challenged traditional notions of nude portraiture by moving closer to his subject and creating images that place the viewer face to face with the sitter. The proximity, nudity, and overt emotional visage of these portraits confront the viewer in a way that is both captivating and disturbing (see fig. 84). Much as the work of Keating and Maurice MacGonigal echoed the prevailing social and cultural conditions of the 1920s and 30s, Miller's work perpetuates that tradition by conveying a sense of Ireland in the 1990s through a style that merges Irish painting with international precedents.

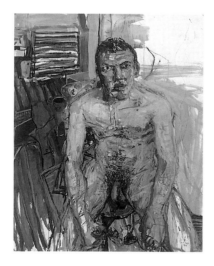

Fig. 84. Nick Miller, *P.P. on Blue Stool*, 1996, watercolor on paper, 60 × 48 in. (152.4 × 121.9 cm), Courtesy of the Rubicon Gallery, Dublin

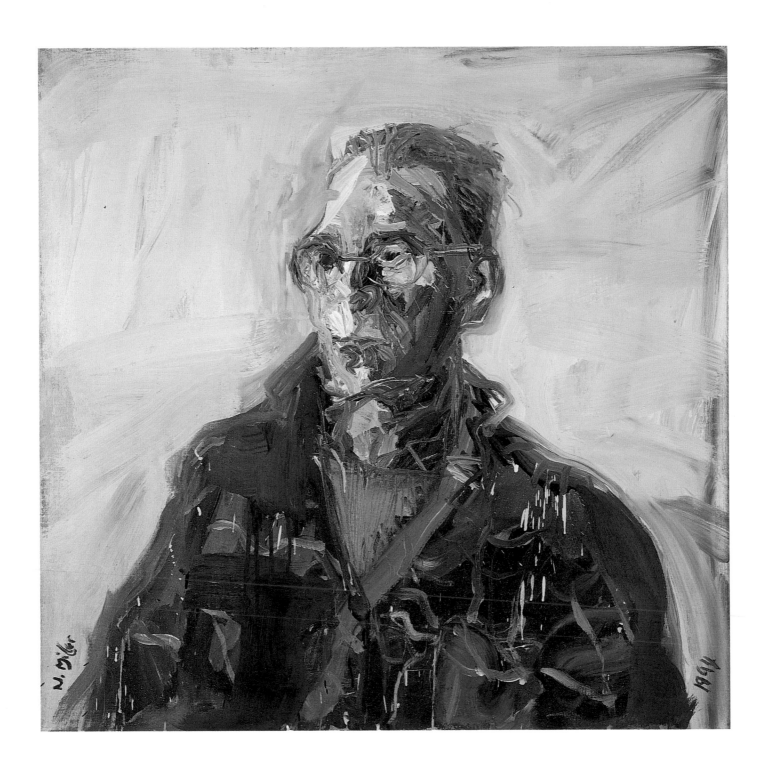

269

74 HUGHIE O'DONOGHUE (born 1953, Manchester, England)

Crucifixion Study II

1993–96
oil on canvas
109⅞ × 97⅝ in. (279 × 248 cm)
Private collection

Hughie O'Donoghue was born and educated in England, but his parents were both Irish and his memories of time spent in the West of Ireland as a child have left him with strong cultural connections to the Irish past.[1] He has recently has moved from the urban setting of London, where he spent some twenty fruitful and important years, to the more contemplative space offered in Co. Kilkenny in the south of Ireland. After his graduation from Goldsmiths College at the University of London, O'Donoghue was selected as artist-in-residence at the National Gallery, London, in 1984. This gave him practically unlimited access to a spectacularly wide and diverse range of paintings, which stimulated his interest in Rembrandt, Titian, Poussin, and El Greco. O'Donoghue's exposure to and appreciation of the work of the Old Masters continued when he went to live and work in Italy for several months in 1986. There, he gained an appreciation of Renaissance art from the fourteenth, fifteenth, and sixteenth centuries, which, combined with his informal education at the National Gallery in London, has had a lasting influence. As he commented in an interview, "One cannot work during the latter part of the 20th century and be unaware of its history, so in my work there are references to the conventions of paintings that have gone before; there is also concern with surface, with texture, and the way the images emerge from the actual painted surface."[2] As well as reacting to Old Master painting, O'Donoghue is responsive to the work of twentieth-century artists whose paintings contain a degree of psychological complexity, including Francis Bacon and Mark Rothko.

Early in his career O'Donoghue was attracted to abstraction, but found it limiting in its ability to communicate meaning. This sense of restriction caused him to seek a new outlet for expression and led to his experimentation with figurative painting, although he did not renounce abstract painting completely, retaining components of it that he felt were useful, such as the large canvas size and use of strong color. By merging these elements with the techniques employed in figurative painting, O'Donoghue developed a unique method of painting, one characterized by building up the canvas through the successive application and removal of layers of paint – a process that involves a literal return to the past. O'Donoghue's work functions as a palimpsest not only in its technical fabrication but in the story it tells of the history of painting. Often only a fragment of a body remains, presented as an artifact such as a religious reliquary that is resonant with meaning.

Crucifixion Study II was done as part of O'Donoghue's cycle of paintings related to the Passion of Christ, a cycle that looks back to Italian Renaissance religious art and calls to mind famous crucifixion scenes by Duccio, Giotto, and Masaccio, works in which iconography and technical skill are deftly fused by the artist to create simple yet compelling narratives. In this particular body of work, O'Donoghue sought to imbue the paintings with a seriousness that would strengthen the impact of the subject and focus attention on the labor involved in the painting – he is often preoccupied with the surface of the painting and the complexity of his process. *Crucifixion*, like the other paintings in the series, has undergone numerous transformations to arrive at its present state. O'Donoghue has applied and removed multiple layers of paint, ultimately achieving a densely painted image inscribed by repeated scoring and sanding. The body's seeming emergence from the ground strongly associates it with the earth, while the deep browns and umber tones evoke comparisons with colors found in nocturnal scenes by Rembrandt and Titian.

1 Sanda Miller, "Hughie O'Donoghue: An Interview," *Irish Arts Review* 2, no. 2 (Summer 1985), p. 17. "My cultural background is totally Irish. Both my parents were Irish, my mother is dead but my father still lives in Ireland. As a child I used to go every year to the West of Ireland, to Mayo, which has the particular type of landscape I seem to respond to."
2 Miller, p. 16.

75 JAMES HANLEY (born 1965, Dublin)

Weight of His Story

1997
oil on canvas
diptych, each panel 74 × 48 in. (188 × 122 cm)
Courtesy of Hallward Gallery, Dublin

In the opening scene of Federico Fellini's film *La Dolce Vita*, a statue of Christ hangs beneath a helicopter flying over the city of Rome. It is a bizarre and extraordinary event, and proves to be a brilliant introduction that hints at hidden realities and sets the stage for the remainder of the film. James Hanley is not a filmmaker as such, but he achieves through his painting a similar result, capturing the viewer's attention with unusual, sometimes grotesque imagery painted with photographic precision that evolves into a narrative revealing a life less than sweet. *Weight of His Story* exemplifies Hanley's approach to painting fraught with psychological tension, toughness, and painterly skill. As in all of Hanley's work to date, the figure functions as a character actor playing out a role. One is both drawn to and repulsed by the sight of Hanley's central characters such as this, and ultimately resigned to the fact that his characters reflect who we are.

Hanley was born in Dublin and is the youngest of the artists included in the present exhibition. Educated at University College Dublin and the National College of Art and Design, Hanley developed a sound understanding and appreciation of art history prior to his entry into art school that has proven inspirational and given him great versatility in subject matter and technique. In the six years since his first one-person exhibition in 1992, Hanley's style of painting has evolved from loose compositions which, in their layering of images, resembled collage, to the precise, photo-realistic painting that characterizes his recent work. He prefers to work directly from study photographs rather than live models and by doing so is able to invest more time in his painting. Hanley's work primarily concerns the lives of men; while ostensibly presented as homages to virility, they paradoxically mock and play on the fears and insecurities underlying the male persona. For Hanley, the male figure is a vehicle for telling the story of humankind – it is not "his" story, but everyone's history against the backdrop of a society in which religion is dominant.

Weight of His Story is a diptych from Hanley's most recent exhibition entitled *Grand Tourists*, referring to the rite of cultural passage for young, wealthy eighteenth-century British gentlemen who travelled to continental Europe with a tutor to complete their education by visiting the great cities and sites, and returned laden with artistic treasures. Hanley has redefined that historical image to describe the contemporary tourist who descends upon cities with little regard for culture and more interest in snatching up kitschy souvenirs. In one panel of the diptych a man swings precariously in outer space clutching the vestiges of his worldly possessions, perhaps keepsakes from Rome. The vacancy in his countenance is echoed by the void left by his missing leg. His malformity and drunken, stuporous gaze represent the antithesis of the eighteenth-century gentleman dandy, but suggests their participation in decadent behavior. He swings over the world in stoic religious piety recalling the statue of Christ hovering over the city of Rome in *La Dolce Vita*. Like the statue, the swinging man's fate is controlled by someone else – in this instance evidently the sinister looking man sitting hunched atop a cross shown in the adjacent panel. Hanley suggests by his title that this figure represents a Christ who is no longer able to bear the burden of man and has severed the rope that now hangs slack over his shoulders, no longer taut with the pressure exerted by man. Hanley distorts the figure atop the cross through dramatic lighting from below, casting shadows that borrow from the sixteenth-century Italian artist Caravaggio. The strange mask resting on the figure's head has been pulled back to reveal an unexpected reality – an impostor posing as Christ. Hanley's choice of a religious theme, presented in a sacrilegious vein, seems to point to a developing trend in contemporary Irish painting in which younger artists make direct references to established beliefs in an effort to deconstruct one of the barriers contributing to the continued unrest in Ireland.

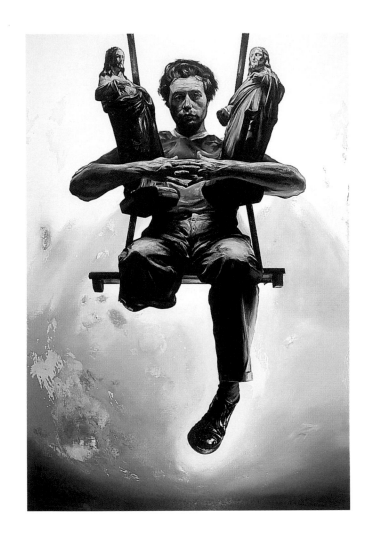

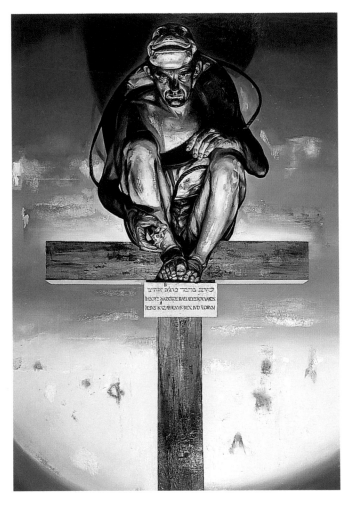

Artists' Biographies

COMPILED BY

JOHN LOSITO

JOHN TAIN

ROBERT BALLAGH
Born in Dublin, 1943
Lives and works in Dublin

EDUCTION
Bolton Street College of
Technology, Dublin

SELECTED INDIVIDUAL EXHIBITIONS
1969 Brown Thomas Gallery,
Dublin
1971 David Hendriks Gallery,
Dublin (also 1972, 1974) Cork
Arts Society Gallery, Cork
1974 Aktions Galerie, Berne
1983 Lunds Kunsthalle, Sweden
1992 Arnott's Henry St., Dublin

SELECTED GROUP EXHIBITIONS
1967 Irish Exhibition of Living
Art (through 1973)
1969 Paris Biennale
1971 The Irish Imagination 1959–
1971, Municipal Gallery of
Modern Art, Dublin
1985 Divisions Crossroads, Turns of
Mind: Some New Irish Art,
Williams College Museum of
Art, Williamstown,
Massachusetts
1990 Irish Art: The European
Dimension, RHA Gallagher
Gallery, Dublin
1991 In a State, Kilmainham Jail,
Dublin

SELECTED BIBLIOGRAPHY
Ballagh, Robert. Dublin. Dublin:
Ward River Press, 1981.
Carty, Ciaran. Robert Ballagh.
Dublin: Magill, 1986.
Kennedy, Maev. "Robert Ballagh."
The Irish Times, July 30, 1977,
p. 12.
Marshall, Catherine. "Choosing
the Battleground: Robert
Ballagh's Paintings." Irish Arts
Review, 12 (1996), pp. 147–55.

BASIL BLACKSHAW
Born in Glengormley, Co. Antrim,
1932
Lives and works in Co. Antrim

EDUCATION
Belfast College of Art, Belfast,
1948–51
CEMA Travel Scholarship, Paris,
1951

SELECTED INDIVIDUAL EXHIBITIONS
1956 CEMA Gallery, Belfast (also
1961)
1973 Tom Caldwell Gallery, Belfast
(also 1977, 1981, 1985, 1992)
1987 David Hendriks Gallery,
Dublin
1990 Kerlin Gallery, Dublin
1994 One Oxford Street, Belfast
1996 Basil Blackshaw – Painter,
Ormeau Baths Gallery, Belfast;
RHA Gallagher Gallery, Dublin;
Crawford Municipal Art Gallery,
Cork; and San Jose Museum of
Art, San Jose, California

SELECTED GROUP EXHIBITIONS
1952 Donegall Place Gallery,
Belfast
1958 Irish Exhibition of Living
Art (also 1959, 1960–61, 1975)
1960 Ritchie Hendriks Gallery,
Dublin (also 1965)
1971 The Irish Imagination
1959–1971, Municipal Gallery of
Modern Art, Dublin
1980 The Delighted Eye: Irish
Painting and Sculpture of the
Seventies, London
Irish Art, 1943–1973, ROSC, Cork
1990 Living Landscape, West Cork
Arts Centre

SELECTED BIBLIOGRAPHY
Basil Blackshaw – Painter. Belfast:
Nicholson & Bass Ltd., 1995.

BRIAN BOURKE
Born in Dublin, 1936
Lives and works in Co. Galway

EDUCATION
National College of Art, Dublin
St. Martin's School of Arts, London
Goldsmith's School of Art, London

SELECTED INDIVIDUAL EXHIBITIONS
1965 Dawson Gallery, Dublin (also
1967, 1969, 1971, 1975)
1978 Taylor Galleries, Dublin (also
1981, 1983, 1985, 1991, 1993,
1995, 1997)
1988 Brian Bourke: Twenty-Five
Years, Galway, Arts Festival
1992 Polyptych, Galway Arts
Centre, Galway
1996 Sweeney Amhann Macha,
Armagh

SELECTED GROUP EXHIBITIONS
1965 Paris Biennale
1971 The Irish Imagination
1959–1971, Municipal Gallery of
Modern Art, Dublin
1980 The Delighted Eye: Irish
Painting and Sculpture of the
Seventies, London
Hibernian Inscape, Douglas Hyde
Gallery, Dublin; Wexford Arts
Centre, Wexford; Crawford
Gallery, Cork; Orchard Gallery,
Derry; and Arts Council of
Northern Ireland Gallery, Belfast
1983 Making Sense – Ten Artists,
1963–1983, Project Arts Centre,
Dublin
1987 Images of Sweeney, Royal
Hospital, Kilmainham, Dublin
1991 Parable Island, Bluecoat
Gallery, Liverpool, England
1993 Six Artists at the Model
School, Model Arts Centre, Sligo

SELECTED BIBLIOGRAPHY
Andalucian Fireworks: Paintings by
Brian Bourke. Dublin: Taylor
Galleries, 1997.
Brian Bourke. Galway, Ireland:
Galway Arts Festival Ltd., 1988.
Brian Bourke: A Catalogue of his
Work. Curragh, Ireland: The
Goldsmith Press Ltd., 1982.
Campbell, Julian. "The Paintings
of Brian Bourke." Irish Arts
Review, 6 (1989–90), pp.
100–106.

CHRISTOPHER CAMPBELL
Born in Dublin, 1908
Died in Dublin, 1972

EDUCATION
Metropolitan School of Art, Dublin

SELECTED INDIVIDUAL EXHIBITIONS
1976 Neptune Gallery, Dublin

SELECTED GROUP EXHIBITIONS
1927 Royal Hibernian Academy
1941 Academy of Christian Art,
Dublin
1944 Munster Fine Art Club
1995 Gorry Gallery, Dublin

SELECTED BIBLIOGRAPHY

Arnold, Bruce. *Christopher Campbell 1908–1972*. Dublin: Neptune Gallery, 1977.

"Christopher Campbell." *The Capuchin Annual* (1956–57), p. 435.

PATRICK COLLINS

Born in Dromore West, Co. Sligo, 1911
Died in Dublin, 1994

EDUCATION
No formal institutional education

SELECTED INDIVIDUAL EXHIBITIONS

1956 Ritchie Hendriks Gallery, Dublin (also 1959, 1961, 1963–65, 1967–68)
1975 Tom Caldwell Gallery, Dublin (also 1976, 1978–79)
1982 Retrospective, Douglas Hyde Gallery, Dublin

SELECTED GROUP EXHIBITIONS

1950 Contemporary Irish Painting, North American Tour
1958 Guggenheim Award Exhibition, New York
1963 *Twelve Irish Painters*, New York
1971 *The Irish Imagination, 1959–1971*, Municipal Gallery of Modern Art, Dublin
1976 *Irish Art 1900–1950*, Crawford Municipal Gallery, Cork
1980 *The Delighted Eye: Irish Painting and Sculpture of the Seventies*, London

SELECTED BIBLIOGRAPHY

Campbell, Julian. "Patrick Collins and 'The Sense of Place'." *Irish Arts Review*, 4, No. 3 (Autumn 1987), pp. 48–52.

Cooke, Harriet. "Harriet Cooke Talks to Patrick Collins." *The Irish Times*, Jan. 10, 1973, p. 8.

Ruane, Frances. *Patrick Collins*. Dublin: An Chomhairle Ealaíon/The Arts Council, 1982.

Pyle, Fergus. "Patrick Collins." *The Irish Times*, June 28, 1972, p. 12.

JAMES HUMBERT CRAIG

Born in Belfast, 1877
Died in Cushendun, Co. Antrim, 1944

EDUCATION
No formal institutional education

SELECTED INDIVIDUAL EXHIBITIONS

1944 Municipal Technical College, Londonderry
1945 Belfast Museum and Art Gallery
1946 Combridge Galleries, Dublin
1978 *James Humbert Craig, RHA*, Oriel Gallery, Dublin

SELECTED GROUP EXHIBITIONS

1915 Royal Hibernian Academy
1928 Royal Scottish Academy
1930 Musées Royaux des Beaux-Arts de Belgique, Brussels
1940 *Twelve Irish Artists*, Waddington Gallery, London

SELECTED BIBLIOGRAPHY

Connell, George A. *James Humbert Craig, RHA (1877–1944)*. Belfast, 1988.

James Humbert Craig, RHA. Dublin: Oriel Gallery, 1978.

DAVID CRONE

Born in Belfast, 1937
Lives and works in Belfast

EDUCATION
Belfast College of Art

SELECTED INDIVIDUAL EXHIBITIONS

1965 Arts Council Gallery, Belfast (also 1968, 1973, 1980)
1980 Tom Caldwell Gallery, Dublin (also 1981, 1982)
1987 Fenderesky Gallery, Belfast (also 1989, 1991)
1990 Kerlin Gallery, Dublin (also 1993, 1996)
1992 Merkmal Gallery, Liverpool
1995 Ormeau Baths Gallery, Belfast

SELECTED GROUP EXHIBITIONS

1963 Irish Exhibition of Living Art
1980 *Hibernian Inscape*, Douglas Hyde Gallery, Dublin; Wexford Arts Centre, Wexford; Crawford Gallery, Cork; Orchard Gallery, Derry; and Arts Council of Northern Ireland Gallery, Belfast
1985 *Divisions Crossroads, Turns of Mind: Some New Irish Art*, Williams College Museum of Art, Williamstown, Massachusetts
1988 *GPA Exhibition of Ulster Art in the 80s*, RHA Gallagher Gallery, Dublin
1991 *Parable Island*, Bluecoat Gallery, Liverpool, England
The Fifth Province – Some New Art from Ireland, Edmonton Art Gallery, Canada
1996 *Art Beyond Conflict*, Crescent Arts Centre, Belfast

SELECTED BIBLIOGRAPHY

David Crone. Belfast: The Fenderesky Gallery, 1991.

David Crone. Belfast: Arts Council of Northern Ireland, 1984.

GERARD DILLON

Born in Belfast, 1916
Died in Dublin, 1971

EDUCATION
No formal institutional education

SELECTED INDIVIDUAL EXHIBITIONS

1946 The Arts Council of Northern Ireland, Belfast (also 1966)
1957 Dawson Gallery, Dublin (also 1958–60, 1962–63, 1965–69, 1971)
1958 The Queen's University Gallery, Belfast
1972 *Gerard Dillon, Retrospective Exhibition, 1916–1971*, Ulster Museum, Belfast; Municipal Gallery of Modern Art, Dublin

SELECTED GROUP EXHIBITIONS

1943 Irish Exhibition of Living Art (also 1944, 1946–53, 1955–71)
Royal Hibernian Academy
1950 *New Irish Painters*, Institute of Contemporary Art, Boston
1958 *Guggenheim International Exhibition*, New York
1965 Municipal Gallery of Modern Art, Dublin
1971 *The Irish Imagination 1959–1971*, Municipal Gallery of Modern Art, Dublin
1984 *A Century of Connemara*, Galway, Arts Festival

SELECTED BIBLIOGRAPHY

Dillon, Gerard. "The Artist Speaks." *Envoy*, 4, No. 15 (Feb. 1951), pp. 38–44.

White, James. *Gerard Dillon: An Illustrated Biography*. Dublin: Wolfhound Press, 1994.

RITA DUFFY

Born in Belfast, 1959
Lives and works in Belfast

EDUCATION
Foundation Studies, Ulster Polytechnic, 1978–79
Art and Design Centre, Belfast, 1979–82
University of Ulster, Belfast, M.F.A., 1985–86

SELECTED INDIVIDUAL EXHIBITIONS

1983 Queen's University, Belfast
1989 Arts Council Gallery, Belfast
1990 Projects Arts Centre, Dublin
1995 *Palimpsest*, Triskel Arts Centre, Cork; The City Arts Council, Limerick; and The Model Arts Centre, Sligo
1996 *Crossing Boundaries: Contemporary Art from Belfast*, San Francisco State University, California
1997 *Banquet*, Ormeau Baths Gallery, Belfast; Hugh Lane Municipal Gallery of Modern Art, Dublin

SELECTED GROUP EXHIBITIONS

1985 *Women on Women*, Fenderesky Gallery; Belfast Royal Ulster Academy; and Ulster Museum, Belfast
1991 *In a State*, Kilmainham Gaol, Dublin
1991 *The Fifth Province: Some Contemporary Art from Ireland*, Edmonton Art Gallery, Canada
1995 *Poetic Land–Political Territory*, City Library and Arts Centre, Sunderland, England
1996 *Art Beyond Conflict*, Crescent Arts Centre, Belfast
1997 *Cruelty*, Fenderesky Gallery, Belfast
Re/Dressing Cathleen: Contemporary Works from Irish Women Artists, McMullen Museum of Art, Boston College, Chestnut Hill, Massachusetts

SELECTED BIBLIOGRAPHY

Chadwick, Whitney, and Hilary Robinson. *Crossing Boundaries: Belfast/Contemporary Art from Northern Ireland.* San Francisco, CA: San Francisco State Univ., 1996.

Ferran, Denise. "Rita Duffy – Mid-Term Report." *Irish Arts Review,* 14 (1998), pp. 151–61.

Rita Duffy. Belfast: Arts Council Gallery, 1989.

Rita Duffy: Banquet. Belfast: The Ormeau Baths Gallery, 1997.

Rita Duffy: Palimpsest. Derry, Northern Ireland: The Orchard Gallery, 1995.

BEATRICE MOSS ELVERY (LADY GLENAVY)
Born in Dublin, 1881
Died in Dublin, 1970

EDUCATION
Metropolitan School of Art, Dublin, 1896–1903
Slade School of Fine Art, London, 1910

SELECTED INDIVIDUAL EXHIBITIONS
1935 Dublin Painters Society Gallery, St. Stephen's Green, Dublin
1955 Waddington Galleries, Dublin

SELECTED GROUP EXHIBITIONS
1902 Royal Hibernian Academy
1904 Arts and Crafts Society of Ireland, Dublin
1910 Metropolitan School of Art, Dublin
1933 Royal Academy, London
1948 Royal Scottish Academy
1957 Ritchie Hendriks Gallery, Dublin

SELECTED BIBLIOGRAPHY
Glenavy, Beatrice Lady. *'Today We will only Gossip.'* London: Constable, 1964.
Gordon Bowe, Nicola. "The Art of Beatrice Elvery, Lady Glenavy (1883–1970)." *Irish Arts Review,* 11 (1995), pp. 169–75.
Kay, Dorothy. *The Elvery Family: A Memory.* Cape Town· Carrefour Press, 1991.

MICHEAL FARRELL
Born in Kells, Co. Meath, 1940
Lives and works in France

EDUCATION
St. Martin's School of Art, London, Colchester College of Art, England

SELECTED INDIVIDUAL EXHIBITIONS
1966 The Dawson Gallery, Dublin (also 1968, 1970, 1973)
1973 Galerie du Luxembourg, Paris
1979 *Michael Farrell 1953–1978,* The Douglas Hyde Gallery, Dublin
1982 Armidale Regional Art Gallery, New South Wales, Australia
1988 Galerie Ouverte, Paris
1990 Robin Gibson Gallery, Sydney, Australia
1991 Orchard Gallery, Derry

SELECTED GROUP EXHIBITIONS
1965 World's Fair, New York
Salon de la Jeune Peinture, Paris
1967 Biennale des Jeunes, Paris
1968 Kunsthalle, Dusseldorf
1971 *The Irish Imagination 1959–1971,* Municipal Gallery of Modern Art, Dublin
1980 *Irish Art 1941–1973,* ROSC, Cork
1990 *Images of Ireland,* Brussels

SELECTED BIBLIOGRAPHY
Kennedy, Maev. "Micheal Farrell." *The Irish Times,* Aug. 27, 1977, p. 12.
Micheal Farrell. Dublin, Ireland: Douglas Hyde Gallery, 1979.

PATRICK GRAHAM
Born in Mullingar, Co. Westmeath, Ireland, 1943
Lives and works in Dublin

EDUCATION
National College of Art, Dublin, 1960–64

SELECTED INDIVIDUAL EXHIBITIONS
1974 The Emmet Gallery, Dublin (also 1976, 1978)
1987 Jack Rutberg Fine Arts, Los Angeles (also 1989, 1990, 1991, 1993, 1997)
1994 *Patrick Graham: The Lark in the Morning,* Douglas Hyde Gallery, Dublin; Crawford Municipal Art Gallery, Cork
1996 *Somewhere Jerusalem,* The Green on Red Gallery, Dublin
1998 *Patrick Graham: Continuum,* Fresno Art Museum, Fresno, California

SELECTED GROUP EXHIBITIONS
1966 *1916–1966: Commemorative Exhibition,* Municipal Gallery of Modern Art, Dublin
1978 *Independent Artists,* Municipal Gallery of Modern Art, Dublin (also 1980)
1983 *Making Sense – Ten Artists, 1963–1983,* Project Arts Centre, Dublin
1986 *Four Irish Expressionists,* Northeastern University Gallery and Boston College Gallery, Boston, Massachusetts
1990 *Irish Art – The European Dimension,* RHA Gallagher Gallery, Dublin
1991 *In a State,* Kilmainham Gaol, Dublin

SELECTED BIBLIOGRAPHY
Hutchinson, John. "Interview with Patrick Graham." *Irish Arts Review* 4, No. 4 (1987), pp. 16–20.
Patrick Graham. Los Angeles, Calif.: Jack Rutberg Fine Arts, Inc., 1989.
Patrick Graham. Dublin: Gandon Editions, 1992.
Patrick Graham: The Lark in the Morning. Dublin: Douglas Hyde Gallery; Cork: Crawford Municipal Art Gallery, 1994.

JAMES HANLEY
Born in Dublin, 1965
Lives and works in Dublin

EDUCATION
University College, Dublin, B.A., 1984–87
National College of Art and Design, B.F.A., 1987–91
Glasgow School of Art, 1990

SELECTED INDIVIDUAL EXHIBITIONS
1992 *Natural Disasters,* Riverrun Gallery, Dublin
1995 *White Lies,* Hallward Gallery, Dublin
1997 *Grand Tourists,* Hallward Gallery, Dublin

SELECTED GROUP EXHIBITIONS
1990 Royal Hibernian Academy (also 1991, 1992, 1996)
1991 *Counterparts,* University of Ulster, Belfast
Taylor Art Awards Exhibition, Royal Dublin Society
1993 Dublin Contemporary Art Fair, Royal Hospital Kilmainham
1994 *Germinations 8.* European Biennale of Young Artists. Breda, Warsaw, Athens, Madrid
1996 *Academy Without Walls.* Banquet Show, RHA Gallagher Gallery, Dublin

SELECTED BIBLIOGRAPHY
Grand Tourists: James Hanley. Dublin: Hallward Gallery, 1997.
Natural Disasters: James Hanley. Dublin: Riverrun Gallery, 1992.
White Lies: Recent Paintings by James Hanley. Dublin: Hallward Gallery, 1995.

PATRICK HENNESSY
Born in Cork, 1915
Died in London, 1980

EDUCATION
Dundee College of Art, Scotland

SELECTED INDIVIDUAL EXHIBITIONS
1945 Society of Dublin Painters Gallery
1956 Thomas Agnew & Sons, Ltd., London
1966 Guildhall Galleries, Chicago
1981 *Tribute to Patrick Hennessy,* Cork Arts Society, Cork

SELECTED GROUP EXHIBITIONS
1939 Royal Scottish Academy
1941 Royal Hibernian Academy (also 1943)
1951 Society of Dublin Painters Gallery
1971 *The Irish Imagination 1959–1971,* Municipal Gallery of Modern Art, Dublin
1988 *Critics' Choice,* Hugh Lane Municipal Gallery of Modern Art, Dublin
1994 *Labour in Art,* Irish Museum of Modern Art, Dublin

Tribute to Patrick Hennessy. Cork, Ireland: Cork Arts Society, 1981.

PAUL HENRY
Born in Belfast, 1876
Died in Bray, Co. Wicklow, 1958

EDUCATION
Methodist College, Belfast
Royal Belfast Academical Institution
Belfast School of Art
Académie Julian, Paris
Académie Carmen, Paris

SELECTED INDIVIDUAL EXHIBITIONS
1931 Combridge's Gallery, Dublin
1934 *In Connemara*, Fine Art Society, London
1952 Victor Waddington Galleries, London
1973 *Paul Henry, 1876–1958*, Trinity College, Dublin; Ulster Museum, Belfast
1978 The Oriel Gallery, Dublin (also 1983, 1990)

SELECTED GROUP EXHIBITIONS
1910 Royal Hibernian Academy
1917 Mills' Hall, Dublin (also 1918, 1919)
1921 Green Gallery, Dublin (also 1922, 1923, 1926)
1991 *The Paintings of Paul and Grace Henry*, Hugh Lane Municipal Gallery of Modern Art, Dublin

SELECTED BIBLIOGRAPHY
"Connemara for the Artist: Mr. Paul Henry's Experiences." *The Irish Times*, Aug. 4, 1925, p. 4.
Henry, Paul. *An Irish Portrait.* London: B.T. Batsford, 1951. *Further Reminiscences.* Belfast: Blackstaff Press, 1973.
Kennedy, S.B. "Paul Henry: An Irish Portrait." *Irish Arts Review*, 6 (1989–90), pp. 43–54. *Paul Henry: 1876–1958.* Dublin: Town House in association with The National Gallery of Ireland, 1991.

MAINIE JELLETT
Born in Dublin, 1897
Died in Dublin, 1944

EDUCATION
Metropolitan School of Art, Dublin, 1914–16 and 1919–20
Westminster Technical Institute, London, 1917–19

SELECTED INDIVIDUAL EXHIBITIONS
1926 Dublin Radical Club
1962 Municipal Gallery of Modern Art, Dublin
1974 Neptune Gallery, Dublin
1976 Octagon Gallery, Belfast
1991 Retrospective, Irish Museum of Modern Art, Dublin
1997 *Mainie Jellett 1897–1944*, One Oxford Street, Belfast

SELECTED GROUP EXHIBITIONS
1918 Royal Hibernian Academy (through 1937)
1923 Society of Dublin Painters (through 1941)
1925 Salon des Indépendants, Paris (also 1926, 1928)
1938 Salon d'Automne, Paris
1943 Irish Exhibition of Living Art

SELECTED BIBLIOGRAPHY
Arnold, Bruce. *Mainie Jellett and the Modern Movement in Ireland.* New Haven, Conn., and London: Yale Univ. Press, 1991.
Barrett, Cyril. "Mainie Jellett and Irish Modernism." *Irish Arts Review*, 9 (1993), pp. 167–73.
Frost, Stella, ed. *A Tribute to Evie Hone and Mainie Jellett.* Dublin: Browne and Nolan, Ltd., 1957.
Jellett, Mainie H. "An Approach to Painting." *Irish Art Handbook.* Dublin: Cahill and Co., 1943.
Mainie Jellett, 1897–1944. Dublin: Irish Museum of Modern Art, 1991.

EITHNE JORDAN
Born in Dublin, 1954
Lives and works in Dublin, Ireland, and Languedoc, France

EDUCATION
Dun Laoghaire School of Art, Co. Dublin, 1972–76
DAAD scholarship to Berlin, 1984

SELECTED INDIVIDUAL EXHIBITIONS
1982 Project Arts Centre, Dublin
1988 Riverrun Gallery, Limerick (also 1990)
 Hendriks Gallery, Dublin
1990 Garter Lane Arts Centre, Waterford
1992 Rubicon Gallery, Dublin (also 1994, 1998)
1995 Limerick City Gallery of Art
1998 *Eithne Jordan Paintings 1992–1998.* Model Arts Centre, Sligo

SELECTED GROUP EXHIBITIONS
1983 *New Artists, New Work*, Orchard Gallery, Derry; Project Arts Centre, Dublin
1986 *Ateliers*, Haus am Lützowplatz, Berlin
 GPA Awards for Emerging Artists, Royal Hospital Kilmainham, Dublin
1987 *Irish Women: Artists from the Eighteenth-Century to the Present Day.* National Gallery of Ireland, Dublin; Douglas Hyde Gallery, Dublin; and Hugh Lane Municipal Gallery of Modern Art, Dublin
1990 *A New Tradition: Irish Art of the Eighties*, Douglas Hyde Gallery, Dublin
1992 *Balance-Imbalance*, Rubicon Gallery, Dublin
1994 *EV+A*, Limerick City Gallery of Art
1996 *Figuration*, Irish Museum of Modern Art, Dublin
1997 *Re/Dressing Cathleen. Contemporary Works from Irish Women Artists*, McMullen Museum of Art, Boston College, Chestnut Hill, Massachusetts

SELECTED BIBLIOGRAPHY
Eithne Jordan. Dublin: Hendriks Gallery, 1988.
Eithne Jordan. Dublin: Gandon Editions, 1994.
Eithne Jordan Paintings 1992–1998. Dublin: The Rubicon Press Ltd., 1998.

MICHAEL KANE
Born in Dublin, 1935
Lives and works in Dublin

EDUCATION
National College of Art, Dublin, 1956–58

SELECTED INDIVIDUAL EXHIBITIONS
1970 Project Arts Centre, Dublin
1986 Galway Arts Centre, Galway Arts Festival
1990 Rubicon Gallery, Dublin (also 1991, 1993)
1995 Retrospective, RHA Gallagher Gallery, Dublin
1996 *Michael Kane: Recent Paintings*, Art Space Gallery, London

SELECTED GROUP EXHIBITIONS
1983 *Making Sense – Ten Irish Artists, 1963–1983*, Project Arts Centre, Dublin
1990 *Irish Art: The European Dimension*, RHA Gallagher Gallery, Dublin
1995 *The Story of Narcissus*, Rubicon Gallery, Dublin

SELECTED BIBLIOGRAPHY
Gillespie, Elgy. "Michael Kane and Structure." *The Irish Times*, March 15, 1974, p. 12.
Michael Kane: 'Where the Poet Has Been.' Dublin: Irish Museum of Modern Art, 1995.
Sharpe, Henry J. *Michael Kane: His Life and Art.* Dublin: Bluett, 1983.

SEÁN KEATING
Born in Limerick, 1889
Died in Dublin, 1977

EDUCATION
Limerick Technical School
Metropolitan School of Art, Dublin, 1911–14

SELECTED INDIVIDUAL EXHIBITIONS
1921 The Hall, Leinster Street, Dublin
1930 Hackett Galleries, New York
1939 Ireland Pavilion, New York World's Fair
1956 Ritchie Hendriks Gallery, Dublin
1963 *John Keating: Paintings-Drawings*, Municipal Gallery of Modern Art, Dublin
1987 *Seán Keating and the ESB*, RHA Gallagher Gallery, Dublin
1989 *Seán Keating, P.R.H.A.: "1889–1977"*, RHA Gallagher Gallery, Dublin

SELECTED GROUP EXHIBITIONS

1917 Royal Hibernian Academy
1924 Royal Academy, London
1953 *Irish Painting, 1903–1953*, Royal Hibernian Academy; Municipal Gallery of Dublin
1973 Municipal Art Gallery, Limerick
1991 *Irish Art and Modernism 1880–1960*, Hugh Lane Municipal Gallery of Modern Art, Dublin
1994 *Labour in Art*, Irish Museum of Modern Art, Dublin

SELECTED BIBLIOGRAPHY

John Keating: Paintings-Drawings. Dublin: Municipal Gallery of Modern Art, 1963.
Seán Keating and the ESB. Dublin, RHA Gallagher Gallery, 1987.
Seán Keating, P.R.H.A.: "1889–1977." Dublin: RHA Gallagher Gallery, 1989.

CHARLES LAMB

Born in Portadown, Co. Armagh, 1893
Died in Carraroe, Co. Galway, 1964

EDUCATION

Portadown Technical School
Metropolitan School of Art, Dublin, 1917–21

SELECTED INDIVIDUAL EXHIBITIONS

1924 St. Stephen's Green Gallery, Dublin
1931 Society of Dublin Painters
1969 *Charles Lamb RHA 1893–1964: A Memorial Exhibition*, Municipal Gallery of Modern Art, Dublin
1981 Stone Art Gallery, Spiddal, Co. Galway

SELECTED GROUP EXHIBITIONS

1919 Royal Hibernian Academy
1930 Irish Art Exhibition, Brussels
1950 Contemporary Irish Art, Boston, Massachusetts

SELECTED BIBLIOGRAPHY

Charles Lamb RHA 1893–1964. Dublin: Municipal Gallery of Modern Art, 1969.
"The Paintings of Charles Lamb, A.R.H.A." *The Irish Statesman*, June 7, 1924, p. 400.

SIR JOHN LAVERY

Born in Belfast, 1856
Died in Kilmoganny, Co. Kilkenny, 1941

EDUCATION

Haldane Academy of Art, Glasgow, 1874
Heatherley's School of Art, London, 1880
Académie Julian, Paris, 1881

SELECTED INDIVIDUAL EXHIBITIONS

1891 Goupil Gallery, London (also 1908)
1904 Leicester Galleries, London (also 1925, 1941)
1926 Carnegie Institute, Pittsburgh, Pennsylvania
1971 Spink & Son, London
1984 *Sir John Lavery RA, 1856–1941*, The Fine Art Society, Edinburgh and London; Ulster Museum, Belfast; National Gallery of Ireland, Dublin

SELECTED GROUP EXHIBITIONS

1890 Grosvenor Gallery, London
1895 Berlin Art Exhibition, Berlin
1910 Irish Pavilion, Venice Biennale, Venice
1927 Belfast Museum and Art Gallery, Belfast
1936 Victoria Art Galleries, Albert Institute, Dundee, Scotland
1968 Glasgow Art Gallery and Museum
1989 Castle Museum, Nottingham, England
1992 Tate Gallery, London

SELECTED BIBLIOGRAPHY

Lavery, Sir John. *The Life of A Painter.* London: Cassell and Co., Ltd., 1940.
Little, James Stanley. "A Cosmopolitan Painter: John Lavery." *The Studio*, XXVII, No. 115 (Oct. 1902), Part I, 3–13; Part II, pp. 110–20.
MacCarthy, Desmond. "Sir John Lavery's Portrait Interiors." *Apollo*, 2 (July to Dec. 1925), pp. 267–73.
McConkey, Kenneth. "The White City – Sir John Lavery in Tangier." *Irish Arts Review*, 6 (1989–90), pp. 55–62.
McConkey, Kenneth. *Sir John Lavery.* Edinburgh: Canongate Press, 1993.

Sparrow, Walter Shaw. *John Lavery and his Work.* London: K. Paul, Trench, Triebiner & Co., Ltd., 1911.

LOUIS LE BROCQUY

Born in Dublin, 1916
Lives and works in France

EDUCATION

St. Gerard's School, Bray, Co. Wicklow
Trinity College, Dublin

SELECTED INDIVIDUAL EXHIBITIONS

1947 Gimpel Fils, London (periodically through 1993)
1951 Waddington Galleries, Dublin
1962 Dawson Gallery, Dublin (also 1966, 1969, 1971, 1973–75)
1966 Hugh Lane Municipal Gallery of Modern Art, Dublin (also 1978)
1967 Ulster Museum, Belfast (also 1987)
1981 Taylor Galleries, Dublin (also 1985–86, 1988, 1992–96)
1996 *Louis le Brocquy Paintings 1939–1996*, Irish Museum of Modern Art, Dublin
1997 Musée d'Art Moderne et Contemporain, Nice

SELECTED GROUP EXHIBITIONS

1956 Irish Pavilion, Venice Biennale, Venice
1987 *Painting Since World War II*, Guggenheim Museum, New York
1989 *Portrait of the Artist: 1949–1960*, Tate Gallery, London

SELECTED BIBLIOGRAPHY

Kearney, Richard. "Le Brocquy and Post-Modernism." *The Irish Review* 5 (1988), pp. 61–66.
Louis le Brocquy and the Celtic Head Image. Albany, NY: New York State Museum, 1981.
Louis le Brocquy: Paintings 1939–1996. Dublin: Irish Museum of Modern Art, 1996.
Louis le Brocquy: The Head Image. Kinsale: Gandon Editions, 1995.
Walker, Dorothy. "'Images, Single and Multiple' 1957–1990." *Irish Arts Review*, 8 (1991–1992), pp. 87–94.

White, W.J. "Contemporary Irish Artists (VI): Louis le Brocquy." *Envoy*, 2, No. 6 (May 1950), pp. 52–65.

WILLIAM JOHN LEECH

Born in Dublin, 1881
Died in West Clandon, Surrey, England, 1968

EDUCATION

Metropolitan School of Art, Dublin, 1899
Royal Hibernian Academy Schools, 1900
Académie Julian, Paris, 1901

SELECTED INDIVIDUAL EXHIBITIONS

1912 Goupil Gallery, London
1945 Dawson Gallery, Dublin (also 1947, 1951)
1996 *William John Leech: An Irish Painter Abroad*, National Gallery of Art, Dublin; Musée des Beaux Arts, Quimper; Ulster Museum, Belfast

SELECTED GROUP EXHIBITIONS

1899 Royal Hibernian Academy (through 1967)
1910 Royal Academy (through at least 1940)
1913 Whitechapel Gallery
1914 Paris Salon
1939 National Art Gallery, Wellington, New Zealand
1953 Dawson Gallery, Dublin
1984 *The Irish Impressionists: Irish Artists in France and Belgium 1850–1914*, National Gallery of Ireland, Dublin; Ulster Museum, Belfast

SELECTED BIBLIOGRAPHY

Denson, Alan. *An Irish Artist: W. J. Leech R.H.A. (1881–1968).* Kendal (Westmorland), 1968.
"W.J. Leech, R.H.A.: A Great Irish Artist (1881–1968)." *The Capuchin Annual* (1974), pp. 119–27.
Ferran, Denise. "W.J. Leech's Brittany." *Irish Arts Review*, 9 (1993), pp. 224–32.
William John Leech: An Irish Painter Abroad. London: Merrell Holberton, 1996.

MAURICE MACGONIGAL
Born in Dublin, 1900
Died in Dublin, 1979

EDUCATION
Metropolitan School of Art,
Dublin, 1923–26

SELECTED INDIVIDUAL
EXHIBITIONS
1929 7 St. Stephen's Green, Dublin
1944 Victor Waddington Galleries,
Dublin
1958 Ritchie Hendriks Gallery,
Dublin
1968 Dawson Gallery, Dublin (also
1970, 1971)
1978 Taylor Galleries, Dublin (also
1981, 1986)
1985 Grafton Gallery, Dublin
1991 Hugh Lane Municipal
Gallery of Modern Art, Dublin

SELECTED GROUP
EXHIBITIONS
1924 Royal Hibernian Academy
(through 1978)
1939 World's Fair, New York
1944 Oireachtas
1946 *Living Irish Art*, Leicester,
London
1974 *The Irish: 1870–1970*,
National Gallery of Ireland,
Dublin
1994 *Labour in Art*, Irish Museum
of Modern Art, Dublin

SELECTED BIBLIOGRAPHY
Allen, Mairin. "Contemporary
Irish Artists XVIII – Maurice
MacGonigal." *Father Mathew
Record* (May 1943), p. 6.
Crofts, Sinead. "Maurice
MacGonigal, PHRA (1900–79)
and his Western Paintings."
Irish Arts Review, 13 (1997), pp.
135–42.
Turpin, John. "The Natural
College of Art Under Keating
and MacGonigal." *Irish Arts
Review*, 5 (1988), pp. 201–11.

BRIAN MAGUIRE
Born in Bray, 1951
Lives and works in Dublin

EDUCATION
Dun Laighaire Technical School,
Co. Dublin, 1968–69
National College of Art, Dublin,
1969–74

SELECTED INDIVIDUAL
EXHIBITIONS
1981 Lincoln Gallery, Dublin (also
1982)
1986 Wexford Arts Centre,
Wexford
1988 Orchard Gallery, Derry;
Douglas Hyde Gallery, Trinity
College, Dublin
1990 Kerlin Gallery, Dublin (also
1993 and 1996)
1994 *Paintings 90/93*, City Art
Gallery, Limerick; Orchard
Gallery, Derry; D'Arte Galleria,
Helsinki, Finland
1996 The Blue Gallery, London
1997 *Violence in Ireland*, Lucia
Douglas Gallery, Bellingham,
Washington
1998 The Butler Gallery, Kilkenny

SELECTED GROUP
EXHIBITIONS
1979 Lincoln Gallery (also 1982)
1985 *Divisions Crossroads, Turns of
Mind: Some New Irish Art*,
Williams College Museum of
Art, Williamstown,
Massachusetts
1986 *4 Irish Expressionists*, Boston
University & Northeastern
University, Boston,
Massachusetts
1990 *A New Tradition: Irish Art of
the Eighties*, Douglas Hyde
Gallery, Dublin
1991 *Inheritance and
Transformation*, Irish Museum of
Modern Art, Dublin
1993 *Hope in Houston*, Moody
Gallery, Houston, Texas
Works from a Room, Brinkman
Gallery, Amsterdam
1994 *IMMA Glen Dimplex Award
Exhibition*, Irish Museum of
Modern Art, Dublin
1996 *Brian Maguire/Alanna O'Kelly*,
Fassbender Gallery, Chicago
1998 São Paolo 24 Bienal, Brazil

SELECTED BIBLIOGRAPHY
Brian Maguire, Paintings 90/93.
Derry: Orchard Gallery; Dublin:
Kerlin Gallery, 1993.
Kuspit, Donald. *Brian Maguire: an
essay*. Dublin: Douglas Hyde
Gallery, 1988.
Maguire, Brian. "On Irish
Expressionist Painting." *The
Irish Review*, 3 (1988),
pp. 26–27.

*The Irish Pavilion/Brian Maguire +
Sheila O'Donnell and John
Tuomey*. Dublin: Gandon
Editions, 1992.

ALICE MAHER
Born in Cahir, Co. Tipperary, 1956
Lives and works in Cork

EDUCATION
National Institute for Higher
Education, Limerick, B.A.,
1974–78
Crawford Municipal College of Art,
Cork, 1981–85
University of Ulster, Belfast,
M.F.A., 1985–86
San Francisco Art Institute,
1986–87 (Post-graduate
Fulbright scholarship)

SELECTED INDIVIDUAL
EXHIBITIONS
1987 *Transfiguration*, On the Wall
Gallery, Belfast
1989 *TRYST*, Belltable Arts
Centre, Limerick
1995 *familiar*, Douglas Hyde
Gallery, Dublin; Orchard
Gallery, Derry; Crawford
Municipal Gallery, Cork; and
Newlyn Gallery, Penzance
(1996)
1995 Green on Red Gallery, Dublin
(also 1997)
1996 Todd Gallery, London

SELECTED GROUP
EXHIBITIONS
1984 *Irish Exhibition of Living Art*,
Douglas Hyde Gallery, Dublin
1987 *EV + A*, City Gallery of Art,
Limerick
The Popening, The Lab Gallery,
San Francisco
Diego Rivera Gallery, San
Francisco Art Institute
1988 *Basquiat, Clemente, Coombes,
Maher, Wilson*, Kerlin Gallery,
Dublin
1990 *A New Tradition: Irish Art of
the Eighties*, Douglas Hyde
Gallery, Dublin
In a State, Kilmainham Gaol,
Dublin
1991 *Strongholds*, Tate Gallery,
Liverpool; Hilden Museum,
Finland
1993 *Relocating History*,
Fenderesky Gallery, Belfast;
Orchard Gallery, Derry
1994 São Paolo 22 Bienal, Brazil
1994 *Beyond the Pale*, Irish

Museum of Modern Art, Dublin
1996 IMMA/Glen Dimplex
Awards, Irish Museum of
Modern Art, Dublin
1997 *Re/Dressing Cathleen:
Contemporary Works from Irish
Women Artists*, McMullen
Museum of Art, Boston College,
Chestnut Hill, Massachusetts

SELECTED BIBLIOGRAPHY
Alice Maher. Belfast: Arts Council
of Northern Ireland, 1990.
Alice Maher. Dublin: Gandon
Editions, 1996.
familiar: Alice Maher. Dublin:
Douglas Hyde Gallery; Derry:
Orchard Gallery, 1995.

EDWARD MCGUIRE
Born in Dublin, 1932
Died in Dublin, 1986

EDUCATION
Accademia di Belle Arti, Rome,
1952–53
Slade School of Fine Art, London,
1954–55

SELECTED INDIVIDUAL
EXHIBITIONS
1969 Dawson Gallery, Dublin
1983 Taylor Galleries, Dublin
1991 RHA Gallagher Gallery,
Dublin

SELECTED GROUP
EXHIBITIONS
1953 Irish Exhibition of Living
Art (also 1953–55, 1958–59,
1961, 1963, 1971)
1962 Royal Hibernian Academy
(also 1968, 1970–76, 1978–79,
1982–86)
1971 *The Irish Imagination
1959–1971*, Municipal Gallery of
Modern Art, Dublin
1973 *Artist's Choice*, Ulster
Museum, Belfast
1980 *Irish Art 1943–1973, Cork
Rosc 1980*, Crawford Municipal
Art Gallery, Cork; Ulster
Museum, Belfast
*The Delighted Eye: Irish Painting
and Sculpture of the Seventies*,
London

SELECTED BIBLIOGRAPHY
Cooke, Harriet. "Harriet Cooke
talks to the painter Edward
McGuire." *The Irish Times*,
April 17, 1973, p. 10.

Fallon, Brian. *Edward McGuire, RHA*. Dublin: Irish Academic Press, 1991.

McGuire, Edward. "The Art of Portraiture." *Martello* (Summer 1983), pp. 31–34.

Murphy, Hayden. "Edward Maguire [McGuire]: A Profile." *The Arts in Ireland*, 2, No. 4 (1974), pp. 38–48.

Walker, Dorothy. "Sailing to Byzantium: The Portraits of Edward McGuire." *Irish Arts Review*, 4, No. 4 (1987), pp. 21–29.

COLIN MIDDLETON

Born in Belfast, 1910
Died in Bangor, Co. Down, 1983

EDUCATION

Belfast Royal Academy
Belfast College of Art

SELECTED INDIVIDUAL EXHIBITIONS

1943 Belfast Museum and Art Gallery (also 1954)
1944 Grafton Gallery, Dublin
1949 Victor Waddington Galleries, Dublin (also 1955)
1964 Armagh County Museum, Armagh
1976 Ulster Museum, Belfast; Hugh Lane Municipal Gallery of Modern Art, Dublin

SELECTED GROUP EXHIBITIONS

1938 Royal Hibernian Academy
1945 *Irish Exhibition of Living Art*, Dublin
1950 *New Irish Painters*, Institute of Contemporary Art, Boston
1951 *Five Irish Painters*, Tooth Galleries, London

SELECTED BIBLIOGRAPHY

Cooke, Harriet. "Colin Middleton." *The Irish Times*, Jan. 25, 1973, p. 8.

Hewitt, John Harold. *Colin Middleton*. Belfast: Arts Council of Northern Ireland and An Chomhairle Ealaíon, 1975.

Longley, Michael. "Colin Middleton." *The Dublin Magazine*, 6, Nos. 3–4 (Autumn/Winter 1967), pp 40–43.

Sheehy, Edward. "Colin Middleton." *Envoy*, 2, No. 1 (April 1950), pp. 32–40.

NICK MILLER

Born in London, 1962
Lives and works on the border of Co. Sligo and Co. Roscommon

EDUCATION

University of East Anglia, Norwich, England, 1984

SELECTED INDIVIDUAL EXHIBITIONS

1986 *Paintings & Drawings*, Temple Bar Gallery, Dublin
1988 *Paintings*, Project Arts Centre, Dublin
1991 *The Shadow Line*, City Arts Centre, Dublin
1994 *South African Works 1991–92*, Irish Museum of Modern Art, Dublin; Model Arts Centre, Sligo
1996 Fenderesky Gallery, Belfast
1998 *Paintings & Drawings, 1994–97*, Rubicon Gallery, Dublin

SELECTED GROUP EXHIBITIONS

1985 *Independent Artists*, Dublin
1987 *S.A.D.E.*, Crawford Municipal Art Gallery, Cork
1993 *The Naked Formed*, Rubicon Gallery, Dublin
1995 *Portraits*, Irish Museum of Modern Art, Dublin
1997 *The Beautiful Junk Shop*, Fenderesky Gallery, Belfast

SELECTED BIBLIOGRAPHY

Dunne, Aidan. "Nick Miller: Irish Museum of Modern Art, April 1994." *Circa*, 68 (Summer 1994), pp. 59–60.

Nick Miller, Paintings & Drawings 1994–97. Dublin: The Rubicon Press Ltd., 1998.

EILEEN MURRAY

Born in Templemore, Co. Cork, 1885
Died in Killiney, 1962

EDUCATION

No formal institutional education

SELECTED INDIVIDUAL EXHIBITIONS

1926 Dublin Sketching Club, Mills' Hall, Merrion Row, Dublin

SELECTED GROUP EXHIBITIONS

1908 Royal Hibernian Academy (also 1923, 1925–26, 1929)
1926 Belfast Art Society
1985 Gorry Gallery, Dublin
1987 *Irish Women Artists: From the Eighteenth Century to the Present Day*, National Gallery of Ireland, Dublin; Douglas Hyde Gallery, Dublin; Hugh Lane Municipal Gallery of Modern Art, Dublin

SELECTED BIBLIOGRAPHY

Irish Women Artists: From the Eighteenth Century to the Present Day. Dublin: The National Gallery of Ireland and the Douglas Hyde Gallery, 1987.

RODERIC O'CONOR

Born in Milltown, Co. Roscommon, Ireland, 1860
Died in Neuil-sur-Layon, France, 1940

EDUCATION

Ampleforth College, York, England, 1873–78
Metropolitan School of Art, Dublin, 1879–81
Royal Hibernian Academy School, 1881–82
Académie Royale des Beaux-Arts, Antwerp, 1884

SELECTED INDIVIDUAL EXHIBITIONS

1937 Galerie Bonaparte, Paris
1986 *Roderic O'Conor 1860–1940*, Barbican Art Gallery, London; Ulster Museum, Belfast; National Gallery of Ireland, Dublin; and Whitworth Art Gallery, Manchester

SELECTED GROUP EXHIBITIONS

1883 Royal Hibernian Academy, Dublin (also 1885)
1890 Salon des Indépendants, Paris (also 1892, 1893, 1903–06, 1908)
1903 Salon d'Automne, Paris (also 1904–06, 1908–13, 1919–32, 1934–35)
1924 Carnegie International Exhibition, Pittsburgh (also 1925)

1966 *Gauguin and the Pont-Aven Group*, Tate Gallery, London
1984 *The Irish Impressionists: Irish Artists in France and Belgium 1850–1914*, National Gallery of Ireland, Dublin; Ulster Museum, Belfast

SELECTED BIBLIOGRAPHY

Benington, Jonathan. "Thoughts on the Roderic O'Conor Exhibition." *Irish Arts Review*, 3, No. 2 (Summer 1986), pp. 57–59.

Roderic O'Conor. Dublin: Irish Academic Press, 1992.

Johnston, Roy. *Roderic O'Conor 1860–1940*. London: Barbican Art Gallery, 1985.

Sutton, Denys. "Roderic O'Conor: Little-Known Member of the Pont-Aven Circle." *The Studio*, 160, No. 811 (Nov. 1960), pp. 168–74 and 194–96.

HUGHIE O'DONOGHUE

Born in Manchester, England, 1953
Lives and works in Co. Kilkenny, Ireland

EDUCATION

Goldsmiths College, University of London, M.F.A., 1982

SELECTED INDIVIDUAL EXHIBITIONS

1984 Air Gallery, London
1985 National Gallery, London
1991 Kilkenny People Gallery, Kilkenny, Ireland
1997 *A Line of Retreat*, Purdy Hicks Gallery, London
Via Crucis, Haus der Kunst, Munich

SELECTED GROUP EXHIBITIONS

1991 *Ten Artists in Residence*, National Gallery, London
1992 *Whitechapel Open Exhibition, Part One*, Whitechapel Art Gallery, London
1995 *Famine*, Claremorris, Ireland
1996 *John Moore's Liverpool Exhibition 19*, Walker Art Gallery, Liverpool

SELECTED BIBLIOGRAPHY
Collier, Caroline. "Hughie
O'Donoghue." *Flash Art*, 128
(May/June 1986), p. 59.
*Hughie O'Donoghue: A Line of
Retreat.* London: Purdy Hicks
Gallery, Ltd., 1997.
Hughie O'Donoghue: Via Crucis.
Munich: Haus der Kunst, 1997.
Miller, Sanda. "Hughie
O'Donoghue: An Interview."
Irish Arts Review, 2, No. 2
(Summer 1985), pp. 15–17.

DANIEL O'NEILL
Born in Belfast, 1920
Died in Belfast, 1974

EDUCATION
No formal institutional education

SELECTED INDIVIDUAL
EXHIBITIONS
1946 Victor Waddington Galleries,
Dublin (through 1955)
1952 *Daniel O'Neill 1944–52*,
Belfast Museum and Art Gallery
1960 Dawson Gallery, Dublin (also
1963, 1971)
1970 McClelland Galleries, Belfast

SELECTED GROUP
EXHIBITIONS
1940 Mol Gallery, Belfast
1945 Irish Exhibition of Living
Art, Dublin (also 1950)
1947 Royal Hibernian Academy
1950 Institute of Contemporary
Art, Boston (also 1954)
1953 Contemporary Irish Art,
Aberystwyth
1994 *Labour in Art*, Irish Museum
of Modern Art, Dublin

SELECTED BIBLIOGRAPHY
ffrench, Cecil Salkeld. "Daniel
O'Neill: A Critical
Appreciation." *Envoy*, 1, No. 1
(Dec. 1949), pp. 31–43.

SIR WILLIAM ORPEN
Born in Dublin, 1878
Died in London, 1931

EDUCATION
Metropolitan School of Art,
Dublin, 1891
Slade School of Fine Art, London,
1897–99

SELECTED INDIVIDUAL
EXHIBITIONS
1901 Carfax Gallery, London
1916 Glasgow Institute of the Fine
Arts
1918 *War Paintings*, Thomas
Agnew and Sons, London
1923 Goupil Gallery, London
1978 National Gallery of Ireland,
Dublin

SELECTED GROUP
EXHIBITIONS
1899 New English Art Club,
London
1901 Royal Hibernian Academy
(through 1930)
1904 Royal Academy (through
1933)
1912 Royal Scottish Academy
1913 Carnegie Institute,
Pittsburgh, Pennsylvania
1926 Irish Pavilion, Venice
Biennale, Venice (also 1928)
1987 *Orpen and the Edwardian Era*,
Pyms Gallery, London

SELECTED BIBLIOGRAPHY
Arnold, Bruce. *Orpen: Mirror to an
Age.* London: Jonathan Cape,
1981.
Orpen and the Edwardian Era.
London: Pyms Gallery, 1987.
Orpen, Sir William. *Stories of Old
Ireland & Myself.* London:
Williams and Norgate, Ltd.,
1924.
Ryan, Thomas. "William Orpen."
The Dubliner, 3, No. 4 (Winter
1964), pp. 22–32.

WALTER FREDERICK OSBORNE
Born in Dublin, 1859
Died in Dublin, 1903

EDUCATION
Royal Hibernian Academy School,
Dublin
Metropolitan School of Art, Dublin
Académie Royale des Beaux-Arts,
Antwerp

SELECTED INDIVIDUAL
EXHIBITIONS
1903 Memorial Exhibition, Royal
Hibernian Academy, Dublin
1983 *Walter Osborne*, National
Gallery of Ireland, Dublin;
Ulster Museum, Belfast

SELECTED GROUP
EXHIBITIONS
1877 Royal Hibernian Academy
(through 1903)
1886 Royal Academy, London
(through 1903)
1900 Exposition Internationale,
Paris
1980 *The Peasant in French 19th
Century Art*, Douglas Hyde
Gallery, Dublin
1984 *The Irish Impressionist: Irish
Artists in France and Belgium
1850–1914*, National Gallery of
Ireland, Dublin; Ulster Museum,
Belfast
1995 *Impressionism in Britain and
Ireland.* Hugh Lane Municipal
Gallery of Modern Art, Dublin

SELECTED BIBLIOGRAPHY
Sheehy, Jeanne. *Walter Osborne.*
Dublin: National Gallery of
Ireland, 1983.
Walter Osborne. Ballycotton, Co.
Cork: Gifford & Craven, 1974.
Walter Osborne, 1859–1903".
Dublin: Town House in
association with the National
Gallery of Ireland, 1991.

JACK PAKENHAM
Born in Dublin, 1938
Lives and works in Belfast

EDUCATION
Queen's University, Belfast, 1959

SELECTED INDIVIDUAL
EXHIBITIONS
1972 Tom Caldwell Gallery, Belfast
(also 1975, 1981)
1987 *Paintings 1984–1986*, Arts
Council Gallery, Belfast
1988 *Selected Works 1961–1978*,
Fenderesky Gallery, Belfast;
Newry and Mourne Arts Centre,
Newry
1990 *A Broken Sky*, Project Arts
Centre, Dublin
1995 *A Broken Sky II*, Ormeau
Baths Gallery, Belfast,

SELECTED GROUP
EXHIBITIONS
1986 *Artists and the Bomb*, Temple
Bar Gallery, Dublin
1987 *Directions Out*, Douglas Hyde
Gallery, Dublin
1991 *Parable Island*, Bluecoat
Gallery, Liverpool

In a State, Kilmainham Gaol,
Dublin
*The Fifth Province – Some New
Art from Ireland*, Edmonton Art
Gallery, Canada
1994 *Small World – Small Works*,
Galerie + Edition CAOC, Berlin
1996 *Art Beyond Conflict*, Crescent
Arts Centre, Belfast
1997 *Artists for Peace Sake: A
Festival of Irish Art and
Thought*, Barrick Museum,
University of Nevada Las Vegas

SELECTED BIBLIOGRAPHY
*Jack Pakenham: Selected Works,
1961–1978.* Belfast: The
Fenderesky Art Gallery, 1988.
Jack Pakenham – Works 1975–89.
Derry: Orchard Gallery, 1990.
Jack Pakenham: A Broken Sky.
Derry: Orchard Gallery; Belfast:
Crowquill; Belfast: Ormeau Baths
Gallery, 1995.

NANO REID
Born in Drogheda, 1900
Died in Drogheda, 1981

EDUCATION
Metropolitan School of Art,
Dublin, 1920–28
La Grande Chaumière, Paris, 1928
Central School of Arts and Crafts
and Chelsea Polytechnic, 1929

SELECTED INDIVIDUAL
EXHIBITIONS
1934 Dublin Painters, 7 St.
Stephen's Green, Dublin
(through 1945)
1947 Dawson Gallery, Dublin
(through 1976)
1964 Arts Council Gallery, Belfast
1975 Ulster Museum, Belfast
1982 Taylor Gallery, Dublin
1991 *Nano Reid: A Retrospective*,
Droichead Arts Centre,
Drogheda, Ireland

SELECTED GROUP
EXHIBITIONS
1925 Royal Hibernian Academy
1943 Irish Exhibition of Living
Art
1950 Irish Pavilion, Venice
Biennale, Venice
1953 Waddington Galleries,
Dublin
1960 Guggenheim International,
New York

1963 *Twelve Irish Painters*, The Arts Council/An Chomhairle Ealaíon, New York

1971 *The Irish Imagination 1959–1971*, Municipal Gallery of Modern Art, Dublin

1980 *The Delighted Eye: Irish Painting and Sculpture of the Seventies*, London

SELECTED BIBLIOGRAPHY

Cooke, Harriet. "Harriet Cooke talks to the painter Nano Reid." *The Irish Times*, July 6, 1973, p. 10.

Mallon, Declan. *Nano Reid*. Drogheda, Ireland: Sunnyside Publications, 1994.

Murphy, Pat. "A Grand Romantic: Pat Murphy talked to the painter Nano Reid." *The Irish Times*, Sept. 11, 1979, p. 10.

Nano Reid: A Retrospective Exhibition. Drogheda, Co. Louth: Droichead Arts Centre, 1991.

Swift, Patrick. "Contemporary Irish Artists (4): Nano Reid." *Envoy*, 1, No. 4 (March 1950), pp. 26–35.

HILDA ROBERTS
Born in Dublin, 1901
Died in Dublin, 1982

EDUCATION

Metropolitan School of Art, Dublin, 1919–21
Regent Street Polytechnic, London, 1921–23

SELECTED INDIVIDUAL EXHIBITIONS

1929 Dublin Painters Gallery (also 1931)
1979 Retrospective, Taylor Galleries, Dublin

SELECTED GROUP EXHIBITIONS

1925 Royal Dublin Society
1927 Royal Hibernian Academy (periodically through 1979)
1933 Munster Fine Art Club, Dublin
1935 *Waterford Art Exhibition*, Waterford
1943 Irish Exhibition of Living Art
1987 *Irish Women Artists: From the Eighteenth Century to the*

Present Day, National Gallery of Ireland, Dublin; Douglas Hyde Gallery, Dublin; and Hugh Lane Municipal Gallery of Modern Art, Dublin

SELECTED BIBLIOGRAPHY

Hilda Roberts. Dublin: Taylor Galleries, 1979.

Irish Women Artists: From the Eighteenth Century to the Present Day. Dublin: National Gallery of Ireland and Douglas Hyde Gallery, 1987.

GEORGE RUSSELL (Æ)
Born in Lurgan, Co. Armagh, 1867
Died in Bournemouth, England, 1935

EDUCATION

Metropolitan School of Art, Dublin, 1880 and 1883–85
Rathmines School, 1882–84
Royal Hibernian Academy School of Art, 1885

SELECTED INDIVIDUAL EXHIBITIONS

1936 Daniel Egan Gallery, Dublin
1967 Hugh Lane Municipal Gallery of Modern Art, Dublin
 National Gallery of Ireland, Dublin

SELECTED GROUP EXHIBITIONS

1903 Leinster Lecture Hall, Dublin (also 1904, 1907–10)
1905 Royal Hibernian Academy
1913 Armory Show, New York
 Whitechapel Art Gallery, London
1922 Galeries Barbazanges, Paris
1994 *Labour in Art*, Irish Museum of Modern Art, Dublin

SELECTED BIBLIOGRAPHY

Denson, Alan, ed. *Letters from Æ*. London; New York; Toronto: Abelard-Schuman, 1961.

Kain, Richard Morgan and James H. O'Brien. *George Russell (Æ)*. Lewisburg, PA: Bucknell University Press, 1976.

Summerfield, Henry. *That Myriad-Minded Man: A Biography of George William Russell, Æ, 1867–1935*. Gerrards Cross, Great Britain: Colin Smythe Ltd., 1975.

DERMOT SEYMOUR
Born in Belfast, 1956
Lives and works in Co. Mayo

EDUCATION

University of Ulster, B.A., 1974–78
University of Ulster, M.F.A., 1980–81

SELECTED INDIVIDUAL EXHIBITIONS

1978 Art & Research Exchange, Belfast
1986 Fenderesky Gallery at Queen's, Belfast (also 1993)
1987 Paula Allen Gallery, New York (also 1988, 1989)
1990 Arts Council Gallery, Belfast
1992 *Fresh Maumratta Hares and other Paintings from the Periphery*, Project Arts Centre, Dublin
1993 *Malerei*, Galerie + Edition Caoc, Berlin
1993 Sligo Art Gallery, Sligo

SELECTED GROUP EXHIBITIONS

1985 *Divisions Crossroads, Turns of Mind: Some New Irish Art*, Williams College Museum of Art, Williamstown, Massachusetts
1988 International Studio Program Exhibition, PS1 Museum, New York
1991 *The Fifth Province – Some New Art from Ireland*, Edmonton Art Gallery, Canada
1993 *On the Balcony of the Nation*, Arts Council Gallery, Belfast
1995 *Poetic Land – Political Territory*, City Library and Arts Centre, Sunderland, England
1996 *Micky Donnelly & Dermot Seymour*, Fenderesky Gallery, Belfast
 Art Beyond Conflict, Crescent Arts Centre, Belfast

SELECTED BIBLIOGRAPHY

Dermot Seymour. Kinsale, Co. Cork: Gandon Editions, 1995.

MARY SWANZY
Born in Dublin, 1882
Died in London, 1978

EDUCATION

Alexandra College, Dublin
Metropolitan School of Art, Dublin

SELECTED INDIVIDUAL EXHIBITIONS

1913 Mill's Hall, Dublin (also 1919)
1922 Dublin Painter's Gallery, St. Stephen's Green (also 1943)
1947 *Recent Paintings*, St. George's Gallery, London
1968 *Mary Swanzy: Retrospective Exhibitions of Paintings*, Hugh Lane Municipal Gallery of Modern Art, Dublin
1974 Dawson Gallery, Dublin (also 1976)
1982 Taylor Galleries, Dublin
1986 Pyms Gallery, London (also 1989)

SELECTED GROUP EXHIBITIONS

1905 Royal Hibernian Academy (through 1977)
1914 Salon des Indépendants, Paris (also 1918, 1923, 1926, 1934)
1920 Dublin Painter's Gallery (also 1921, 1943)
1975 *Irish Art, 1900–1950*, Rosc Exhibition, Crawford Gallery, Cork
1987 *Irish Women Artists: From the Eighteenth-Century to the Present Day*, National Gallery of Ireland, Dublin; Douglas Hyde Gallery, Dublin; and Hugh Lane Municipal Gallery of Modern Art, Dublin

SELECTED BIBLIOGRAPHY

An Exhibition of Paintings by Mary Swanzy, HRHA, 1882–1978. London: Pyms Gallery, 1986.

Mary Swanzy: Retrospective Exhibition of Paintings. Dublin: Hugh Lane Municipal Gallery of Modern Art, 1968.

PATRICK TUOHY
Born in Dublin, 1894
Died in New York, 1930

EDUCATION

Metropolitan School of Art, Dublin

SELECTED INDIVIDUAL EXHIBITIONS

1911 Small Concert Room, Dublin

SELECTED GROUP EXHIBITIONS

1911 Royal Dublin Society (through 1918)

1918 Royal Hibernian Academy
(through 1927)
1922 *Exposition d'Art Irlandais*,
Galeries Barbazanges, Paris
1925 Royal Academy, London
1929 Hackett Gallery, New York

SELECTED BIBLIOGRAPHY
MacEoin-Johnston, Gerrailt.
"Patrick J. Tuohy, RHA."
Martello, Spring 1985, pp.
42–44.
MacGreevy, Thomas. "Patrick
Tuohy, RHA (1894–1930)."
Father Mathew Record 37, No. 7
(July 1943), p. 5.
Mulcahy, Rosemarie. "Patrick J.
Tuohy, 1894–1930." *Irish Arts
Review*, 6 (1989–90), pp. 107–18.

LEO WHELAN
Born in Dublin, 1892
Died in Dublin, 1956

EDUCATION
Belvedere College, Dublin
Metropolitan School of Art, Dublin
Royal Hibernian Academy School,
Dublin

SELECTED INDIVIDUAL
EXHIBITIONS

SELECTED GROUP
EXHIBITIONS
1911 Royal Hibernian Academy
(through 1956)
1922 *Exposition d'art irlandais*,
Galeries Barbazanges, Paris
1927 Imperial Gallery of Art,
London
1930 Musées Royaux des Beaux-
Arts de Belgique, Brussels
1933 Royal Institute of Oil
Painters, London
1940 *Twelve Irish Artists*,
Waddington Galleries, London

SELECTED BIBLIOGRAPHY
Smolin, Wanda Ryan. "Leo
Whelan (1892–1956)." *Irish
Arts Review*, 10 (1994), pp.
227–234.

JACK B. YEATS
Born in London, 1871
Died in Dublin, 1957

EDUCATION
South Kensington School of Art,
London
Chiswick School of Art, London
Westminster School of Art, London

SELECTED INDIVIDUAL
EXHIBITIONS
1897 Clifford Gallery, London
1899 Walker Art Gallery, London
(also 1901, 1903, 1908, 1912,
1914)
Leinster Hall, Dublin (also 1900,
1905–06, 1909–10)
1943 Waddington Galleries,
Dublin (also 1945–47, 1949,
1953, 1955)
1948 Retrospective, Temple
Newsam House, Leeds; Tate
Gallery, London; and Aberdeen
Art Gallery and Royal Scottish
Academy, Edinburgh
1951 Retrospective, Institute of
Contemporary Art, Boston;
Phillips Collection, Washington,
D.C.; M.H. De Young Museum,
San Francisco; Colorado Springs
Fine Arts Center, Colorado; Art
Gallery, Toronto; Detroit
Institute of Arts; and National
Academy, New York
1956 Belfast Museum and Art
Gallery, Belfast
1958 Waddington Galleries,
London (also 1961, 1963, 1965,
1967)
1971 National Gallery of Ireland,
Dublin (also 1986)
1972 Municipal Gallery of Modern
Art, Dublin
1991 *The Late Paintings*,
Whitechapel Art Gallery,
London
1996 *Visions of Ireland: Jack B.
Yeats*, Queens Museum of Art,
Flushing Meadows–Corona Park,
New York
Jack B. Yeats: A Celtic Visionary,
City Art Galleries, Manchester;
Leeds City Art Galleries; and
Ormeau Baths Gallery, Belfast

SELECTED GROUP
EXHIBITIONS
1895 Royal Hibernian Academy
(also 1896–1900, 1904, 1911)
1913 Armory Show, New York
Whitechapel Art Gallery, London

1921 Society of Independent
Artists, New York (through
1926)
1925 International Exhibition,
Carnegie Institute, Pittsburgh,
Pennsylvania (also 1931,
1934–39)
1942 *Nicholson and Yeats*, National
Gallery, London
1943 Irish Exhibition of Living
Art, National College of Art,
Dublin (also 1944–45, 1948–49,
1955, 1957)
1962 Irish Pavilion, Venice
Biennale, Venice

SELECTED BIBLIOGRAPHY
Hewitt, John Harold. "Coming to
Terms with Jack B. Yeats."
Threshold, 33 (Winter 1983), pp.
43–50.
*Jack B. Yeats, 1871–1957: A
Centenary Exhibition*. London:
Martin Secker & Warburg
Limited, 1971.
McGreevy, Thomas. *Jack B. Yeats:
An Appreciation and an
Interpretation*. Dublin: Victor
Waddington Publications, 1945.
Pyle, Hilary. *Jack B. Yeats, a
Biography*. London: Routledge
and Kegan Paul, 1970.
*Jack B. Yeats: A Catalogue
Raisonne of the Oil Paintings*. 3
vols. London: Deutsch, 1992.
Rosenthal, T. G. *The Art of Jack B.
Yeats*. London: Deutsch, 1993.

Select Bibliography

Note: Monographic texts are included in the artists' biographies.

A New Tradition: Irish Art of the Eighties. Dublin: Douglas Hyde Gallery, 1990.

A Sense of Ireland. Dublin: A Sense of Ireland Ltd., 1980.

AIB Art: A Selection from the AIB Collection of Modern Irish Art. Dublin: AIB Group Public Affairs, 1995.

Arnold, Bruce. "The Confines of Irish Art." *The Dublin Magazine*, 6, Nos. 3–4 (Autumn/Winter 1967), pp. 74–80.
A Concise History of Irish Art. New York and Toronto: Oxford University Press, 1977.
"Art and Politics: 4 Irish Expressionist Painters." *Working Papers in Irish Studies* Paper 86–4/5 (1986).

Art Beyond Conflict: An Exhibition of Work by Eight Belfast Artists. Belfast: Crescent Arts Centre, 1996.

Aspects of Irish Art. Columbus, Ohio: Columbus Gallery of Fine Arts, 1974.

Barber, Sarah and Myrtle Hill, eds. *Aspects of Irish Studies*. Belfast: The Institute of Irish Studies, Queen's University, 1990.

Barrett, Cyril. "Irish Nationalism and Art." *Studies* (Winter 1975), pp. 393–409.

Bell, Sam Hanna, John Hewitt, and Nesca A. Robb, eds. *The Arts in Ulster: A Symposium*. London: George G. Harrap & Co., Ltd., 1951

Benson, Ciarán. "Modernism and Ireland's Selves." *Circa*, 61 (January/February 1992), pp. 18–23.

Bhreathnach-Lynch, Sighle. "The Peasant at Work: Jack B. Yeats, Paul Henry and Life in the West of Ireland." *Irish Arts Review*, 13 (1997), pp. 143–51.

Bodkin, Thomas. *Twelve Irish Artists*. Dublin: Victor Waddington Publications Ltd, 1940.
Hugh Lane and his Pictures. Dublin: The Stationary Office, 1956.

Boylan, Henry. *A Dictionary of Irish Biography*. New York: St. Martin's Press, 1988.

Brown, Terence. *Ireland: A Social and Cultural History, 1922–1979*. London: Fontana, 1981.

Campbell, Julian. *The Irish Impressionists: Irish Artists in France and Belgium 1850–1914*. Dublin: The National Gallery of Ireland, 1984.

Carola, Leslie Conron, ed. *The Irish: A Treasury of Art and Literature*. New York: Hugh Lauter Levin, 1993.

Catto, Mike. *Art in Ulster: 2*. Belfast: Blackstaff Press, 1977.

Coagan, Tim Pat, ed. *Ireland and the Arts*. London: Newgate Press Ltd, n.d.

Contemporary Irish Painting. Dublin: Sign of the Three Candles, 1950.

Coonan, Rory. "Looking for the Irishness." *Art Monthly*, 34 (March 1980), p. 18.

Coxhead, Elizabeth. *Daughters of Erin: Five Women of the Irish Renaissance*. London: Secker & Warburg, 1965.

Crookshank, Anne. *Irish Art from 1600 to the present day*. Dublin: Department of Foreign Affairs, 1979.

Crookshank, Anne and The Knight of Glin. *The Painters of Ireland, c. 1660–1920*. London: Barrie & Jenkins, 1978.

Cronin, Michael and Barbara O'Connor, eds. *Tourism in Ireland: A Critical Analysis*. Cork, Ireland: Cork Univ. Press, 1993.

Cullen, Fintan. *Visual Politics: The Representation of Ireland 1750–1930*. Cork, Ireland: Cork Univ. Press, 1997.

Curtis, Penelope, ed. *Strongholds: New Art from Ireland*. Liverpool: Tate Gallery, 1991.

Dalsimer, Adele M., ed. *Visualizing Ireland: National Identity and the Pictorial Tradition*. Boston: Faber and Faber, 1993.

Davis, Gerald. "Irish Art – Does it Exist?: Illusive or Allusive?" *Studies*, 81, No. 321 (Spring 1992), pp. 7–13.

De Breffny, Brian, ed. *Ireland: A Cultural Encyclopedia*. New York: Facts on File, 1983.

Deane, Seamus. "Synge's Western Worlds." *Threshold*, 29 (Autumn 1978), pp. 25–42.
"The Longing for Modernity." *Threshold*, 32 (Winter 1982), pp. 1–7.
ed. *The Field Day Anthology of Irish Writing*. Derry, Northern Ireland: Field Day Publications, 1991.

Directions Out: An Investigation into a selection of artists whose work has been formed by the post-1969 situation in Northern Ireland. Dublin: Douglas Hyde Gallery, 1987.

Duddy, Tom. "Irish Art Criticism: A Provincialism of the Right?" *Circa*, 35 (July/August 1987), pp. 14–18.

Eagleton, Terry. *Heathcliff and the Great Hunger: Studies in Irish Culture*. London and New York: Verso, 1995.

Edwards, Owen Dudley. *Eamon de Valera*. Cardiff: GPC Books, 1987.

Edwards, O. Dudley and T. Desmond Williams, eds. *The Great Famine*. Dublin: Lilliput Press, 1995.

Fallon, Brian. *Irish Art, 1830–1990*. Belfast: Appletree Press, 1994.

Fallon, Brian. "Irish Painting in the fifties." *Arts in Ireland*, 3 (n.d.), pp. 24–36.

Five Irish Painters: Thurloe Conolly, Gerard Dillon, Nevill Johnson, Colin Middleton, Daniel O'Neill. London: Arthur Tooth & Sons, Ltd., 1951.

Foster, Robert F. *Modern Ireland, 1600–1972*. London: Allen Lane, The Penguin Press, 1988.

Fowler, Joan. "Art and Independence: An Aspect of Twentieth Century Irish Art." *Circa*, 14 (January/February 1984), pp. 6–10.

From Beyond the Pale: Art and Artists at the Edge of Consensus. Dublin: Irish Museum of Modern Art, 1994.

Gibbons, Luke. *Transformations in Irish Culture*. Notre Dame, Indiana: Univ. of Notre Dame Press, 1996.

Gillespie, Raymond and Brian P. Kennedy, eds. *Ireland: Art into History*. Dublin: Town House; Niwot, Colorado: Roberts Rinehart Publishers, 1994.

Harbison, Peter and Homan Potterton and Jeanne Sheehy. *Irish Art and Architecture from Prehistory to the Present*. London: Thames and Hudson, 1978.

Hewitt, John Harold. *Art in Ulster: 1*. Belfast: Blackstaff Press, 1977.

Higgins, Judith. "Art from the Edge (Part I)." *Art in America*, 83, no. 12 (December 1995), pp. 37–43.
"Art from the Edge (Part II)." *Art in America*, 84, No. 4 (April 1996), pp. 56–63.

Hughes, Eamon, ed. *Culture and Politics in Northern Ireland, 1960–1990*. Milton Keynes, England and Philadelphia, Penn.: Open University Press, 1991.

In a State: An Exhibition in Kilmainham Gaol on National Identity. Dublin: Project Arts Centre, 1991.

Inheritance and Transformation. Dublin: Irish Museum of Modern Art, 1991.

Innovation from Tradition: Some Recent Irish Art. Dublin: Department of Foreign Affairs, 1996.

Irish Art, 1770–1995: History and Society. A touring exhibition from the collection of the Crawford Municipal Art Gallery. Cork, Ireland: City of Cork, VEC, 1995.

Irish Art 1900–1950. Cork, Ireland: Rosc Chorcaí, 1975.

Irish Art, 1943–1973. Cork, Ireland: Rosc Chorcaí, 1980.

Irish Art: A Volume of Articles and Illustrations. Dublin: The Parkside Press Ltd., 1944.

Irish Art Handbook. Dublin: Cahill and Company Limited, 1943.

Irish Art Loan Exhibitions, 1765–1927. 3 vols. Dublin: Manton Publishing, 1990–95.

Irish Art: The European Dimension. Dublin: An Chomhairle Ealaíon/The Arts Council, 1990.

Irish Directions. Dublin: Irish Printers Limited, 1974.

Irish Renascence: Irish Art in a Century of Change. London: Pyms Gallery, 1986.

Irish Women Artists: From the Eighteenth Century to the Present Day. Dublin: The National Gallery of Ireland and the Douglas Hyde Gallery, 1987.

Irish Women: Image and Achievement. Dublin: Arlan House, 1985.

Kearney, Richard, ed. *Across the Frontiers: Ireland in the 1990s.* Dublin: Wolfhound Press, 1988.

Kelly, Liam. *Thinking Long: Contemporary Art in the North of Ireland.* Kinsale, Co. Cork: Gandon, 1996.

Kennedy, Brian P. *Dreams and Responsibilities: The State and Art in Independent Ireland.* Dublin: Arts Council, 1990.
Irish Painting. Dublin: Town House, 1993.

Kennedy, S.B. *Irish Art and Modernism, 1880–1950.* Belfast: The Institute of Irish Studies at The Queen's University of Belfast, 1991.

Kiberd, Declan. *Inventing Ireland: The Literature of the Modern Nation.* London: Vintage, 1996.

Knowles, Roderic. *Contemporary Irish Art.* Dublin: Wolfhound Press, 1982.

Labour in Art: Representations of Labour in Ireland (1870–1970). Dublin: Irish Museum of Modern Art, 1994.

Lippard, Lucy R. *Divisions, Crossroads, Turns of Mind: Some New Irish Art.* Madison, WI: Ireland America Arts Exchange Inc., 1985.

Loftus, Belinda. *Mirrors: William III and Mother Ireland.* Dundrum, Co. Down, Northern Ireland: Picture Press, 1990.

Longley, Michael, ed. *Causeway: The Arts in Ulster.* Belfast: Arts Council of Northern Ireland, 1971.

MacCarvill, Eileen, ed. *The Artist's Vision: Lectures and Essays on Art.* Dundalk, Ireland: Dundalgan Press, Ltd., 1958.

MacCurtain, Margaret and Donncha Ó Corráin. *Women in Irish Society: The Historical Dimension.* Westport, Conn.: Greenwood Press, 1979.

Maguire, Brian and Patrick Hall, Timothy Hawksworth, Patrick Graham, and Seamus Heaney. "On Irish Expressionist Painting." *The Irish Review*, 3 (1988), pp. 26–39.

Manning, Maurice and Moore McDowell. *Electricity Supply in Ireland: The History of the ESB.* Dublin: Gill and Macmillan, 1984.

McAvera, Brian. *Art, Politics and Ireland.* Dublin: Open Air Press, 1990.

McConkey, Kenneth. *A Free Spirit: Irish Art, 1860–1960.* London: Antique Collectors Club, 1990.
Impressionism in Britain and Ireland. Dublin: Hugh Lane Municipal Gallery of Modern Art, 1995.

Mac Giolla Léith, Caoimhín. "Contemporary Irish Art: A Well-kept Secret?", *Contemporary Art*, 1, No. 4 (Summer 1993), pp. 25–28.

McGonagle, Declan. "Looking Beyond Regionalism." *Circa*, 53 (Sept./Oct. 1990), pp. 26–27.

McGreevy, Thomas. "Developments in the Arts." *Studies*, XL, No. 160 (Dec. 1951), pp. 475–78.

McRedmond, Louis, ed. *Modern Irish Lives: Dictionary of 20th-Century Irish Biography.* New York, N.Y.: St. Martin's Press, 1996.

McWilliams, Joseph. "Violence and Painting in Northern Ireland." *Circa*, 4 (May/June 1982), p. 7.

Moffett, Margot. "Young Irish Painters." *Horizon*, XI, No. 64 (April 1945), pp. 261–67.

Moynahan, Julian. *Anglo-Irish: The Literary Imagination in a Hyphenated Culture.* Princeton, N.J.: Princeton Univ. Press, 1995.

Murphy, Donie. *"The Men of the South" in the War of Independence.* Newmarket, Co. Cork: Inch Publications, 1991.

O'Brien, Conor Cruise. *Ancestral Voices: Religion and Nationalism in Ireland.* Dublin: Poolbeg Press Ltd., 1994.

O'Brien, George. *The Four Green Fields.* Dublin: The Talbot Press, Limited, 1936.

O'Céirín, Kit and Cyril. *Women of Ireland: A Biographic Dictionary.* Minneapolis, Minn.: Irish Books and Media, Inc., 1996.

O'Grady, John M. *The Life and Work of Sarah Purser.* Blackrock, Ireland: Four Courts Press, 1996.

On the Balcony of the Nation. Belfast: The Arts Council of Northern Ireland, 1990.

100 Years of Irish Art: The Oriel Gallery Silver Jubilee. Dublin: Oriel Gallery, 1993.

Overy, Paul. *Hibernian Inscape – A Selection of 12 Irish Artists.* Dublin: Douglas Hyde Gallery, 1980.

Parable Island – Some Aspects of Recent Irish Art. Liverpool, England: Bluecoat Gallery, 1991.

Plunkett, Sir Horace. *Ireland in the New Century.* New York: E.P. Dutton & Company, 1908.

Poetic Land – Political Territory: Contemporary Art from Ireland. Sunderland, Great Britain: Northern Centre for Contemporary Art, 1995.

Rockett, Kevin. *Cinema and Ireland.* Syracuse, N.Y.: Syracuse Univ. Press, 1988.

Sharpe, Henry J. *Making Sense: Ten Irish Artists, 1963–1983.* Dublin: Project Arts Centre, 1983.
Patrick Graham/Brian Maguire. Belfast: Octagon Gallery, 1984.

Sheehy, Edward. "Recent Irish Painting: The Irish Exhibition of Living Art, 1950." *Envoy*, 3, No. 10 (Sept. 1950), pp. 45–52.

Sheehy, Jeanne. *The Rediscovery of Ireland's Past: The Celtic Revival 1830–1930.* London: Thames and Hudson, 1980.

Six Artists from Ireland: An Aspect of Irish Painting. Dublin: Arts Council, 1983.

Smyth, Ailbhe. "Feminism in the South of Ireland – A Discussion." *The Honest Ulsterman*, 83 (Summer 1987), pp. 41–58.

Snoddy, Theo. *Dictionary of Irish Artists: 20th Century.* Dublin: Wolfhound Press, 1996.

Stevenson, Mary Lou Kohlfeldt. *Lady Gregory: The Woman behind the Irish Renaissance.* New York: Atheneum, 1985.

Strickland, Walter G. *A Dictionary of Irish Artists.* 2 vols. Dublin: Maunsel & Company, Ltd., 1913.

Synge, J.M. *The Playboy of the Western World and other Plays.* Oxford: Oxford Univ. Press, 1995.

"The Artist Speaks: Five Irish Painters join in a Symposium of Artistic Opinion." *Envoy*, 4, No. 15 (February 1951), pp. 38–44.

The Delighted Eye: Irish Painting and Sculpture of the Seventies. Belfast: Arts Council of Northern Ireland; Dublin: An Chomhairle Ealaíon/The Arts Council, 1980.

The Fifth Province: Some Contemporary Art from Ireland. Edmonton, Alberta: Edmonton Art Gallery, 1991.

The Irish Imagination 1959–1971. Dublin: An Chomhairle Ealaíon, 1971.

The Irish Pavilion/Brian Maguire + Sheila O'Donnell and John Tuomey. Dublin: Gandon Editions, 1992.

The Irish Revival. London: Pyms Gallery, 1982.

Tóibín, Colm. *The South.* New York: Viking, 1991.
The Heather Blazing. New York: Viking, 1993.
Bad Blood: A Walk along the Irish Border. Vintage, 1994.

Ward, Margaret. "Feminism in the North of Ireland – A Reflection." *The Honest Ulsterman*, 83 (Summer 1987), pp. 59–70.

White, James. "The Visual Arts in Ireland." *Studies*, 44 (Spring 1955), pp. 101–08.

Wynne, Michael. *Fifty Irish Painters.* Dublin: National Gallery of Ireland, 1983.

Notes on Contributors

BRUCE ARNOLD is Literary Editor of the *Irish Independent*, where he is also Political Columnist and Chief Critic, covering art and theater. Educated in England and Trinity College, Dublin, he joined *The Irish Times* in 1961 and has worked as a journalist in Dublin ever since. He is the author of twelve books, including *A Concise History of Irish Art* (1969), *Orpen: Mirror to an Age* (1981), *Mainie Jellett and the Modern Movement in Ireland* (1991), and a forthcoming life of Jack B. Yeats (Yale University Press). Arnold is also the author of four novels, has made four films (two on the life of James Joyce), and is the librettist for *A Passionate Man*, an opera about Jonathan Swift.

DR. SIGHLE BHREATHNACH-LYNCH is a Dublin-based art historian and writer. She teaches regularly at University College Dublin and at the Open University, and lectures on a regular basis at the National Gallery of Ireland. An expert on Irish art of the nineteenth and early twentieth centuries, she explores issues of national identity, the role of women in Irish art, and politics and public monuments. She is currently researching a book on early twentieth-century Irish sculpture.

AIDAN DUNNE studied at Ireland's National College of Art and Design. He has been art critic of *In Dublin* magazine, *The Sunday Press*, and *The Sunday Tribune*, and is currently art critic of *The Irish Times*. He has contributed to numerous publications and catalogues on contemporary Irish art, and has written monographs on several artists.

MARIANNE HARTIGAN is a Dublin-based journalist and critic. She holds a B.A. in Art History and Archaeology, and an M.A. in Art History from University College Dublin, as well as a postgraduate diploma in journalism from Dublin City University. She has written extensively on the life and work of Norah McGuinness.

JOHN LOSITO has served as Research Assistant on this exhibition, and is, since March 1998, Assistant Curator at the Berkeley Art Museum. He received an M.A. in art history from the University of California, Los Angeles.

CAOIMHÍN MAC GIOLLA LÉITH teaches in the Department of Modern Irish at University College Dublin, where he is also currently Director of Film Studies. He has published extensively on various aspects of Irish literature, both medieval and modern, and on contemporary art.

KENNETH MCCONKEY is Dean of the Faculty of Arts and Design at the University of Northumbria at Newcastle. A specialist in turn-of-the-century British and French art, he has been involved with numerous exhibitions, including monographic shows of the work of Henry La Thangue (1978), Sir George Clausen (1980), and Sir John Lavery (1984), along with important survey exhibitions of British and Irish Impressionism. He is the author of *Edwardian Portraits: Images of an Age of Opulence* (1987), *British Impressionism* (1989), *A Free Spirit: Irish Art 1860–1960* (1990), and *Sir John Lavery* (1993). Professor McConkey is a Fellow of the Royal Society of Arts.

DR. PAULA MURPHY is College Lecturer in the Department of the History of Art at University College Dublin. She holds the B.A., M.A., and Ph.D. from UCD, where she wrote her dissertation on the nineteenth-century Irish sculptor Thomas Farrell. She writes and lectures frequently on Irish art and modernism, with a particular emphasis on nineteenth- and twentieth-century Irish sculpture. She is a past member of the Advisory Committee to the Hugh Lane Municipal Gallery of Modern Art, and has been a board member of the Irish Museum of Modern Art since 1995.

PETER MURRAY is Curator of the Crawford Municipal Art Gallery in Cork, Ireland. He studied art history at University College Dublin and was awarded an M. Litt. degree for a thesis on the nineteenth-century Irish artist and antiquarian George Petrie. He has written extensively on nineteenth- and twentieth-century Irish art, and organized the traveling exhibition *Irish Art 1770–1995: History and Society*.

DR. JAMES CHRISTEN STEWARD is organizing curator of the present exhibition for Berkeley Art Museum, where he was formerly Chief Curator; he is currently Director of the University of Michigan Museum of Art. A specialist in European painting and architecture of the eighteenth through twentieth centuries, he has organized or prepared major exhibitions on the art of Edvard Munch (1993), Gertrude Jekyll (1993), William Hogarth (1997), Greene and Greene (1996), and Bernard Maybeck (1997). He is the author of *The New Child: British Art and the Origins of Modern Childhood, 1730–1830* (1995), and *The Mask of Venice: Masking, Theater, and Identity in the Art of Tiepolo and His Times* (1997). He studied at the University of Virginia and the Institute of Fine Arts at New York University, and holds a doctorate in the history of art from Oxford University.

COLM TOÍBÍN is an award-winning novelist whose sixth and most recent book is *The Story of the Night* (1997). Born in Ireland in 1955, he is also the author of *The South*, which won the Irish Times/Aer Lingus Prize, and *The Heather Blazing*, which won the Encore Prize for the best second novel published in England in 1992. He is the author of three travel books, *Homage to Barcelona*, *The Sign of the Cross: Travels in Catholic Europe*, and *Bad Blood: A Walk Along the Irish Border*, the account of a walk along the Irish border from Derry to Newry the summer after the Anglo-Irish Agreement.

Index

Figure numbers are given in italic.
Plate numbers are given in bold.